Assembling a Black Counter Culture
DeForrest Brown, Jr.

Primary Information

Table of Contents

Two Idealized Alternative Future Outcomes to the Threat of Overshooting the Carrying Capacity of "Spaceship Earth"

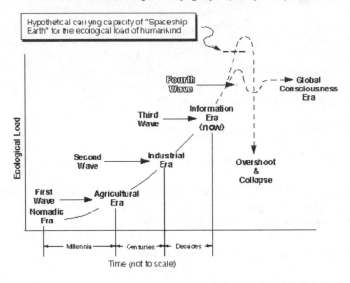

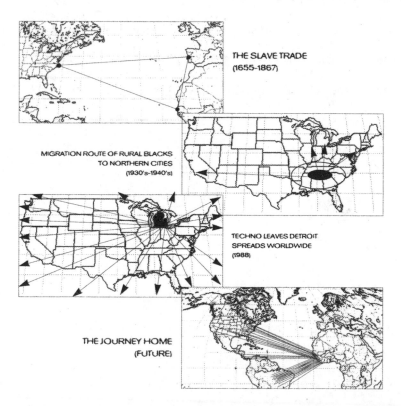

THE SLAVE TRADE
(1655–1867)

MIGRATION ROUTE OF RURAL BLACKS
TO NORTHERN CITIES
(1930's–1940's)

TECHNO LEAVES DETROIT
SPREADS WORLDWIDE
(1988)

THE JOURNEY HOME
(FUTURE)

WHITE SILENCE: INTRODUCTORY NOTES ON HOW THE WEST WAS WON

"You gotta look at it like, techno is technological. It's an attitude to making music that sounds futuristic: something that hasn't been done before."[1]

– Juan Atkins

"An imitation may be quite successful in its own way, but imitation can never be Success. Success is a first-hand creation."[2]

– Henry Ford

The primary intention of this book is to detach the term "techno" from the electronic dance music culture industry and the British lexical standard of the hardcore continuum[3] to reconsider its origins in the community of Detroit and its context within African American history. Formulated out of an intuitive response to the urban degradation plaguing Detroit and other cities around the United States in the late twentieth century, techno is evidence of post-Civil Rights Movement Black youth adapting to the industrialized Northern states, using the technology available; techno is not, as is widely believed, a generic component of the globalized drug-induced

1 Juan Atkins, quoted in Jon Savage, "Machine Soul: A History of Techno," *Village Voice* (Summer 1993), Rock & Roll quarterly insert, n.p.

2 Henry Ford, *Ford Ideals: Being a Selection from "Mr. Ford's Page" in the* Dearborn Independent (Dearborn, MI: The Dearborn Publishing Company, 1922), 67.

3 Between 1992 and 1999, music journalist Simon Reynolds documented "a continuum of musical culture that emerged out of the British rave scene," published as a six-part series in *The Wire* magazine: "I call it a 'continuum' because that's what it is: a musical tradition/subcultural tribe that's managed to hold it together for nearly 20 years now, negotiating drastic stylistic shifts and significant changes in technology, drugs, and the social/racial composition of its own population. It's been a bumpy but exhilarating ride, but let no one doubt that it's the same rollercoaster at every stage of the journey (a ride which most likely has yet to reach its end). And I call it 'Hardcore' because the tradition started to take shape circa 1990 with what people called Hardcore Techno or Hardcore Rave, or sometimes simply Ardkore. These early sounds – bleep tunes from the North East, breakbeat house and ragga techno from London – were the first time that the UK came up with its own unique mutant versions of House and Techno (ironically by adding elements from dub reggae, dancehall, and hip hop that weren't British in origin, but equally would never have been let into the mix back in Chicago and Detroit). From Jungle and 2-step to today's Grime and Bassline, the basic parameters of the music have stayed the same as they were in the early Hardcore, although the relative balance of various sources (reggae, rap, R&B, Eurotechno, etc) has shifted, and the beats-per-minute rate has fluctuated wildly. Those core elements are: beat-science seeking the intersection between 'fucked up' and 'groovy'; dark bass pressure; MCs chatting fast over live-mixed DJ sets; samples and arrangement ideas inspired by pulp soundtracks and orchestrated pop. In a profound sense, underneath two decades of relentless sonic mutation, this is the same music, the same culture. What's also endured has been the scene's economic infrastructure: pirate radio stations, independent record shops (often in out-of-the-way urban areas), white labels and dubplates, specific rave promoters and clubs (again often in the less glitzy, non-central areas of cities)." Reynolds, *"The Wire* 300: Simon Reynolds on the Hardcore Continuum: Introduction," *The Wire*, February 2013, https://www.thewire.co.uk/in-writing/essays/the-wire-300_simon-reynolds-on-the-hardcore-continuum_introduction.

nightlife economy.[4] At the same time, techno attests to a collective engineering of stereophonic intelligence, a modernized method of Black expression that would transform the African American musical continuum of the slave song, the Negro Spiritual, blues, and jazz, spanning several centuries, into a technologically optimized form of soul music.

Juan Atkins first encountered the term "techno" in futurist and businessman Alvin Toffler's 1980 book *The Third Wave*, which describes the transition of "developed" nations from industrial manufacturing to data-driven enterprise. Atkins was assigned the volume as a textbook in a class called "Future Studies," and Toffler's concepts would present a promising theoretical backdrop for him as he began to experiment with his first electronic instruments at home. A sequel to his *Future Shock* (1970), which sought to define the cognitive states of societies living under the condition of "too much change in too short a period of time,"[5] *The Third Wave* detailed what Toffler suspected to be the long-term psychological and social effects of living in planned environments within a "one size fits all" model of technological production. Toffler warned of the Industrial Revolution's potential to destabilize class mobility and communities through a "technocratic divide" that favors the "informed" opinions of technical experts over a marginalized, and presumably unreliable, general public.[6] In short, Toffler concluded that within a technological society there exist two castes; when that society owned slaves to kickstart the process of developing such a system, the humanity of the undesignated caste became a dangerous loophole in the human condition.

Atkins' use of the prefix "techno" was in direct reference to the word "technology," which etymologically combines the idea of art or craft with emergent early-seventeenth-century logic stemming from the Greek word *tekhnologia*, meaning "systematic treatment."[7] It can also be considered a reference to Toffler's use of the word "technocracy," designating a society or governing system led by an elite class of technical experts who build platforms of production for a class of largely unskilled

4 Anthropologist and anarchist activist David Graeber describes an early example of economic barter systems amongst the Nambikwara population of Brazil as a kind of party, or rave, in which hundreds of people who were oftentimes "strangers, even enemies," negotiate the terms of a stock and exchange before "everyone puts aside their weapons to sing and dance together—though the dance is one that mimics military confrontation." David Graeber, *Debt: The First 5,000 Years* (Brooklyn: Melville House, 2011), 29–30.

5 "In 1965, in an article in *Horizon*, I coined the term 'future shock' to describe the shattering stress and disorientation that we induce in individuals by subjecting them to too much change in too short a time. Fascinated by this concept, I spent the next five years visiting scores of universities, research centers, laboratories, and government agencies, reading countless articles and scientific papers and interviewing literally hundreds of experts on different aspects of change, coping behavior, and the future. Nobel prizewinners, hippies, psychiatrists, physicians, businessmen, professional futurists, philosophers, and educators gave voice to their concern over change, their anxieties about adaptation, their fears about the future." Alvin Toffler, *Future Shock* (New York: Random House, 1970), 4.

6 Alvin Toffler, *The Third Wave* (New York: Bantam Books, 1980), 354.

7 Henry George Liddell and Robert Scott, *A Greek-English Lexicon*, abridged ed. (Oxford, UK: Oxford University Press, 1980).

consumers. Toffler's writing is a sober consideration of what American culture would eventually become: a civilization that treats the world and ways of living systematically, wherein society serves as a kind of medical treatment for humanity, pulling humans out of their "savage" engagements with nature. When factoring in the specificity of African Americans' four-hundred-year history of oppression by an exclusively white European colonial governing body, this understanding of technocracy appears a lot more sinister. Industry, as an operable structure in America, designates specific options within a set of limited, infallible conditions that extract hourly labor and statistical information from Americans to buffer natural materials towards projected immaterial gain in an imagined "future."

Twentieth-century understandings of society and culture irrevocably updated the value of nature and experience with the introduction of what Toffler calls a "collision of waves." These waves exist across the Western world's engagements with collections of individuals and their perceptually owned environments, extending across techniques for cultivating a living condition in which nature nurtures the individual by means of distributed ownership. Space and place—as well as the people occupying both—become potentially limitless resources. Analyzing history as a "succession of rolling waves of change" with a potential leading edge, Toffler describes the development of the United States in three waves: 1. Agriculture, 2. Industry, and 3. Information. A 1995 interpretation of Toffler's alternative futures prediction by professor Oliver W. Markley illustrated in the previous pages of this book focuses on the possibility that society may be headed for a "mega-crisis" as waves of change usher the man-made experiment of civilization forward, into an era of either sustainability or collapse. Also referencing Buckminister Fuller's 1969 book *Operating Manual for Spaceship Earth*, Markley sought to chart "two idealized alternative future outcomes to the threat of overshooting the carry capacity of 'Spaceship Earth.'"[8] When considering the development of capital and empire through twentieth-century urban planning and technology, the annexing and reformatting of labor extraction must be brought into question as well. From 1619, when the first West Africans were brought to American shores by the transatlantic slave trade,[9] to today, African Americans have lived in the United States as *de facto* hostages under the conditions of an unspoken second-class citizenship, bearing the full brunt of the atrocities of the white colonial death drive in the "New World."

The sound of techno exists as a peak intersection in Black history, reorganizing centuries of African American cultural expressions under capital and empire into a material and usable vibrational technology. While enslaved by British and European

8 Oliver W. Markley, "Global Consciousness: An Alternative Future of Choice," *Futures* 28, no. 6/7 (August–September 1996): 623.

9 Beth Austin, "1619: Virginia's First Africans," Hampton History Museum, December 2018, https://hampton.gov/DocumentCenter/View/24075/1619-Virginias-First-Africans?bidId=.

colonizers on the American continents, captured West Africans, who were kept from learning to read or write,[10] adapted a tradition of vocal outcries, which became songs, and redesigned a culture from remnants of rituals recuperated from their former homelands, communicating the grooves and passageways of a subalternate social reality through movement and dance.[11] The term "Black music" refers to a kind of music that is completely removed from the entire context of white European history, knowledge, and opinion[12]—a direct result of Black people strategically learning to feel, speak, and be heard while in bondage.[13]

As a matter of function, this book draws a direct correlation between the abolishment of the chattel slavery of African Americans and the rise of modern industrial complexes fueled by human bodies.[14] The agricultural revolutions between the seventeenth and nineteenth centuries sectioned off plots of land as a formal zone of habitation: those living within it also occupied it as laborers. The Industrial Revolution optimized space with technologies that smoothed out the hardship of labor. Finally, the digital revolution transformed every resource, product, and laborer into a calculable imaginary whose existence is abstracted and consolidated into a singular, manageable use-value. Within a matter of decades, Americans' relationship to labor, production, and ownership shifted from being independently cultivated as a private entrepreneurial practice by individuals living amongst and in semi-collaboration with other individuals, to a multiscale managerial model under which workers and their labor are consolidated into large organizational structures. Rather than produce for oneself, one's family, and one's community, the American worker began to offer their labor in the name of a greater good designated by corporate and government leaders. The dual decline of civilization and socialization is a process and result of gross extraction and accumulation. What America considers "normal" is an unfortunate white supremacist standard, preceded and set to scale by the communally sanctioned and justified mass murder of native peoples of the Americas and the kidnapping, torture, and enslavement of multiple factions of West African tribes who would be renamed "Negro."[15] Consequently,

10 Smithsonian American Art Museum, "The American Experience in the Classroom: Literacy as Freedom," https://americanexperience.si.edu/wp-content/uploads/2014/09/Literacy-as-Freedom.pdf.

11 W. E. B. Du Bois, *The Souls of Black Folk* [1903] (New York: Barnes & Noble Classics, 2003), 177. See also Kariamu Welsh-Asante, *African Dance* (Trenton, NJ: Africa World Press, 2002), xv.

12 Du Bois, ibid. See also Amiri Baraka, *Blues People: Negro Music in White America* (New York: Harper Perennial, 1963), 17.

13 "Slave families were completely shattered and cultural continuity almost totally disrupted. The Blacks who were kidnapped and dragooned to these shores were not only stripped of most of their native African languages. They were forced to speak in the tongue of the masters and to adapt to the master's culture. In short, Blacks were the victims of a pervasive cultural imperialism which destroyed all but faint remnants (chiefly in music) of the old African forms." Robert L. Allen, *Black Awakening in Capitalist America: An Analytic History* (Trenton, NJ: Africa World Press, 1992), 13.

14 Cedric J. Robinson, *On Racial Capitalism, Black Internationalism, and Cultures of Resistance*, ed. H. L. T. Quan (London: Pluto Press, 2019), 9.

15 Alexander Falconbridge, *An Account of the Slave Trade on the Coast of Africa* (London: J. Phillips, 1788).

8

the United States operates as an experiment seeking to replicate what a society and nation state could look like when starting from a cultural and ethnic blank slate. While civilizations have advanced since the Neolithic era through waves of agricultural, industrial, and most recently, digital revolutions, within the context of American colonialism by European nations and the importation of varying ethnically distinct West Africans to a place populated by indigenous communities, several waves of human development were collapsed into the five-hundred-year-long formative project of redesigning the Americas into the compositional structure of the United States. One must imagine Europe's understanding of the uncharted landscape of the Americas as a blank slate devoid of history and lived or inscribed experience.

The initial voyages of Christopher Columbus across the Atlantic Ocean in 1492 initiated a process of expansion of the Western world into a broader formation. Columbus' landing in what is presently known as the Bahamas Islands—named Guanahani by the indigenous population who occupied them—was an accidental discovery that began a process of cultural study, quasi-assimilation, and extraction.[16] On a second voyage to the Americas, Columbus captured upwards of 1,500 Taino people from South America and the Caribbean, with the intention of establishing a captive labor force to cultivate the surrounding environment and generate income for the Spanish state. Of that 1,500, five hundred were brought to Spain by Columbus— only two hundred would survive the journey to be surveyed by the Royal family before being released and sent back to America.[17] Many became deathly sick due to contact with the Europeans, and the Taino population was almost entirely wiped out.[18] Add to Columbus' "discovery" of the "New World" the capture and trade of slaves across the Atlantic Ocean: close to 12 million Africans are estimated to have survived the journey to North America, the Caribbean, and South America between 1525 and 1866, according to the Trans-Atlantic Slave Trade Database.[19] Historian Henry Louis Gates Jr. reports that, "In fact, an overwhelming percentage of the African slaves were shipped directly to the Caribbean and South America; Brazil received 4.86 million Africans alone!" He documents that another sixty to seventy thousand Africans were

16 "On December 4, 1492, Columbus escaped the onshore winds that had prevented his departure from the island that we now call Cuba. Within a day he dropped anchor off the coast of a larger island known to its people as Quisqueya or Bohio, setting into motion what historians call the 'conquest pattern.' It's a design that unfolds in three phases: the invention of legalistic measures to provide the invasion with a gloss of justification, a declaration of territorial claims, and the founding of a town to legitimate and institutionalize the conquest. The sailors could not have imagined that their actions that day would write the first draft of a pattern whose muscle and genius would echo across space and time to a digital twenty first century." Shoshana Zuboff, *The Age of Surveillance Capitalism* (New York: Public Affairs, 2019), 176.

17 Howard Zinn, *A People's History of the United States, 1492-Present* (New York: Perennial Classics, 2003), 4–5. See also Gerald Horne, *The Dawning of the Apocalypse* (New York: Monthly Review, 2020), 56.

18 Robert M. Pool, "What Became of the Taino?" *Smithsonian Magazine*, October 2011, https://www.smithsonianmag.com/travel/what-became-of-the-taino-73824867/.

19 Slave Voyages: Trans-Atlantic and Intra-American Slave Trade Databases, https://www.slavevoyages.org/voyage/database.

9

eventually transported to the United States from the Caribbean, remarking, "Incredibly, most of the 42 million members of the African-American community descend from this tiny group of less than half a million Africans. And I, for one, find this amazing."[20] Together, these colonial enterprises in the New World pioneered the transformation of domestic, indentured servitude, which had existed on the European and African continents for thousands of years, into a multinational economic enterprise.[21]

Capitalizing on the fragmentation and colonization of Africa in the sixteenth century, the transatlantic slave trade began the project of mechanical reproduction of European culture and ideology onto foreign soil. Much like a viral entity woven into the fabric of the Americas, Europe constructed an imaginary empire, participatory sport, and collective psychosis that expanded even further with the Industrial Revolution of the 1800s, which accelerated the landscaping and design of this newly captured space. The twentieth century, in comparison, could be considered interior decoration. American legal, constitutional, financial, and amendment documents are game pieces towards a fictional world of normalcy. Though the land of the Americas had been "tamed," modes of living had to be organized to effectively fuel the country's economy through industry, leading to a mass standardization of culture around labor and leisure as a subtle and effectively progressive form of continued colonialism. As a societal framework, the United States is decidedly malleable and erasable, and first and foremost, religiously ideological.

By 2021, the indigenous population had been reduced to 6.79 million[22] from a presumed 145 million throughout the nineteenth century,[23] and the America that had come into formation was steeped in fractured European values, distorted Christian Science, and a systematic process for reproducing the appearance of a structurally sound ethno-state, which would at no time acknowledge its torture of the African American population or the near decimation of indigenous peoples. According to the 1950 US census, white Americans formed 90% of the population; at this point in the long-term project of the colonization of America, individuals from Europe who now

20 Henry Louis Gates, Jr., "How Many Slaves Landed in the US?" *The Root*, January 6, 2014.

21 James C. Clark, "How Columbus Created Slave Trade That Changed the World's Economy," *Orlando Sentinel*, May 17, 1992.

22 "Native American Population 2021," *World Population Review*, https://worldpopulationreview.com/state-rankings/native-american-population; Russell Thornton, "Population History of Native North Americans," in Michael R. Haines and Richard Hall Steckel, eds., *A Population History of North America* (Cambridge: Cambridge University Press, 2000), 36.

23 "In the 1940s and 1950s conventional wisdom held that the population of the entire hemisphere in 1492 was little more than 8,000,000—with fewer than 1,000,000 people living in the region north of present-day Mexico. Today, few serious students of the subject would put the hemispheric figure at less than 75,000,000 to 100,000,000 (with approximately 8,000,000 to 12,000,000 north of Mexico), while one of the most well-regarded specialists in the field recently has suggested that a more accurate estimate would be around 145,000,000 for the hemisphere as a whole and about 18,000,000 for the area north of Mexico." David E. Stannard, *American Holocaust: Columbus and the Conquest of the New World* (New York: Oxford University Press, 1992), 11.

called themselves Americans had successfully seized control over the entirety of a continent.[24] The color-based designation of race has long organized the inheritors of this wealth and free land into a hierarchical caste system. Race, as opposed to ethnicity, operates as classification towards an economic ordinance, irrevocably branding African Americans as "Negroes."[25] In other words, American-born African descendants of the slave class are designated as being in an existential Black region, without wealth or value. While Black and white Americans have inhabited the same country for nearly half a millennium, the political and social dynamics structured by the transatlantic slave trade, continued through Jim Crow-era segregation and optimized into modern forms of perpetuated systemic racism, have ensured that two timelines of the American narrative exist in tandem, with much violent crossover. Because of the status of Black Americans and their labor contributions while enslaved, a more rigorous material examination must take place if there is to be any understanding of what it means to live a Black life, as structurally subordinate to both workers and elites who wield and gamble a free-market democratic economy built on the extraction and exploitation of Black bodies. As a reference text, this book intends to assemble an alternative view of the future from Black historical analyses and a contextual reexamination of articles, liner notes, interviews, and books published on the electronic dance music industry during the late-twentieth-century advent of technological and economic global consciousness.

In 1969, scholar Theodore Roszak published *The Making of a Counter Culture: Reflections on the Technocratic Society,* a book that circulated widely amongst hippies, beatniks, Vietnam veterans, radical student groups, and other categories of white American youth rebels who related to Roszak's opposition to the complex organizational structures of the technology-dominated society that had taken shape around them. White suburban inheritors of colonial wealth, guilt, and trauma—what Roszak called "technocracy's children"—were born into a technocratic regime run by industry experts. The youth of the 1960s were expected to fulfill specific roles in the industrial labor force, reinforce the nuclear family model, and invest in a prospective "future" of economic possibility from the basis of their generational inheritance. Roszak considered the counter culture to be a type of "matrix in which an alternative, but still excessively fragile future is taking shape."[26] Somewhat unconcerned with the holistic social stratification of people and cultures inhabiting and struggling against the United States and white hegemonic social structures, Roszak privileged white

24 Campbell Gibson and Kay Jung, "Historical Census Statistics on Population Totals by Race, 1790 to 1990, and by Hispanic Origin, 1970 to 1990, for the United States, Regions, Divisions, and States, US Census Bureau, Population Division," working paper no. 56, Washington, DC, September 2002, https://www.census.gov/content/dam/Census/library/working-papers/2002/demo/POP-twps0056.pdf.

25 Du Bois, "Of Our Spiritual Strivings," in *The Souls of Black Folk*, 7.

26 Theodore Roszak, *The Making of a Counter Culture: Reflections on the Technocratic Society and Its Youthful Opposition* (Garden City, NY: Anchor Books, 1969), xiii.

youth culture as the torchbearer of the epic of America: his scholarship delimited who can resist cultural optimization in a capitalist industrial complex. For him, the struggle against Black oppression in America was not part of the purview of the movements animating white collegiate youth:

At this point, the counter culture I speak of embraces only a strict minority of the youth and a handful of their adult mentors. It excludes our more conservative young, for whom a bit less Social Security and a bit more of that old-time religion (plus more police on the beat) would be sufficient to make the Great Society a thing of beauty. It excludes our more liberal youth, for whom the alpha and omega of politics is no doubt still that Kennedy style. It excludes the scattering of old-line Marxist youth groups whose members, like their fathers before them, continue to tend the ashes of the proletarian revolution, watching for a spark to leap forth. More importantly, it excludes in large measure the militant black young, whose political project has become so narrowly defined in ethnic terms that, despite its urgency, it has become as culturally old-fashioned as the nationalist mythopoesis of the nineteenth century. In any event, the situation of black youth requires such special treatment as would run to book length in its own right.[27]

This book seeks to acknowledge the obvious legitimacy and significance of Black liberation and fulfill the required "special treatment" that the situation of Black youth deserves. Techno music was invented by the Black youth of Detroit and inherited by the Black youth of today: it expresses an inherent romance and trauma that carries with it centuries worth of stories. Toffler wrote of techno-rebels who could gain access to the very technology intended to maintain and operate the living standards of white American society, and utilize it as "the basis for humanizing the technological thrust."[28] He instructed his readers not to take for granted how novel and unpredictable a technological society is. This book hopes to establish an understanding of the African American experience as distinct from, though intertwined with, the chaos of the twentieth century and the creation of the future.[29]

Assembling a Black Counter Culture has several anchors, which collectively depict another plane of existence, communicated by the rhythms and vibrations of techno. Inspired by Diego Rivera's 1933 commissioned series of Detroit Industry Murals at the Detroit Institute of Arts, illustrator and futurist AbuQadim Haqq designed the cover

27 Ibid., xii.

28 Toffler, *The Third Wave*, 169.

29 "The notion of afrofuturism gives rise to a troubling antinomy: Can a community whose past has been deliberately rubbed out, and whose energies have subsequently been consumed by the search for legible traces of its history, imagine possible futures?" Mark Dery, "Black to the Future: Interviews with Samuel R. Delany, Greg Tate, and Tricia Rose," in *Flame Wars: The Discourse of Cyberculture*, ed. Mark Dery (Durham, NC: Duke University Press, 1994), 180.

of this book with an understanding that techno is an advanced vibrational technology that can be integrated into the mind, body, and soul: it creates "something of a higher dimensional soul technology that these artists access to reach the highest states of their soundcraft."[30] Haqq's connection with the sounds and circumstances of techno through decades of artistic contributions to classic Detroit record labels such as Metroplex, Transmat, and Underground Resistance informed his *Technanomicron* (2008), a thirty-page art book and CD compilation in which he predicts the rise of "technolords" at the end of a thousand-year, multigenerational evolution occurring at the end of the twentieth century, or toward the end of the future. "By enhancing their souls with vibrational technology," he wrote, "they were able to achieve new levels of awareness, creativity and discovery. Their vibrational creations were able to explore the darkest regions of space, travel multi-dimensionally and establish sonic empires."[31] In his tightly woven epic tale, these figures—real and imagined—found existence possible across their own time and space continuum, even within the modern framework of a colonized American Empire and its attendant cultural-industrial complexes.

Haqq's mythscience[32] evolved further in his 2019 graphic novel, *The Book of Drexciya*, in which he visualized the potential narratives and cultures underpinning the mythic Black Atlantic civilization of Drexciya, envisioned in the early 1990s by the Detroit-based Afrofuturist techno duo of the same name (composed of James Stinson and Gerald Donald). Haqq reconsiders their insight and expansion of centuries-old African diasporic folktales that gave voice to the mass revolts and escapes from slave ships,[33] which constitute, in part, the four-hundred-year context of African American migration—a context that frames Drexciya's 1997 compilation album, *The Quest*, as well as concepts evoked by Stinson in conversations that took place during the making of *Neptune's Lair* in 1999. Haqq's *Book of Drexciya* envisioned the rise of Drexaha, the first King of the Drexciyan Empire, as an African diasporic bridge within a counter culture of modernity canonized in historian Paul Gilroy's 1993 book *The Black*

30 AbuQadim Haqq, unpublished statement, quoted in S. David, "Inside the Stunning Black Mythos of Drexciya and its Afrofuturistic 90s Techno," *Ars Technica*, February 28, 2021, https://arstechnica.com/gaming/2021/02/inside-the-stunning-black-mythos-of-drexciya-and-its-afrofuturist-90s-techno/. See also Haqq, interview by Ashley Zlatopolsky, "The Art of Drexciya: Abdul Qadim Haqq Breaks Down the Art Behind the Aquatic Electro Icons," *Red Bull Music Academy Daily*, October 21, 2016, https://daily.redbullmusicacademy.com/2016/10/art-of-drexciya.

31 AbuQadim Haqq, *The Technanomicron* (n.p.: Third Earth, 2008), 1.

32 "MythScience is the field of knowledge invented by Sun Ra, and a term that this book uses as often as it can." Kodwo Eshun, *More Brilliant Than the Sun: Adventures in Sonic Fiction* (London: Quartet Books, 1998), -004.

33 "In May 1803 a group of enslaved Africans from present-day Nigeria, of Ebo or Igbo descent, leaped from a single-masted ship into Dunbar Creek off St. Simons Island in Georgia. A slave agent concluded that the Africans drowned and died in an apparent mass suicide. But oral traditions would go on to claim that the Eboes either flew or walked over water back to Africa." Thomas Hallock, "How a Mass Suicide by Slaves Caused the Legend of the Flying African to Take Off," *The Conversation*, February 18, 2021, https://theconversation.com/how-a-mass-suicide-by-slaves-caused-the-legend-of-the-flying-african-to-take-off-153422.

Atlantic.[34] British Ghanaian writer, theorist, and filmmaker Kodwo Eshun extended the speculative research, thought, and sonic experiments that index the adaptation of Africans across the diaspora to the then-industrial and now-cybernetic aspects of Euro-American colonization and modernity in his 1998 study, *More Brilliant Than the Sun: Adventures in Sonic Fiction*. Engineering concepts and neologisms as a means of decoding and transcribing the essence of African usage of media and machines in the context of electronic dance music, Eshun outlined what the music collective Underground Resistance described as the "operating system for the redesign of sonic reality."[35] In his 2003 article "Further Considerations on Afrofuturism," he extended his conceptualization of the Black Atlantic counter culture as a fragmented diasporic consciousness capable of reorienting the architectural trajectory of modern history.[36]

Another key reference informing the project of this book is *The Last Angel of History* (1996), a fictional documentary by director John Akomfrah and writer Edward George of the Black Audio Film Collective, which introduces the "Data Thief," a poet and scavenger of history, played by George, who travels through "the internet of Black culture" studying the connections between the displacement of Africans across the diaspora and the innovative music that emerged from those Africans with the advent of consumer technologies.[37] Throughout the film, the Data Thief explores George Clinton's concept of "The Mothership Connection" as it relates to Afrofuturist visions of other Black musicians like Sun Ra, alongside talking-head commentary by Detroit techno musicians Juan Atkins, Derrick May, and Carl Craig; writers Samuel R. Delany, Octavia E. Butler, Ishmael Reed, Greg Tate, and Kodwo Eshun; and electronic music producers DJ Spooky, Goldie, and A Guy Called Gerald. As the documentary opens, the Data Thief describes the origin of the Black vocal music tradition as explored in poet and critic Amiri Baraka's 1963 book *Blues People: Negro Music in White America*—a tradition that was standardized and exported through the recording music industry of the Northern states,[38] while slavery continued after the Civil War and into

34 "This book addresses one small area in the grand sequence of this historical conjunction—the stereophonic, bilingual, or bifocal cultural forms originated by, but no longer the exclusive property of, Blacks dispersed within the structures of feeling, producing, communicating, and remembering that I have heuristically called the Black Atlantic world." Paul Gilroy, *The Black Atlantic: Modernity and Double Consciousness* (Cambridge, MA: Harvard University Press, 1993), 3.

35 Eshun, *More Brilliant Than the Sun*, 7.

36 Kodwo Eshun, "Further Considerations on Afrofuturism," *CR: The New Centennial Review* 3, no. 2 (Summer 2003): 287–302.

37 *The Last Angel of History*, directed by John Akomfrah (Brooklyn: Icarus Films, 1996). Transcript made available on the website of the Seattle Art Museum's exhibition "John Akomfrah: Future History" (March 5–September 7, 2020), https://akomfrah.site.seattleartmuseum.org/wp-content/uploads/sites/33/2020/09/The-Last-Angel-of-History-Transcript.pdf.

38 "For one class of Negroes, as the developing strata of the city emphasized, the blues could extend in a kind of continuum from rhythm & blues all the way back to country blues. In the cities all these forms sat side by side in whatever new confusions urban life offered, and the radio made them all equally of the moment. Although at this point rhythm & blues was the most constantly played blues music heard throughout the country, it also created a revived demand for the older form—to be played on those same radio circuits." Amiri Baraka, *The Blues People* (New York: Harper Perennial, 1963), 171.

the 1960s alongside Jim Crow-era segregation, white supremacist terrorism, and the institution of a school-to-prison pipeline.[39] He remarks:

> We came across a story of a bluesman from the 1930s, a guy called Robert Johnson. Now the story goes, that Robert Johnson sold his soul to the devil at a crossroads in the Deep South. He sold his soul, and in return, he was given the secret of a Black technology, a Black secret technology, that we know now to be the blues. The blues begat jazz, the blues begat soul, the blues begat hip-hop, the blues begat R&B.[40]

Investigating the interconnected web of Black culture two hundred years into a speculative future, the Data Thief is told of a crossroads similar to the one Robert Johnson encountered: "If you can find the crossroads, a crossroads, this crossroads, if you can make an archeological dig into this, you'll find fragments, techno-fossils. And if you can put those elements, those fragments together, you'll find the code. Crack that code, and you'll have the keys to your future. You've got one clue and it's a phrase: Mothership Connection."[41] While searching for the secret of the Mothership Connection, the Data Thief discovers the word "Africa," the concept of "the New World," and two rooms marked "Lee Perry Black Ark" and "Sun Ra Arkestra." Lee Perry and Sun Ra tell him that "Our music is a mirror of the universe. We explore the future through music." Eshun appears in the film to discuss the writings of musician and writer Greg Tate and the transportation of Africans from the "Old World" to the "New World": "All the stories about alien abductions, all the stories about alien spaceships taking subjects from one place and taking them to another, genetically transforming them," Eshun reflects, "[h]ow much more alien do you think it gets than slavery? Than entire mass populations moved and genetically altered, entire status moved, forcibly dematerialized? It doesn't really get much more alien than that." Turning to electronic music, Eshun continues, consumer technologies of the Western postwar period empowered young Black people, who were able to gain access to discarded synthesizers, drum machines, and sequencers to create techno and a new digital audio ecology:

> The connection between the architects of Afrofuturism, between Sun Ra, and Lee Perry, and George Clinton, and between techno and jungle later on in the '80s and the '90s, is simply that they pulled nothing in common with the common idea of Black music, which is that it belongs to the street or to the

39 See Antoinette Harrell, as told to Justin Fornal, "Black People in the US Were Enslaved Well Into the 1960s," *Vice*, February 28, 2016, https://www.vice.com/en/article/437573/blacks-were-enslaved-well-into-the-1960s; ACLU, "School-to-Prison Pipeline," https://www.aclu.org/issues/juvenile-justice/school-prison-pipeline; NPR, "The Untold History of Post-Civil War 'Neoslavery,'" Talk of the Nation, March 25, 2008, https://www.npr.org/templates/story/story.php?storyId=89051115.

40 The Data Thief, in *The Last Angel of History*.

41 Ibid.

stage.... They're studio music, they're impossible, imaginary music. And yet, because they're imaginary, they're even more powerful because they suggest the future. They don't reflect the past. They imagine the future.[42]

Detroit techno, a concept of sonic world-building and coded information exchange borne out of a centuries-long lineage of African American struggle and insurrection, would eventually be exported, repackaged, and financialized within foreign markets as a colloquial term and categorical standard of 120–140 beats per measure, and assimilated into the multicultural "hardcore continuum" of the British and European postcolonial drug and rave revolution—replicating the profit-oriented process of extraction. Yet Detroit techno builds upon previous iterations of African American uprisings, from the first slave insurrection in 1505, to the Bacon's Rebellion of 1676, the Nat Turner Rebellion of 1831, the Red Summer of 1919, and the long, hot summer of 1967, when riots spread across the US in response to the state-initiated assassinations of Martin Luther King, Jr. and Malcolm X. Situated within this lineage, *Assembling a Black Counter Culture* charts a survey of the works of key Detroit techno producers, working in the context of a transitional moment in Black history and in the overwhelming framework of a capitalist, post-industrial America.[43] To do this, the book acknowledges Cybotron's simulations of modern metroplexes through experiments in sonic technology and stereophonic intelligence; the Belleville Three's articulation and popularization of the term "techno" as a descriptor of sense-altering electronic funk and hi-tech soul in the midst of inner-city decay; Underground Resistance's mobilization of tactical electronic warfare, accompanied by chords of healing by the hi-tech jazz ensemble Galaxy 2 Galaxy; and Drexciya's coded cartographic audio visualizations of a "Journey Home." A journey beyond the savage and failing free-market capitalist industrial system imagined within the frames of white American technological utopianism.

42 Eshun, in ibid.

43 "Since the masses of Black people are not going to be integrated into the economy in the foreseeable future, as the reformers would have one believe, and since there are few signs of an imminent revolution in this country, contrary to the hopes of some radicals, it is necessary for the Black liberation movement to devise a transitional program, which will operate until such time as conditions develop that will make possible full liberation through social revolution." Allen, *Black Awakening in Capitalist America,* 274.

16

1.
TECHNO CITY, THE FINAL FRONTIER

"Greetings to the privileged generation of Earth. One hundred years ago, millions of people across the expanse of your planet looked into the heavenly skies... and they asked the question, 'What would life be like in the year 1981?'"[1]

– The Electrifying Mojo

"Millions are already attuning their lives to the rhythms of tomorrow. Others, terrified of the future, are engaged in a desperate, futile flight into the past and are trying to restore the dying world that gave them birth. The dawn of this new civilization is the single most explosive fact of our lifetimes."[2]

– Alvin Toffler

In today's social memory, techno is considered an international phenomenon and globalized product of the leisure class, promoting the liberation of mind, body, and soul through continuous electronic music, ecstatic dance, and transcendent experience. Yet the initial ingredients of techno were assembled conversationally in Detroit in the early 1980s by Juan Atkins and Rik Davis, the imaginative bedroom-studio producers who formed the group Cybotron.[3] These sounds were shared with and expanded upon by Derrick May, Eddie Fowlkes, James Pennington, Anthony "Shake" Shakir, Blake Baxter, and Kevin Saunderson over the course of the decade. In the mid 1980s, the reel-to-reel and turntable-based underground "house"[4] music coming out of Chicago from Farley "Jackmaster" Funk, Ron Hardy, Frankie Knuckles, and Jesse Saunders, and out of New York from Larry Levan, crossed over with Detroit techno's technological sonic fictions once the pre-owned, often discontinued electronic equipment being used to concoct and transmit a shared alternate reality became more accessible to

1 The Electrifying Mojo, quoted in Ashley Zlatopolsky, "Theater of the Mind: The Legacy of the Electrifying Mojo," *Red Bull Music Academy Daily*, May 12, 2015, https://daily.redbullmusicacademy.com/2015/05/electrifying-mojo-feature/.

2 Alvin Toffler, *The Third Wave* (New York: Bantam Books, 1980), 25.

3 "Techno is music that sounds like technology, and not technology that sounds like music, meaning that most of the music you listen to is made with technology, whether you know it or not. But with techno music, you know it." Juan Atkins, quoted in "Juan Atkins," *Dance Music Report* 15, no. 9 (May 22, 1992): 19.

4 "The word 'house' comes from a record that you only hear in a certain club. The DJs would search out an import that was as obscure as possible, and that would be a house record. You'd hear a certain record only at the Powerplant, and that was Frankie Knuckles' house record. But you couldn't really be guaranteed an exclusive on an import, 'cos even if there were only 10 or 15 copies in the country, another DJ would track one down. So the DJs came up with the concept of making their own house records. It was like 'hey, I know I've got an exclusive because I made the record.'" Juan Atkins, quoted in Simon Trask, "Future Shock," *Music Technology* (December 1988): 42.

consumers. British journalist and talent scout Neil Rushton caught wind of the influx of house music exports to the United Kingdom and reached out to May, hoping to invest in what looked to be a burgeoning economy. *Techno! The New Dance Sound of Detroit*, which hit shelves on May 4, 1988, compiled a decade of Detroit electronic music into a single package consisting of Atkins, May, and Saunderson as the marketable young pioneers, often referred to as the "Belleville Three." While the album introduced the term "techno" to European music listeners, recognition of the sound's origins in middle-class Black America did not spread as far or wide. A process of assimilating techno into the British and European rave culture industry was initiated by the compilation itself, as early as its liner notes, penned by journalist Stuart Cosgrove: "Think of Detroit," he wrote, "and you automatically think of Motown, but be careful not to think too loud because the new grandmasters of Detroit techno hate history."[5]

Detroit, the "Motor City," emerged as the United States' fourth largest city in the 1920s, greatly contributing to the rising standards of living across the nation with its investments in the "Big Three" (Ford, Chrysler, and General Motors) automotive empire. Black Detroit's early twentieth-century musical history—from the blues and jazz of Old Hastings Street in the 1920s to Motown in the 1960s—thrived because of the auto industry, and loomed over the youth counter culture that was beginning to experiment with turntables, drum machines, synthesizers, and other studio recording devices as a way of absorbing and distilling the rhythm and soul of the past into a form of progressive music that eventually became techno. "Berry Gordy built the Motown sound on the same principles as the conveyor belt system at the Ford Plant. Today the automotive plants use robots and computers to make the cars, and I'm more interested in Ford's robots than Gordy's music," Atkins remarked.[6] Learning from his time as an assembly-line worker at Ford's Lincoln-Mercury Plant, Gordy founded Motown Records in the late 1950s with the intent of applying Ford's managerial strategy to mass-produce Black music as an efficient, pristine, and readily consumable commodity. "At the plant, the cars started out as just a frame, pulled along on conveyor belts until they emerged at the end of the line," Gordy explained. "I wanted the same concept for my company, only with artists and songs and records. I wanted a place where a kid off the street could walk in one door an unknown and come out another a recording artist—a star."[7] Throughout the 1960s and the Civil Rights Movement, the success of the Motown "hit factory"—a portmanteau of "motor" and "town"—paralleled that of Detroit's automotive industry: Motown produced 110 Top 10 hits on the Billboard charts over the decade, fulfilling a version of Gordy's dream to "educate customers about the beauty of jazz."[8] Gordy sold optimized soul music from African

5 Stuart Cosgrove, liner notes, *Techno! The New Dance Sound of Detroit* (10 Records, 1988).

6 Atkins, quoted in ibid.

7 Berry Gordy, quoted in Chris Perkins, "How Detroit Assembly Lines Changed Music Forever," *Road and Track*, October 29, 2020, https://www.roadandtrack.com/car-culture/a34518490/motown-assembly-line-berry-gordy/.

8 Berry Gordy, *To Be Loved: The Music, the Magic, the Memories of Motown* (New York: Warner, 1994), 59.

American ensembles of vocalists, session musicians, and studio engineers who were recruited and assembled under contract to produce copyrighted populist earworms that could be experienced and consumed by all demographics under the slogan: "The Sound of Young America."

In 1960, the Ford Foundation hired urbanist, lawyer, and housing expert Charles Abrams to study what he described as "urban problems in our urban age," with the goal of initiating urban renewal projects to improve the housing conditions of the American people. Abrams eventually published the study in 1967 as the book *The City Is the Frontier*.[9] He put heavy emphasis on the regulation of housing and the economic status of African Americans facing daily racial discrimination, while providing blueprints and examples of ways to design cities as comfortable environments that could improve American citizens' everyday lives. Abrams called for a standardized, modern way of living across all metropolitan cities in the United States in the wake of the country's three-hundred-year history of displacement, development, and rationalization. He closed his study with the presentation of a "new philosophy for cities" that aimed to dismantle the divide between city and suburbs and redefine the city's role in state and federal funding, to support general welfare for its citizens and their right to live. That same year, in the midst of the hippie revolution and the "Summer of Love," racial tensions between Black and white Americans boiled over in Detroit— and in more than one hundred other cities across the United States—where a riot left forty-five people dead and over two thousand buildings destroyed, eventually leading to mass "white flight" from the city of Detroit to the suburbs. More recently, Cosgrove published the study *Detroit 67: The Year That Changed Soul* (2016), detailing the 1967 race riots within the context of the chaotic Vietnam war and Motown's exodus from Detroit to Los Angeles.[10] "It was a summer of street-level rebellion when the complex threads that held Detroit together finally unravelled," Cosgrove recalled in 2015. "I was making toast in my mum's kitchen in a council house in Perth as a live report led the BBC Scotland news and I can still remember the sense of wonder, disbelief and history in the American reporter's voice as he said the prophetic words: 'What has happened to America? The Motor City is burning?'"[11]

Vince Carducci, cultural critic and Dean Emeritus of the College of Creative Studies in Detroit, offers a brief history of Motown's industrialization of music alongside the financial collapse of the Motor City:

9 Charles Abrams, *The City Is the Frontier* (New York: Harpers & Row, 1967).

10 Stuart Cosgrove, *Detroit 67: The Year That Changed Soul* (Edinburgh: Polygon, 2016).

11 Stuart Cosgrove, "Motown Burning: How Detroit Exploded in the Summer of 1967 as Stars Made the World Dance While Their City Was Ablaze," *Daily Record*, February 15, 2015, https://www.dailyrecord.co.uk/news/uk-world-news/motown-burning-how-detroit-exploded-5164489.

The late 1960s and early 1970s saw the first outsourcing of the American automobile industry with investments in the maquiladoras of Mexico, a transformation in manufacturing often referred to as post-Fordist to distinguish it from the previous production regime. So, too, did Motown begin its exit from the city that gave it its name, a mission accomplished in 1972 when its headquarters officially moved from Detroit to Los Angeles. As with the auto industry, Motown left many workers behind, including the Funk Brothers. Most of the Motown records of this period, including Stevie Wonder's classics *Music of My Mind*, *Talking Book*, and *Innervisions*, featured freelance studio musicians recording at outsourced facilities in New York or LA (in addition to Wonder's multi-instrumental talents). The exception was Marvin Gaye's *What's Going On*, the first Motown record for which the Funk Brothers received liner-note credit and generally considered the greatest soul album ever made.[12]

In the years after Motown's departure from Detroit, a youthful Black music scene gained access to secondhand electronic instruments, underused recording studios, and mastering plants to develop what they thought of as "progressive music," in the aftermath of the large-scale failure to desegregate Black and white communities throughout the United States. In 1972, Charles Johnson took on the mantle of The Electrifying Mojo as a vehicle for sharing crafted sonic journeys on WGPR ("Where God's Presence Radiates"), the first Black owned and operated radio station in the United States.[13] Amplifying his cosmology of the "Theater of the Mind," Johnson's novel sensibility for musical eclecticism and the transmutability of space, place, and one's emotional attachment to both through sonic programming was a skill honed by buying and DJing imported music while stationed in the Philippines as an active duty officer in the US Air Force. From 1977 to the mid-'80s, Mojo's show was presented to a primarily urban Black audience every night at 10 p.m. His show eventually became a beacon of cultural cohesion, wherein songs were played as a cinematic soundtrack while he spoke his mind and truth to Ontario, Ohio, Michigan, and the world, for an hour, occasionally driving through and conversing with local communities of Black Detroit. In 1982 Mojo relocated from WGPR to WJLB, another legacy radio station, broadcasting urban contemporary and Quiet Storm[14] to a growing African American middle class from the top of the eighth tallest building in the world, Detroit's Penobscot Building. The elevated vantage point inspired the new, on-air studio concept of the

12 Vince Carducci, "Manufacturing Motown," *Pop Matters*, January 26, 2009, https://www.popmatters.com/69384-manufacturing-motown-2496071565.html.

13 WGPR was established in 1964 by lawyer and minister William Venoid Banks of the International Free and Accepted Modern Masons. See Kelley O'Neill, "The Nation's First Black-Owned TV Station, Founded in Detroit, Is Now a Historic Landmark," *Detroit Metro Times*, February 17, 2021, https://www.metrotimes.com/detroit/the-nations-first-black-owned-tv-station-founded-in-detroit-is-now-a-historic-landmark/Content?oid=26461644.

14 Quiet Storm is a late-night format developed at Howard University's WHUR-FM radio station by Melvin Lindsey in 1976. It blends beautiful Black music genres such as soul, jazz, R&B, and adult contemporary music, spanning from Smokey Robinson, Anita Baker, Toni Braxton, Marvin Gaye, The Isley Brothers, among others.

"Mothership," in connection to George Clinton's assemblage of the Motown-inspired Parliament–Funkadelic (P-Funk) ensembles. Building on P-Funk's liberation of Black music through psychedelic Afrofuturist explorations of mental and emotional states in the post-Civil Rights era,[15] The Electrifying Mojo instrumentalized the airwaves to design sonic fictions as an overlay to the everyday lives and urban blues of the beginning of the Information Age. He remarked in a 1995 interview on the TV show *Black Journal*[16] that he "just wanted to be a voice on the radio, a face in the crowd, a figment of the imagination.... When you elevate [a persona] too high on a pedestal, you remove yourself from the earshot of what regular people have to say and how they feel, and sometimes that makes it impossible to relate on a relative level."[17]

The Electrifying Mojo's stated mission to "save Detroit and the world from the musical blahs" undoubtedly had an effect on his community of listeners, including the young producers who later ignited the electronic dance music revolution that is "techno": it provided them with a window into other worlds and a blueprint for developing a lasting, personal, and cerebral relationship to music of all genres. Starting at 10 p.m. with the "Landing of the Mothership," Mojo would speak over blended spaceship sound effects, segueing into the "Awesome '84, '85" segment, during which he played new music, or entire albums, before drifting down "Lover's Lane" with a half hour of R&B and "slow jams." The final movement of The Electrifying Mojo's broadcast invited listeners to join the "Midnight Funk Association." Before being inducted with the brain-rewiring carnal syncopations of electro[18] and funk acts like Parliament-Funkadelic, the Gap Band, and Zapp, Mojo beckoned listeners:

15 "It was a metaphor for the boundlessness of art, and also for the ways that art found its way to people; the Mothership Connection had something to do with an extraterrestrial DJ beaming booty-shaking, soul-quaking, mind-liberating music down to the Earth's benighted inhabitants." Ben Greenman, "'Mothership Connection'—Parliament (1975)," Library of Congress, 2011, https://www.loc.gov/static/programs/national-recording-preservation-board/documents/MothershipConnection.pdf.

16 *Black Journal* was the first nationally broadcasted African American television program. It reported on politics and urban life during the Civil Rights and Black Liberation Movements from an African American perspective. "*Black Journal*'s claim to advocacy and community was openly stated from the first episode, in June 1968: in his introduction, the host, Lou House, said, 'It is our aim in the next hour and in the coming months to report and review the events, the dreams, the dilemmas of Black America and Black Americans.' The program editor Lou Potter told a journalist later that year, 'Our challenge was to do something truly new and meaningful: Not just Black faces bearing a white message, but black ideals, Black achievements—a Black world.' *Black Journal* was designed to foster a shared vision of a national Black community by transcending regional, generational, and class differences in its coverage. *Black Journal* had the potential to present its audience with a vision of common ground." Devorah Heitner, "No Thanks for Tokenism: Telling Stories from a Black Nation, *Black Journal*, 1968–1970," in *Black Power TV* (Durham, NC: Duke University Press, 2013), 85.

17 The Electrifying Mojo, interview by Darryl Wood on the *Detroit Black Journal*, Season 45, Episode 35, 1995, https://video.kpbs.org/video/detroit-black-journal-interview-electrifying-mojo-emdg5d/.

18 "Cybotron coincided with the birth of a sound known as 'electro,' presumably a shortening of 'electronic funk.' Electro was one of the great dance music developments of the early 1980s that was neither a derivation nor an extension of disco. Instead, it was a 'switched-on' funk variant, exaggerating the electronic sounds that Midwestern groups like Parliament-Funkadelic had perfected in the studio and brought onstage. Most critics point to New York, however, for the genre's watershed moment." Dan Sicko, *Techno Rebels: The Renegades of Electronic Funk* [1999] (Detroit: Wayne State University Press, 2010), 45.

Wherever you are, you're in the right place. The Funk is upon you. WJLB Detroit presents the Midnight Funk Association each night at midnight. the world comes to life. It's the return of the international MFA. If you're in your car, flash your lights. if you're at home go and turn your porch light on. If you're on your boat, make waves. If you're in the shower, let it splash. if you're in bed, you don't have to get up but we would love for you to get down. The members of the Midnight Funk Association please rise. If you're in your car honk your horn right now. Hold on tight, don't let go. Whenever you feel like you're nearing the end of your rope, don't slide off. Tie a knot, keep hanging, 'cos' there ain't nobody bad like you. This session of the international Midnight Funk Association is hereby called to order. Electrifying Mojo presiding. May the Funk be with you. Always.[19]

The *Midnight Funk Association* sometimes ran overtime, extending into the early morning with open-ended segments where listeners could call in requesting a shout-out and submit to the competitive mix series, "Star Wars," or "the Mixadome," a citywide mix-off. The Electrifying Mojo was an innovator in the Black community and in radio broadcasting, beaming in sounds from distant lands that expanded the imaginations of anyone his signals reached. Mojo even aired a rare interview with Prince in 1985 following a birthday concert at Detroit's Cobo Arena. "He was an underground cult hero. We would listen to him religiously every night," Atkins once reminisced. "You'd sit there in a trance waiting for each record."[20]

In the liner notes for that inaugural compilation, *Techno!*, Cosgrove failed to identify the exact influence Mojo had had on the collective imaginations and emotions of the Belleville Three, claiming that Detroit techno was a "post-soul" music defining "a deliberate break with previous traditions of Black America music."[21] When asked about the phrase "techno" in a 2000 interview, Neil Rushton noted that it was being used as an adjective as opposed to a hard label, denoting a quality of sound rather than a name: "[W]hen I went over to license the album, which was the first time I'd met either Kevin [Saunderson] or Juan [Atkins], whereas before Derrick [May] had said 'techno' in passing, they were all saying it. But they weren't using it as a description for the records they were making. It was just a phrase that they used."[22] May was labeled the "philosopher" of Detroit techno because of his keen understanding of how to describe the music, which he called a "complete mistake" and "like George Clinton

19 The Electrifying Mojo, *Midnight Funk Association* radio broadcast, WJLB Detroit, June 1985, https://www.mixcloud.com/tony-romanov/the-electrifying-mojo-wjlb-detroit-midnight-funk-association-june-1985/.

20 Atkins, quoted in Zlatopolsky, "Theater of the Mind."

21 Cosgrove, liner notes, *Techno!*.

22 Neil Rushton, interview by Bill Brewster, originally published in DJhistory.com, February 2000, republished in *Red Bull Music Academy Daily*, July 6, 2017, https://daily.redbullmusicacademy.com/2017/07/neil-rushton-interview.

and Kraftwerk caught in an elevator, with only a sequencer to keep them company."[23] A knowing lyrical wit can be detected in May's illustration, which quite clearly challenges the types of assumptions that could be made about the neutral image of a Black man and European men engaging in cultural exchange. The ironic truth of the matter is that Clinton's innate ability to create sense-altering pulses through electronic synthesizers would more or less overtake and hotwire Kraftwerk's structural test sequences, much like what is heard in Atkins' 1987 song "Sound of Stereo" (recorded as Model 500)[24] or May's explanation of his own music as a kind of hi-tech soul that exists "beyond the beat."[25]

May also articulated the difference between Chicago house and Detroit techno: "It's a question of respect, house still has its heart in 70's disco, we don't have any of that respect for the past, it's strictly future music. We have a much greater aptitude for experimentation." He described what became of Detroit after the explosive decades of racial tension and techno's exportation to the UK. "The old industrial Detroit is falling apart," he noted, "the structures have collapsed. It's the murder capital of America. Six-year-olds carry guns and thousands of Black people have stopped caring if they ever work again. If you make music in that environment it can't be straight music. In Britain you have New Order, well our music is the New Disorder."[26] Bill Brewster and Frank Broughton, authors of a history of DJing titled *Last Night a DJ Saved My Life* (1999), described the concepts and terminology Atkins had developed while col-laborating with Davis as "sci-fi mumbo-jumbo": "Because Detroit's decay is striking and there's no club scene to write about," they asserted, "the music was relentlessly characterised as a soundtrack to post-urban desolation, rather than music to make people sweat on a dance floor."[27] Brewster and Broughton imagined that "the fact that techno is made with computers somehow became a mysterious truth about mankind's cybernetic future."[28] In a 2000 interview, Brewster asked Rushton whether "all this sci-fi mambo jumbo and technological stuff was thought up after the fact, or was it part and parcel of what they were doing?" Rushton responded:

> I don't know. I'm always a bit skeptical about all of that. One of the things I always thought was the techno stuff had a jazz feel to it—as Carl Craig proved

23 Derrick May, quoted in Stuart Cosgrove, "Seventh City Techno," *The Face* 97 (May 1988): 86.

24 "Yes, Kraftwerk was definitely an influence on my professional recording career. But this was two years after I had already been dealing with synthesizers. The beauty of first hearing Kraftwerk was that the sounds were so similar to what I was doing, and these guys were halfway across the planet. I knew it was electronic as soon as I heard it. But the thing is that their stuff was clean and precise . . . [while] I had all kinds of weird UFO sounds . . . [Atkins' music] was [more] psychedelic." Juan Atkins, quoted in Sicko, *Techno Rebels*, 71.

25 May, quoted in Cosgrove, "Seventh City Techno," 86.

26 Derrick May, quoted in Cosgrove, liner notes, *Techno!*

27 Bill Brewster and Frank Broughton, *Last Night a DJ Saved My Life: The History of the Disc Jokey* [1999] (New York: Grove Press, 2006), 356.

28 Ibid.

later—and when we were over there we kept saying that. We kept making comparisons to the past. And the other thing people got completely wrong is this image of techno being a new wave of dance music made in super studios. In fact, it was all made on old equipment. There were a lot of paradoxes going on there. I think that Derrick was very articulate and was quick to see what people wanted.[29]

The Belleville Three were the focus of an article in the May 1988 issue of *The Face* magazine titled "Seventh City Techno." Further adapting the origin story of "Detroit's new robosound," Cosgrove defined techno as "the sound of young Detroit: built with machines, and driven by despair." Alongside additional profiles of Blake Baxter and the Detroit house music group Members of House, Cosgrove retells the story of *Gambit and Associates*, an underground comic written and drawn by Detroit DJ and artist Alan Oldham (a childhood friend of May's), which shipped with copies of May's *Nude Photo* (recorded as Rhythim Is Rhythim).[30] *Gambit and Associates* takes place in a world under the control of a "weird technocracy," visualizing a futuristic metropolis in the place of present-day postindustrial reality. To set the scene, Cosgrove notes that Detroit is the murder capital of the United States, before introducing the comic's lead character Johnny Gambit, an archetype of Alvin Toffler's techno-rebel: "a big fan of Belgian group Front 424, and a dude who can draw a gun at 122 beats-per-minute."[31] Cosgrove's article shifts into a series of profiles of the Belleville Three, listing each of the key players and their varying monikers while surveying the climate of the Detroit scene and its technological sound, comparing it to modern soul singers like Whitney Houston, Anita Baker, and Alexander O'Neill, who were defining Black popular music towards the end of the '80s. "I don't really sing," Baxter told Cosgrove. "I speak in a soft voice almost like hiding beneath the beat. I love records with whispering vocals—it's nothing like the gospel sound." Saunderson pointedly addressed Detroit's initially mild reception to techno at a time when there was a noticeable increase in the production and sales of popular music, recounting that he was fired from a radio station for being "too ahead of his time": "I took them a clipping from *Billboard* and they told me to come back when we were on the front cover," he remembered. "That's Detroit. I've turned my back on this city. I don't care if they don't buy one of my records—other people will." May also shared a story of being let go from a Detroit nightclub with a ballroom dance floor named the Lidernacht, German for "Night Song," which catered to industrial music. "They only wanted to hear The Smiths or Severed Heads. I was playing Black underground sounds and they couldn't take it." Having worked to build a racially mixed crowd at the club, May described the manager eventually

29 Rushton, interview by Brewster.

30 "In the 80s, comics were changing with 'Love and Rockets', 'Mister X', and the first modern Japanese Manga and Anime were coming to America at that time. I was into New Wave at the time, too (not so much punk, I liked the stylish stuff and still do). So I combined all those influences into one character, 'Johnny Gambit'. Once I kind of made my own style, I got noticed and published." Alan Oldham, interview, "Drawing a Picture: Alan Oldham," *Innate*, June 10, 2014, https://inn8.net/interview-with-alan-oldham/.

31 Cosgrove, "Seventh City Techno," 86.

dismissing his efforts because he didn't want to operate a Black club, before firing May and banning him from the club for life. "They used to say 'Get this nigger shit off!' They even went as far as having a sit-down strike on the dancefloor. All these dickheads in black shirts trying to be so English and so progressive and refusing to listen to underground music that was happening under their noses."[32]

Exasperated, May continued, "This city is in total devastation. Factories are closing, people are drifting away, and kids are killing each other for fun. The whole order has broken down. If our music is a soundtrack to all of that, I hope it makes people understand."[33] Cosgrove takes stock of the local scene, rejecting techno and the Detroit producer's disillusionment with the city's musical legacy, mentioning that many of the tracks on *Techno!* were recorded at United Sound Studios—often credited as "Techno Sound Lab"—where Motown producer and songwriter Don Davis worked with artists like the Dramatics, George Clinton, The Dells, and David Ruffin.[34] Likewise, Eddie Fowlkes contemplated the period of time after Motown "left and took the whole structure of Detroit music with them. They left a vacuum that has taken over 15 years to fill."[35]

Yet, despite Cosgrove's knee-jerk assumption of European influence, the artists who created techno were part of a resilient cultural moment in Detroit from 1972 to 1987, as the population of the city flipped into a Black working-class majority during a post-industrial decline rife with economic lows and high unemployment. Members of the House, a Berry Gordy-inspired production group led by Mike Banks, told Cosgrove that "Techno is about simplicity. We don't want to compete with Jimmy Jam and Terry Lewis. Modern R&B has too many rules: big snare sounds, big bass, and even bigger studio bills." Earlier in the article, Cosgrove spoke with Atkins in his basement studio space in West Detroit. Atkins built on Banks' intuition not to follow the blueprint of Black popular culture and standardization of commercial music, summarizing: "Within the last 5 years or so, the Detroit underground has been experimenting with technology, stretching it rather than simply using it. As the price of sequencers and synthesizers has dropped, the experimentation became more intense. Basically, we're tired of hearing about being in love or falling out, tired of the R&B system, so a new progressive sound has emerged. We call it techno!"[36]

32 Ibid., 88.

33 Ibid.

34 Alongside working on Motown's first ever hit record, Barrett Strong's "Money (That's What I Want)" in 1959, and on Parliament's *The Mothership Connection* in 1975, Davis purchased and grew First Independence Bank, the twelfth largest African American-owned bank in the US. See Alan Hughes, "First Independence's Sweet Song of Growth," *Black Enterprise*, March 1, 2010, https://www.blackenterprise.com/first-independence%E2%80%99s-sweet-song-of-growth/?test=prebid.

35 Cosgrove, "Seventh City Techno," 89.

36 Ibid., 86.

2.
DRIFTING INTO A TIME OF NO FUTURE

"To visualize the future role of Negroes in a cybernated society, one must review, if only briefly, their past role in American society and what this means at the present stage of industrial development."[1]

– James Boggs

"Unlike any nation in Europe, the United States holds whiteness as the unifying force. Here, for many people, the definition of 'Americanness' is color."[2]

– Toni Morrison

"Contrary to popular belief, Negroes are the only substantial minority group in America who have a culture to guard and protect. The small, but crucial retentions of African tradition, the slavery experience, the post-slavery history of oppression, the reemergence of the non-white world, and America's refusal until recently to allow integration—all have combined, for better or for worse, to give the Negro a different reality, a different culture with which to master that reality, and a unique perspective by incongruity on American society that may be this nation's outstanding and redeeming virtue."[3]

– Charles Keil

A generation before the Black youth of Detroit harnessed the machine soul of techno, political activist and autoworker James Boggs foresaw the automation and elimination of labor as the future of modern society and warfare. Boggs had migrated from Alabama to Detroit in the late 1930s, leaving behind the sharecropper labor and white supremacist violence of the Deep South for salaried job opportunities at the auto factories of Detroit. That very experience led to his involvement in political activism. His writings, alone and in collaboration with his partner, Grace Lee, challenged mainstream notions of labor rights and revolution, and theorized the unraveling society at the center of the American industrial empire that had formed in the wake of the Second World War. In 1964, Boggs spoke at the First Annual Conference on the Cybercultural Revolution–Cybernetics and Automation, centering on the theme of

1 James Boggs, "The Negro and Cybernation," in *The Evolving Society: The First Conference on the Cyberculture Revolution—Cybernetics and Automation*, ed. Alice Mary Hilton (New York: The Institute for Cybercultural Research, 1966), 168.

2 Toni Morrison, "Making America White Again," *New Yorker*, November 21, 2016, https://www.newyorker.com/magazine/2016/11/21/making-america-white-again.

3 Charles Keil, *Urban Blues* (Chicago: Chicago University Press, 1991), 191.

"The Evolving Society." His paper "Negro and Cybernation" expressed a concern for the Black people, like himself, who had migrated from the militarized white supremacist oppression of the American South to the labor and class struggles of the industrial- and corporate-run northern states in the 1930s and 1940s. He wrote:

> In each industry where machinery played this vital role, the Negro played a special role—that of being the last to be recruited and usually only on an emergency basis, e.g., war. Only in agriculture was he the first mass force. Elsewhere he has been relegated to the most menial, manual labor under the worst conditions, e.g., foundry, pick and shovel in the mines, rolling mills, furnace rooms, janitors, material handlers. Thus, in the work process, within American society, the role of the Negro has been that of the scavenger. He got the jobs which white Americans would not do, which they considered beneath their dignity, which they had abandoned, or in dying industries.[4]

The United States' transition from chattel to wage slavery was a slow, multi-decade process, unfolding from the 1880s to the 1950s. "Today," Boggs remarked, "very few college-trained whites are going into these civil and social service jobs. Instead they are going into scientific research and development—for industry, for government—on the basis of the new and highly developed technological level of modern industry. Meanwhile, few Negroes are being admitted into these fields except on a token basis."[5] The plantation industry of the Confederacy in the American South served as an initial means of mechanization against the ecosystem to develop a flowing economy, utilizing African American slave labor and eugenic breeding to significantly increase the rate of production. At the beginning of the nineteenth century, America began to shift gears from being an enticing blank slate of available resources for the colonial project to symbolizing an obelisk of production and security for the select few. The United States' "victory" in the Mexican American War also resulted in the genocide of over seventy distinct groups of Native Americans. After the financial crisis and complete system collapse of 1837, the United States sought relief from the economic panic, deflation, and extended depression that lasted through 1842. The Mexican American War and gold rush of the mid-1800s simultaneously spurred national economic growth and established multiple states within the grasp of the Greater United States empire.[6] The discovery and distribution of gold as a unit of measurable value in 1848 was key to the country's economic rebound.[7]

4 Boggs, "The Negro and Cybernation," 169.

5 Ibid.

6 See Daniel Immerwahr, *How to Hide an Empire: A History of the Greater United States* (New York: Farrar, Straus and Giroux, 2019).

7 News of gold in California reached Michigan just as a major presidential election was taking place, pinning Detroit's Democratic candidate, Lewis Cass, against Whig Party candidate, Zachary Taylor. Following Cass' loss, the Michigan newspapers began to devote less non-advertising space to politics, switching focus to commissioned accounts of gold discoveries. These articles encouraged locals to venture out West to see if they could also acquire

Now in full swing, the Industrial Revolution yielded a large supply of oil and metal materials, transported from extraction sites and city centers via newly built railroads. Production on the railroad system increased to accommodate the influx of new land and wealth, as well as the mass of people crossing the country to gain access to the newest US acquisition. Transcontinental travel in the US became a way to maintain control and easily transfer resources during this economic boom. Unlike the Roman Empire, in which all roads lead back to Rome, the US seemed to wrap the whole of the North American territory in its draining tentacles. As technology and materials became more and more accessible, the economic upswing also shifted the established class structure of the developing United States. Manual labor became much easier to perform with the assistance of novel, though crude, work-in-progress inventions of the 1800s such as the cotton gin, ushering in the transition into the twentieth century. "Cotton constituted well over half of all American exports by midcentury—it grew into by far the biggest sector of the economy—and the American South was soon supplying over 70 percent of the world's raw cotton, producing well over one billion pounds annually," writes Bhu Srinivasan in his 2017 history of American capitalism, *Americana*.[8] Technological updates and a burgeoning concept of man-machine relations lessened the need for slave labor on a national scale, with newly landed immigrants from China and Ireland providing cheap and more humanized labor. America lurched forward to a prime moment of rapid advancement into automation and cybernetics. A once-large mass of land made up of singular clusters of cities and states could now extract resources domestically, on a free market.

At the peak of the Antebellum-era South, a large portion of the US economy and production had been upheld by Africans imported and sold in the transatlantic slave trade.[9] In the Confederacy, an aristocracy of slave owners who ran plantations with over fifty slaves was consolidated, and gained political influence in the process. The pre-Antebellum South had a relatively weak economy due to widespread anti-industrial and -technological sentiment. States in the Black Belt, a large geological region with rich soil stretching from central Alabama to northern Mississippi, made for an ideal place to forge an agricultural revolution against the technological one mounting in the United Kingdom and, by proxy, the Union of the northern states.[10]

some amount of gold and bring wealth to Detroit. This was in effect America's first "get rich quick" scheme, marking the beginning of the nation's draw towards infinite economic growth and its individualist approach to community development. See also Robert Whaples, "California Gold Rush," *Economic History Association Encyclopedia*, ed. Robert Whaples, March 16, 2008, http://eh.net/encyclopedia/california-gold-rush/.

8 Bhu Srinivasan, *Americana: A 400-Year History of American Capitalism* (New York: Penguin Books, 2018), 118.

9 "When the rulers of the Old South 'calculated the value of the Union,' one of their prime considerations was the question of slave control. Some felt that it was not wise to repudiate a constitution which provided for the assistance of the entire nation, if needed, to suppress an insurrection; others, that secession, even if peaceably accomplished, would accentuate the discontent of the Negros, and if resulting in war, would certainly have that effect and thus weaken the South." Herbert Aptheker, *American Negro Slave Revolts* (New York: International Publishers, 1970), 34.

10 "There are twelve counties in Alabama in each of which the blacks are twice as numerous as the whites. These twelve counties, stretching across southern Central Alabama from Georgia and Mississippi, constitute the principal

Heavily reliant on the physical labor of African American slaves, the Antebellum South plantation complex cultivated cotton, grain, tobacco, sugar, and rice—base materials in the global industrial economy. Plantation economies greatly impacted the structural integrity of the natural ecosystem of the South. In some ways, the plantation modeled the beginnings of big business as a general threat to the planet itself, let alone the millions of West Africans forced into physical labor. Within and around the Antebellum plantations, armed forces, including but not limited to the police, military, and armed citizens, enclosed people, machines, and natural resources that are considered non-human. "As the constitution awarded congressional power and Electoral College votes based on population, the southern states wanted all slaves to be counted as 'persons,' even if they had no rights," Srinivasan details. "The delegates finally settled on a slave counting for three fifths of a person when it came to allocating political power."[11] He continues: "In debates about how new states should be allowed into the Union as the vast American territory out west continued to be settled—how the balance between slave states and free states could be maintained—an idea known as popular sovereignty gained currency: Prospective new states would decide thorugh popular referendum—elections within their territories—whether to enter as slave states or free."[12]

Escapes and insurrections by enslaved peoples increased, prompting the passing of the Fugitive Slave Act as part of a package of congressional compromises in 1850, which stated that runaway slaves, like property, must be returned to their legal owner, sometimes with financial incentives. The two colonialist factions of the Union and the Confederacy—the Democratic Party and Republican Party—ultimately agreed to allow the white minority of civilians and slave owners in the Southern states to receive more seats in Congress and thus more votes than Northern states. The Electoral College would then cast final votes after the popular presidential votes had been counted—a control mechanism for ensuring that the electoral process would run smoothly and unhindered by the influence of African American voters. Furthermore, in counties in the Southern states, five percent of white farmers owned around forty percent of fertile farmland, subverting the legal statutes of racial equality in favor of the economic power inherited from four hundred years of colonial wealth gained from the transatlantic slave trade and the near genocide of the indigenous population.[13] In a 1858 presidential debate with Democratic Party nominee Stephen Douglas, Abraham Lincoln expressed his stance on the types of relations he saw fit for the population of

portion of the famous Black Belt. . . . the counties in which there are few negroes are the portions of the State in which the soil is comparatively sterile, and inhabited largely by small white farmers, the conditions of whose lives are now hard as they always have been, and who have an hereditary jealousy of the richer planters and of the town populations." "Politics and the Race Question in Alabama," *The Nation* 59, no. 1525 (September 20, 1894): 211–12.

11 Srinivasan, *Americana*, 118.

12 Ibid., 120–21.

13 Manning Marable, *Race, Reform and Rebellion: The Second Reconstruction and Beyond in Black America, 1945-2006* (Jackson: University Press of Mississippi, 2007), 5.

the United States to the audience's great applause: "I will say then that I am not, nor ever have been in favor of bringing about in any way the social and political equality of the white and Black races."[14] Despite the strategic maneuver of disarming the Confederacy of its human capital and labor production by freeing African American slaves, Lincoln felt that there was, "a physical difference between the white and the black races which I believe will forever forbid the two races living together on terms of social and political equality . . . while they do remain together there must be the position of superior and inferior, and I as much as any other man am in favor of having the superior position assigned to the white race."[15] Lincoln was assassinated in 1865 by actor and Confederate spy John Wilkes Booth; in his final speech, he voiced that it is "unsatisfactory to some that the elective franchise is not given to the colored man. I would myself prefer that it were now conferred on the very intelligent, and on those who serve our cause as soldiers."[16]

The implausible economics and politics of owning human beings eventually led to war between the states from 1861 to 1865. With Union forces recruiting militarized runaways, and Confederates enlisting slaves in its armed forces, the Civil War became the first war in which Black and white men fought alongside one another. In the aftermath, Southern states relied heavily on a faction of "slave patrols,"[17] which served as an early form of law enforcement, controlling and maintaining the movement and behaviors of the enslaved Black population through physical force. The patrollers were oftentimes on duty on a volunteer basis, and occasionally paid to enforce curfews and state and county borders, as well as disrupt unlawful assemblies and suppress uprisings from the African American slaves. After the Civil War, slave patrols grew into unionized American police departments, civil service militia groups, and/or white supremacist organizations like the Klu Klux Klan, founded in 1865 to commit acts of domestic terror on the African American population while spreading propaganda to influence public perception of the former slave class. "Behind the political and legal framework of domestic colonialism stood the police power of the state, the state militia, and the U.S. Army," writes journalist and ethnic studies professor Robert L. Allen in *Black Awakening in Capitalist America*. "As if this were not enough, an informal colonial army was created by the Ku Klux Klan and other 'white citizens' groups.

14 Abraham Lincoln, "Fourth Debate with Stephen A. Douglas at Charleston, Illinois," September 18, 1858, in *Collected Works of Abraham Lincoln,* vol. 3 (New Brunswick, NJ: Rutgers University Press, 1953), 146.

15 Ibid., 146–47.

16 Abraham Lincoln, "Last Public Address," April 11, 1865, in *Collected Works of Abraham Lincoln*, vol. 6 (New Brunswick, NJ: Rutgers University Press, 1953), 403.

17 "The genesis of the modern police organization in the South is the 'Slave Patrol' . . . Following the Civil War, these vigilante-style organizations evolved into modern Southern police departments primarily as a means of controlling freed slaves who were now laborers working in an agricultural caste system, and enforcing 'Jim Crow' segregation laws, designed to deny freed slaves equal rights and access to the political system." Gary Potter, "The History of Policing in the United States," *Eastern Kentucky University School of Justice Studies Online*, June 25, 2013, https://ekuonline.eku.edu/blog/police-studies/the-history-of-policing-in-the-united-states-part-1/. See also Alex Vitale, *The End of Policing* (London: Verso, 2017), 48.

It was the armed terrorism of these groups that helped in successfully undermining Reconstruction. And anyone who has lived in a 'modern' Black ghetto knows, it is no mere figure of speech when the predominantly white police forces which patrol these communities are referred to as a 'colonial army of occupation.'"[18]

Reconstruction in the nineteenth century instated a massive shift in the general size and jurisdiction of the United States government, resulting in an economic boom in the northern industrial states of the Union while simultaneously bankrupting the southeastern Confederacy states. The issue of whether or not African American slaves should be counted toward a state's total population was raised at the 1787 Constitutional Convention, after Black people were granted provisional freedom and the civil rights of second-class citizens, dependent on taxable income and subjective perspective. Amendments to the Constitution between 1865 and 1870 adjusted the legal regulation of Black people as non-human property of Southern slave owners.[19] "The difficulty with this legalistic formula was that it did not cling to facts," sociologist and historian W.E.B. Du Bois rebuked in his study *Black Reconstruction in America*. "Slavery was not abolished even after the Thirteenth Amendment. There were four million freedmen and most of them on the same plantation, doing the same work that they did before emancipation, except as their work had been interrupted and changed by the upheaval of war."[20] Du Bois' research on the period of American Reconstruction foregrounds the hierarchical legal and labor status of freed Black people during a time of immense change and acceleration into what would be a new century marked by great global wars, erratic economic activity, exponential population growth, and the eventual establishment of the nation states and commonwealth in the modern era. Central to today's understanding of the margins of human rights and labor is Du Bois' dutiful attention to the fact that former slaves of the late 1800s "were getting about the same wages and apparently were going to be subject to slave codes modified only in name."[21] He probed further into the coverage of the Constitutional amendments, noticing that there were "fugitives in the camps of the soldiers or on the streets of the cities, homeless, sick and impoverished," who would still be subject to the conditions of slavery if sent to prison.[22] Du Bois concluded that Black people "had been freed

18 Robert L. Allen, *Black Awakening in Capitalist America* (Trenton, NJ: Africa World Press, 1992), 10.

19 The Civil War, or Reconstruction Amendments, consisting of the Thirteenth, Fourteenth, and Fifteenth Amendments, were designed to ensure equality for recently emancipated slaves, with the Thirteenth Amendment banning slavery and all involuntary servitude, except in the case of punishment for a crime, the Fourteenth Amendment defining a citizen as any person (including Black people) born in or naturalized in the United States, and the Fifteenth Amendment prohibiting governments from denying citizens the right to vote based on race, color, or past indentured servitude. See "U.S. Senate: Landmark Legislation: Thirteenth, Fourteenth, & Fifteenth Amendments," https://www.senate.gov/artandhistory/history/common/generic/CivilWarAmendments.htm.

20 W.E.B. Du Bois, *Black Reconstruction in America: Toward a History of the Part Which Black Folk Played in the Attempt to Reconstruct Democracy in America, 1860-1880* [1935] (New York: Meridian Books, 1964), 188.

21 Ibid.

22 "The United States has the highest rate of incarceration of any nation on Earth: We represent 4 percent of the planet's population but 22 percent of its imprisoned. In the early 1970s, our prisons held fewer than 300,00 people;

practically with no land nor money, and save in exceptional cases, without legal status, and without protection."[23] A 2020 study published by the National Economic Association on the "Wealth Implications of Slavery and Racial Discrimination for African-American Descendants of the Enslaved" estimated the total of reparations due to be worth upward of $13 trillion, in addition to the "40 acres and a mule" for each Black citizen, which were never distributed.[24]

At the beginning of the twentieth century, a Black nation with a population of nearly twelve million, or 11% of the overall population, was slowly forming through waves of technological change and domestic violence, including frequent lynchings of African Americans and ensuing insurrections erupting from the organized protests in response to those lynchings.[25] The violence against and irreparable abuse of Black people by various independent, though coexisting, factions of the white American population was intricately connected to the overrepresentation of white Southerners in voting and governmental positions. Ninety percent of the Black population in America lived in the Black Belt region of the country from 1780 to 1910, following the governmental and economic structural changes established after the Southern Confederacy's loss against the Northern Union states in the Civil War.[26] Southern Democrats' dispro-portionate political power prevented Congress from reducing the number of seats Southerners could hold in the House of Representatives, creating a tautological loop of single-party state representatives winning repeatedly and controlling the institutional and economic structure of the Southeastern, formerly Confederate, states through a semi-democratic aristocracy, which continues to prevail in elections and govern in

since then, that number has grown to more than 2.2 million, with 4.5 million more on probation or parole. Because of mandatory sentencing and 'three strikes' laws, I've found myself representing clients sentenced to life without parole for stealing a bicycle or for simple possession of marijuana. And central to understanding this practice of mass incarceration and excessive punishment is the legacy of slavery." Bryan Stevenson, "The 1619 Project: Slavery Gave America a Fear of Black People and a Taste for Violent Punishment. Both Still Define our Criminal-Justice System," *New York Times Magazine*, August 14, 2019, https://www.nytimes.com/interactive/2019/08/14/magazine/prison-in-dustrial-complex-slavery-racism.html.

23 Du Bois, *Black Reconstruction in America,* 188.

24 Thomas Craemer, Trevor Smith, Brianna Harrison, Trevon Logan, Wesley Bellamy, and William Darity, "Wealth Implications of Slavery and Racial Discrimination for African American Descendants of the Enslaved," *Review of Black Political Economy* 47, no. 3 (September 2020): 218–54.

25 For a year-by-year chronicle of major efforts by African Americans to organize to effect change through the courts as well as through the establishment of educational institutions and the strong resistance of those efforts through mass lynchings, see Library of Congress, "African American Perspectives: Materials Selected from the Rare Book Collection," African American Timeline, 1881 to 1900, https://www.loc.gov/collections/african-american-perspectives-rare-books/articles-and-essays/timeline-of-african-american-history/1881-to-1900/.

26 "The refugees could not know what was in store for them and for their descendants at their destinations or what effect their exodus would have on the country. But by their actions, they would reshape the social and political geography of every city they fled to. When the migration began, 90 percent of all African-Americans were living in the South. By the time it was over, in the 1970s, 47 percent of all African-Americans were living in the North and West. A rural people had become urban, and a Southern people had spread themselves all over the nation." Isabel Wilkerson, "The Long-Lasting Legacy of the Great Migration," *Smithsonian Magazine*, September 2016, https://www.smithsonianmag.com/history/long-lasting-legacy-great-migration-180960118/.

the United States today. With the country locked in a constant inner struggle for a democratically regulated colonial republic, the Black population—a living currency and outmoded technology—developed communities and cultures of their own in spite of the violence inflicted on them in the process, like the 1921 white supremacist riot and massacre in the economically thriving "Black Wall Street" of Tulsa, Oklahoma, or the 1923 Rosewood Massacre in rural Florida, in which white men lynched African Americans and burned down their homes after a white woman falsely accused a Black man of beating her.[27] Migration to the North became widespread during the 1910s and '20s, as thousands left behind one kind of white supremacist disenfranchisement in the form of lynchings, house bombings, and legal restrictions on voting rights, only to find the brewing class and labor struggles of the urban industrial complexes upon arrival.[28]

Northern cities like Detroit, where churches and Black communities had previously doubled as safe havens for runaway slaves, became destinations for the nearly 500,000 African Americans who fled the South during the first Great Migration, in the mid- 1910s.[29] Located at the intersection of at least seven escape routes, Detroit had been an important stop along the Underground Railroad, which slaves traveled to run away from bondage in the plantation industrial complex of the Southern states between the 1820s and 1865. With the migration northward, Detroit's Black population grew to 300,000 by 1950—the fourth highest in the US after New York (155,000), Philadelphia (375,000), and Chicago (113,300) among a total of more than 15,000,000 Black people nationwide.[30] Black migration patterns from the 1940s to the 1960s retraced the routes of runaway slaves, routes soon to be even more heavily trodden as the cities experienced massive job growth: deskilled and routinized workflow processes were becoming a production standard for employing workers with little to no expertise, thus opening up more opportunities.[31]

The labor, economic, and population boom in Detroit in the early twentieth century resonated throughout the surrounding Midwestern states through the invention and production of the automobile, which linked together cities and citizens more

27 Gillian Brockell, "Tulsa isn't the only race massacre you were never taught in school. Here are others," *The Washington Post*, June 1, 2021, https://www.washingtonpost.com/history/2021/06/01/tulsa-race-massacres-silence-schools/.

28 "Migrations," in *The African-American Mosaic: A Library of Congress Resource Guide for the Study of Black History & Culture*, first published by the Library of Congress in 1994, https://www.loc.gov/exhibits/african/afam008.html.

29 "Whole churches moved north, and the first thing many of the poor Negroes did when they reached that Promised Land was to pool their meager resources and set up their church again, and get their preacher a good place to live. The storefront church was a Northern phenomenon simply because in the cities these country people found it was impossible to just buy some wood and build a church, as they had done in the South." Amiri Baraka, *Blues People: Negro Music in White America* (New York: Harper Perennial, 1963), 125.

30 Ibid. See also 1950 Census, https://www.census.gov/history/www/through_the_decades/overview/1950.html.

31 Wilkerson, "The Long-Lasting Legacy of the Great Migration."

effectively than the railroads that had initially unified the disparate American regions and territories. The progressive, multi-century-long invention of the modern automobile gained traction in the United States,[32] beginning with the creation of the luxury car company Cadillac in 1902.[33] The following year, the industrialist businessman Henry Ford, one of the richest men in the world during his lifetime, founded the Ford Motor Company with the intention of optimizing manufacturing; he pioneered the production model of the assembly line, a lean process that allowed Ford's factory to employ and train mostly unskilled workers to build cars quickly and at low cost, while paying them enough to be able to afford the car itself and make "a decent living." "Fordism" designated a prescription for high efficiency in worker production, ensuring quick profit turnaround by accelerating the movement and decisive settling of Americans in the area. Ford Motors' cheap and efficient update of the automobile, combined with its implementation of the conveyor belt "assembly line" production model, ensured that Detroit—home to the three largest automobile manufacturers in the country—became one of its leading financial centers by the 1930s. Moreover, Ford's business model organized and streamlined productivity in the factory and office divisions and standardized labor practices and manufacturing processes in the global industry,[34] triggering a shift in workforce development from slave to wage labor[35] and introducing a distinction between white- and blue-collar work.

"The white-collar people slipped quietly into modern society," wrote American sociologist C. Wright Mills in the introduction to his 1951 book *White Collar: The American Middle Classes*.[36] Mills studied social alienation in the modernizing New World, and argued that the United States was becoming a society of employees. He wrote about the rise of technicians, who operate and manage varying levels of bureaucratic tasks within a corporate entity. Employed to maintain and upgrade the technocracy from within, the technician, for Mills, is a person who has "ceased to

32 The question "Who Invented the Automobile?" does not have a straightforward answer, according to the Library of Congress' page "Everyday Mysteries: Fun Science Facts from the Library of Congress." It lists Nicolas-Joseph Cugnot in France, Robert Anderson in Scotland, Karl Friedrich Benz, Gottlieb Wilhelm Daimler, and Wilhelm Maybach in Germany, as well as George Baldwin Selden and brothers Charles Edgar and Frank Duryea in the United States as inventors of different types of early automobiles, https://www.loc.gov/everyday-mysteries/item/who-invented-the-automobile/.

33 Named for Detroit's founder, Antoine de la Mothe Cadillac. Herb Boyd, *Black Detroit: A People's History of Self-Determination* (New York: Harper Collins, 2017), 15.

34 Nicola Pizzolato, "The Making and Unmaking of Fordism," in Pizzolato, *Challenging Global Capitalism: Labor, Migration, Radical Struggle, and Urban Change in Detroit and Turin* (New York: Palgrave Macmillan, 2013), 19–45.

35 Near the end of the First World War, Henry Ford was the biggest employer of Black people, offering a wage of five dollars a day rather than the standard of five dollars a month, but as Herb Boyd notes: "These future workers were not aware that one of Ford's motives for five-dollar-a-day pay was to impede the growth and effectiveness of the Industrial Workers of the World and the Communist Party. Offering workers what he viewed as a decent salary would, he hoped, be incentive enough to keep them from the pull of an alternative economic system. Nor did these workers know or care about Ford's racial ambivalence." Boyd, *Black Detroit*, 92–93.

36 C. Wright Mills, *White Collar: The American Middle Classes* (Oxford, UK: Oxford University Press, 1951), ix.

be in any sense a free intellectual"; the "good-willed" technician's self-image has become "more solidly middle class, a man at a desk, married, with children, living in a respectable suburb, his career pivoting on the selling of ideas, his life a tight little routine, substituting middle-brow and mass culture for direct experience of his life and his world, and, above all, becoming a man with a job in a society where money is supreme."[37] The concept of status and social hierarchy, alongside the necessities of food, shelter, and community, form a desperate simulation, now the norm for a new kind of industrial middle class. Mills pointedly refers to it as "the morale of the cheerful robots." As he saw it, "Management effort to create job enthusiasm reflects the unhappy unwillingness of employees to work spontaneously at their routinized tasks; it indicates recognition of the lack of spontaneous will to work for the ulterior ends available; it also indicates that it is more difficult to have happy employees when the chances to climb the skill and social hierarchies are slim."[38]

White Collar's incisive critique of workplace management offers greater perspective on aspects of the average American's style of living; understanding of power, ideology, value; and overall built environment, all of which would be aggressively uprooted and transformed for the needs of corporate expansion and governmental oversight of bureaucratic and economic projects. Mills' work highlights a fault line between technical workers in the office and those who perform physical, manual, and infrastructural tasks out in society—blue-collar workers. In a technocratic society—and in spite of the United States' agricultural beginnings—jobs in government, entertainment, and communications industries that directly advance a company's economic growth are deemed far more valuable than the work that is done to maintain the essential functions of the very society in which the technocrats and their white-collar class live.

Yet a decade earlier, claims for the advanced mechanization of society through industrialization still held strong. In 1963, *Monthly Review Press* published a humble and impassioned document of general thoughts and revolutionary provisions for workers and foreign policy by Boggs, titled "The American Revolution: Pages from a Negro Worker's Notebook." Boggs drew on his experiences as an assembly-line worker at a Detroit Chrysler automotive plant in this tract, which he opened with the following remarks: "I am a factory worker, but I know more than just factory work," echoing Mills' acknowledgement of the employee's unwilling enthusiasm for work in an industrial society:

> I know the difference between what would sound right if one lived in a society of logical people and what *is* right when you live in a society of real people with real differences. It may sound perfectly natural to a highly educated and logical person, even when he hears people saying that there is going to be a big riot, to

37 Ibid., 156.
38 Ibid., 233.

assume that there will not be a big riot because authorities have everything under control. But if *I* kept hearing people say that there was going to be a big riot and I saw one of these logical people standing in the middle, I would tell him he'd better get out of the way because he sure was going to get killed.[39]

Boggs discusses labor unions, which "manufactured a new definition of democracy; the holding of one election after another until the workers vote the way the union wants them to vote."[40] Collapsing twenty years of union conflict against corporate capitalists into twenty pages, Boggs established a firmly post-Marxist stance on class struggle by detailing the specificity of the Black population's position within the United States' history of labor management systems, as a newly integrated working class born to former government-sanctioned slaves.[41] Boggs' musings could be extrapolated into roles assigned to the labor management structure of the United States' recent past, by considering company executives as comparable to plantation owners; unions as akin to slave drivers; and workers—both white- and blue-collar with respectively divergent experiences—as fulfilling the lowest roles of house and field slave laborers. Migrating to Detroit in 1940, Boggs had hitchhiked and ridden trains northward in flight from the racial violence and mandated segregation across all spheres of public and civic life between white and Black communities that was legally instituted across the Southern states. Transportation was no exception: the state of Louisiana, for instance, passed the Separate Car Act in 1890, allowing train companies to seat and separate riders according to color.[42] In 1892, Homer Plessy, a Louisiana resident, legally challenged the constitutionality of the law based on his own ancestral heritage of being "seven-eighths white" and "one-eighth Black" in the *Plessy v. Ferguson* case. The landmark case circulated through multiple courts before landing in front of the US Supreme Court, which chose to uphold existing law. While the Fourteenth Amendment granted equality between white and Black Americans, it did not, the Supreme Court ruled, legally protect from social and governmental "distinctions based upon color."

In Detroit in the midst of the Great Depression, as Black workers and homeowners began to protest for equal rights, racial tensions were high; over the years they built up

39 James Boggs, *The American Revolution: Pages from a Negro Workers' Notebook* (New York: Monthly Review Press, 1963), 11.

40 Ibid., 26.

41 "Under these circumstances, what shall we say of the Marxian philosophy and of its relation to the American Negro? We can only say, as it seems to me, the Marxian philosophy is a true diagnosis of the situation in Europe in the middle of the 19th Century despite some of its logical difficulties. But it must be modified in the United States of America and especially so far as the Negro group is concerned. The Negro is exploited to a degree that means poverty, crime, delinquency and indigence. And that exploitation comes not from a Black capitalistic class but from the white capitalists and equally from the white proletariat." W.E.B. Du Bois, "Marxism and the Negro Problem," *The Crisis* 40, no. 5 (May 1933): 104.

42 Supreme Court of the United States, U.S. Reports: Plessy v. Ferguson, 163 U.S. 537, 1896, https://www.loc.gov/item/usrep163537/.

36

and bled over into the race riot of 1943 and the subsequent rise of the Nation of Islam.[43] On June 20, 1943, a riot broke out in Detroit when assembly-line jobs introduced the requirement that Black and white workers would have to work alongside one another, spurred by pre-existing tensions over the migrating Black population and subsequent concerns from the white population about job and housing shortages.[44] The final toll left 34 dead, 433 injured, and 1,800 arrested.[45] That year, lawyer and civil rights activist Thurgood Marshall published a pamphlet-length analysis titled "What Caused the Detroit Riot?" with NAACP leader Walter White, alongside another text titled "The Gestapo in Detroit."[46] In it, he reported that the police had targeted Black citizens, who made up 85 percent of the arrests, while whites burned down cars, homes, and businesses. Marshall reprimanded the city's police and governing officials, saying, "This weak-kneed policy of the police commissioner coupled with the anti-Negro attitude of many members of the force helped to make a riot inevitable."[47]

In the transitional years after the insurrection, the city began to reorganize its design, replicating the six-foot-high and one-foot-thick segregation wall built in 1941 along Detroit's northern boundary of 8 Mile Road. Throughout the following decade, the racial crisis widened, as the relationship between unions and Black workers dissolved in favor of Ford's paternalistic social welfare services, even as the city of Detroit saw great economic growth through a wave of company mergers and the formation of an oligopoly—an industry dominated by a small group of sellers and distributors. The Fordist method of business and labor management greatly improved and set a standard for productivity in the US industrial labor market, but Ford's ideology for a fine-tuned and streamlined economic and social system set a pace of living that accelerated modern convenience while reducing the number of workers and materials necessary to produce sellable goods. The lean margins of Ford's assembly line and salary-based labor framework hinged on the three principles of synchronization, precision, and specialization—a slim proposal for labor management when compared to Toffler's six principles of product and demographic programmability: standardization,

43 "One of the basic tenets for members of the Nation of Islam was the Yakub theory, which posited that white people were created as a race of devils by selective breeding conducted by an evil Black scientist named Yakub (the biblical Jacob) about 4,600 BC. Despite their outspoken hatred for white people, the Black Muslims cannot be blamed for the Detroit race riot of 1943." Boyd, *Black Detroit*, 150.

44 "During the 1920s, the KKK's heyday, Michigan reportedly had more Klansmen than any state in the country— as many as 800,000, according to some estimates, though historians today believe a figure in the range of 80,000 to 120,000 is more plausible. Roughly half lived in metro Detroit. Prospective members—many of whom were white factory workers originally from the South—had to swear to be a 'native born, true, and loyal citizen . . . a white male Gentile person . . . a believer in the tenets of the Christian religion, the maintenance of White Supremacy, and principles of pure Americanism.'" Richard Bak, "The Dark Days of the Black Legion," *Hour Detroit*, February 23, 2009, https://www.hourdetroit.com/community/the-dark-days-of-the-black-legion/.

45 Boyd, *Black Detroit*, 150–54.

46 Thurgood Marshall and Walter White, *What Caused the Detroit Riots?: An Analysis* (New York: National Association for the Advancement of Colored People, 1943).

47 Thurgood Marshall, quoted in Vivian M. Baulch and Patricia Zacharias, "The 1943 Detroit Race Riots," *Detroit News*, February 10, 1999, http://blogs.detroitnews.com/history/1999/02/10/the-1943-detroit-race-riots/.

specialization, synchronization, concentration, maximization, and centralization.[48] When set in motion, Ford's utopian vision for a labor-management system tailored the manufacturing process to the relationship between the worker and the machine: both would labor together in cybernetic harmony, with the worker contributing to every task towards the final step of the process—a gesture of human dominance in project management and intellectual capability that ensured that the worker felt needed.

"Automation is a change in the mode of production which is more radical than any since the introduction of the assembly line,"[49] Boggs wrote in the second chapter of *The American Revolution*, forecasting that the lean production schemes that ran Detroit would become even leaner by relying more heavily on automated machinery. In the same way, it had seemed that the technocrats had suddenly surged forward into a future without its core labor force and partial consumer. Motioning for an empathy for human value, Boggs describes the blue-collar class as living, feeling people who have wants and desires that are unfortunately strung up in the "stuff of reality": commodities in a capitalist industrial society.[50] He notes that working people labor to maintain their class status and the "personal things" they have invested their hard-earned money into, at the expense of noticing the looming potential for mass unemployment, let alone organizing around it. The personal crisis of one's standard of living concerned Boggs: corporations were an essential life force for workers, but the recent introduction of automation optimized manufacturing processes beyond the need for workers; the government, a burgeoning moralist capitalist empire, offered little in the way of welfare.

In *The American Revolution*, Boggs provided an evolutionary theory extending far beyond Karl Marx's increasingly outdated understanding of industrial production and economics. Considering where the United States began and where it was heading, he wrote that "American Marxists have tended to fall into the trap of thinking of the Negroes as Negroes, i.e., in race terms, when in fact the Negroes have been and are today the most oppressed and submerged sections of the workers, on whom has fallen most sharply the burden of unemployment due to automation."[51] Declaring the United States a "warfare state" and "the citadel of world capitalism today,"[52] rather than the manufactured reality being sold to US citizens through big box stores, mail-order catalogs, and the media,[53] Boggs pointed to the larger postwar context: the United

48 Alvin Toffler, *The Third Wave* (New York: Random House, 1970), 62–73.

49 Boggs, *The American Revolution*, 23.

50 Ibid., 33–36.

51 Ibid., 85.

52 Ibid., 42.

53 "Almost from its initial European settlement, America participated in an economy of commercial exchange, and gradually over the centuries a market revolution increased the amount of goods that Americans purchased rather than made at home (or did without). Not only did people consume more ready-made products as time passed, but

States was the only nation worldwide to ever weaponize nuclear warheads, dropping two nuclear bombs on Hiroshima and Nagasaki, Japan, and killing more than 200,000 people.[54] For Boggs, the society the US had built was based on a class system that had extracted its wealth from an unpaid, unwilling slave population, violently forced to relocate across the grand continent of the Americas to secure and maintain the white colonizer's comfort. As civil rights leaders and supporters of a new and much needed Black nationalist ideology protested and opposed the opaque legal status of being relegated to the category of second-class citizens in a nation full of workers and immigrants, white people and private and governing institutions responded by urging the oppressed to assimilate, scale the ranks of the capitalist utopia of their oppressors, and exploit others within a government-sanctioned, hierarchical, socioeconomic game.[55]

Boggs struggled to respond with any positivity to the instrumentalization of enforced Black integration within the unveiled farce of American democracy, lamenting and speaking out against how Black citizens were left out of the socioeconomic benefits of the New Deal following the Great Depression: "The right to live has always been so tied up with the necessity to produce that it is hard for the average person to visualize a workless society."[56] To be workless in this sense implies a present state in which Americans are free to experience life while endowed with the support of governing institutions, without the reciprocity of indentured labor—working for the right to live in a country that often doesn't pay its Black citizens equitably. "To this day, the American nation celebrates the Civil War and records it as a war to free the slaves," Boggs stated, retracing the history of race-based labor movements and uprisings. He settled on an understanding of the Black population as "outsiders," "rebels with a cause" whose physical and existential contributions to the foundations of the United States held no value. Rather, "in the eyes of Negroes the Civil War was the war which made it possible for the United States to be industrialized, the war which resulted in the Bargain of 1877 between Northern capital and Southern landed aristocracy, which left the former slaves living and working under a caste system as brutal as that of slavery itself."[57] His 1963 essay "The Meaning of Black Revolt in the U.S.A.,"

the accumulation of luxury goods—at first, imported china and textiles, later fineries manufactured domestically—marked distinctions among Americans, such as between urban and rural dwellers and among social classes." Lizabeth Cohen, *A Consumer's Republic: The Politics of Mass Consumption in Postwar America* (New York: Vintage Books, 2003), 20–21.

54 Seren Morris, "How Many People Died in Hiroshima and Nagasaki?" *Newsweek*, August 3, 2020, https://www.newsweek.com/how-many-people-died-hiroshima-nagasaki-japan-second-world-war-152226.

55 "Both nationalism and assimilation spring from Black people's wish to be an integral part of a jargon society. This, after all, is what is meant by saying that man is a social animal. Nationalism, however, is rooted in the Afro-American's experience of being forcibly excluded from and rejected by a society which is usually overtly, and always covertly, racist and exploitative. In periods of social crisis—that is, when repression and terror are rampant or hopes of progress have been dashed—the resulting suspicion that equal participation is impossible becomes a certainty." Allen, *Black Awakening*, 89.

56 Boggs, *The American Revolution*, 46.

57 Ibid., 75.

posits what he saw as a unique social structure unraveling into an ongoing political crisis, in which the archetype of the Negro revolt operates as a natural antagonist to the American system that exposes an undergirding hypocracy in the nature of the law, wealth distribution, housing development, educational resources, and general quality of life:

> Thus within its borders the United States has its own colony to be exploited by every other segment of the population economically, socially, and politically. In order to justify this exploitation, the results of which can be seen everyday in the stark contrast between the life, work, and rights of Blacks and the life, work and rights of whites, the American people became racists. In order to reassure themselves day after day, year after year, decade after decade, that they were the melting pot of the world where all cultures and races had equal opportunity and merged—when this was obviously not true—they had to believe that the only reason why the Negroes continued to remain outcasts from the American way of life was because they were racially inferior. Thus when we deal with the American philosophy of race relations, we must realize that we are not dealing with ignorance or accumulated prejudice, but with a racist philosophy that has been created by the privileges of the rest of the population.[58]

In a following essay from his worker's notebook, titled "Black Revolt and the American Revolution," Boggs questions the legitimacy of American democracy as well as the general population's capacity to accept, process, and mobilize against the central issue of Negro, or Black, rights, as well as the lives and loss of the native Americans: "For the United States is the country in the world which fought a war for independence and did not free the slaves; then had to fight a civil war to free these same slaves; but then, having freed them, segregated them off to be systematically exploited and degraded on the basis of color."[59] Boggs' indictment of the United States as a nation state founded on the exploitation of workers frames a "brutal crime," and yet, he writes, "the American people can talk about the crimes of fascism, of Communism, etc., and never even mention the fact that the Negroes in the United States have lived under fascism every day of their lives for over 300 years."[60] Slowly turning the proverbial knife, Boggs infers that the ability of America—and of the general population of democratic nations around the world's—to ignore and profit off of the history of industrial capital accumulation and its eventual collapse, "is itself the acid test of integrity which no American can pass."[61]

58 James Boggs, *Race and the Class Struggle: Further Pages from a Black Worker's Notebook* (New York: Monthly Review Press, 1970), 10.

59 Ibid., 20.

60 Ibid.

61 Ibid.

In 1979, Boggs spoke about the considerable growth of possibility for an African American middle class to exist after the passing of the Civil Rights Act in 1964. In his speech "The Challenge Facing Afro-Americans in the 1980s," delivered at the Center for Afro-American and African Studies at the University of Michigan, Boggs described the ontological social construct of racism as "the principal and fundamental contradiction of American society." If the contradiction of a racial caste system within the American free-market republic was resolved, he reasoned, Black people "would no longer be systematically relegated to the bottom of society, we would no longer feel inferior to other Americans, and we would be free to pursue happiness as we saw other Americans pursuing it all around us." He continued:

> Until a few years ago Blacks were very critical of the individualistic and materi-alistic values of white Americans because it was so obvious that the high standard of living enjoyed by white Americans was largely at the expense of Blacks and other people of color. The Black community prided itself on the trust and respect that Blacks had for one another, contrasting it with the way that whites would do anything for a buck. However, since the barriers of racism have been lifted to let Blacks into the system, the individualistic and materialistic values that were always at the heart of the American Dream have become as much a part of Black relationships as they are of the relationships among other Americans.[62]

Boggs' analysis of the position of the Black worker in the labor industrial system of the United States follows on the heels of Du Bois' *Black Reconstruction in America*, in which he argues that, "Easily the most dramatic episode in American history was the sudden move to free four million Black slaves in an effort to stop a great civil war, to end forty years of bitter controversy, and to appease the moral sense of civilization."[63] Considering the culture shock and slow orientation of Black people from the South to their new homes in the industrialized, liberalized Northern cities, poet, critic and play-wright LeRoi Jones cultivated an art practice of using music, poetry, and theater as a testing ground for a Black revolutionary art. After a dishonorable discharge from the US Air Force in 1954, Jones moved to Greenwich Village in New York City, where he worked at a warehouse that stocked and shipped music records, developing an interest in jazz and its critical and commercial reception. During this time, he encountered a collective of local Beat poets and graduates from Black Mountain College, including Allen Ginsberg, Jack Kerouac, Frank O'Hara, and others. Over time, Jones grew frustrated with his contemporaries, and relocated to his hometown of Newark, New Jersey, changing his name to Amiri Baraka in 1965 in response to the assasination of Malcolm X at the Childs Memorial Temple Church of God in Christ in Harlem. His

62 Boggs, "The Challenge Facing Afro-Americans in the 1980s," in *Pages from a Black Radical's Notebook: A James Boggs Reader*, ed. Stephen M. Ward (Detroit: Wayne State University, 2011), 309.

63 Du Bois, *Black Reconstruction in America*, 3. See also 1860 Census, https://www.census.gov/history/www/through_the_decades/overview/1860.html.

evolution towards co-founding the Black Arts Movement with Audre Lorde, Ishmael Reed, Larry Neal, Maya Angelou, Nikki Giovanni, and others formed out of his own culture shock with the (white) American avant-garde of the early '60s, drawing a firm line between the leisurely experiments of the white youth counter culture and the artistic manifestations of Black spiritual liberation.

In his 1963 essay "Jazz and the White Critic," Baraka derides white critics' presumed intellectual capacity to understand and empathize with the emotive expressions of free jazz, which he describes as a Negro music whose "sources were *secret* as far as the rest of America was concerned, in much the same sense that the actual life of the Black man in America was secret to the white American."[64] He explains further that "the first white critics were men who sought, whether consciously or not, to understand this secret, just as the first serious white jazz musicians (Original Dixieland Jazz Band, Bix, etc.) sought not only to understand the phenomenon of Negro music but to appropriate it as a means of expression which they themselves might utilize."[65] That same year, Baraka published his first book, *Blues People*—a history of Negro music in white America that retells the music history of "so-called nonliterate peoples (called by Western man 'primitive'), whose languages, and therefore whose cultural and traditional histories, are not written, and thus are the antithesis of Western man and his highly industrialized civilization."[66] Baraka asserted that the ethnic material simmering within the Negro slave population came from a philosophical substance and system that was alien to the Western world and the American nationalist ideology. "Afro-Americans (by whom I mean the first few generations of American-born Black people, who still retained a great many *pure* Africanisms), and later, American Negroes, inherited all these complexities with, of course, whatever individual nuances were dictated by their particular lives," Baraka insisted. "The ugly fact that the Africans were forced into an alien world where none of the references or cultural shapes of any familiar human attitudes were available is the determinant of the *kind* of existence they had to eke out here: not only slavery itself but the particular circumstances in which it existed."[67]

Enduring rigorous work schedules, poor quality of life and food,[68] slaves surfaced

64 Amiri Baraka [as LeRoi Jones], "Jazz and the White Critic" [1963], in *Black Music* (New York: Da Capo Press, 1998), 14–15.

65 Ibid.

66 Amiri Baraka, *The Blues People: Negro Music in White America* (New York: Harper Perennial, 1963), 6.

67 Ibid.

68 "I cannot remember a single instance during my childhood or early boyhood when our entire family sat down to the table together, and God's blessing was asked, and the family ate a meal in a civilized manner. On the plantation in Virginia, and even later, meals were gotten by the children very much as dumb animals get theirs. It was a piece of bread here and a scrap of meat there. It was a cup of milk at one time and some potatoes at another. Sometimes a portion of our family would eat out of the skillet or pot, while someone else would eat from a tin plate held on the knees, and often using nothing but the hands with which to hold the food." Booker T. Washington, *Up from Slavery: An Autobiography* [1901] (New York: Signet Classics, 2010), 6.

new vocalized sounds in their songs.[69] The workers sang communally, expressing their hopes for a better future and the sorrows of a hellish present. Coded messages were interwoven within these songs, creating a multi-directional, stereophonic communication system using voice and drum.[70] Spiritual hymns are in effect a cultural divergence, the beginning of a multi-century process of West African slaves converging into an existential socio-economic category of "Black," further subdivided into a gradient/genetic hierarchy of Negro, mulatto, quadroon, octroon, etc.[71] "Among the duties of the enslaved was the enslaver's entertainment," writer and critic Wesley Morris explains. "Black people were called upon to fiddle and dance for their white owners and their guests."[72] Morris asserts that the "birth of American popular culture" is situated in the activity of white colonizers, such as the businessman and circus ringmaster P.T. Barnum, who from the 1840s to the 1870s organized tours during which minstrels performed their impressions of Black people. "It wasn't Black music at all but blackface minstrelsy—white men painted pitch-black doing dopey (but not unskilled) dances and singing comic songs as they imagined Black people might," Morris adds. "What minstrelsy offered the country during this period was an entertainment of talent, ribaldry, and polemics. But it also lent racism a stage upon which existential fear could become jubilation, and contempt could become fantasy."[73] Under the management of their masters, slaves adapted the syncopated beats and dances on the slave ships as they crossed over from Africa to the New World, giving rise to professional forms of entertainment, like the spectacle of Thomas "Blind Tom" Higgins, an enslaved multi-instrumentalist child prodigy, promoted as the "Wonder of the World."[74] The child of a Georgia slave, Blind Tom made his masters a fortune by performing and touring America and Europe, while being kept uncompensated for decades both before and after the Emancipation Proclamation was passed in 1863.[75] Over time, however, such songs developed into a Black secret technological language

69 "Black music is a bridge between elective muteness and the scream, between excess and disguise. Every variation of speech and speechlessness at our disposal begins as song. Every song pursues the silence after its last note. On the passage to that silence we encounter low hummed sounds, hysterical sounds, requiem sounds, healing sounds, masochistic sounds, unsounds, murmurs, and, in dire conditions, we refuse all sound and let the aura play its field around us, and suspense, menace, and near threat become the condition of our singing and our silence." Harmony Holiday, "The Black Catatonic Scream," *Triple Canopy*, August 20, 2020, https://www.canopycanopycanopy.com/contents/the-black-catatonic-scream.

70 "Antiphony (call and response) is the principal formal feature of these musical traditions. It has come to be seen as a bridge from music into other modes of cultural expression, supplying, along with improvisation, montage, and dramaturgy, the hermeneutic keys to the full medley of Black artistic practices." Paul Gilroy, *The Black Atlantic: Modernity and Double Consciousness* (Cambridge, MA: Harvard University Press, 1993), 78.

71 Du Bois, *Black Reconstruction in America*, 3.

72 Wesley Morris, "Music," in *The 1619 Project: A New Origin Story*, ed. Nikole Hannah-Jones (New York: One World, 2021), 366.

73 Ibid., 367.

74 Langston Hughes and Milton Meltzer, *Black Magic: A Pictorial History of the African-American in the Performing Arts* (New York: Da Capo Press, 1990), 7–15.

75 Ibid.

for altering reality and making objects, machines, and even environments speak. From the depths of Blackness, a hue of blues would emerge through personal songs and call-and-response vocalizations—consider the rebellion led by the enslaved preacher Nat Turner, who mobilized songs to signal and coordinate on-the-ground warfare.[76]

Baraka points to the blues as a social phenomenon born during a time of enslavement, but not because of slavery: "*Blues* means a Negro experience, it is the one music the Negro made that could not be transferred into a more general significance than the one the Negro gave it initially."[77] The "work song or shout," comprised of a few English words and the conglomeration of available syllabic vocalizations, grew into the blues as a separate language, which after emancipation would take the form of a personal song for one's self, rather than the intercommunal spirituals that forged a culture of solidarity between enslaved workers.[78] "The spirit will not descend without song," Baraka writes, quoting an African idiom applicable to the community ritual of "Afro-Christian worship"—"church of emotion" that differs from work songs through its use of melodic and lyrical content.[79] Inside of the colonized, industrializing America, Black culture began to absorb, hack, and reformat European constructions, such as the Napoleonic military marching band style.[80] Cultural gatherings formatted around two drums, a violin, and communal singing in New Orleans' Congo Square[81] reshaped the blues into "jass" or "dirty" brass bands that transmits the magical technology of "Jes Grew"[82]—an audio virus that novelist and playwright Ishmael Reed

76 Aptheker, *American Negro Slave Revolts*, 294–306. See also Thomas R. Gray, *The Confessions of Nat Turner* (Baltimore: Thomas R. Gray, 1831), 7, 11, 18; and Erik Nielson, "'Go in de Wilderness': Evading the 'Eyes of Others' in the Slave Songs," *Western Journal of Black Studies* 35, no. 2 (March 2011): 106–17.

77 Baraka, *Blues People*, 94.

78 "Some of the work songs, for instance, use as their measure the grunt of a man pushing a heavy weight or the blow of a hammer against a stone to provide the metrical precision and rhythmical impetus behind the singer." Ibid., 67.

79 Ibid., 41.

80 "One example of the way Negroes used European rhythms in conjunction with their own West African rhythms was the funeral processions. The march to the cemetery was played in slow, dirgelike 4/4 cadence. It was usually a spiritual that was played, but made into a kind of raw and bluesy Napoleonic military march. The band was followed by the mourners—relatives, members of the deceased's fraternal order or secret society, and well-wishers." Ibid., 74.

81 "This kind of gathering in Congo Square was usually the only chance Negroes had to sing and play at length. And, of course, even this was supervised by the local authorities: the slaves were brought to the square and brought back by their masters. Still, in Congo Square sessions were said to have included many African songs that were supposedly banned by the whites for being part of the vodum or voodoo rites. The slaves also danced French quadrilles and sang patois ditties in addition to the more African chants that they shouted above the 'great drums.'" Ibid., 72.

82 "A 'plague' called Jes Grew has spread from New Orleans and caused half the country to dance recklessly, enjoy jazz and have a new appreciation for African American culture. Religious orders like the Knights Templar and the hi-tech Wallflower Order (responsible in Reed's novel for the Depression and the US occupation of Haiti) seek to destroy an ancient Egyptian text that the Jes Grew may 'want'. But Jes Grew is 'an anti-plague', the spirit of innovation and freedom of self-expression itself: 'Jazz. Blues. The new thang…Your style.' [Ishmael] Reed took a snatch of the preface to 1922's *The Book of American Negro Poetry*, in which James Weldon Johnson says 'the earliest Ragtime songs, like Topsy, 'jes' grew" – they just happened – and turned it into a clever literary device that exposes people's prejudice. While some believe the media invented Jes Grew to sell papers, Harlem Voodoo priest

describes as "going around in circles until the 1920s when it impregnated America's 'hysteria.'"[83] Canadian media theorist Marshall McLuhan was preeminently aware of this phenomenon of Black people taking and forging new outcomes from technology produced during the nineteenth and twentieth century, as evidenced in his 1968 book with graphic designer Quentin Fiore, *War and Peace in the Global Village*:

> The American Negro who has long coexisted with this literate culture especially feels anger when he gets "turned on," because he can see that the causes of his degradation are to be found in a technology that is now repudiated by his masters. When the electric age began to be felt during and after the First World War, the world of Negro jazz welled up to conquer the white. Jazz was a Negro product because it is directly related to speech rhythm rather than to any printed page or score.[84]

In 1900, writer and civil rights activist James Weldon Johnson wrote "Lift Every Voice and Sing," an uplifting poem transcribed into music by his brother, John Rosamond, to be performed on the anniversary of Lincoln's birthday by a choir composed of five hundred children at the segregated Stanton School in Jacksonville, Florida, where James Weldon Johnson was principal. During the Red Summer of 1919—a term coined by Johnson in response to white supremacist terrorism, race riots, and lynchings across the United States[85]—the National Association for the Advancement of Colored People (NAACP) named the hymn the "Black national anthem," embracing its lyrics, which called on the African American community to "Sing a song full of the faith that the dark past has taught us, / Sing a song full of the hope that the present has brought us; / Facing the rising sun of our new day begun, / Let us march on 'til victory is won." In 1939, artist Augusta Savage was commissioned by the New York World's Fair to create a sixteen-foot plaster sculpture titled *The Harp*, illustrating the anthem as a monument; composed of a group of twelve singers figured as harp strings, the sculpture featured the hand and arm of God before a man embodying the foot pedal and the

Papa LaBas is drawn into the search for its ancient text. Unbeknown to him, a Muslim scholar has already found it, translated it and had it rejected by a publishing house. The slip is found next to his dead body: "The 'Negro Awakening' fad seems to have reached its peak and once more people are returning to serious writing . . . A Negro editor here said it lacked 'soul' and wasn't 'Nation' enough." Jonathan McAloon, "Mumbo Jumbo: A Dazzling Classic Finally Gets the Recognition It Deserves," *Guardian*, August 1, 2017, https://www.theguardian.com/books/booksblog/2017/aug/01/mumbo-jumbo-a-penguin-classic-2017-ishmael-reed.

83 Ishmael Reed, *Mumbo Jumbo* (New York: Scribner, 1996), 211.

84 Marshall McLuhan, *War and Peace in the Global Village* (New York: Bantam Books, 1968), 79–80.

85 "Nineteen-nineteen was a period of great anxiety. The economy was topsy-turvy. Inflation was out of control. There were an enormous amount of strikes. The Bolsheviks had taken over the Soviet Union, and communists and anarchists were agitating all over the world. The Red Scare was underway. Black equality and Black assertions of rights were being equated with some sort of radical action and radical message, but the link between African-American efforts to achieve full rights in America and communism were pretty non-existent at the time." Cameron McWhirter, interview by Olivia B. Waxman, "'It Just Goes On and On': How the Race Riots of 1919's 'Red Summer' Helped Shape a Century of American History," *Time*, July 29, 2019, https://time.com/5636454/what-is-red-summer/.

harp's music.[86] When Savage was unable to raise the money necessary to preserve and store the sculpture, it was destroyed after the American World's Fair—the second-most expensive to produce to date—closed. The fair, which promised the "Dawn of a New Day" and a view into "the world of tomorrow," heralded a different message.

"[T]he conjoining of writing and sound has particular ramifications for Black cultural production, given the importance of orality as the major mode of cultural transmission in this temporal setting," writes Alexander G. Weheliye, who documents the concept of "grooves in sonic Afro-modernity" in his book *Phonographies*. "Because alpha-betic writing was such an embattled terrain for Black subjects in nineteenth-century America, the phonograph did not cause the same anxieties in Black cultural discourses, and musical notation and writing were not necessarily understood as the most natural way of recording music."[87] He reasons that the invention of the phonograph in 1877 allowed for a kind of speaking beyond written language—an extended, disembodied voice and vision that could take the fractured African songs that had traveled the Atlantic three hundred years prior and intercept and transcribe them as an ethnic, "non-American" material in the New World. Situating Du Bois as a scribe of "secular messianism," Weheliye paraphrases his chronology of Black culture, experience, and music as a phono-optical emulsion, a divine source, captured and distributed within the confines of a Western colonial economy based on industry and technology:

> As a result, these sanguine harmonies and melodies "poison" the body politic of U.S. national culture by suffusing it with other ways of becoming human, which is to say that Black subjectivity not only functions as a constitutive trace or outside of whiteness, reason, citizenship, full humanity, and so on, but as an event horizon for "human promise." Possibly, this is what Du Bois has in mind when writing "Negro blood has a message for the world." Here, poisoning and offering concoct an alchemic brew of Blackness—a pharmakon, as Plato and Derrida would call it that recolors, via the sonic (the gift of song), the very grounds of Western modernity. In the end, double consciousness does not so much critique as gift (poison and bless) the disembodiment of vision and by extension the human in modernity in its excavation and amplification of aural materiality, the "tremulous treble and darkening bass" veiled by scopic racial formation, as it throws phono-optics into the mix of the phonographic grooves of sonic Afro-modernity.[88]

86 Concepción de León, "The Black Woman Artist Who Crafted a Life She Was Told She Couldn't Have," *New York Times*, March 30, 2021, https://www.nytimes.com/2021/03/30/us/augusta-savage-black-woman-artist-harlem-renaissance.html.

87 Alexander Weheliye, *Phonographies: Grooves in Sonic Afro-Modernity* (Durham, NC: Duke University Press, 2005), 36.

88 Ibid., 44.

In addition to the invention of the phonograph, the Radio Acts of 1912 and 1927 created a national telebroacasting network[89] that further captured and distributed Black music as "race music"[90] throughout the nation, establishing a superstructural "blues continuum," which Baraka retraced in *Blues People* as the evolution of blues, the introduction of jazz, and the secularization of Black music as a whole in the period after emancipation. "By the time the large dance and show bands started to develop into jazz bands, the more autonomous blues forms had gone largely underground, and had returned, as it were, to be enjoyed by the *subculture* in which they were most functional as a collective expression," Baraka writes.[91] He considered the commercialization of Black music as a signifier of assimilation into the middle-class American culture of the northern states and a distillation of the Negro spirit into an open-access commodity. "All these blues forms existed together in the cities; the phonograph record and later the radio helped push this blues continuum into all parts of the country" Baraka writes. The blues continuum displayed a potent form of "authenticity" that had been tamed into a "more easily *faked*" rhythm and blues structure made for the radio.[92] "By the forties, after the war had completely wiped out remaining 'race' record[93] categories, the radio became the biggest disseminator of blues music."[94] The overall growth of the music and entertainment industries, Baraka argues, was hindered by the fact that "large white companies" couldn't maintain a profitable business model on the recording and exclusive ownership of Black music, because so many songs were being recorded and released within Black communities, where many signed artists lived and performed—the multi-million dollar recording industry of Old Hastings Street in Detroit stands as a perfect example of this phenomenon. For Baraka, "Rhythm &

89 "Throughout the twenties, Americans bought millions of radio units, with thousands of radio stations broadcasting all manner of programming. For millions of rural Americans, the battery-powered radio was often the first electric device in the household. Even at the end of the war in 1918, strikingly only half of American homes had been wired for electricity, with rural households largely left out. Before the pleasures of Edison's lightbulb and the alternating-current standard propagated by Westinghouse became ubiquitous, the next generation of their respective corporations brought pop culture to the nation's living rooms, where Americans in the city and out in the country huddled to spend their evenings—often in a collective trance, listening to the same thing at the same time for the first time in history." Srinivasan, *Americana*, 306.

90 "Race records were commercial recordings aimed strictly toward the Negro market (what large companies would call their 'special products division' today, in this era of social euphemism). The appearance and rapid growth of this kind of record was perhaps a formal recognition by America of the Negro's movement back toward the definable society. This recognition was indicated dramatically by the Okeh Record Company's decision to let a Negro singer make a commerical recording. Strangely enough, the first Negro blues singer to make a commerical recording was no Ma Rainey or Bessie Smith, or any other great classic or country blues singers, but a young woman, Mamie Smith, whose style of singing was more in the tradition of the vaudeville stage than it was 'bluesy.'" Baraka, *Blues People*, 99.

91 Ibid., 166.

92 "The fragmentation and subdivision of Black music into an ever increasing proliferation of styles and genres which makes a nonsense of this polar opposition between progress and dilution has also contributed to a situation in which authenticity emerges among the music makers as a highly charged and bitterly contested issue." Gilroy, *The Black Atlantic*, 96.

93 Ibid.

94 Baraka, *Blues People*, 169.

blues was a popularization, in a very limited sense, of the older blues forms, and in many cases merely a commercialization, but it was still an emotionally sound music. Its very vulgarity assured its meaningful emotional connection with people's lives."[95]

Comparatively, jazz musician and historian Charles Keil classifies Black music according to three distinct categories of African American expression: "sacred music—spirituals, jubilees, and gospels; secular music—blues (country and urban) and most jazz before World World War II; 'art' music or jazz since 1945."[96] Rhythm & Blues, a term coined in 1948 by music journalist Jerry Wexler of *Billboard* magazine, was meant to replace the catch-all African American music genre of "race music" as a new secular and commercial genre, full of metropolitan emotions, unfamiliar to the rural and pre-industrialized communities of the South. Soul music thereafter and into the Civil Rights and Black Power movements of the 1950s and '60s formed a two-pronged ritual and outlet for Black creative expression between the secular and spiritual. Keil notes that "Bluesmen and preachers both provide models and orientations; both give public expression to deeply felt private emotions; both promote catharsis—the bluesman through dance, the preacher through trance; both increase feelings of solidarity, boost morale, strengthen the consensus."[97]

Black congregations in the industrial Northern states, in conjunction with the post-Civil Rights possibility of gaining middle-class status, facilitated the emergence of a new untapped market demographic. "To this day, Clive Davis, who was the president of CBS, claims it was his brainchild to move aggressively into Black music," critic Nelson George suggests in his book *The Death of Rhythm and Blues,* citing an inflammatory report submitted to CBS on May 11, 1972, by the Harvard University Business School titled, "A Study of the Soul Music Environment Prepared for Columbia Records Group."[98] "The growth of CBS's involvement in Black music in the years following the Harvard Report was immense," George writes. "In 1971, the CBS roster included two cutting-edge Black artists, Sly and the Family Stone and Santana," but, "by 1980, it had 125 acts, among them big names like Earth, Wind and Fire, Teddy Pendergrass, the O'Jays, the Isley Brothers, and Weather Report."[99] George also directs attention to the "Soul Content of Artist's Repertoire" chart in the report, which defines "soul" and "the soul market" using a three-category gradient of potential to reach "Almost All, Mixed, Almost None" consumer demographics. "By analyzing the total size of the record industry in 1970 ($1.66 billion), the report estimated the soul share at $120

95 Ibid., 170–74.

96 Keil, *Urban Blues*, 30–34.

97 Ibid., 164.

98 Nelson George, *The Death of Rhythm and Blues* (New York: Plume, 1988), 135. See also Logan H. Westbrooks, *The Harvard Report: A Study of the Soul Music Environment Prepared for Columbia Records Group* (Los Angeles: Ascent Book Publishing, 2017).

99 George, *The Death of Rhythm and Blues*, 136.

million, or approximately 10 percent," George surmises.[100] In his view, the historical development of Black music could be framed as a large scheme of the major recording music industry to absorb and shut out independent record labels. In his introduction to the book, George questions how Black music would be revised by the major music recording industry as a means of establishing a profitable business model from the cultural assimilation taking place in the post-Civil Rights era:

> By linking the evolution of Black radio to the growth of the independent labels, the development of retail outlets, and the structure of today's record companies, I hope both to fill a gap in the critical imagination and to tell a story that is the essence of R&B. All those factors and actors, along with performers' creativity and talent, interact to determine which artists are deemed important and which aren't—who will become today's stars, and where to look for tomorrow's.[101]

In 1992, George coined the term "Post-Soul" in his book, *Post-Soul Nation: The Explosive, Contradictory, Triumphant, and Tragic 1980s as Experienced by African Americans (Previously Known as Blacks and Before That Negroes)* to define "the twisting, troubling, turmoil-filled, and often terrific years since the mid-seventies when Black America moved into a new phase of its history."[102] George understood the moment of racial integration after the assassinations of Martin Luther King Jr. and Malcolm X as "a time when America attempted to absorb the victories, failures, and ambiguities that resulted from the soul years."[103] Baraka had made it his prerogative to preserve the oral history of Black music and situate it within a long lineage as it accelerated toward the 1970s, absorbing the urban, social, economic, and technological advancements that preceded the "terrific years" George refers to. His 1966 essay "The Changing Same (R&B and New Black Music)," for instance, opens with a description of the blues as a primal Black musical form that contains the essence, history, and expression of culture. Stretching this continuum from the African call-and-response form to its repositioning within the construct of Western instrumental ensembles, Baraka proposed that Black music, as an expression, regrouped/embodied a nation within a nation. He writes, "Black music is African in origin, African-American in its totality, and its various forms (especially the vocal) show just how the African impulses were redistributed in its expression, and the expression itself became Christianized and post-Christianized."[104]

100 Ibid., 136.

101 Ibid., xiii.

102 Nelson George, *Post-Soul Nation: The Explosive, Contradictory, Triumphant, and Tragic 1980s as Experienced by African Americans (Previously Known as Blacks and Before That Negroes)* (New York: Penguin, 1992), ix.

103 Ibid.

104 Baraka, "The Changing Same (R&B and New Black Music)" [1966], in *Black Music*, 175.

Baraka considered the formalization of the African vocal tradition in the late twentieth century into rhythm and blues to be an "expression of urban and rural (in its various stylistic variations) Black America."[105] He articulates that a truly free and Black music can transmit and materialize images, environments, emotions, and worlds that are—and ought to be—alien to white Americans. The migration from the rural South to the northern industrial states, he argued, changed the content of Black music considerably and most noticeably into a commodity that could integrate with the tastes and financial interests of the white American music recording industry.[106] "The R&B people left the practical God behind to slide into the slicker scene, where the dough was, and the swift folks congregated," Baraka wrote of the changing expressions of a Black America in migration. "The new jazz people never had that practical God, as practical, and seek the mystical God both emotionally and intellectually."[107] In the essay's conclusion, Baraka called for a "Unity Music" that would combine the religious and secular expressions of Black music and R&B towards a "social spiritualism" as well as an "action and reaction, a seeing, thrown in swift slick tone along the entire muscle of a people."[108]

105 Ibid., 178.

106 "In urban Black popular culture, there is nothing hipper than a 'con.' But it's ironic that the practice and execution of the con is often revered as an art form in Black popular culture because Blacks and other recent arrivals to American cities were the victims of these schemes; over time, Black men and women perpetrated new and modified forms of the trade for the specific purpose of fleecing other Blacks (as well as whites). At the risk of understatement, the con game, as an income-generating activity, became an American urban cultural practice to which urban Black popular culture greatly contributed. It was also organically linked to the bourgeois, romantic vision of the city as a place filled with opportunities there for the taking as well as opportunities to take anyone who exposed their vulnerability." John Jeffries, "Toward a Redefinition of the Urban: The Collision of Culture," in *Black Popular Culture*, ed. Gina Dent (Seattle: Bay Press 1992), 161.

107 Baraka, *Black Music*, 185.

108 Ibid., 203.

3.
THE SPIRIT OF THE PEOPLE IS GREATER
THAN MAN'S TECHNOLOGY

"The techno-rebels have not as yet formulated a clear, comprehensive program. But if we extrapolate from their numerous manifestos, petitions, statements, and studies, we can identify several streams of thought that add up to a new way of looking at technology—a positive policy for managing the transition to a Third Wave future."[1]

– Alvin Toffler

"I'd got into Alvin Toffler and his comments concerning the electronic village. I considered that there had to be more than three waves and extrapolated the necessity of interfacing the spirituality of human beings into the cybernetic matrix: between the brain, the soul and the mechanisms of cyberspace."[2]

– Juan Atkins

In December 1988, *Music Technology,* a prominent UK-based gear-oriented electronic music magazine, published an interview with Juan Atkins, introducing him as a quiet inventor whose creation had already exceeded by far what he could have ever imagined.[3] The magazine ran at a pivotal time, from 1985 to 1994, when the globalized music industry was beginning to take a leap forward into the digital age with the introduction of MIDI (Musical Instrument Digital Interface), the emergence of a new form of "additive" and "subtractive" synthesis within frequency modulation technology, and the advent of sampling—all of which would expand the horizons of possibility and accessibility for both the professional musician and the average consumer. "We watched the economics of music making turned over," *Music Technology* editor Tom Goodyer recalled in 2016. "We watched major recording studios close, and sequencers become digital audio workstations." In that time, he witnessed "the reinvention of the DJ and the ascent of dance music."[4]

The interview with Atkins was conducted by UK journalist Simon Trask, a regular contributor to *Music Technology*, whose writing over the years often veered into

1 Alvin Toffler, *The Third Wave* (New York: Random House, 1970), 167.

2 Juan Atkins, quoted in Jon Savage, liner notes, Cybotron, *Interface: The Roots of Techno* (Southbound, 1993).

3 Simon Trask, "Future Shock," *Music Technology* (December 1988): 38–43.

4 Tom Goodyer, "Remembering *Music Technology*," introductory note to the magazine's archive on *muzines*, March 2016, http://www.muzines.co.uk/mags/mt/active?note=1.

speculation about where this new relationship between music and technology would lead. Trask's profile was apt in its framing of Atkins as a similarly minded explorer of the future. Writing about two recent remixes by Atkins (of Inner City's single "Good Life" and his own track "Techno Music," both included on the 1988 *Techno!* compilation), Trask pinpointed the moment when techno transformed into something new and moved away from Atkins. The fact that a dance music track could top the charts at that time had opened up new territory for the growth of the electronic music industry. Indeed, Kevin Saunderson, as Inner City, had broadcast the techno sound into commercial success in the UK with singles "Good Life" and "Big Fun" (also on the 1988 *Techno!* compilation): they weren't just examples of technologically innovative Black music—they were popular, topping several dance and singles charts throughout the US, UK, and Europe. Trask had met with Saunderson in London, where he was recording material at Battery Studios, a few months prior, and recounted their conversation in the September 1988 issue of *Music Technology*.[5] Trask's underlying assumption—that European techno-pop influenced the Detroit music scene—becomes apparent. He quotes one of Derrick May's many critiques of the Anglo-Saxon approach to electronic production: "English bands ten years ago hardly knew what they were doing. They left us waiting. Somebody like Gary Numan started something he never concluded." Trask does concede that "many early '80s techno-pop groups have proven incapable of providing a convincing technology-driven music for the late '80s."[6]

"With the charts once again opening up to groups of a technological persuasion, Atkins seems set to follow in the footsteps of the early techno-pop bands he so admires,"[7] Trask announces, making the case to *Music Technology*'s readers that they can relate to Atkins' experiments and the ensuing expressions by Saunderson, May, and Eddie Fowlkes on the basis of their mutual love of British and European popular music. The article overinflates Atkins' "enthusiasm" for Kraftwerk and Giorgio Moroder (in particular through his production work for Donna Summer) as Trask and Atkins discuss The Electrifying Mojo's introduction of electronic music to the Black community. "He played all the Parliament and Funkadelic that anybody ever wanted to hear. Those two groups were really big in Detroit at the time. In fact, they were one of the main reasons why disco didn't really grab hold in Detroit in '79,"[8] Atkins explains. Mojo's nightly tele-sonic fictions succeeded in capturing and reenvisioning how a community could experience this music in a time of economic duress, while creating a bridge from the blues and jazz of Old Hastings Street in the 1920s to the Motown "Hit Factory" of the 1960s, through to the pre-techno progressive music of the 1970s and '80s. In essence,

5 Simon Trask, "The Techno Wave," *Music Technology* (September 1988): 70, 73.

6 Ibid.

7 Trask, "Future Shock," 38.

8 Ibid.

as Atkins saw it, Black Detroit's musical history spans much of the twentieth century as a continuous—though sometimes interrupted—train of thought.

Atkins began his first sonic experiments during the summer of 1980. His father worked as a promoter in Detroit, booking jazz and soul musicians such as Michael Henderson and Barry White in the aftermath of the 1967 race riot and Motown Records' relocation to Los Angeles in 1972. He bought Atkins his first electric guitar for his tenth birthday; Atkins used the instrument to imitate the psychedelic effects and heavy guitar stylings of Jimi Hendrix and Sly Stone, before moving on to learn to play drums and bass guitar. Trouble in school and the kind of negative influences that a teenager can encounter in a city led Atkins to leave his mother and younger siblings in Detroit when he was fourteen to live with his grandmother in the suburban village of Belleville, thirty miles outside Detroit. In this less stimulating environment, he was able to find the time and space to process his musical inclinations: "My grandmother had a Hammond B3 organ, and we'd often go to the music shop where there was a little room with synthesizers in it. Whenever I went I'd play with them and make all these weird sounds."[9] His grandmother bought him his first electronic instrument, a Korg MS-10, an entry-level analog synthesizer: "I messed around with that synthesizer all summer, and I'd got to the point where I was making up all sorts of drum beats on it." On the subject of equipment and workflow, the conversation between Atkins and Trask is detailed, offering a glimpse into Atkins' systems-oriented thinking. He talks about adapting a method, pioneered by Bernie Worrell of Parliament, of playing chromatic modular synthesizer bass lines on his Korg MS-10, recorded onto a Yamaha four-channel mixer with Kenwood cassette decks, which he would bounce and overdub with sounds and sequences to replicate a modest take on the sophisticated stereophonic effects that could be found in bigger budget studios. The bedroom productions that occupied much of Atkins' summer of 1980 were a perfect example of the landscape that *Music Technology* and Trask's own writing anticipated in this new technological era of music making, when even a nineteen-year-old Black kid in Detroit could dream of the sounds of the future.

In autumn 1980, Atkins began attending Washtenaw Community College in Ann Arbor, Michigan, where he took music classes. While playing the half-dozen tracks he had compiled over the summer, Atkins attracted the ear of his classmate Richard "Rik" Davis, a kind of philosopher with a very abstract style of electronic production. Sharing an interest in futurism, Atkins and Davis dove into deep conversations about Toffler's theories of industrial realism and parascientific mysticism. Davis was a loner, a twenty-eight-year-old veteran of the Vietnam War—the first American war in which Black and white soldiers were formally assigned integrated units, though instances of overt racism and white supremacist terror tactics still occurred. In a 2016 interview, Davis spoke candidly about the war, during which he caught malaria twice;

9 Ibid., 39.

he recalled how his unit was tasked with protecting the Chiêu Hồi Psychological Operations Program (PSYOP), which broadcast and distributed propaganda and American popular culture to South Vietnam: "The jungle they sent us into, even the Viet Cong wouldn't go in there. It was virgin jungle. All the Vietnamese thought we were completely nuts. There was nothing in that jungle but rock, apes and tigers. Everything in it was poisonous."[10] Being drafted into the apocalyptic scene of the war had been an escape for Davis, the population of whose hometown of Black Bottom, a predominantly Black neighborhood of Detroit, mostly found employment in the surrounding automotive and manufacturing plants. A significant musical hub in the 1950s, the area had been deemed substandard and was pushed into abject poverty by the discriminatory housing policies of the New Deal, a series of public programs, financial reforms, and regulations put in place by President Franklin D. Roosevelt in the 1930s to push towards the recovery of the United States during the Great Depression. By 1959, Black Bottom and Paradise Valley, an adjacent neighborhood, had been demolished as part of an urban renewal initiative pursued by the City of Detroit, and were replaced by Lafayette Park, a modernist residential district designed by architect Ludwig Mies van der Rohe.

In 1978, Davis produced and pressed the two-track, 7-inch "Methane Sea" on his own record label, Deep Sea. Titled after a highly flammable chemical compound found on the seafloor, Davis' sculptural sound, following on the heels of industrial blues, envisioned a devastated landscape that didn't differ very much from his own reality. "Methane Sea" portrays a fundamentally rotten atmosphere, represented by swathes of panning, and multichannel granular sound, combined with Davis' affected vocals, in which he declares himself to be ethereal, infinite, and beyond the morbid constraints of the capitalist military industrial complex built up around him before he even had a chance to reach adulthood. Nearly three decades later, Davis explained that "Methane Sea" was a meditation on some lessons from the Book of Isaiah: "'I am God, there is none beside me. I am the Lord, there's no one else.'"[11] Attesting to his experience of the 1967 Detroit race riots as a teen and the savagery of sloppy warfare as a member of the Marines in his twenties, Davis' two five-minute sketches on "Methane Sea" contain a lifetime of emotional and experiential information. Davis spoke candidly about his difficulties reintegrating American civilian society as a veteran. He returned home from Vietnam after going AWOL, and wasn't able to accept American counter culture after being exposed to the psychological warfare techniques employed by the US government during the war, as well as the rampant white supremacy of the military:

10 Rik Davis, quoted in Mike Rubin, "Rik Davis: Alleys of His Mind," *Red Bull Music Academy Daily*, May 24, 2016, https://daily.redbullmusicacademy.com/2016/05/rik-davis-alleys-of-his-mind.

11 Ibid.

What changed me after I got back was I saw the hippies and the Beach Boys side with their friend Charles Manson. His picture was all over the underground papers, talking about, "Charlie, he ain't done nothing." Later on you find out that he's a fucking Nazi and that his whole plan was to cause a race war between Blacks and whites so that he could reign out of the bottomless pit or some such shit, but they sided with him. He's Jesus to them, but I'm the fiend, I'm the monster.[12]

The supposed statute of equality that African Americans had obtained following the Civil Rights Act of 1964 presented a contradictory reality: in truth, the general white population seemed to hold a subconscious preoccupation with the complete annihilation of the Black race.[13] The US government limited African Americans' access to the most basic means of survival necessary within a capitalist society, while drafting more Black men into the Vietnam War than whites—enabling the domestic formation of the hippie counter culture movement. Academic Theodore Roszak documented this phenomenon in *The Making of a Counter Culture* (1969), noting that these young white hippies were children of the technocracy, a youth generation designed by the elite class. The white youth counter culture sought liberation from the ideological confines of their urban and suburban environments and collectively rejected their responsibility, as American citizens, to fight an unjust war designed to maintain the social contract of the American Dream. Roszak referred to the African American subset of the counterculture as the "other Americans," whose very existence asserted "a forceful, indignant campaign fixated on the issue of integrating the excluded into the general affluence."[14] In essence, the hypocrisy of the United States that weighed on his contemporaries became for Davis a defining feature of his daily lived experience as an African American who had been funneled through too many facets of the American industrial machine within the short span of his lifetime.

Living with future shock, Davis fostered a counter culture of his own, burrowing into metaphysical philosophy, theology, and electronic music, the latter of which bears resemblance to the stereophonic stylings that had emerged through the multi-engineer studio productions of Parliament and Jimi Hendrix, as well as through jazz fusion artists like Herbie Hancock and Les McCann, and Egyptian composer Halim El-Dabh's pre-German and French *musique concrète* experiments in modified audio and tape manipulation techniques of the 1940s. Davis' lyrical content filtered these sonic influences through portable synthesizers in multitrack recordings, in

12 Ibid.

13 "It would have made sense at the close of the Civil War to plan for the assimilation of Black people as a group into the American mainstream. Racism made this impossible. Now, as racism begins to crumble, the requirements of an advanced technological economy increasingly exclude Black workers from the active labor force. Hence racism, the stepchild of slavery, prevented Black people from following in the footsteps of other ethnic groups." Robert L. Allen, *Black Awakening in Capitalist America: An Analytical History* (Trenton, NJ: Africa World Press, 1992), 51.

14 Theodore Roszak, *The Making of a Counter Culture: Reflections on the Technocratic Society and Its Youthful Opposition* (Garden City, NY: Anchor Books, 1969), 13.

which he evoked concepts developed from a deep trauma that surfaced as esoteric poetry stemming from numerology and referencing the writings of H.P. Lovecraft and Biblical scripture. The literary and imagistic elements of Davis' approach to electronic music, both under his own name and under the pseudonym 3070, shouldered the burden of proving that sound can do more than simply be heard, given how much emotion and historical material he managed to pack into the 7-inch—a very human factor that is often overlooked in favor of a fascination with the computational and probable outcomes of electronic instruments.

"He had an ARP Odyssey, ARP Axxe, Roland RS09 string machine, the ARP analogue sequencer and an early Roland sequencer, and the Boss DR55 Dr Rhythm. I had my little Korg MS10,"[15] Atkins recounted. He was "blown away" by Davis' home studio. "It was during the day, but it was dark—the blinds were closed. The only lights you could see were coming from the keyboards. It wasn't really consumer gear—the stuff you could see anywhere. They had these LEDs. It looked like an airplane cockpit."[16] The meeting of Atkins and Davis was kismet, an opportunity to merge their isolated worlds and bridge a generational gap. At first, wanting to maintain his privacy, Davis chose not to meet at his home, which Atkins attributed to the assumption that collaborative music projects require multiple people—consider the number of large ensemble groups common to the funk and soul genres. But what Atkins was looking for was a distilled sound, using the electronic equipment to cover more ground with less manpower—a lean, homemade production model scaled from the industrial processes pioneered in Detroit auto factories. "Rik had a lot to do with me realizing that you could actually release your own record," Atkins recalled. Atkins and Davis both owned copies of a book titled *How to Make & Sell Your Own Recording,* by Diane Sward Rapaport.[17]

Over time, their conversations began to reshape into a new manner of speaking, eventually producing a techno-futurist dictionary and imagined virtual environment called the "Grid." As the video game phenomenon was gaining traction, Atkins and Davis drew from gaming terminology to describe activities in the Grid. "We conceived of the environment as being like the Game Grid," Atkins later explained. "Certain images in a video program are referred to as 'sprites,' and Cybotron was considered a 'super-sprite' with extra powers."[18] The synthesis and creation of new terms was as central to Atkins and Davis' collaboration as was sonic experimentation, which

15 Atkins, in Trask, "Future Shock," 9.

16 Juan Atkins, interview by Dave Tompkins, "The Things They Buried: On Cybotron's Embattled Techno Sci-Fi Masterpiece, 'Enter,'" *SPIN,* October 30, 2013, https://www.spin.com/2013/10/cybotron-clear-reissue-dave-tompkins-sci-fi-techno/.

17 Juan Atkins, interview by Vanessa Jane Brown, "Techno's Godfather Speaks: An Interview With Juan Atkins," *Reverb*, March 6, 2021, https://reverb.com/news/interview-juan-atkins.

18 Juan Atkins, quoted in Simon Reynolds, *Generation Ecstasy: Into the World of Techno and Rave Culture* (New York: Routledge, 1999), 18.

they cemented by adopting the name Cybotron—a portmanteau Atkins made up by combining the words "cyborg" and "cyclotron," a particle accelerator invented by American nuclear scientist Ernest O. Lawrence in 1930.[19] During this process of creation, Davis shared with Atkins the records he had collected while on active duty abroad, encouraging him to take notice of European electronic musicians like Kraftwerk. Until then, Atkins had been unaware of canonical examples of synthesizer music beyond Bernie Worrell, and this encouraged him to pursue and refine his specific idea of techno music. He told Trask that he respected the musical contributions of Kraftwerk, Devo, etc.—"but they weren't funky."[20] The sense-altering extra musical effects of funk music—the point at which sounds seem to shift beyond perceptibility, levitate, and protrude from the speakers—were more interesting to Atkins: "I felt that if I could take that type of music and add a funky element to it then it would be a smash. We did that, but we just didn't get recognized. Soul Sonic Force came along and beat us to it."[21] In 1981, Cybotron established their own label, Deep Space, and produced the track "Alleys of Your Mind," which combined synthesized bass lines played in the style of Parliament's Bernie Worrell with Kraftwerk's investments in the future of audio technology.

As the story goes, Atkins passed along a demo of the single to sixteen-year-old May, who lived near the WGPR studio where The Electrifying Mojo broadcast his nightly show. May decided that he would get his friend's music on the radio, and hung out at the café where Mojo was known to go after his show, playing the alien-invasion shooter game Defender, until he finally managed to intercept Mojo and convince him to play "Alleys of Your Mind" on his next show.[22] Davis' music had already gotten considerable airplay on The Electrifying Mojo's show: "Methane Sea" served as its theme. Cybotron's first single was a winning combination of optimized funk that would gain them considerable popularity in Detroit. For a time, it even outperformed Prince's hit "Little Red Corvette" on the Detroit radio station WCSB.[23] Looking back on this moment in 1988, Atkins told Trask about the early misreadings of his and Davis' electronic funk, even as it gained substantial popularity for an independent release: "I had people come up to me and say they thought Cybotron was some white guys from Europe. People couldn't believe we were actually Detroit musicians. We sold between 7,000 and 10,000 copies of that record in Detroit."[24] The shuffled beat and

19 Earnest O. Lawrence and Stanley M. Livingston, "The Production of High Speed Light Ions Without the Use of High Voltages," *Physical Review* 40, no. 1 (April 1932): 19–35.

20 Atkins, in Trask, "Future Shock," 39.

21 Ibid.

22 Account by Atkins, quoted in Ashley Zlatopolsky, "Theater of the Mind: The Legacy of the Electrifying Mojo," *Red Bull Music Academy Daily*, May 12, 2015, https://daily.redbullmusicacademy.com/2015/05/electrifying-mojo-feature/.

23 Atkins, interview by Brown.

24 Atkins, in Trask, "Future Shock," 39.

claps provided by Atkins contrasted with Davis' phaser-like ARP melodies on "Alleys of Your Mind." The B-side "Cosmic Raindance" proposed an imaginary soundtrack to Samuel R. Delany's *Dhalgren* (1975), a science-fiction novel about a ruinous city in the American Midwest isolated from the outside world by technological failure, the natural intrusion of storm cloud coverage, and the psychological dissolution of the city's inhabitants. Delany's writing verges into the delirium of modernity and its rule-bound excesses in a way that offers a glimpse into what Davis and Atkins were trying to produce with their music.[25] "Where is your sense of time?," Atkins mutters on "Alleys of Your Mind," his vocals buried in a prismatic mix of staunch percussion, while soft, pointed synth keystrokes punctuate Cybotron's conception that this funk of the future, this techno music, could "Pop your mind at the seams." From the depths of the self to the environment of the other, "Cosmic Raindance" expands the vision of "Alleys of Your Mind" into a pointillist, multi-channel jam, utilizing overdubbing to layer and delay sounds, to surround the listener.

Cybotron's second single was released the next year, in 1982, as Detroit hosted its first Grand Prix Formula One automotive race. "Cosmic Car" saw Atkins and Davis hone in on the macrostructures brought about by urban renewal. Based on Atkins' own car—a 1980 Oldsmobile Cutlass—"Cosmic Car" envisions a sonic interpretation of the sensation of machine-produced acceleration. "Stepping on the gas. Driving alone," intone the lyrics. A metronome locks into place several multitrack and delayed drum patterns. "All I see are stars, and other cosmic cars." Atkins and Davis' world pulses with information and increasingly updates its ability to activate the listeners' senses, while psychologically attuning them to the pace of life in their own industrial future. Toffler referred to a kind of "break with the past" as a feature of future shock. For Atkins and Davis, as African Americans, the transition into the future was something worth exploring in and of itself. Similar to "culture shock," in which a stranger enters a new society and experiences emotional distress and mental resistance in response to the change of environment, "future shock" describes the barrier of entry that Atkins and Davis were crossing with their musical experiments.[26]

Eventually a third member, John "Jon-5" Housely, joined Cybotron, occasionally on guitar, which centered the group's sound and situated the band between sonic futures in electronic funk and progressive rock, rhythm, and soul. "The Line," the B-side of their single, imprints the very modern scenario of rationing moments of one's life while waiting for the next consumable event. "Life is a line, just take your place," Davis sings in the New-Wave-style chorus, over Jon-5's pensive guitar and Atkins' drum & bass couplets. A consistent four-over-four, four-on-the-floor pulse slowly

25 "But I realized something. About art. And psychiatry. They're both self-perpetuating systems. Like religion. All three of them promise you a sense of inner worth and meaning, and spend a lot of time telling you about the suffering you have to go through to achieve it." Samuel R. Delany, *Dhalgren* (New York: Bantam Books, 1975), 334.

26 Alvin Toffler, *Future Shock* (New York: Random House, 1970), 4.

accelerates the song through arpeggiated and pitched keyboards, displaying a sense of linearity as it follows a more classic verse-chorus-verse-bridge-chorus format, addressing concerns similar to Toffler's own thoughts on the "duration of expectancy."[27] One's perception of time is undoubtedly altered as the surrounding environment is optimized, while one's experience of time is compressed. In their productions, Atkins and Davis sought to create their own version of the future.

"Cosmic Cars" was a commercial success for Deep Space, selling around 15,000 copies and even reaching the ears of Fantasy Records, an independent record label in San Francisco founded in 1949 by brothers Max and Sol Weiss, known for releasing records by jazz pianist Dave Brubeck, Chet Baker, and Beat poet Allen Ginsburg. Rather than "discovering" Cybotron through the conventional method of sending a scouting agent to observe acts before they gain an audience, the Weiss brothers decided to send a contract in the mail—a straightforward measure to ride the initial wave of a rising phenomenon of electronic sound homegrown by the African American youth counter culture. Having signed and released tracks by disco vocalist and "male diva" Sylvester in the late '70s, Fantasy had already put their support behind initial sounds of the Hi-NRG movement that had taken shape in the '80s queer San Francisco scene. In 1983, Atkins, Davis, and Jon-5 released their debut album *Enter,* leading with the single "Clear," on Fantasy.

Beginning with a mic check, Cybotron's latest upgrade was designed to be a palette cleanser. Paring down the sound of their rock-oriented music, "Clear" was a leaner production, recalling Atkins and Davis' earlier works together: it takes a single word and spirals into the tangible possibilities of the word's meaning. Like in Davis' solo works, "Clear" represents an unpeopled city mired in destruction, but in contrast, as Atkins once noted, "Clear" concluded with an optimistic statement: "Out with the old / In with the new." This closing line was ultimately edited out of the radio version, in which the vocals invoke Toffler's understanding of America as a "throw-away society." In the depths of the song, "Clear" makes a provocative claim about the military industrial complex, as well as the United States' position as both an empire that had "cleared" the land and native people to establish itself, and a monstrous force that "clears" other populations in a self-determined rapture. The biblical deterrents found in the Book of Revelations in part inspired Davis to consider where he himself was located in the cycle of human civilization. His experiences of the backend of the United States, acquired through his military service, soured Atkins' more hopeful view of the future and its potential. Where Davis saw inevitability and conceit, Atkins saw revolution and opportunity. This undoubtedly began to test their working relationship, as well as call into question whether or not Cybotron's shared vision of the future was a utopia or a dystopia. In 2013, thirty years after its initial release, Fantasy reissued

27 Ibid., 40.

Cybotron's "Clear" and connected Davis with journalist Dave Tompkins to discuss the album:

> Embrace the world-destroyer. It's the only way to live. Because whatever you cling to, it'll be destroyed. The hippies perished in it. They thought it was forever. When you go away into something like [Vietnam] and come back, you find that everything has been destroyed. Your youth is gone. There's no place for you. Everybody has moved on. The pain is terrific. Nobody wanted to be bothered with us. When you come back, you're out of style.[28]

Their electronic funk experiment, *Enter*, was another hit release for the band, reaching number 52 on the Billboard Black Singles chart and amassing a significant African American audience. With a record deal and popular album under their belt, Atkins and Davis struggled to compromise on whether they wanted to move forward as a rock band or an electronic act. Davis feared ceding autonomy to the future and its technologies, whereas Atkins wanted to dive further into the potentials of electronic instrumentation; effectively, the two techno-rebels were at an ideological crossroads between man and machine. Their response to the popularity of "Clear" was an inviting ballad called "Techno City," released in 1984. Marked with a decidedly chrome finish, the song is a sonic fiction about being born and raised in a city designed for technical workers; this resonated with listeners around the world who were also hoping to rethink their urban surroundings and leap into the future.[29] "We hope you enjoy your stay," Davis warns with a breathy vocal, "you'll never want to go away." "Techno City" broadened their environment of imaginary, interpretive objects and places beyond the superimposition of the self in "Alleys of Your Mind"; while in "Cosmic Car," Cybotron harped on the promise of the freedom of automotive mobility. "Techno City" ultimately drew up the portrait of a pious civilization erected to nominally house these imagined objects and scenarios. Having condensed the Motown studio production engineering model down to a small group of technologically enhanced multi-instrumentals, Cybotron achieved what Atkins and Davis had set out to do as techno-rebels: to explore the futurity of their own sonic fictional world.[30]

28 Rik Davis, quoted in Tompkins, "The Things They Buried."

29 "'Techno City' was the electronic village. It was divided into different sectors. I'd watched Fritz Lang's *Metropolis* which had privileged sectors in the clouds and the underground worker's city. I thought there should be three sectors: the idea was that a person could be born and raised in Techno City—the worker's city—but what he wanted to do was work his way to the cybodrome where artists and intellectuals reside. There would be no Morloch, but all sorts of diversions, games, electronic instruments. Techno City was the equivalent of the ghetto in Detroit: on Woodward Avenue the pimps, pushers, etc. get overlooked by the Renaissance Tower." Rik Davis, quoted in Savage, liner notes, Cybotron, *Interface*.

30 "Cybotron's 'Techno City,' like all these possibility spaces, is Sonic Fiction: electronic fiction, with frequencies fictionalized, synthesized and organized into escape routes. Sonic Fiction replaces lyrics with possibility spaces, with a plan for getting out of jail free. Escapism is organized until it seizes the means of perception and multiplies the modes of sensory reality." Kodwo Eshun, *More Brilliant Than the Sun: Adventures in Sonic Fiction* (London: Quartet Books, 1998), 103.

60

Meanwhile, Detroit's economy was in a freefall caused by the slowing of automotive production that resulted from the Reaganomic principle of instrumentalizing complex, abstract indicators of the data-driven stock market. But the Black counter culture movement continued to grow alongside the commercial success of Cybotron's techno funk sound, even as the city became overwhelmed with crime and poverty. To quote "Industrial Lies" (on the eponymous 1983 album), Cybotron's response to the conservative political economics of the early '80s Reagan Revolution: "Well, it's just industrial lies hidden behind your eyes / Maximize, profitize exploitation / Take what you want and leave the rest behind." Appealing to speculative economics, the United States government abandoned the industrial systems that had supported American families, in the process excluding the Black families that had migrated northward in the 1940s. In the 1980s, white middle-class, white-collar workers flocked from cities enduring the harsh hit of a recession to the suburban outskirts. Taking advice from a friend, May's mother moved from the city of Detroit to the suburban town of Belleville to shorten her commute to work and gain access to a good (and predominantly white) school system and environment. "I lived in the city until I was 13, then we went out to the suburbs for three or four years before moving back," May recalled in a 2004 interview.[31] For May, those four years spent out of the city were the most defining years of his life.

"We weren't from small town Belleville. We moved to Belleville, all for different reasons," May mused on the disrupted family structures that he, Atkins, and Saunderson were all raised in. "Kevin's mom had her [reasons] for getting her home out there. She had two kids, Kevin and his sister. Juan's father had his reasons. He had two brothers, so... Various reasons, but it's funny because it brought us all together."[32] May recalled that the sonic fiction of Detroit techno began during a period of isolation, away from the city, in part because of its financial collapse. With only vague memories of what a functioning, bustling Detroit looked like, through the patchy filter of childhood memories, May developed a fascination with an idea of the future placed firmly in the historical past. Though a decade had passed since the long, hot summer of race-related riots scorched the nation—and specifically Detroit—May remembered his first few days of high school as a crash course on the passive-aggressive, semi-subconscious behavioral coordination and control mechanisms developed and employed by suburban white people fearing that their close-minded way of living within a planned environment would be altered by the presence of difference. Having spent most of the summer getting to know the white kids in his apartment complex, May was unfortunate enough to have believed that he had formed a community with the children of white families who had fled the failed racial integration project of the city of Detroit.

31 Derrick May, interview by Bill Brewster and Frank Broughton, originally published on DJhistory.com, August 2004, republished in *Red Bull Music Academy Daily*, May 22, 2017, https://daily.redbullmusicacademy.com/2017/05/interview-derrick-may.

32 Ibid.

"When we went to school the first day, I'll never forget it," May recalled:

> Troy was the kid's name. He was my best buddy all summer. After waiting in line to get his lunch, he went and just sat down at the first table. I was right behind him, so when I got my lunch I went and sat down with Troy. I'll never forget it, because all of the white kids at the table looked at me. They gave me this really strange look. Troy didn't notice it and I didn't really pay much attention to it, either. I had not been subjected to any kind of racism before. I think the city kids live a kind of protected life in a sense. If you live in a predominantly white or Black area in the city, you don't ever come into contact with certain elements. You think you're rough and tough, you're schooled and seasoned, but you're not really, because you've never been subjected to the oneness, you know. So I noticed it, but Troy didn't. Then a kid came up, a Black kid, and he looked at me and said, "Hey man, why you sitting up here with all the honkies?" I looked at him and I said, "The honkies?" It hadn't even dawned on me that I was sitting with a bunch of white kids. It never occurred to me. And then one of the school-teachers came up to me and said, "You should be sitting back there."[33]

May experienced the social phenomenon of voluntarily segregated lunchrooms at supposedly integrated schools like Belleville High School.[34] "I pitied these people," May continued. "There were about 40 tables in this lunchroom and this was basically the whole Black population of kids going to school there. The other 40 tables were all full of white kids." The culture shock stayed with May, who felt himself to be more well-mannered than the rest of the Black kids who had also been uprooted from their homes to the less stimulating, controlled environment of the suburbs, governed by white, small-town logistics: "I used to look left at the table just across from me, a table that was all white kids, and observe how they used to look over at these Black people who acted like fucking animals. These Black kids were all from West Willow, from what had once been well-to-do decent families who had migrated from the South a couple of generations ago. Proud people who no longer had a job."[35] The United States as a whole was going through a large-scale identity crisis and transformation that American historian Nell Painter refers to as a series of enlargements of whiteness as

33 Ibid.

34 "Walk into any racially mixed high school cafeteria at lunchtime and you will instantly notice that in the sea of adolescent faces, there is an identifiable group of Black students sitting together.... How does it happen that so many Black teenagers end up at the cafeteria table? They don't start out there. If you walk into racially mixed elementary schools, you will often see young children of diverse racial backgrounds playing with one another, sitting at the snack table together, crossing racial boundaries with an ease uncommon in adolescence. Moving from elementary school to middle school (often at sixth or seventh grade) means interacting with new children from different neighborhoods than before, and a certain degree of clustering by race might therefore be expected, presuming that children who are familiar with one another would form groups. But even in schools where the same children stay together from kindergarten through eighth grade, racial grouping begins by the sixth or seventh grade." Beverly Daniel-Tatum, *Why Are All the Black Kids Sitting Together in the Cafeteria* (New York: Basic Books, 2017), 131–32.

35 May, interview by Brewster and Broughton.

a race category for American landowning and indentured working-class citizens who could visibly pass as white, in direct opposition to the existentially Black population comprised of the African American former slave class. Painter writes that, "The civil rights movement, it seemed, had spawned the ugly specter of Black power, a source of alienation for white people"—"white versus Black," she summarizes, "now sufficed as an American racial scheme."[36]

Like May, Saunderson was having a hard time adjusting to the planned environment of suburban housing and retail developments, explaining in 2018:

> When I moved to Belleville, I moved into a nice, I guess middle class neighborhood around lakes and stuff like that and it might have been three or four black families that lived in that whole kind of... They called it a subdivision. So it's might be, I don't know, 150 houses, whatever. I used to always wake up, I'm doing whatever, I look outside and I see all this trash in my yard. I'm like, "Well, how'd that get there?" But it was continuously. So one day, I was outside and I heard... You see cars go by, whatever, and these cars go by and they say... they blurt out these words like, "N---a, n---a, n---a." And I'm like... I don't really know. I didn't know at that time what racism was, I didn't know what the word meant. But I watched this movie called *Roots* and that's when I got my first education about slavery, and then about racism, and then I put two and two together and I could tell that these people didn't want me in this neighborhood. When I first moved into Belleville, the first whatever, first month, two months, that's what I got when I first moved there.[37]

Saunderson met May around this time, when they were fourteen, during an altercation that resulted in him punching May and giving him a concussion; the two subsequently became close friends. May met thirteen-year-old Aaron Atkins, Juan Atkins' brother, at a table in the front of the cafeteria before they were both invited to sit with the Black kids. "It was a culture shock for me. It blew me away. I had never experienced, like... voluntary segregation," May remembered. "I think that changed me. That was a defining moment in my life, because it put me... it made me feel outside who I thought I was."[38] One day, Aaron Atkins took May with him on a drive in his Fleetwood Cadillac with crushed-velvet seats. "Aaron was chillin' man! He had the Funkadelic pumpin' through the soundsystem, and I was like, 'What is that?' And that's what changed my life." May reminisced about hearing Parliament's "Mr. Funkenstein" (1976), the first moment he felt the pulse of hi-tech music and its sense-altering effects within an urban and suburban reality: "That shit just blew me away. I was outside playing with my two

36 Nell Irvin Painter, *The History of White People* (New York: W. W. Norton & Company, 2011), 382.

37 Kevin Saunderson, lecture, hosted by Christine Kakaire, Red Bull Music Academy, Berlin, 2018, https://www.redbullmusicacademy.com/lectures/kevin-saunderson.

38 May, interview by Brewster and Broughton.

buddies, Tom and Jerry—those were genuinely their names—and Aaron pulled up with the gangster lean and the George Clinton and Funkadelic pumpin' out of the car. I was like, 'Wow. This music, this car, this thing, this guy!' He took me for a ride and it changed my life. It was another defining moment."[39]

May, Atkins, and Saunderson eventually found one another and began to exchange music and other interests. Describing Atkins as an introvert with permed hair who constantly practiced on his bass guitar, May noted that it had taken him a while to gain his trust: "I'm looking at this dude, he looks at me and he instantly doesn't like me because I'm a square. I'm a complete square for these guys. I mean, these guys come from Detroit, the other side of town. They've come up another way and have another lifestyle."[40] They ultimately connected when May challenged Atkins to a game of chess. By this point, May's mother had moved the family back to Detroit, letting him finish the school year in Belleville, where he moved in with Saunderson's family. One day, May wanted to listen to a cassette tape that he had left behind at Atkins' house. "I felt like the tape was valuable, so after some weeks I said, 'Can I have my tape back?' Juan said to me, 'Listen man, to be honest with you there's some shit on the tape you're not gonna like. Let me just give you another tape for that tape, because you ain't gonna like what's on the tape.' But I said, 'No, give it back to me! I want my tape.'"[41] So May played the tape. "We were just chillin', listening. What was on the tape? Giorgio Moroder, some early Tangerine Dream shit, that kind of thing. It was completely psychedelic. It was another digestive lesson I was being given. This time it wasn't just for me, but also for Kevin. I had some familiarity with some of the stuff because I'd been round Juan's house, but it was the first time Kevin had heard this music. It freaked him out."[42] May never gave Atkins that tape back, but he did start listening to The Electrifying Mojo with Saunderson, and a true friendship started to develop between May and Atkins over their shared interest in the possibilities of electronic music.

Forming the Deep Space collective a few months later, the trio set out to make a name for themselves in Detroit's progressive music scene, alongside other DJs like Jeff Mills and Mike "Agent X" Clark. In time, May moved in with Atkins in Detroit, and they lost touch with Saunderson, who was still living in Belleville. "There was this period where it was just myself and Juan again," May mused. "Music was becoming our common denominator. We would just sit in his bedroom and analyze records." After the initial success of Cybotron, May described Atkins as feeling like he had lost his footing after leaving the band: "There was no help in sight, he had this creative, brilliant idea and there was nobody out there to share it with. He thought that nobody

39 Ibid.
40 Ibid.
41 Ibid.
42 Ibid.

would ever understand him."[43] While visiting his mother in Chicago, May heard "Feel the Drive"—an imported Italo disco song by the group Doctor's Cat—on the radio; it increased his confidence in the electronic sounds that he and Atkins had been developing throughout their high school years. Released in 1983, the same year as Cybotron's debut album, "Feel the Drive" was popularized amongst the Chicago and Detroit dance music circles by producer and DJ Frankie Knuckles, who frequently played it during his sets at the Power Plant, a popular club he opened in Chicago in 1982. After calling around, May visited Importes, Etc., an infamous Chicago record store frequented by DJs looking for vinyl to play in their sets, known for almost exclusively selling dance music. After hearing Frankie Knuckles' DJ sets on Hot Mix 5, May set out to find the developing house music scene. This assured him that Atkins wasn't alone in his technological explorations, and that there was something brewing in the twin urban centers. Chicago, like Detroit, had experienced a significant influx of Black people from the South, which led to a mass white flight to the suburbs. Unlike Detroit, the city of Chicago wasn't inherited by the Black population; instead, discriminatory home-loan practices called redlining and blockbusting created a concentrated Black minority culture and demographic.

Scaling down further to an even leaner product, Atkins took the name Model 500 after departing from Cybotron and went on to release two albums for Fantasy Records (*Empathy* in 1993 and *Cyber Ghetto* in 1995). In the 1988 *Music Technology* interview, Trask inquired into the project name's, assuming that it bore a direct relation to the Ford Model-T, the first affordable automobile built on an assembly line.[44] "It has nothing to do with Ford," Atkins initially refuted, stating instead that the name placed him in the tradition of the work he had begun with Davis, which explored technology as a modifying, neutralizing instrument. "I wanted to use something that repudiated an ethnic designation, something that was really techno 'cos I've always been into a techno/futurist thing. We always used numbers and computer phrases, like Jon5, 3070, Enter, Clear."[45] Now on his own, Atkins was able to think and compose broadly according to his own vision of the future, starting his label and simulated built environment, Metroplex.[46] "No UFO's," the first song to come from his new project, was originally meant for Cybotron, but had been refashioned into an isolated meditation on the limits of what can be known about the cosmos and who can inhabit it. "This was around when MIDI (Musical Instrument Digital Interface) first came out," Atkins recalled. "[Rik Davis and I] were so excited about being able to now finally run two or three

43 Ibid.

44 Atkins, in Trask, "Future Shock," 39.

45 Ibid.

46 "Simulations are the real-world activations of data to calculate and predict future action and movement: how a star will explode, how a hurricane will move. They are both literal products of equations that describe what actions can happen inside of a virtual world, and potent metaphors for future-casting. We *simulate* when we imagine ourselves and others in the future, and we base our current actions on that mental simulation." Nora N. Khan, "Seeing, Naming, Knowing," *Brooklyn Rail*, March 2019, https://brooklynrail.org/2019/03/art/Seeing-Naming-Knowing.

different drum machines or play Roland equipment with Korg equipment or with Yamaha. Because before MIDI, if you had a Korg synthesizer, you had to have a Korg drum machine and a Korg sequencer, [or] else they wouldn't talk to each other."[47] Atkins' TR-909 and Sequential Circuits Druntraks could now be connected and played together in sync, creating a profound, dynamic pulse and momentum. Released in 1985, "No UFO's" and its B-Side, "Future," distilled the electronic funk sound that Akins had developed even further, both musically and lyrically. Like Davis, who expressed apprehension towards the government and public relations, Atkins questioned the possibility of thought control and a programmable society: the song plays out a scenario in which Atkins speaks directly to hypothetical, intelligent extraterrestrials arriving to Earth in unidentified flying objects (UFOs).[48] Though his lyrics start with phrases like "I hope they don't catch us, analyze and test us," they end with a surly, sanguine outlook: "If we get together. Cut out all the game, maybe catch our tempers, maybe act more tame. Put down all our weapons. Strange as it may seem, then maybe we can travel beyond our wildest dreams."[49]

Selling upwards of 15,000 copies, Atkins' first experiment with a one-man music production model under the alias Model 500 and his own Metroplex record label was becoming increasingly profitable. As he had done with Cybotron's first single, May, who split his time between the twin cities, was on the ground distributing copies of "No UFO's" directly to record shops, consumers, and local DJs. The momentum that "Clear" had initiated in the Black youth culture in 1983 had gained speed following the formation of Deep Space. "At that time you could get records that were just rhythm tracks of popular songs, and it had become popular for these rhythm tracks to be spun in between other records," explained Atkins, discussing how techno made its way into the public domain three years earlier. "As I was already making my own music, I had the idea that Derrick and me could bring a drum machine into a party for mixing in between records."[50] A kind of urban arms race for electronic instruments and innovative ways of using them was becoming a cultural norm and mode of expression for African American youth in the city and suburbs: "We unveiled our secret weapon, which was that we'd brought a Roland 808 to the party to play live rhythm tracks between the records."[51] Atkins' sound developed while taking an audio engineering course

47 Atkins, interview by Brown.

48 "The notion that unidentified flying objects (UFOs) belong to extraterrestrial life or non-human aliens from other planets occupying physical spacecraft visiting Earth, is known as the extraterrestrial hypothesis (ETH). It can be traced back to a number of earlier ideas, starting with Emanuel Swedenborg, who in *The Earths in the Universe* stated that he conversed with spirits Jupiter, Mars, Mercury, Saturn, Venus, the Moon, as well as spirits from planets beyond our solar system, describing them as human-like but immaterial beings who communicated telepathically." David Livingstone, "The UFO Phenomenon," in *Black Terror White Soldiers: Islam, Fascism, and the New Age* (n.p.: Sabilillah Publications, 2013), 361.

49 Model 500, lyrics, "No UFO's," *No UFO's* (Metroplex, 1985).

50 Atkins, in Trask, "Future Shock," 42.

51 Ibid.

at the Recording Institute of Detroit, where he acquired a preference for gear with the most electronic sounds and feel, as opposed to "digitally-sampled real drums." "When Roland discontinued the 808 and 909 to come out with the 707 and 505," he noted, "they tried to come out with a more true drum sound, but the whole beauty of Roland was that they had drum sounds which were different from everybody else's."[52] Atkins was looking for sounds native to the machine, and injecting soul and feeling directly into the interface. Because of his preference for older, outmoded drum machines, Model 500 was able to produce and maintain a singular and technically unreplicable sound.

During their conversation, Trask relates Atkins' insular and independently released electronic music to the big-budget success of Jimmy Jam and Terry Lewis, whose techno-adjacent productions on Janet Jackson's *Control* won the Grammy Award for "Producer of the Year" in 1987, a year before *Techno!* hit the shelves. Humble and self-assured, Atkins replies, "A lot of things have been happening in Detroit for a long time now, and it's all starting to come to the forefront. It's a shame for America that the music's happening first in the UK as opposed to there, though."[53] He adds: "As far as I know, nobody had applied technology to music using that term [techno], especially in dance music. You had electronic musicians out there, but most of them were really abstract. Nobody's claiming that we invented electronic music."[54] Distancing himself from the public and media perception of techno as a generalized form of dance music, Atkins acknowledged that "some people" would "get all bent out of shape" over the assertion that he invented dance music, but assured that "Techno is something that just happened. People looked at you like you have some big, preconceived plan, [but] it's the general public who designated us to be who we are."[55]

Atkins' electronic funk resonated within the Chicago club circuit that included May and his roommate Eddie Fowlkes, who would eventually upgrade to DJing hybrid live sets with three turntables, a mixer, and guitar effect pedals with drum machines. Fowlkes had first visited Chicago in 1981 with Detroit DJ Ken Collier and a group of people from the local progressive music scene. Arriving at the Warehouse club at 2 a.m., they witnessed Frankie Knuckles mixing his own edits of classic Philly International tracks and European imports on a reel-to-reel tape machine. "That was an experience!" Fowlkes declared. "Chicago had the best parties. Hands down."[56] As word spread, Blake Baxter, a musician then enlisted in the US Special Operations

52 Ibid.

53 Ibid., 43

54 Juan Atkins, quoted in Sicko, *Techno Rebels: The Renegades of Electronic Funk* [1999] (Detroit: Wayne State University Press, 2010), 70–71.

55 Ibid.

56 Eddie Fowlkes, quoted in Heiko Hoffmann, "From the Autobahn to I-94," *Pitchfork*, November 28, 2005, https://pitchfork.com/features/article/6204-from-the-autobahn-to-i-94/.

Forces, drove the four hours from Detroit to Chicago himself in 1986. "Detroit people drove to Chicago all the time," remembered Fowlkes. "Everyone from K. Hand to Derrick May was going because Chicago had the best clubs and a good underground scene."[57] Once there, Baxter met the owner of D.J. International Records, who asked him to record a demo at a local studio. There, he connected with Chicago musicians Marshall Jefferson, Joe Smooth, Chip-E, and Tyree Cooper, as well as May, while recording keyboard and vocals over an affordable Juno 60. "At that time I was strictly a drummer in calypso bands doing studio session stuff," Baxter noted; he hadn't yet gotten access to a drum machine, and was recording "some drums on electronic drum pads."[58]

Atkins claimed to have bought "the first 808 in Michigan" while still in high school: "I had a class called Future Studies, about the transition from an industrial society to a technological society. I just applied a lot of those principles to my music-making." He explains, "The 808 allowed you to actually build your own patterns—you were able to put the kick drums and snares where you wanted them. It opened up a lot of creativity."[59] Fowlkes remembers Atkins introducing the 808 in 1984: "At one point we stopped the turntables and Juan would start to work on his 808. He would start switching that shit and motherfuckers just went nuts. The next thing you saw was Jeff Mills using an 808 and all of a sudden every DJ had a drum machine."[60] In the 2006 documentary *High Tech Soul*, Fowlkes divulged what he jokingly called "the true story" of how drum machines permeated inner city Detroit: Atkins' brother-in-law briefly moved in after being released from prison and as a token of his gratitude, shared a "credit card scam tip" with Fowlkes and May. "We started ordering equipment, everything, all types of shit!" Fowlkes said.[61] But regardless of the origins of its initiation, the Chicago house scene began to catch onto the possibilities of the 808 rhythm composer through May and Fowlkes. "Derrick [May] sold Chicago DJ Frankie Knuckles a TR-909 drum machine," Atkins recalled. "This was back when the Powerplant was open in Chicago, but before any of the Chicago DJs were making records. They were all into playing Italian imports; 'No UFO's' was the only US-based independent record that they played."[62] In a 2005 interview, Atkins recounted that "Derrick was going to Chicago and they tried to call our music the house sound of Detroit. In Chicago, you had the Jesse Saunders stuff and the Jamie Principle stuff and

57 Ibid.

58 Baxter, quoted in ibid.

59 Juan Atkins, quoted in Ben Beaumont-Thomas, "The Roland TR-808: The Drum Machine That Revolutionized Music," *Guardian*, March 6, 2014, https://www.theguardian.com/music/2014/mar/06/roland-tr-808-drum-machine-revolutionised-music.

60 Fowlkes, quoted in Hoffmann, "From the Autobahn to I-94."

61 Fowlkes, in *High Tech Soul: The Creation of Techno Music*, directed by Gary Bredow (New York: Plexifilm, 2006).

62 Atkins, quoted in Trask, "Future Shock," 42.

titles like 'acid house' or something like that. But that was Techno! They just didn't call it that because it would give Detroit too much influence."[63]

Atkins didn't use a Roland TB-303 because his initial idea of techno was "to take things that exist, mix them with your own ideas and create something totally new." He continues: "I didn't want to sound exactly like everybody else out there, but I like the acid feel and I like the reason why acid is out there, because it enabled me to step out a little bit."[64] Fowlkes specifies that "Juan was very protective of his sound and Derrick didn't understand this," because May was so concerned with transmitting through Detroit and beyond. "That's how the 909 sound came to Chicago," he continued. "This is how the sound between Detroit and Chicago merged."[65]

63 Atkins, quoted in Hoffman, "From the Autobahn to I-94."

64 Atkins, quoted in Trask, "Future Shock," 43.

65 Fowlkes, quoted in Hoffman, "From the Autobahn to I-94."

4.
GLOBAL TECHNO POWER: JAPANESE ELECKTRONICS, BLACK MACHINE MUSIC

"Music is the most powerful way to inspire the human spirit."[1]

– Don Lewis

"One day I got a yearning to play music, but the instruments I wanted did not yet exist and so I had to make them on my own."[2]

– Ikutaro Kakehashi

"There are no drum-machines, only rhythm synthesizers programming new intensities from white noise, frequencies, waveforms, altering sampled drum sounds into unrecognizable pitches. The drum-machine has never sounded like drums because it isn't percussion: it's electronic current, synthetic percussion, syncussion."[3]

– Kodwo Eshun

Roland Corporations, a leading supplier of electronic musical instruments, was founded by Japanese engineer and inventor Ikutaro Kakehashi in 1972. Kakehashi never had the opportunity to pursue musical training, but he developed a strong attachment to the songs he heard on the radio. From his amateur perspective, he was able to perceive a market gap in Japan, at a time when American music modernizers, like Robert Moog and Alan R. Pearlman, were beginning to finance and distribute their own inventions for consumer use, establishing, respectively, Moog Music and ARP Instruments over the course of the 1970s. Manufacturing affordable audio equipment for the modern musician, Kakehashi's Roland Corporation (which outlasted ARP Instruments, officially bankrupt in 1981) forged a legacy of innovation that continues to this day, designing, building, and distributing user-friendly and reasonably priced machines like the Juno-106 synthesizer, TR-808 and TR-909 drum machines, and the TB-303 bass line.[4]

1 Don Lewis, quoted on his website, donlewismusic.com.

2 *Music Is My Drug: Psychedelic Trance*, directed by Martin Meissonnier and Jean Jacques Flori (Paris: Canal+, 1996).

3 Kodwo Eshun, *More Brilliant Than the Sun: Adventures in Sonic Fiction* (London: Quartet Books, 1998), 78–79.

4 Gordon Reid, "The History of Roland: Part, 1979–1975," *Sound on Sound*, December 2014, https://www.soundonsound.com/people/history-roland-part-2.

Kakehashi's childhood held a balance of trauma and wonder. Born in 1930, he grew up in Osaka with his grandparents, following the death of his parents. By the end of the Second World War, the city had been mostly destroyed by bombings from the United States Air Force during ten weeks of coordinated air raids that killed more than ten thousand Japanese civilians. Osaka, the second largest city in Japan, had been a center for industrial development and shipping, making it a prime target, whose destruction forced the Japanese military to surrender. Living conditions in Osaka during the war and its aftermath were harsh; Japan experienced poor harvest seasons and food shortages, as well as mass poverty. Kakehashi started his first business, Kakehashi Clock Store, after the war. He remained curiously preoccupied with machines and their function, even as he himself became the subject of experiments after contracting tuberculosis at Osaka University: for the rest of his adolescence, Kakehashi was confined to a sanatorium, where he became a pilot patient for a new antibiotic called streptomycin, of which he was prescribed forty doses each day. Despite its debilitating side effects, the untested medicine proved successful. "Fortunately," he noted, "I was spared the occasional side effect of streptomycin-induced deafness, so I could continue my relationship with musical instruments."[5]

Scaling a century's worth of research and development of circuitry and electricity into sellable objects for everyday life became a primary goal for Kakehashi after he took on the challenge of repairing a Lowrey Organo, an upright electric organ invented and marketed by industrialist Frederick C. Lowrey in Chicago in 1949. "The manufacture and repair of timepieces had a long history in Japan, and a body of literature existed to help me learn more about the subject," Kakehashi wrote in his biography. "That was not the case during the mid-1950s, when I turned my attention to music."[6] The combination of his attraction to machinery and the electronic transmission of sound inspired him to produce instruments that could be played by anyone. "In Japan, electronic music was an unknown concept. There was neither precedent nor history, and there was no body of literature to guide me."[7] In 1960, Kakehashi launched Ace Electronics Industries, or Ace Tone, a precursor to Roland Corporation, which produced organs, analog drum machines, and amplifiers. He developed personal relationships with other manufacturers by selling a small rhythm programmer called the Rhythm Ace FR-8L as an accessory to the Hammond organ—a direct competitor of the Lowrey Organo that had initially inspired him. Invented by Laurens Hammond and John M. Hanert in 1935, the Hammond organ was a fast-selling instrument of the future that had made its way into jazz clubs and Black churches, popularized in Chicago by pastor Clarence H. Cobbs, who installed a Hammond organ in the First Church of Deliverance in 1939. The Hammond Organ Company eventually absorbed Ace Tone in a joint venture with

5 Ikutaro Kakehashi, *I Believe in Music: Life Experiences and Thoughts on the Future of Electronic Music by the Founder of the Roland Corporation* (Milwaukee, WI: Hal Leonard Corp, 2002), 21.

6 Ibid., 159.

7 Ibid.

Sakata Shokai, a Japanese chemical manufacturer. Using his experience working with and building relationships through Ace Tone, Kakehashi founded the Roland Corporation, intending to turn it into a supplier of simple, easy-to-use machinery, that, like the Hammond Organ, could both electronically mimic and expand the sonic possibilities of a given instrument. He viewed the music business as a process of harnessing potential artistic capability within a cultural ecosystem of music educators, artists, composers, music publications, and distributors.[8]

Kakehashi launched Roland by releasing the Roland Rhythm 77 (TR-77) drum machine, an update of the Rhythm Ace, in 1972. In 1973, Roland produced its first synthesizer, the SH-1000, inspired by the success of Moog and ARP products. The compact SH-1000 was designed to replicate the sound and feel of the church organs the TR-77 was meant to complement; it was updated with editable programming features and scaled down sufficiently to be portable for traveling musicians or the casual user. There was no equivalent for it in the Western world. Just before his death in 2017, Kakehashi published *An Age Without Samples*, a meditation on the evolution of Roland and music technology as a whole:

> Nothing can be more difficult than forecasting the future. While a variety of forecasts were made during the 1990s—a decidedly chaotic period in our world—in the area of the economy as well as in communication, which was undergoing the so-called IT revolution, a large percentage of these forecasts never came to pass. In the eighties, we saw the emergence of individuals who called themselves futurists, but these people largely lost their relevance after the collapse of the bubble economy. Nevertheless, I have great respect for these people who approached their areas of expertise with diligence and had the courage to announce their visions of the future.[9]

For Kakehashi, Japan's Meiji Restoration era, dating from 1868 to 1889, had been a time of great change. At the time, Japan was the only industrialized country to make music education mandatory in schools, inspiring Euro-American cultures to do the same. The US occupation of Japan during the postwar period, from 1945 to 1952, would prove largely influential to the country's political, economic, and social values as it moved towards demilitarization and the establishment of a judiciary democracy. Japan underwent a phase of recovery and modernization in Kakehashi's

8 "'Artware' is everything that supports the creator of music in his or her activities. Since the end product, actual music, is focused on appealing to the sensibilities of the public, some artists do not wish to use the term 'business.' This is a potentially dangerous misconception on their part. A businesslike viewpoint is vital if they are to succeed in realizing their intentions. The best solution is for the artist to retain the services of a professional manager. The manager can provide business skills in such areas as negotiations, leaving the artist free to concentrate on music and expression." Ibid., 25.

9 Ikutaro Kakehashi, *An Age Without Samples: Originality and Creativity in the Digital World* (Milwaukee, WI: Hal Leonard, 2017), 1.

lifetime—changes he reflected on, as a futurist and venture capitalist, in his final writings. Concerned with originality in a modern age of global media influence, Kakehashi argued that businesses and societies must learn from and experiment with "samples" of other cultures to grow and develop a healthy, long-lasting legacy like that of Roland:

> While the West had developed a method of notation common to most instruments, traditional Japanese music uses different notations for different instruments. Even then, what might remotely be referred to as notation is often simply made up of auxiliary symbols that provide little more than hints to the player. Another characteristic of traditional Japanese music training is the one-on-one relationship between teacher and student. More to the point, in the Japanese style, music is learned more with the body than with the rational mind. This way of doing things is shared not only among the traditional musicians but among traditional craftspersons as well. The traditional way of transmitting skills in Japan is by observing and then "stealing" what you've observed from your master, as opposed to learning through verbal exchange.[10]

In *War and Peace in the Global Village* (1968), Canadian media theorist Marshall McLuhan argues that the US' industrial growth allowed it to become the world's richest nation, citing the world wars as exemplary of how military power advances "national interest" by upward of $60 billion a year in the intellectual and technological arms initiatives of its military industrial complex.[11] Describing the American Civil War and the First World War as battles to advance trade by way of railroads, McLuhan traced a shift in "national interest" with the Second World War towards the establishment of the radio, which "awakened the energies of the Negro and enabled him to dominate the culture of the 1920s in the United States through his tribal songs and dances."[12] McLuhan found the invention and public dissemination of the radio to be "a disaster for a goal-oriented America" as it "inspired multiple goals and a multiplicity of new images, depriving the country of a simple visual-mindedness which was

10 Ibid., 4.

11 The term "military industrial complex" was coined by US President Dwight Eisenhower in his 1961 farewell address before ceding his place to the youngest President to date, John F. Kennedy. Eisenhower spoke about the development of an American arms production industry that would flood the global market with military weapons, rather than directing focus toward civic needs and infrastructure. He also warned of a public domain controlled by a "scientific-technological elite," stating, "Now this conjunction of an immense military establishment and a large arms industry is new in the American experience. The total influence—economic, political, even spiritual—is felt in every city, every Statehouse, every office of the Federal government. We recognize the imperative need for this development. Yet, we must not fail to comprehend its grave implications. Our toil, resources, and livelihood are all involved. So is the very structure of our society" he warned. "We must never let the weight of this combination endanger our liberties or democratic processes." Eisenhower's Farewell Address to the Nation, January 7, 1961, https://www.eisenhowerlibrary.gov/research/online-documents/farewell-address.

12 Marshall McLuhan, *War and Peace in the Global Village* (New York: Bantam Books, 1968), 126–33.

unprecedented in all political history."[13] Equating the psychological destruction caused by the radio to the physical destruction incurred by the Second World War, he suggests that consumer electronics, namely television (and later the computer), irrevocably alter one's "vision and identity" by situating people inside of mechanically produced and fully automated virtual environments, where "the public is now participant in every phase of the war, and the main actions of the war are now being fought in the American home itself."[14] By 1968, when McLuhan published *War and Peace in the Global Village*, Japan had surpassed West Germany as the second largest economy in the world by leading in the manufacture of cars and consumer electronic goods. Reflecting Kakehashi's preference for "sampling" through observation rather than dialogue, McLuhan expressed—from his Western, though non-US imperialist perspective—that the absorption, replication, and redistribution of sounds, images, and participatory culture neutralizes the possibility of a naturally occurring community or future by generating intense nostalgia and sensory overload: "Any technological innovation in any culture whatever at once changes all these sensory ratios, making all the older songs and dances seem very odd and dated to the young."[15]

In the early years of the Roland Corporation, Kakehashi reached out to Don Lewis, a multi-instrumentalist and electrical engineer who had been doing contractual work with the Hammond Company, helping design new instruments. After meeting in Anaheim, California, at the 1969 National Association of Music Merchants (NAMM)[16]—the world's largest trade convention for music products in the tech industry—they became fast friends and collaborators. Kakehashi took an interest in Lewis' ability to manipulate and consolidate a machine's functionality: he had heard of Lewis' "circuit-bending" modifications to both the organ and Ace Tone rhythm box, which he had hacked and rewired to produce different rhythms from what Kakehashi had programmed into the accessory. "I had modified my Ace Tone to death, changed all the rhythms because none of them fit my style of playing," Lewis remarked. "I also wired it through the expression pedal of the Hammond, so I could get [percussion] accents, which no one was doing then."[17] Lewis put Kakehashi's inventions to work in front of a live audience at the NAMM. "After the show this man from Japan came up and the first thing out of his mouth was 'that looks like my rhythm unit, but it doesn't sound like my rhythm unit! How did you do that?'"[18]

13 Ibid., 134.

14 Ibid.

15 Ibid., 136.

16 The NAMM's mission is to "explore the accomplishments and impact of the music products industry through educational and interactive exhibitions and programs and directly connect visitors with hands-on music making," https://www.namm.org/.

17 Don Lewis, quoted in Trent Wolbe, "From Deadmau5 to Don Lewis, Trent Wolbe Explores the Nerdy Past, Present, and Future of Music at the Anaheim Convention Center," *The Verge*, January 30, 2013, https://www.theverge.com/2013/1/30/3932574/how-the-808-found-its-cymbal-musical-tales-namm-geeky-underbelly.

18 Ibid.

Stationed in Roswell, New Mexico, in the early 1960s, for four years Lewis had worked as a nuclear weapons specialist in the United States Air Force after majoring in electrical engineering at Tuskegee Institute, a historically Black land-grant university founded by scientist Booker T. Washington.[19] While at Tuskegee, Lewis performed Negro spirituals and gospel songs adapted for the Civil Rights Movement at demonstrations and rallies led by Dr. Martin Luther King. Born and raised in Dayton, Ohio,[20] Lewis at a young age had taken pleasure in the Hammond organ music that had filtered into the Black church community of middle and southeastern America. As he listened to the Metropolitan Opera on the radio with his mother, he imagined the instruments and the overarching shapes and arrangements being transmitted through this new technology, which allowed Americans to feel connected from the intimacy of their individual family units and homes. Music bears such a precise affectivity—it can move a listener to see and feel realities—and electronic telecommunication technology made it possible to format and broadcast these sonic possibilities as a seemingly limitless resource across the nation and beyond.

"My interest in playing the organ was piqued by a young man playing at our church—I sat behind him and watched him play," Lewis reminisced in a 2016 interview. "One evening I went to sleep and had a dream that I was sitting there playing the organ. The feeling I had in that dream, I had never felt anything like it."[21] This revelation stayed with Lewis for the rest of his life as he learned to build radio transmitters and stereos, eventually challenging himself to resign from the Air Force and pursue a career in music. "During the early 70's my earliest performances with multi-keyboard setups consisted of playing organ and four monophonic keyboards. It was an exciting

19 Tuskegee Institute, now Tuskegee University, is known for both for training the Tuskegee Airmen—the African American group of Second World War fighter pilots—and for the Tuskegee syphilis experiment, in which physicians from the US government infected Black people with the bacterial disease and neglected to treat them between the years of 1932 and 1972 in order to track and understand its long-term effects in a live specimen. Scientist and inventor George Washington Carver took over as head of Tuskegee's Agricultural Department in 1896, and in his later years collaborated with Henry Ford on sustainable alternative fuel options for cars. Ford in turn donated large sums of money to Tuskegee. See Budd Bailey, *Booker T. Washington and the Tuskegee Institute* (New York: Cavendish Square, 2017); J. Todd Moye, *Freedom Flyers: The Tuskegee Airmen of World War II* (New York: Oxford University Press, 2012); and Fred D. Gray, *The Tuskegee Syphilis Study: The Real Story and Beyond* (Montgomery, AL: Black Belt Press, 1998).

20 Dayton is a central point for shipping and manufacturing in the United States, as well as being the birthplace of modern aviation technology, among other innovations in engineering. Originally, the Ohio Valley territory was a stretch of land west of the Appalachian Mountains, named after the river that runs along the northern shoulder of the state. It had been systemically absorbed into the Northern colonial Union after numerous massacres of the indigenous populations, leading up to the Indian Removal Act of 1830. Ohio was an important location for the Northern Union amid the Civil War against the Southern Confederacy, due to its geographic position at the base of a river, strategically positioned for shipping supplies while also being shielded by the Appalachian Mountains. Ohio would continue to thrive well into the twentieth century as the Orville and Wilbur Wright brothers began their technological experiments in designing operable airplanes in the city of Dayton.

21 Don Lewis, interview by Julia Reis, "Tri-Valley Hero: Don Lewis, Impacting Music and Lives," *Pleasanton Weekly*, November 13, 2016, https://pleasantonweekly.com/news/2016/11/09/tri-valley-hero-don-lewis-impacting-music-and-lives.

time for me as I explored sound synthesis."[22] In the 1970s, Lewis worked as a sound designer in Los Angeles, for artists like Michael Jackson and studio producer Quincy Jones, even touring with the Beach Boys.[23] As the decade went on, Lewis began to acquire and integrate more and more equipment into his acts, using a self-designed controller that allowed him to connect analog synthesizers from different manufacturers to create a "Live Electronic Orchestra" in 1974. "Since electronics were of major interest to me in my educational pursuits and music performances, I wanted people to see all the circuitry therefore I encased LEO in a clear acrylic case," Lewis explains. "During performances the stage lights accented the edges which added an intriguing and dynamic visual ambiance."[24] The Live Electronic Orchestra concept could scale the entire spectrum of electronic possibility into a small, hand-built modular ensemble, regardless of who manufactured each individual machine. Lewis reminisces on his website about the years-long process of designing the LEO system:

> It was an exciting time for me as I explored sound synthesis. It was also challenging as I was surrounded with many keyboards, some of which could only play one note at a time. Depending on the music and the sound desired, my arms were often stretched out to the limit to just reach the keyboards around me. I decided to design a keyboard console that would allow better access to the synthesizer and keyboards for performance.[25]

The creation of a mobile, full-spectrum audio production workstation was a complex achievement that Lewis worked through patiently and intuitively, assembling his roster of instruments, including the ARP Pro Soloist synthesizer, the Yamaha DX7, and varying Roland audio effect units, into a circuitous orchestra centered on the state-of-the-art 1972 Hammond Concorde—the first organ with a large-scale integrated circuit and drawbars for control over harmonic intervals and tonal dynamics. It lived up to the Hammond company slogan: "Hammond Enters Tomorrow in One Giant Step!" Lewis' modified electronic ensemble effectively invented the open-source connective protocol of MIDI, or Musical Instrument Digital Interface, four years prior to its presentation at the Audio Engineering Society conference in New York in 1981, in an academic paper titled "Universal Synthesizer Interface" delivered by Dave Smith

22 Don Lewis, "Don Lewis & LEO, The Live Electronic Orchestra," *Synthopia*, January 16, 2013, https://www.synthtopia.com/content/2013/01/26/don-lewis-leo-the-live-electronic-orchestra/.

23 Don Lewis worked with Michael Jackson and a member of his synthesizer personnel named John Barnes on sound design and music for *Captain EO*, a 3D science-fiction film written by George Lucas and directed by Francis Ford Coppola, which was shown at Disney theme parks between 1986 and 1998. See "Conversation with Electronic Music Pioneer Don Lewis," Brave Sound podcast, hosted by Austin Zhang and Michael Shapira, first aired December 18, 2020, https://www.youtube.com/watch?v=iZsoFskbbp0. In this interview Lewis mentions meeting Quincy Jones in 1974, after being invited to a studio to assist Stevie Wonder in incorporating the ARP 2600 into the backing band's rhythm section.

24 Lewis, "Don Lewis & LEO."

25 Don Lewis, "Memories of LEO," https://donlewismusic.com/leo.

and Chet Wood, founders of the synthesizer company Sequential Circuits.[26] "By 1980, many manufacturers were marketing electronic instruments, but musicians were not able to operate a unit made by one manufacturer that would be compatible with an instrument made by a different manufacturer," Kakehashi explains.[27] His desire for an ecosystem in which machines could converse with one another led him to initiate a collaboration between Roland, Yamaha, Korg, Kawai, and Sequential Circuits to design a singular digital interface. "After the MIDI 1.0 Specification was released in October 1982, MIDI became a universal standard and it is not an overstatement to say that there are no instruments today that have not been affected by MIDI in one way or another," Kakehashi wrote. "For the first time, electronic instruments acquired the ability to communicate directly with other instruments and computers. MIDI brought many benefits, including the improvement of sound and functionality through digital control, but I personally feel this capability of an instrument to communicate with something other than itself is the largest benefit to electronic instruments."[28]

Lewis started working with Kakehashi at Roland Corporation in 1972, just as the company was looking for ways to foster electrical interactivity in their product line, pioneering the scalability of electronic music's future within the general consumer population. Their first codesigned product was the CompuRhythm CR-78, released in 1978—the first drum machine with editable features that allowed users to save and play back programmed rhythms and beats.[29] With its unique, modifiable features, the CR-78 became an essential instrument for soft rock and New Wave musicians like Phil Collins, Hall & Oates, and Roxy Music. Lewis and Kakehashi's next collaborative project was the 1980 release of the TR-808 drum machine, which improved on the CR-78's flexibility: it was the first programmable drum machine to use analog synthesis for digital sampling and MIDI capabilities. In concept, the TR-808 was designed to be a drum synthesizer that generated sound, reproducing real drum and percussion directly from the hardware and opening up the path for electronic drumming that is both haptic and synthetic. Lewis worked closely with Tadao Kikumoto—the chief engineer and head of research and development

26 The MIDI Association, "MIDI History: Chapter 6-MIDI Is Born 1980–1983," https://www.midi.org/midi-articles/midi-history-chapter-6-midi-is-born-1980-1983.

27 Kakehashi, *I Believe in Music*, 198.

28 Ibid., 198-99.

29 "Nobody paid much attention to the CR78 when it first appeared. Kakehashi claims that it was the first musical instrument to contain one of those new-fangled microprocessor thingies but, at first sight, it seemed no more interesting than any of a host of other manufacturers' rhythm boxes. It offered just 14 sounds and four-note polyphony and, while it was nicely designed, its numerous bossanova, samba, beguine, rhumba and waltz presets did little to dispel the 'home organ' impression. Nevertheless, there were a couple of bits of magic about the CR78. These were 'Program Rhythm' and the WS1 Write Switch, which made the little box the first drum machine that allowed you to devise, store, and replay user-programmed patterns." Gordon Reid, "The History of Roland: Part 1, 1930–1978," *Sound on Sound*, November 2004, https://www.soundonsound.com/music-business/history-roland-part-1#para16.

for Roland—on the drum machine, which was used by professional musicians during tech demonstrations like NAMM as a sample of the future of commercial computerized music.

The engineering of the TR-808 was open-ended and amenable to experimentation, offering a wide range of options for tuning, rather than having to make use of sounds pre-recorded and programmed into the machine. The overall sound of the 808 was uniquely artificial: at Kakehasi's request, it used damaged semiconductors in order to coax out a specific "sizzle"-like texture, along with its other affective, electrical sounds, like the vibrational hum of the drum machine's kick, the subtle high-frequency tonal differences of opened and closed hi-hats, or the synthetic reverberations of the 808's infamous cowbell. The three technicians—Lewis, Kakehashi, and Kikumoto—set out to create completely new electronic machinery with its own kind of acoustimatic voice that could be heard without a physical point of origin outside of a speaker, but human elements and reactive decisions went into the compiling and programming. In one session with Lewis, Kikumoto accidentally spilled tea onto a prototype of the TR-808, causing it to produce a "pssh" sound that the team later spent months attempting to capture—a glitch that gave way to the 808's crash cymbal.[30] Lewis' wiring of the voltage control, audio outputs, and various other knobs made the 808 feel unlike any other small-scale equipment available at the time. "The 808 still had analog circuitry, it wasn't digital. The only thing that was digital was the sequencer,"[31] Lewis clarified, noting that there wasn't much difference between the 808 and the Ace Tone's electrical systems. "I wanted those controls that were *inside* of the Ace Tone—the little trimmer parts that you would tune and so forth. They were inside, they weren't on the outside." He told the team: "Those things *have* to be on the outside."[32] When the rhythm synthesizer was released, Roland noted in its advertisements that "The Roland TR-808 will undoubtedly become the standard for rhythm machines of the future because it does what no rhythm machine of the past has ever done. Not only does the TR-808 allow programming of individual rhythm patterns, it can also program the entire percussion track of a song from beginning to end, complete with breaks, rolls, literally anything you can think of."[33]

A few years before the TR-808 was released, Yellow Magic Orchestra, a Japanese band that had formed in 1978, rented a drum machine from the Roland Japan sales department. Two of the group's founders, Haruomi Hosuno and Ryoichi Sakamoto, had experimented with electronic equipment such as ARP and Moog synthesizers and the Ace Tone rhythm box before starting the band, later using the novel equipment with

30 Wolbe, "From Deadmau5 to Don Lewis."

31 Lewis, "Conversation with Electronic Music Pioneer Don Lewis."

32 Ibid.

33 Kurt Werner, "The Roland TR-808 and the Tale of the Marching Anteaters," *Ethnomusicology Review*, November 29, 2015, https://ethnomusicologyreview.ucla.edu/content/roland-tr-808-and-tale-marching-anteaters.

electric guitars and bass on their self-titled debut album of 1978. In 1979, *Billboard* magazine published the article "Artists and Producers Strive for Inroads Overseas" by Junichi Goto, a promoter from Yellow Magic Orchestra's label in Japan, who characterized Yellow Magic Orchestra as an act that "creates a sound mixing the rhythms of Central and South America, disco and computerized synthesizer . . . a sound that was not possible until now."[34] Goto spoke to the magazine about their strategy for selling culturally distinct music to the American market:

> There is a language barrier when making inroads overseas and there are huge expenses involved so it is important for the industry to keep looking ahead. And musically, a completely Japanese sound will not work, an intermingling of elements that will be well received overseas along with some sort of Japanese fascination is necessary. Yellow Magic is a group which is more than meeting those demands.[35]

Peaking at number 81 on the Billboard 200 chart and 18 on the R&B Singles chart in the United States, Yellow Magic Orchestra's self-titled album and its single "Firecracker" gained crossover notoriety among the Black and white American demographic. Their second album, *Solid State Survivor*, quickly followed in 1979, selling two million units worldwide and winning Best Album at the Japan Record Awards. The next year, Yellow Magic Orchestra were featured as musical guests on *Soul Train*, an American television program based in Chicago that primarily targeted a Black demographic, featuring disco, soul, funk, and hip hop with a live, dancing studio audience.[36] *Soul Train*'s host, Don Cornelius, introduced Yellow Magic Orchestra as a domestic success, calling them the most popular contemporary band in all of Japan and adding that in the year 1980 alone, they had put out four platinum records. Performing their single "Firecracker" and a cover of "Tighten Up," a 1968 funk track by R&B vocal group Archie Bell and the Drells, Yellow Magic Orchestra offered a novel global scene of joyous dancing to electrified beat and sound. A cross-cultural exchange had occurred, which acknowledged a modern musical discourse that had been emerging through the mass-factory distribution of music as commodity. The performance was met with a wave of sincere applause, the room collectively took a breath, and Don Cornelius walked over to the band, amused by their take on the soul and funk sounds.

"In case you folks out there in television land are wondering what's going on, I haven't the slightest idea," Cornelius addressed the viewers at home and the studio audience, who responded with laughter, charmed by the performance. He introduced each member of the band: "See, if somebody offered me a million dollars to tell

34 Junichi Goto, "Artists and Producers Strive for Inroads Overseas," *Billboard*, May 26, 1979, 14.

35 Ibid.

36 "Yellow Magic Orchestra: 'Tighten Up' + Interview," *Soul Train*, 1980, YouTube, https://www.youtube.com/watch?v=CT1st0QZPNE.

you somebody's name up here, you know I couldn't collect it, right?" The off-color joke drew more laughter, but also displayed a process of making sense of difference. "You fellas have a great sound. I know we have a slight language barrier here, but I'd only like to ask your opinion on Einstein's theory of relativity?" Even more laughter erupted as Cornelius stimulated the audience's attention with quick-witted jokes. He asked Yukihiro Takahashi, the band's drummer and lead vocalist, if he'd ever seen a show like *Soul Train* before. Takahashi responded briefly, saying that he'd watched the show in Japan, and that he hoped others from his home country were tuning in as well. Cornelius asked who his favorite American artists were. Takahashi mulled it over for a moment, then said, "Of course, soul and disco." The crowd applauded, and Cornelius probed further, asking Takahashi to which current artists he would compare Yellow Magic Orchestra's own sound. In a retaliatory jab, Takahashi asked Cornelius if he knew Kraftwerk; he was rewarded with substantial laughter: "Hey! This big Don here, brotha!" Even more laughter erupted before Cornelius confessed that he was "not familiar with the record."

The TR-808 became an integral part of Yellow Magic Orchestra's ensemble of impossible sound-generating machines, but despite the band's chart-topping crossover success, the TR-808 remained relatively obscure. Produced between 1980 and 1983 and sold at a relatively affordable price compared to the alternative rhythm boxes and digital drum-kit samplers on the market, the 808 was a commercial failure upon release, in part due to widespread apprehension from tech and music journalists, one of whom compared the 808's digitally constructed sound to that of "marching anteaters."[37] Having sold less than 12,000 units, Roland discontinued production of the TR-808 in 1983—in part due to Kakehashi's insistence on using faulty semiconductors in the machine to maintain its signature "sizzle" sound, which made restocking the device difficult and expensive. Throughout the 1980s, though, the TR-808 garnered a cult following, appearing in Juan Atkins' initial experiments with Cybotron and Model 500 (1980 to 1993), Marvin Gaye's "Sexual Healing" (1982) and Afrika Bambaataa and The Soulsonic Force's "Planet Rock" (1982). The 808 would be used in more popular songs than any other drum machine. Following on its heels, the Roland TR-909 Rhythm Composer was released in 1983 as an optimized take on the TR-808 model that Lewis had helped build. Expanding on Lewis' freeform circuit-bending, Kikumoto designed the TR-909 to be the first drum machine with inbuilt MIDI functionality and a sequencer that could cycle through upwards of one hundred sound samples. The 909, too, was a commercial failure and was discontinued in 1985, though in the next decade it gained notoriety as the instrument of choice for Detroit producers Jeff Mills and Derrick May.[38] Kikumoto

37 "The unit is a big improvement over electronic-sounding drum machines that only do 4/4 time and sound like marching anteaters (unless of course you prefer marching anteaters and being locked into 4/4 time)." Dominic Milano, "Keyboard Report," *Keyboard Magazine*, November 1982, 72–73.

38 Jeff Mills described the significance of his discovery of the Roland TR-909 around the late '70s in a 2018 interview: "I don't have any secrets, but the way that the 909 was made makes it possible to really play the machine, not just program it. Because of the stop/start function, you can manipulate it as if you're playing a sample, and if

remained unaware of the popularity of Roland's first line of instruments and their second life within the Black community, particularly in the Detroit techno and Chicago house scenes, until much later.

The TB-303 Bass Line was also designed by Kikumoto in 1982, but its fame emerged a few years later, in 1985, from the intuitive exploitation of a technical glitch and error in the machine by the Chicago house group Phuture—composed of Nathaniel Pierre Jones (DJ Pierre), Earl Smith Jr. (Spanky), and Herbert Jackson (Herb J)—who coaxed an acidic-sounding squelch from the machine. The accident, and following experimentation, culminated in "Acid Tracks," a 1987 release by Trax Records that created the genre and led to the European spread of electronic dance music—acid house.[39] "[Phuture] did the first tweaking of acid," Pierre Jones recalled.[40] The 303 was meant to be used as a bass-line generator for practicing and fine-tuning lead and rhythm guitar playing, but Kakehashi's interest in creating Roland products for amateur musicians resonated with the latent curiosity of the Black midwestern youth experimenting with his machines, despite their limited technical understanding. Jones eventually sold his 303 to Spanky, who continued to work with it, twisting knobs and inserting emotion into the machine. "We said forget trying to make a baseline, let's program it like this and just twist the knobs. And so that's what we did, you know."[41] Once Jones and Spanky figured out how to stabilize and record the sequence, they brought it to Chicago DJ Ron Hardy. "He was the guy we listened to; we knew he played a lot of different sounds," Jones recalled:

> We took it to Ron, and Ron said he liked it and then, as the story goes, he dropped it four times. The first two times, people were like "What the heck is this?" The third time people were like, "Okay, this sounds alright, I guess." Then the fourth time, people went crazy. So he literally broke the record. He could have played it twice and been like, forget it, these people don't get it. But he got it, and he had the vision that it was something. So really, he's very important. Almost as

you're really good, almost as if you're a live drummer playing a drum kit." Mills, "Jeff Mills Celebrates the Iconic Roland TR-909 Through His History and Cherished Secrets," *Mixmag*, September 9, 2018, https://mixmag.net/feature/909-brandededitorial/. Derrick May recalled: "I love the 909... In fact, I sampled it and ran tremendous amounts of dbx on it to create my own kick, compressing the fuck out of it and then taking it almost to the point of distortion." May, in Simon Trask, "Techno Rhythm," *Music Technology* (November 1990): 40.

39 "The machine was not malfunctioning; the group did not misuse it. Although both Spanky and Pierre had limited technical understanding of the 303, their exploration of it, and the resultant recording, could equally constitute discovery rather than error." Mark Fell, "Collateral Damage," *The Wire*, January 2013, https://www.thewire.co.uk/in-writing/essays/collateral-damage-mark-fell.

40 DJ Pierre, quoted in Ruth Saxelby, "Back to the Phuture: DJ Pierre on Inventing Acid and Why EDM Fans Need to Learn Their History," *The Fader*, August 4, 2014, https://www.thefader.com/2014/08/04/back-to-the-phuture-dj-pierre-on-inventing-acid-and-why-edm-fans-need-to-learn-their-history.

41 Ibid.

important as we are in the creation of acid and acid house, because he broke it and he made it a sound that the whole city of Chicago was singing.[42]

Unbeknownst to Jones, his song was locally known as "Acid Tracks," with most clubbers thinking the song was made by Ron Hardy. "That was in '85, but it didn't come out [as a record] until like '86 or something. It was buzzing in the clubs for a while, but we didn't know how to make a record, how to put it out at that time; we didn't know anything about those things."[43] The duo eventually left a note with Jones' phone number for Marshall Jefferson—a record producer for the Universal Recording Studios who had also recently begun to DJ and produce music[44]—that read: "My name is DJ Pierre, I'm with the group called Phuture, and we made a track called 'Acid Tracks.' Can you help us get a record deal?" Jefferson called the next day. "There was a note on the fridge saying Marshall Jefferson called—my mom would put notes on the fridge—and I was thinking, who's kidding around with me?" Jones jokes. "But when I called, of course it was Marshall Jefferson and the rest is history in that regard."[45] The next year, in 1987, "Acid Trax" was packaged and released internationally alongside two other tracks—"Phuture Jacks" and "Your Only Friend." Much like in Chicago, "Acid Tracks" was an immediate hit in the UK, where venues such as Shoom held the first parties to grow into full-blown raves, gathering thousands of British clubbers in the summer of 1988. "We thought it was just popular in Chicago, I thought we were just on a par with the other guys we looked up to," Jones remembers. "We had no idea it started a cultural movement outside of the US."[46] Phuture was only paid $1,500 by Trax's owner, Larry Sherman, who never told them about the song's popularity overseas; meanwhile, police were beginning to crack down on parties in Chicago as part of a larger initiative of policing drug distribution in urban communities. Pierre later declared that he wasn't too bothered by the deceit: "in the end it kick-started our careers, so I never look back and complain," though he maintains that "Trax is the most crooked label on the planet. But good came of it. Phuture was born, and DJ Pierre was here to stay. Keep it moving is the motto."[47]

A few years prior, Derrick Harris, a local Guitar Center salesperson who talked Jefferson into buying his first electronic instruments, began producing a slightly earlier iteration of acid house that bypassed the technical glitch of Phuture's take on the sound, under the name Sleezy D. His track, "I've Lost Control," written and recorded

42 Ibid.

43 Ibid.

44 Universal Recording Studios, established in 1955 by Bill Putnam, pioneered many technical innovations in music post-production, such as isolated vocal recording booths, multitrack recording, tape echo, and overdubbing.

45 Ibid.

46 Nathaniel Pierre Jones, quoted in Andrew Whitehurst, "Game Changers: Phuture 'Acid Tracks,'" *DJ Mag*, July 9, 2014, https://djmag.com/content/game-changers-phuture-acid-tracks.

47 Ibid.

with Virgo (Jefferson and Michael A. Smith) in 1984, was released through Trax in 1986. In 1985 Virgo released their own single "Go Wild Rythm Trax" on Other Side Records. "[Larry Sherman, owner of Trax] made a lot of money off of that," Jefferson recalled. "I thought I was going to quit [music] after that."[48] Disappointed with the scam-like nature of the local underground music business, Jefferson considered leaving a scene in which he wasn't getting paid for his work. Ultimately, he made more tracks and regained momentum, especially after he started going to the Music Box Club, where Ron Hardy played his tracks to an excited crowd of dancers. "People were screaming and everything," he recalled, "and I guess that gave me the confidence to carry on."[49]

At the same time that the unconventionally hotwired and sequenced home studio compositions of acid house and techno made their way out of Chicago and Detroit into the British and European markets, Lewis stepped away from his career as a full-time musician after protests from the American Federation of Musicians (AFM), a labor union for professional musicians in the United States and Canada, denounced Lewis' innovative upgrades of commercial music hardware equipment as a threat to both solo and ensemble musicians playing live, acoustic instruments. According to a court appeal filed against Lewis, the union picketed his performances at the Hyatt Regency in Oakland from December 20 to December 31, 1984, with signs that read: "To the Public: Don Lewis Non-Union Musician Is Unfair to Musicians Union Local 6, AFM, AFL-CIO."[50] Lewis had been working under contract as a consultant for Roland Corporation and the Hammond Company since the 1970s, but in the AFM's legal suit, Lewis was considered a lone actor in his innovations, despite the industry rollout of MIDI as a standard for connecting electronic music devices in the mid 1980s—an innovation developed out of Lewis' own hacking techniques with electrical circuits and gear. The sacrifice and appropriation of Lewis' circuit-bending potentially saved the electronic instrument manufacturers from bankruptcy by allowing each of their financially unviable machines to operate together, rather than competing within a niche market.[51] The court appeal does mention that there had been no effort on either side to discuss Lewis joining the union, let alone negotiate the terms prior to filing the suit. The case was eventually dismissed by an administrative law judge, but by then the damage was done. As the AFM was suing Lewis, it also initiated a tax on the use of electronic music equipment, making the technology more affordable through agreements with sellers to offer discounts or promise to discard their overstock to pawn shops. This mandated that musical equipment ought to be seen as a business

48 Marshall Jefferson, interview by John Doran, "Respect Due: Marshall Jefferson Interviewed," *The Quietus*, October 21, 2013, https://thequietus.com/articles/13646-marshall-jefferson-trax-records-interview.

49 Ibid.

50 National Labor Relations Board, Petitioner, v. Musicians Union, Afm Local 6, Affiliated with the American Federation of Musicians, Respondent, 960 F.2d 842 (9th Cir. 1992).

51 Lewis, "Memories of LEO."

investment producing an income, while drawing a distinct line between the amateur and professional musician. The AFM's motions against Lewis, in turn, made it possible for young producers like Atkins and Phuture to afford Roland's products.[52]

While Don Lewis was assisting in the engineering of the next phase of electronic music production, Andre Lewis, a musician and sound engineer, toured and recorded in a six-piece funk and soul band called Maxayn (named after his wife, Maxayn, also a member of the band). The band built on Maxayn Lewis' experience as a member of the Ikettes, the trio of backup vocalists for Ike and Tina Turner, to create a psychedelic, guitar-led sound.[53] Releasing three studio albums between 1972 and 1974, Maxayn was an undersold act, enjoying only marginal chart success; but the music they produced is a stunning example of the manifestation of African American soul speaking through Western music instruments and studio equipment. *Bail Out for Fun!* was Maxayn's final album before breaking up in 1974, when Andre Lewis started a somewhat solo venture called Mandré. Over the following years, Lewis harbored a considerable interest in exploring the possibilities of newly available music technology, while also touring alongside Donna Summer, Patrice Rushen, Earth Wind & Fire, The Gap Band, The Pointer Sisters, and playing guitar in Frank Zappa's studio and touring lineup. Lewis also found himself working with electronic instrument designer Roger Linn on the Linn LM-1 Drum Computer,[54] the first drum machine to process samples, which came to be used by musicians including Prince, Michael Jackson, and Gary Numan.

After Lewis passed away in 2014, Maxayn Lewis recalled Linn's frequent visits to Andre in search of creative guidance: "I'd be in bed and wake up, and Roger [Linn] was there asking Andre how to fix something that he couldn't make work. Then Roger would leave, and he'd come back again, minutes later, needing more of Andre's help."[55] A powerhouse vocalist and musician in her own right, Maxayn talked about looking

52 "When you ask members of [Underground Resistance] how the sound came to be, they'll most likely start by telling you the story of how a slew of sequencers, samplers, and other electronic audio gear became affordable by way of the American Federation of Musicians (AFM)'s tax against electronic music in the mid-'80s. Musicians who could afford this equipment at original cost, and who were finding it difficult to get gigs, would sell their gear at discounted rates or pledge them to pawn shops. This opened the door for a younger, more Black audience to scoop up these toys and start playing." Salome Asega, "Manual Not Included," *Cultured*, July 23, 2019, https://www.culturedmag.com/manual-not-included/.

53 Nate Patrin, "Mandré: A Tribute," *Red Bull Music Academy Daily*, December 4, 2014, https://daily.redbullmusicacademy.com/2014/12/mandre-tribute-feature.

54 "The general product category of instruments is drum machine. I just called that particular model drum computer because it made sense at the time. When it was released, which was around 1979, it was a time when people were putting little chip computers into musical instruments and using that as a way to expand their capabilities." Roger Linn, "Roger Linn, inventor of the LM-1 drum machine, talks Prince and 'When Doves Cry,'" *The Current*, March 1, 2017, https://www.thecurrent.org/feature/2017/03/01/roger-linn-inventor-of-the-lm1-drum-machine-talks-prince-and-when-doves-cry.

55 Maxayn Lewis, quoted in Melissa A. Weber, "In Memoriam: Andre Lewis: The Man Behind Mandré," *Wax Poetics*, February 2012, http://djsoulsister.com/mandrestory.pdf.

at one of the first synthesizers with Andre, on the eve of a major turning point for music technology and commerce: "Andre was talking about MIDI and layering sound before anyone else."[56] Seeped in the exploratory techniques developed by working with a more open and conceptual side of the music industry than the popular music market and its interest in Top 40 charts, Andre Lewis had combined his mainstream and more obtuse approaches to music making with his new project, Mandré. Having signed to Motown Records, Mandré boasted, in its 1977 debut record, a consolidated future sound, which was accessible in a way not yet achieved by abstract expressions of electronic composition combined with African American soul. Mandré's electronic funk consisted of elements that would later be funneled into the Detroit techno sound: freehand keyboard synthesizer playing as a melodic and harmonic companion to persistent electronic percussion, landing on the down and up beats to create the effect of a looping groove.[57] Combining this with his semi-anonymous aesthetic, Lewis took electronic music to a new place, where static, machine-driven sounds could finally feel organic and made for human emotional experience, in contrast to the intellectual fodder coming out of insular European academic circles. Lewis became a tester for Roland products and was one of the first musicians to record with the completed Roland TR-808.[58] "[H]e thought the music sounded other-worldly. He was to be the Masked Marauder, a mystery man sent from space to create peace on Earth through the (sound) frequencies," Maxayn explained, noting that Andre wore a custom mask in live performances. "Berry Gordy really liked it a lot, but it wasn't a R&B act. Motown understood the importance, but had no idea how to market him."[59] In the next two years, Mandré put out two more albums: *Two* in 1978 and *M3000* in 1979, which were promoted as being "funkier than Parliament."[60]

The availability of the TR-808 also led to a technological update for hip hop, which emerged out of the Bronx in 1982 from Black and Latino American youth, who combined free-form rapping and turntablism. "*Hip Hop America* starts 'back in the day'—the late '70s—when hip hop sprang off the uptown streets of New York City via block parties and jams in public parks, sparked by the innovative moves of a handful of pioneering men," writes cultural critic Nelson George. He describes the genre "[springing] off the uptown streets of New York City via block parties and jams in public parks, sparked by the innovative moves of a handful of pioneering men." George continues: "Working under wild monikers, they called themselves 'DJs,' but they left in the dust

56 Ibid.

57 "Not since the albums Mandré cut for Motown in the mid-'70s had Black pop been so keyboard-based and hi-tech. This was dance music by someone who understood New Wave starkness and minimalism." Ben Watson, *Honesty Is Explosive!: Selected Music Journalism*, ed. W. C. Bamberger (Rockville, MA: Borgo Press, 2010), 49.

58 Maxayn Lewis, quoted in Weber, "In Memoriam: Andre Lewis."

59 Ibid.

60 Ibid.

any traces of the AM radio jocks who first popularized that term."[61] Illustrating a scene of aggressive youth, making do in the inner-city conditions of the Reaganomic era, George sees the creative works of Kool Herc, Afrika Bambaataa, and Grandmaster Flash as the beginning of a much larger form of youth expression. "But it didn't come out of nowhere—no spontaneous generation of this deadly virus," he writes. "The b-boys—the dancers, graffiti writers, the kids just hanging out—who carried the hip hop attitude forth were reacting to disco, to funk, and to the chaotic world of New York City in the '70s. These b-boys (and girls) were mostly Black and Hispanic. They were hip hop's first generation. They were America's first post-soul kids."[62] This era after the Civil Rights Movement, just before the Information Age that birthed the possibility of techno, sowed the seeds of a redefinition of the expression of postindustrial, postmodern youth, in the face of a future foreclosed by the failing economy and collapsing urban infrastructure. "DJ Kool Herc essentially created hip-hop in the 70s crack-burdened New York with a broken record player which kept skipping and playing the same portion of a record over and over again," writes English journalist Johny Pitts of the genre:

> The very foundations of hip-hop are rooted in the cultivation of creativity within strict constraints, and the traditionally inflexible musical rules—a 4/4 beat at around 96 bpm often with no live instruments or formal musical training, just a sample of music replaying over and over—mimic the constraints of the Black experience in a poor area where a life has to be made without local amenities, jobs, healthcare or hope. Lyricists spat themselves free, weaving intricate, multisyllabic rhyme schemes and evocative stories, often imbued with revenge fantasies (rappers aren't really killing cops; it's the other way round) within a musical prison.[63]

In Steven Hager's 1984 book *Hip Hop*, Kool Herc describes his experience of America's inner-city culture and the emergence of rap as distinct from the sound system culture of his native Jamaica, noting that he "couldn't play reggae in the Bronx. People wouldn't accept it. The inspiration for rap," he specifies, "is James Brown and the album *Hustlers Convention*"[64]—an underappreciated proto-hip hop album recorded in 1973 by Lightnin' Rod, the pseudonym for Last Poets member Jalal Nuriddin,

61 Nelson George, *Hip Hop America* (New York: Viking, 1998), xi.

62 Ibid.

63 Johny Pitts, *Afropean: Notes from Black Europe* (London: Penguin UK, 2019), 68.

64 Kool Herc, quoted in Steven Hager, *Hip Hop: The Illustrated History of Break Dancing, Rap Music, and Graffiti* (New York: St. Martin's Press, 1984), 45.

with funk band Kool & the Gang.[65] Though the function of rap and the MC share similarities with the rhymed speech of "toasting" in Jamaica, Herc says:

Hip-Hop, the whole chemistry of that came from Jamaica, cause I'm West Indian. I was born in Jamaica. I was listening to American music in Jamaica and my favorite artist was James Brown. That's who inspired me. A lot of the records I played were by James Brown. When I came over here I just had to put it in the American style and a drum and bass. So what I did here was go right to the "yoke." I cut off all anticipation and played the beats. I'd find out where the break in the record was at and prolong it and people would love it. So I was giving them their own taste and beat percussion wise. Cause my music is all about heavy bass.[66]

This oratory, diverging from the Black sermonic tradition, took on a new cybernetic expression when Afrika Bambaataa and The Soulsonic Force released their first hit record, "Planet Rock," in 1982.[67] The 808 drum machine and other Japanese synthesizers opened up the scope of rhythm production in a movement that would carry disco into the technological future; it was reborn as electro-boogie, or electro, for short. "Planet Rock" was produced by Arthur Baker, a music journalist and DJ who started his career producing music in the funk/disco group T.J.M. on the label Casablanca, which was run by disco producer Tom Moulton, a pioneer of remixing recorded music by looping and extending "breakdown sections" in songs.[68] Baker worked with Tommy Boy, a record label in New York that signed up-and-coming hip hop acts like Queen Latifah and De La Soul at the end of the 1980s. His meeting with DJ and rapper Lance Taylor (Afrika Bambaataa), facilitated by Tommy Boy's manager, led to the creation of Jazzy Five's "Jazzy Sensation"—the label's first hip hop single—at Intergalactic Studios in 1981. "Planet Rock" was recorded in the same studio across three overnight sessions with a borrowed TR-808, found by publishing an ad in the *Village Voice* offering $20 per session with the drum machine. In the studio, Taylor and his Soulsonic Force,

65 "Without sales or radio play, *Hustlers Convention* sank commercially, but its reputation grew via word of mouth. In New York, Fab 5 Freddy memorised chunks of lyrics before he even knew it was an album. 'On the street somebody recited it and I thought it was amazing, the most epic jail toast of all time,' he says. 'I memorised it and would recite it to friends on my block, then someone told me it was based on a record. I stumbled upon that and passed it on. Hip street guys like Melle Mel would know about it. I could hear the influence in their raps.'" Graeme Thomson, "Hustlers Convention: Rap's Great Lost Album," *Guardian*, January 30, 2014, https://www.theguardian.com/music/2014/jan/30/hustlers-convention-rap-lost-great-album-hip-hop.

66 Kool Herc, interview by Davey D, "Interview w/ DJ Kool Herc: 1989 New Music Seminar," Davey D's Hip Hop Corner, 1989, http://www.daveyd.com/interviewkoolherc89.html.

67 Chris Norris, "The 808 Heard Round the World," *New Yorker*, August 31, 2015, https://www.newyorker.com/culture/culture-desk/the-808-heard-round-the-world.

68 "I don't know how else to describe it, but to me it just had so many movements and passages that just take you to this other place. And then I realised that one part of the song, I wanted to extend." Tom Moulton, lecture, hosted by Todd L. Burn, Red Bull Music Academy, New York, 2013, https://www.redbullmusicacademy.com/lectures/tom-moulton.

made up of Ellis Williams (Mr. Biggs), Robert Darrell Allen (Pow Wow), John Miller (The G.L.O.B.E.), John Byas (DJ Jazzy Jay), and Ben Spaander (Cosmic Force) played Kraftwerk's "Numbers" for Baker as an example of how they envisioned their new single would sound. They wanted to be the first Black electronic music group.[69]

Inspiration for the project also came from George Clinton, who for years had been performing synthesizer-oriented funk music with psychedelic and science-fiction themes. For Taylor, Afrika Bambaataa and The Soulsonic Force was meant to be a modular ensemble. Many of its members had been a part of the Universal Zulu Nation, an international hip-hop awareness initiative. "We had the saying: 'This is not a gang. We are family. Do not start trouble, let trouble come to you, and then fight like hell.'"[70] Taylor considered the Zulu Nation to be a mindset and a community across dimensions, connecting inner-city Black youth back to the motherland and heritage through a wider musically accessed religious theodicy.[71] The name "Zulu" was lifted from the eponymous 1964 film about the 1879 war between the British colonial army and the South African Zulu Kingdom, and applied to a street gang called the Organization (later renamed the Black Spades).[72] Throughout the 1970s and '80s, the Zulu Nation hosted community events with Bronx youth, organizing local music and dance movements into a single cohort that, over time, produced the formative language of hip hop, encompassing everything from beat-making to emceeing (MCing)—acting as the "master of ceremonies" following the West African griot practice of rhythmically telling stories and sharing oral traditions over drum beats. The success of "Planet Rock" was a slow burn; first received as a type of funk music, it could slip onto the radio at a time when mainstream stations were convinced that the entire genre of hip hop was a

69 Afrika Bambaataa, interview by Frank Broughton, originally published on DJhistory.com, October 1998, republished in *Red Bull Music Academy Daily*, April 7, 2017, https://daily.redbullmusicacademy.com/2017/04/afrika-bambaataa-interview.

70 Afrika Bambaataa's mission: "stop the foolishness and lies that's been taught through this century and let's get on with truth. We want right knowledge, right wisdom, right overstanding and right-sound reason. Like telling us Columbus discovered America, or Greece is the mother and father of western Civilization, when they got all their knowledge from Egypt and Africa. . . . Let's tell the truth about what Black people, brown people, red people, white people, yellow people has done to better civilization, on this planet so-called Earth. And let's get into the universal thing that's going on with our planets and galaxies and stuff, because we're shitting on mother earth and mother earth is getting tired of this shit, and she's spitting out humors left and right." Ibid.

71 In 2016, Bronx political activist Ronald "Bee-Stinger" Savage accused Taylor of molesting him in 1980, when he was 15. Taylor was sued in 2021 for abuse and sex trafficking from 1991 to 1995, when the accuser was 12. Dave Wedge, "Afrika Bambaataa Allegedly Molested Young Men For Decades. Why Are the Accusations Only Coming Out Now?" *Vice*, October 10, 2016, https://www.vice.com/en/article/8xx5yp/afrika-bambaataa-sexual-abuse-zulu-nation-ron-savage-hassan-campbell. See also Marc Hogan, "Afrika Bambaataa Sued for Child Sex Trafficking From 1991 to 1995," *Pitchfork*, September 9, 2021, https://pitchfork.com/news/afrika-bambaataa-sued-for-child-sex-trafficking-from-1991-to-1995/?utm_source=twitter&utm_social-type=owned&utm_brand=p4k&utm_medium=social&mbid=social_twitter.

72 "In Zulu Nation we always told them that there's 12 planets in our galaxy and a 13th one that comes every 26,000 years. They thought we were crazy, but they only found the ninth planet in 1930. It's gonna get up to 12, watch. Because the Sumerians, the Aztecs, the Incas, the Dogons, the Egyptians, all knew about this science and stuff, and all these Hindus talked about the beings in the flying ships." Afrika Bambaataa, interview by Broughton. See also *Zulu*, directed by Cy Endfield (London: Diamond Films, 1964).

fad that would soon pass. The release landed the same summer as Grandmaster Flash and the Furious Five's "The Message" broadcast the lyrics: "Don't push me 'cause I'm close to the edge / I'm tryin' not to lose my head / It's like a jungle sometimes / It makes me wonder how I keep from going under"—a disillusioned comment on the visible onset of urban decay befalling Black communities in America under President Ronald Reagan's economic policies.[73] Afrika Bambaataa followed "Planet Rock" with a new song called "Looking for the Perfect Beat," just in time for the release of their full length, *Planet Rock: The Album* (1986). Taylor reminisced:

> I always was into "Trans Europe Express," and after Kraftwerk put "Numbers" out, I said, "I wonder if I can combine them two into make something real funky with a hard bass and beat." So we combined them. But I didn't want people to think it was just Kraftwerk, so we added a track called "Super Sperm," by Captain Sky. The breakdown as the synthesizers going up, that's the "Super Sperm" beat. And then we added "The Mexican" by Babe Ruth, another rock group, and we speeded it up.[74]

Upon their release, many assumed that "Planet Rock" and "Looking for the Perfect Beat" sampled Kraftwerk. "I'd been into Kraftwerk and Bam was into Kraftwerk, and we just had the idea of merging the two songs together," Baker later recalled.[75] "He had been hearing those songs all over the city, seemingly from every boombox and car stereo. John Robie, the studio engineer, only used those songs as a starting point for his own synthesizer compositions on the Micromoog and Prophet 5. . . . When we went in to do 'Planet Rock,' we were worried that we'd have problems with Kraftwerk, so we did another melody line," Baker specified, evoking the way he and Soulsonic Force took to building their studio music out of several interchangeable parts.[76] Nonetheless, Kraftwerk sued the label Tommy Boy, angry about not having been credited; they settled on receiving a dollar for every copy of the record sold, even though their music had not actually been sampled. The label soon recouped the fine and raised the price of the single from $4.98 to $5.98 to compensate. The next year, as part of the vocal electro and freestyle group Planet Patrol, Baker remixed unused tracks from *Planet Rock* into a new song, "Play at Your Own Risk," that reached number 64 on the Billboard R&B Albums chart. "I'm not a fan of somebody just straight ripping off somebody else's track via sampling," Atkins remarked in a 2012 interview. "There are a lot of innovative ways that the sampler came to be used—it brought an awful lot of sounds

73 See Grandmaster Flash and the Furious Five, *The Message* (Sugar Hill Records, 1982).

74 Afrika Bambaataa, interview by Broughton.

75 Arthur Baker, interview by Bill Brewster and Frank Broughton, "Making Musical History: Arthur Baker and Electro in 1980s New York," originally published on DJhistory.com, January 1999, republished in *Red Bull Music Academy Daily*, January 16, 2018, https://daily.redbullmusicacademy.com/2018/01/arthur-baker-interview.

76 Ibid.

to fruition that you wouldn't otherwise have been able to hear."[77] Yet in an ironic twist of fate, while visiting New York on business around that time, Atkins overhead "Planet Rock" and was both inspired and upset that another act had beat him to the idea of a Black techno-funk sound, noting that Afrika Bambaataa's vision of the future was superior to his own.[78] He was inspired to pursue his own Afrofuturist electronic production even further.[79] "The advent of MIDI was a real godsend because it enabled different manufacturers' devices to talk to one another," explained Atkins. "It was great for us because we didn't necessarily want to use Roland keyboards just because we had a Roland drum machine. We might want to use Korg or Oberheim, and before MIDI, a lot of that stuff wouldn't work together. After that, digital sampling opened up the whole industry."[80]

Nearly 3,000 miles away, in Los Angeles, Gregory Broussard, a rapper and DJ who performs under the name Egyptian Lover,[81] quickly rose from mixing Rick James and Prince tracks at high-school dances to large-scale arenas after encountering his first drum machine:

> When I went to Club Radio I was talking to Afrika Islam and he said he knew Afrika Bambaataa, like, "That's my pops, man." And I was like, "Yeah? Well, how did they get that sound on 'Planet Rock'?" Because I wanted to do that sound—in my mind I'm like, "I want to do that sound." He said, "Well, they used a drum machine called the 808." I'm like, "Damn! A drum machine? What is that?" He said, "I'll show you, they've got them at the Guitar Center." So we went over to the Guitar Center and I saw the 808 and the guy at the place taught me how to program a beat. And so I programmed "Planet Rock" and I heard it and I'm like, "Oh yeah, this shit sound nice." So I bought it right then and there, went home, programmed the whole 808 full of beats, brought it to an Uncle Jamm's Army party and played it and that was it right there.[82]

77 Juan Atkins, interview by Chris Baker, "Interview: Juan Atkins on the Detroit Techno Sound," *Music Radar*, March 3, 2012, https://www.musicradar.com/news/tech/interview-juan-atkins-on-the-detroit-techno-sound-532619.

78 "At the time, [Atkins] believed ['Techno City'] was a unique and adventurous piece of synthesizer funk, more in tune with Germany than the rest of Black America, but on a dispiriting visit to New York, Juan heard Afrika Bambaataa's 'Planet Rock' and realized that his vision of a spartan electronic dance sound had been upstaged. He returned to Detroit and renewed his friendship with two younger students from Belleville High, Kevin Saunderson and Derrick May, and quietly over the next few years the three of them became the creative backbone of Detroit Techno." Stuart Cosgrove, sleeve notes, *Techno! The New Dance Sound of Detroit* (10 Records, 1988).

79 Ibid.

80 Atkins, interview by Baker.

81 "The Egyptian Lover is a DJ who wanted to make a record to catch women, so I made a record called 'Egypt, Egypt' with my name all in it, so all the women could say, 'That's his name, now I can go ask for him as a DJ.' That's it. (Laughter) I just got lucky and sold four million copies, but that was it." Egyptian Lover, lecture, hosted by Noz, Red Bull Music Academy, New York, 2013, https://www.redbullmusicacademy.com/lectures/egyptian-lover-lecture.

82 Ibid.

In 1984, while scoring the West Coast hip hop documentary, *Breakin 'n' Enterin'*,[83] Egyptian Lover released his debut album *On the Nile*, selling 425,000 copies and reaching number 56 on the Top Black charts. Two years later, his next album, *One Track Mind*, reached number 37 on the Billboard R&B albums chart. Meanwhile, in Brooklyn's Bedford-Stuyvesant neighborhood, lifelong friends Ben "Cozmo D" Cenac, his future wife Yvette "Lady E" Cook, his cousin Monique Angevin, and her future husband "Chilly B" Crafton formed Positive Messenger, a band of wholesome, purpose-driven electronic musicians; they worked independently within a larger group called Jam-On Productions, started in 1977.[84] Cenac had started making his own music in 1979, collecting electronic equipment to experiment with pushing the boundaries of the sonic format established by MCs and DJs at local block parties: "When I first decided to try my hand at making my own music in 1979, I was an office messenger in a mailroom. I couldn't afford any of the professional equipment that was out there."[85] His first synth was an Electro-Harmonix Mini Synthesizer, "a monophonic, toy-looking thing with membrane keys that was made out of cheap, thin plastic with a cardboard underside"[86]; his first drum machine was a palm-sized, semi-programmable Roland Boss DR-880, which led him to get a Roland RS-09 polyphonic synth. "That was all I had, so I would use two cassette decks and built my earliest tracks, tape to tape."[87] Cenac found Roland's instruments to be affordable enough to buy on a budget and accessible enough to use while teaching himself, using beginner's music theory books, how to compose music within the Western classical structure.

"However, it was when Roland released the TR-808, and then the TB-303, that my music and my life would change,"[88] Cenac stated; the two instruments were complementary and allowed him to layer beats and basslines into looped grooves and pressurized funk. In summer 1980, Cenac assembled his first completed recordings with rappers MC Harmony (Al "T" McLaran) and Lady E (Yvette Cook) onto a cassette titled *Freak City Rapping*. Sketches of freestyle verses flow over electronic rhythm and soul that Cenac made by first laying an initial track of drums and bass to a standard stereo cassette deck, then playing that tape back while adding an additional performance of synth or vocal and recording both simultaneously to a second cassette deck. This process of layering was done over and over until the full arrangement of the song was recorded. Each additional generation or layer of recordings would add noise and lose quality, until the final result would be very high in noise and very low in

83 *Breakin 'n' Enterin' – West Coast Hip Hop Documentary*, directed by Topper Carew (Los Angeles: Rainbow TV Works, 1983).

84 John Bush, "Biography," Allmusic.org, https://www.allmusic.com/artist/john-bush-mn0001245192/biography.

85 Cozmo D, "Legacy Series: Cozmo D and Newcleus," n.d., Rolandcloud.com, https://www.rolandcloud.com/news/legacy-series-cosmo-d-and-newcleus.

86 Ibid.

87 Ibid.

88 Ibid.

fidelity.[89] The result is a rustic, yet polyphonic studio artifact held together by a sparse, metronomic beat; a rolling bassline; and subtle, razor-thin synthesizer melodies coloring the recordings' backdrop. Cenac himself rhymes over his music, telling the story of the intergenerational oral tradition that became the vocal practice of rapping. "Many, many, many, many years ago when rap was still in stone, my great great great grandpa had a boogie on his own. He took a little Beethoven and added a funky beat, and then he grabbed a lady by the waist, and he invented the freak," he raps. "When I was a little baby boy, my momma gave me a brand new toy: two turntables with a mic, and I learned to rap like a dolemite."[90] In another recording titled "Destructabooty," Cenac, as Cozmo D, used sped-up vocals resembling the animated musical group Alvin and the Chipmunks in a sonic fiction about a rapping robot.[91]

In 1981, Salvador Smooth, a DJ in the Jam-On crew, heard these early recordings and suggested that Cenac make more rap music. "I didn't like the rap records that were happening," Cenac commented. "See, in Brooklyn, we had a battle mentality when it came down to hip hop. Every party was a battle. I mean we didn't have DJ crews—some did—but very few had routines like they did in the Bronx and Harlem. Yunno, everyone's rapping together, and they take their turns and answer each other."[92] He continued: "Now, we ain't do that shit. You could be a member of a crew but everyone took 16, 32 [bars] or longer, and the next guy would go and try to blow him out. And you'd all be best friends. But getting on the mic was about the battle. We had a battle mentality."[93] The hip hop records that began to circulate the scene and airwaves couldn't quite capture the communal, spontaneous energy of the rap battles that Cenac experienced. "Even though they were using Brooklyn beats, stuff that worked in Brooklyn, a lot of the rhymes were all this sing-songy routine shit," he remarked. "We thought they were corny. So when he said to make a rap record, and yunno, I'm doing serious music, I said, 'Ok, I'm going to have some fun.'"[94] In 1984, Cenac decided to take influence from the psychedelic funk of George Clinton and Parliament Funkadelic to create an "anti-rap record" titled *Jam On Revenge*, accentuated with his chipmunk vocal effect. The parodic track recounted a story "Jam On Productions riding into town, and chasing off the wack rappers before sundown."

After shopping demo recordings around to different record labels, the group was signed by producer Joe Webb, first to Mayhem Records, and then to Sunnyview,

89 Jam-On-Productions website, "Tape 2 Tape Cassette Tape Dub Demos and Ideas," https://www.jamonproductions.com/tape-2-tape-demos/.

90 Jam-On Productions, lyrics, "Freak City Rapping" (unreleased, 1980).

91 Cozmo D, "Destructabooty" (unreleased, 1980).

92 Ben "Cosmo D" Cenac, interview by S. H. Fernando, Jr., "Key Tracks: Newcleus's 'Jam On It,'" *Red Bull Music Academy Daily*, June 12, 2015, https://daily.redbullmusicacademy.com/2015/06/key-tracks-newcleus-jam-on-it.

93 Ibid.

94 Ibid.

which promised many successes in the teenage band's future. At this stage, the group changed its name to Newcleus, a direct reference to their family being a music-making team, which Cenac felt was a better fit for them now that their music was shifting away from the original impetus to make strictly positive, uplifting music. Now that the group had access to a professional studio, they re-recorded and renamed the song "Jam On Revenge (The Wikki-Wikki Song)," which was released as a single that reached the Top 40 on the US R&B chart. Their follow-up track, "Jam On It," reached 56 on the Billboard Hot 100 ahead of their debut album, *Jam On Revenge*, which came out in 1984. The opening track and the band's second single, "Computer Age (Push the Button)," displayed a more fleshed-out vision of the Newcleus sound, introducing a sonic fiction that runs throughout the album: a narrative about "a band of musicians from a far-off galaxy, a place where music and dancing are against all cosmic and computer law."[95] The album was commercially successful; yet, while Cenac received songwriting credits, Newcleus had signed away royalties from the recordings in their contracts. "By the time it came to make the second Newcleus album, I'd made a little money and could afford some new equipment. MIDI had arrived, and my first MIDI sequencer was a Roland MKS-70," Cenac explained. "I bought a Roland Jupiter 6, a JX-3P, a TR-727, an MC-202, but perhaps the two most essential synths that I ever purchased were the Roland Juno-106 and JX-8P. The strings, pads and horns on those two synths are so warm, fat, and luscious that they became irreplaceable to my music."[96] These instruments formed the basis of his next, cosmic, Afrofuturist-themed album with Newcleus, *Space Is the Place,* as well as his ventures into producing sultry acid house music as Dream 2 Science in the '90s.

In 1991, at the onset of the British and European rave revolution, Tsutomu Noda, a writer at *Sony Magazine*, came across *Retro Techno / Detroit Definitive: Emotions Electric*, a compilation of tracks released that year and recorded by Juan Atkins, Kevin Saunderson, Santonio Echols, Derrick May, Blake Baxter, and Mark Kinchen between 1982 and 1988 that refinanced and reintroduced limited pre-rave-culture Detroit techno to a global audience. "Detroit techno was one of the musics that I felt was symbolic of that era. It had its own distinctive sound. Chicago house and New York's garage house was also available in record shops at the time, but the music from Detroit struck me as particularly unique," Noda told May in a 2014 conversation.[97] In 1991, Noda recorded some Rhythim Is Rhythim tracks onto a cassette tape and took it to his friend Masakazu Hiroishi, who worked at Alfa, the label that had released Yellow Magic Orchestra's two records, and asked them to release it. Hiroishi's boss at Alfa told him that May's music "sounds like Kraftwerk and very interesting, but we don't think

95 Newcleus, lyrics, "Computer Age (Push the Button)," *Jam On Revenge* (Sunnyview, 1984).

96 Ibid.

97 Tsutomu Noda, interview by Derrick May, "Derrick May Interviews *ele-king*'s Tsutomu Noda," *Red Bull Music Academy Daily*, October 23, 2014, https://daily.redbullmusicacademy.com/2014/10/derrick-may-interviews-tsutomu-noda.

we can release it."[98] Hiroishi went on to become the director of Sony Techno, before founding the label Third Ear Japan and starting the Mix-Up DJ series through Sony, which distributed mix CDs from May, Mills, Ken Ishii, Takkyu Ishino, and Fumiya Tanaka, with cover art by Japanese science-fiction illustrator Shigeru Komatsuzaki. "Ah, so that's how [Hiroishi] comes into the picture... it's interesting to learn this," May mused during his conversation with Noda, adding, "The relationship with Hiroishi is also very important. From that relationship came the Mix-Up series, the Japanese relationship with the Dutch label R&S Records, and the career of Japanese artists such as Ken Ishii, of course. There are so many things that came out of such a simple cassette that you made. That is influence."[99] Noda replied that he felt strongly about techno, which he saw as reflecting early consumer productions that made use of commercial, electronic equipment:

> Detroit techno... basically messed up my life. [*laughs*] No, I'm just kidding, but at the time, music journalism was built around what was popular. Not to say that it's that much different now, but it was very much about rock stars and about their success in the business. Whereas Detroit techno wasn't just about the music, but artists from that scene were clearly different. It was all DIY. It was counterculture to the music industry. They had an attitude to rebel against what was powerful. As I was just a rookie music journalist, that really gave me a guideline as where I should find my standpoint in this industry. I felt like I found something I should follow and support. So for me, it was interesting not only musically, but it gave me a perspective, a way of thinking.[100]

In January 1995, Noda published the first issue of the magazine *ele-king* with a cover story on May and Ishii titled "Global Techno Village." He recalled seeing May DJ in 1994 at Hard Wax in Berlin and again the following year with Mills, at Club Rockets in Osaka, telling him: "You were unbelievably good. I honestly had never seen a DJ that skillful before. Japanese DJs are good in their own way, but your DJ set completely blew me away."[101] Noda also saw Underground Resistance and Atkins DJ in Japan in the early '90s: "It was around that time that the Japanese audience was exposed to Detroit DJs. It was just so different to what we were used to. How you used the EQs and faders, the rhythmic way of using mixers... everything was new to us. But it wasn't that Detroit techno blew up immediately. NY house or UK dance music was much more popular and featured in many more music magazines than Detroit techno. It was still niche."[102] *ele-king* was distributed across Japan, with 5,000 copies of the

98 Ibid.
99 Ibid.
100 Ibid.
101 Ibid.
102 Ibid.

94

magazine sold at the record shop Wave in Shibuya, Tokyo. Noda told May, "We realized then that there was a huge craving for information about techno music in Japan. People like me, Hiroishi, and Hoshikawa may have contributed to the recognition of this music, but there were already people who were waiting for it."[103] In September 1998, Noda visited Detroit after receiving an invitation over email from Mike Banks, of Members of the House and Underground Resistance, which read: "Come to Detroit if you want to find out more." Taking in the environment, he immediately noticed differences between Detroit and Tokyo—two cities undergoing economic recessions that would spill over into the following decades.

Noda reminisced about his time in Detroit, visiting Submerge: "There was Mike Banks' race car in the parking garage. On the wall of the garage, there was graffiti saying "Fuck the Majors" written by Drexciya." He met AbuQadim Haqq and Neil Olivierra, working in the office at Transmat. "It was only ten days, but I will never forget that experience,"[104] he recalled. Years later, he documented the music of postindustrial America more fully in his book *Black Machine Music & Galactic Soul* (2005).[105] It offered Japanese readers polite commentary and interviews covering the formation of Detroit techno and its development from funk and soul alongside house. "I wanted to write about the background of the music," Noda recalled. "I got great reactions from people. I was happy that people who didn't know techno or house enjoyed it."[106] After *Black Machine Music* and a few years of publishing *ele-king*, interest began to grow from the dedicated circles that had discovered techno in their own way, creating a genuine market demand in the Japanese music industry. "Listeners of '80s synth pop hated house and techno initially. So I think the idea that Japanese people love electronic music is a fantasy of outsiders. It is one of exoticism around YMO and Japanese technology," Noda opined. "But whether it is from Detroit or Germany, techno has always been popular in Japan. When I first published *ele-king*, we used to say it was 'the first techno magazine in the world.' So I am happy that I got to be a part of this culture."[107]

103 Ibid.

104 Ibid.

105 Tsutomu Noda, *Black Machine Music & Galactic Soul: Disco, House, Detroit Techno* (Tokyo: Kawade Shobō Shinsha, 2001).

106 Noda, interview by May.

107 Ibid.

5.
HI-TECH DREAMS, LO-TECH REALITY

"There'll be dancing / They're dancing in the street / It's just an invitation across the nation / A chance for folks to meet / There'll be laughing, singing and music swinging / Dancing in the street / Philadelphia, PA / Baltimore and D.C. now / Can't forget the Motor City / All we need is music, sweet music / There'll be music everywhere / There'll be swingin', swayin' and records playing / And dancing in the street / Oh, it doesn't matter what you wear / Just as long as you are there / So come on, every guy grab a girl / Everywhere around the world."[1]

– Martha and the Vandellas

"I've seen a city, once thriving with Motown and the motor industry, become dreary and quiet as if the past were an illusion. Part of the inner-city is made up of ruins and homeless people, America's hidden reality. The Music Institute in 1987 drew a boundary between past and future by accepting reality and preparing the future for a generation of brave people. Being close to the 21st century, Detroit has wiped its bygone glories and tried to move towards a new interpretation of the world. It's electronic music reaches those people trying to dream in life and has been shining ever more year by year. Even if the reality is in fact, like hell, the many shining stars from the city allow us to empathize miles and miles away from the city."[2]

– Tsutomu Noda

As he walks along a graffiti-covered concrete Berlin Wall and past empty lots and demolished buildings, Blake Baxter—"the Prince of Techno"—describes the function of sampling and how it changed over the years, after techno made its way to Europe. Sampling, for Baxter, is a way for frequencies to come together to "honestly compose music" and harmonize a new sound: "Now, everyone samples from Detroit style stuff, or they mimic and copy, and a lot of these artists are making a killing off of it."[3] Baxter explains that techno began to slip away from its Detroit originators in part because of a gap in access to technology and equipment: "We don't have the studios or the money to come across as loud and as strong as the people who copy or are influenced by our music."[4] The 1996 documentary *Universal Techno*, produced by French-German

1 Martha and the Vandellas, *Dancing in the Street* (Gordy, 1964).

2 Tsutomu Noda, liner notes, The Detroit Escalator Co., *(Excerpts)* (Peacefrog Records, 2000).

3 Blake Baxter, interview in *Universal Techno*, directed by Dominique Deluze (Paris: Les Fil à Lou and La Sept ARTE, 1996).

4 Ibid.

public television service ARTE,[5] features interviews with such major players as the Belleville Three, Aphex Twin, and LFO, in an attempt to historicize techno and rave culture as a form of global collaboration. As one of the oldest artifacts of the dance music phenomenon, *Universal Techno* documents their first encounters with rave culture and offers a pre-global oral history of techno's origins in Detroit through detailed discussion of the socio-economic conditions of '80s Detroit and its influence on key figures of the movement's interpretative use of music technology.

In the next scene, Jonathan Fleming, author of the 1995 visual history of rave culture in Europe, *What Kind of House Party Is This?* flips through the pages of a magazine feature on the Belleville Three. As he does so, he gives a succinct, culturally distant portrayal of each of their contributions to techno: "Since these people were being influenced by Kraftwerk, this has become not a culture or a community in Germany, but a life thing. That is why there is such a passion for techno music in Germany as opposed to anywhere else in the world." The Belleville Three, too, each appear in turn. In a confessional-style scene earlier in the film, Juan Atkins sits in a studio, recounting how he came to produce music at the age of seventeen: "I knew that I wanted to make a record, but that was the extent of my dream at the moment. To have it played and to have people hear it." He had no idea that the music would travel to Europe and the world. A discussion of Kevin Saunderson's vocal house project, Inner City—the release that brought techno to the masses—follows. Two of Inner City's songs, "Big Fun" and "Good Life," were crossover hits in both the dance and pop markets. Later in the documentary, Saunderson is shown at the Detroit offices of the label Submerge Recordings, pulling and playing his remix of Underground Resistance's first release, "Living for the Night," featuring vocalist Yolanda Reynolds—which he called one of his favorite remix jobs. Saunderson explains how The Electrifying Mojo's midnight show included music that was different from any of the marketable hits programmed during the day: "All of these mixed sounds, which was never heard before until he came on, definitely had a lot to do with the inspiration in Detroit."

Derrick May, who is referred to earlier in the film as "the crazy man of the group," talks about his understanding of machinery, electronics, and industry. He explains his transition from DJing to experimenting with electronic instruments, a decision he made after watching Atkins develop a relationship with his machines over the years—in a direct affront to their typically cold, industrial working-class environment. "Machines have no love nor any feeling," he explains, "and sometimes the people that work for these machines end up having no feeling nor love because they're working relentless hours, they're putting in total commitment to something that is giving nothing back." As a DJ, May developed a philosophy of "making music with music

5 ARTE was founded in 1991 as a joint European venture that sought to broadcast programming that could "familiarise the Germans and French with each other's cultures and by bringing them closer to promote further integration," https://www.arte.tv/sites/corporate/en/the-birth-of-arte/.

records," which carried over into his music productions. "We took these same ideas of machinery—not necessarily the synthesizer, but it was more or less the *sound* of the synthesizer—that we created our own sounds, and all these sounds subconsciously came from the idea of industry." He takes the *Universal Techno* camera crew to the Michigan Theater, an abandoned 4,000-seat French Renaissance-style establishment built in downtown Detroit in 1925 by the infamous sibling architects, Cornelius W. and George L. Rappas. "Inside this building was a theater," he recalls, "and they tore out the theater and they made a car park . . . I don't feel sad, I feel angry. Angry at stupid people." May comments on the arrogant exuberance of American utopian thinking, which inevitably leads to great catastrophe. "In America, nobody cares about these things... People in America tend to let this shit die, let it go with no sort of respect for history," he complains. Despite being a controversial figure in techno, due to his pointed quips, predatory behavior toward women, and impassioned improvisational lectures on the arts and all things romantic in the world, May was attuned to the unsustainability of Detroit's economy and its global export of cars and music: "Being a techno-electronic-futurist, high-tech musician, I totally believe in the future, but I also believe in a historic and well-kept past. I believe that there are some things that are important. Now maybe this is more important like this, because in this atmosphere, you can realize just how much people don't care, how much they don't respect—and it can make you realize how much you should respect."

In another scene of side-scrolling through aged and neglected houses and corner stores in Detroit, the camera draws visual connections with the previous shot of the Berlin Wall. "Detroit, probably as you've noticed, is somewhat of a depressed postindustrial city, and I think that the general attitude here with the powers that be, with the government, with the local government is that, you know, industry must die to make way for technology. I think Detroit is a city in North America that's probably experienced the technological revolution first, and I think that it affects all of the occupants of Detroit, including the artists, the musicians and what have you." Having coined the term "techno" from his own readings of Alvin Toffler, Atkins reflected that, "The climate has definitely affected us, and I think... we probably wouldn't have developed this sound in any other city in America other than Detroit, and that's the major reason why I stay here and I haven't moved." He concludes: "There is a certain atmosphere here that you can't find in any other city that lends to the technological movement."[6]

*

Beginning in the 1930s, the Black Bottom district of Detroit thrived, affirming its status as a notable musical and cultural hub, as well as one of the first neighborhoods to attempt integrating Black and white Americans.[7] Like the Black Belt region from

6 *Universal Techno.*

7 Thomas J. Sugrue, *The Origins of the Urban Crisis: Race and Inequality in Postwar Detroit* (Princeton, NJ: Princeton University Press, 2005), 23–24, 47, 62, 196.

which many African Americans had emigrated, Black Bottom was named for its rich soil foundation, with most of its inhabitants employed by Detroit's Big Three automotive manufacturing plantations. The emergence of the modernist tradition of African American rhythm and soul music—and its Information Age cybernation into Detroit techno—began with this Great Migration. Old Hastings Street was a long stretch of retail shops and commercial real estate running from Black Bottom to the adjacent Paradise Valley community. Joe Von Battle, a producer of blues and gospel music in Detroit, owned a record store on Hastings Street where he set up a recording studio, which became an epicenter for the music and nightlife of the city. Battle's record store and label would be the starting force of the "Detroit sound," and a catalyst for the transmutation of Amiri Baraka's "blues continuum" into sellable documents of Black industrial culture, which unfolded into rhythm and blues as well as rock 'n' roll, eventually ballooning Von Battle's company's value to nearly $3 million.[8] Battle's record shop and Old Hastings Streets were immortalized in the documentary-style lyrics of the 1948 Motor City blues song "Hastings Street Opera," released on Battle's J-V-B imprint by Bob "Detroit Count" White, who could often be found performing long improvisational piano sets on Saturday nights, at the massive Forest Club. Battle lived a long and successful life, working with musicians from Motown records despite ongoing disagreement with Berry Gordy about his manufactured and market-ready methodology. Battle's influential record store was destroyed during the 1967 race riots in Detroit in response to police brutality in the Black community.

Throughout the mid-twentieth century, "Black and tan" music venues fueled Paradise Valley and Black Bottom's sometimes multi-racial, working-class nightlife scene, which also welcomed an influx of white partygoers from the nearby, wealthy Grosse Pointe neighborhood. Hastings Street was rezoned, defunded, and demolished in a re-urbanization project led by the Detroit city council in order to build highway I-375 in the 1960s. Jazz and bebop continued to develop in the nightlife scene, alongside the commercially released rhythm and blues of Berry Gordy's first record label, Tamla, creating dual outlets for African American soul to manifest and surface. Gordy had started his first venture in the 1950s, the short-lived record store 3D Record Mart. "We created a heavy jazz atmosphere that you could feel the moment you walked in," Gordy mused in his autobiography.[9] He wrote of trying to bring the latest forms of jazz expression to the local working-class community who had a strong preference for the blues, particularly Muddy Waters and B.B. King: "Using the album covers, we decorated the walls with the hottest jazz musicians of the time. Constantly playing was the cool jazz of Miles Davis, the fluid chords of George Shearing, the dexterity and

8 Joe Von Battle "was the first to record 14-year-old Aretha Franklin's voice when she was just a singer in the New Bethel Baptist church choir and subsequently produced her first record." Ashley Zlatopolsky, "Before Motown: A History of Jazz and Blues in Detroit," *Red Bull Music Academy Daily*, August 7, 2015, https://daily.redbullmusicacademy.com/2015/08/detroit-jazz-and-blues. See also Lars Bjorn with Jim Gallert, *Before Motown: A History of Jazz and Blues in Detroit 1920–1960* (Ann Arbor, MI: University of Michigan Press, 2015).

9 Berry Gordy, *To Be Loved: The Music, The Magic, the Memories of Motown* (New York: Warner Books, 1994), 60.

sensitivity of Oscar Peterson, the commercial groove of Erroll Garner, or the Bird—Charlie Parker—just blowing like mad, as only he could. I felt great."[10] Whereas jazz musicians Alice Coltrane, Charlie Parker, Elvin Jones, and Miles Davis used their time in Detroit to mutate musical expression into innovative sonic constructions, Motown's technologically produced ensemble earworms permeated the radio waves and blanketed the United States, setting a gold standard for how popular music ought to sound. To create the perfect pop hit, Gordy employed a design strategy implemented by the United States Navy called "KISS," or "Keep It Simple Stupid."[11] Taking inspiration from the doo-wop style of rhythm and blues, Motown songs were composed of few parts, brought together by new recording studio engineering technology manned by Norman Whitfield—an innovator of new psychedelic soul and the "Motown Sound" with Gordy.[12] Whitfield and a team of A&R, producers, and songwriters, made up of William "Mickey" Stevenson, Brian Holland, and Lamont Dozier, controlled how the instruments and voices were mixed and positioned in the stereo output alongside complex orchestral arrangements, peeled back into precise textures and qualities, producing a new kind of music that was beyond human. They manufactured a sound of African American soul that was easy to listen to and pleasing to hear on the radio for ears across the nation.

Many competing record labels tried to copy Motown's signature sound in the 1960s, but the stereo-modified Black soul that Gordy meticulously crafted was singular to the writers, musicians, engineers, and executives who instrumentalized studio technology and market distribution there. "Motown's genius for mechanization ensured that, in its wake, other artists could also leave a meteor's dent in the national consciousness," observes writer and critic Wesley Morris. "Gordy built an auto plant around Black expression that neither wrecked it nor watered it down. His company confirmed what African Americans had always known about Black culture: that it was American culture, indeed."[13] Maintaining the universality of the Motown sound, Gordy and his artists largely veered away from radical Black ideology. The rising racial tensions of the Civil Rights Movement and its demonstrations of boycotts and marches spurred Gordy to start a subsidiary label called Black Forum in 1970, two years after the surprising, but not unexpected, assassination of Reverend Martin Luther King and three years after the Detroit race riots, which left 43 dead, 1,189 injured, over 7,200 arrested, and over 2,000 buildings destroyed from 483 fires, with nearly 230 incidents reported within an hour.[14] "Motown's Hitsville studio escaped largely unscathed,

10 Ibid.

11 Arwa Haider, "Motown: The Music that Changed America," *BBC*, January 9, 2019, https://www.bbc.com/culture/article/20190109-motown-the-music-that-changed-america.

12 Gordy, *To Be Loved*, 60.

13 Wesley Morris, "Music," in *The 1619 Project: A New Origin Story*, ed. Nikole Hannah-Jones (New York: One World, 2021), 363.

14 Herb Boyd, *Black Detroit: A People's History of Self-Determination* (New York: HarperCollins, 2017), 208.

except for damage to a front window caused by a tank shell fired across West Grand Boulevard," Stuart Cosgrove writes in his 2015 book *Detroit 67,* nearly three decades after his liner notes for the seminal *Techno!* compilation. "But Detroit's wooden-porch image as the home of soul music had been damaged to the core, and the family myth that had been crucial to the Motown story was brutally displaced by darker visions of a charred city under martial law."[15] Black Forum was dedicated to spoken word and oral history recordings around the Black struggle for freedom, civil rights, and humanity; it released Dr. King's "Why I Oppose the War in Vietnam" sermon given at Atlanta's Ebenezer Baptist Church in 1967, as well as Amiri Baraka's album of political poetry and afro-modernist free jazz and soul, *It's Nation Time - African Visionary Music* in 1972. That same year though, Gordy decided to move Motown from Detroit to Los Angeles, looking to the West Coast for a better financial environment in which to develop more pop hits, and leaving 300 employees without work in a city crumbling socially and economically.

On December 26, 1980, jazz composer and bandleader Sun Ra accepted the key to the city of Detroit as part of a residency at the Jazz Center in Detroit. Alongside an exhibition of his films and paintings, Sun Ra and his Omniverse Jet Set Arkestra performed and recorded over twenty-six hours of material across eleven shows over the course of a week. Sun Ra humbly began his residency by saying, "I want to thank you very much. Now I have the key to the city of Atlanta, the key to the city of New Orleans and now the key to Detroit."[16] Born Herman Poole Blount in Birmingham, Alabama, in 1914, Sun Ra was a voracious reader and studied under John T. "Fess" Whatley, "the maker of musicians," who formed the first jazz band in the city and structured an independent music education curriculum in Black-only schools and universities throughout the violently segregated and racist Jim Crow era in the South. Many of the musicians who came out of Whatley's pedagogy later moved North to join the jazz ensembles of bandleaders such as Duke Ellington and Louis Armstrong, or to spread their own musical message[17]—most notably through the jazz ambassadors tour,[18] as a part of the Central Intelligence Agency's broader culture war initiative, "Operation Long Leash."[19] Herman Poole Blount emerged in the Chicago jazz scene in the 1940s

15 Stuart Cosgrove, *Detroit 67: The Year That Changed Soul* (Edinburgh, UK: Polygon, 2016), 334.

16 Sun Ra, "Sun Ra Accepts the Key to the City of Detroit," *Sun Ra and The Omniverse Jet Set Arkestra - The Complete Detroit Jazz Center Residency* (Transparency, 2008).

17 "The weapon that we will use is the cool one." Dizzy Gillespie, "'The Jazz Ambassadors': Cold War Diplomacy and Civil Rights in Conflict," NPR, May 5, 2018 https://www.npr.org/2018/05/05/608802931/-the-jazz-ambassadors-cold-war-diplomacy-and-civil-rights-in-conflict.

18 "[The Jazz Ambassadors Program] is a vehicle for improving understanding of U.S. society and for opening doors to a variety of publics. Jazz is a metaphor for many of the values we hold dear as Americans, and helps foster the people-to-people connections that promote mutual understanding." U.S. Department of State Bureau of Educational and Cultural Affairs, "Evaluation of the Jazz Ambassadors Program FINAL REPORT VOLUME 1," March 2006, https://eca.state.gov/files/bureau/jazz-amb-program-vol.-i-final-report-march-2006.pdf.

19 "The decision to include culture and art in the U.S. Cold War arsenal was taken as soon as the C.I.A. was founded in 1947. Dismayed at the appeal communism still had for many intellectuals and artists in the West, the

under the name "Sun Ra," a reference to the Egyptian god of the sun. Blount had spent years touring in military-styled dance orchestras in the Birmingham jazz scene and in ensembles at Alabama Agricultural and Mechanical University; while there, he claims to have had the experience of being transported to Saturn, where he met and studied with aliens that instructed him to speak, reassuring him that the world would listen.[20] Setting off on a journey towards heliocentric enlightenment, Sun Ra formed an "arkestra"[21] in every city he traveled to, working with local musicians, even becoming one of the first musicians to use electronic instruments, including a prototype of the Minimoog, given to him by Robert Moog in the fall of 1969.[22] Creating a "free music" parallel to the free jazz of Ornette Coleman, Cecil Taylor, Albert Ayler, and others, Sun Ra sought to build world systems with his own impulses towards impossible sonic expression: "[S]ometimes when I'm playing for a band, playing space music . . . I'm using ordinary instruments, but actually I'm using them in a manner . . . transforming certain ideas over into a language which the world can understand."[23]

In 1981, as Juan Atkins and Rik Davis were releasing "Alleys of Your Mind" as Cybotron, Sun Ra was featured on the television program *Black Journal*, hosted by Deborah Ray, to discuss his residency in Detroit. The interview begins with Sun Ra discussing the nature and authenticity of Black music manufactured in a thriving military-entertainment complex.[24] He remarks: "Most Black musicians are not part of the Black race anymore, you see, because they don't have any feeling." He asserts the fundamental importance of cultivating cultural independence: "They're thinking about money, they're thinking about fame, they're thinking about integration. They're not thinking about people . . . you have to play for your people, you see. You have to

new agency set up a division, the Propaganda Assets Inventory, which at its peak could influence more than 800 newspapers, magazines and public information organisations. They joked that it was like a Wurlitzer jukebox: when the C.I.A. pushed a button it could hear whatever tune it wanted playing across the world." Frances Stonor Saunders, "Modern Art Was CIA 'Weapon,'" *Independent*, June 14, 2013, https://www.independent.co.uk/news/world/modern-art-was-cia-weapon-1578808.html.

20 John F. Szwed, *Space Is the Place: The Lives and Times of Sun Ra* (Durham, NC: Duke University Press, 2020), 26–30.

21 "... for well over forty years he managed to successfully hold together the Arkestra, his band of dozens of musicians, dancers, and singers, which performed in every conceivable venue, from conservatory to country-and-western bar; his longevity as leader was longer than most symphony conductors', longer even than Duke Ellington's; he recorded at least 1,000 compositions on over 120 albums (many for his own company, El Saturn Research), and his hand-painted records have long been high priced collectors items, with arguments over even the existence of some of them becoming the basis of legends." Ibid., xvii.

22 Ibid., 98. See also Thom Holmes, "Sun Ra & the Minimoog," Bob Moog Foundation, November 6, 2013, https://moogfoundation.org/sun-ra-the-minimoog-by-historian-thom-holmes/.

23 Sun Ra, quoted in Szwed, *Space Is the Place*, 247.

24 "A recurrent theme in many discussions of sonic warfare within the military-entertainment complex is that of the dissemination and repurposing of military technologies. This dimension of sonic warfare has been theorized in key yet underdeveloped notions in media theory and the history of technology that investigate modes of control by unearthing the military origins of everyday tools." Steve Goodman, *Sonic Warfare: Sound, Affect, and the Ecology of Fear* (Cambridge, MA: MIT Press, 2010), 31.

develop your ethnic structures . . . without that any nation can forget it. I don't care how righteous they are. If they don't have a music, if they don't have a philosophy, if they don't have things on a higher plane, they're not gonna make it."[25] Expounding on Sun Ra's profound cosmology of the Black situation, Kodwo Eshun identifies the underlying influence of Southern gospel and soul, as well as "the entire Civil Rights project," as a posthuman transformation that seeks to levitate and liberate African Americans out of the manufactured historical materialism of the United States into an alternate destiny in the future.[26] "That's what I'm trying to do, to play a superior type of music, not music that deals with the body, not music that deals with the mind, but music that deals with the spirit, the way it should be," Sun Ra tells Ray and the *Black Journal*: "You can encourage people to fight against the bad conditions on this planet, you can encourage them to change things, simply by the music."[27]

In 1979, a year before Sun Ra landed in Detroit and two years after The Electrifying Mojo began his *Midnight Funk Association*, the disco revolution came to a crashing halt on the "the day disco died," July 12, 1979, with "Disco Demolition," an act of symbolic racial violence instigated by Chicago radio show host and anti-disco campaigner Steve Dahl on his new radio station WLUP "The Loop."[28] On the show, Dahl frequently broke disco records or tore through the vinyl's grooves with a needle while it played, encouraging his listeners to do the same. "Disco music is a disease," Dahl declared over radio waves. "I call it Disco Dystrophy. The people victimized by this killer disease walk around like zombies. We must do everything to stop the spread of this plague."[29] This provocation built up to a targeted riot, during which 50,000 white people broke, burned, and blew up disco, soul, and funk records in the center of the field at Comiskey Park in Chicago during a professional baseball game between the Chicago White Sox and Detroit Tigers, in which the former were forced to forfeit due to damage on the field—a clear show of white supremacist and homophobic terror carried out against the American Black and queer dance community. Journalist Dave Marsh of *Rolling Stone* was one of the few voices to pinpoint the exact meaning and cause of the violently symbolic event at the time: "Your most paranoid fantasy about where the ethnic cleansing of the rock radio could ultimately lead... White males, eighteen to thirty-four are the most likely to see Disco as the product of homosexuals, Blacks and Latins, and therefore they're the most likely to respond to appeals to

25 Sun Ra, interview by Deborah Ray on the *Detroit Black Journal*, 1981, https://abj.matrix.msu.edu/videofull. php?id=198-733-51.

26 Kodwo Eshun, *More Brilliant Than the Sun: Adventures in Sonic Fiction* (London: Quartet Books, 1998), 154–55.

27 Sun Ra, interview by Ray.

28 Alexis Petridis, "Disco Demolition: The Night They Tried to Crush Black Music," *Guardian*, July 19, 2019, https://www.theguardian.com/music/2019/jul/19/disco-demolition-the-night-they-tried-to-crush-black-music.

29 Bill Brewster and Frank Broughton, *Last Night a DJ Saved My Life: The History of the Disc Jockey* [1999] (New York: Grove Press, 2006), 290.

wipe out such threats to their security."[30] Dahl's 2016 book on the subject defended his and others' actions that day: "I'm worn out from defending myself as a racist homophobe," Dahl whined, claiming that the event "was not anti-racist, not anti-gay." He felt that people should view the purposeful destruction of Black music in a country like America through the lens of 1979: "We were just kids pissing on a musical genre," he jokes, adding that disco's 12-inch single format took gigs and money away from the rock bands that he and his angry mob of music destroyers worshipped. "Any of us could go to a club now and take molly. It's not so out of reach for everybody." Pivoting into an expression of cultural alienation, most likely due to being a situational minority in counter-cultural spaces that didn't cater to his whims, Dahl admits: "I guess it's how culture progresses."[31]

<p style="text-align:center">*</p>

From 1973 to 1985, the Black youth of Detroit instigated a new wave of music and culture amid the financial fallout and cancellation of their own urban futures in the declining city, trudging along in the wake of Motown's departure and transitioning away from the populist tunes that emerged from Gordy's stab at cybernated soul. More intimate and underground music developed, making use of turntables to play and blend disco, soul, and funk songs into a thread of continuous music composed in the moment and for the dancefloor.[32] Before Detroit's collapse, live rhythm and soul groups played in four-piece units that over time grew into full-on ensembles; the sound morphed into disco and funk. Those morphologies of soulful harmonics and blues tonalities, when recorded, mastered, and pressed to vinyl, offered new usages for the next generation through the manipulation of copyrighted music with turntablist techniques. The advent and musicianship of DJing was technologically new and unphased by the absurdity of the disjunctive possibility of extracting recorded audio and intuitively retuning and remixing it. In effect, a device made for listening had been transformed into a tool for creating. In the same way, DJs presented an opportunity for clubs and music venues to cut costs by booking a single turntablist rather than a large ensemble band, scaling the means of music-making from a group, synergistic practice to a sole proprietor's taste and reflexes.

30 Dave Marsh, "The Flip Sides of 1979," *Rolling Stone*, December 27, 1979, https://www.rollingstone.com/music/music-news/the-flip-sides-of-1979-113608/.

31 Dahl, quoted in Petridis, "Disco Demolition." See also Steve Dahl, *Disco Demolition: The Night Disco Died* (Chicago: Curbside Splendor Publishing, 2016).

32 "I try to mention [the city's pre-techno history—the disco and post-disco era that spawned the techno movement itself] in interviews, but it gets deleted because it predates techno. It would be great to finally have Detroit heard and understood before techno." Mike "Agent X" Clark, quoted in Ashley Zlatopolsky, "The Roots of Techno: Detroit's Club Scene 1973–1985," *Red Bull Music Academy Daily*, July 31, 2014, https://daily.redbullmusicacademy.com/2014/07/roots-of-techno-feature.

In lieu of large-scale disco and funk ensembles, a progressive music spawned from DJs who were absorbing and repurposing disco tropes at a much faster rate, taking over both dancefloors and the airwaves via radio stations in the American Midwest and in doing so, changing their formats entirely to incorporate the new possibility of disseminating promotional music. "The [funk] bands were being pushed out because a band cost $500 and a [disco] DJ cost $50. The DJ got all the popular records, so why would anyone pay for a band?"[33] recalls Felton Howard. Starting his DJ career in 1977 at a bar in Detroit called the Bronze Kitten, Felton became known for his long-format mixing sessions of pre-techno soul music that lasted from the late afternoon until the break of dawn. "You have to understand, in the Black community, you had to mix disco and funk," Howard states. "You couldn't just put on Gloria Gaynor's 'I Will Survive' and not do 'Brick House' by Commodores."[34] Delano Smith, a DJ who turned to producing in the mid-'90s, was at the heart of Detroit's progressive scene as part of the Soundwave crew, with Carl Martin and Avon McDaniel of the social club Next Phase. "I think we were all inspired by disco music. A lot of the radio stations completely changed their format and played disco music day and night," Smith said, observing the music industry's transition from professional bands to amateur selectors. "Not many of us [teenagers] knew how to beat match very well back then; some caught on and some didn't. I think I was one of the fortunate ones that caught on early."[35] Smith points to a young DJ named Ken Collier as one of the more prominent figures of the progressive music scene; Collier's DJ group with Renaldo White and Morris Mitchell, True Disco, favored disco over funk, creating an aesthetic and conceptual split in focus in Detroit's musical development at the beginning of the MTV era.[36]

"There was no mixing in straight clubs. The DJs that mixed were gay," another DJ, Stacey "Hotwaxx" Hale, told the *Detroit Metro Times* in a retrospective article on the progressive music scene. Inspired and determined, Hale "went up to [Collier] and was like, 'Is there a female that plays music?' And he was like, 'No,' so I said, 'I'm gonna be your head girl.'"[37] Hale started out by making her own reel-to-reel dance mixes for basement parties in middle school, before taking a gig at a local radio and becoming one of the first DJs to play house music over the airwaves. "At age 12 is when my second oldest brother went to Vietnam and he was able to buy a component set there—a turntable, a receiver and two speakers. He knew I liked music so he shipped

33 Felton Howard, quoted in ibid.

34 Ibid.

35 Delano Smith, quoted in ibid.

36 "MTV was originally designed to be a rock music channel. It was difficult for MTV to find African American artists whose music fit the channel's format that leaned toward rock at the outset." Buzz Brindle, MTV's former director of music programming, quoted in Margena A. Christian, "Why It Took MTV So Long to Play Black Music Videos," *Jet*, October 9, 2006, 18.

37 Stacey Hale, quoted in Carleton S. Gholz, "The Search for Heaven," *Detroit Metro Times*, July 14, 2004, https://www.metrotimes.com/detroit/the-search-for-heaven/Content?oid=2179150.

it back to me. I saved up my money and bought my other brother's reel-to-reel."[38] Hale wanted to play '60s and '70s jazz records that she had heard at home and during family gatherings, intending to use the home studio to replicate that experience for her young neighborhood friends.[39] Through trial, error, and intuitive engineering, Hale was able to develop a style of mixing she called "sneak-a-mixx," where she would surreptitiously blend a song into another to create a seemingly endless stream of music. "At age 16 I had these basement parties—now the adults were gone, I feel like I'm grown. I remember guys asking, 'How come you don't ever have any silence or pause between the records?' I said, ''Cause I don't want to ever hear any silence. This has to be continuous.'"[40] She also made mixes for The Electrifying Mojo's Midnight Association and won the WJLB Motor City Mix competition in 1985. "I didn't do it to be the first woman doing it, I did it 'cause it was inside of me,"[41] Hale said of her early rise as DJ. She played 12-inch singles by Chic, Diana Ross, and Shalamar, blending the ensemble and voice recordings into a composite groove and soul music she dreamed would last forever. "I was fortunate enough to get a job very early DJing at Club Hollywood. It was an after-hours club, and I would play from 12 until six in the morning to about 800 girls. Some guys would come, but it was primarily a female club."[42] As she spread house music, Hale often saw True Disco spin at the Chessmate, an infamous nightclub named for its owner Morrie Widenbaum, a Michigan state chess champion. Located on Six Mile Road, Chessmate was frequented by a crowd of students from the University of Detroit and catered to their tastes over the years by playing folk and blues in the 1960s, and disco in the 1970s, before becoming a private gay club.

Ken Collier often played on WLBS (102.7 FM), a soul, gospel, and disco station, and also DJed late-night parties at Detroit's smaller-scale iteration of Studio 54, pushing a new sound that bridged the gap between 1970s disco and 1980s techno—a sound parallel to the house music Frankie Knuckles and Ron Hardy were creating in Chicago. Late into the night and early mornings, he played multiple DJ residencies at members-only night spots like Bayside and Club Fever, providing for the entire ecosystem of the early dance music scene. A cassette tape mix labeled *Ken Collier: 82-83-84* stands as one of the few documents attesting to his transitional music production: pounding post-disco, proto-techno. In a 1995 interview with M. Terrence Samson for the Black LGBT magazine *Kick!*, Collier asserted that he didn't really know how to describe his modern underground disco music, which created an overall progressive sound:

38 Harley Brown, 'Stacey "Hotwaxx' Hale: The Godmother of House Music," *Red Bull Music Academy Daily*, May 23, 2018, https://daily.redbullmusicacademy.com/2018/05/stacey-hale-interview/.

39 "Fusion is what we call it. Fusion, which is almost a pre-birth of techno, but it was written music. It was actually written music by classical musicians that were playing riffs, and they wouldn't be a four-on-the-floor, they would be a different count—maybe a 5/4 or derivatives of that." Ibid.

40 Ibid.

41 Hale, quoted in Brown, "The Godmother of House Music."

42 Ibid.

"I would call it music with a feeling. If there's a description, I don't have one of those for it. Maybe I have to think about that. Come up with one."[43] Asked by the magazine whether a DJ should be allowed to have the power to manipulate music for the crowd, or if the format should have a democratic element wherein the DJ takes requests from dancers, he responded: "DJs are the performers, entertainers, and you have all these folks that you have to keep dancing all night long. So you have to become a mind reader, you have to look out to your audience, see what they're doing. They can't come and tell you what to do. You have to have the ability to know what to do. I've always had that."[44]

Cheeks, a nightclub located on Eight Mile Road, extended the disco sounds of the 1970s into the next decade, hiring John Collins as its first Black resident DJ while he worked his day job as an oncology researcher. "I was hired at Cheeks around 1982," Collins told music journalist Mike Rubin in a 2019 cover story for *Detroit Electronic Quarterly*. "Most of the patrons were white and from the suburbs; there weren't many Black people patronizing the club even though it was in the city of Detroit. Cheeks was very popular and upscale, like Studio 54 in New York, where one of the owners would select who could come in and refuse admittance to others."[45] A Detroit native, Collins briefly relocated to Ohio where he studied to be a scientist at Wilberforce University,[46] before returning to Detroit in 1982 after completing his degree. He took up residency at Cheeks with Larry Harrison and Marshall Jackson, two African American men, and gained ownership of the club a few years later, which led to a demographic shift towards Black dancers and music. Collins worked at Cheeks until 1988, getting his own mix radio shows on WJLB FM 98 and WDRQ FM 93.1 in the early 1990s. Looking back, Collins described Cheeks and the transitional era between the supposed "death of disco" and the futuristic sounds of techno as a slow opening up and crossing over of both the consumer demographic and the music producers:

> Cheeks previously had a reputation as being very selective, so that turned a lot of people off. It eventually became a club for everybody: Black, white, straight, and gay. I was the first DJ hired, followed by Stacey Hale, Jeff Mills, Al Ester, and a lot of DJs after that. We programmed house music from Chicago, techno, Kraftwerk, progressive music from New York. It was really an eclectic crowd of people, and that made me more versatile. I learned to read crowds better and we played music that a lot of other clubs would not. We were very selective. We had a gay night as well, and I remember one time the bartender asked me, "How come

43 Ken Collier, interview by Terrence Samson, "Legendary House: Detroit's Own Ken Collier Talks About His in Music," *Kick!*, April 1995, 18–19.

44 Ibid.

45 John Collins, interview by Mike Rubin, *Detroit Electronic Quarterly* 16 (Summer 2019): 33.

46 Wilberforce University was the first college to be historically owned and operated by African Americans. It was founded in 1865 by the Cincinnati Conference of the Methodist Episcopal Church and the African Methodist Episcopal Church (AME).

you don't play music like this on straight nights?" and I was like, "Really, I don't think they can take it." In the gay clubs at that time, the music was so far advanced compared to what straight clubs were playing. The way gay people partied was a little different than straight people. We were able to educate people in music. People talked about Cheeks like they talked about Studio 54 in New York.[47]

As Cheeks developed its audience and reputation, the nightclub Heaven opened in 1984, quickly becoming a central space for a mostly Black and gay crowd to gather and dance in the wake of several venues shuttering in Detroit. Collier became Heaven's resident DJ, playing on Saturday nights, often with impromptu performances by the trans illusionist and entertainer DeAngela "Show" Shannon, who lip synced along to songs and danced on top of the speakers. Heaven followed the prototypical model of New York's Paradise Garage, a gay club, opened in 1977, where Larry Levan, "The Jimi Hendrix of Dance Music,"[48] created the soundtrack for the rise and fall of the disco revolution with his innovative experiments in spinning gospel and R&B records underpinned with drum machines and synthesizers—experiments that formalized Levan's idea of constructing a new, intuitive electronically produced "Garage" music that would never end.[49] Levan and Francis Warren Nicholls, Jr., who DJed as Frankie Knuckles, were lifelong friends from Harlem's early '70s ballroom scene, where they both contributed musically and designed and made costumes and dresses. The two friends eventually met David Mancuso—a hippie DJ who held a particular interest in Black men, and entered a business and pleasure relationship with Levan.[50] Mancuso founded the infamous invitation-only underground party The Loft, where Levan DJed for an elite and fashionable crowd of people well connected in the music industry, using state-of-the-art sound systems designed by Mancuso's friend and audio engineer, Robert Long.[51] The Loft influenced the Paradise Garage's business and technology

47 Collins, interview by Rubin, 34.

48 "Larry was, to us, the Jimi Hendrix of dance music. Which was both good and kind of freaky-sad in a way—like, the world lost Jimi, and then we lost Larry to drugs. But that's what made him legendary, an icon, and what we're standing here and talking about now. He was known to be moody, and I guess that acted out on his mood of the day. You hear stories of how he [would] come down and push a speaker a half a foot. [It] made a difference to him, and that made a difference to us that it made a difference to him, and we'd talk about it the next day: 'He knew something wasn't right.' I'm sure that there were times that he heard a speaker fatiguing and it would annoy him. It was nothing short of a performance. He was thinking along the lines of a rock band onstage." Danny Tenaglia, "Remembering Larry Levan, 'The Jimi Hendrix of Dance Music,'" NPR, December 6, 2011, https://www.npr.org/sections/therecord/2011/12/06/143205414/remembering-larry-levan-the-jimi-hendrix-of-dance-music.

49 Frank Owens, "Paradise Lost," *Vibe Magazine* 1, no. 3 (November 1993): 64.

50 "One night while our boys were hanging out at the Planetarium, a club in the East Village, Larry was cruised by David Mancuso, who had an affinity for Black boys, and the two had a brief affair. The relevancy here is that through this fortuitous meeting Larry and Frankie were introduced into the world of dance music, DJs and producers through Mancuso's legendary Loft parties." DJ Apollo, "House Music 101: Do It Till You're Satisfied," on his Wordpress, entry dated June 2, 2014, https://djapollo2k.wordpress.com/. See also Brewster and Broughton, *Last Night a DJ Saved My Life*, 165.

51 Andy Beta, "Magic Touch: Richard Long's Life-Changing Soundsystems," *Red Bull Music Academy Daily*, May 20, 2016, https://daily.redbullmusicacademy.com/2016/05/richard-long-feature.

model: Long even built the club's speakers as prototypes for club environments in order to invigorate the New York City club scene.

Paradise Garage shut down on September 26,1987, amid the increasing number of AIDS-related deaths and illnesses, and the coinciding heroin and crack epidemic, which plunged Levan, who no longer felt appreciated by the club he helped build up, into a depressive state.[52] Levan moved to London in 1990 to DJ at the newly opened club Ministry of Sound and toured Japan; he passed away on November 8, 1992. Meanwhile, Frankie Knuckles left New York much sooner, in 1977, to DJ in Chicago at the club Warehouse.[53] Initially a Black and gay members-only spot, Warehouse offered space to Knuckles to play regularly for an audience and experiment with DJ sets that culled together under-the-radar gospel and soul records along with imported and domestic disco, combining them with Knuckles' personal "House" style of music that could only be heard at Warehouse. Knuckles' sound extended from the drag ballroom and voguing culture that freed slave William Dorsey Swann first initiated in Washington, DC, in the 1880s and '90s,[54] to its later adaptation during the Harlem Renaissance of the 1920s, and to the vibrant and soulful dance music culture of the Continental Baths and Paradise Garage with Larry Levan in the 1970s and early '80s. Ken Collier and DeAngela "Show" Shannon led a Detroit iteration of the countercultural phenomenon that consolidated fashion and dance music into a competitive, participatory event series and shared community. Throughout the early '80s, the Detroit music scene began to integrate with a straight demographic that saw Black youth forming social clubs and throwing parties at unlikely community venues like the local YMCA and restaurants, while looking to magazines like *The Face* and *GQ* as style guides and beaming in audio transmissions from The Electrifying Mojo. Todd Johnson, a founder of the club Gables, wanted to host upscale events, in contrast to the wild, "get loose" high-school Charivari parties on the third floor of the Women's City Club, organized by Kevin Bledsoe—a young promoter who wanted to carry over the clubbing atmosphere he had experienced in New York while studying at the Fashion Institute of Technology. "[The party scene] brought the crowds together momentarily. It was a brief mix. I don't think it lasted more than a year before violence came in,"

52 The United States government completely ignored the rise of the HIV/AIDS epidemic, while at the same time introducing highly addictive drugs like heroin and crack cocaine into inner cities across the nation in a campaign to disrupt the social and economic foundation of the Black community as well as distort the perception of Black people in the media. The highly mediated "War on Drugs" campaign started in the late 1960s, as President Richard Nixon came to power. "We knew we couldn't make it illegal to be against the war or Black, but by getting the public to associate the hippies with marijuana and Blacks with heroin, and then criminalize them both heavily, we could disrupt those communities," John Ehrlichman, a domestic policy adviser in the Nixon Administration, confessed to journalist Dan Baum in 1994. "Did we know we were lying about the drugs? Of course we did." John Ehrlichman, in Dan Baum, "Legalize It All," *Harper's Magazine*, April 2016, https://harpers.org/archive/2016/04/legalize-it-all.

53 Frankie Knuckles, lecture, hosted by Jeff "Chairman" Mao, Red Bull Music Academy, Madrid, 2011, https://www.redbullmusicacademy.com/lectures/frankie-knuckles-lecture.

54 Channing Gerard Joseph, "The First Drag Queen Was a Former Slave," *The Nation*, January 31, 2020, https://www.thenation.com/article/society/drag-queen-slave-ball/.

Johnson recalled, "and it came in fast. When you try to expand the boundaries, when you mix volatile situations, you're going to have violence that destroys the party scene every time. The elusive crowd that everybody's chasing starts disappearing—it's not cool to get socked in the eye or shot at."[55] Crime in Detroit had been on a steady uptick since the 1960s, but by 1980, the city began to reach a turning point, as gangs and organized drug franchises grew at a faster pace than the parties that had aspired to occupy the youth of Detroit's idle time and pent-up energy.

Mike "Agent X" Clark attended his first party at the age of twelve, in 1978, when he tagged along with his older brother, who produced an event called Gentleman. From there, Clark branched out and started going to the Charivari parties. "Around '81, we started getting other DJ groups coming in [such as Deep Space]. Kevin Dysard, Ray Berry [and others] were the second generation of Direct Drive—Direct Drive DJs that came in after '82," Clark remembered. "I was brewing myself to step into the next lane, but in the meantime, while all that stuff was going on, Deep Space [Juan Atkins, Kevin Saunderson, Derrick May, Eddie Fowlkes] came in. They were the new cats on the block but they came in way left, on the industrial side… more catered to the suburban audience [because they were from Belleville]."[56] May confirms, "We had already done our fair share of high school parties and come up through the ranks of that. We were left of the establishment. We were known as guys who played weird music, but also cool music."[57] A big promoter in Detroit named Darryl Tiggs booked Deep Space for his house party, the Pink Poodles, where they first encountered Ken Collier's progressive turntable mixes. "He's about six foot two and was wearing this big be-bop leather jacket," May recalls. "He walks in with his record crates, sets one down, sets another one down and looks at us. We kind of brushed to the side a little bit, Juan and myself. He takes out a record, takes our makeshift slipmat off the turntables and he puts on a real slipmat. He pops this record on, listens on the headphones, cues up, pulls back and then, boom, he drops it." According to Atkins, Collier remarked, "Here, let me show you boys how it's done."[58] May remembers his set starting with Frankie Smith's "Double Dutch Bus," and then, "The place went off. Within ten seconds the whole floor was full. I'll never forget that." He reiterates, "That was another defining moment. We knew we didn't have the records and we weren't DJs. We knew that we were nothing that we thought we were. It was embarrassing, for real. Truly embarrassing."[59]

55 Todd Johnson, quoted in Sicko, *Techno Rebels: The Renegades of Electronic Funk* [1999] (Detroit: Wayne State University Press, 2010), 17–22.

56 Zlatopolsky, "The Roots of Techno."

57 Derrick May, interview by Bill Brewster and Frank Broughton, originally published on DJhistory.com, August 2004, republished in *Red Bull Music Academy Daily*, May 22, 2017, https://daily.redbullmusicacademy.com/2017/05/interview-derrick-may.

58 May, phone call with Juan Atkins, in ibid.

59 Ibid.

Between 1981 and 1982, DJ collectives like Deep Space and Direct Drive competed in DJ battles, spinning rhythm tracks and remixes with other records. "In those days, we didn't think much of Deep Space," Hassan Nurullah, from the club Gables, remarked. "They were never really the competition. They'd have the parties that we were too booked up to handle."[60] At this particular intersection of Detroit music, many different styles and genres of music were being mixed, but the introduction of Atkins' "secret weapon," live beat-making on the TR-808, extended the modality of turntablism even further—perhaps too far. "All those so-called snob parties, playing for all those kids and organizations—for us was dress rehearsal," May said of the future-shocked youth scene. With an outsider's vantage point, and having learned to mix records from Atkins, May framed the bedroom studio productions that Atkins had been working on since he was seventeen as the next step for Detroit's progressive music. "Even though we were young, we had serious dedication for what we were doing. That's why Juan [Atkins] called it Deep Space. We always saw ourselves as being 'out there.'"[61]

Around the same time as Atkins was experimenting with homegrown electronic funk, another group from the Black youth counter culture of Detroit, A Number of Names (Paul Lesley, Sterling Jones, and Roderick Simpson), released a remix, and eventually went on to work with the short-lived label Capriccio Records to press a few hundred copies of their own electronically produced Italo disco-influenced track, "Sharevari," in 1981—a tribute to the New York clothing store from which the local party Charivari took its name. With accompanying vocals from Ira Cash and Sheila Wheaton, "Sharevari" was a succinct snapshot of the dance music scene at the time, and the first example of a kind of local, post-disco club music that would later merge with Atkins' Afrofuturist, electronic funk to produce the genre category of Detroit techno.[62]

On July 25, 1981, Detroit experienced the "state of the art" live performance of Kraftwerk's *Computer World* tour at Nitro Rock Club. Three days later, Mark Dighton, the arts editor of the *Michigan Daily*, published a review of the concert, titled "High Priests of High-Tech Living Bring Mission Control to Detroit." Dighton recounted the two-hour, twenty-three-song performance as a testament to digital music that predicts the next stages of the band's evolution: "Kraftwerk are up to some pretty weird games, and I'm not just talking about those synthetic pinball sounds . . . Overhead,

60 Hassan Nurullah, quoted in Sicko, *Techno Rebels*, 32.

61 Ibid., 32.

62 In the following years there would be many debates as to who created the blueprint for Detroit techno, Cybotron or A Number of Names: "All you got to do is look at 'Alleys of Your Mind,'" Atkins explains, "and if you know anything about vinyl, and how vinyl is mastered and pressed, there's an inscription within the inner part of the vinyl, where the person who mastered that record and plated that record puts the date in the vinyl." He points to the inscription on the label of Cybotron's single, saying, "you'll see it says April something [1981], and theirs says October or November, something like that." Juan Atkins, interview by Vanessa Jane Brown, "Techno's Godfather Speaks: An Interview With Juan Atkins," *Reverb*, March 6, 2021, https://reverb.com/news/interview-juan-atkins.

three wide-screen TVs display ambient computer graphics timed to coincide with the polished electronic sounds that bounce from speaker to speaker."[63]

Throughout the article, Dighton describes an audience frozen in shock at the "over-whelming commercial for wholesale mechanization." He remarks, "Kraftwerk seem a little taken aback by this; Ralf Hütter reminds us at one point that the large wooden area where a good portion of the audience is seated is supposed to be a *dance* floor."[64] Still, he could envision the potential of Kraftwerk's calculated beats as the blueprint for the future. "Live, Kraftwerk replace the cerebral, flat sound of their albums with earthquake-like bass and high-hat zaps that can nail your eardrums together . . . But their demeanor did nothing to encourage us to get physically involved with their music; their imperturbable composure could have easily been mistaken for catatonia." Under the subheader, "Music for computer games," Dighton's report of Kraftwerk's public demonstration of the future of audio technology is positive, yet unconvinced by the possibilities of a fully-automated music listening experience. "They even interact-ed with the audience at this point, allowing some of them to contribute to the song . . . Nevertheless, it wasn't until the third and final encore that they really let randomness run rampant as they jammed in a rabidly erratic fashion, occasionally tangling in each others' dissonance, but always able to rely on the prerecorded rhythm tracks to keep them on course." The second hour of the concert gestured at the orchestrated, near animatronic quality of Kraftwerk's studio performance concept. Dighton concludes:

> As they left the stage one by one, their equipment continued to sputter furious-ly syncopated dance rhythms. I remained unconvinced, however. Kraftwerk's ability to wrench qualities like humor, funkiness, passion, and spontaneity out of reluctant little black boxes qualifies them as "musicians" as far as I'm concerned. The fact that their tools are devoid of expressive range per se—and so hardly "instruments" at all, but machines—capable of understanding only on and off, sound and silence—makes their work as musicians doubly impressive . . . No doubt it's a "concept" or something—constructing and then destroying the barriers of alienation, considering technology a toy that ultimately changes the meaning of fun, or some such nonsense. Not only do I find that idea relatively irrelevant to their music, I worry that they may go too far with it. Having already created androids in their own image in order to (yet again) make the point that they are incidental, expendable accessories to their own show, the obvious next step is for Kraftwerk to find some way to replace the audience . . . It's hard to tell whether that would be Kraftwerk's ultimate triumph or their ultimate self-trivialization.[65]

63 Mark Dighton, "High Priests of High-Tech Living Bring Mission Control to Detroit," *Michigan Daily*, July 28, 1981, 7–9.

64 Ibid., 9.

65 Ibid.

Coming from a modernizing postwar Germany, a leading global economy, manufacturing a simultaneously new and retro future with computer technology as a part of its national identity, Kraftwerk operates their machines—both in the studio and during performances—as a statement on the nature and relations between labor and popular culture in the Information Age. The live show was intended to bring onto the stage Kraftwerk's entire studio, which they envisioned to be a laboratory where they could work with their research and technology while also displaying visuals of archival footage and photographic stills. A young Juan Atkins attended the concert, curious to witness Kraftwerk compute in person. "I wasn't 18 yet so I had to borrow an ID from someone in line to get in [laughs]. It was the most exhilarating experience I'd ever had," Atkins reminisces. "It was so different, such a departure from the whole idea of a 'band.' There were no guitars or drums. Just these electric panels."[66] The *Computer World* tour took the man-machine unit around most of the world, including Europe, Australia, India, and Japan, but the seventh city of the United States would leave a lasting impression. "We've been to Detroit several times with our friends, Juan Atkins and Derrick May, visiting some clubs and some locations over the past many years ago," Hütter recalled in 2015. "There's quite a techno connection, Kraftwerk to Detroit. Maybe you know that photograph of the robots in front of the theater—that's the State Theatre in Detroit. The industrial sound of Motor City and Kraftwerk on the autobahn, there's a spiritual connection. Automatic rhythms, robotic work, robotic music—all kinds of fantasies are going on."[67]

Androids and aliens had descended upon Detroit from the future. The bleeding edge events of Kraftwerk's German modernist music technology and Sun Ra's Afrofuturist jazz expressions marked an integral turning point for the city and its neglected music culture industry, left behind by Motown a decade prior. In 1982, George Clinton, a former Motown songwriter and engineer,[68] signed a record deal with Capitol Records for his first solo album, *Computer Games*, backed by the Parliament-Funkadelic band. Plagued by legal and financial troubles due to copyright and royalty agreements, Clinton was eager to experiment in the studio with plans to chart his own contribution

66 Juan Atkins, interview by Hobey Echlin, "Juan Atkins and The Birth of Techno," *The Standard*, n.d., https://www.standardhotels.com/culture/juan-atkins-and-the-birth-of-techno.

67 Ralf Hütter, quoted in Geeta Dayal, "Kraftwerk on Cycling, 3D, 'Spiritual Connection' to Detroit," *Rolling Stone*, August 26, 2015, https://www.rollingstone.com/music/music-news/kraftwerk-on-cycling-3d-spiritual-connection-to-detroit-56548/.

68 Prior to forming the militant techno collective Underground Resistance and the soulful house music band Members of House, Mike Banks worked and toured with George Clinton: "I met my studio guru George Clinton, just sitting around like we do in the lunchroom where we talking. And he give me advice on how to separate the bass drum from the kick drum. Spacial . . . It's one of the battles of mixing, but I also was privileged to see tape looping, . . . and then you got whole industries based on that Detroit invention. George Clinton was a part of inventing tape looping. It was him, I believe Jim Vitti, an engineer, but George Clinton did that. And for all the people that think that George Clinton is kinda like a space cadet, no he ain't. My man knows the mixing board . . . And furthermore, he's very forthright about sharing." Mike Banks, in conversation with Dimitri Hegemann and Carola Stoiber, hosted by Torsten Schmidt, Red Bull Music Academy, Berlin, November 27, 2018, https://www.redbullmusicacademy.com/lectures/mad-mike-banks-tresor-berlin-detroit-lecture.

to the future-music arms race. "The psychedelia in Atkins's music came through his love of George Clinton's Parliament-Funkadelic, which he had seen perform a number of times while growing up," journalist Dan Sicko explains. "In fact, Aaron Atkins believes that his brother picked up his guitar less and less after he heard what Parliament-Funkadelic member Bernie Worrell could do with keyboards."[69] Guided by Detroit session musician David Lee Spradley, Clinton was able to assemble an electronic funk sound that could parallel, if not lapse, the next-generation developments of Cybotron's "Alleys of Your Mind" and Afrika Bambaataa's "Planet Rock."

Computer Games peaked at number 3 on the Billboard R&B/Hip Hop Albums charts with its first single, "Loopzilla,"[70] reaching number 19 on the Billboard R&B charts and number 48 on Billboard Dance Club Songs chart. "Atomic Dog," the second single, became an unlikely hit, topping the US Billboard R&B charts at number 1. "I did the (first) session on January 25th, 1982," remembers Spradley, who had previously worked with the Parliament ensemble on the stereophonic voyage of "The Big Bang Theory" in 1979. "I put down the very first track . . . (using) the Man in the Box [which] was our nickname for a drum machine that would essentially be our click track, 'cause it was more fun to play to some kind of beat than to just a metronome."[71] Two bass lines—designated "A-bass line" and "beat bass line"—produced on Prophet 5 and Minimoog synthesizers, created the structural backbone of "Atomic Dog," supporting a litany of recorded and overdubbed voices provided by Jessica Cleaves, Lige Curry, Ray Davis, Mallia Franklin, Shirley Hayden, Sheila Horne, and Jeannette McGruder, engineered by vocalist and guitarist Garry Shider. "One of the most exciting sessions was the panting and Mallia is the one that started that," Spradley recalled. "She started panting and Garry said, 'Yeah, let's do that.' And we all started panting. We got so dry mouthed it was crazy. Stop the tape. Nobody had any moisture left! That was fun."[72] On top of the chorus, keyboardist Bernie Worrell laid down pitched and oscillatory tones that color the interlocking groove, punctuated by alternating compressed and pumping kick drums. "He did the beautiful synthesizer part that sort of leads in," Spradley says. "I play my little line, he plays his little line and then we both go off into it. It's beautiful."[73] A multitrack doo-wop chorus at the beginning of "Atomic Dog" gives way to Clinton's vocoded voice filling the cybernated funk with libidinal human

69 Sicko, *Techno Rebels*, 44.

70 "Loopzilla" samples "The Breaks" by Kurtis Blow, "I Can't Help Myself (Sugar Pie, Honey Bunch)" by The Four Tops, and "Dancing in the Street" by Martha Reeves & The Vandellas (who auditioned George Clinton for his position at Motown). The song also interpolates "Planet Rock" by Afrika Bambaataa & Soulsonic Force, "More Bounce to the Ounce" by Zapp, "One Nation Under a Groove" by Funkadelic, and "(Not Just) Knee Deep" by Funkadelic.

71 David Lee Spradley, quoted in Melissa A. Weber, "The Empire Strikes Back: 'Atomic Dog' and the Rebirth of Parliament-Funkadelic in the Early 1980s," *Red Bull Music Academy Daily*, May 22, 2019, https://daily.redbullmusicacademy.com/2019/05/atomic-dog-p-funk-rebirth.

72 Ibid.

73 Ibid.

vigor, narrating, "Yeah, this is the story of a famous dog, about a dog that chases its tail…" Clinton remembers the word "dog" was stuck in his mind after Ted Currier, an early New York disco DJ on WBLS and the head of Black Music A&R at Capitol Records, suggested that he save the title "Atomic Dog" when he signed him.[74] Clinton says, "That's all I had in my mind. I had to ad lib a lot of it. The track was atomic. It's a futurist track… I don't still hear no tracks like that one."[75]

The stilted industrial regimentation of creativity and culture envisioned by the post-war and pre-unification periods of German society defined Kraftwerk's understanding of machines and their purpose as an agent of nationalism in the Cold War era. Alternatively, the contemporary examples of Cybotron and Afrika Bambaataa imply a progression of the human creativity of Sun Ra's Arkestra and George Clinton's "Mothership Connection" that signify possibility, during a time of both economic recession and postindustrialization. A few months ahead of *Computer Games* hitting shelves and "Atomic Dog" traversing airwaves, The Gap Band—a group made up of brothers Charlie, Ronnie, and Robert Wilson—released their sixth album of ensemble funk music, *The Gap Band IV*, on May 17, 1982; it peaked at number 1 on the Billboard Black Albums chart and 14 on the Pop Albums chart. Named after the acronym for streets in their hometown (Greenwood, Archer, and Pine) that were bombed by a white mob who were given weapons and airplanes by local police during the 1921 Tulsa race massacre,[76] the band's second single, "You Dropped a Bomb on Me," landed in August 1982, earning the number 2 spot on the Billboard Black Singles while also transmitting a lost history of racial terrorism in America. "We knew we were going to go all over the world—at least I did," Charlie Wilson remarked candidly. "People

74 Ibid.

75 George Clinton, "George Clinton, Still Radiating the Funk," NPR, November 20, 2006, https://www.npr.org/2006/11/20/6505058/george-clinton-still-radiating-the-funk.

76 "The Tulsa Race Riot and Three of Its Victims," a ten-page manuscript written by Oklahoma attorney Buck Colbert Franklin, recounts details of the massacre: "I now knew the mob-spirit. I knew too that government and law and order has broken down. I knew that mob law had been substituted in all its fiendishness and barbarity. I knew that the mobbist cared nothing about the written law and the constitution and I also now knew that he had neither the patience nor the intelligence to distinguish between the good and the bad, the law abiding and the lawless in my race. From my office window, I could see planes circling in mid-air. They grew in number and hummed, darted and dipped low. I could hear something like hail falling upon the top of my office building. Down East Archer, I saw the old Mid-Way hotel on fire, burning from its top, and then another and another and another building began to burn from the top. 'What, an attack in the air too?,' I asked myself. Lurid flames roared and belched and licked their forked tongues in the air. Smoke ascended from the sky in thick, black volumes and amid it all, the planes—now a dozen or more in number—still hummed and darted here and there with the agility of natural birds of the air. Then a filling station farther down Easy Archer caught on fire from the top. I feared now an explosion and decided to try and move to safer quarters. I came out of my office, locked the door and descended to the foot of the steps. The side-walks were literally covered with burning turpentine balls. I knew all too well where they came from and I knew all too well why every burning building first caught from the top.I paused and waited for an opportune time to escape. 'Where,oh where is our splendid fire department with its half dozen stations?,' I asked myself. 'Is the city in conspiracy with the mob?,' I again asked myself." Buck Colbert Franklin, "The Tulsa Race Riot and Three of Its Victims" (1931), 6–7, https://edan.si.edu/transcription/pdf_files/37850.pdf.

were just kinda lookin' at us like, 'Are you sure? I've never heard this story before.'"[77] Wilson maintains that the bomb referenced in the song is "one of love."[78] He also recounts learning of the massacre from Lucille Figures, an elder of the community who survived the attacks. "She told me a lot of things, but she made me promise, 'Don't ever speak about what I told you until I'm gone.'"[79]

Using early synthesizer and rhythm machine technology that could mimic the sound of a bomb descending from an aircraft in the sky, in conjunction with the fully human, multi-instrumentalist band format of the '70s funk aesthetic, The Gap Band exploded the boundaries of popular music with rhythm & blues that carries the trauma of the past into the computerized future. Also in 1982, the vocoded synthesizer soul of Zapp & Roger, on their album *Zapp II*, reached number 25 on the US Billboard 200 chart and enjoyed the number 2 position on the US Billboard R&B chart a few months prior. Three singles from the album—"Doo Wa Ditty (Blow That Thing)," "A Touch of Jazz (Playin' Kinda Ruff Part II)," "Dance Floor"—successively topped the charts. In New York, Grandmaster Flash and the Furious Five's album *The Message*, released in October 1982, contributed to early conceptions of hip hop with their single "The Message" and electro with "Scorpio," accelerating funk, boogie, and call-and-response rapping with electronic drum programming and turntable sampling techniques. A month prior, Sun Ra and his Arkestra recorded the extended piano and double-bass-led jazz song "Nuclear War" at Variety Recording Studios in New York, featuring rap-adjacent oration from Sun Ra himself that recalls the woeful downtempo bebop of Charles Mingus' "Oh Lord Don't Let Them Drop That Atomic Bomb on Me" (1962).

Partying through the apocalypse became a frequent theme during the early 1980s as Black musicians and bands were dealing with a sense of impending doom, a little over a decade after integration. After releasing the hit albums *Dirty Mind* (1980) and *Controversy* (1981), Prince, a 23-year-old virtuosic musician who had made a name for himself as a controversial and sexually expressive figure in a largely conservative music industry, began to work with a Linn LM-1 drum computer, which he would route and transform through guitar pedals to create a customizable mobile studio unit that allowed him to combined the rock, disco, and funk of the '70s into a malleable and processed uproar at the end of the world. "My goal is to excite and to provoke on every level.... The most important thing is to be true to yourself, but I also like danger. That's what is missing from pop music today," Prince says in a rare interview

77 Charlie Wilson, quoted in Alex Noble, "Tulsa Race Massacre: How The Gap Band Was a Tribute to the Former 'Black Wall Street,'" *Yahoo*, May 27, 2021, https://www.yahoo.com/entertainment/tulsa-race-massacre-gap-band-010242782.html.

78 Charlie Wilson, quoted in Jimmie Tramel, "The Gap Band's Charlie Wilson Talks About Race Massacre, 'You Dropped a Bomb on Me' in ABC podcast," *Tulsa World*, April 6, 2021, https://tulsaworld.com/entertainment/the-gap-bands-charlie-wilson-talks-about-race-massacre-you-dropped-a-bomb-on-me/article_820506fa-96fd-11eb-9c2f-bf3fe9323f46.html.

79 Ibid.

in the *Los Angeles Times*.[80] "Don't worry, I won't hurt you / I only want you to have some fun," a voice distorted in metallic sludge sluggishly warns at the beginning of the album *1999* (1982) and its titular radio single. Draped over the cyber-sexual percussive synths and guitar licks are lyrics that translate fears of communal death due to the quickening pace of technological growth: "I was dreamin' when I wrote this / Forgive me if it goes astray / But when I woke up this mornin' / Could've sworn it was judgment day / The sky was all purple, there were people runnin' everywhere / Tryin' to run from the destruction / You know I didn't even care / Say say two thousand zero zero party over, oops, out of time / So tonight I'm gonna party like it's nineteen ninety-nine." In the second verse, quickly inscribing and translating a prophetic dream, the lyrics impart, "But life is just a party and parties weren't meant to last / War is all around us, my mind says prepare to fight / So if I gotta die I'm gonna listen to my body tonight." At the end of the song, an incidental bystander asks the lingering question: "Mommy, "Why does everybody have a bomb?""[81]

From November 30 to December 3, 1982, Prince performed sold-out shows at the Masonic Temple Auditorium in Detroit with support from two of his bands Vanity 6 (Vanity, Brenda Bennett, and Susan Moonsie) and The Time (Morris Day, Jimmy Jam and Terry Lewis, Anton (Tony) Johnson, David Eiland, Jellybean Johnson, Monte Moir, Jerome Benton, and Jesse Johnson). Early the next year, "Little Red Corvette," the second single from *1999*—with its lyrical double entendre blending the imagery of the freedom of driving a sports convertible with the act of being enthralled in casual sex—received considerable airplay.[82] The song, a crossover hit reaching both Black and white listeners almost equally, widened Prince's own consumer demographic. It was dethroned on a local Detroit radio station chart by Cybotron's "Cosmic Cars," which trades cyber-sensuality with a space-age sonic fiction. As Atkins recalled, the AM radio station WCSB had a chart that determined "the top records in the city, and then would go to the whole industry." He explained that the charts dictated which songs and albums were stocked and sold in record stores. "It was one of the things that let me know that we had been kind of successful. . . . I was surprised that we didn't get bumped because of some politics. So I was surprised that something like it was true to what was happening in the streets chart," he adds. "Of course if you're a record company like Warner Brothers . . . how do you spend a million dollars in promotion and you go into a market and there's a local group that's No. 1 ahead of your group . . . ?"[83]

80 Prince, quoted by Robert Hillman, "The Renegade Prince," *Los Angeles Times*, November 21, 1982, https://sites.google.com/site/prninterviews/home/los-angeles-times-21-november-1982.

81 Prince, lyrics, "1999," *1999* (Warner Bros. Records, 1982).

82 "'Little Red Corvette' is actually a 1964 Mercury Montclair Marauder. Prince helped her buy it at auction in 1980 in Minneapolis. Lisa still owns the car. (Although, we need to restore it.) It's still essentially original... Prince even gave it a few dents." Lisa Coleman, quoted in Jason Torchinsky, "Everybody Was Wrong About the Car That Inspired Prince's 'Little Red Corvette,'" *Jalopnik*, April 25, 2016, https://jalopnik.com/everybody-was-wrong-about-the-car-that-inspired-princes-1772882304.

83 Atkins, interview by Brown.

Bringing together many of the varying strains of Afrofuturist electronic ensemble music coming from many different regions and perspectives of a Black nation within a nation, Cybotron's debut album *Enter* (1983) and its lead single "Clear" forged a path into the far future, beyond racial capitalism and beyond the binary of the human versus the machine. "That was basically the concept behind the whole album," Atkins reflects. "Clear out the old program," and push society towards a "technological revolution."[84]

<div align="center">*</div>

Through a confluence of radio shows programmed by Detroit DJs The Electrifying Mojo, Ken Collier, Duane "In the Mix" Bradley, Jeff Mills as The Wizard, and Farley "Jackmaster" Funk, the art of mixing with turntables and vinyl records, as well as the electronic sound of Detroit, quickly spread across the Midwest. In New York, Grandmaster Flash and the Furious Five were leading a new wave of electronic funk, followed a few years later in the decade by Newcleus, Mantronix, and The Soulsonic Force with Afrika Bambaataa. Having relocated from New York City to Chicago in the late 1970s, Franklie Knuckles was already rerecording and modifying tracks in music studios to fit his DJ sets, cutting up and editing tape reels to shorten or extend parts of a song and make it easier to mix in real time—the key to maintaining momentum on the dance floor:

> Things happen for whatever reason they do, but you wake up, it's five years later, I've got to make a decision about what I'm doing. And before I know it, I'm in Chicago, we open up the Warehouse, I've got a piece of the business, I'm 20 years old and I'm just having a good time. That's the only thing I was concerned about, having a good time and showing everybody a good time. A few years later, I reached a point where I have to think about the next logical step in this. You're having a great time playing records and showing everybody a good time, but what's the next logical step? How long can you continue to do this? That's when I began to think about production.[85]

Beginning with a simple metronomic rhythm-maker, Knuckles was able to produce beats for every measure of his redesigned songs, but he wouldn't get a proper drum machine until 1984, after leaving the Warehouse and playing at Power Plant. May called Knuckles from Detroit to tell him that he had two TR-909s:

> Derrick May and his friends would come down to my new club, the Power Plant.

84 Juan Atkins, interview by Dave Tompkins, "The Things They Buried: On Cybotron's Embattled Techno Sci-Fi Masterpiece, 'Enter,'" *SPIN*, October 30, 2013, https://www.spin.com/2013/10/cybotron-clear-reissue-dave-tompkins-sci-fi-techno/.

85 Knuckles, lecture, hosted by Jeff "Chairman" Mao.

One night he was carrying a bag, and inside was something wrapped in a towel. I asked him what it was and he just said, "Oh, I got you something very special—but you got to wait till the end of the night." After I finished my set—which was about 11 a.m. the next day—we went into the booth and he pulled out a box with some buttons on it. I said, "Wow! That looks great, but what the hell is it?" Derrick said, "This is a Roland 909 drum machine, and it's going to take us to the future. It will be the foundation of music for the next 10 years."[86]

Knuckles took the drum machine home and started to play. Using his ears and natural rhythm to synthesize and compose beats, he immediately felt a jolt into the future: "After a few days programming, I took it into the club and wired it up to the mixer. Let me tell you, every record I played that night had a 909 running underneath it. I loved that machine! Sometimes I'd just leave it running by itself, just so I could hear those kick drums. I think the crowd were pretty much sick of it by the end of the night, but I couldn't get enough. It just made sense to me."[87]

Knuckles started using his new TR-909 while spinning at the Power Plant, and eventually people began to sing over the beats. Irwin Larry Eberhart II, who performs as Chip E and worked at the record store Importes, Etc., also got his hands on a TR-909, promptly releasing six records between 1985 and 1988, including minimalist productions like his first extended-play release, *Jack Trax*, with the lead single "Time to Jack" and songs like "It's House" and "House Energy," through House of Mirage and D.J. International Records, in 1987.[88] Knuckles and Bryan Walton—a Chicago native also known as Jamie Principle—collaborated throughout the 1980s, after being introduced in the club scene by their mutual friend Jose "Louie" Gomez. Together, they produced numerous hits, like "Baby Wants to Ride" and "Bad Boy." With Jamie Principle filling entire notebooks with lyrics edited down to be sung over Knuckles' beats, the two were able to produce crossover pop songs that worked both for the dance floor and as radio-friendly ear candy. Most famous was their 1986 song "Your Love," written by Jamie Principle as a love poem to a woman named Lisa after he decided that he would forgo dating to focus on his music. The song was recorded with uncredited backing vocals by Adrienne Jette, who had also featured on Ron Hardy's "Sensations," an 1985 12-inch for Trax Records. On "Your Love," her voice played as an anonymous counterbalance to Principle's lovelorn New Wave-style crooning,

86 Frankie Knuckles, interview by Computer Music Specials, "Frankie Knuckles Talks the Birth of House Music," *Music Radar*, February 28, 2012, https://www.musicradar.com/news/tech/interview-frankie-knuckles-talks-the-birth-of-house-music-531865.

87 Ibid.

88 Irwin "Chip E" Eberhart, interview by Bill Brewster and Frank Broughton, "Time to Jack: Chip E on the Birth of Chicago House," originally published on DJhistory.com, May 2005, republished in *Red Bull Music Academy Daily*, January 8, 2019, https://daily.redbullmusicacademy.com/2019/01/chip-e-interview/.

which an engineer friend of Principle's captured using a reel-to-reel recorder, manually stitching the parts together and turning them over to Knuckles, who made his own edits using his TR-909 for the first time with Principle's instruments and studio space, extending the song into an almost eight-minute house track.[89]

"Your Love" spawned many imitations, including Jesse Saunders' 1983 megamix "On and On," which became one of the first beat-based house music tracks and combined many loops from varying disco and funk songs alongside a Roland TR-808, a Korg Poly-61 synthesizer, and a Roland TB-303 bass synthesizer. The first big mainstream hit to surface from the Chicago house music scene was "Music Is the Key" by J.M. Silk (Steve "Silk" Hurley and Keith Nunnally), which sold 85,000 copies domestically. It was followed in 1986 by a cover of Isaac Hayes' "I Can't Turn Around" that reached number 1 on the Billboard Dance charts. Hurley's roommate, Farley Keith Williams (or Farley "Jackmaster" Funk), produced parts of "I Can't Turn Around"; he then decided to rework the frame of the song into his own version, called "Love Can't Turn Around," with new lyrics by Vince Lawrence, a dance music producer and businessman who exposed many artists from the Chicago house music scene to a wider mainstream audience, and new vocals by Darryl Pandy, a multi-octave gospel and opera-trained Broadway singer. "Love Can't Turn Around" reached number 15 on the US Dance chart and number 10 on the UK Top 75 charts, spurring Hurley's "I Can't Turn Around" to peak at number 62 in the UK. As a DJ, Hurley became known for his unconventional turntablist techniques that blended hip hop tropes like scratching, cutting, and back spinning with the metronomic beat, a mix of styles developed within the framework of Chicago house music. Appearing weekly on the *Saturday Night Live Ain't No Jive Dance Party* show on radio station WBMX, Hurley wove technical sounds well into the 1980s. In 1987, J.M. Silk signed to RCA/London Records and scored a number 1 hit on the UK Singles chart with "Jack Your Body." The compilation *Work It Out*, which featured vocals and contributions from Jamie Principle, Charisse "Risse" Cobb, Sampson "Butch" Moore as Jackson & Moore, and Marc "M. Doc" Williams, came out on Atlantic Records in 1989, produced and mixed by Steve Hurley. *Work It Out*'s eponymous lead single was released with an extended remix radio edit, as well as acid house and dub versions of the track, soaring to number 3 on the US Billboard Hot Dance Music/Club Play charts.

Pivoting off of the momentum started by Jesse Saunders' house music classic, Steve Poindexter, a young producer who started DJing parties at Mendel High School in the mid-'70s, when he was just ten years old, and his cousin, John Hunt, began to transfer their beat matching skills to drum machines. Poindexter's percussive ability came naturally, picking up on his parents' experiences as professional musicians—his father had been a drummer in Duke Ellington's jazz orchestra while his mother was a backing vocalist for Mahalia Jackson, "The Queen of Gospel." Poindexter's first track

89 Brewster and Broughton, *Last Night a DJ Saved My Life*, 326–29.

"Work That Mutha Fucker," constructed on a Casio RZ-1 drum machine and featuring his own voice filtered and looped through a guitar pedal and sampler, instructing both him and the listener to "work that mother fucker," reiterated an animistic quality that is inherent in Black music, and which has a tendency to reach inside of objects and make them talk, speak, and shout. "I was just sitting down, just beating the track... and the track messed up, and I was like, 'Oh, this motherfucker!'" Poindexter explained in 2014, describing his freehand approach to rhythm synthesizers. "It wasn't right, so I started tweaking the voice a little bit with the knobs on the DOD [guitar pedal] until I got my voice like I wanted it to sound. Everybody thought that was a sample voice, but that actually is my voice. I just filtered it just a little bit. We was just messing with what we had, not knowing down the line that what we had would be historical, just go blow up like that."[90] "Work That Mutha Fucker" was a unique hit on the dance floor, adding more of a raw edge to the Chicago house sound that would eventually morph into the ghetto house sub-genre and scene of the '90s. Knuckles even played the track as a sonic stimulant during his DJ sets at Power Plant. Poindexter joined the group Chicago Bad Boys, composed of Brian Harris and Terry Hunter, which soon grew into a forty-unit electronic dance music production team. "Work That Mutha Fucker" eventually got a release in 1989 on Poindexter's debut EP of the same name through Warehouse Records, a label run by Armando Gallop—a former star baseball player who switched to DJing dance music after a spinal injury. Gallop launched Warehouse Records shortly after successfully putting out "Land of Confusion" on Westbrook Records in 1987—an international hit that served as an early influence for the imitation and emergence of Chicago house music in Britain in the 1990s. "Computer Madness," the second track on Poindexter's EP, had a similarly resourceful backstory, akin to that of DJ Spanky and Pierre Jones' "Acid Tracks," with its incidental invention and adaption of the glitched acid line that could be ripped out of TR-303 Bass synthesizers a few years earlier, in 1987. Poindexter explained:

> On "Computer Madness" I was tweaking, playing the drum machine, but I was moving stuff. I was trying to change the filter sounds. Wes [Green], my partner, he came in, he's like, "OK, while you're playing that, I'll just tweak the keyboard sound." So we tweaked the sounds, and we got them just how I wanted it, and I was like, "This is it—computer madness!" It just sounded like something that was out of the future.[91]

Working with his friend Wes Green in a shared basement studio, Poindexter stayed up through the night extracting novel sounds from a small Roland TR-505 configuration and Kawai and Casio CZ-101 drum machines, paired with Casio and Sony keyboards. Using a station similar to that of multi-instrumentalist Don Lewis—who innovated

90 Steve Poindexter, quoted in Jacob Arnold, "That Raw Basement Sound," *Resident Advisor*, September 12, 2014, https://ra.co/features/2304.

91 Ibid.

the format of connecting electronic drum machines and keyboards together to work in tandem—but scaled down to a few pieces of essential gear, Poindexter was able to infer and withdraw a distinctive sound of his own, which he would continue to develop throughout the '90s, releasing *Chaotic Nation* in 1991 and *Man at Work* in 1996.

<p style="text-align:center">*</p>

Somewhat oblivious to the house music scene that was gaining commercial traction, a fifteen-year-old Larry Heard worked night shifts a few blocks away from the Warehouse, intrigued but unbothered by the crowd of people that frequently formed outside of it. Sonically, Heard's interests were elsewhere. Having picked up playing the drums in 1977 after playing guitar and bass, Heard jumped from band to band, seeking out a sound influenced by progressive rock groups like Yes, Genesis, and King Crimson—sounds that he could extend to jazz and Motown. Thinking of himself as an improvisational musician, while not necessarily fitting in within the standard rock band ensemble format, Heard presumably wanted to put his piano skills to use; as a child he would mimic and transpose music from the television and radio, blending sounds and generating patterns from them. Around 1984, Heard decided to scale his ideas down into a singular unit of interconnected electronic equipment that could open up new methods of communicative expression in his own audio world. "The last band I was in, I guess it wasn't really customary for the drummer to have musical ideas," Heard noted in 2018, describing feeling physically confined by the idea of having to play drums and keyboard by himself to produce the sound that he was looking to create. "I ended up having to buy my own synthesizer, and then buy a drum machine to keep the time, since I wasn't gonna be able to hold the sticks and do the keyboard part."[92] Having purchased a Roland TR-707 and Roland Jupiter 6, Heard could begin his experiments with computer-generated audio, feeling out where and how to place soul into the machine.

The 1985 track "Mystery of Love," one of Heard's first productions under the name Mr. Fingers, garnered a lot of attention. A friend compared his sound to the type of house music Knuckles and Ron Hardy had been crafting at the Warehouse before they moved on to residencies at Power Plant and Music Box that same year. The track quickly ended up in both of their DJs sets. Heard saw the two founding DJs of house music taking ownership of his track as a kind of compliment; he would later share his observations and admiration for them, noting that Knuckles' style was good music for socializing, while Ron Hardy's DJing was more energetic for a younger, more flexible crowd. As for the reception of his track "Mystery of Love," he remarked:

> [T]he reactions were great. They were actually so great, that it was to the point

92 Larry Heard, lecture, hosted by Chal Ravens, Red Bull Music Academy, Moscow, 2018, https://www.redbullmusicacademy.com/lectures/larry-heard-2018.

that Ron Hardy claimed that he made the song, and Frankie Knuckles claimed that he made the song (*laughter*). And I kind of show up on the scene and kind of spoil everything for both of them, when people who knew me saying this was the guy who made the "Mystery of Love" track. So, that kind of put a little tension in the relationship between myself and Frankie and Ron Hardy. Not from my perspective, but I think they maybe always felt like I would harbor some resentment for that, but to me it was more of a compliment. I mean, who would claim something that they feel is crap? So it confirmed for me that I was at something, that I was onto something that people could relate to.[93]

"Mystery of Love" was re-recorded in a studio as "Mysteries of Love" the following year by the group Fingers Inc. with singer Robert Owens, and released on the album *Another Side* (1988). The second version of the track felt more "rehearsed" to Heard, but with vocals included, "Mysteries of Love" was able to reach number 10 on the Billboard Dance charts. London Records compiled the track alongside Steve "Silk" Hurley, Chip E, Farley "Jackmaster" Funk, and Marshall Jefferson on the compilation album *The House Sound of Chicago*, which preceded the introductory *Techno! The New Dance Sound of Detroit* compilation by two years, giving house music and the city of Chicago a head start and competitive advantage in spreading its sound around the world. *Techno!* was even almost called *The House Sound of Detroit*, despite Detroit's progressive music scene and Juan Atkins' commercial success with the group Cybotron in the early '80s. Stuart Cosgrove wrote the introductory liner notes to both *Techno!* and *The House Sound of Chicago*, along with an August 1986 article for *New Music Express* (*NME*) called "The DJs They Couldn't Hang." Cosgrove posited that house was not a fad, but a traditional music born out of the church, emphasizing the influence of Reverend Thomas Lee Barnett Jr.,[94] a local pastor at Life Center Church of Universal Awareness on Chicago's Southside, who recorded albums with his Youth Choir for Christ. From there, Cosgrove drew a connection between Southern gospel, soul, and house, peppering in his own interest in the usual suspects of British New Wave and Europop. Farley "Jackmaster" Funk is quoted saying: "House music is the modern sound of Chicago made by DJs and local singers using the most up-to-date studio techniques. It's a club sound: dub, sampling, cross-fading and jacking the house."[95] Marshall Jefferson is also quoted, adding: "House is old style music like

93 Larry Heard, lecture, hosted by Gerd Janson, Red Bull Music Academy, Seattle, 2005, https://www.redbullmusicacademy.com/lectures/larry-heard-fingers-inc-lecture.

94 "To get to the roots of House you have to visit the Life Center Church Of Universal Awareness on Indiana Avenue, where Chicago's most versatile preacher, The Rev T.L. Barrett Jr. teases his congregation with Luther Vandross impersonations, blue jokes, tales of bright red Porches, and sexually explicit sermon, 'what exactly was Lazarus trying to raise?' One of the House scene's best vocalists, Darryl Pandy, a classically trained opera singer who's the featured voice on Farley Jackmaster Funk's 'Love Can't Turn Around,' and several minor House musicians are to be found in the church choir. But the pastor can never be upstaged, he has released his own gospel records, which by a strange irony are used by a young Chicago DJ Tyree Cooper who mixes at house parties on Chicago's South Side." Stuart Cosgrove, "The DJ's They Couldn't Hang," *New Music Express*, August 1986, 13.

95 Farley "Jackmaster" Funk, quoted in ibid., 14.

Harold Melvin and the O'Jays. Don't let them tell you it's a new synthesized sound, it's real instruments and a voice."[96] The next year, vocalist Chuck Roberts from the group Rhythm Controll preached a similar message in a gospel-infused *My House* EP:

> In the beginning, there was Jack, and Jack had a groove. And from this groove came the groove of all grooves. And while one day viciously throwing down on his box, Jack boldly declared, "Let there be HOUSE!" And house music was born. "I am, you see, I am The creator, and this is my house! And, in my house there is ONLY house music. But, I am not so selfish because once you enter my house it then becomes OUR house and OUR house music!" And, you see, no one man owns house because house music is a universal language, spoken and understood by all. You see, house is a feeling that no one can understand really unless you're deep into the vibe of house. House is an uncontrollable desire to jack your body. And, as I told you before, this is our house and our house music.[97]

In 1988, Fingers Inc. released their debut album *Another Side*, adding vocalist Ron Wilson to the group; Heard produced the music, handling keyboard and drum programming on top of background vocals. Owens moved to New York soon after, later signing to the UK record label 4th & Broadway Records and releasing a solo album, *Rhythms in Me*, in 1990. In 1989, Trax Records compiled productions from Heard onto an album called *Amnesia*, without obtaining Heard's permission—a considerably different act of profiteering off of Heard's work than what Frankie Knuckles and Ron Hardy had committed when they claimed his tracks as their own during their DJ sets; DJs promote music, whereas record labels distribute music and income with an artist and their copyrighted material. Trax Records was started in 1984 by Larry Sherman, a former Vietnam veteran.[98] The other Chicago electronic music label, D.J. International Records, was started by Rick Jones the next year, in what could be seen as a split effort to quickly profit from the recorded works of young amateur musicians in a local, independently owned and run industry. In 2020, Heard and Owens filed federal copyright infringement lawsuit against Trax, accusing the label of "building its catalog by taking advantage of unsophisticated but creative house music artists and songwriters by having them sign away their copyrights to their musical works for paltry amounts of money up front and promises of continued royalties throughout the

96 Ibid.

97 Rhythm Controll, lyrics, "My House," *My House* (Catch a Beat Records, 1987).

98 "The key to Sherman's success was the fact that he not only owned the city's most profitable house label, he owned the only record-pressing plant in Chicago. Even if you ran your own label, you still had to pay Larry Sherman to make your records. And as people found out, there was nothing stopping him from making some more copies that you didn't know about and selling them himself." Brewster and Broughton, *Last Night a DJ Saved My Life*, 333–34.

life of the copyright."[99] That same year, Adonis posted on his Facebook page:

> Do not buy or support Trax Records! Because this label has not paid me one penny in 34 years. Trax Records do not own any rights to my music. Please share this post everywhere. Also tell all distributors to not sell this record or any other of my songs from this horrible label. Enough is enough.[100]

Introduction, Heard's proper debut album as Mr. Fingers, arrived in 1992 through Music Corporation of America (MCA), a talent agency which recruited Heard after he contributed production work on *From the Mind of Lil' Louis*, a major label debut for the DJ and producer who had been a staple of the Chicago scene since the mid-'70s. The first single from *Introduction*, "What About This Love?" was a creative milestone for Heard, the first track on which he sang lead vocals. "David Hollister was the one who was planned to sing the song, but he didn't show up at the studio that day and so I just ended up laying down a rough vocal track, so I could remember the basic melody I had thought of for the lyrics, and pretty much everybody that was present at the studio that day was saying that they liked what I had done and thought I should probably keep it that way," Heard recalled. "To my good fortune I took their advice and we actually released this as a single, even before the MCA deal, because this was done."[101] Heard soon left his major record label backing, to avoid feeling like an employee of the music industry—he was already employed full-time at the Social Security Administration. At the tail end of the '80s, Heard began to release more self-reflective and exploratory styles of electronic music—under his own name and many aliases—that veered into Detroit techno futurism (his 1990 release under the name Gherkin Jerks), or ambient (the 1994 and 1995 releases *New Age* and *Sceneries Not Songs*, volumes one and two; the 1996 *Alien*; the 1999 *Genesis*; and the gospel and R&B inflected *Love's Arrival* in 2001). Heard wouldn't return to his Mr. Fingers moniker until 2016, when he released the *Outer Acid* EP, following in 2018 by *Cerebral Hemispheres*, an album that brought together three decades of tracks that Heard described as "seasons" of his creative development.

At the same time that Heard began producing his first tracks, Michael E. Smith—a former bandmate of his—began to make electronic music as well, under the name Adonis. As a child, growing up on the West Side of Chicago, Smith taught himself how to play the bass guitar. Over time, he learned to play keyboard, drums, and

99 Larry Heard and Robert Owens, quoted in Claudia Rosenbaum, "Trax Records Hit With Federal Copyright Infringement Lawsuit Over Royalties," *Billboard*, June 25, 2020, https://www.billboard.com/articles/news/9409421/trax-records-federal-copyright-infringement-lawsuit-over-royalties/.

100 "I would say not one artist ever received any royalties. If anyone can find an official income statement I would love to see it because I've never seen one myself." Adonis, quoted in Marissa Cetin, "Fundraiser Aims to Pay Adonis's Never-Seen Royalties for Trax Records Releases," *Resident Advisor*, June 5, 2020, https://ra.co/news/72781.

101 Heard, lecture, hosted by Janson.

vocals and learned formal music composition, which he studied more intently in the jazz ensemble and orchestra structure at Chicago's American Conservatory of Music. In 1984, Smith began recording post-disco and boogie music as part of the band Clockwork with Jesus Wayne, who produced electronic funk on his own as Handsome Wayne. Like Heard and Poindexter, Smith caught wind of the formation of a resounding and defining spirit sweeping across Black inner-city communities and spurring the emergence of house music in Chicago and techno music in Detroit. Smith wanted to create a bolder listening experience than the beat-oriented tracks he had been hearing in circulation on the radio and in nightclubs; he sought to create a fuller auditory experience using electronic instruments, approaching the TB-303 and TR-909 rhythm synthesizers as compositional tools from which to extract a more concentrated version of the sharp glitch and squelch uncovered by the acid house duo Phuture in 1985. Smith, as Adonis, soon became a leading voice in the house music movement. His first single, "No Way Back," was released independently in 1986, selling 100,000 copies, even as he confessed in the lyrics: "I sold my soul, I lost control." over tight, percussive patterns. At the same time, the economic strain of the Reagan administration—coupled with the by-then widespread crack cocaine and AIDS/HIV epidemics—put insurmountable pressure on urban Black communities.[102] Phuture's Pierre Jones explained that he thought his track was called acid because of acid jazz: "I tend to have a very innocent way of looking at things, like sometimes things will go right over my head."[103] He understood that the 303 made a "gritty sound," but he didn't necessarily catch on to the term's connection to LSD-usage in the club:

> I was never exposed to drugs, I don't drink, I don't do any of that stuff, you know. So, I didn't think of it as a drug. I didn't even know there was a drug called acid. So, when I heard why it was really called that, I immediately wrote a track called "Your Only Friend," to put on that same record, to kind of dispel the fact that Phuture is in support of the drug culture like that. I know you've heard that song, it went, *I can make you cry for me, I can make you fight for me, I'll make you steal for me, I can make you kill for me, and in the end I can be your only friend.* Basically I was saying, listen, you're doing this stuff and eventually your life will be torn down and all you'll have is yourself and that drug. At the end of that song, I go, *Take a whiff of me you'll feel high, take a sniff of me, you'll feel fine, a shot of me, I'll make you fly, too much of me, I'll make you die.* I was just trying to explain something. But it didn't even get across like that, people

102 "Between 1984 and 1989, crack was associated with a doubling of homicides of Black males aged 14 to 17. By the year 2000, the correlation between crack cocaine and violence faded amid waning profits from street sales." Aaron Morrison, "50-Year War on Drugs Imprisoned Millions of Black Americans," *AP News*, June 23, 2021, https://apnews.com/article/war-on-drugs-75e61c224de3a394235df80de7d70b70.

103 DJ Pierre, quoted in Ruth Saxelby, "Back to the Phuture: DJ Pierre on Inventing Acid and Why EDM Fans Need to Learn Their History," *The Fader*, August 4, 2014, https://www.thefader.com/2014/08/04/back-to-the-phuture-dj-pierre-on-inventing-acid-and-why-edm-fans-need-to-learn-their-history.

literally, in Chicago, would go get their drugs when that song came on. And I was thinking, Oh crap, you guys, I'm trying to tell you something.[104]

In November 1989, two months after members of ACT UP (the AIDS Coalition to Unleash Power, founded in March 1987) chained themselves inside of the New York Stock Exchange to protest the inflated pricing of the AIDS medication AZT, writer and DJ Robert T. Ford, alongside Trent Adkins and Lawrence Warren, self-published the first issue of *THING* magazine, with the motto "She Knows Who She Is." *THING*, published from 1989 to 1993, documented LGBTQ+ and nightlife culture in Chicago, with editorial features and fiction submitted by individual contributors. In his previous magazine project, *Think Ink*, Ford had aspired to embrace an emergent intersectional counter culture, as the turbulent second half of the twentieth century accelerated from the Black Power and Black Arts Movements into a broader chosen community, bonded by the excesses of an integrationist post-soul aesthetic. In *Think Ink*'s two issues, published in 1987, Ford drew from the repertoire of artists at Rose Records, where he worked, to feature artists from the house music scene: he included "best of" lists, reviews, and a music column edited by Andre Halmon titled "Real Estate," as well as style and lifestyle editorials. In the second issue of *Think Ink*, common terminology and cultural slang was defined and contextualized by Trent Adkins in a "Tee Glossary," which archived the language of Chicago nightlife, counter-cultural music, fashion, and art. *THING*'s second issue, "Whose House Is it Anyway?," presented a survey of the rise of house music from queer underground Chicago and New York club spaces, with a cover image of Little Richard, alluding to the singer's significance as an early example of a Black queer icon crossing over into the music industry.

In an article titled "Acid Soup," Chris Nazuka of the acid house trio Symbols and Instruments reminisced about his first time tripping on LSD while dancing at Music Box, noting that "this music is only about the intoxication, the trip is the destination."[105] In another article, *THING* interviewed the deep house DJ Riley Evans about the Chicago nightlife scene and his complex infusion of gospel and classical music tropes into house music. "Music shouldn't just be the same thing over and over and not really say much of anything; it should take the person somewhere,"[106] Evans declared, recounting his personal fascination with long-form songs like "Love in C Minor" by Cerrone, a fifteen-minute disco suite with a salacious voiceover intro describing a group of friends making eyes with a man across a bar, in search of an intimate connection. As Evans lost many dance musicians and friends to the AIDS epidemic, he recalled feeling a tightened sense of community among all of the loss. In 1992, Terry Martin, who frequently contributed music writing to *THING*, started *Crossfade* with Robert Ford as co-publisher, a music magazine marking the overlap between

104 Ibid.

105 Chris Nazuka, "Acid Soup," *THING*, no. 2 (1991).

106 Riley Evans, "The Life of Riley," *THING*, no. 2 (1991).

music and gay culture. "Long before it was labeled, house music began to evolve to meet the demands being made on dancefloors in Chicago," Martin wrote in an article about "Chicago's House History" in *Crossfade*'s November 1992 issue. "So, just to set the record 'straight', it was from the cradle of the Black urban gay experience that house music was born."[107]

Detroit in the late 1980s was an apocalyptic scene, plagued with hundreds of acts of arson in abandoned buildings across the city—a symptom of Detroit's financial collapse was real-estate speculation, with buildings purposefully burned to recoup insurance money. Concurrently, President Ronald Reagan instituted the Economic Recovery Tax Act (ERTA) in 1981, which cut taxes to stimulate economic growth through private investments, and followed it with further tax reform in 1986 that lowered federal income tax and increased the incentive to invest in housing and real estate.[108] With the freefalling economy as a backdrop, Detroit techno differed from the house sounds of Chicago in that it was composed in the absence of a live audience: Juan Atkins' experiments, for instance, were done in the home, tailored for listening, but imagined to function on a dancefloor. Throughout the rest of the decade, Atkins, as Model 500, released a series of singles on his own label Metroplex, such as "Testing 1-2," "Technicolor" with Doug Craig as Channel One in 1986, "Sound of Stereo" in 1987, and two mixes of "Interference" in 1988. The electronic funk that Atkins had been working on since the late '70s and into the '80s held a low-frequency humming in the background, while house music caught the attention of the American record-ing music industry, with DJs such as Frankie Knuckles, Lil' Louis, Ten City (Byron Stingily, Herb Lawson, and Byron Burke), and Colonel Abrams[109] signing contracts with major labels; it gained much traction overseas, securing international notoriety alongside the disco revolution house had modeled itself after.

<center>*</center>

During the second half of the '80s, Atkins, May, and Saunderson parted ways, exploring music separately before bringing elements progressively back together. Saunderson went on to study telecommunications, play football, and pledged Phi Beta Sigma fraternity at Eastern Michigan University—a public research institute in the small town of Ypsilanti. During an extended break, Saunderson decided to try his hand

107 Terry Martin, "Chicago House History," *Crossfade* (November 1992).

108 "H.R.4242 - 97th Congress (1981–1982): Economic Recovery Tax Act of 1981," Congress.gov, Library of Congress, August 13, 1981, https://www.congress.gov/bill/97th-congress/house-bill/4242.

109 "In conventional industry terms, Colonel Abrams' international success with the MCA singles 'Trapped' and 'I'm Not Gonna Let' represents the surprising emergence of a New York street/dance style overseas, even before its crossover at home. But there's more to it than that, as Abrams himself states the case. 'A lot had to do with [foreign music fans] not categorizing me as dance or Black,' he says, 'but appreciating me as just a major pop artist or a major artist.' . . . Abrams sees himself as a groundbreaker for all artists who might be pigeonholed by the 'dance' appella-tion. He says that his international profile 'represents dance and opens other avenues for other artists.'" Brian Chin, "Colonel Abrams Enjoys Overseas Success," *Billboard*, April 19, 1986, 27.

at making music more seriously, initially DJing on college radio before airing a half-hour show of mixes multiple days a week. Ambitiously, he wanted to play the house music that he had been hearing through May on his shows; but he was eventually fired, only for the radio station to start playing house music during peak hours and main airing slots a few months later. The experience made Saunderson want to make his own music: he set up a studio in his apartment, starting with what he listed as "a Yamaha DX100, Roland Juno 106, Fostex eight-channel mixer, Tascam eight-track recorder, several reverbs, and giant speakers that could handle 800 watts each."[110] Under the name Kreem, Saunderson produced his first record *Triangle of Love* with Atkins and house music vocalist Shanna Jackson (performing as Paris Grey), later followed by *Groovin' Without Doubt* in an ensemble with May and Saunderson's roommate, James Pennington, in 1987, released on his own label KMS, a subsidiary of Atkins' Metroplex. Leaning more on the Chicago house sounds he DJed on his radio show and on the New York garage music he had experienced firsthand during his teens,[111] Saunderson can be said to have reformatted Motown ideology for the Information Age. In attempting to extract these two genres' uplifting and radio-friendly qualities and update them with a techno mindset, Saunderson ultimately developed a sustainable business practice to build his very own hit factory, with technical assistance from his younger brother Ronnie Saunderson, who had done engineering work from the disco/funk bands Brass Construction, B.T. Express, and Skyy.

Saunderson's view of Detroit was sober in the face of one of the United States' many avoidable disasters, he told *Music Technology* in September 1988. "It's very depressing, and there's nothing really positive I can say about the city as far as what's going on and the people that're running things." He cited the record lows in unemployment as contributing to the violence that rose out of widespread, desperate conditions: "I really believe that a lot of drugs were planted in America. They were put among the minorities as a way of breaking down communities, of keeping Blacks and other

110 Kevin Saunderson, quoted in Simon Trask, "The Techno Wave," *Music Technology* (September 1988): 70.

111 "When Saunderson was in his later teens, he decided that he wasn't going to let his time in what was then the nightlife capital of the world go to waste. In the late '70s, the New York City area was awash in groundbreaking selectors, and he experienced some of the all-time best: David Mancuso at the Loft, Tony Humphries at Zanzibar and, especially, Larry Levan at the Paradise Garage. 'One day, my cousin said, 'Come on, we're going out to the Paradise Garage,'" Saunderson recalls. 'I didn't know anything about it, but after going the first time, I couldn't wait to go back the second and third times, pretty much any time I had the opportunity. It was an enlightening experience. I mean, the place was all gay, or 90 percent gay, and before then, I didn't know anything about that kind of sexuality. But seeing the way that people danced at the Garage, and experiencing that love of the music they had... that was something. Me and my cousin, we'd just be in our own worlds, in our own little areas, dancing away.' That world was created by Levan, and Saunderson sees his nights at the Garage as early lessons in the control a DJ can have over a crowd. 'At that point, just hearing mixing was something new to me,' he admits, 'but even then I could tell that Larry was very good at those transitions. He might play one record for 30 minutes, 40 minutes, maybe an hour, and he would make it exciting. Like [Chic's] 'Good Times'—he would just start that record over and over again, and the crowd would go crazy.' It didn't hurt that the Garage's setup, designed by the fabled audio engineer Richard Long, was one of the best club systems to ever have existed. 'Just hearing that kind of soundsystem, where you really feel the pulse of the bass hitting your heart, was something I'd never experienced before.'" Bruce Tantum, "Kevin Saunderson: The E-Dancer returns," *DJ Mag*, October 21, 2021, https://djmag.com/longreads/kevin-saunderson-e-dancer-returns.

minorities against each other, of keeping the Black race from rising. If someone asks me a thousand times, I'll swear that's the reason, that's what's happening." Feeling the effects of President Reagan's war on drugs, Saunderson turned towards the entertainment industry and sought to break his way in: "The only thing we can do is achieve something positive, set a good example. Beat the system by not doing what they want us to do."[112]

Reese & Santonio, a collaborative project between Saunderson and his college classmate Santonio Echols, active between 1987 and 1989, produced a string of tracks that included "The Sound," "Rock to the Beat," "How to Play Our Music," and the high-definition electronic soul of "Just Want Another Chance,"[113] which attained recognition as Chicago house music rose in popularity overseas. "We tried to combine the two sounds together and create our own sound out of Detroit,"[114] Echols said of the project. In the following months, Saunderson also started the duo Inner City with Shanna Jackson (Paris Grey), and created the prototype for his biggest hit, "Big Fun." "I was in Chicago and a DJ friend told me about Kevin Saunderson, who needed a singer," Jackson recounted in 2019, describing how she began working with Saunderson as Inner City. "Back then there was no internet or email, so Kevin sent me a tape in the post. I put it on my little cassette recorder and out came Big Fun. The version was very basic, just a keyboard line I think, but I listened to the melody and sang whatever came into my head."[115] During a visit to Detroit, Jackson got to work with Saunderson and meet Atkins and May, who each created their own remix of the session, while James Pennington and Art Forrest helped form the song's structure. The recording process was do-it-yourself but thorough, with a lean mic setup in Saunderson's living room, from which Jackson sang alongside a single keyboard line. For their follow-up single "Good Life," Saunderson exchanged ideas with Jackson via cassette tape demo before flying to Chicago to record the song in a proper studio. "I'd grown up singing in church and had been a girl scout and a cheerleader, so lyrics about positive thinking and good vibes came naturally," Jackson noted. For her, the formation of the Inner

112 Saunderson, in Trask, "The Techno Wave."

113 "The Reese bass got its name from influential DJ / producer Kevin Saunderson's early side-project moniker, Reese. In 1988, Saunderson dropped a dark and groovy single titled 'Just Want Another Chance,' which featured a massive, warbly, chorused bass synth . . . Unfortunately, Saunderson, an early Detroit techno producer, didn't receive recognition for the sound right away. It took time for the sound to disseminate to those who were most craving it, and even more time for the larger music community to track down where it originated. The breakout moment for the Reese bass sound was when Ray Keith sampled Reese's record in the early '90s for the jungle classic, 'Terrorist,' under his moniker Renegade. Early rave producers who were spearheading the drum & bass movement in the UK couldn't get enough of this massive, pulsing, living bass sound, and it ended up defining a good deal of what we know that genre to sound like, even to this day." John Hull, "Exploring the History of the Reese Bass," *Splice*, October 7, 2020, https://splice.com/blog/reese-bass-history/.

114 Santonio Echols, quoted in Jacob Arnold, "When Techno Was House," *Red Bull Music Academy Daily*, August 14, 2017, https://daily.redbullmusicacademy.com/2017/08/chicago-house-detroit-techno-feature.

115 Shanna Jackson, interview by Dave Simpson, "How We Made Good Life: Paris Grey and Kevin Saunderson on Inner City's House Classic," *Guardian*, August 6, 2019, https://www.theguardian.com/music/2019/aug/06/how-we-made-good-life-paris-grey-and-kevin-saunderson-on-inner-citys-house-classic.

City project was an aspirational exit strategy for the troubling times that had befallen the inner-city Black community during the process and policies of Reaganomics and the failures of trickle-down economics. "The 80s had been very hard for people: Good Life and Big Fun tapped into a feeling that things were getting better."[116]

Saunderson transitioned from DJing to making his own music after watching Atkins and May build a musical system over the course of six months: in 1986 they recorded the hip-hop inspired "Let's Go" under the name X-Ray, with Saunderson credited for vocals. While playing football and attending college in the early '80s, Saunderson had forged a musical connection with Atkins, May, and Eddie Fowlkes that had a formative influence on his approaches to composing once he picked up making music again at the end of the decade. Saunderson described himself and his friends as entangled in a closed system of collective knowledge exchange and production. Sharing equipment, experimenting with combinations and outputs, the four music technicians began to construct a broader manifestation of Atkins' techno music. As Saunderson recalled:

> I mean, Juan was kind of just in his own world, he was well above us as far as his knowledge, his skill level, and he had records out. But that was kind of the beginning for Derrick for sure and, I'm trying to think, Eddie had a track that he was working on. Like I said, we were all working on music. X-Ray was probably finished before Eddie's track but Juan wanted to release Eddie's track first, so that's what I remember.[117]

Designed to be a sort of conglomerate of self-contained imprints, Metroplex branched out with Saunderson's KMS and May's Transmat, subsidiary record labels through which they could release music. Metroplex released Fowlkes' debut single "Goodbye Kiss" in 1986, and a follow-up the next year entitled "Get it Live / In the Mix," a 12-inch of samples and instrumental tracks. Atkins continued to chip away at an optimized technological funk sound as Model 500 and Saunderson designed prototypes for systemized popular music hit records, while May toiled away at his own iteration of techno, aspiring to create a sound that could stretch electronic emotions into an upgraded vision of soul music, queued to the collapsing industrial-turned-digital age. Taking a stance against using the latest gear on the market, May dove into acquiring and connecting outmoded electronic equipment, mostly to feel out the soul of discarded machines. In a 1988 interview with *Music Technology*, the "premiere hi-tech magazine," May explained:

> Most of the electronic sound that comes from myself has got nothing to do with trying to be trendy with the latest equipment. It's about using what you use to

116 Ibid.
117 Kevin Saunderson, lecture, hosted by Christine Kakaire, Red Bull Music Academy, Berlin, 2018, https://www.redbullmusicacademy.com/lectures/kevin-saunderson.

the best of your ability, and that's all I care about. I started out with a couple of S900s, a DX100, a Poly 800, a Mirage, an SQD1, a 909, an 808, a 727 and a Fostex 260 four-track, and I still use that stuff. Also now I use a Kawai K3, a Yamaha DX21, some old ARPs, shit like that. One instrument that I'm trying to get hold of is a Korg 707. I'm into keyboards that are not popular, that everybody else slags off. I tell you one keyboard I used to use that had some phenomenal bass sounds: the Casio CZ5000. I had some fierce bass sounds on that which I used on some tracks I never released.[118]

May also exerted influence on the house sound of Chicago, where the songs he made were played in clubs by Farley "Jackmaster" Funk, Ron Hardy, and Frankie Knuckles. Tapping into the same trade route that he had established with Atkins when he distributed Cybotron and Model 500 records between the two cities in the early '80s, May knew that he could utilize the club and the radio circuit in combination to sell records alongside Saunderson and Atkins under the banner of Metroplex, without the burden of bureaucracy. In 1987, May established the record label Transmat; the first two singles he released, "Nude Photo" and "Strings of Life" (as Rhythim Is Rhythim), in time garnered a global audience, due to May's billiards-like logic of stacking his deck for optimal trajectory and reach. "Nude Photo" was made in an uneven collaboration with eighteen-year-old Thomas Barnett, whom May had met through their mutual friend Anthony Pearson, or Chez Damier. Pearson had overheard Barnett listening to music that he had made, and told him that he could connect him with Atkins, May, and Saunderson. Barnett paid for studio time with May after Pearson facilitated the introduction; he brought his own Yamaha DX-100, Roland TR-909, Ensoniq Mirage, and Korg SQD-1. The two producers worked closely together that night, passing ideas back and forth until "Nude Photo" emerged from the recording session. "There wasn't a genre called techno yet," Barnett mused, remembering 1987 as an exciting time for music. "There was house, and acid house was just beginning to pick up. 'Nude Photo' was actually categorized as acid house at the time."[119] According to a commenter on the online database and marketplace Discogs, Barnett stated that he conceived of "Nude Photo" during recording sessions with May:

The original concept I had reached way back to when I was in high school in Detroit (University of Detroit Jesuit High School & Academy) in the early to mid 1980's. I was in a band and we worked on many songs as a group and I also worked on songs as a solo artist when I wasn't doing band related music.

118 Derrick May, interview by Simon Trask, "Techno Rhythim," *Music Technology* (December 1990): 38.

119 Thomas Barnett, quoted in Arnold, "When Techno Was House."

As a band member, I contributed to the many different styles of music, some uptempo and some mid or even slow tempo pieces.

When I played alone I would play a lot of the more dance/party related themes, and with "Nude Photo" I kept the theme with bouncy octave notes that felt like a jerking New Order "Blue Monday" type feel that could be repeated in a four measure sequence. Since being a very young child I loved the electronic "synthy" sound as much as I loved science fiction films and outer space news/ trivia, I really wanted to capture that with my solo work and I think this may show in the many versions of "Nude Photo" that I have released over the years.[120]

Barnett's idea of electronic music was considerably more studied than what Atkins, May, and Saunderson were creating, in that his approach mirrored a classical composition structure not unlike that of Marshall Jefferson, who applied his conservatory training to the house music formula. Barnett expanded on the process of creating the basic melodic and rhythmic function of "Nude Photo," explaining that a counterpoint constructed between two of his synthesizers "was a side-effect of 'step-writing' the lines into the Korg SQD-1 sequencer." He was familiar with the Korg sequencer and used it to randomize and sample laughter from the 1982 song "Situation" by English synth pop duo Yazoo: "Each step must be put in with either a note or a 'rest'. So one could just randomly tap on notes, then later add rests or pauses. This allowed for that nearly random 'talking to each other' funky effect to appear."[121] Shortly thereafter, May got to work on a new song in collaboration with Michael James. Hanging out with May in his living room one day, James began playing a ballad of his own titled "Lightning Strikes Twice." May recorded the song into his sequencer, dismantling it into smaller fragments that aligned with his "beats and strings" synthesizers and drum machines, while also increasing the speed of James' track from its original 80 bpm. Without a bassline, "Lightning Strikes Twice" opened up techno music to a new horizon that was more flexible and orchestral in design and mechanics, while still serving as an energizing tool for DJs: Frankie Knuckles played it out for the dance floor, renaming the song, "Strings of Life." "When I made 'Strings of Life' I listened to it for 24 hours. It freaked me out, so I couldn't finish it," May remembers:

120 Thomas Barnett, quoted by Discogs commentor Alain_Patrick, a self-proclaimed "enthusiast of the worldwide electronic scene" and co-founder of the Quadraphonia Consulting Company, https://www.discogs.com/release/4282-Rythim-Is-Rythim-Nude-Photo.

121 Ibid. "I hated sampling. The only sample that I ever used was the laugh from Yazoo, on 'Nude Photo'—and I let Tom Barnett do that. . . . Sampling is the ultimate sin for me. Now it's accepted, but it doesn't mean it's cool. Artists look forward to their work getting sampled, hoping it's on a hit record. But that's the only reason artists are even OK with it. Other than that, artists aren't cool with it, they're like, 'What a joke.' You hear 'Strings of Life' get sampled or looped and everyone's coming out with these versions. You think, 'OK, look at the publishing end of it,' but in reality you're thinking, 'Could you guys not do something better with your time?'" Derrick May, interview by Bill Brewster and Frank Broughton, originally published on DJhistory.com, August 2004, republished in *Red Bull Music Academy Daily*, May 22, 2017, https://daily.redbullmusicacademy.com/2017/05/interview-derrick-may.

It took me six months to put out "Strings," because when I finally decided to do it, I had Mike James' weird piano parts. I did some of the piano and he did some of the piano. His piano was by accident. He had done his piano a year before, but not for my song. He had made a ballad. I just ended up running across a piece of it, so I chopped it and looped it on top of my orchestration. It worked perfectly. I added all the piano parts, so the song was there, but it wasn't edited.[122]

While Atkins helped May figure out how to edit the cassette recordings that made up the song, another friend, Jay Dixon, worked with him on gaining a deeper understanding of the studio process. Both "Nude Photo" and "Strings of Life" exploded on the Chicago club scene and abroad, careening along as a part of the acid house phenomenon, while also anticipating the Detroit techno music to come. Eventually they reached the ears of Neil Rushton, a record label entrepreneur in England who was tapped into the Detroit music scene of yesteryear as a founder of the Heart of England Soul Club (HESC), which organized and promoted Northern soul and Jazz Funk "all-dayers" in the 1960s. "When Detroit house records—nobody was using the term techno then—started being imported into the UK, I was intrigued because of my love for Detroit soul. I was mesmerised by Rhythim Is Rhythim's 'The Dance,' so I rang up the phone number on a Transmat label."[123] Reaching May, Rushton launched into conversation. "We clicked immediately and I told him we had the label and had endless enthusiasm and ambition but no money." Rushton offered to distribute May's music in the United Kingdom, and invited him to England over Christmas 1987:

> Derrick got a passport and we raised the air fare and asked him to bring a couple of boxes of 'Strings of Life' which we would sell and put towards the costs of the flight and hotels! Derrick arrived and we got him three remixes so he made some money from the trip and he asked me to manage him. He explained what was going on in Detroit with Kevin Saunderson and Juan Atkins having their own labels. That got me thinking and I did a deal with Virgin for me to licence them a Detroit compilation, that became the 10 Records *Techno! The New Dance Sound of Detroit* album that is now regarded as iconic. Inner City's "Big Fun" exploded from that and I managed Kevin and Inner City.[124]

Based on the success of this visit, the Detroit producers who had been experimenting for the better part of the decade came together to discuss how to release their tracks to the rest of the world. Rushton brought in journalist Stuart Cosgrove to write the liner notes, as he had for *The House Sound of Chicago* compilation two years prior. Following May's advice, based on his experiences overseas in London, Atkins,

122 May, interview by Brewster and Broughton.

123 Neil Rushton, interview by Matt McDermott, "Network Records Relaunches with an Expanded Edition of Derrick May's 1991 Classic, *Innovator*," *Resident Advisor*, December 22, 2019, https://ra.co/news/71480.

124 Ibid.

Saunderson, and Fowlkes each offered up tracks, alongside other local musicians like Blake Baxter, Anthony "Shake" Shakir, and the group Members of House, who all wanted to distance their music from Chicago house: they considered their work as unique and specific to the city of Detroit. When asked what they wanted to call it, May insisted on the term "Hi-Tek Soul." Atkins countered, "We call it techno."[125] But May held strong. "I don't say that,"[126] he explained."I kept begging him, for like that whole year, not to call this music techno. He said, 'Nah man, this is techno.' To me techno was that bullshit coming from Miami,[127] because they tried to call their music techno. I didn't want to be associated with it. I thought it was ugly, some ghetto bullshit."[128] In time May came to accept the term techno as a descriptor for the sound he had inherited from Atkins and developed with Frankie Knuckles, Ron Trent, and others, agreeing that, "Detroit music is not house music."[129] Decades later, he shared with *Attack Magazine* that, "When I use the motto Hi-Tek Soul, it's not just a marketing campaign, Hi-Tek Soul is really what Detroit techno is."[130] The music, for May, was about technology, soul, and the people who made it. Ultimately, as the producer who had been crafting the sounds and concepts of techno the longest, Atkins submitted "Techno Music," an aptly named track that summarized their home studio electronic music as *Techno! The New Dance Sound of Detroit*.

In May 1988, the Music Institute opened in Detroit as a prototype club for techno music. With DJs George Baker (a former fashion designer), Alton Miller, and Pearson at the helm, the Music Institute launched as a members-only club, open from midnight to 3 a.m. two nights a week: Fridays were "Next Generation" nights, featuring forward-thinking electronic music, which Baker described as "as young as possible, as fast as possible, as aggressive as possible."[131] Saunderson DJed Friday nights, before being replaced by May and Darryl Wynn, with Atkins and Mike Huckaby coming on as frequent guest DJs when May played clubs overseas. Saturdays were "Back to Basics" nights: the owners themselves DJed, creating a classic environment reminiscent of the

125 May, interview by Brewster and Broughton.

126 Ibid.

127 "That gut-churning rumble you feel coming from those neon-lit IROCs and Cherokees that crawl the mall in the southern US is Miami Bass. The guiltiest of guilty pleasures, Miami Bass is about one thing and one thing only—booty. With more unrepentant ribaldry than Rudy Ray Moore, Redd Foxx, and Blowfly put together, the collected works of Miami Bass serve as a Satyricon for the late-twentieth century. What's interesting about booty music, though, is not so much that it's lasted for some fifteen years with its only subject matter being a fascination with the female posterior, but that its earthiness is expressed exclusively through the most purely electronic sound this side of Iannis Xenakis." Peter Shapiro, *Modulations: A History of Electronic Music: Throbbing Words on Sound* (New York: Caipirinha Production, 2000), 106.

128 May, interview by Brewster and Broughton.

129 Ibid.

130 Derrick May, quoted in "Derrick May Hi Tek Soul: This Is Who We Are," *Attack Magazine*, n.d., https://beat.com.au/derrick-may-hi-tek-soul-this-is-who-we-are/.

131 Ray Philip, "Nightclubbing: The Music Institute," *Red Bull Music Academy Daily*, May 23, 2017, https://daily.redbullmusicacademy.com/2017/05/music-institute-nightclubbing.

Chicago, New York, and Toronto clubs that had first inspired Baker to pitch the idea for a club. Between 1988 and 1989, the Music Institute occupied a four-story building that once served as a shoe store, and became known as a club for serious dancers looking to let loose, making it a singular source of life in the ruinous and near-abandoned downtown Detroit. As publicity from *Techno!* circulated through magazines like *The Face* and *Melody Maker*, middle-class Black kids and rich suburban white kids reenacted their fantasies of living in fashionable cities like New York and London on this Detroit dance floor.

With a diverse crowd—Black and white, queer and straight—and its single strobe light and mural by Sarah Gregory, the Music Institute became a "must-see" spot for music journalists and even the English band Depeche Mode, who nevertheless complained of the venue's strict no-alcohol policy. "We had a line around the corner. It was 25 bucks to get in, and we're talking 1988," May recounts of the club's short life and the clientele that briefly became a community. "With membership you paid 15 bucks, but you paid 200 bucks to get the membership. The membership was like an ID with a picture on it. The Music Institute was only open a year-and-a-half. People think it was open longer."[132] After the release of *Techno!*, much of May, Saunderson, and Atkins' focus was outside of Detroit as they tried to maintain the momentum of the compilation. "Because myself and Kevin got busy with our work. Inner City took off. Kevin had to go to work. Kevin played with me a few times at The Music Institute, but myself and Darryl Wynn were doing it," May explains. "All of a sudden I started getting offers to come play in Europe. I was getting remixes, stuff like that here [in the UK]. I got infatuated with England. I couldn't leave." May admits that in the end, "we abandoned it."[133] The marketable Belleville Three had left behind what could have been the beginning of a local techno community, as opposed to the preppy youth clubbers of Detroit's progressive dance music era or the nearby Chicago house scene. "The guys who we put in charge to play, they just couldn't cut it. They tried, but the crowd was the ultimate judge," May says. "These kids in Detroit grew up with the music, so they weren't idiots. Frankie Foncett came to Detroit to hang out with me for a couple of weeks at the house. We let him play there for an hour and those kids walked off the dancefloor. That was at the height of his DJing career. They just weren't interested."[134]

While pursuing the possibility of fame, legacy, freedom, and financial stability in the British and European markets, the Detroit scene eventually veered away from dance music. "London was totally different,"[135] Saunderson remarks, speaking to the differences between the serious dancing he saw at the Music Institute and what existed abroad, where drug usage was a more important factor in nightclubbing than the

132 May, interview by Brewster and Broughton.

133 Ibid.

134 Ibid.

135 Saunderson, quoted in Philip, "Nightclubbing."

music. He noticed how the music being played soured past peak hours and worsened throughout the night, and was careful not to repeat this in his own DJ sets: "You had these bad records that were becoming hits or anthems in clubs. It wasn't because the record was good. It was because the moment and the drug that the people were taking made that record bigger and larger than it ever should have been."[136] Comparatively, May suspects that without England techno would have stayed underground. "I believe that it had to have a diving board and the diving board was Detroit," he opines. "The pool that it dived into would be England, then into Europe and into Asia. Through pop culture. Britain is the home of pop culture—the cesspool of that shit." For May, "England gave the music and us market value, which changed the way we saw the music and what we saw the music was worth."[137] Through their engagements with the United Kingdom and its media-heavy culture industry, the Belleville Three learned about the pitfalls and complications of the music business. "We were just really disappointed when we found out that people make promises in this business and plans simply change," May acknowledged. "It was me being hopelessly romantic about the whole thing in the beginning that hurt my feelings. I took this business personally. Big mistake. I look back at articles I did where I say I was hurt because of the music business. Well yeah, of course I was hurt, because I came into it wide-eyed and..."[138]

On November 24, 1989, the Music Institute closed, following a number of homophobic threats from men wearing shirts that read "world peace" who waited outside of the club armed with baseball bats. May DJed the club's final night, wryly closing Detroit techno short-lived home with a blend of "Strings of Life" and the chiming clock. "At the end of the day, we couldn't pay the bills," Baker explained. "That's why we closed. Fortunately for us, we chose the date that we were going to close, because I saw the handwriting on the wall."[139] "I just don't think Detroit was ready for the Music Institute," acknowledged Patrick Burton, a clubber who was a member of Paradise Garage in New York, had seen Frankie Knuckles and Ron Hardy DJ in Chicago, and was a frequent attendee of the Detroit nightspot. "Even the people that created it, I don't think, were ready for the Music Institute."[140] The final night of the club was listed as "the end of an era," but also as a chance for rebirth. "I remember people were crying on the dancefloor when the last record was played. They were in tears," May says. "I try not to think about the Music Institute. I feel like if I think about it, I can't play. Because nothing compares to it. Nothing. Nowhere, not even in Japan... And we were just changing the world, and we didn't know it."[141] In time, each of the people involved with the Music Institute eventually left Detroit, except for Baker, who briefly ran another club, the Parabox Cafe, before leaving clubbing behind altogether.

136 Ibid.

137 May, interview by Brewster and Broughton.

138 Ibid.

139 George Baker, quoted in Philip, "Nightclubbing."

140 Patrick Burton, quoted in ibid.

141 May, quoted in ibid.

6.
WAKE UP AMERICA, YOU'RE DEAD!

"We as people in the world today / Should come together / And help one another / We should build our nation / Free from inner city decay."[1]

– Inner City

"In the city where the assembly line was made a staple of modern life, techno's Henry Ford and his disciples welded together Motor City funk, European avant-garde composition, and Japanese gadgetry to form a whole new chassis, but found their invention unappreciated in the American marketplace. Like jazz musicians from Ben Webster to Dexter Gordon in the 1960s, Atkins, May, and Saunderson embarked for Europe in the late '80s to find their fame and fortune."[2]

– Mike Rubin

In a 1993 summer issue of *The Village Voice*, British music journalist and punk music historian Jon Savage penned a feature titled "Machine Soul: A History of Techno"—a comprehensive guide to techno that charted the genre's development before and after its exportation, financialization, and reception overseas, where it was marketed as a European pop genre rather than a manifestation of the technological concept of Black futurism:

> Techno is everywhere in England this year. Beginning as a term applying to a specific form of dance music—the minimal, electronic cuts that Detroiters like Derrick May, Juan Atkins, and Kevin Saunderson were making in the mid '80s—techno has become a catchall pop buzzword: this year's grunge. When an unabashed Europop record like 2 Unlimited's "No Limit"[3]—think Snap!,[4] think

1 Inner City, lyrics, "Inner City Theme," *Paradise* (10 Records, 1989).

2 Mike Rubin, "A Tale of Two Cities: Our 1998 Feature on the Racial Politics of Detroit Techno," *Spin Magazine*, October 1998, https://www.spin.com/featured/juan-atkins-derrick-may-kevin-saunderson-carl-craig-detroit-techno-october-1998-feature-a-tale-of-two-cities/.

3 2 Unlimited is a Dutch Eurodance group made up of producers Jean-Paul De Coster and Phil Wilde with contributions from Surinamese Dutch rapper Ray Slijngaard and vocalist Anita Doth. From 1991 to 1996, 2 Unlimited created many hit records and sold 18 million records worldwide. Their song "No Limit" reached number one on charts in the UK, the Netherlands, Sweden, Spain, Austria, Switzerland, France and Norway as well as gaining significant attention in American sports events.

4 Snap! is a Eurodance project based in Frankfurt, Germany, founded in 1989 by Michael Münzing (Benito Benites) and Luca Anzilotti (John "Virgo" Garrett III) as a semi-anonymous production group with rotating vocalists to avoid negative perceptions of German music. Their song "The Power" (created in their previous group, Power Jam) was an instant hit in Europe and the US upon its release in 1990. It was constructed from samples of Mantronix's "King of

138

Black Box[5]—blithely includes a rap that goes "Techno techno techno techno," you know that you're living within a major pop phenomenon.[6]

Savage imagined techno to be "the perfect travelling music," citing its intuitive modulations of rhythmic and textural qualities, in tandem with each of the Detroit producers' customized composition and recording methods, as "perfect for the constantly shifting perspectives offered by high-speed travel." Such speed was captured at the microcosmic level as well: he noted a fascination with techno's ability to "accurately reproduce the snap of synapses forced to process a relentless, swelling flood of electronic information."[7] Originally imagined by Juan Atkins as a homemade, technologically produced studio music, techno represented a significant leap forward in the Black musical tradition. Its potent and distilled iteration of the kind of energy music found in jazz, soul, and funk ensembles of the 1970s led by George Clinton, Herbie Hancock, Miles Davis, among others, could summon worlds and transmit concepts. But instead, following the trajectory of acid house, techno was received overseas as a commodity to be replicated and mass-produced.

Chicago house and Detroit techno arrived on British shores just as the use of ecstasy and other psychedelic drugs began to gain popularity. An underground cartel formed, drawing profit from raves and parties that sometimes hosted up to five thousand people, and centered around the importation, replication, and standardization of Black American music—not unlike the Northern Soul movement Neil Rushton had participated in during the 1970s.[8] "The U.K. likes discovering trends," Rushton admitted to Savage. "Because of the way that the media works, dance culture happens very quickly. It's not hard to hype something up."[9] Rushton was a journalist and avid storyteller in his own right. In his account, "the Detroit innovators couldn't take it to the next stage." Techno's success was only secured when "kids . . . in the U.K. and

the Beats Lesson #1," rapper Chill Rob G's "Let the Words Flow," and Jocelyn Brown's "Love Gonna Get You." On Snap!'s 1990 debut album *World Power*, the duo expanded to include African American rapper and beatboxer Turbo D and singer-songwriter Penny Ford, who sang for Chaka Khan, Kool & the Gang, George Clinton, and The S.O.S. Band. American singer-songwriter and dancer Thea Austin joined Snap! in 1991 and co-wrote "Rhythm Is a Dancer" (1992), which sampled Newcleus' "Automan," reaching number 1 in Germany, the UK, France, Switzerland, Austria, the Netherlands, and Belgium, and number 5 in the US.

5 Black Box is an Italian house trio composed of DJ Daniele Davoli, classically trained clarinet teacher Valerio Semplici, and electronic musician Mirko Limoni, with the French Caribbean fashion model and gogo dancer Katrin Quinol representing the group on the cover of releases, in music videos, and during live performances, where she lip-synced vocals recorded by African American singer Martha Wash on the group's debut album, *Dreamland* (1990).

6 Jon Savage, "Machine Soul: A History of Techno," *Village Voice,* Summer 1993, Rock & Roll Quarterly Insert, http://music.hyperreal.org/library/machine_soul.html.

7 Ibid.

8 "Coined by Dave Godin, a music journalist for Blues and Soul magazine, 'Northern soul' is a term to describe a musical phenomenon that gripped the working-men's clubs and casinos in industrial cities in the north of England in the 60s and 70s." Johny Pitts, *Afropean: Notes from Black Europe* (London: Penguin, 2019), 27.

9 Rushton, quoted in Savage, "Machine Soul."

Europe started learning how to make those techno records. They weren't as well-made, but they had the same energy. And, by 1990–91, things became more interesting, because instead of three people in Detroit, you suddenly had 23 people making techno, in Belgium, in Sheffield."[10]

With the marketing campaign for *Techno! The New Dance Sound of Detroit* and the Belleville Three in the rearview—the former had not, despite significant efforts, made its production budget back in sales—the sound and designs of techno triggered a dance phenomenon in northern England, the Netherlands, and reunified Germany, erupting into these countries' versions of the 1967 "Summer of Love," when white American hippies partook in psychedelics and celebrations of peace and love, even as the difficult realities of race riots and the collapse of the urban sector manifested in over one hundred and fifty cities across the US. Rather than be taken up as a sign of the rapidly globalizing concept of technological societies run by technical experts—only a decade into what Alvin Toffler had described as the "information era" in his book, *The Third Wave*—Juan Atkins' term "techno" was adopted like a meme to be circulated by mainly white journalists, a catch-all phrase for music made using technology. European clubbers similarly parroted "techno" as shorthand for the musical supplement to drug-stimulated celebrations of "freedom" and "love," which had spread throughout Europe like a modern iteration of the mysterious dancing epidemic that plagued the inhabitants of Strasbourg in 1518.[11]

While the futuristic concepts that Atkins and Rik Davis had implanted into the techno sound in 1980 were intellectually fascinating to many of the brokers behind the scenes of the music industry, the music—though not necessarily their own—was spreading like a virus across Europe, drawing momentum from the meteoric rise of Chicago house succeeding the residual high of the disco revolution, which had become the continental genre of Eurodance. According to Dan Sicko's 1999 history of electronic dance music, *Techno Rebels*, miscommunication amongst Rushton and the Belleville Three led to a number of other missteps (including a failed record deal for the three Detroit pioneers of techno as Intelex with ZTT Records, which was releasing acts like Afrika Bambaataa, Art of Noise, and 808 State).[12] Rushton continued to manage the Belleville Three through the mild commercial reception of the *Techno!* compilation, which had the advantage, however, of briefly attracting the attention of jazz pioneer Herbie Hancock, who considered hiring May and Saunderson to produce a

10 Ibid.

11 The 1518 event was the most thoroughly documented and probably the last of several such outbreaks of convulsive dancing in Europe, which took place largely between the tenth and sixteenth centuries. Another well-documented outbreak took place in 1874 in several towns along the Rhine River. John Waller, "A forgotten plague: making sense of dance mania," *The Lancet*, February 21, 2009, https://www.thelancet.com/article/S0140-6736%2809%2960386-X/fulltext.

12 Dan Sicko, *Techno Rebels: The Renegades of Electronic Funk* [1999] (Detroit: Wayne State University Press, 2010).

techno-inspired album. (May even took a large advance for a multi-album deal with the Belgian label R&S, without ever producing an album.) Rushton ultimately signed Saunderson and Paris Grey's Inner City project to his label 10 Records, activating his distribution connections in the United States by way of Atlantic Records, and in the United Kingdom through Virgin/EMI Records. With a major label sensibility, the song "Big Fun" was released as a single and music video with "Power of Passion" as its B-side, reaching number 1 on the US Dance chart and 8 on the UK charts. In 1989, Inner City's debut album, *Paradise,* hit number 3 on the UK charts; their next three singles—"Good Life," "Ain't Nobody Better," and "Do You Love What You Feel"—all took the number 1 spot in the US Dance charts, while the group's fourth single, "Whatcha Gonna Do With My Lovin," appeared at number 8 in the Dance Top 10. Much like Berry Gordy before them, Saunderson and Grey were tapping into a macro-rhythm of populist appreciation, creating an assembly line of statistically proven pop hits. Saunderson's aspirations to elevate techno from the loose and decen-tralized vinyl single format through a "real" album was largely a success.

A second compilation released in 1990, titled *Techno 2: The Next Generation*, pre-sented a new batch of Detroit producers like Carl Craig, Octave One (Lenny Burden and Lawrence Burden with their siblings Lance Burden, Lorne Burden, and Lynell Burden), Marc Kinchin, and Jay Denham, as the Belleville Three found themselves coming firmly down to earth, while trying to maintain a grip on the genie they had let out of the proverbial bottle. In the liner notes of *Techno 2*, music critic John McCready redefined the genre as "a hyperactive electronic dance music still perceived as an underground phenomenon despite influence now beyond all control."[13] The brief inner sleeve notes aimed to recapture the element of surprise offered to listeners of the 1988 *Techno!* compilation, at a time before the spread of dance music worldwide: "This is a music of such vibrancy it has no time to stop and spin back though the samples and similarities, Juan Atkins may never be inducted into the Rock 'N' Roll Hall of Fame, but techno continues to develop not as some tributary influence on European dance but as a creative force with a life of its own."[14]

After a few years of contributing to *New Music Express* (*NME*) as a freelancer, McCready had moved from Liverpool to Manchester, where he became the sole resident DJ at The Gay Traitor bar, in the lower level of the nightclub The Haçienda. Known to "pillage and plunder from lots of musical styles,"[15] the "Madchester" scene rose to prominence at the end of the 1980s after Anthony "Tony" Howard Wilson, a music, culture, and evening news anchor at Granada Television, started Factory Records in 1978, then opened The Haçienda in 1982. In

13 John McCready, liner notes, *Techno 2: The Next Generation* (10 Records, 1990).

14 Ibid.

15 Stuart Maconie and James Brown, in *Madchester: The Sound of the North*, directed by Simon Massey (Manchester, UK: Granada Television, 1990).

the 1990 documentary *Madchester: The Sound of the North*, produced by Granada Television, Wilson lectures the film's narrators, *NME* reporters Stuart Maconie and James Brown, on the importance of using the income earned from the global music industry to build infrastructure for future music-makers and consumers:

> You make it, you go to London, and I think the difference it makes to Manchester, 10cc for example, make a load of cash, they build Strawberry Studios in the early '70s so that when come, Factory comes on as a record company we have an international recording facility just around the corner from us. Similarly, New Order makes a whole pile of money, and they're able to get together with other people and are able to build the Haçienda, which is so vital to what's happening in the second half of the '80s in this town.[16]

Named after a Situationist slogan from the early 1950s, stating that "The Haçienda Must Be Built,"[17] the nightclub became a platform for the Manchester music scene to experience live concerts by artists signed to Factory Records, such as New Order and Happy Mondays, as well as other local groups like The Stone Roses, Oasis, 808 State, and The Chemical Brothers. The club wasn't very profitable at first, but Wilson attained a leading edge when Haçienda DJs Hewan Clarke, Greg Wilson, and Mike Pickering began to mix Chicago house music along with other imported records during the club's "Nude" and "Hot" nights, while DJ Paulette (Paulette Constable) began her career at the club's Wednesday gay night, "Flesh."

In September 1987, four club and pirate-radio DJs based in London—Nicky Holloway, Paul Oakenfold, Danny Rampling, and Johnny Walker—took a trip to Ibiza to visit DJs Trevor Fung and Ian St. Paul at the nightclub Amnesia. Fung and St. Paul had experienced the rise of the "Balearic beat" sound, pioneered by Argentinian DJ Alfredo Fiorito by combining imported Italo disco and American pop, soul, funk, jazz, and house music with the Roland 909.[18] The Balearic archipelago islands became a luxury destination for runaway American hippies and vacationing colonizers from the European continent—the same crowd that could be found in London at the party Shoom, organized by Danny Rampling and held at a 200-people-capacity gym. On Shoom's opening night in December 1987, local DJ Carl Cox, known for mixing disco, house, techno, and hardcore records on three turntables, combined the Balearic Ibiza sound with Chicago acid house: "Over the years, people have got used to labeling me a techno DJ," Cox noted. "But I've been a drum & bass DJ, a house DJ, a

16 Ibid.

17 "Il faut construire l'hacienda." See Ivan Chtcheglov, "Formulaire pour un urbanisme nouveau" [1953], *Internationale Situationniste* 1 (June 1958): 15.

18 Amnesia was opened in May 1976 by Spanish philosopher Antonio Escohotado, who used his lease on the land to start the discotheque, originally naming it "El taller de los olvidadizos," or "The Workshop of the Forgetful Ones."

hardcore DJ, a soul DJ—some called me a trance DJ in my F.A.C.T. days.[19] I just try not to be pigeon-holed."[20]

The rigged, misfired squelch of acid house exploded in the UK in the summer of '87, when it was intentionally paired with the German pharmaceutical-turned-psychedelic drug ecstasy, which had escaped from the Rajneesh, or the Osho commune, in Wasco County, Oregon, in 1984, after cult members committed a political bioterror attack.[21] Ecstasy and its powdered counterpart MDMA[22] reemerged in the blissed-out nightlife scenes of New York in 1985, before traveling to Ibiza and filtering into The Haçienda in 1988. In a brief history of ecstasy's infiltration of the UK, journalist Max Power wrote that an early batch of two hundred pills were brought over from the US and handed out at a Manchester gay club named Stuffed Olives, while the drug was still relatively unknown, even to police. "A shipment of over 15,000 pills were smuggled into the UK from Amsterdam by people close to the Happy Mondays in late 1987, and these fuelled the rise of acid house in the north of the UK, according to someone familiar with the band and the deal," Power sleuthed. "These friends of the Mondays began to sell it in an alcove near the speakers in the Haçienda known as 'E corner.'"[23]

Within weeks, acid house, ecstasy, and a yellow smiley face logo became the signifiers of a mass future shock of sorts that ultimately curtailed and spoiled a generation of British youth, reacting against the conservative nationalism of the postindustrial Thatcher era. "In the UK in early 1987, most city's nightclubs were violent dens of sexual harassment and terrible music," Power explained. "Fast forward a year or two,

19 The acronym "F.A.C.T." stands for "Future Alliance of Communication and Tecknology" and is the title of a 2-CD album by Carl Cox released in 1995 on React.

20 Carl Cox, "Top 100 DJ Polls," *DJ Mag*, November 1, 2007, https://djmag.com/node/9168.

21 Max Power, "Ecstasy Island: How MDMA Reached the UK in 1988," *Mixmag*, May 3, 2018, https://mixmag.net/feature/ecstasy-island-this-is-how-ecstasy-reached-the-uk.

22 "The modern story of MDMA begins with its rediscovery in the early 1960s by Alexander Shulgin, widely regarded as 'the stepfather of Ecstasy'. Shulgin was then a biochemist working for Dow Chemicals and pursuing an interest in psychedelics on the sly. Later in the decade, he opened his own government-approved laboratory in San Francisco dedicated to the synthesis of new psycho-active substances, all of which he tested on himself and his wife/co-researcher, Ann. Shulgin soon became a prime mover in America's network of neuro-consciousness explorers. By 1976, the first reports on MDMA's therapeutic potential were appearing in medical journals. In the late seventies and early eighties, MDMA—then nicknamed Adam, because of the way it facilitated a sort of Edenic rebirth of the trusting and innocent 'inner child'—spread throughout a looseknit [sic] circuit of therapists in America. Used in marriage therapy and psychoanalysis, the drug proved highly beneficial. Advocates claimed that a five hour MDMA trip could help the patient work through emotional blockages that would otherwise have taken five months of weekly sessions." Simon Reynolds, *Energy Flash: A Journey Through Rave Music and Dance Culture* [1998] (Berkeley: Soft Skull Press, 2012), xxix. "Nobody really knew much about Ecstasy, about how it worked or what was the best way to take it. People quickly worked out that alcohol dulled the E buzz; at Shoom, Lucozade became the beverage of choice, partly because it replenished energy and partly because it was the only drink available at the Fitness Centre. Myths sprang up around the new drug, like the notion that Vitamin C killed the buzz, which ruled out orange juice. There was also considerable confusion over Ecstasy's legal status, and nobody knew if it was an addictive substance or not. The other big Ecstasy myth concerned the drug's aphrodisiac powers." Ibid., 43–44.

23 Power, "Ecstasy Island."

and tens of thousands of previously uptight Brits—even heterosexual footy hooligans—were ecstatically embracing each other, dancing til dawn to house music in fields, quarries, warehouses, nightclubs, and basements."[24] Ecstasy was initially used by Britons as a stimulant during upscale cocktail parties carried over from the '70s. "The music was the wrong backing to it," Dave Dorrell, an earlier user of the drug, recalled. "Everyone was just kind of wobbling around like Jell-O on a chair."[25] Noel Watson, a DJ at the London party Delirium, explained that the combination of ecstasy and house was better suited for converted warehouse spaces: "Suddenly everybody who was anti-house music loved it. They were hugging each other. It was amazing. I played 'Strings of Life' there and people would go mad."[26] Watson recalled the impact of the stories, music, and drugs brought over from New York by his brother Maurice, a tailor in the fashion industry who rubbed shoulders with Jean-Michel Basquiat and the Beastie Boys. Maurice first took the drug while partying at the Paradise Garage, and according to Noel, he "had ecstasy tablets before anybody in this country even knew what they were."[27] Music journalists Bill Brewster and Frank Broughton speculated, in *Last Night a DJ Saved My Life*, their history of DJing, that "while the long-term mental health implications of this remain dauntingly unknown, the social effects have been profound." Ecstasy, they thought, constituted a universal experience for thousands of young people in the UK; in time, it would become a rite of passage, much to the horror of parents around the country. "Anything that can get murderous football hooligans skipping round a dancefloor holding hands with transvestites," they opined, "must be viewed with a certain respect."[28] On July 14, 1989, sixteen-year-old Clare Leighton became the first person to die from ecstasy when she collapsed after taking a tablet at The Haçienda.[29] In response, police motioned to revoke the club's license and increase their presence there, given that ecstasy had been illegal since the Misuse of Drugs Act of 1971 had been amended in 1977 to include the substance. Ultimately, Graham Stringer, the Labour leader of the Manchester City Council, wrote a letter pushing back against reenforcing security at The Haçienda due to its profitability as a focal point of the city's nightlife economy.

Meanwhile, during the 1980s, children of the Windrush Generation—Afro-Caribbeans who had been permitted to immigrate from the former British colonies to the United Kingdom to help rebuild the nation between the years 1948

24 Ibid.

25 Dave Dorrell, quoted in Bill Brewster and Frank Broughton, *Last Night a DJ Saved My Life: The History of the Disc Jockey* [1999] (New York: Grove Press, 2006), 428.

26 Noel Watson, quoted in ibid.

27 Noel Watson, "Noel Watson on Bringing House Music to London in the 1980s," originally published on DJhistory.com, May 2005, republished in *Red Bull Music Academy Daily*, January 7, 2019, https://daily.redbullmusicacademy.com/2019/01/noel-watson-interview.

28 Brewster and Broughton, *Last Night a DJ Saved My Life*, 429.

29 Matthew Collin and John Godfrey, *Altered State: The Story of Ecstasy Culture and Acid House* (London: Serpent's Tail, 1998), 160.

and 1973—were experiencing the industrial capitalism of a quickly modernizing postwar Western world. Along with them came an evolving Jamaican musical culture forged by Clement "Coxsone" Dodd,[30] Joe Gibbs, Osbourne Ruddock (King Tubby), and Lee "Scratch" Perry that included DJing and record selecting, as well as emcee battles backed by custom sound systems stacked up to twelve feet high to create subatomic bass and reality-shifting vibrations. "Dub is strange," explains Edward George, a British Caribbean writer and researcher. "Dub takes place through a kind of violence, an act of reducing archival audio documents to fragments and traces, yet is associated, in its sound system context, with communal reverie and meditative states."[31] George describes dub as a studious excavation of amplified audio. "And yet, in spite or perhaps because of its broad cultural resonance, dub has at its heart a concern with ideas of emptiness and silence, being and presence, space and repetition, and these ideas intersect with themes, especially in reggae, of Diaspora, and 'race', history and memory, longing and loss."[32] Mirroring the term "house" in Chicago was the concept of "specials," developed by sound engineer King Tubby—exclusive edits of imported US R&B music, and "dubs" made on multitrack mixing boards—and forming the basis for the modern remix in electronic music. Using his skills as an electronic technician, Gibbs worked with Perry and Dodd, producing "Hold Them" (1968) by Roy Shirley, one of the earliest examples of the transition from the accented rhythms and bass of ska to the slower tempos and offbeat patterns of rocksteady. Perry soon distanced himself from the group to start his own label, Upsetter Records, releasing "Run for Cover" in 1967 and "People Funny Boy" in 1968—two successive diss tracks aimed at Coxsone and Joe Gibbs, respectively.[33] Perry recorded six records with his house band, The Upsetters, between 1968 and 1972, combining many different styles and moods, including pulp narratives in *Return of Django* (1968), *Clint Eastwood* (1970), and *Eastwood Rides Again* (1970), and a cumulative solo release titled *Africa's Blood* (1971), gaining considerable attention in Jamaica and the UK. He also mentored Bob Marley and The Wailers for two years with The Upsetters, a collaboration that dove deep into the transcendental elements of their African roots.[34]

30 "He's obviously the founding father because he was the first to start recording popular dance music. Our first indigenous music was mento [a style of Jamaican folk music built on musical traditions brought by enslaved West Africans, most popular in the 1940s and '50s] but it wasn't as popular as the early things done by Mr Dodd, such as the shufflebeat and ska." Bunny Goodison, "'Father of Jamaican music' dies," *BBC Caribbean*, May 5, 2004, https://www.bbc.co.uk/caribbean/news/story/2004/05/printable/040505_coxsone-dodd.shtml.

31 Edward George, "The Strangeness of Dub," Morley Radio, 2019, https://morleyradio.co.uk/programmes/the-strangeness-of-dub-ep1/.

32 Ibid.

33 "An insult to his exploitative former boss Joe Gibbs, the track [People Funny Boy] was inspired by the sound and sense of spirituality Perry had experienced at Kendal Baptist Church. It opens with the sound of a baby crying—the first sample ever used in recorded music. It featured some of Perry's signature traits: a syncopated beat, reflecting traditional African Burru and Kumina drum styles; a strong electric bass; and guitars used not just for melody, but as a rhythmic element. It was one of the first songs that moved rocksteady into reggae. The single sold 60,000 copies and established Perry as a successful recording artist." Francesca Gavin, "Alpine Dub," *Kaleidoscope* (Fall/Winter 2020–21), https://www.kaleidoscope.media/article/lee-scratch-perry.

34 "[Bob Marley] was a little person, not giant in stature. But he'd learn about history and could understand

In 1973, Perry built the Black Ark recording studio, with circuitry designed by King Tubby, as a spiritual space of his own, where he could produce a new sound with drum machines, an Echoplex delay unit, a Roland space echo, and layers of overdubs recorded onto a four-track tape mixer.[35] His experiments at Black Ark were released through his label, Black Art; they display a deeper, more immersive exploration of sound that mines the literal depths of the audio devices he used and of the projective stereo field, with albums like *Cloak and Dagger* (1972), *Black Board Jungle* (1973), and *Revolution Dub* (1975). "I see the studio must be like a living thing, a life itself," Perry said of his music. "The machine must be live and intelligent. Then I put my mind into the machine and the machine perform reality."[36] Having his own studio allowed Perry to record whenever he felt the vibe; he proceeded to put out into the world a series of albums that featured curated vocalists, blended together and overdubbed with instrumentation, similar to Norman Whitfield's work with The Temptations at Motown. "I see myself rebuilding the temple of King Solomon," Perry stated, referencing the Rastafarian iteration of the tale of the tribes of Israel transporting the Ark of the Covenant to the promised land of Canaan. At the end of the production process, Perry would bless the final masters with marijuana smoke:

> I blew smoke because smoke it was the breath of life. If you have good breath, you can put it in the music. The breath of life God breathes in to man. If he says everything is perfect, everything is perfect. It can be perfect magic, perfect logic, perfect science. And even when you do the finance… So all the dollars, the cash, the riches, are coming back for my family, for my imperial family.[37]

Perry's music had an impact on Jamaica and the Windrush Generation, spilling over into mod and skinhead groups in the UK, who began incorporating ska, dub, and

everything, very fast. You'd tell him something and he'd pick it up instantly. We did a song called Duppy the Conqueror about conquering demons. I said: 'If you aren't going to conquer demons they're going to conquer you.' He listened and we did that song. Then we did the song Jah Live. We were talking about God—Jah Rastafari—and I just said to Bob: 'Jah live,' and he started singing it, instantly, and after that everything started to work good. He sang with my Upsetters musicians, but later on, some of the Upsetters became the Wailers who signed to Island Records, and that was that. Much later on, when he was ill, people told him to come and see me, a spiritual person, and I would tell him how to conquer the cancer. I really thought he would conquer the cancer, but he didn't come to see me and then something changed. Yeah. That's how life go." Lee "Scratch" Perry, in Dave Simpson, "Lee 'Scratch' Perry at 80: 'I Am a Prince and the Music Is the King,'" *Guardian*, March 21, 2016, https://www.theguardian.com/music/musicblog/2016/mar/21/lee-scratch-perry-at-80-birthday-reggae-interview.

35 "As soon as you have echo, listening has to completely change. Your ear has to chase the sound. Instead of the beat being this one event in time, it becomes a tail which is always disappearing round the corner and your ear has to start chasing it. If you're wearing headphones or a walkman it becomes a chase through the headphones. The Echoplex turns listening into running. You can't catch the beat, the tails of sound as they turn the corner, disappear down a corridor." Kodwo Eshun, *More Brilliant Than the Sun: Adventures in Sonic Fiction* (London: Quartet Books, 1998), 64.

36 Lee "Scratch" Perry, quoted in Jon Pareles, "Lee (Scratch) Perry, Bob Marley Mentor and Reggae Innovator, Dies at 85," *New York Times*, August 30, 2021, https://www.nytimes.com/2021/08/30/arts/music/lee-scratch-perry-dead.html?smtyp=cur&smid=tw-nytimes.

37 Simpson, "Lee 'Scratch' Perry at 80."

reggae into their music scenes—Perry even featured on The Clash's self-titled debut album in 1977. Perry eventually burned Black Ark down in 1983 to exterminate negative spirits he felt had inhabited the studio, before leaving Jamaica to spend time in the UK and US. "There was some bad energy, because my intention was to help poor people and most of the people were in poverty," Perry explained. "So I was taking their poverty and giving them my energy, but they remained poor. All I wanted to take from them was their demons. So burning up the studio was a way of burning the demon, burning up the bad luck that had come to the people who lived in Jamaica."[38]

Tuned into the creole culture spilling out of the Black Atlantic and aligned with Perry's mythscience of the mixing desk,[39] the Dread Broadcasting Corporation operated from 1980 to 1984 as Britain's first Black-owned radio station, which Polish Nigerian DJ Camilla Obinyan argued during a meeting with the House of Congress was an alternate means of hearing and distributing culturally diverse music outside of the mainstream music industry. In 1986, radio broadcaster Lindsay Wesker helped to legalize the pirate radio station, Kiss FM, before taking over the position of Head of Music. "The UK Black music scene was absolutely buzzing," Wesker remembered. "There were tons of pirate radio stations, the clubs were full, the record shops were doing brisk business and the UK acts were really starting to make noise."[40] Responding to the imported reggae, pop, soul, calypso, funk, and hip hop songs that were becoming more readily accessible across the six-hundred-plus pirate radio stations in operation, a new wave of independently produced soul music surfaced in UK inner-city communities as the decade went on. Alongside this, imported vinyl from across the Atlantic contributed to the burgeoning cultural scene.

Pre-acid house, the UK maintained a cultural division between the northern and southern regions, but pirate radio DJs like Norman Jay and his *Original Rare Groove Show* on Kiss FM gradually bridged the gap. Though the UK census does not categorize the population by race, the 1961 iteration showed that 161,000 people were marked as born in the Caribbean.[41] Immigration into the Commonwealth ultimately filled in the declining post-industrial labor force, but created, in turn, a schism in British class politics that resulted in a clash of migrating cultures erupting in the Notting Hill race riots of 1958; the riots across Birmingham, Leeds, Liverpool, London, Manchester, and Nottingham in 1981; and the Brixton and Broadwater Farm riots

38 Ibid.

39 "Far from Rastafari's flat-earth metaphysics, its fundamentalist blood and fire, Lee Perry's productions and theory fictions open up an entirely new field: the MythScience of the mixing desk, The Upsetter taps into the secret life of sound machines, opens the cybernetics of the studio." Eshun, *More Brilliant Than the Sun*, 62.

40 Lindsay Wesker, quoted in in Kyra Hanson, "How Black Pirate Radio Stations Revolutionised London's Music Scene," *Londonist*, n.d., last updated January 4, 2021, https://londonist.com/2015/09/how-black-music-pirate-radio-stations-shaped-london-s-music-scene.

41 United Kingdom General Register Office, 1961 Census database, National Archives website, https://discovery.nationalarchives.gov.uk/details/r/C15558.

of 1985, among others. In direct contrast to the cultural conflicts between native and immigrant populations playing out across the UK,[42] the import-heavy Northern Soul scene of the '60s helped spread an image of Black American industrialized culture as a consumable aesthetic and profit generator, which in many ways opened up a shared space and culture for multi-ethnic groups. Norman Jay tapped into what he referred to as the UK's "appreciation society," which had developed around imported American jazz, R&B, and Motown records, paving the way for a new genre—a mirror image of "quiet storm" in the US.[43] "'How many records have you got? I don't care and I don't know, that's not relevant to me," Jay commented on the hobbyist vinyl collector culture of the Northern soul scene.[44] "The only way to have old records is to buy them new, I've always bought new tunes, been interested in new music, which eventually becomes yesterday's history, rare groove."[45]

In his 1993 study of the double consciousness that emerged in African diasporic communities in the Black Atlantic, Paul Gilroy writes that, "The experience of Caribbean migrants to Britain provides further examples of complex cultural exchange and of the ways in which a self-consciously synthetic culture can support some equally novel political identities."[46] Gilroy reexamines the Black Atlantic trade routes as a site for reallocating the African diaspora through the distribution of citizens and goods. "The cultural and political histories of Guyana, Jamaica, Barbados, Grenada, Trinidad, and St. Lucia, like the economic forces at work in generating their respective migrations to Europe, are widely dissimilar," he writes.[47] Within this framework, African American media culture, inherited and enhanced by post-Emancipation Afro-Caribbean settlers,

42 "The issue of the identity and non-identity of Black cultures has acquired a special historical and political significance in Britain. Black settlement in that country goes back many centuries, and affirming its continuity has become an important part of the politics that strive to answer contemporary British racism. However, the bulk of today's Black communities are of relatively recent origin, dating only from the post-World War II period. If these populations are unified at all, it is more by the experience of migration than by the memory of slavery and the residues of plantation society." Paul Gilroy, *The Black Atlantic: Modernity and Double Consciousness* (Cambridge, MA: Harvard University Press, 1993), 81.

43 "I was the one who coined the phrase rare groove. I had no idea the show was becoming as influential as it became, because the first generation of UK hip-hop makers, a large number of them were listening to my shows. And they were actually educating me as well, because I was playing a lot of these funky, jazzy, rare-groove-style records, which in essence were proto-hip-hop records. These guys would contact me and say: 'What's that break you were playing?' 'Break, what's a break?' I realized I had a shed full of those records that they could sample breaks from." Norman Jay, lecture, hosted by Emma Warren, Red Bull Music Academy, London, 2010, https://www.redbullmusicacademy.com/lectures/norman-jay-public-mbe-no-1.

44 "More than anything, the Northern soul scene was for collectors, and was born of a strange situation in the 60s and 70s, when DJs from the UK would go over to America and buy huge batches of records that hadn't sold. But these young British DJs were also shrewd entrepreneurs—they had identified a market, and it would be years before the labels got savvy to what they were doing: buying stock and reselling it as hard-to-find imports from America to a hungry audience of white people in the north of England and making a fortune in the process. These tracks, often unbeknown to the artists and record labels, would become huge underground club hits." Pitts, *Afropean*, 29–30.

45 Jay, lecture, hosted by Warren.

46 Gilroy, *The Black Atlantic*, 82.

47 Ibid.

called for a new pattern of nationalism to be established—one that built off of the particularities of the American chattel slavery economy and post-Emancipation legal status of "Black," and encompassed nearly 6,000 Negro slaves escaped from the Southern plantations to the Bahamas through an Atlantic coastal waterway called the Saltwater Railroad.[48]

From these fugitive interactions and the mass telecommunicative distribution of African American soul, sold as a commodity labeled "music," Gilroy turns to "reggae, a supposedly stable and authentic category, [as] a useful example here. Once its own hybrid origins in rhythm and blues were effectively concealed, it ceased, in Britain, to signify an exclusively ethnic, Jamaican style and derived a different kind of cultural legitimacy both from a new global status and from its expression of what might be termed pan-Caribbean culture."[49] He continues: "Appearing in Britain through the circulatory system that gave a central place to the musics which had both informed and recorded Black struggles in other places, they were rearticulated in distinctively European conditions."[50] Gilroy's insistence on a "politics of authenticity" in many ways retroactively reconnects the shards of African cultural and religious expression that were injected into the UK and Europe's electronic dance music scenes— themselves sub-economies of the global recording music industry—at the same time as mass-produced illegal psychedelics spread and economic inflation rose within the post-industrial, modernized Western colonial empire:

> How the appropriation of these forms, styles, and histories of struggle was possible at such great physical and social distance is in itself an interesting question for cultural historians. It was facilitated by a common fund of urban experiences, by the effect of similar but by no means identical forms of racial segregation, as well as by the memory of slavery, a legacy of Africanisms, and a stock of religious experiences defined by them both. Dislocated from their original conditions of existence, the sound tracks of this African-American cultural broadcast fed a new metaphysics of Blackness elaborated and enacted in Europe and elsewhere within the underground, alternative, public spaces constituted around an expressive culture that was dominated by music.[51]

48 Nicole Campbell, "The Saltwater Railroad (1821–1861)," BlackPast.org, April 25, 2020, https://www.blackpast.org/african-american-history/the-saltwater-railroad-1821-1861/.

49 Gilroy, *The Black Atlantic*, 82.

50 Ibid., 83.

51 Ibid.

Black music would become part of a transatlantic, cultural-industrial "circulatory system" described by Gilroy, stemming from the establishment of "race music" as a faction of the early American recording music industry in the 1920s and '30s through to Berry Gordy's Motown "Hit Factory." The Black popular culture being imported from America took root in the UK, influencing a wave of music that helped identify the cultural distinctness of Black experiences within the British postindustrial empire. British Nigerian computer programmer Toyin Agbetu collected Motown and other American soul, jazz, and funk records and noticed the prominent usage of the Roland 808 in much of the music he liked. "[All of them] had the words 'Produced by Jimmy Jam and Terry Lewis' printed on them," he said of the electronic funk musicians who had upstaged techno in the US with big-budget studio productions for artists like Janet Jackson, the S.O.S. Band, Cherrelle, Alexander O'Neal, and Change. "As a musical movement, our history was linked to our U.S. counterparts, but we also had our own distinct identity," Agbetu reflected, considering the mutual influences that the American pop music machine and the locally distributed home studio street soul in the UK had on him, as he went on to establish multiple record labels and music projects throughout his life.[52] In 1988, Agbetu and his friend Earl Myers released the album *Rough & Ready* under the name Soul Connection, expanding on Jam and Lewis' adult contemporary pop music format by including breakbeats and acid lines. "I had fallen in love with an album by Loose Ends called *Zagora*," Agbetu recalled, describing the high-production output of this band in the context of mid-'80s R&B soul. "Loose Ends was a highly visible, immaculately presented, slickly produced, all-African-heritage group that did not compromise on their musical roots. This was significant: They were not a funk band, they were Britain's first major soul-jazz band." His own shoestring budget productions consisted of basslines made on a Roland SH-101 and Juno 106, with melodic parts recorded on a Yamaha TX7 and Akai S950, combined with 808 drums patterned after Jam and Lewis' style of electronic soul. He remarked: "Our tracks were protests against excess, our independence a cry for self-determination."[53]

Raised in Hackney Central, London, by a single father, Agbetu attributes his taste for soul music and his career as a Pan-African social activist to early moments in his childhood home.[54] "One of the greatest things he [Agbetu's father] did though,

52 Toyin Agbetu, quoted in Andy Thomas, "A History of Street Soul, the Sound That Swept the UK Underground," *Bandcamp Daily*, November 19, 2020, https://daily.bandcamp.com/features/uk-street-soul-history.

53 Ibid.

54 In 2007, Agbetu interrupted a service at Westminster Abbey commemorating the 200th anniversary of the abolishment of the transatlantic slave trade in 1807, attended by the Queen and Prime Minister Tony Blair. Agbetu condemned the event, yelling directly at the Queen before being arrested by security: "You should be ashamed. We should not be here. This is an insult to us. I want all the Christians who are Africans to walk out of here with me!" That same year, he wrote in the *Guardian*: "I then turned to Tony Blair and told him he ought to feel ashamed for his behaviour. Blair quickly averted his gaze. The rest of what I said was directed to the members of my own community who were present. I don't believe it was right for us to have remained in a venue in which the British monarchy, government and church—all leading institutions of African enslavement during the Maafa—collectively refused to atone for their sins." Toyin Agbetu, "My Protest Was Born of Anger, Not Madness," *Guardian*, April 3, 2007, https://

which set me up for life, was every Sunday—I don't know why he picked Sunday, he was a Muslim, he didn't go to church—he would play Afrobeat," Agbetu reminisced. "I'd hear King Sunny Ade and Fela Kuti. These words of empowerment, of pride and culture, just seeped into my consciousness throughout my whole childhood."[55] Though he was unaware of the politics of Afrobeat, developed in the late 1960s by Fela Kuti and drummer Tony Allen, Agbetu says that "as a young adult, I suppose I was always a soul head, that's what we used to call ourselves back in the day. So even though I liked my reggae and boof-boof [sound-system/dub], it was always soul that drew me more than anything else." Pirate radio stations would dramatically expand his musical range:

> I was just transfixed, thinking, "What on earth is that!" I had found a jazz-funk station, Invicta. And that tune was Level 42's "Star Child." So I took this detour from soul through to funk. My father already had introduced me to funk, I'm talking stuff like Bootsy Collins, Isaac Hayes, Earth, Wind & Fire and The Brothers Johnson, he'd kind of already grounded me in that, but then there was Brit-funk. And that kind of helped a lot. It wasn't so political, but then I had a love of hip-hop, and the political stuff came through there.[56]

The UK street soul sound quickly spread from city to city through legal and pirate radio stations, developing the most in Manchester, where a club called The Gallery opened in the early 1980s as an underground urban alternative to The Haçienda and other venues in the city's center. The Gallery's resident DJ, Soul Control—a group, formed in 1984, composed of Junah Bailey, Robert Brown, and Delroy Edwards—had installed their own 10,000-watt double-bass sound system in the space. Soul Control rivaled another sound-system group called Soul II Soul (Jazzie B, Nellee Hooper, Rose Windross, Do'reen and Caron Wheeler),[57] which mixed creole with hip hop breaks, acid house, and R&B with their own dub plates to produce a blended, bass-heavy

www.theguardian.com/theguardian/2007/apr/03/features11.g2. See also David Smith, "You, the Queen, Should Be Ashamed!" *Guardian*, March 27, 2007, https://www.theguardian.com/uk/2007/mar/27/race.world1.

55 Toyin Agbetu, interview by Theo Fabunmi-Stone, "Who Is Toyin Agbetu? A Conversation with the Godfather of Street Soul," *Resident Advisor*, August 25, 2020, https://ra.co/features/3733.

56 Ibid.

57 "Soul II Soul may be best known for a string of international hits—'Back to Life,' 'Keep On Movin',' *Club Classics Vol. 1*, 'A Dream's a Dream' and so on—but this is merely a reflection of their greater achievement: to legitimize unadulterated street sounds and styles in a way the mainstream industry couldn't ignore. Led by frontman Jazzie B, they instigated an underground-meets-mainstream situation, to set up the kind of DIY, street-driven musical revolution the British music business hadn't seen since punk. This more than anything else, paved the way for styles such as jungle, dubstep and grime to develop and flourish free from corporate interference. Soul II Soul triggered this shake up by leading a generation of London soundsystems away from the predominant notion of apparently-threatening "dungeon session" reggae dances, all the while maintaining the spirit of the operations as a philosophy rather than merely a means to play records. A tricky balance, but a pretty straightforward procedure: they stayed totally true to the workings of soundsystems as they came to the UK from Jamaica in the '50s—impenetrable as these machinations often appear." Lloyd Bradley, "Soul II Soul's Enduring Influence on the Music of the UK," *Red Bull Music Academy Daily*, July 9, 2013, https://daily.redbullmusicacademy.com/2013/07/soul-ii-soul-feature.

UK sound at the legendary night club called The Africa Centre in London's Covent Garden. Entrenched in the Northern England club scene, Gerald Simpson partied at both The Haçienda and the Jamaican sound-system parties in Manchester's Moss Side neighborhood, where he saw Foot Patrol and the Jazz Defektors perform amongst an ethnically mixed crowd.[58] During the early 1980s, Simpson studied contemporary dance, but eventually left school to pursue a career in electronic music, just as hip hop, electro, breakdancing, and b-boy culture were making their way from the US to the UK. "My major influence was Black music when you used to be allowed to call it Black music," Simpson explained. "James Brown, Stevie Wonder, Michael Jackson & The Jackson Five, Funk, Soul, Dub Reggae and Jazz."[59] He noted the environment he grew up in as a direct influence: "It was boring as shit in Manchester and dangerous so there was nothing else to do. It kept me out of trouble and I didn't have to look up to anybody, just focus on my own ideas." He continued, "The only entertainment was the music and dancing at places like Legends, Sandpipers, The Reno and Jamals. There was a night every day of the week when I was in my teens and then there was The Haçienda when Greg Wilson started playing there and brought all the crowd with him."[60]

Simpson saw Manchester's Black underground scene as "a perfect concoction of the technology and the musical structure creating an irresistible compulsion to dance."[61] At The Haçienda, Mike Pickering's Friday night party Nude paralleled the Moss Side gatherings, which over time began to overlap culturally. Graham Massey, formerly a member of Danny and the Dressmakers and the Manchester punk band Aqua, attended the Nude parties. "Friday nights were a lot more black, yet much more to my taste in the jazzy area," Massey observed; "people that took dancing seriously in that jazz dancing kind of way."[62] According to Pickering, "a young kid from Moss Side" gave him a copy of Adonis' "No Way Back" (1986) to play while he was DJing.

58 "Foot Patrol can lay claim to being the original House music foot shufflers (although some people nowadays look across the world to cite Australia and 'The Melbourne Shuffle' as the starting point in the late '80s), their style is traceable back to the Jazz-Funk scene of the late '70s / early '80s, and the 'fusion crews' that challenged each other (it was from these crews that many of the UK's archetypal breakdancers emerged, having already developed the athleticism to attempt the dynamic moves demanded)." Greg Wilson, "How House Music Really Hit the UK," *Fac51-The Hacienda*, June 18, 2013, https://www.fac51-thehacienda.com/greg-wilson-how-house-music-really-hit-the-uk/. The Jazz Defektors are a British jazz-dance band that released a self-titled album on Factory Records in 1987, and featured in the film *Absolute Beginners*, directed by Julien Temple (London: Goldcrest/Palace Pictures/ Virgin, 1986).

59 Gerald Simpson, interview by Alexandra Leo on Pulse Radio, "A Guy Called Gerald: 'I Am A Futurist'," December 15, 2014, transcribed on A Guy Called Gerald Unofficial Web Page, http://homepages.force9.net/king1/ Media/Articles/2014-12-15-Pulse-Article.htm.

60 Ibid.

61 Vivienne Bellamy, "A Guy Called Gerald Unofficial Web Page: Biography," force9.net, http://homepages. force9.net/king1/Biography/2010Biography.html.

62 Graham Massey, quoted in Wilson, "How House Music Really Hit the UK."

When he did, "the club went crazy."[63] Pickering and Simon Topping, who were both in the Factory Records band Quando Quango, used Adonis' song and Tito Puente's Latin jazz drumming as inspiration for their song "Carino"—effectively the first UK house track.

While digging for records towards the end of the decade, Simpson discovered the music of Juan Atkins, Derrick May, and Kevin Saunderson, which was being played by Stu Allan on Piccadilly Radio and was stocked at record shops like Eastern Bloc, which specialized in imports. Much like techno in Detroit, UK street soul came from youth gaining access to consumer electronic instruments like the Roland TR-808 and 909. Simpson partied in both Moss Side and at The Haçienda; shopping at Eastern Bloc, he met the store's owner, Martin Price, and Massey, also a customer. With Eastern Bloc as a reliable income generator, Price financed music projects, starting with the hip hop group Hit Squad MCR, which released a single track, "Line of Madness," on a split vinyl with the MC and DJ crew, The Shure 4, and Simpson's collaboration with Nicky Lockett as the S-B-M (Scratch Beatmasters) & MC Tunes in 1988. Later that year, Simpson, Price, and Massey formed their group 808 State, after the Roland drum machine, and released their debut album *Newbuild* on Price's label, Creed Records. Though the album was recorded directly to old tape that had been cut up and discarded in a dumpster behind the BBC studio building in Manchester, *Newbuild* reengineered the Chicago acid house sound by upgrading its bedroom-studio origins to a full-scale recording studio, installed inside of The Haçienda and used after hours. "The 808 sound is to do with, like, not having any real instruments in it, hardly at all, and it's complete machine sound," Massey explained. "Basically these machines allowed us to make Black music for the first time, you know, and not actually having a sense of rhythm or anything, but basically with a drum machine you can get funky straight away."[64]

In 1989, Simpson, the sole Black member of the trio, started work on a track that Massey and Price finished without informing him, released as a single titled "Pacific State"; it gained mainstream success, appearing on the UK charts for eleven weeks and reaching number 10 on the UK Singles chart. Simpson subsequently departed from 808 State as they released the EP *Quadrastate* and the album *90* (both 1989), on which he is credited as writer and producer. Simpson retold the story in a 2010 lecture:

> I was more into being a studio kind of person. I was more into the electronic side and wanted to experiment more. There were parts of the group—not Graham, because he was also part of the same thing—but he wanted to create... I wanted to do more experimental music, which I started out doing, and the kind of ethos of 808 State had changed. They wanted to become a pop band, and I was actually

63 Ibid.

64 Massey, in *Madchester*.

really against becoming a pop band, because I wasn't into that kind of thing. So, I went my separate ways and started to do my own underground thing. That actually ended up in the charts, so it was kind of strange in a way. We still ended up meeting in a strange situation. We fell out, anyway, over this situation, and in the end we ended up becoming friends again later on. I actually see them every now and again around Europe or whatever. I'll bump into them sometimes and do revival stuff. 808 State are part of the Manchester scene, and also part of the Haçienda sometimes, and Peter Hook does Haçienda things, so we'll meet up and we're good friends. I actually learned a lot from Graham, and I think Graham learned a lot from me. We were doing an "each one, teach one" kind of thing because he got schooling from a recording/engineering school, and I showed him the rough guide to hooking synths up and how to wire things, in a way.[65]

Simpson decided to remove himself from the dance music scene, adopting the moniker A Guy Called Gerald, and equipping himself with keyboard synthesizers, FX pedals, and a Tascam four-track recorder. He set up a home studio with his mom's stereo and charted a path to making his own electronic music, which encompassed and combined elements of the jazz fusion, street soul, and creole culture that he had grown up around. "The more equipment I got, the more I learnt about the art of synching it up," Simpson recalled of his isolated experiments, reflecting on what acid house and techno meant outside of the clubbing and drug culture of the UK rave scene. "When hearing about acid house for the first time without having a clue about drug references, he initially understood "acid" as a technical term. I thought they must have meant p-funk which was put into a batch of acid and all the melodies were burned out of it."[66] Out of this conjecture came the album *Hot Lemonade* and the EP *Voodoo Ray* (both 1988), with an eponymous single that reached number 12 on the UK Singles chart, selling out its five hundred copies in one day. He also provided the cassette soundtrack for *Trip City*, the "first rave novel," written by Trevor Miller about London's underground nightlife scene and the proliferation of a fictional drug, FX, which gave its name to a song that appeared on Simpson's 1990 album *Automanikk*, featuring additional production by May.[67] While on tour in the US in 1990, Simpson met May in Detroit and worked on music with him in a studio. "It wasn't really fun being in Detroit city. I could see the influences," Simpson said of his time in the city, now a decade into its collapse. Though the UK and Manchester had also suffered the side effects of postindustrialism, Detroit's environment was something of a revelation for Simpson. "[Techno] is like

65 Gerald Simpson, lecture, hosted by Torsten Schmidt, Red Bull Music Academy, London, 2010, https://www.redbullmusicacademy.com/lectures/a-guy-called-gerald-ring-gerald.

66 Gerald Simpson, interview by Jaša Bužinel, "My Own Jazz: An Interview with A Guy Called Gerald," *The Quietus*, July 29, 2021, https://thequietus.com/articles/30267-a-guy-called-gerald-interview-2.

67 "To technofy is to turn the automatic sequence into what A Guy Called Gerald terms an automanikk track. Far from being mechanically predictable, the automatic becomes manic. The gated-noise kick of the Roland 808 and 303 machines, their signature hardstrike, causes language to onomatopoeize the 'c' into 'kk'. With Techno the machine goes mental." Eshun, *More Brilliant Than the Sun*, 107.

dance music, but really electronically based," he affirmed.[68] Going to the US had a major impact on his outlook: "As I was growing up and listening to a lot of American music I was trying to mimic that kind of vibe, you know? You don't really hear what you're adding to it until you go to that place and find out that it doesn't really sound like their thing at all."[69] Simpson explained:

> I am a futurist. The whole system has glorified the DJs and the system implodes on itself because it's all clogged up with it's [sic] own regurgitation. There are no original ideas coming into the mix. The original electronic dance music producer does not exist in his own right outside of the word "DJ," who actually only plays and consumes the music. It seems to me that most people think this music is only made by "DJs." It's a real misconception. But I am looking forward to seeing a Manchester crowd again. They always lift a place.[70]

As they worked together on tracks for *Automanikk* in the studio, the sessions "got a little funky," May recalled, comparing the end result to a "rough, beautiful" diamond that should be appreciated as art. "His music is the most important thing to him as it is to us," May adds. "It's strange that he fits into this area over here with us. Maybe it's the DNA and the water, I don't know."[71] Simpson found Detroit's environment to be harsh and barren, but valued that emptiness, in which he could envision music with no distraction. "There's loads of people who have been influenced by Derrick May," Simpson says, "but I know that there's no denying it, like, dance music comes from America."[72]

<p style="text-align:center">*</p>

In the 1990 edition of the New Music Seminar held at the Times Square Marriott Marquis, the tersely named panel "Wake Up America, You're Dead!," seemed to catalyze the tense and welling frustration and disillusionment beginning to play out amongst the first generation of techno producers. On January 2, the Dow Jones Industrial Average—the stock market index that measures the national stock performance of the thirty largest companies in the United States—closed above average for the first time ever, presumably a direct effect of the large tax cuts and free-market spending and acquiring initiatives of the Reagan era. The American entertainment industry, by proxy, increased budgets and production value as the compact disc began to surpass both cassette tapes and vinyl in revenue growth. On the ground, the wealth

68 Simpson, in *Madchester*.

69 Gerald Simpson, interview by Edward Moore, *Jocks & Nerds*, November 24, 2014, http://homepages.force9.net/king1/Media/Articles/2014-11-24-JocksAndNerds-Article.htm.

70 Simpson, interview by Leo, "A Guy Called Gerald."

71 May, in *Madchester*.

72 Simpson, in ibid.

gap between the Black and white population had also increased significantly: according to a 2016 survey of Consumer Finances by the United States Federal Reserve Board, the median family wealth of white American families grew from approximately $120,000 to $170,000 per year between 1992 and 2001, before the recession that occurred in the wake of the 9/11 terrorist attacks, while Black and Hispanic Americans remained well below the $50,000 range during that same time.[73] Feeling elated from the significant highs in the power of the US dollar and the lower overhead production costs of compact discs, major record labels began to take more risks on talent and promotion, giving rise to the mainstream explosion of bicoastal African American hip hop, which had, by then, reached a fever pitch as a result of the tense social and economic effects of the thirty years following the Civil Rights Movement. Covering the eleventh edition of the New Music Seminar[74] for the *Chicago Tribune*, rock music critic Greg Kot remarked that:

> From the heat beating off the pavement to the angry lyrics and music welling up from the clubs, the recent New Music Seminar in New York City wasn't so much a celebration of new music as a demonstration of how difficult it is to make it these days. . . . Music, like all creative expression, feeds off the society that created it, for better or worse. No wonder the seminar's myriad panel discussions often stank of politics and ill will, a battleground where self-righteous voices were raised in anger and accusation. Some of them actually made sense, even if the messages they bore were hardly soothing.[75]

Kot quoted Ice-T's mantra-like statement "Lawyers, money and war"—a reaction to the controversy, media representation, public response to, and political censorship of hip hop and the culture and conflicts that it emerged from. Ice Cube had to leave the conference early after a fight broke out between his group Da Lench Mob, aided by Zulu Nation, and the hip hop group Above the Law, over gang-related grievances and a rivalry around the record label Ruthless Records, which signed Above the Law after Cube left NWA.[76] Though the topic of rap music monopolized much of the New Music Seminar's attention through the early '90s, dance music also featured, and saw its own controversy unfold at the conference. The provocatively titled panel "Wake Up America, You're Dead!," convened by Tony Wilson of Factory Records and The Haçienda to address the rise of the global dance music industry, brought together an

73 Board of Governors of the Federal Reserve System, 2016 Survey of Consumer Finances, https://www.federal-reserve.gov/econres/scf_2016.htm.

74 The New Music Seminar was started in June 1980 by a group of record industry executives—Tom Silverman, Mark Josephson, Joel Webber, Danny Heaps, and Scott Anderson—who gather two hundred people in a rehearsal studio in New York City to discuss the state of the music industry in the US.

75 Greg Kot, "Harmony 'n' Discord," *Chicago Tribune*, July 29, 1990, https://www.chicagotribune.com/news/ct-xpm-1990-07-29-9003030679-story.html.

76 Dkelsen, "The Truth Behind Ice Cube's Legendary Brawl With Above The Law," *OC Weekly*, September 7, 2016, https://www.ocweekly.com/the-truth-behind-ice-cubes-legendary-brawl-with-above-the-law-7490822/.

unlikely confluence of experts: in addition to Marshall Jefferson and Derrick May, it consisted of Robert Ford, former hip hop reporter for *Billboard* and early adopter of rap music; Screaming Rachel, a white Chicago DJ and self-proclaimed "Queen of House Music"; Nathan McGough, manager of the English rock band Happy Mondays; Paul Dennis, who ran nightclubs in London; and Keith Allen, an actor and expert on drugs and drug culture from the Post-Freudian Therapy Center in Geneva, Switzerland. The group was skewed against May and Jefferson. "It's so strange in America," Allen said, describing how conservative Americans were when it came to drug usage. "You're so embarrassed about fucking drugs aren't you? It didn't do Guns N' Roses any harm."[77] He seemed to know nothing of, or care little about, the war on drugs being waged against the very communities that May, Jefferson, and varying members of the hip hop scene had been born and raised in.

The Black Midwestern producers defended their incarnation of Black music. May stated outright that "Dance music is dead when a guy like (Manchester artist) Adamski goes to No. 1 on the charts."[78] Kot's review took up this quote, acknowledging that "Though house music was born in Chicago and nurtured in Detroit and New York, late-arriving Manchester acts such as Adamski, Happy Mondays and 808 State have turned it into a fashionable, money-making commodity."[79] Provocations like Allen's started as soon as the panel was convened: in his opening remarks, Wilson tapped into the dramatic and leading humor he'd honed through his career as a television presenter, asserting what he saw as the negative cultural effects of the merging worlds of American and British culture:

> I'd like to begin with a quote. The quote is: "The kids wanna dance." That does not come from Manchester or Madchester 1989 or The Haçienda or Ibiza in 1987; it comes from the Family Dog in San Francisco in 1964. You used to know how to dance here. God knows how you fucking forgot.

> What people in America don't seem to know is that the music which has come out of Chicago and Detroit in the last 10 years has so changed British pop music—not only dance music but also rock music—that now, if you're a British rock group and you cannot play rock music in the style to which you can dance and with the rhythms that have come out of America but that have been ignored here, then you aren't a rock group that matters. You're dead.

> There are groups that American A&R men go berserk over—The Sundays, The House of Love, people like that who, in England, are so marginalised that

77 Keith Allen, quoted in Steve Sutherland, "New York Story: Wake Up America, You're Dead!" *Melody Maker,* August 4, 1990, http://dewit.ca/archs/JD/New_York_Story.html.

78 Derrick May, quoted in Kot, "Harmony 'n' Discord."

79 Ibid.

they're completely irrelevant. It's a strange situation to be living in a country like that and then to come over here—which is why this panel is called "Wake Up America, You're Dead!"[80]

While Jefferson and May were able to recount some of the history of the beginning of house and techno and describe the troubles they'd encountered during distribution negotiations with record labels, the war of words continued throughout the panel. Jefferson and May were faced with a diluted, mutated, and abstracted version of the music they had had a hand in putting out into the world. Wilson lobbed more insults, challenging the house and techno producers' marketability—"If you can play a kazoo in Manchester you get signed these days"[81]—before offering a blatantly revisionist account of how the electronic dance music industry had reached the United Kingdom. He claimed that its sources were Mike Pickering, a DJ at his Factory Records' club The Haçienda, and Graeme Park, a buyer for the Select-a-Disc record store in Nottingham, England, who bought and imported Chicago house music records and later played them in his DJ sets at the Garage and The Haçienda in the late 1980s. In 1988, Pickering and Park had compiled and released *North - The Sound of the Dance Underground*, a month after *Techno! The New Dance Sound of Detroit* and two years after the *House Sound of Chicago* came out. *North* featured the famed "Voodoo Ray" track by Gerald Simpson (as A Guy Named Gerald), among others. In the liner notes, Park identified the producers he had gathered in the compilation as the "people [who] have helped establish the northern clubs as the home of house."[82] The underground house music made by English producers found in the compilation had diverse influences, including the African American genres of hip hop and acid house they had largely copied. Those sounds had filtered into northern England in the summer of 1986, introducing the region to two divergent strains of third-wave sounds emerging from Black techno rebels. Park concluded their liner notes for the *North* compilation with a discernible sense of hopeful idealism:

> The northern house continues to grow and be influenced by a number of diverse styles. Like hip hop, the genre is here to stay and will develop. Trends come and go and soon fashion will be dictating a new soundtrack for some clubgoers, but in the north the house scene now resembles the northern soul scene in terms of its dedication and fanaticism. Almost three years ago the north adopted house and "north" sees its coming of age. As long as house music packs the dancefloors with sweaty bodies then the story of "north" will continue . . . this one will run and run.[83]

80 Tony Wilson, quoted in Sutherland, "New York Story."

81 Ibid.

82 Graeme Park, sleeve notes, *North - The Sound of the Dance Underground* (Deconstruction Records, 1988).

83 Ibid.

Allen, the world drug expert on the panel, picked up the story, lunging into a shocking diatribe about the history of ecstasy, the drug fueling the dancefloors: "'The basic psychology was in 1987 in a club called Schoom, I had a load of Ecstasy topped off with a little amyl-nitrate sort of sex-inducing vibe and I would give people one of these tablets and they would give me £20. That's psychology."[84] Allen burrowed deeper into America's judgmental perspective on drug usage, describing how he'd managed to gain a transcendental perspective. Screaming Rachel abruptly cut him off: "I'd like to say something concerning the drug. I don't wanna sound sick and wimpy, but a lot of the Chicago people thought that acid was this natural high that you got from listening to this music." Allen found the concept amusing, but responded that he didn't believe in "natural highs," stating flatly: "I think you should pay for it." Wilson interrupted, beginning on the subject of Ibiza and how vacationers and expats took in house as the music of "free love." Wilson interrupted again:

> I went into my club, The Haçienda, two weeks ago and one and a half thousand 18-year old kids were going mental, dancing like crazy to Northside, to Mondays, to Marshall Jefferson, to Derrick May, to Pink Floyd, to The Beatles . . . I've never seen anything like it in my life and I felt old for the first time. The wave is that strong. I think if we talk about the fulcrum moments, one was when the Balearic all-night Ibiza dance attached itself to house music in the beginning of '88 and the other great moment was when people like Ronnie and Paul Ryder, the drummer and bass player of Happy Mondays, began to be able to put the dance rhythms out of Chicago and Detroit into rock music. They soon became the first generation of British groups with the Roses and Inspiral Carpets and now there's a dozen or more.

Nathan McGough, the manager of Happy Mondays, added context: "We're not really trying to play house music with your traditional rock instruments. It's more that house music became the backdrop and the setting for the club culture which then focused and determined the new attitude and the new culture of British youth which Happy Mondays then took and expressed as a group and, through that, became the focal point, the anti-heroes for the new youth culture." Robert Ford, the early hip hop journalist, cut in with a much-needed sober statement: "So, in other words, your boys are drug dealers, they're not musicians." McGough responded, "Correct." Getting somewhat defensive, Wilson pointed out that the British youth were having the time of their lives—it didn't matter where the psychedelics that fueled the Summer of Love came from. He chided: "I don't see any kids in fucking America having the time of their lives." McGough remarked that 80% of the top 40 British Billboard charts were dance records that drew their sound from Chicago and Detroit musicians, but that their British counterparts had gained significant airtime on daytime radio and were as

84 Allen, quoted in Sutherland, "New York Story." All subsequent quotes from the conversation are taken from Sutherland's account of the event.

marginalized as the communities that originally produced house and techno. "I think that is a prime thing to say to America," Wilson rebuked:

> The New Music Seminar began about a whole host of American and English groups who were still marginalised. This was a cult thing, our music, y'know... The Cure, Joy Division, Talking Heads... they were still marginal things in 1980 when we began. This thing in England and Europe is not marginal. As Nathan says, they're the only records that fucking sell in large numbers in England and in Europe. This is what has happened, the music and the rhythms that you lot created have changed British and European pop music, it's changed Australian pop music, it's happening in Japan, all over the world. Do you find it strange that it isn't strong in America, or as strong as it obviously is elsewhere?

May exploded, presumably confused by all the entitlement being wielded in this clash of cultures:

> Let me tell ya something. Dance music has been fucked up. You've got all these motherfuckers who don't know shit about where the shit comes from, they don't have no fucking idea what the fuck is happening and they're making money and they're fucking up the scene. Dance music is dead. I hate to say it. I do it for a living. I love it. I do it as an art, okay: But I know that when I have to sit back and see some bullshit Adamski shit... that's bullshit. On the charts! Number F-ing One! Okay?

Wilson replied that the Rolling Stones and the Beatles must have "sounded pretty shitty to the real R&B people," but that without those two British bands, "you'd never have even known you had R&B in America." May, flustered, replied bluntly that the music industry was a dictatorship that only bent to difference and truth when they proved themselves to be financially viable, "It took some particular bureaucrat to give a nigger a chance. That's the bottom line to that, okay?" He continued:

> We can kick you in the ass, but guess what? You gonna stab us in the fuckin' back! All right? So don't tell me. We—and when I say we, I mean Blacks—we all do something and you'll come behind us and turn it around and add somebody singing to it or some sort of little funky-ass or weak-ass chord line or whatever and get some stupid record company that doesn't know jack shit about shit to put £50,000 behind it and you got a fucking hit because you stuffed it down mother-fuckers throats. So, this group, y'know, has tremendous success and I don't know what to say, man. I've just been busting my ass, it comes from the heart y'know. They do it and they just take drugs! Obviously dance music has to progress in one form or another and there was always some sort of relationship between pop music and dance music. But, we as Black people have always had to deal with the fact that we've had to be better because, since the beginning of time, we've

had to walk into a white person's house and clean a white motherfucker's ass, okay? So don't tell me.

Allen interjected: "Listen Derrick, I might have white skin, but I'm Black for fuck's sake! Look at me Derrick—look at me—I'm Black." McGough quickly retorted, "None of the stuff you're talking about, the money, the record industry, none of that means shit." Records in England, he argued, gain momentum with little to no investment in the United States, where the music recording industry is a complex and beleaguered system of copyrights and distribution clauses, geared towards maximum financial gain and audience reach. McGough pointed out that a record could be pressed in the hundreds in the UK and easily make its way to the number one radio spot with enough exposure. For him, house and techno were "a true, pure music" that had been "pirated and bastardised" before an industry had formed around it with the intention of flooding the scene with white kids in the lead-up to an eventual audience satura- tion point—a common method of colonization both consciously and unconsciously used by British and European colonizers when encountering a new subject of desire and interest. McGough conceded to Wilson's overarching point about house music curtailing the role of rock in British youth counter culture, stating that "the major record labels were shitting their pants for the last 12 months because they'd invested hundreds of thousands of pounds in groups which they could no longer sell because it was dead music." He specified: "The whole Ecstasy and House culture from 1988 was like year zero, Pol Pot. The same way as '76 with the Pistols and anarchy, year zero. Anyone who's like 14 years of age, 15, 16, that's their marker, that's where they start. That's day one, year one."

May chimed in again, more calmly this time: "In America, the club scene is in trouble and, yeah, in England you have the clubs and the people, but you don't necessarily have the DJs. It's typical of the world, but your DJs are more or less followers— they're very intimidated by playing anything new. Our DJs are technically better than yours." Wilson retorted angrily, "Bullshit. Let's talk about DJs right? The Haçienda played Chicago seven nights ago, it was fine. We played Detroit six nights ago, it was a bunch of shit. Your Detroit DJs didn't have one record that was made in the last fucking six months and they wouldn't play one thing under 130 bpm. They're all stick-in-the-muds and they should get themselves fucked." Finally, May erupted, "Guess what? None of us were there. We didn't even show up for that. I don't wanna dog you, but if you want me to, I'll dog you flat-assed motherfucker."

After asking what "flat-assed motherfucker" meant, Allen retorted, "Well, the reason we've got a really big long-assed back is because we can actually take the weight of the world on it. D'you know what I'm saying Derrick?" Wilson yelled about having his own television show. Then the panel opened up to the audience for questions. In his report of the conference, Steve Sutherland, a Black British DJ and journalist, iden- tified the audience respondents as a "midwestern jock" who was offended by Allen's

comments about drug usage, and a person who told the panelists it seemed that white people thought too much about music while Black people actually put in the effort to create it. May cut in, latching onto the opportunity for a jab at the Englishmen: "That's also the reason why white people can't play basketball." While the room laughed, Allen replied, "'Yeah, but that's the reason why Black Americans don't ride horses. You've got to remember the reason that white guys don't play basketball is the same reason black guys don't ride horses." Without saying a word, but clearly repulsed, Marshall Jefferson stood up from his chair and walked off the stage while people in the audience booed. "He's got a point," May took the solid cue, while Screaming Rachel called after Jefferson: "This panel is ridiculous because what you've done is turned it into intimidating warfare." Wilson, feigning shock and embarrassment, responded, "We have?" May grew more upset: "I don't have to stand up for my manhood. You can argue with yourself. You can pull out your little two-inch penis and dog yourself, okay? I'll see you later. Good night. And thank you very much, crowd. It's been nice." As May and Jefferson exited the room, Screaming Rachel called out to the African American men: "Derrick! Marshall! Come on! Somebody's gotta stand up for America!" The panel concluded.

*

The next year, while Underground Resistance and the current lineup of Members of House were taking the 1991 edition of the New Music Seminar by storm, Neil Rushton was hard at work compiling the rebranding of Detroit techno for his new label Network, putting out the album *Retro Techno / Detroit Definitive: Emotions Electronic*. With new liner notes by Rushton himself and reedits of previous interviews with the Belleville Three by music journalist and Haçienda resident John McCready, originally published in *New Musical Express* (*NME*), *Retro Techno* was designed to reign in and recreate the phenomenon that the first compilation had sparked: "In the new music of Detroit the future is already here."[85] Recapitulating the pitch that Detroit techno was the only true underground sound of electronic music within a rapidly rising economy and industry of commercialized dance music, Rushton wrote that "within 12 months Techno had established itself as the most enduring influence on dance music."[86] The liner notes bemoaned the fact that "too many conversations were about money," selling *Retro Techno / Detroit Definitive* as a high-definition home listening album from the days "when techno was a secret society" of bedroom musicians.[87] The compilation features May's mixes of both Atkins' Model 500 classic "No UFOs" and Kevin Saunderson's "Rock to the Beat" (as Reese), alongside the Belleville Three's collaboration (as X-Ray) "Let's Go" and tracks by Blake Baxter and Separate Minds (Lou Robinson, Marc Kinchen, Terrence Parker, and Vernell Shelton).

85 John McCready, sleeve notes, *Retro Techno / Detroit Definitive: Emotions Electronic* (Network Records, 1991).

86 Neil Rushton, ibid.

87 McCready, ibid.

"Alvin Toffler's book is a kind of bible to Detroit's new musical revolutionaries," McCready claimed in the liner notes, suggesting that "Alvin Toffler, like Kraftwerk, is not afraid of the pocket calculator and if he knew of them, it's likely the academic would approve of Model 500, Rhythim Is Rhythim and their positive futurism."[88] McCready drew the line between Detroit techno from New York and Chicago house, making the antithetical assumption that "the traditional understanding of Black music and the accepted concept of soul become useless." "Techno, Black music with a soul which refers rather to the passionate commitment of its protagonists," he wrote, "has upturned these things in a way that house with its allegiance to the Philly sound never could. Detroit has declared itself a satellite state of Germany."[89] His assertion that the young Black men recording futuristic music with outmoded electronic equipment in their homemade studios were staging a kind of stereo-intellectual exodus from the post-Civil Rights, post-industrial damnation of colonized states of white America, incidentally, was correct in the context of writer and filmmaker Nelson George's concept of a "post-soul" Black America.[90] Indeed, May is quoted as saying that "Strings of Life" was about Martin Luther King, Jr.: "When they killed him, they destroyed the hopes and dreams of a generation. It was about the hope in his message."[91] For May, by listening to Detroit techno—"hi-tech soul" in a "post-soul" Black America—he could "see the confusion of a city lost in transition from one age to another. The city is dying but Juan and the rest of us are all part of the third wave, the future,"[92] he declared.

After *Retro Techno*, Atkins quickly set to work producing new material, striving to establish a new standard. He released *True Techno* in 1992 through Network as Model 500, and *The Future Sound* in 1993 under his own name for Underground Level Recordings, the ambient division of the London-based label, Great Asset.[93] The next year, Southbound, a British sub-label of the '70s soul and funk imprint Ace Records, reissued Cybotron's debut album as *Interface: The Roots of Techno*. Liner notes by Jon Savage perpetuated the narrative of techno's history he had penned in the pages of the *Village Voice*. Ten years after its release, Savage writes, "As our past, present and future start to spin before our eyes, and our feet start to slip the positivism inherent in

88 Ibid.

89 Ibid.

90 Nelson George, *Post-Soul Nation: The Explosive, Contradictory, Triumphant, and Tragic 1980s as Experienced by African Americans (Previously Known as Blacks and Before That Negroes)* (New York: Penguin 1992), ix.

91 Derrick May, liner notes, *Retro Techno / Detroit Definitive: Emotions Electronic*.

92 Ibid.

93 "They're all back at it. Eddie Flashin Fowlkes is bashing them out at an incredible rate. Derrick May is in action and here comes the other missing Detroit originator with a very laidback and futuristic techno mission. 'Urban Tropics' is cool, calm beauty with a bass and a shuffle to keep it complicated. 'Serene' is more clean but without being sharp. 'Sundog' is harder and heavier. And 'Interpret' is light and trancey. Not exactly dancefloor friendly—it's a touch slow—but classy and sophisticated. Back to the future as Detroit goes forward once again." David Davies, "Juan Atkins: *The Future Sound* EP," *Mixmag*, no. 273, March 1993.

techno (which, according to Davies, reflects 'the shamanistic tendency in the late 20th century man') remains a guide."[94]

Meanwhile, Richie Hawtin and John Acquaviva, two white men from the Canadian town of Windsor, Ontario, started the label Plus 8 Records after frequenting the Music Institute and other Detroit music venues like the Majestic and Shelter. In a 2013 conversation with music journalist Todd L. Burns, Hawtin described the venture as "focused on electronic music, not just techno, not just house music."[95] Hawtin spoke openly about his beginning stages as a producer, actively studying, xeroxing, and optimizing Atkins and May's arrangement of electronic instruments and their creative approach to music-making that led the very equipment to sing. When asked why his earliest works—and particularly "Spastik," a 1993 song under his Plastikman moniker—was recorded live rather than composed and sequenced over time, Hawtin recalled, "You know, you follow the people and the influences around you, by following what you see." After a brief pause, he continued, "I used to go to Detroit and see some people making music, Derrick May and Kevin Saunderson and these guys and they all did their things by playing live and jamming." Growing up with a father who worked as a robotics engineer at General Motors, and as a listener of European electronic music like Tangerine Dream and Kraftwerk, Hawtin wondered about how the Detroit producers made their tracks, acknowledging that when he tried to copy them directly, the music felt manufactured and inauthentic; by playing live, however, he could find his way around the gear and the multi-dimensional possibilities of computing sound. When asked why he was in Detroit—supposedly "the murder capital of the United States"—Hawtin favored a kind of deflection that can often be often observed when white men are faced with the realization that a previous, opportunistic or entrepreneurial endeavor had lasting negative consequences. "Windsor in Canada is a very small place, so if you think you're different, or you want to be different, you very quickly have to cross over into America and into Detroit for other opportunities." Hawtin continued:

I started going there, I think, before it was for records, it was for like resale shopping, because there was really big places where you could find really cool clothes. And then that went from the resale shop and next door there was a place called Off the Record. There was a small record store in Windsor, but that cool group of... I don't know, we thought we were cool. A little group of people were picking over those records, so if you wanted to have a record that nobody else had, you went to Detroit. If you wanted to have clothes that looked a little different, you went to Detroit. And so that just kind of became my weekend thing to do. I didn't really find music being played in the nightclubs in Windsor. At that

94 Jon Savage, liner notes, Cybotron, *Interface: The Roots of Techno* (Southbound, 1994).

95 Richie Hawtin, lecture, hosted by Todd L. Burns, Red Bull Music Academy, New York, 2013, https://www. redbullmusicacademy.com/lectures/richie-hawtin-2013-lecture.

point it was actually more concerts. So I was into Skinny Puppy, Severed Heads, Front 242, these people were coming to Detroit and playing. So it was always going to Detroit. If you didn't go there, it was pretty boring in Windsor.[96]

Eventually Hawtin and Acquaviva started to throw their own parties across the border in Detroit, bringing in a flurry of upper-middle-class white youth who had no memory of the cycles of riots, gentrification, and white flight that had occurred there throughout the twentieth century. In November 1990 Hawtin pressed his first release as F.U.S.E. ("Futuristic Underground Subsonic Experiments," "Futuristic Underground Sound Experiments," or "Further Underground Sound Experiments"), called "Approach & Identify." He mastered his first release at the National Sound Corporation, where Detroit producers also finalized their productions. In their 2013 interview, Todd L. Burns gingerly presses Hawtin: "Plus 8 early on was really interesting, I guess, in the sense that it was very international quite quickly. Why did that happen so quickly?" Hawtin responds, "Yeah, it was an accident. I guess what John [Acquaviva] and I noticed was that we were part of the Detroit scene, but we were always outsiders. So we weren't from Detroit, but we were hanging there and doing our thing." Burns interjects, "You got into a little bit of trouble with the first release." Hawtin smiles, wryly, "Yeah, well, 'cause we stamped on the first record, 'Two White Kids From Canada,' with a red stamp saying 'The Future Sound of Detroit.'" The audience laughs. "There's still some people today that want my head for that," he adds, drawing more laughter. Hawtin takes a breath and continues:

At that point, when we did that, we felt very part of that scene. But after that, we did feel that, "OK, maybe we're not as part of that scene as we thought we were." And we could really see Metroplex and Juan Atkins had their camp, Derrick had his camp and his friends and so, it came back to us, "OK, who are our friends? What can we do here?" And Daniel Bell was another Canadian who was coming down to Detroit every weekend to play music and listen to music. You know, Kenny was from Detroit, but we were all bonded by our love of Detroit techno. We used to drive around the freeways, Kenny and I, listening to Derrick May tapes on repeat. Like, not talking, just like smiling, turning it up, and trying to feel part of what was happening. So, as we started to grow with Plus 8, we wanted to find our own family and we wanted to find other people around the world who were in the same boat as us. Perhaps not from Detroit, but heavily inspired by Detroit. So that first few records, you know, Kenny was from Detroit, so we were like, "OK, Detroit on the label." John was from London, Ontario, so we put London—most people thought it was London, England—and then, we started to get demo tapes from around the world. One of the first demo tapes we got was from Holland, from a guy Speedy J, Jochem Paap, and so Rotterdam was on the label. So very early on, where most labels at that point, were very regional,

96 Ibid.

you had this Plus 8 record that said, London, Detroit, Rotterdam, and there is probably something else on there. So, it was like that, you know?[97]

Plus 8 Records' compilation *From Our Mind to Yours*, released in 1991, set the pace for the next phase of techno—a phase that would do without its inventors, both internationally and domestically. "You are about to experience the future as foreseen by our minds and transmitted to yours, a future that relies on the synthesis of human perception and electronic impulses," recites an articulate female voice over Hawtin's cold science-fiction strings and pads in its opening track. "The integration of man and machine, these sounds penetrate your subconscious, an audio-sensory stimulation from our minds to yours …"[98] Tracks by Hawtin under various aliases—"My Reflection" by Chrome, "Xenophobia" by Xenon, and "Invasion of the Techno Snatchers" by Prophet 5—illustrated Hawtin, Bell, and Acquaviva's intention (conscious or not) to colonize, replicate, and manufacture Detroit techno as a global production of which they were the central pivoting point. Hawtin remembers: "The UK first, then Italy and Rotterdam and Amsterdam and Hamburg and Berlin and Frankfurt."[99]

Shortly after the compilation's release, the Plus 8 crew went on tour in the UK and continental Europe with the Dutch producer Speedy J, but without Kenny Larkin—"which naturally didn't sit well with the label's only African American artist."[100] While DJing a hardcore Gabba, or Gabber[101] party at Rotterdam's Parkzicht club, Hawtin, Bell, and Acquaviva came face-to-face with white rage, with ravers shouting "Joden! Joden!"—Dutch for Jews—during their sets. "Gabba is Dutch for buddy. A lot of the guys are dock workers, they're into harder music, so gabba is basically the sound of the buddies letting off steam," Acquaviva explains. "Our Dutch friends are, like, 'no worries, it's just a football chant.' But I'm like, 'fuck that, that's not who I am. I'm not a Nazi, I can make people rock without making them be hostile.'"[102] "Those tracks [the harder ones like 'Thrash'] sound really rigid now," Hawtin reflects, distancing himself from his own creation. "We liked machine-driven music, but we didn't like it so rigid—that was the difference with Detroit music. None of us were making hard music just for the sake of it… We weren't slamming people

97 Ibid.

98 F.U.S.E., lyrics, "From Our Minds to Yours (Intro)," *From Our Minds to Yours, Vol. 1* (Plus 8 Records, 1991).

99 Richie Hawtin, interviewed by Joe Muggs, "How Richie Transformed Electronic Music Again and Again and Again," *Mixmag*, July 3, 2019, https://mixmag.net/feature/richie-hawtin-mixmag-cover-feature-interview-2019.

100 Sicko, *Techno Rebels*, 89.

101 "Imagine a jackhammer beat that pounds as hard as a heart overdosing on adrenaline and steroids. This is gabba, the ultra-fast, super-aggressive form of hardcore techno developed by the Dutch in the early nineties, which has since spread as an underground sound throughout the world. Above all, gabba's berserker frenzy seems to plug into the Viking race-memory of ginger-pubed peoples across Northern Europe, from Scotland and Northern Ireland to Germany, the Netherlands and Austria." Reynolds, *Energy Flash*, 256.

102 John Acquaviva, quoted in ibid., 214.

over the head just for the sake of it. It was just intense."[103] Hawtin later left Plus 8 as his and Acquaviva's musical directions diverged, but not before releasing albums by many techno artists who were neither Black nor from Detroit, such as Speedy J and V-Room from the Netherlands, Sysex from Germany, and Ken Ishii from Japan, as well as Joey Beltram from New York City, whom journalist Simon Reynolds claimed had "revolutionized techno twice before he reached the age of twenty-one."[104] .

*

In 1991, eighteen-year-old Neil Ollivierra found himself in the depths of the youth counter culture of Detroit, clubbing at the Music Institute, where he rolled into a job as promoter, before eventually taking a role at May's record label, Transmat, founded in 1986. Riding the momentum of its initial success with Rhythim Is Rhythim's "Nude Photo" and "Strings of Life" (both 1987), and May's own 1991 album *Innovator - Soundtrack for the Tenth Planet,* Transmat began releasing a series of singles by Atkins and James Pennington in the late '80s and into the '90s. As production towards the next phase of Transmat establishing itself as transatlantic company was underway, May hired Ollivierra to create the cover art for an album, a job that took Ollivierra to London, to work out of the Virgin Records office—an experience that Ollivierra captured in his unpublished, tersely titled novel, *Reality Slap.* Written over the course of three weeks after his return to Detroit from London, *Reality Slap* depicts a bleak yet comedic Detroit inhabited by young creatives, in a psychedelic prose style that mirrors the string of satirical, transgressive fiction published by Bret Easton Ellis in the late '80s. "I'm now alone, alone and naked to the waist in the vast empty space of the loft on Gratiot Avenue, downtown. Home." Ollivierra opens the novel by taking LSD and driving a motorcycle at 87 mph; he pens himself as the lead character, Todd, whose fractured and flowing inner monologues guide readers through the hedonistic life of an unemployed artist in his early twenties.[105] Ollivierra's writing throughout oscillates between modes of erratic sense-making and retroactive introspection that stretch his lived experience into a calculated confabulation. While the book does not necessarily paint a picture of techno's origins, it does, however, relate the disparate conditions of Detroit, a fallen futuristic city of the New World, and London, a modern city born from an ancient Roman settlement. "They got a big company over there. They pretty much know what they're doing," May states in his appearance in the novel. He briefs the narrator on the business venture: "But vibewise, they don't know shit about techno or anything about Detroit for that matter. These songs mean a lot to me, and I want the whole shit to come across; the music, the pictures, the artwork—everything. I wouldn't feel comfortable letting some motherfucker from Gent or Birmingham do

103 Hawtin, quoted in ibid., 90.

104 Ibid., 108.

105 Neil Ollivierra, *Reality Slap*, unpublished novel, copyrighted 1992, http://ambientmusicguide.com/wp-content/uploads/2016/04/Neil-Ollivierra-Reality-Slap.pdf.

the shit. I mean—I guess I'm trying to say… I'm trying to come correct. You know what I'm saying?"[106]

A longtime friend of May's, Alan Oldham set off on his own international venture in artmaking and music space with Transmat. Oldham began drawing comics in elementary school, as he got older branching out from reimagining existing comic book properties like Marvel comics, Teenage Mutant Ninja Turtles, and imported anime such as Speed Racer to develop his own world of Johnny Gambit. May asked Oldham to create cover art for a new album, which turned out to be *Nude Photo*.[107] Oldham continued to do artwork for Transmat and was introduced to Atkins, Saunderson, and Carl Craig, as well as Jeff Mills and Mike Banks just as they were in the beginning stages of forming Underground Resistance. He felt a pull away from the world of art and graphic design to dance music, and was eventually hired to host a late-night radio program he called *Fast Forward* on Detroit's public radio station WDET-FM. From 1987 to 1992, Oldham led the first radio program in the city to play exclusively electronic music, mixing songs from across the quickly widening spectrum of dance music, from Detroit techno to British rave music, alongside industrial and jazz-fusion. "Detroit techno, in my view, was originally about futurism," Oldham noted. "Futuristic Black music. Look no further than Juan Atkins for that. A lot of old sci-fi movies and TV shows portrayed a future that had no Blacks in it. [Detroit techno] was a statement that Black people would be around in the far future." As an artist, he visualized techno to be more than just music; it could encompass an entire world. "You can also connect Sun Ra and Mothership Connection-era Parliament/Funkadelic to that aesthetic,"[108] he argued. As pirate radio stations began to surface, ping, and intercept transmissions between the UK and the Caribbean, Atkins, Saunderson, and May made plans to tap into the signals of the Black Atlantic. "'88 and '89 were THE pirate radio years [in England]," Saunderson remembers:

> In the UK, there were several [pirate radio stations] and they were playing all of our music along with all of the early house music. They were making an impact and we were trying to duplicate it. They had people listening; they were cultivating a scene of people with new music from Detroit and Chicago, and people were ecstatic over it… I didn't really understand what pirate radio was all about when I first went over there [to the UK]. It was just radio to me, but it was cool to hear my track on the radio. It was very underground… nothing real glamorous about it. It was all about getting the signal out and getting it to the people.[109]

106 Derrick May, quoted in ibid.

107 Alan Oldham, quoted in Ashley Zlatopolsky, "Alan Oldham: The Art of Techno Futurism," *Red Bull Music Academy Daily*, November 9, 2014, https://daily.redbullmusicacademy.com/2014/11/alan-oldham-feature.

108 Ibid.

109 Kevin Saunderson, quoted in Ashley Zlatopolsky, "A Spin on Frequency: A History of Dance Music Radio in Detroit," *Red Bull Music Academy Daily*, November 25, 2014, https://daily.redbullmusicacademy.com/2014/11/detroit-radio-feature.

The Belleville Three began a guerilla campaign of unlicensed broadcasts from varying locations throughout Detroit, where they could secretly air their mixes without alerting police or the Federal Communications Commission. "There was one [broadcast] on a friend's boat on the Detroit River," Saunderson revealed. "It was harder to track [pirate radio on the water]. That's what we were told, at least."[110] Having been fired from a radio station for being "too ahead of his time,"[111] Saunderson feared that techno would never find a proper home on American radio, but the pirate radio transmissions offered a temporary platform for the techno rebels. In time, the Belleville Three received a slot on WGPR, where The Electrifying Mojo communicated with his Midnight Funk Association. "We weren't really playing, but they had this open air where you could buy radio time, and it was more like you could be a sponsor of the show," Saunderson explained. "And if you're a sponsor, you can basically control the music, so that's when we started doing Deep Space. It lasted maybe about eight months."[112] Jennifer Witcheris, also known as DJ Minx, introduced the once-a-week airing.[113] "It was spoken word, a lot of effects, atmosphere," Saunderson remembers. "I had an intro that lasted about three minutes and sounds going, 'Deep Spaaaace'... all that kind of stuff. We had this DJ called DJ Minx and she was also a voice that introduced the show. Sometimes it was me, sometimes it was Juan, sometimes it was Derrick, and sometimes it was Eddie Fowlkes."[114]

Saunderson's chart success with Inner City in the UK inevitably led him to a tour overseas in 1989, with a stop to perform at the 2,100-capacity Art Deco cinema-turned-concert-venue called Town & Country Club, in North London. Fronted by vocalist Paris Grey, Saunderson's home studio music extended into a live concert setting, with the addition of a keyboardist, bassist, drummer, backup singers, and even male dancers—a complete realization of the live performance model engineered by the American major recording music industry. Though techno had been received in the UK as a kind of machine-made dance music formatted for vinyl playback, Saunderson and Grey's ambitions for Inner City as a live studio performance band were comparable to Jimmy Jam and Terry Lewis' combination of live musicians and studio electronics. Joining Inner City on the tour, May and Craig debuted a hi-tech soul ensemble under the name Rhythim Is Rhythim. "We had prepared for that show in Derrick's loft, which was

110 Ibid.

111 Kevin Saunderson, quoted by Simon Trask, "The Techno Wave," *Music Technology* (September 1988): 72.

112 Zlatopolsky, "A Spin on Frequency."

113 "Detroit's 'First Lady of Wax,' DJ Minx, is a true gem of a DJ/producer and dance music OG. She's been going hard for three decades, yet is still wildly under celebrated. Back in 1996, she founded the Women on Wax DJ collective to celebrate and promote fellow Detroit women DJs and artists, expanding it with a still-active label called Women On Wax Recordings in 2001. She spun at the inaugural Movement festival in her hometown in 2000 and has been a regular at the iconic house and techno event, as well as others across the city and globe." Ana Monroy Yglesias, "Record Store Recs: DJ Minx Brings the Detroit Heat," *Grammy*, July 28, 2021, https://www.grammy.com/grammys/news/record-store-recs-dj-minx-brings-detroit-heat.

114 Saunderson, in Zlatopolsky, "A Spin on Frequency."

kind of central to everybody who was in the party movement back in Detroit," Craig recalled. "At the time, that's what you did; come by Derrick's house. So, we were working on the show for quite a while without actually being able to do much."[115] On stage, their synthesizer band resembled Bernie Worrell's keyboard arrangement during his time in Parliament-Funkadelic and the Talking Heads, but veered towards Herbie Hancock and Stevie Wonder's use of the Fairlight CMI (Computer Music Instrument) as a futuristic live unit. Optimizing these approaches, each of Craig and May's synths were interconnected through a single sequencer, which could store and output the combined audio as a consolidated, harmolodic, technological sound. Craig explained that May "had the songs on these little kind of mini discs, they looked like little floppy discs. He had to change the disc for each song, so we had to find a way to make it work together."[116]

Craig's role in the ensemble was to program the drum machine, and act as an inter-locker for all of the competing computerized elements that May conjured. They had designed a type of hybrid live performance that positioned May as an improvisational DJ, replacing vinyl with floppy discs loaded with samples: "We were both playing textures of sounds on top but the soloing was mainly left to Derrick," Craig recounted. "I had a sequencer running at the same time as his. But there wasn't anything that was so defined like it would be in a band, like Derrick's the guitar player and I'm the bassist."[117] Routed through a sequencer, Craig and May as Rhythim Is Rhythim approached the jazz and soul formula as a closed circuit ensemble that operates like an orchestra, or even John Coltrane's generative quartets, which converged in unison to produce a contained universe of musical expressions. Craig's first visit to London was in 1989, to open for Inner City with May: "By the second performance we knew what we were dealing with and we sharpened up, we were able to do a really great performance." The experience was formative for Craig, but was also helpful for May, who was still trying to establish Detroit's presence in the burgeoning British electronic music industry. As Craig put it:

> It was amazing for me to see it, but I didn't really go to a lot of concerts when I was growing up, so that's probably what made it so amazing to me. I was not only at this big concert, I was actually on stage. Growing up, I'd never been one of those kids who'd go and watch Parliament/Funkadelic live, I'd never seen Prince live. I had never really been to a proper concert that I can remember, so that was the first one. I'd been to big DJ gigs, Jeff Mills, watching scratch DJs, so I'd seen people respond how they would in a club environment, Music Institute,

115 Carl Craig, interview by Marko Kutlesa, "Carl Craig Interview: Life in a Northern Town," *Skiddle*, n.d., https://www.skiddle.com/news/all/Carl-Craig-interview-Life-In-A-Northern-Town/38571/.

116 Ibid.

117 Ibid.

Shelter and all that was. But being at a concert like this, where there were 3000 people in the audience, that was a big deal for me.[118]

Craig's first trip out of Detroit led him into the regional London and Manchester scenes, which he described as "a complete shock to the system." The first party he went to was the queer-centric Kinky Gerlinky, a clubbing event that combined rave culture, high-street fashion, and drag culture. He also went to Heaven, a gay "superclub" that brought the Studio 54 format to London; the tabloid industry frequently reported on the club's events and patrons. With influential nights—Spectrum with Paul Oakenfold and Ian St. Paul, RAGE with Fabio and Grooverider, Colin Faver, and Trevor Fung, and DELIRIUM!, Frankie Knuckles' four month-long residency—Heaven carried forward the ecstasy-fueled hardcore raves started by Shoom, while also maintaining the Ibiza connection. "David Morales was playing. That was where I first heard Technotronic 'Pump Up the Jam'. I'm not sure it had been released quite yet, but he played it," Craig remembers. "The crowd reaction to it was quite incredible. Back then, the reaction to hearing a record for the first time was way different to what it is now. You cheered for the record, not for the mix or the DJ, you cheered because the record was amazing. I'd heard a lot of stuff but that sounded quite different. It was Belgian, I think." Reflecting on the Detroit scene from the vantage point of UK rave culture, Craig remarked: "We always had the thought that America was going to be ass backward when it came to electronic music. That's why there was a certain effort to grab on to where the music did take hold. In the US we did have big records like 'Good Life' and 'Big Fun' from Inner City. House techno records. But then it would die out." America's distaste for electronically produced music could be considered to be a kind of future shock. "It was almost like the guitar and synthesizer couldn't coexist in the US music industry," Craig contemplated. "It was always in and out. I'm happy about the growth of rap music, because hip hop kept electronic music at the forefront of American culture, it's just that nobody realised that it was electronic music."[119]

In 1992, May released *Relics - A Transmat Compilation*, a new 80-minute snapshot of Detroit techno that returned it to its original form—home studio ensemble music—with tracks by Atkins, James Pennington, May, and Craig, produced between 1986 and 1990. The lush orchestral "Intervals" by Rhythim Is Rhythim threaded the archival recordings together into a single sonic journey, articulated by a motto printed on the back of the vinyl: "Comprehend Mental and Physical Contributions, Apprehend, Formulate, Create and Design - The Alternative. Why? Cos Within the Middle Lives the Redundant!"[120] Several tracks by Craig as Psyche appear on the album, including many collaborations with May; the song "Info World," a contribution by Atkins as Model 500; and "The Art of Stalking" by James Pennington as the Suburban Knight.

118 Ibid.

119 Ibid.

120 Various, back cover, *Relics - A Transmat Compilation* (Transmat, 1992).

Third Earth Visual Arts, a design studio born out of the art program at the College for Creative Studies in Detroit and founded by AbuQadim Haqq in 1989, provided artwork and concepts alongside Transmat staffers Neil Ollivierra and Mike Lindow. With *Relics*, a coherent mythology and continuity in design began to emerge from the Detroit techno scene, informed by Haqq's domestic, personal, and cultural perspective and by Ollivierra's own excursions into electronic music production.

On the strength of the *Relics* album, in 1991 Craig launched his own label, Planet E Communications, with a new EP titled *4 Jazz Funk Classics* under the moniker 69, which reoriented Detroit techno toward a looser, atypical place that elevated the genre. In November 1992, Planet E released the *Intergalactic Beats* CD compilation, nodding towards the label's future with a notable number of tracks by Craig flanked by Kenny Larkin's "War of the World (Epic Mix)" and "A Touch of Heaven" by Stefan Robbers from the Netherlands; Hani, a Kuwaiti-American DJ; and British DJ Kirk Degiorgio. In a 2014 retrospective of his work, Haqq recalled that Craig wanted something new and unseen for the *Intergalactic Beats* cover art, in order to represent where he planned to take techno. "We came up with this robot [called the E-2000], and then we did a painting from it for the album *Intergalactic Beats*."[121] Haqq considers E-2000 to be an early signifier of the Planet E aesthetic, and his own first real foray into collaborating for mass consumption, allowing his mind to roam free and imagine what places, objects, and beings could emerge from Detroit techno. "Originally there was supposed to be a human being inside the dome," Haqq explained. "The dome would lift up and a human being would be inside as a pilot." Influenced by both his immediate urban environment and rural music making its way into Detroit through the radio, Craig's solo recordings scaled down from his hi-tech ensemble with May to focus on essential technologies. Playing remarkable melodies, on top of driving drum-machine patterns, Craig sought to bridge the gap between Brian Eno's ambient excursions[122] and the explosive sample-based hip hop of Public Enemy,[123] while also keeping in mind legendary Detroit jazz musicians such as Marcus Belgrave and Wendell Harrison.

121 AbuQadim Haqq, in Ashley Zlatopolsky, "Abdul Qadim Haqq: 25 Years of Techno Art," *Red Bull Music Academy Daily*, November 9, 2014, https://daily.redbullmusicacademy.com/2014/11/abdul-qadim-haqq-feature.

122 "In 1978, [Brian Eno] started to use the term "ambient music": the concept stretched back to describe 'Discreet Music' and the work of earlier composers, like Satie, who coined the term 'furniture music,' for compositions that would be more functional than expressive. In the liner notes of 'Ambient 1: Music for Airports' (1978), Eno wrote, 'Ambient Music must be able to accommodate many levels of listening attention without enforcing one in particular; it must be as ignorable as it is interesting.'" Sasha Frere-Jones, "Ambient Genius: The Working Life of Brian Eno," *New Yorker*, June 30, 2014, https://www.newyorker.com/magazine/2014/07/07/ambient-genius.

123 "Making old records talk via scratching or sampling is fundamental to hiphop. But where we've heard rare grooves recycled for parodic effect or shock value ad nauseam, on 'Show Em Whatcha Got' PE manages something more sublime, enfolding, and subsuming the Coltrane mystique, among others, within their own. The martial thump that kicks in after the obligatto owes its bones to Funkadelic's baby years and Miles Davis's urban bush music. But the war chants from Chuck D and Flavor Flav that blurt through the mix like station identification also say, What was hip yesterday we save from becoming passé. Since three avant-gardes overlap here—free jazz, funk, hip hop—the desired effect might seem a salvage mission." Greg Tate, "Public Enemy: The Devil Made 'Em Do It," *Village Voice*, July 19, 1988, https://www.villagevoice.com/2018/08/07/bring-the-artful-noise-looking-back-30-years-at-public-enemy/.

Meanwhile, in the UK, rave culture was becoming a quickly appreciating industry, the formats of Detroit techno and Chicago house having converged with Black British and Afropean[124] diasporic culture, sparking an accelerative, alternate future scenario. "If you listen to Black music emanating out of Europe in the '90s and '00s, you can hear the sounds of the last wave of generation X coming of age; of true multiculturalism," English writer and television presenter Johny Pitts reflects. Detecting, "a subtle shift into an age of fusion, of Acid Jazz, Jungle, Drum N Bass, Trip-Hop, UK Hip-Hop, Garage and Grime, of French Hip-Hop, Swedish Soul and German reggae," Pitts asserts that "these are styles that really are a musical melange of influences and experiences, that aren't merely referencing either Black or white culture, but had been born out of an organic union of the two."[125]

A foundational scholar for British cultural studies, Jamaican British sociologist Stuart Hall emerged in the 1970s, applying Marxist political theory to the study of sociocultural conditions of alienation amongst Africans and Afro-Caribbeans in postwar Britain. His theories of mass media and telecommunication, explored in essays including "Encoding and Decoding in the Television Discourse" (1973) and "Cultural Identity and Diaspora" (1990), detail the ways in which citizens of the modern Western world receive and perceive ideas, images, and information produced and circulated by television and media companies. His primary concern was the "visual representation of the Afro-Caribbean (and Asian) 'blacks' of the diasporas of the West," which he engaged through continued consideration of the cultural practices and ethnic identities behind the images propagandized in television, cinema, and the media.[126] He refers to the work of Armet Francis, a Jamaican photographer who immigrated to Britain at a young age. "Francis's photographs of the peoples of The Black Triangle, taken in Africa, the Caribbean, the USA and the UK, attempt to reconstruct in visual terms 'the underlying unity of the black people whom colonisation and slavery distributed across the African diaspora,'" Hall ponders, the "act of imaginary reunification" lingering.[127]

124 "Originally coined in the early '90s by David Byrne and Belgian-Congolese artist Marie Daulne, front woman of music group Zap Mama, I first encountered this notion of 'Afropean' in the realms of music and fashion. . . . Initially, then, I saw 'Afropean' as something of a utopian alternative to the doom and gloom that has surrounded the Black image in Europe in recent years and an optimistic route forward. I wanted to work on a project that connected and presented Afro-Europeans as lead actors in our own story and, with all this glorious Afropean imagery in mind, I imagined this would result in some kind of coffee-table photo-book with snippets of feel-good text to accompany a series of trendy photographic portraits. There would be images of the 'success stories' of Black Europe: young men and women whose street style effortlessly and elegantly articulated an empowered Black European mood." Pitts, *Afropean*, 1–2.

125 Johny Pitts, "Why Afropean? - The 7.30 Train to Frankfurt," *Afropean*, March 16, 2014, http://afropean.com/why-afropean-the-7-30-train-to-frankfurt/.

126 Stuart Hall, "Cultural Identity and Diaspora" [1996], in *Identity: Community, Culture, Difference*, ed. John Rutherford (London: Lawrence & Wishart, 1990), 222.

127 Ibid., 224.

"No one who looks at these textural images now, in the light of the history of trans-portation, slavery and migration, can fail to understand how the rift of separation, the 'loss of identity', which has been integral to the Caribbean experience only begins to be healed when these forgotten connections are once more set in place. Such texts restore an imaginary fullness or plentitude, to set against the broken rubric of our past."[128]

Hall's cultural analysis deconstructs the uneven power dynamics latent in the act of immigrating into the British colonial empire and commonwealth economy as a descendent of slaves. In "Gramsci's Relevance for the Study of Race and Ethnicity," Hall likens the unsavory social condition of being a displaced African longing for an "imagined community"[129] to the plight of the proletarian worker seeking ownership of their labor and profits, as discussed by the Italian Marxist philosopher Antonio Gramsci in his writing on the historical conditions that determine the stability of the hegemonic political, ideological, and economic structures of industrialized capitalist societies. "In the analysis of particular historical forms of racism, we would do well to operate at a more concrete, historicized level of abstraction (that is, not racism in general but racisms)," Hall writes of the "antihuman" and "antisocial" practice of racism as it plays out in a capitalist society. "Even within the limited case that I know best (that is, Britain), I would say that the differences between British social formation now, in a period of relative economic decline, when the issue is confronted, not in the colonial setting but as part of the indigenous labour force and regime of accumulation within the domestic economy, are greater and more significant than the similarities."[130]

For Hall, the term "black" in the United Kingdom designated the experiences of various ethnic groups and their different histories of immigration and marginalization in a postwar, modernized society. Quite different from the American legal construct of "Black" or "Negro" as a racial caste in an industrialized labor system and economy, Hall's conception of "black" is a debatable aesthetic category, which he explains "cannot be grounded in a set of fixed trans-cultural or transcendental racial categories and which therefore has no guarantees in nature."[131] Seeking to deconstruct the notion of

128 Ibid., 224–25.

129 "In the original edition of *Imagined Communities* I wrote that 'so often in the nation-building policies of the new states one sees both a genuine, popular nationalist enthusiasm, and a systematic, even Machiavellian, instilling of nationalist ideology through the mass media, the educational system, administrative regulations, and so forth.' My short-sighted assumption then was that official nationalism in the colonized worlds of Asia and Africa was modelled directly on that of the dynastic states of nineteenth-century Europe. Subsequent reflection has persuaded me that this view was hasty and superficial, and that the immediate genealogy should be traced to the imaginings of the colonial state. At first sight, this conclusion may seem surprising, since colonial states were typically anti-nationalist, and often violently so. But if one looks beneath colonial ideologies and policies to the grammar in which, from the mid nineteenth century, they were deployed, the lineage becomes decidedly more clear." Benedict Anderson, *Imagined Communities: Reflections on the Origin and Spread of Nationalism* (London: Verso, 2006), 163.

130 Stuart Hall, "Gramsci's Relevance for the Study of Race and Ethnicity," in *Stuart Hall: Critical Dialogues in Cultural Studies*, ed. David Morley and Kuan-Hsing Chen (London: Routledge, 1996), 435.

131 Stuart Hall, "New Ethnicities," in ibid., 443.

"multiculturalism" and decouple the national identity of Englishness from the African and Afro-Caribbean experience of being "Black British," Hall further describes ethnicity as representative of having a collective history, language, and culture that is bound to space, time, and place. In so doing, he posits multiple points of entry to the situation of race, ethnicity, and identity as social constructs capable of navigating and negotiating the historical epochs that underpin the political superstructure of the state.[132] He calls for "an awareness of the black experience as a diaspora experience" and considers "the consequences which this carries for the process of unsettling, recombination, hybridization and 'cut-and-mix'—in short, the process of cultural diaspora-ization (to coin an ugly term) which it implies."[133]

Three distinct presences of diasporic identity (the African, the European, and the American) occupy Hall's theory of film and language. He urges a liberal application of cut and paste montage for the encoding and decoding of representational models in audio-visual media technology towards the construction of a new, ethnic cultural identity. Similarly, *Ultimate Breaks & Beats*, a series of albums compiled between 1986 and 1991 by New York DJ Louis Flores (aka BreakBeat Lou), featured samples of instrumental drum breaks repurposed as artifacts called breakbeats that built the foundation of hip hop. "Grandmaster Flash is now best known as a recording artist, but there are several purely technical DJ breakthroughs that owe their existence to his hand-and-eye coordination," Nelson George recounts in *Hip Hop America*. "'Punch phrasing'—playing a quick burst from a record on one turntable while it continues on the other—and 'break spinning'—alternately spinning both records backward to repeat the same phrase over and over—are credited to Flash."[134] He continues: "Flash, who at one point trained to be an electrician, was always exploring and refining his equipment. Out of his curiosity came the 'clock theory' of mixing where Flash was able to 'read' records by using the spinning logo to find the break."[135] In the context of electronic dance music, breaks offered a degree of flexibility and swing that was not readily available with programmable rhythm synthesizers. "The Breakbeat is a

132 "Identification turns out to be one of the least well-understood concepts - almost as tricky as, though preferable to, 'identity' itself; and certainly no guarantee against the conceptual difficulties which have beset the latter. It is drawing meanings from both the discursive and the psychoanalytic repertoire, without being limited to either. This semantic field is too complex to unravel here, but it is useful at least to establish its relevance to the task in hand indicatively. In common sense language, identification is constructed on the back of a recognition of some common origin or shared characteristics with another person or group, or with an ideal, and with the natural closure of solidarity and allegiance established on this foundation. In contrast with the 'naturalism' of this definition, the discursive approach sees identification as a construction, a process never completed - always 'in process'. It is not determined in the sense that it can always be 'won' or 'lost', sustained or abandoned. Though not without its determinate conditions of existence, including the material and symbolic resources required to sustain it, identification is in the end conditional, lodged in contingency. Once secured, it does not obliterate difference. The total merging it suggests is, in fact, a fantasy of incorporation." Stuart Hall, "Who Needs Identity?" in *Questions of Cultural Identity*, ed. Stuart Hall and Paul Du Gay (London: SAGE Publications, 2003), 2–3.

133 Stuart Hall, "New Ethnicities," in *Stuart Hall: Critical Dialogues in Cultural Studies*, 447.

134 Nelson George, *Hip Hop America* (New York: Viking, 1998), 19.

135 Ibid.

motion-capture device, a detachable Rhythmengine, a movable rhymotor that generates cultural velocity," Kodwo Eshun, a British Ghanian theorist of Afrofuturism, explains. "Indifferent to tradition, this functionalism ignores history, allows HipHop to datamine unknown veins of funk, to groove-rob not ancestor-worship."[136]

Folding over the habitual heuristic of techno's four-on-the-floor, breakbeats catalyzed British electronic dance music into a new plane of future shock. In the late '80s, the London producer Michael Alec Anthony West, under the name Rebel MC, released his debut album *Rebel Music*, merging Afro-Caribbean influences into the trending hip house hybrid genre. His second album, *Black Meaning Good* (1991), put more emphasis on the breakbeats through dancehall and reggae, while recapitulating Public Enemy and the Bomb Squad's radical sonic weaponry to promote a positive self-image among the Black British community. The album's title track explicates the extending definitions and public perception of the global export of Blackness as a caste within labor class hierarchies endemic to the Western empires of generational wealth and commonwealth. West raps:

> Definition of black is the opposite to white, right?
> On the mic to set the wrong right
> The prefix of 'Black' to a word means bad
> Black sheep, Black magic, kinda tragic, uhm, sad
>
> Black is sinister, peace in the light
> Conditioned negativity, stereotyped
> White is pure, pure is white
> Many they are sufferin' from short sight
> Check the story of the past, pure lies
> And race hate, you see it in their eyes
> Conditioned to thinkin' that bad is Black[137]

Rebel MC assures the listener that this line of thought is logical, "So don't check this as a racial reaction / It's just a study of Black exploitation." *Word, Sound and Power*, his next album, probed further into studio production techniques. At the same time, two young Black British youth named Carl "Smiley" Hyman and Philip "PJ" Johnson also set out to experiment with imported music genres undergirded by breakbeats. Adopting the name Shut Up and Dance, Smiley and PJ came together to form an independent record label and band; they broadcast their music over pirate radio stations and sold it directly to distributors and consumers from their car. Their albums *Dance Before the Police Come* (1990) and *Death Is Not the End* (1992) pressurized hip hop drum breaks into a bass-heavy rotary groove, with ragga vocalizations, and occasional

136 Eshun, *More Brilliant Than the Sun*, 14.

137 Rebel MC, lyrics, "Black Meaning Good," *Black Meaning Good* (Desire, 1991).

acoustic guitar accompaniment, transforming the UK strain of "hardcore" techno into a new sound called "jungle."[138] The cultural progression of hardcore took shape when Shut Up and Dance produced the 1991 album *Reggae Owes Me Money* by the Ragga Twins, two emcees from the London sound-system crew Unity, Deman Rocker (David Destouche) and Flinty Badman (Trevor Destouche).[139] "We started using those beats on the sound system. We'd take old Def Jam tracks, push them from 100 to 130 bpm, and let rip on the mike," the duo detailed in 1991. "The next step was to put something of our own on vinyl, but a lot of people said it sounded too fast. A couple of years later and millions of hardcore groups are having hit singles with our idea, while we've been left out in the cold. We think there's been a conspiracy against us."[140] Shut Up and Dance released the single "Raving I'm Raving," an overt anthemic expression of the rave euphoria that had overtaken the UK youth scene, selling 50,000 copies upon its release and reaching number 2 on the UK charts. It would soon be banned due to an uncleared sample of the Grammy-nominated song "Walking in Memphis," by country singer-songwriter Marc Cohn. The nature of copyright and creative freedom frustrated Smiley and PJ:

> "That you can't do this, you can't say that" attitude is bollocks. We proved that a couple of years ago with a tune that used samples from Eurythmics' "Sweet Dreams." We asked for clearance from RCA, Eurythmics' label, and had given up hope of ever hearing from them when they suddenly released another dance version of "Sweet Dreams." They'd obviously thought, "This is a good idea, we'll have some of this ourselves." At the time we were really pissed off, but now I have to admit that the experience taught us a lot. After that, we'd never ask permission to use a sample again. If people don't like it, they can fuck off. They can fucking sue us.[141]

138 "Even the name 'jungle' comes from Jamaica (as does its more baldly descriptive synonym, 'drum and bass'). According to MC Navigator from London's ruling pirate station Kool FM, 'jungle' comes from 'junglist,' and was first heard in 1991 as a sample used by Rebel MC (who pioneered British hip-house in the early nineties, then formed the proto-jungle label X Project). 'Rebel got this chant—'alla the junglists' —from a yard tape,' Navigator told me, referring to the sound-system mix tapes imported from Jamaica. (Yard is the slang term for Kingston and the root of 'yardie,' a hustler or hoodlum.) 'There's a place in Kingston called Tivoli Gardens, and the people call it the Jungle. When you hear on a yard tape the MC sending a big-up to 'alla the junglists,' they're calling out to a posse from Tivoli. When Rebel sampled that, the people cottoned on, and soon they started to call the music 'jungle.'" Simon Reynolds, *Generation Ecstasy: Into the World of Techno and Rave Culture* (New York: Routledge, 1999), 257.

139 "[W]hen we moved over to Shut Up and Dance, there wasn't no reggae people doing none of that music over there. To make a scene, you need the people. With us coming over there, people from the reggae industry were like 'wow, if Deman and Flinty is over there, something must be good over there.' So they start coming, and when they started coming the more people would put more reggae influence into the music, which started to fill up and was eventually jungle. We never made the word jungle. As far as I'm concerned, I think the first person that used the word jungle on his record label was Paul Ibiza. We were just calling it ragga hardcore, ragga breaks." Flinty Badman, interview by Charlie Allenby, "Ragga Twins on jungle's year zero," *Dazed Digital*, April 30, 2014, https://www.dazeddigital.com/music/article/19750/1/ragga-twins-on-jungles-year-zero.

140 Carl "Smiley" Hyman, "Shut Up and Dance: Raving Mad," *Melody Maker*, June 6, 1992, http://www.pushstuff.co.uk/mmfeatures/shutupanddance060692.html.

141 Ibid.

In the wake of Shut Up and Dance's short-lived chart success followed a longer legacy of jungle's impassioned vocals and rough rhythms. The genre began to animate MCs who entangled African American rapping with Jamaican toasting, punctuating their tracks with patois outcries like "Booyacka." US hip hop and UK jungle splintered the use of breakbeats into separate, though uncannily parallel, patterns; at their center was "the Amen break," a six-second rhythmic construction derived from Gregory Coleman's drumming in the 1969 soul song "Amen, Brother" by The Winstons, which was sampled more than any other song. According to Richard Lewis Spencer, bandleader of The Winstons, neither he nor Coleman knew about this practice until he was contacted, in 1996, by a British record label that wanted to buy the masters and copyright to their song. "I was still in Washington DC. I was attending university and working in the transit system," Spencer said. "I felt as if I had been touched somewhere that no-one is supposed to touch. I felt invaded, like my privacy had been taken for granted."[142] He was unable to seek legal action: the statute of limitations had long passed. "I'm flattered that you chose it, but make it a legal interaction—pay me," he insisted. "The young man who played that drumbeat, Gregory Coleman, died homeless and broke in Atlanta, Georgia,"[143] Spencer lamented.

RAGE, a weekly Thursday night party at the London nightclub Heaven, was a space where resident DJs Fabio & Grooverider, filling in for Colin Faver and Trevor Fung, were able to thrust sound-system culture into the future. "RAGE changed dance music forever," they asserted. "We channeled some of that acid energy but pitted it against the new and exciting sounds emanating from Belgium, Amsterdam, Detroit, Sheffield, Essex and Hackney—and in turn we created a new style. Not many club nights can say that [they] have created a genre that has been going for nearly three."[144] With its capacity for over 2,000 ravers, Heaven enabled a junglist[145] spirit to materialize out of the many competing rhythmic technologies circulating throughout the UK, hotwiring a sea of transcending minds and connecting them in a psychoacoustic spiral from which they could momentarily glimpse into the future. During his time in London in the early '90s, Saunderson attended RAGE, witnessing and contributing to the acceleration of Black British breakbeat rhythm science. "I used to hang out with Fabio and Grooverider so I was right there when drum and bass was taking off," he remembers. "They was like, 'Ah yeah, man. That Reese record. The bass is fat!' then I went to their night at Heaven [RAGE] and there were all these records that sound like Reese

142 Richard Lewis Spencer, quoted in Marc Savage, "Amen Break Musician Finally Gets Paid," *BBC*, November 11, 2015, https://www.bbc.com/news/entertainment-arts-34785551.

143 Ibid.

144 Fabio and Grooverider, interview by Phillip Williams, "Watch a Documentary on RAGE, the London Club Night That Invented Jungle," Redbull.com, March 12, 2019, https://www.redbull.com/gb-en/rage-documentary-fabio-grooverider-premiere.

145 "Someone who comes from the area in West Kingston, Jamaica," or "a lover of jungle music." Jonathon Green, *Cassell's Dictionary of Slang* (New York: Sterling Publishing Company, 2005), 820.

bass. Almost every record. And it sounded great, too!"[146] Saunderson revealed that he created the bass line that became the central component of drum & bass using a CZ-5000. "No samples, just straight-up parameters, getting down with the oscillators, and I found some magic."[147] Ahmud Farhad Dookhith (Ray Keith), a DJ and producer who disseminated jungle through his label Dread Recordings and his radio show *Dreadcast Breakage*, heard Grooverider play Reese's "Just Want Another Chance" many times while clubbing at RAGE, sampling it in his 1994 track "Terrorist," recorded under the name Renegade with sound engineer Nookie (Gavin Cheung). "Jungle is just something else," Andrew Green (Two Fingas) and Eddie Otchere (James T. Kirk) wrote in their novel *Junglist*, an auto-fictional survey of RAGE and the nightlife scene surrounding it. In one passage, they describe jungle and the implicit meaning it held for the people who were able to experience its collision of percussive angles and propulsive thrusts:

> Jungle is more than the sum of its myriad parts. It is the lifeblood of a city, an attitude, a way of life, a people. Jungle is and always will be a multi-cultural thing, but it is also about a Black identity, Black attitude, Black style and outlook. It's about giving voice to the urban generation left to rot in council estates, ghettoised neighbourhoods and schools that ain't providing an education for shit. Jungle kickin ass and taking names. It run things, seen.[148]

A snapshot of the Manchester jungle soundscape, Simpson's third album as A Guy Called Gerald, *28 Gun Bad Boy* (with Nicholas William Dennis Hodgson, aka MC Tunes, a British rapper from Moss Side), came out in 1991 on his own label, Juicebox. Produced at the Manchester recording studio Machine Room Studio, the album speaks to Simpson's attempt to reproduce the impulse of live mixing with an ensemble of Akai S950 samplers, an Akai MPC60 sequencer, an Atari tape machine, Lexicon reverb and delays, two Yamaha SBX90s, a Roland JD-800 digital synthesizer, and other gear that could be routed into a multichannel mixing board. "The inspiration for the whole thing was the mix-tape format," Simpson points out. "People were taping DJ sets and I wanted to use that as a concept for the album. As I'd already released a few 12-inches, the idea was to mix some of them into one track for the album."[149] The album's opening 20-minute track, called "Mix," churns through an extended array of sounds and previously released material from Simpson's label. "I started production of the album with this mix track, and I wanted the mix to introduce a flow into the

146 Kevin Saunderson, interview by Greg Scarth, *Attack Magazine*, August 1, 2014, https://www.attackmagazine.com/features/interview/kevin-saunderson-2/.

147 Ibid.

148 Jamies T. Kirk and Two Fingas, *Junglist* (London: Repeater, 2021), 45.

149 Gerald Simpson, "The Classic Album: A Guy Called Gerald - 28 Gun Bad Boy," *FutureMusic*, no. 230 (September 2010): 20, archived on A Guy Called Gerald Unofficial Web Page, http://homepages.force9.net/king1/Media/Articles/2010-09-FutureMusic-Article.htm.

album. As far as I was aware, there had never been a Jungle Techno album before. There had been loads of mix-tapes, so I wanted to have that mix-tape feeling as an intro."[150]

In London, producers Mark "Marc Mac" Clair and Denis "Dego" McFarlane released the album *In Rough Territory* (1991) as 4 Hero on their own label Reinforced Records, with additional members Gus Lawrence and Ian Bardouille. Their song "Mr Kirk's Nightmare," constructed from a sample of The Isley Brothers' 1970 soul funk song "Get Into Something," captivated ravers. It also featured a clip from American studio band Think's song "Once You Understand," which addressed the cultural differences between Silent Generation parents and their Baby Boomer teenage children. Opening with the statement "Mr Kirk? Your son is dead. He died of an overdose,"[151] the song interpolated the ecstasy-raging club scene. Reinforced Records quickly became one of the most important staples of the transition from jungle to drum & bass, with a roster consisting of Joachim Shotter and Richard McCormack as Nebula II, solo releases from "Marc Mac" and "Dego," as well as the trio Rufige Kru (Linford Jones, Mark Rutherford, and Clifford Price). 4 Hero's 1991 EPs *The Head Hunter* and *Golden Age* and the 1993 album *Journey from the Light* built upon their previous releases and pirate radio broadcasts on Strong Island FM, plunging the "happy hardcore" phase of the rave era into bleaker territory.[152] Starting out with a basic set up of two turntables and a mixer, 4 Hero slowly transitioned from playing records using transmitters they had built as college students, to producing music with electronic instruments. Their musical output overflowed into different platforms and formats including club spaces, radio, and traditional music distribution channels, which they attempted to manage closely with their own record label.

"The electronics came in handy in terms of us being able to understand what we were doing, and that led to everything we did with Reinforced. It wasn't about just music. It was always the technology behind the music, too," Marc Mac explained. "We were building the speakers for our soundsystem and building the transmitters for our radio station. Then, it wasn't just about making music. We had to run a label."[153] In time, the upkeep of running a record label outpaced 4 Hero, after the distribution company they were affiliated with went bankrupt due to outstanding debts, partially from uncleared samples. "We saw chopping up samples in our bedroom as the same thing as hip hop DJing—playing with another person's piece of music," Bardouille recollected. "We

150 Ibid.

151 4 Hero, lyrics, "Mr. Kirk's Nightmare," *In Rough Territory* (Reinforced Records, 1991).

152 "If anyone can claim to have invented darkcore, it's 4hero," Reynolds, *Generation Ecstasy*, 213.

153 Marc "Marc Mac" Clair, Ian Bardouille, and Gus Lawrence, interview by Hanna Bächer, "Reinforced Records," *Red Bull Music Academy Daily*, April 12, 2016, https://daily.redbullmusicacademy.com/2016/04/reinforced-interview.

went from being rich kids to broke kids in debt."[154] Lawrence also considered the rough territory of copyrights in a global music recording industry:

> I didn't know about VAT [value-added tax] in those days, either. I just thought it was more money. The VAT man came knocking on the door after bankruptcy and said, "Why are you asking for VAT? Are you VAT registered?" He sat me down with my dad in the front room and said, "This is very serious—the office can close you down." They were trying to put the shakers on the young kid. So anyway, they went bust, the VAT office let us off, and then we started to do business properly.[155]

A collection of "bands" and collectives, Reinforced Records experienced minor forms of success that sent a signal to the larger recording industry that there was money to be made off of the bedroom musicians innovating from the margins by updating recycled materials. "The debt put us into overdrive, production-wise," Lawrence remembered. "Because we had to make records to pay off our debt that we had to the pressing plant, we were knocking them out left, right and center. By the time we got to record number nine, we'd paid it off and had developed a following."[156] 4 Hero's Marc Mac and Dego (who also recorded together under the alias Tom & Jerry) dropped a string of singles that built up to their magnum opus of a second album, *Parallel Universe* (1994), voted Dance Album of the Year by *NME*. "Universal Love" christens this latest structural progression from jungle to drum & bass with smooth vocals by Carol Crosby gliding over a composition of soft pads, martial breakbeats, and alto saxophone licks, arranged in the stereo field to resemble a jazz fusion studio ensemble.

In his study *More Brilliant Than the Sun*, Kodwo Eshun, understood *Parallel Universe* to be a constructive stereo experience that intentionally drifts between fast and slow paces, while also shaping the ear through the placement of bass, percussion, and melodic sounds, which seemingly inverted the documentary realism of hip hop and exceeded the futurism of techno—even breaking the fourth wall with sampled commentary by two young boys declaring: "Oh my God!... this is a record album!"[157] Tuned into the "rhythmic psychedelia" produced by 4 Hero's expansive approach to breakbeat science, Eshun suggests that *Parallel Universe*—as well as the group's fusion of jungle and techno as Jacob's Optical Stairway, on their self-titled album for R&S Records (1995)—presumes the "future of computer music." The "rhythmhacking" occurring in the album, Eshun argues, is a revelation of the "secret technology" locked inside of the breakbeat; an artifact of African American soul, set free by Black British counter culture. He writes:

154 Ibid.

155 Ibid.

156 Ibid.

157 4 Hero, lyrics, "Parallel Universe," *Parallel Universe* (Reinforced Records, 1995).

In [*Paranormal Universe*] rhythm is a heatseeking break which goes awol, reorganizing sound into an aerodynamic epic. Each break branches, the rattlesnake break in the right speaker travels around your head, fading away behind your neck, swallowing its tail. The left-side break fades away behind your head, intersecting with the right in a subsonic turbulence, reemerging so close it grazes your head while the right is far off, subaudible. Simultaneously the left-side break distresses into a high-pitched tone which drops out only to loom up in your ear, shrieking like a jetfighter. Behind you space trembles as each flightpath agitates the other's orbit at different speeds.[158]

Beginning in 1992, music journalist Simon Reynolds charted a timeline of the research and development of breakbeat science,[159] offering an overview of this generation's feeling of rhythm and time in the final years of the millennium. Establishing what he called the "hardcore continuum," Reynolds documented the British rave scene across multiple articles in *The Wire* magazine, describing 4 Hero's *Parallel Universe* as "hardcore's first full-length album that isn't just a compilation of old tracks"— much like the first wave of Detroit techno. In his first article about the continuum in November 1992, Reynolds had proposed that "Those looking for the next revolution would do better to watch for what crawls out of the Ardkore morass than to carry a torch for Detroit"[160]—a rash prophecy, he admitted in his September 1994 follow-up piece. The recurring dilemma of genre, format, and copyright standardization troubled the independently-owned Black underground techno and jungle scene that remained seemingly incompatible with the structure and standards of the global music recording industry, even as it stimulated so much human emotion and engagement. Reporting from the press division of the music industry, Reynolds drew up a telegraphic narrative that located and categorized the Black Atlantic evolution of techno into jungle—a root genre that would further progress into drum & bass through the influence of the white consumer gaze:

> Always more multiracial than other post-Rave scenes, Hardcore got "blacker" as hiphop, Ragga, dub and Soul influences kicked in, and by 93 it had evolved into Jungle. By this point, Hardcore/Jungle (the terms remain interchangeable) was universally scorned by dance hipsters and banished from the media. But the

158 Eshun, *More Brilliant Than the Sun*, 69.

159 On breakbeat science, Eshun writes: "The science in Breakbeat science doesn't drain sensation; instead it opens up a possibility space of hypersensation. Rhythmically speaking, science sensualizes. Physics doesn't numb the senses, it intensifies them. When the eye's capacity to explain the ear breaks down, physics takes over. Science takes control as soon as the visual collapses. The cognitive dissonance of science amplifies the perceptual wrench of rhythmic psychedelia." Ibid., 70.

160 Simon Reynolds, originally published as "Above the Treeline," *The Wire* 127 (September 1994), republished as "The Wire 300: Simon Reynolds on the Hardcore Continuum #2: Ambient Jungle (1994)," https://www.thewire. co.uk/in-writing/essays/the-wire-300_simon-reynolds-on-the-hardcore-continuum_2_ambient-jungle_1994_.

scene thrived thanks to a self-sufficient network of small labels, specialist record shops, pirate radio stations and clubs.[161]

Reynolds waxed about the "maturity" and "intelligence" of the multicultural hardcore movement, categorizing drum & bass as "a multi-tiered percussion and rhythm-as-melody approach that took the ideas of hip hop and dub into the 21st Century." He continues:

> Jungle may be on the verge of a similar generationally-based schism, as older hardcore artists get frustrated by the limits of the 12" and start to make music that works better at home than on the dancefloor. But it would be a shame if the scene repeated the mistakes of so much "electronic listening music," and, in trying to make "armchair hardcore," ended up producing easy listening with breakbeats. Already, the more run of the mill intelligent tracks can make me feel a nostalgic pang for the days when hardcore was 'mere' trashy fun, a mad blast of squeaky voices and epileptic riffs. 4 Hero's *Parallel Universe* (Reinforced) is hardcore's first full-length album that isn't just a compilation of old tracks, and it illustrates some of the pitfalls of armchair hardcore. Much of it is brilliant, but some of the treatments and effects are a tad muso, a bit for fellow engineers ears only. And the deployment of genu-wine, authentically cheesy saxophone playing on a couple of tracks seems a misguided stab for "real music" legitimacy.[162]

Probing the emergence of the label Metalheadz, started by Kemistry & Storm and Goldie in 1994 in dialogue with LTJ Bukem, 4 Hero, and A Guy Called Gerald, Reynolds detected a strain of "ambient jungle" conversion in their array of albums released that year. LTJ Bukem (Daniel Williamson, so dubbed after his nickname "Book 'em," a reference to the television show *Hawaii Five-0*) began DJing as the dance music industry was starting to form in the UK. He contributed a string of singles through his own label, Good Looking, including "Demon's Theme" (1992), "Atlantis" and "Music"[163] (both 1993), and "Horizons" (1995), culminating in his mix album *Logical Progression* in 1996. "I called my first tune 'Logical Progression' because that's what it was," Williamson said of his first foray into electronic production. "It was time for the music to move on. I couldn't get the kind of music I wanted to play out, so I ended up making new tunes from finding beats and mixing them with house, and vice versa."[164] Reynolds labeled Williamson's progressive vision for jungle "oceanic

161 Ibid.

162 Ibid.

163 "The first time that I heard 'Music' was at Venue 44 in Mansfield. Danny was on after me and he'd told me he was going to play a track which would blow me away. It did. I'd always thought music like that could be made, but nobody ever did it. I remember playing it at Universe at 6am and, to this day, I still have people saying, 'Hearing you spin 'Music' changed a lot for us, especially at that time of morning,' I still play it at Speed most weeks." Fabio, "The Pace Maker," *Muzik* 11 (April 1996): 86.

164 LTK Bukem, quoted in ibid.

Hardcore": "over a whispery sea of beats float languorous quiet storm-style diva 'mmmm's and moans, rippling harps and strings, scintillating motes and spangle-trails of sound."[165] He compared his track "Atlantis" to Jimi Hendrix's 1983 "A Merman I Should Turn to Be," a stereophonic studio performance music, thus identifying that oscillating quality of sound in Black Atlantic music culture that can liquify the boundaries of the phenomenal world. "'Atlantis showed that speeding up the beat until it bypassed the body altogether could transform hardcore into relaxing music; rhythm itself becomes a susurrating, soothing stream of ambience, a fluid medium in which you immerse yourself, while the body responds to the half-speed, heart-murmur bassline."[166]

Gerald Simpson appears elsewhere in Reynolds' article, discussing his then-forthcoming album, *Black Secret Technology*, released in 1995, shortly after 4 Hero's *Parallel Universe*. "I'll use about five or six drum loops, add electronic percussion, pan 'em across the speakers, feed 'em through effects," he tells Reynolds. "If people are gonna pay five quid for a track, I'll give 'em their money's worth! If you listen in a room with your eyes closed, things should leap out at you. I create as much dynamics within the music as possible. And my personal rule is that the samples must be totally masked, beyond recognition."[167] Eshun follows this logic in *More Brilliant Than the Sun*, positing that *Black Secret Technology* is a sonic event that reconnects the spiritual circuitry between African polyrhythms and the present African diaspora on the verge of bursting into the future. "We have advanced to a level where we can control time sonically by stretching a sound... we play with time," Eshun quotes from the album's sleeve notes:

> Say someone has created a drumbeat. They've done that in a space and time. If you take the end and put that at the start, or take what they've done in the middle, you're playing with time. With a sample you've taken time. It still has the same energy but you can reverse it or prolong it. You can get totally wrapped up in it. You feel like you have turned time around.[168]

Eshun references a graffiti mural made in 1986 by Goldie with Birdie and Kris that reads "Future World Machines" as he outlines the artistic growth displayed in Goldie's cosmological debut album *Timeless* (1995). "The graffiti artist cracked the letter first," Goldie says to Eshun. "Now I use a Mac to do the same thing. The loops, they've been sculpted, they're in 4D."[169] Much like graffiti, drum & bass offered Goldie a

165 Reynolds references a song from Jimi Hendrix's 1968 album *Electric Ladyland* that transmits a sonic fiction about a war between two underwater civilizations, in Reynolds, "Above the Treeline."

166 Ibid.

167 Ibid.

168 Eshun, *More Brilliant Than the Sun*, 76.

169 Ibid., 74.

canvas and a trajectory beyond hip hop culture, as displayed in *Timeless'* title track, which reconstructs the jazz fusion inflections of Black British jungle's hi-tech street soul into a twenty-two-minute symphonic odyssey sung by the British vocalist Diane Charlemagne. The song was scaled down to a seven-minute single and three-minute radio edit titled "Innercity Life" that reached number 49 on the UK Singles chart. "Technically, 'Timeless' is like a Rolex,"[170] Goldie explains his usage of "time-stretching," a technique enabling a sample to be captured within a specific tempo and rendered as malleable as gooey plastic, lost in time. The album's recording engineer Rob Playford explains: "On *Timeless*, there are three sections of strings. They're all the same sounds but each section has a different set of controls, like pitchbend or modulation or gating."[171] Unraveling more of the studio engineering, Playford says: "We'd go round a loop, filter, effect, pitch things up or down, then put it back on DAT. Then we'd pick up that sound later on and go through a different route with the effects and filters so it would end up even farther away from what we'd started with."[172]

As these Black Atlantic sounds surfaced in parallel with the rising second wave of Detroit techno musicians, a group of Portsmouth Polytechnic film students—John Akomfrah, Lina Gopaul, Avril Johnson, Reece Auguiste, Trevor Mathison, Edward George, and Claire Joseph (later replaced by David Lawson)—formed the Black Audio Film Collective in 1983. Their work throughout the 1980 and '90s sutured together a political ideology influenced by Indian English critical theorist Homi Bhabha and cultural theorist Stuart Hall, aimed at decolonizing the British Caribbean and Asian diasporic mind, ahead of a collapse of empire in the midst of postindustrial, colonial melancholia. Their first film, *Signs of Empire* (1989), explores the mythic nature of the British empire and the inherited alienation of diasporic youth. The collective footage of art schools and galleries, shot with a Kodak dissolve unit, was paired with audio objects extracted from and arranged using manipulated tape loops, composed of orchestral and chorale recordings and spatial sonifications of ships at sea, spliced with political speeches: "In the beginning – the archive – imperialism – the hinterlands of narrative – the impossible fiction of tradition – the treatise / in national identity – the decentred autobiography of Empire – the rhetoric of race…"[173]

In 1996, the Black Audio Film Collective's fifth film, *Last Angel of History* continued on this trajectory, forging a new multicultural identity under imperialism and reflecting on the historical and cultural process Zimbabwean American poet and academic Tsitsi Ella Jaji has referred to as "stereomodernism," or "dubbing in stereo for solidarity." Jaji writes that, "A stereophonic sound system operates on the principle of minute

170 Goldie, in Reynolds, "Above the Treeline."

171 Rob Playford, quoted in Eshun, *More Brilliant Than the Sun*, 75.

172 Ibid.

173 Kodwo Eshun and Anjalika Sagar, eds., *The Ghosts of Songs: The Film Art of the Black Audio Film Collective, 1982–1998* (Liverpool: Liverpool University Press, 2007), 18.

temporal delays in the signal received by each ear, mimicking the way that in an acoustic space sound from any given direction arrives at one side of our heads milliseconds before it reaches the other side, and with slightly different amplitudes."[174] The stereo effect is sculpted from two audio channels, allowing for musicians to create a new conception of modernity "as an illustration of how 'diaspora' articulates the body of global Black presence, both connecting (just as joints are the connections between bones) and giving expression to (in a more familiar sense of articulation) 'difference within unity.'"[175] Traveling through time, the Data Thief, played by co-writer Edward George, logics his way through an intensive encoding and decoding process of Black Atlantic media culture, conjuring the connective word-images—"Africa," "the New World," "Lee Perry Black Ark," and "Sun Ra Arkestra"—retracing the stereomodern construction of a Black Atlantic sonic fiction told across the progression of blues, jazz, soul, funk, techno, reggae, jungle, drum & bass, and beyond. In so doing, he arrives at an understanding of Black music as a latent Afrofuturist guidepost, conceived with stereophonic intelligence within a global consciousness.

The Data Thief meditates on the idea and need for "sonic warfare, sonic Africa, Afrofuturism, digitized diaspora, analog ecology," and a collective African memory. "Every entrance into these vaults brings new information of victories and defeat, dreams and catastrophes,"[176] he says. The film transitions into an exploration of jungle music as it emerged from dub and techno to complete the triangular network of a Black Atlantic world. A Guy Called Gerald describes how the studio recording mechanics that produced jungle represented a leap into the future: "You know, it's changing from something that was more analog into something that is turning totally digital. I think jungle is using, well the rhythms anyway, rhythms that came from drums, normal drums, which had been like put through a process—digitized and manipulated digitally to create sounds unheard before, you know, really."[177] Goldie builds on his observation: "I feel that's where the difference between techno jungle and I jump to techno when I'm ready to play. There's no difference." He insists that the question "wasn't what techno is, it's what we took from techno. It's like anything else. It's not what hip hop is, it's what we take from it. You know, stuff that Derrick May made and stuff Carl Craig made because it was—it came from somewhere. It was something which had a better meaning to me." Derrick May mulls over the British Caribbean optimization of techno, remarking: "Jungle… I hate the way—I hate the word 'jungle' if you want to know the truth about it. What the fuck does jungle mean? Okay, it was called Breakbeat before, now it's called jungle. Where does jungle come from? What is jungle? What does that mean?" A Guy Called Gerald corrects May, asserting that,

174 Tsitsi Ella Jaji, *Africa in Stereo: Modernism, Music, and Pan-African Solidarity* (Oxford, UK: Oxford University Press, 2014), 11–12.

175 Ibid.

176 *The Last Angel of History*, directed by Black Audio Film Collective (Brooklyn: Icarus Films, 1996).

177 Ibid.

"Jungle actually comes from an area in Jamaica that they call The Jungle, you know? And MCs from there, I think elaborated on that. So… it's sort of like when it came out on sound system tapes, people latched onto it and started using it as a name." In the scene that follows, May describes Gerald Simpson as "sad inside, happy face on the outside. Put all his heart and love into some big record company and they sold him out." Simpson, in turn, speaks of his admiration for May and his work: "I mean me, to me it's like he kicked me off, you know? Without listening. It is what it is. Feels surreal—all the early like, Transmat stuff, I would've been lost. I was lucky to, sort of like, to hear his things on the radio and think, 'Yeah, that's like… a direction—that's where I want to go; otherwise I don't know what I'd be doing now.'"[178]

Goldie suggests that, "We are the future now, we are in the future." He wonders what music would sound like if the blues had never been recorded. In turn, Atkins asserts that techno was intended to be a music for the technological present-in-motion, which would update and evolve with the times: "I think it's inconceivable as to where we will be in the next five years, but I see just a lot of new ways of listening to music, new ways of buying music through computer networks." Eshun ends the film with an extended reading of eighteenth-century narratives written by African American slaves Harriet Jacobs, Harriet E. Wilson, Phillis Wheatley, Fredrick Douglass, and Booker T. Washington—necessary texts that offer one of the few windows into the lived experience of American chattel slavery. He points out that Negro slaves wrote "to prove that they were human, to prove that they weren't furniture, to prove that they weren't robots, to prove that they weren't animals." He concludes:

> In that sense, a certain idea of cybernetics has already been applied to Black subjects ever since the 18th century. I think what we get at the end of the 20th century in music technology is a point where producers kind of willingly take on the role of the cyborg—willingly take on that man-machine interface. Just to explore that mutation that's already happened to them and to accelerate them some more. Now the question is like, kind of, cyborgs for what? Well the reason is of course, to get out of here. To get out of this time here, this space now.[179]

In 1996, Edward George (the Data Thief) was focused primarily on scriptwriting and cinematic language, but his idea of "found images" embedded in an inventory of traditions spanning across the African diaspora would eventually find an outlet in music. "There used to be a shop in Camden called Zoom Records and every lunch hour, before going to work and after going to work, I would go there and dig for new music," George recalled.[180] His interest in music before that point had been that of a collector, acquiring

178 Ibid.

179 Ibid.

180 Edward George, quoted in Matt McDermott, "Label of the Month: Basic Channel," *Resident Advisor*, December 31, 2018, https://ra.co/features/3365.

house and techno imports since 1985. "That year coincided with a moment in Jamaican music when there was this big transition from analog bass production, especially in regards to dub, to digital. . . . So I walk into Zoom Records, they have this single on I think it was Planet E, it was definitely a Paperclip People single and I think the B-Side was called 'Remake (Basic Reshape).'" He listened to the record and was blown away. George began to think about the impact of Carl Craig's musical conversation with the Berlin duo Basic Channel (Mark Ernestus and Mortiz von Oswald). "The reason my mind was blown was because this felt like, somehow or other, we didn't know how they'd done it, but something of the dub process and dub technique and dub's image of space was at work," he explained. "Somehow techno has found a way of intersecting with the excesses and extremes of Jamaican music."[181]

From then on, George began to collect Basic Channel records alongside techno and house, without ever knowing exactly who produced what track. "It's like, this is what techno sounded like before techno was invented, before the grammar had been defined. At the same time, there's a concern for forms that have present in them their dissipation," George expounds on his love of dub and studio recording. "There's a bit in Lee Perry's 'Dub Revolution Part 1' where you can hear the microphone being on with no signal coming up but the EQ and faders are so high you hear a kind of whoosh—it's the hiss in the transfer from reel-to-reel in dub mixing that Sylvan Morris made a motif in his Studio One engineering and mixing, but in the classic audiophile sense, it's the detritus of sound recording," he remembers. "It's the bit where you can't go any further before your technology gives the lie to transparency."[182] In his essay "(ghost the signal)," George decodes a pattern from clusters of informative noise, much like the Data Thief, and documents fragments of scenes of Black prophetic figures throughout modern history. He writes:

> In his low-budget studio, Perry produces a unique music developed around a kind of heresy, a rewriting, a relocation, a blurring of the word of God into the apocalyptic mysticism and political demands of the Jamaican under-classes, that He may speak through their voices, make Himself present through their songs. The devices of songwriting and record production as low-tech media necromancy. The Ark is also a time machine, shifting the sound of Black misery and suffering to a time before slavery, to the days of Noah where: "everything was safe in the Ark" a machinery of divine redemption; "down in the dungeon, that's where I used to break my bread. . . " a sonic mythic-time machine, controls set for the days before the days of Moses.[183]

181 Ibid.
182 Ibid.
183 Edward George "(ghost the signal)," in *The Ghosts of Songs*, 206.

The Black Ark studio space and Sun Ra's Arkestra ensemble operated as early iterations of the Black Atlantic sound. George considered these crossed frequencies in both writing and film to ascertain their uses for escape from the profound trauma of the Maafa:

> To finally have done with this God. To finally abandon the search for a place in this world. To become something other than human, here and now, while also hailing from some far away land, from ancient Egypt, Africa before the slave trade, and from somewhere out there too, from deep in the harsh winds of Saturn, stopping over here and then continuing the flight. The moment of Black radicalism's shift into a new phase of civil protest, as if walking was going to change the world, is foreshadowed, prefaced, by Sun Ra's cosmologically themed poetic vision of the future… New bodies, new machines. Hence, George Clinton's Mothership, the Funk-technophilic permutations, the numerous personae, or Lee Perry' s studiocentric transformation of the metaphor of the Biblical Ark of the Covenant to the Black Ark, a pun, a cosmo-theophonic echo and inflation of the gold-plated case with the two tablets stating God's Ten Commandments, and the name of Perry's recording studio, and with Black Art, the name of one of his record labels. Hence, the incessant conjurations of an impossible sound environment—meteorological changes, atmospheric shifts, the rendering of signal as trace; hence, the innumerable voices and layering and thickening and dissolution of spaces rendered as traces of their former selves.[184]

George's interest in the repurposing of signal noise as a dysfunctional aspect of music paired well with Trevor Mathison's use of post punk and industrial influenced compositional techniques when composing for the Black Audio Film Collective. In *The Last Angel of History*, Mathison sought to create a soundtrack that distanced itself from the musicians present in the film, instead focusing on lacing elemental sounds that resemble the signals and air that the Data Thief would be wading through. "This is their sonic baggage that follows them through these interventions or these journeys and collections," Mathison explains. "I was trying to evoke this sort of electronic or atonal kind of sound, I guess… there's lots of things, a lot of elements that have been made before and tried to be massaged back into position or new positions or in new relationships between what's been cut."[185] Mathison and George's work together extended beyond film into the studio art world and even further into an encoded lingual ethnic identity and sound world. Their installation "The Black Room," presented at the group exhibition *Mirage: Enigmas Difference and Desire* (1991), "effectively translated these spaces from moving images into sculptural volumes that acted as

184 Ibid., 205–6.

185 Trevor Mathison, "At Home: Artists in Conversation | John Akomfrah and Trevor Mathison," Yale Center for British Art, August 9, 2021, https://www.youtube.com/watch?v=pr34c_-mCKA.

televisual shrines to contemporary African urbanism,"[186] and later the video portrait *Three Songs on Pain, Time and Light* (1995) about Donald Rodney, a famed British artist that worked with mass media and pop-cultural representations of racial identity, who died in 1988 from complications caused by sickle-cell anaemia.[187]

In 1998, George was introduced to Ernestus and Oswald and a number of artists on the Basic Channel label by Eshun, who had been tasked with writing a profile of the label for *The Wire*. After that meeting, George and Mathison, alongside the scientifically-minded artist and musician Anna Piva (who also collaborates with George in the multimedia project Flow Motion) formed Hallucinator and began to release their abstracted take on dub techno: *Landlocked* (1999), *Frontier* (2000), and *Morpheus* (2003), on Basic Channel's Chain Reaction sub-label. As George put it: "I think what we're really talking about is the formation of a space where hybridity could take place. Where all these new kind of formations and different kind of moments of realization can come and take shape. Here's the weird thing—the condition is that you have to stay primal, you have to keep it early as a way of getting in touch with something that's almost prelinguistic."[188]

Scientific and data-derived speculation as applied to the sculptural aspects of dub studio production is deeply embedded in the Hallucinator project, but as George and Piva explained, "there's also a concern in the titles of our tracks with the cosmos as a pre-enlightenment, metaphysical space shaped by a process of figuration, which oscillates between cosmos as an opening onto the sacred and transcendent, and cosmos as object of scientific speculation."[189] On *Landlocked*, the tracks "Red Angel," "Black Angel," "Moonshot," and "Rocket" are concerned "with the blurring, the collapsing of opposing thematics into new shapes and forms" as well as "an idea of the cosmos as a space of new associations and a proliferation of new, hybrid forms and relations: the Egyptology and natural philosophy of Sun Ra finds a companion in the beatific immortalism of Nikolai Fedorov, founding figure of Cosmism, the 19th century Russian tradition of text based speculation on the place and role of humanity in the universe, and in whose trail we discovered we had been walking along for

186 Kodwo Eshun, "Drawing the Forms of Things Unknown," in *The Ghosts of Songs*, 83.

187 "Diseases—cancer, leukaemia, Parkinson's disease etc—are to an extent afflictions that pay no heed to racial or national boundaries. This is important because in an age in which 'identity' has become the most slippery of constructs, 'sickle-cell' has become a rock-solid signifier of Blackness and Black people. All Black people might not develop sickle cell, but only Black people will develop sickle cell. And because only Black people are affected by it, the government, the medical profession and the nation at large accord sickle cell scant recognition. At least, that seems to be the prevalent view at the moment. So those who suffer from sickle cell become living barometers of 'woe is me' racial injustice, whether they want to be or not. Enter Three Songs on Pain Light & Time." Eddie Chambers, "Three Songs on Pain Light & Time," *Art Monthly*, no. 200 (October 1996): 65.

188 Edward George, quoted in McDermott, "Label of the Month: Basic Channel."

189 Flow Motion (Anna Piva & Edward George), "Flow Motion: Out There," *Leonardo/Olats*, October 2003, http://archive.olats.org/space/colloques/artgravitezero/t_FlowMotion_en.html.

longer than we knew." For Hallucinator, the space and event within film and recorded music offered an opportunity to disfigure reality into a more favorable construction. "The concern with Capitalism's totalising, territorial space mission shifts from an exploration of cynical openings onto profit and domination, into a series of art based explorations of the substance of the universe itself," Piva and George write. "The heightening of the importance of the invisible and the audible in astronomy over an older idea of the universe as observable and silent, suggests new ways of experiencing the universe, which is where we came in, and where we are now."[190]

*

While the hardcore acceleration of jungle to drum & bass was taking place in the UK, Carl Craig was busy in Detroit recording his latest optimization of the techno sound, releasing the album *The Sound of Music* (1995) under the pseudonym 69. Later that year, Craig's proper debut album under his own name, *Landcruising,* was released exclusively in the UK and Japan through a subsidiary of Warner Music UK, Blanco Y Negro; *Landcruising* offered foreign audiences a tailored transmission, beginning and ending with a stereophonic recording mimicking the sensation of a car's revving motor in "Mind of a Machine," before the next track, "Science Fiction" thrusted the listener into a sonographic future. Craig's ear was tuned to the rapid, hardcore acceleration from jungle to drum & bass occurring in the UK while he was at work on his own studio performance music. "I liked what some of the guys were doing: Dillinja, 4 Hero, Goldie, Photek. There is some really great stuff, and some really great producers who came out of it," Craig reflected. "I think we all got on the same level of thinking, and I can really respect that."[191] Expressing an appreciation for the musical craftsmanship of jungle, Craig persisted in pushing the boundaries of his own creativity while signed to a major record label. "I learned a lot," he said:

> My dream had always been to be on Warner or Sire Records. A lot of the music I was into came out on one of those two labels. Parliament/Funkadelic, B-52's, Talking Heads, Yazoo, those two labels had really progressive A&R guys at the time. I didn't know halfway shit about A&R people, I just knew the seal of approval. If it was on Warner or Sire in the early '80s then that shit was going to be hotter than a motherfucker. Blanco Y Negro had Geoff Travis then, which was really important for me because [he] managed the Smiths and he was Rough Trade. So I was happy to be part of this history, but what disgruntled me was how the whole mechanism worked. It made me realize that they don't give a fuck about music. They give a fuck about stuff that's gonna sell like hotcakes. They're

190 Ibid.

191 Carl Craig, interview by Todd Hytlock, *Stylus Magazine*, March 9, 2006, http://stylusmagazine.com/articles/interview/carl-craig.html.

in the music sales business. It was a lesson that I'm glad I learned. But it fucked my head up for a little bit.[192]

The roster May put together at Transmat foregrounded the productions of his local protégés, Carl Craig, Stacey Pullen, and Kenny Larkin. He conceived of his label as the international seed distributor of "authentic" techno. Though Craig leveled up to the major record label industry, he continued to work actively with May who was busy establishing Transmat's presence overseas. During this time, Neil Olivierra continued to work at Transmat back in Detroit, where he meditated on the experiences that inspired him to write *Reality Slap*: "When I returned to the States, I had this burning desire to document the last few years of my life. To build a sort of iconic shrine to the fantastic people I'd been privileged to meet over the years."[193] While at Transmat, he was involved in signing a so-called second wave of Detroit techno producers like Larkin and Pullen. His novel was eventually released as a free download alongside Pullen's album *The Theory Of* (1995); Olivierra's own debut album, *Soundtrack [313]*, produced under the name Detroit Escalator Co., arrived the next year. His intention with this synthesizer-based version of Detroit techno was to capture and resample sounds by drawing out "microscopic details" such as "Lush chords and pads. Evolving textures and sweeps. Skittering metallics, compounded with tape delays and cavernous reverb."[194] Recorded over a year before its release date, *Soundtrack [313]* adapted Olivierra's self-taught music programming into a unique formulation of techno using a Korg X5, "a digital multi-timbral keyboard synthesizer with a built-in effects processor," alongside a Kurzweil K2000 recorded with Logic Audio on a desktop computer. "Some of the programming I compiled on the device at that time seemed very musical to me. The best bits occurred to me after a night's ride through downtown Detroit on Derrick May's bicycle," Olivierra recalled:

> There was something truly mystical about riding a bicycle through the empty downtown streets of Detroit at 3 am. Nights so quiet and desolate that you could hear the traffic lights click when they changed colour. There'd be hours between sightings of any human beings at all. Reality would drop away, leaving me to bathe in the absolutely authentic notion that I was literally the last man living on earth. The things I saw and heard during those midnight bicycle excursions evoked very deep feelings in me that I couldn't begin to describe in words. I heard things that inspired not only synthesizer programs, but musical compositions. After each ride, I'd get home and go straight to the keyboard in order to expand on the things I'd heard that night and compound them with the overall feelings

192 Dimitri Nasrallah, "Carl Craig: Intergalactic Beats," *Exclaim*, February 21, 2008, https://exclaim.ca/music/article/carl_craig-intergalactic_beats.

193 Neil Olivierra, interview by Mike G, "Riding the Detroit Escalator: An Interview with Neil Olivierra," *Ambient Music Guide*, November 2013, http://ambientmusicguide.com/interviews/detroit-escalator-co/.

194 Ibid.

evoked by that night's excursion. Within a few weeks, I had a compilation of entire songs.[195]

In a 2013 interview, Ollivierra wondered aloud about whether *Soundtrack [313]*—which was released a year after *Landcruising*—had been influenced by the same sentiments that animated Craig. "I also knew that while the music I was doing wasn't exactly Detroit techno, I had to similarly pay tribute to the pioneers of that musical genre, without unfairly riding on their coattails," he divulged. "By mastering a complex technical process of composing and recording within a genre of music that was at the time being advanced almost exclusively by native Europeans, pioneers such as Juan Atkins, Kevin Saunderson, Derrick May, Jeff Mills, Mike Banks and Carl Craig literally changed the world's limited perception of what African-Americans were capable of, musically speaking. I wanted to join them in advancing that notion through my own endeavors." Ollivierra eventually left Transmat and Detroit, moving to Chicago to study music composition at Columbia College. After compressing nearly three years of education into just a year and a half, he decided to remain in the city for a while and started an office job. "While working at that job, which had absolutely nothing to do with arts and music, I thought about art and music all day long." In 2001, Ollivierra's concept for a solo exhibition of geo-cubic paintings and accompanying album titled *Black Buildings*, hatched during his time working at a desk, debuted at Detroit's Cpop Gallery. His work would take a different direction, accelerating Detroit techno with the addition and optimization of breakbeats to his software-based audio constructions: "My approach to programming and music composition very much changed when I had the pleasure of meeting Gerald Simpson aka A Guy Called Gerald for the first time."[196]

As Transmat was establishing a transatlantic distribution channel, connecting Detroit techno to the European dance music industry, exchanges also took place through instances of interpersonal communication. Simpson visited Detroit in 1995, shortly after the release of his *Black Secret Technology*. Ollivierra heard the record just as his own *Soundtrack [313]* was hitting shelves, "and it absolutely blew [him] away": "I'd long viewed Gerald as a musical genius of paramount importance," he enthused. "His recordings were hailed as anthems in clubs around the world, including The Music Institute in Detroit."[197] For Ollivierra, Simpson's music "reflected precision and an almost insane attention to detail with respect to programming and arrangement, yet it brimmed over with very real and very warm soul." He asserts that Simpson's *Black Secret Technology* upgraded the techno sound with an infusion of jungle and breakbeats to such an extent that "You couldn't listen to that album without closing your eyes, seizing your bottom lip in between your teeth, and bobbing your head, all

195 Ibid.
196 Ibid.
197 Ibid.

the while wearing a bass face. Each song was an auditory journey through a vast and surreal galaxy of cosmic anomalies." When Simpson visited Detroit, May made sure to introduce him to Ollivierra:

> The next thing I knew, Gerald was in the basement studio that I shared with my brother on the east side of Detroit, and I was watching Gerald noodle around on my Kurzweil K2000. He was interested in a drum kit that I'd programmed out of car factory sounds. There were kicks, snares and hats comprised of samples of drills, punches and metal lathes. He was tickled pink, and I thought it a surreal moment to have Gerald Simpson in my ghetto-ass basement composing beats out of my programs.[198]

Ollivierra marveled over Simpson's innovations, and the adjacent possibilities of a Black Atlantic stereomodernism:

> I never thought for one second to propose a collaboration. I merely wanted to watch his process and learn. And what I learned was that Gerald Simpson takes his time. He sat in front of my keyboard and took nearly a half hour to compose two bars of kicks and snares. It was like watching snails fuck. You'd never know anything was happening at all, unless you were watching from the very beginning. Then all of a sudden the brilliance was made apparent, the payoff would be there, a thoughtfully tailored pastiche of sounds. And you'd think: oh my dear lord, I see it now. He truly has a gift.[199]

In 1996, Craig took a step away from his work with Transmat to pursue a solo career as a self-sufficient musician and label owner, setting the pace with the retrospective compilation *Elements 1989–1990*, which featured artwork by Haqq, and centralized his early musical discoveries as a teenage bedroom producer. "I have a bad habit of getting my hands dirty in every little thing, and I really do enjoy it, but unfortunately, it makes it really hard to put all my attention into one thing," Craig joked in 2006. "I think, though, that the best thing for me is to just be able to sit around in the studio and mess around with sounds and not even really have a starting idea—just to come up with tracks."[200] Craig had a keen inclination towards prosumerist production and sought to generate his own revenue model by investing his consumption of music and electronic equipment back into his music production and distribution—he published several projects at once through his record label Planet E Communications. In 1996, he put out *The Secret Tapes of Dr. Eich* under the name Paperclip People, a reference to Operation Paperclip, a secret US intelligence program that employed over a thousand German scientists, engineers, and technicians after the Second World

198 Ibid.
199 Ibid.
200 Craig, interview by Hytlock.

War.[201] A cold-blooded sonic fiction emanates from the album's sparse hi-tech funk compositions, mimicking the affect of European horror films such as *The Cabinet of Dr. Caligari* (1920) and *Eyes Without a Face* (1960). Craig also filled out his new Innerzone Orchestra project, bringing on former Sun Ra drummer Francisco Mora Catlett and jazz bassist Rodney Thomas Whitaker; together they put on wax two versions of a song called "Bug in the Bass Bin" that accentuate the outer regions of the compositional structure of the techno sound with re-engineered studio performance jazz that resituates the UK junglist sound system studies and breakbeat science in the syncopated dance music at the root of the African American music continuum.

Craig's hi-tech jazz fusion fully crossed over when 4 Hero and Goldie began to play the track during the DJ sets. "When I first heard a DJ playing [Innerzone Orchestra's] 'Bug in the Bassbin', I knew they were playing it faster than normal, but I didn't really have the concept of how it would inspire people," Craig reflected. "I knew that I wanted to inspire, but I didn't have any idea of how it would be an integral part of inspiring guys to make breakbeat or drum and bass or whatever. I mean, breakbeat itself was something that was going on at the time when I made 'Bug...', with Shut Up and Dance [UK pioneers of old skool breaks and rave], that kind of stuff. But when people were inspired by 'Bug...' to make early drum and bass, I had no clue that would be the case."[202] Craig was blown away the first he heard Goldie's *Timeless* during an interview with Eshun: "It was something that, even though he took some inspiration from us, [Goldie] definitely got really deep in the arrangement of it, and the emotion of it," Craig acknowledged. "'Bug In The Bassbin' is a kid of voodoo, tribal thing with a relentless groove that you kind of fall into, but 'Timeless' had this emotion and an amazing movement."[203]

Innerzone Orchestra was meant to be a project for Craig to stretch his musical scope into the avant-garde while also maintaining a healthy touring schedule as a DJ in the clubbing industry. "[W]hen I started doing stuff that was more of a jazz thing, that came from doing a remix of 'Bug in the Bassbin', for the [1996] Mo Wax version of it," he explains. "And a girl at the time that I was hanging out with, Ife Mora,

201 "In the fall of 1944, the United States and its allies launched a secret mission code-named Operation Paperclip. The aim was to find and preserve German weapons, including biological and chemical agents, but American scientific intelligence officers quickly realized the weapons themselves were not enough. They decided the United States needed to bring the Nazi scientists themselves to the U.S. Thus began a mission to recruit top Nazi doctors, physicists and chemists—including Wernher von Braun, who went on to design the rockets that took man to the moon. The U.S. government went to great lengths to hide the pasts of scientists they brought to America. Based on newly discovered documents, writer Annie Jacobsen tells the story of the mission and the scientists in her book, *Operation Paperclip: The Secret Intelligence Program That Brought Nazi Scientists to America* (New York: Little, Brown and Company, 2014)." NPR Staff, "The Secret Operation to Bring Nazi Scientists to America," All Things Considered, NPR, February 15, 2014, https://www.npr.org/2014/02/15/275877755/the-secret-operation-to-bring-nazi-scientists-to-america.

202 Carl Craig, quoted in Tristan Parker, "Carl Craig and Innerzone Orchestra," *Clash Music*, November 2, 2009, https://www.clashmusic.com/features/carl-craig-and-innerzone-orchestra.

203 Carl Craig, interview by Aaron Coultate, "Interview: Carl Craig," *Juno Daily*, February 28, 2011, https://www.juno.co.uk/junodaily/2011/02/28/interview-carl-craig/.

her father Francisco—who would become a major part of Innerzone Orchestra—he was the one that really turned me onto Sun Ra, onto Seventies Miles Davis stuff."[204] Craig considered Francisco to be a mentor who pushed him to pursue music in ways he felt he wouldn't have on his own, "especially when it came to 'out' music and music that had a very different structure to it than what electronic music had—and he introduced me to Rodney Whitaker, who was the bassist on that, and plays with Wynton Marsalis, and to Craig Taborn, and on to Kelvin Sholar, who I do a lot of work with now."[205] In a 2006 interview, Craig recalled the explosion of creative energy in urban communities amid the postindustrial crises of the 1980s, looking back on the progress he has made from his bedroom-studio beginnings:

> I grew up in a time and a place where I believe that music—especially music exposed on the radio—was very diverse. Especially with Black music, because there were so many different types of music that people in Detroit were listening to: funk and soul and rock and everything in-between. I mean, I grew up listening to Peter Frampton and that kind of stuff, but I also heard a lot of Prince and George Clinton and Motown and Gil Scott-Heron, all this stuff. I think if I had grown up listening to only, say, classical or something, then I wouldn't have any interest in what else was going on out there, and it would be the same way if I was only listening to soul or blues or jazz. I really believe that what was available when I was growing up has really instilled that urge to stay diverse and to conjure things from my spirit instead of following trends or trying to do things that fit in.[206]

With *More Songs About Food and Revolutionary Art* (1997), Craig advanced his creative vision even further, taking techno through lush, hi-definition compositions best fit for headphones or home-speaker systems. Scrawled along the cover art, a quote from writer Jeff Sawtell reads: "Revolutionary art is not determined by its avantgarde content; nor its formal or technical trickery, its interpretation of reality or its verisimilitude, but, rather, by how much it revolutionizes our thinking and imagination; overturning our preconceptions, bias and prejudice and inspiring us to change ourselves and the world."[207] Though techno had been dislocated from its source in Detroit, Craig lit a torch that continued to update and redefine the boundaries of the sound as an art form outside of and alongside the British and European rave culture industry.

204 Carl Craig, interview by Joe Muggs, "theartsdesk Q&A: Producer/DJ Carl Craig," *The Art Desk*, February 5, 2011, https://theartsdesk.com/new-music/theartsdesk-qa-producerdj-carl-craig.

205 Ibid.

206 Craig, interview by Hytlock.

207 Jeff Sawtell, quoted on Carl Craig, cover, *More Songs About Food and Revolutionary Art* (Planet E, 1997).

*

In the mid-'90s, May was working closely with R&S Records through a pressing and distribution deal designed to structure and maintain Transmat's presence in the European market. One signee, Kenny Larkin, who had been absent for most of the "first wave" of Detroit techno because of his military service as part of the Gulf War Operation Desert Storm/Desert Shield, released his first singles *We Shall Overcome* in 1990 and *Integration* in 1991 on Richie Hawtin's Plus 8 Records. His debut album of ambient, minimal electronic funk, *Azimuth*, arrived on Warp Records in 1994, followed by *Metaphor* on R&S in 1995. In the 2000s, Larkin switched focus, starting a career as a stand-up comedian—just as the overall revenue of physical album sales in the United States leaned into a dramatic decade-long decline. During this market low, Transmat maintained a vital international connection for electronic dance music between the US and Europe. Through May's working relationship with R&S Records, Pullen was able to produce techno under the names Bango, Kosmik Messenger, and Silent Phase. Pullen approached Detroit techno as an expansive Afro-spiritual jazz:

> I discovered techno around '87 or '88. After I left college in '89 I came back to Detroit and started going down to the Music Institute, which was the first club here that featured Derrick [May] and Juan [Atkins] and the whole Detroit techno movement. I would meet Derrick out every once in a while. He was like a god to me, because here's this guy making this futuristic music, and for some reason I wanted to be connected with that.[208]

Though his interaction with Atkins and Saunderson was limited, Pullen felt ready to pursue his own vision of the techno sound. In the fall of 1990, Pullen approached May and asked him to release his music. May told him that the tracks needed work, but the momentary rejection made Pullen want to make music even more. "My dad was in the touring group The Capitols ('Cool Jerk'). Of course there was music around the house, he was also in the high school choir with Melvin (the deep bass vocalist of The Temptations). My dad's sister (my aunt) dated Smokey Robinson in high school as well,"[209] Pullen explained. Growing up in Detroit for him meant seeing the real-life hardships of a city under financial duress, while also having a proud, rooted musical history, popularized by Motown, and accelerated by techno. Pullen eventually met Jay Denham, who would "studio sit" for May: "When he took a break I would get in and do a little bit of work there myself." Denham taught Pullen that "the kick drum should be the strongest thing in the mix so you can fill a dance floor, because we're dealing with dance music. It's not guitar-based rock music." May told him that "on Transmat,

208 Stacey Pullen, "Mentors: Stacey Pullen on Learning the Ropes from Derrick May," *Electronic Beats*, December 8, 2015, https://www.electronicbeats.net/mentors-stacey-pullen/.

209 Stacey Pullen, interview by Will Troup, "Interview with Stacey Pullen: Legendary Innovator of Detroit Techno," *The Ransom Note*, May 2012, https://www.theransomnote.com/music/articles/interview-with-stacey-pullen-legendary-innovator-of-detroit-techno/.

we don't sample. Everything an artist gives me is 100 percent that artist's creation."[210] This was key to the label's strategy for competing with overseas acts while wading its path through the American recording industry. Denham related to Pullen that the Transmat sub-label, Fragile Records, "is where the artist can do more creative sampling—not relying on the sampler to make the track, but sampling something that helps you create."[211] *Bango*, Pullen's first EP, released in 1992, featured two mixes of a song titled "Ritual Beating System" that sampled a track called "Drums of Passion" by Nigerian drummer and activist Babatunde Olatunji. "He's a Nigerian percussionist that I was listening to at the time, and I felt that when I started creating techno, I wanted to take a more African approach to the music," Pullen noted. "I was learning about my heritage, my culture, and I wanted to fuse a little bit of that with techno. So my first track, 'Bango', came out on Fragile when I really wanted to be a Transmat artist, because that's what I heard first: 'Nude Photo'; 'Beyond the Dance' and all those. I was a little taken aback, but I was learning about the concepts of techno, and about Derrick's vision."[212] That October, Pullen toured with Transmat, and performed his only live shows, with Alton Miller from the Music Institute playing bongos.

"At this point, I'd had my own release, I had an agent who was working out of Transmat, and Derrick had moved over to Amsterdam." While settling in the Netherlands, May told Pullen, "Okay, the only way we can continue our friendship, our relationship, our mentorship, is I'll give you 500 bucks as an advance for your release, and I'll give you a plane ticket to come over to Amsterdam, so you can see what else is going on outside Detroit." Pullen lived with May for over a year in Amsterdam before taking a chance and deciding to stay and "experience the music from a European perspective while keeping true to my roots in Detroit."[213] May quickly went to work building out a career path for Pullen, passing his music along to his business partner Renaat Vandepapeliere, who runs R&S Records with his wife Sabine Maes. Vandepapeliere thought Pullen's music wasn't ready to be released and needed more work, but May insisted. Vandepapeliere ultimately found a single track that suited his taste and commissioned a full-length album based around that sound. Under the name Silent Phase, Pullen released his debut album *(The Theory Of)* in 1995. It pleased Vandepapeliere, though as Pullen recalls, "he felt that I should have stayed a little closer to techno's origins instead of fusing it with African music." Pullen felt that the "track that [Vandepapeliere] liked had nothing to do with where I was mentally," but admitted, "Looking back, I can see that there was a little bit of a disconnect culturally, but at the same time, he still respected our decision to go ahead with releasing the album."[214] Alongside acknowledgements to God, his mother, his grandmother, and The Belleville

210 Pullen, "Mentors."

211 Ibid.

212 Ibid.

213 Ibid.

214 Ibid.

Three, the album's back sleeve contained a simple, reverberating message: "Music is a feeling that is unseen, but when u think about it u become a thinking machine."[215]

*

All the while, the American music industry was cashing in on the profitability of the compact disc format and the rise of popular music and music videos in a new age of 24-hour television programming. In contrast, the European rave scene, which had accelerated into a feverish, drug-induced, euphoric Summer of Love, waned into a hippie-led ambient chill-out movement. Electronic music in Europe experienced a change of platform, from collective club experiences to solo home listening, as parties lapsed further into a delirious spiral of financial growth and global expansion. Towards the end of the '80s, *Mixmag*, a UK-only dance music zine launched in 1983, began to establish itself as the first electronic music publication; its editors Bill Brewster, Frank Broughton, and Dom Phillips, among others, went on to document the rave and dance culture phenomenon, acting as its storytellers in the pages of the magazine as well as in books and on websites. From their primarily British colonial perspective, they built on the groundwork laid by their publisher Disco Mix Club, a British mailing service, newsletter, and weekly magazine that illegally sold "megamixes" and remixes of copyrighted and imported American disco and house music. *Mixmag*'s covers consistently featured Black musicians, like Bobby Brown, Janet Jackson, and James Brown, among others, as American pop culture began to filter into the UK. Meanwhile, white American consumers took a clear stance against dance music by destroying Black jazz, funk, soul, and disco records during "Disco Demolition" in 1979.[216] Kevin Saunderson described the suppression of house and techno music from airtime on mainstream radio in a 2020 interview: "Music was very segregated at that time, when I started making music. Musically, you had R&B radio, you had pop radio, and most tracks were rock 'n' roll and very pop and by white artists. Black artists would be on the R&B stations." Saunderson spoke about how, when he started making techno, the parties were predominantly Black, noting that the initial interest in Detroit music from Europe "ignited techno" beyond race and the occasional batch of gentrifying white suburbanites, "but then when I got there in America, the first things they said was, 'We love your music, but you have to go through the R&B division first.'"[217] As a means of addressing the cultural divisions of music in the recording industry, Raymond Leon Roker—a former DJ, club promoter, and graffiti artist—started the

215 Silent Phase, sleeve note, *(The Theory Of)* (R&S Records/Transmat, 1995).

216 On July 12, 1979, a box of disco records was exploded on the field at Chicago's Comiskey Park during Disco Demolition Night, Nearly forty people were arrested during the ensuing bonfire and riot. See Alexis Petridis, "Disco Demolition: The Night They Tried to Crush Black Music," *Guardian*, July 19, 2019.

217 Kevin Saunderson, interview by Kate Bain, "Dance Music Pioneer Kevin Saunderson: The Scene Is Still Failing Black Artists," *Billboard*, June 25, 2020, https://www.billboard.com/articles/news/dance/9408240/kevin-saunderson-dance-music-scene-failing-black-artists-interview/.

magazine *Urb* in 1990.[218] Until it folded in 2009, *Urb* ran content around electronic music, hip hop, and lifestyle and culture aimed at Black youth, with the goal of filling in the demographic gap.

Throughout the 1990s, a dance music industry established itself, based on the practice of global travel to underdeveloped or un-colonized locales, spreading the falsities of "peace and love" while using other people's home countries as playgrounds for drug addiction.[219] At the same time, European records labels like Belgium's R&S Records and Berlin's Tresor started distributing records, just as the clubs were transcending into trance, gabber, and many other sub-genres of Eurocentric and African diasporic electronic dance music. The psytrance genre emerged as one of the most salient examples of this phenomenon, in that it was created as a result of wealthy US and European expats traveling to the Goa Islands to party and live out a kind of hippie commune fantasy, contributing to the islands' eventual deforestation, as the Information Age began to "switch-on" society with an upsurge in internet usage at the end of the 1990s.[220] A series of compilation albums resulting from this movement, regrouped under the name *Global Underground* and released under the label of the same name, sourced and collated recordings of performances that were then edited down to tracks by DJs and producers from around the world. Liner notes written by *Mixmag* editor Dom Phillips described exotic rave destinations, while the albums featured newly spanned genres of electronic music such as progressive house, breakbeat, and trance. These compilations provided introductions to superstar DJs like Paul Oakenfold, John Digweed, Danny Tenaglia, Carl Cox, and Solomun, now the highest paid and respected in the dance music industry. A hierarchical economic system was taking shape, one that ultimately

218 In 2020, Roker became the Global Head of Editorial at Amazon Music, a music streaming platform and online music store within the American multinational e-commerce and information technologies conglomerate, Amazon: "What immediately appealed to me about Amazon Music, was the unfettered desire, and like-minded drive of the team to create compelling content and storytelling across a variety of different vessels. Amazon Music is uniquely positioned to develop a creative editorial portfolio across voice, visual, and streaming, and I'm thrilled to build upon the incredible work that's already been done, creating premium content for music fans around the globe." Raymond Leon Roker, quoted in Murray Stassen, "Raymond Leon Roker Joins Amazon Music as Global Head of Editorial," *Music Business Worldwide*, August 17, 2020, https://www.musicbusinessworldwide.com/raymond-leon-roker-joins-amazon-music-as-global-head-of-editorial/.

219 "The Easyjet ravers are the defining element of European clubbing culture in the noughties. They came, without any great fanfare, and developed into one of the most important subcultural groups of the present time. Their significance is huge. They have fundamentally altered Europe's club geography. In view of their enormous influence, it's astounding that Easyjet ravers were the chance offspring of two essentially unrelated developments: the liberalisation of European air travel: rather than being an expensive luxury, jetting off to a European city for the weekend is now a budget treat for the masses." Tobias Rapp, *Lost and Sound: Berlin, Techno and the Easyjet Set* (Berlin: Innervisions, 2010), 81.

220 "The Internet was designed to be an open network where any connected computer could access another computer speaking a standard language, a protocol. In this decentralized system, academics in one university could publish a set of papers or experimental data and researchers in any other university could access the information. Secure communications and e-mails could be exchanged as well. By the late 1980s, the utility of the Internet was fairly established, with academia and the military its primary users. What launched the consumer Internet, however, was a visual method of organizing and accessing all of the information on the network." Bhu Srinivasan, *Americana* (New York: Penguin, 2017), 466.

sidelined Detroit producers, who were still limited by the technology available to them, and the barrier of overseas travel. In a 2020 essay for *Mixmag* titled "Why I Quit DJing," Marshall Jefferson took note of this emergent dynamic in the years after the New Music Seminar, noticing a turning point in publicity and booking strategies at the end of the 1990s. Dutch DJs, he noted, began to do audience polls and *DJ Mag* started their Top 100 list:

> We laughed at them at the time but guess what? Those Dutch DJs literally came out of nowhere and started topping those polls, and cashing in. BIG TIME. Their fees jumped into the hundreds of thousands. Again, that wasn't racism, because all the Black DJs thought we were too cool to promote ourselves like that. This could've happened with Norwegian DJs, or Slovakian DJs, or Croatian DJs. But the Dutch thought of it, and actually did it, so they deserved to cash in. When I first thought about racism in music, I tried to break it down into numbers: There are more white people than minorities. If you have ten times more white people than any one minority, you have ten times the audience. White people want white heroes; Black people want Black heroes; Indian people want Indian heroes; Chinese want Chinese heroes. If you put out music [as] a white artist that's ten times the audience of anyone else. So if a record label gives a white artist a million, then gives a more talented Black artist fifty thousand, that's economics.[221]

As the fiscal culture war over authenticity and popularity in electronic dance music waged on, the illegal free raves that had future-shocked a generation into the Information Age grew more commonplace and continued to be franchised. In the UK, rave culture had exceeded its peak; questions regarding the possibility (and legality of drug use) of building a community around sensations were being raised, as the industry entered a comedown phase. It was clear to some that there was an inherent contradiction in the ritual consumption of imported culture while under the influence of psychedelics. "These Ecstasy-enhancing aspects latent in house and techno were unintended by their original creators, and were only discovered accidentally by the first people who mixed the music and the drug," Simon Reynolds writes in his study on raving and dance culture, *Energy Flash*. "But over the years, rave music has gradually evolved into a self-conscious science of intensifying MDMA's sensations. House and techno producers have developed a drug-determined repertoire of effects, textures and riffs that are expressly designed to trigger the tingly rushes that traverse the Ecstatic body."[222] He explains that the experience of dancing to techno and acid house while under the influence of Ecstasy and MDMA had a synesthetic effect that makes the music feel tactile and sculptural. "In a sense, Ecstasy turns the entire body-surface into an ear, an ultra-sensitized membrane that responds to certain frequencies," he

221 Marshall Jefferson, "Why I Quit DJing," *Mixmag*, October 28, 2020, https://mixmag.net/feature/marshall-jefferson-why-i-quit-djing.

222 Reynolds, *Energy Flash*, xxxii.

writes, "which is why the more funktionalist, drug-determined forms of rave music are arguably only really 'understood' (in a physical, non-intellectual sense) by the drugged, and are only really 'audible' on a big club sound-system that realizes the sensurround, immersive potential of the tracks."[223] Ultimately, the activity of gathering people in a physical space to fully activate the revolutionary potential of drugs and music became a legal concern for the UK Parliament: on the heels of the May 1992 Castlemorton Common—a free, five-day festival held in the rural village of Malvern with over twenty thousand attendees[224]—the Criminal Justice and Public Order Act was passed in 1994, restricting public gatherings of more than twenty people at night while playing amplified music composed of "repetitive beats," as a deterrent to future illegal raves.

In 1989, the independent record label Warp was founded by Steve Beckett, Rob Mitchell, and Robert Gordon, all employees of the studio space and record shop, FON (Fuck Off Nazis), in Sheffield. In the early 1990s, the label was able to divert the functionality of dance music into a listening music. Five hundred vinyl records of Warp's 1989 debut release, "Track With No Name" by Forgemasters (Robert Gordon, Winston Hazel and Sean Maher) were pressed and distributed by British dance music sub-label, Outer Rhythm, and financed by the Enterprise Allowance Grant (a Thatcher era guaranteed income scheme), and sold 20,000 vinyls. Gordon's artist liaison work for Warp helped to define the sound of British minimalist Bleep and Bass,[225] alongside Unique 3, a rave and hip hop band hailing from Bradford, Yorkshire's sound-system culture.[226] "There's a very particular drumbeat programming style on ['Track With No

223 Ibid.

224 "Five months after Castlemorton, the music seems to have gotten harsher and more punitive; one Spiral-affiliated outfit plays a set of undanceably fast, stiffly regimented, metallic beats, which sounds like ball-bearings rattling around in a concrete pipe. As the matt-grey mid-winter dawn filters weak and sickly through the skylight, exposing some seriously haggard E-casualties around us, the consensus is: this is the end of an era." Ibid., 146.

225 "By the autumn of 1989, when Forgemasters' 'Track With No Name,' Unique 3's 'The Theme' and Nightmares On Wax's 'Dextrous' were dominating clubs, illegal raves and pirate radio stations, the sound already had many names: 'Yorkshire bleep and bass,' 'Yorkshire bass' and, simply, 'bleep.' What followed was little short of a landmark shift in the fabric of British dance music. There had been British house and techno records before, but with a few notable exceptions they were generally poor pastiches of popular American hits. Bleep and bass was different. It was fresh, mysterious and distinctly British. The inspiration bleep provided resulted in a sharp burst of productivity, followed by chart success for LFO, Nightmares On Wax and Unique 3. Yet by the tail end of 1991, the style had all but died, overtaken by faster, more frenetic forms of dance music." Sell By Dave, "Bleep: The Story of Britain's First Bass Revolution," *Resident Advisor*, December 2, 2014, https://ra.co/features/2349.

226 "In some ways, Unique 3 were unlikely techno heroes. They started life as a B-boy DJ crew in the mid 1980s, and by 1988 were renowned across West Yorkshire for their love of hip-hop, house and 808 electro. The crew was initially made up of DJs Ian Park and Kevin 'Boy Wonder' Harper, plus mic man Patric McGill. The latter rapped as if he was from Brooklyn, rather than Bradford, and was regarded as something of a ladies' man. The trio was particularly well regarded on West Yorkshire's black music scene, which was as good a place as any to hear the latest, cutting-edge American dance music sounds. Aside from the Warehouse in Leeds, the Hacienda in Manchester and Jive Turkey in Sheffield, few mainstream clubs in the region played house music. Back then, Detroit techno—a particularly fresh influence—was regarded simply as another strain of house." Matt Annis, "Dusted Down: The Unlikely Origins of Bleep Techno," *Juno Daily*, November 11, 2014, https://www.juno.co.uk/junodaily/2014/11/17/dusted-down-the-unlikely-origins-of-bleep-techno/.

Name'],'" Gordon explains. Steppers reggae, a genre pioneered by Carlton and Aston Barnett with Winston Grennan of Bob Marley and the Wailers, and consisting of one dominant beat drop over a continuous bass drum, was a big influence on the song's background, which Gordon used to enliven the rhythmic elements of techno and house with swing and irregular beats. "I did that drum programming to say, 'I don't like house music, but if I heard these beats it would get me going.' A straight four-to-the-floor like house wasn't for me—I needed something else."[227] A remix of the single appeared on *The Black Steel* EP in 1991 through Neil Ruston's Network Records, while the label was also queuing Derrick May's *Innovator* album (as Rhythm Is Rhythim) and the *Retro Techno* compilation, as part of a campaign to reintroduce Detroit techno and reaffirm its position as inner-city bedroom studio music, distinct from Chicago house and the "mainstream techno" of the UK and Europe.

Gordon grew up listening to reggae and funk in Sheffield after his parents immigrated to the UK from Jamaica. In the late '80s, he was a local hero for his studio production work at FON with Mark Brydon of the industrial funk band, Chakk. Gordon admired techno and dub as an example of the fundamentals of what studio music could be. As an audio engineer, he wanted to merge the component parts of techno and house into a minimalist sound-system music that accentuates the sonar-like effects of a synthesized bleep engulfed in the vibrational pulse of bass. Gordon's multi-octave high frequency and sub-bass-based synthesizer sound created a new way of thinking about (and ultimately selling) rave music in the UK. "Things were starting to change quite a lot with the advent of samplers," Winston Hazel, the "Black music buyer" at FON said of the beginning stages of the Forgemasters. "I saw Robert Gordon, who was an old schoolmate and a bit of a techno boff, that never used to go out or anything like that. He would be fixing electronic equipment, breaking electronic equipment, and so forth."[228] Gordon and Hazel worked with an Akai S900 during a four-hour recording session that resulted in the making of "Track With No Name," which samples from a vinyl copy of Manu Dibango's "Abele Dance" that Hazel had brought to the studio from a turntable. "The music we'd made—it felt like it needed to be aired," Hazel remembers. "It got played it [*sic*] on the radio, and the phones went mental the next day. In the shop, people were calling asking for the track that we'd made. It was very exciting—even more exciting for me, because I had played it for the first time on my radio show."[229]

As a duo, Forgemasters were able to enter the recording music industry from multiple angles, using Gordon's skills as a record producer and Hazel's radio slot—in

227 Robert Gordon, quoted in Matt Annis, "Bleepography: 18 - Forgemasters 'Track With No Name," *Join the Future*, April 15, 2020, https://jointhefuture.net/2020/04/15/bleepography-18-forgemasters-track-with-no-name/.

228 Winston Hazel, "We Spoke to Winston Hazel About the Birth of Forgemasters," *Vice*, July 25, 2014, https://www.vice.com/en/article/ez9zne/warp-25-forgemasters.

229 Ibid.

conjunction with Steve Beckett's business connections in London—to quickly disseminate a transmission from the very near future. Among many of the Detroit techno and Chicago house tracks that had been imported through FON, "Track With No Name" offered a UK alternative that helped shape the sound that allowed Warp to disengage from the illicit rave scene and sell units as an independent business. "The whole thing was a crime from the start," Beckett said of rave culture. "It was an illegal place, selling illegal drugs, with the gangs on the door taking their illegal money. But people were having this amazing time and I can't ever remember fights going on."[230] Beckett intended to run Warp as a record shop that supplied techno and house to the aging raver demographic, while releasing new material that jettisoned the sound away from the dance floor into an album-oriented format: "It felt like a lot of dance music around at the time had got quite throwaway, just white labels from people jumping on the bandwagon to make a quick £500 or a grand. It felt like somebody should start paying attention to the production and the artwork—the whole way music was presented."[231] Warp enlisted Ian Anderson of The Designers Republic to design the distinctive purple color of the label's record sleeves. On the music curation side of the business, Gordon worked in the studio with LFO (Gez Varley, Mark Bell, and Martin Williams), Nightmares On Wax (George "DJ E.A.S.E." Evelyn and Kevin "Boywonder" Harper), Ital Rockers, and Tricky Disco while producing records with Richard H. Kirk of Cabaret Voltaire as XON in 1991. "I wanted to do a label to represent what was happening and release music that appealed to both my Black friends and white friends: techno sounds, but with heavy sub-bass from reggae. It worked," Gordon explains. "Bleep was not Black music or white music: it was working people's music."[232] This ethos carried through the signing of Tuff Little Unit, made up of Gordon's school friend, Glyn Andrews, and Isaiah Hill, whose track "Join the Future" with local vocalist Warren Peart—released after a few disagreements and re-edits by Gordon—signaled a new, more pop direction for Bleep and Bass at the end of an era.

After signing Forgemasters, Rushton's Network Records was able to profit from Gordon's optimization of the techno sound already established by the label with the two *Bio Rhythm* compilations. Subtitled *"Dance Music With Bleeps"* and *"808 909 1991,"* these included a mixture of American and British musicians such as Rhythm Is Rhythm (Derrick May), Psyche (Carl Craig), Model 500 (Juan Atkins), Paris Grey, Suburban Knight (James Pennington), and XON (Robert Gordon and Richard H. Kirk), as well as Rhythmatic (Leroy Crawford and Mark Gamble), who would release the sampler *Beyond the Bleep* in 1991 and the *Energy on Vinyl* LP in 1992. Arguments had begun to break out between Gordon and the two other founders of Warp, who

230 Steve Beckett, quoted in Richard King, "The Secret History of Warp Records," *Fact Mag*, April 2012, "https://www.factmag.com/2012/04/17/oh-my-god-what-have-we-done-the-secret-history-of-warp-records/2/.

231 Steve Beckett, quoted in Sell By Dave, "Label of the Month: Warp Records," *Resident Advisor*, November 12, 2019, https://ra.co/features/3557.

232 Robert Gordon, quoted in ibid.

were concerned by the distribution deal that the label had signed with Outer Rhythm. Wanting to make the label more profitable, Beckett and Mitchell pushed for Tuff Little Unit to pursue more vocal-led music after their disappointing second single, "Inspiration,"[233] while also cutting Tricky Disco from the roster after only one single, to tighten their production budget and streamline the Warp sound. Altercations continued to build, until Beckett and Mitchell eventually bought Gordon's shares, phasing him out of the company.

"A long time after our relationship with Warp proper ended for us, the bassline movement started becoming a thing in Sheffield,"[234] Hazel said of his and Gordon's distinctly British contribution to the Black Atlantic sound and the hardcore continuum. In 1991, George Evelyn, as Nightmares On Wax, honed their take on Bleep and Bass with the release of his debut album *A Word of Science: The 1st and Final Chapter*, fashioning experimental hip hop and stereophonic chill out music representative of the club-adjacent electronic music that Beckett and Mitchell envisioned for the label's future.[235] Between 1992 and 1994, Warp curated and distributed *Artificial Intelligence*, a compilation and series of releases of "electronic listening music" that would inform the "intelligent dance music" or "braindance" sub-genres as a retail category for dance music outside of the rave context—"electronic music for the mind created by trans-global electronic innovators who prove music is the one true international language."[236] With contributors that included Aphex Twin, Autechre, Speedy J, and Richie Hawtin as F.U.S.E., *Artificial Intelligence* was advertised as a sonological leap into the future for headphone and home audio systems. "Real people whose unity lies in a common sound + spirit and whose 'listening music' cannot be described as either soulless or machine driven," reads a text in the eight-page fold-out booklet: "The atmosphere and emotion both come from the musicians, their machines are merely the means to a human end."[237] Autechre, composed of Rob Brown and Sean Booth, who had met in Manchester's graffiti scene, took a subversive approach

233 "Warp had high hopes for Tuff Little Unit's second single, 'Inspiration.' Seemingly an attempt to fuse their style with the breakbeat hardcore sound that was becoming increasingly popular nationwide, the song was the result of their London studio sessions and has not aged all that well. While I have more time for 'Inspiration' than Glyn and Zye, who say they have always hated it, I agree that it is a mediocre follow-up to a track as good as 'Join the Future.' The loved-up call for unity and 'Inspiration' contained within the lyrics is probably the best thing about it, capturing the 'we can change the world' ethos of the rave era." Matt Anniss, "Bleepography: 12 - Tuff Little Unit 'Join the Future,'" Join the Future, April 4, 2020, https://jointhefuture.net/2020/04/04/bleepography-12-tuff-little-unit-join-the-future/.

234 Hazel, "We Spoke to Winston Hazel About the Birth of Forgemasters."

235 "Curiously, Evelyn and [Kevin] Harper say that they never thought they were making a British brand of Techno, but rather bass-heavy House music influenced by Reggae, Soul and Hip-Hop. Getting the heaviest bass sound imaginable was fundamental though, as besting their Yorkshire rivals remained Evelyn's top priority. 'It was call and response,' he says sternly. 'When Gerald came with "Voodoo Ray" I felt like we had to respond. Then we came with a record, Forgemasters responded and then LFO. We just wanted to make the biggest, baddest record possible to represent our crew.'" Matt Anniss, *Join the Future: Bleep Techno and the Birth of British Bass Music* (London: Velocity Press, 2019), 7.

236 Various artists, liner notes, *Artificial Intelligence: Electronic Listening Music from Warp* (Warp, 1992).

237 Ibid.

to their music, mocking the UK's Criminal Justice and Public Order Act with their 1994 *Anti* EP, whose cover came with a sticker informing prospective buyers that the album's three tracks were composed using non-repetitive beats that could be "played at both forty-five and thirty-three revolutions under the proposed law." They advised that DJs should "have a lawyer and a musicologist present at all times to confirm the non-repetitive nature of the music in the event of police harassment."[238] In the early 2000s in the United States, similar measures to curb raves and parties were passed, including the 2001 RAVE Act, or "Reducing Americans' Vulnerability to Ecstasy," authored by senator Joe Biden, and the 2003 Illicit Drugs Anti-Proliferation Act, which made club owners and promoters legally responsible for the distribution of drugs and harm incurred in their spaces. At the same time, Rudy Giuliani, Mayor of New York City, revitalized the hundred-year-old Cabaret Law—a 1926 ban on dancing that was designed to prevent Black and Brown populations from gathering—while introducing racist "broken windows" policing to combat the supposed overall escalation in crime by targeting people of color.

As the psychedelic delirium of British, Dutch, and German rave scenes spiraled into a worldwide leisure culture, Detroit producers found themselves in unfamiliar territory, confused by the casual and heavy usage of drugs occurring overseas, and the religious cult route that electronic dance music had gone into. Octave One's Lawrence Burden later told Matthew Collin, in his book *Rave On: Global Adventures in Electronic Dance Music*, that he found it "hauntingly strange to see all those people on drugs," and that he "couldn't relate to or understand that part of what was going on."[239] He ultimately landed on the image of "Night of the Living Dead" to describe what he was seeing: "Look at all of these Zombies!" Collin's book delved deeper into the subject of the Detroit techno producers' impressions of the ecstasy and LSD movement over-taking global dance culture; then briefly shifted focus to a 1993 panel discussion at the Institute of Contemporary Arts in London that featured Derrick May and Fraser Clark, the Scottish, self-proclaimed "technogaian" rave advocate, drug connoisseur, editor of *evolution*^ magazine, and founder of the underground London club Megatripolis (on the opening night, in 1993, Clark hosted a lecture with Terence McKenna, an American ethnobotanist and advocate for the usage of psychedelic substances). Clark developed the concept of the "Zippie,"[240] hi-tech hippies associated with the Zeitgeist International Party movement inspired by the 1960s US hippie group, Yippies of the Youth International Party. Clark was a frequent attendee of the acid house parties held at the nightclub Heaven, and promoted the concept of "Peace Love Unity Respect"

238 Autechre, text printed on sticker placed as a seal, *Anti* (Warp, 1994).

239 Lawrence Burden, quoted in Matthew Collin, *Rave On: Global Adventures in Electronic Dance Music* (Chicago: University of Chicago Press, 2018), 43.

240 "[Fraser] Clark coined the term 'zippie' to describe a new kind of hippy who rejected sixties Luddite pastoralism and embraced the cyberdelic, mind-expanding potential of technology." Reynolds, *Energy Flash*, 167.

(PLUR)[241] as integral to the cult religious mysticism forming within the UK and emerging US rave culture. Bill Brewster and Frank Broughton, two British *Mixmag* editors living in New York in the 1990s, recorded in their history of the globalization of dance music, *Last Night a DJ Saved My Life*, that "the spread of house into America's suburbs was initially driven by Anglophile American DJs and ex-pat Britons who, having experienced acid house first-hand in the UK, brought it stateside."[242]

In an article for the *Independent*, Alix Sharkey describes Clark as "the son of a gentlemanly lawyer who 'would never dream of getting his hands dirty,'" noting that "Clark studied psychology at Glasgow University and became a beatnik, 'probably the only one in the city.'"[243] Graduating with honors, Clark ventured out to Ibiza where he met American 'hipsters'[244] who urged him to try psychedelic drugs for the first time. Writer Norman Mailer offers that the white Americans mimicking urban Black culture in the 1940s and later 1960s were "interested not only in the dangerous imperatives of his psychopathy but in codifying, at least for himself, the suppositions on which his

241 A term coined in the early 1990s by New York DJ Frankie Bones, "the founding father of America rave culture" and organizer of Storm Rave, the first techno warehouse parties on the East Coast with his brother Adam X: "When I started to throw house parties in New York I had no support from anybody. Everybody thought I was crazy. I actually am crazy but… I just started with a few friends. They liked the idea of it, and somehow it went from six people to 12 people next week. Then to 24 people the week after that; then to 48. It just kept doubling in numbers until we did 5,000 people in a warehouse in Brooklyn. It took about a year and a half. Everything that I witnessed in London in '89 is what I really tried to do here in America. I sometimes don't think that I get the credit that I deserve for it. When I brought rave here, there was nothing like it at all. It was just the club scene in New York, that's it. . . But we had a good year and a half run. I did one party where it was Sven Vath, Doc Martin, Richie Hawtin, Lenny Dee, Frankie Bones, my brother Adam X, Caspar Pound from the U.K. So we had the first real all-star lineup. The club scene always had one DJ. You didn't have multiple DJs in a night. To go to a club and bring another DJ besides the one they already had was unheard of before 1990." Frankie Bones, "Interview: Frankie Bones on Bonesbreaks and the Early Days of New York Techno," *Red Bull Music Academy Daily*, January 30, 2014, https://daily.redbullmusicacademy.com/2014/01/frankie-bones-interview.

242 Brewster and Broughton, *Last Night a DJ Saved My Life*, 509.

243 Alix Sharkey, "What a Long Weird Trip It's Been: Many Drop Out Only to Drop in Again. But Not Fraser Clark. He Has Kept the Faith and His Time Has Come," *Independent*, November 23, 1993, https://www.independent.co.uk/life-style/what-a-long-weird-trip-it-s-been-many-drop-out-oly-to-drop-in-again-but-not-fraser-clark-he-has-kept-the-faith-and-his-time-has-come-alix-sharkey-reports-1504864.html.

244 "Hipsters were usually middle-class white youths seeking to emulate the lifestyle of the largely-black jazz musicians they followed. But the subculture grew, and after World War II, a burgeoning literary scene attached itself to the movement: Jack Kerouac and poet Allen Ginsberg were early hipsters, but it would be Norman Mailer who would try and give the movement definition. In an essay titled 'The White Negro,' Mailer painted hipsters as American existentialists, living a life surrounded by death–annihilated by atomic war or strangled by social conformity–and electing instead to 'divorce oneself from society, to exist without roots, to set out on that uncharted journey into the rebellious imperatives of the self.' As the first hipster generation aged, it was replaced by the etymologically diminutive hippies, who appropriated their fears about the Cold War but embraced the community over the individual. The word would fade for years until it was reborn in the early '90s, used again to describe a generation of middle-class youths interested in an alternative art and music scene. But instead of creating a culture of their own, hipsters proved content to borrow from trends long past. Take your grandmother's sweater and Bob Dylan's Wayfarers, add jean shorts, Converse All-Stars and a can of Pabst and bam—hipster." Dan Fletcher, "Hipsters," *Time*, July 29, 2009, archived at https://web.archive.org/web/20090730232530/http://www.time.com/time/arts/article/0,8599,1913220,00.html.

inner universe is constructed."[245] In the 1990s, Clark hoped to migrate the psychedelic idealism of the '60s onto the new frontier of cyberspace. "We thought acid was the answer to all society's ills," Clark professes. "You just watched one person after another trying it, having a blissful experience and becoming beautiful, sensitive, loving people. It seemed just a matter of time until the President would try it, and that would be the end of all problems."[246]

Academic Theodore Roszack had studied the phenomenon of elite youth counter culture in the United States in his 1968 essay "Youth and the Great Refusal." Reflecting on the white youth of the 1960s—whom he had baptized "technocracy's children" in his book *The Making of a Counter Culture*—he noted their deadlocked conflict with the Silent Generation adults of their time. They refused to participate in this past generation's careerism and consumerism, prescribed by the industrial-capitalist system prevailing in the newly minted white colonial ethnostate of the United States of America. Irrespective of their duty to the society that had killed and enslaved so many in order to perform a play called normalcy within manmade, planned urban and suburban environments, Roszak wrote that "the dropouts stall in a protracted adolescence out of which they are eager to break, but not as their parents did."[247] In this state of denial, many began to flee the country. According to Roszack, the FBI reportedly arrested thousands of runaway hippies throughout the 1960s. Picking up the mantle of this generation's cause, Clark's stance as a thinker and entrepreneur of what he considered to be a renewal of the psychedelic revolution stood in direct contrast to May's adamantly drug-free way of being. "I never took ecstasy, smoked a joint—never," claimed May, who held a strong distaste for the word "rave," dismissed the use of psychedelics, and made clear that he didn't need drugs to transcend his mind and body and feel at ease or in tune with the dynamic sounds of techno.[248] Clark and his zippies had been the first in the UK to disobey the Criminal Justice and Public Order Act, insisting that drugs and psychedelics were crucial to African rituals and spiritual communion. May objected: "If that's African dancing, my ancestors should've had their asses kicked!"[249]

*

In 1996, ten years after the beginning of the rave revolution in the UK, *True People: The Detroit Techno Album* was released through React, a London-based label

245 Norman Mailer, "The White Negro (Fall 1957)," republished by *Dissent*, June 20, 2007, https://www.dissentmagazine.org/online_articles/the-white-negro-fall-1957.

246 Ibid.

247 Theodore Roszak, "The Counter Culture: Part 1 - Youth and the Great Refusal," *The Nation* 106, March 25, 1968, 400–6.

248 Derrick May, quoted in Collin, *Rave On*, 31.

249 Ibid.

co-owned by Thomas Foley and James Horrocks. The compilation pulled together many different voices from the first and second waves of Detroit producers, including Atkins, May, Saunderson as E-Dancer, Anthony "Shake" Shakir, Drexciya, James Pennington, Claude Young, and more, to form a cumulative statement about the techno sound at the time, with liner notes from Colin Dale, better known as Fabio. In its initial conception, techno was defined by its aim to broadcast sonic fictions detailing alternate futures through the hacking and redesigning of available technical equipment and systems of distribution. As an album, *True People* performs a collective optimization of that original idea, stretching the form while mirroring the format of *Techno! The New Dance Sound of Detroit.*

Ahead of *True People* hitting the shelves, the British magazine *Muzik*, "the ultimate dance music magazine," sent journalist Calvin Bush and photographer James Harry to Detroit to meet the artists in their home environments, culminating in a feature titled "Talkin' Techno: The Detroit Debate." From 1995 until its closure in 2003, *Muzik* printed issues that sold 50,000 copies a month, marketed directly to a young (white) male audience. Bush introduces the article, which appeared in the March 1996 issue of the magazine, as a gathering of the "biggest names in Detroit Techno for an eye-opening debate on the current state of the scene."[250] In the accompanying photograph by Harry, Bush stands in front of the Detroit producers, who are spread out in a semicircle on the receiving end of a portable microphone and recorder. Setting up the discussion, Bush frames the city of Detroit as "too mired in its past, too entrenched in one sound to count." "There are many who would dispute its [techno's] continued dominance in the global pantheon of electronic music," Bush jabs, asking his interlocutors: "There is no question that 'True People' is an excellent album. But is it important as an arena for music production? And if so, why?" The question is complicated. Techno was meant to play on the potential qualities of an electronic instrument, rather than emerge as readymade, polished studio music. By synchronizing a Roland 808 with a Korg MS-10 in the pre-MIDI era, for instance, Atkins had expressed a particular inclination to create a bold sound by putting the technology in conversation and generating unlikely and somewhat improvisatory results. To the British music industry and press, this theoretical approach didn't necessarily hold value amid the empirical economy of folk-nationalist cultural production. "Detroit is important because it's a unique city," Atkins reminded Bush, *Muzik*, and the magazine's UK readers. "There are lots of Black people doing something, not negative or positive, they're just doing something. New York has hip hop, Chicago has house, and there are a million things happening here, too." His comments underline the importance of regionalism in American culture as a factor when approaching techno. The experience inside of the UK's 93,628 square-mile empire doesn't necessarily measure up to the US's nearly 4 million square-mile colonial nation states.

250 Calvin Bush, "Talkin' Techno: The Detroit Debate," *Muzik*, March 1996, 36.

Defending Detroit, Pullen adds, "First and foremost, it's the birthplace and the beginning is always important." He points to techno's roots in the city as a central component of the music's ability to reach out and connect millions, claiming that "If it hadn't been for what happened then, we wouldn't be having this conversation now." Bush nevertheless wonders if the origin of techno is still important a decade later, to which the collective responds with a resounding "chorus of 'Yeah!' and 'Yep!'" Alan Oldham, whose track "D May 87" pays homage to his moment of entrance into the electronic music world, offers an incisive reading of the British and European conglomerate clubbing industry:

> What I've noticed in this business is that it goes in cycles. Different cities in Europe become the European birthplace of techno. Like Brussels was big, London was big and now you've got Paris with F Communications.[251] But I think it always comes back to Detroit because people will always buy our records to get ideas. Rotterdam and gabba was real big, but it still all came back here. Even with jungle, even stuff like Reinforced, it comes back here. Dego, Mark, and all of those guys come over here and hang out with us.[252]

Throughout the '90s, Oldham created art for a variety of labels and artists. His work with Dutch house label Djax-Up-Beats started when Amsterdam DJ Miss Djax signed Chicago artists like Paul Johnson, Steve Poindexter, Felix Da Housecat, Glenn Underground, Mike Dearborn, and Oldham (under the moniker Signal to Noise Ratio). At that time, Afro-Dutch[253] DJ and producers Orlando Voorn and Steve Rachmad connected with May and carried over the Detroit techno sound.[254]

251 F Communications is a French record label founded in Paris in 1994 by Eric Morand and Laurent Garnier.

252 Bush, "Talkin' Techno," 37.

253 "The Surinamese community make up the Netherlands' largest ethnic minority, but there are many Surinamese ethnicities. Afro-Surinamese are the descendants of Black men and women brought over to Suriname from West Africa by Dutch slave ships; Indian and Chinese communities came later, to fill the cheap-labour market shortage after the abolition of slavery; while the maroons have a rich and distinct history connected to those who escaped and fought against slavery before abolition and formed their own culture, communities and settlements, sometimes mixing with the indigenous population who had been displaced in their own land by the Dutch." Pitts, *Afropean*, 133.

254 Voorn and Rachmad both acknowledged the importance of Detroit techno. "I got pretty much recognition in my own country when I started working with the Detroit elite. Before that it was really kind of rough to get anywhere, to get acknowledged in house music. When I started making house & techno records back in '88, the first real recognition was always from outside, outside of where I was from and then it comes back. But I heard that's quite a common thing with producers on their own turf. That they're more known elsewhere than on their own turf first." Orlando Voorn, interview by Ian [no last name given], "30 Years in the Game: Orlando Voorn Talks," *Ransom Note*, https://www.theransomnote.com/music/interviews/30-years-in-the-game-orlando-voorn-talks/. "I was making a lot of music and went to every techno label I could find to hand in my demos. More often than not they refused and told me to come back with something better. But I always returned back to my drum computer and synth to make something new and try again and again. A proud moment for me came in '93 when I released the 'Aqua Dance' single on Derrick May's Transmat/Fragile as A Scorpion's Dream. Derrick was living in Amsterdam in the early nineties and after I found out I chased with demos almost every single day haha." Steve Rachmad, interview by Milan van Ooijen, "Exclusive Interview with Steve Rachmad," *Deep House Amsterdam*, https://www.deephouseamsterdam.com/exclusive-interview-steve-rachmad/.

Oldham's astute observation on the rapidly growing industry in a state of economic flux came a year before his debut album *Enginefloatreactor*, released on his own label Generator and recorded between July 1995 and May 1996. Unlike his track on *True People*, which attempted to recreate a point of origin, his album embraced all of his wide-ranging influences, spanning from industrial to shoegaze, as components of the techno format. In the article, Larkin expands on Oldham's argument about industrial cycles and consumer attention being a major factor in the perception of techno, noting that imitations of techno produced in Europe were "track-based, it's not music." He implies that the European model is based on business, with vinyls as drug-assisted commodities in the service of a larger clubbing and luxury touring industry. Larkin agrees: "We stand apart from everyone else because it's a music thing. Over here you can feel the emotion." Claude Young picks up on Larkin's point: "As someone coming in a bit on the late side, it seems like they take chances here. I've worked with people in other countries, I listen to other DJs all the time, but I find I just tend to play a lot of records from home because this is a place where it's okay to take risks." Somewhat passionately, Young, who began releasing as Brother From Another Planet in 1992, reflects on the decade:

> You get a lots [*sic*] of producers in Europe who are afraid to do that because they are worried because it doesn't sound like Dave Clarke, or like somebody in Detroit. People here have always thrived on being themselves. It's a self-expression thing. A Kenny Larkin track is a Kenny Larkin track and a Juan Atkins track is a Juan Atkins track. We're individuals doing individual things. Collectively, that's Detroit.[255]

Atkins reenters the conversation: "I think a certain standard was set by Cybotron, Transmat and KMS. And for a lot of the newer artists who came in, the standard was so high everyone who came along afterwards had to hit that mark." Having meditated on Toffler's theories of standardization and optimization in a society bound to technocracy and economy, Atkins understood what the futurist called "The Music Factory"—a production ecology made up of individual investors, producers, and consumers who coordinate and communicate culture as a sellable product, tiered according to its financial returns.[256] Bush, still trying to fully grasp how the innovations of the past could continue to have a notable effect on the present and persist well into the future, references a 1995 interview with May, in which the latter stated that he no longer felt that techno could be radical. Anthony "Shake" Shakir, who appeared on the original

255 Bush, "Talkin' Techno," 37.

256 "Music provides a striking example. As the Second Wave arrived, concert halls began to crop up in London, Vienna, Paris, and elsewhere. With them came the box office and the impresario—the businessman who financed the production and then sold tickets to culture consumers. The more tickets could sell, naturally, the more money he could make. Hence more and more seats were added. In turn, however, larger concert halls required louder sounds—music that could be clearly heard in the very last tier. The result was a shift from chamber music to symphonic forms." Alvin Toffler, *The Third Wave* (New York: Bantam Books, 1980), 48.

Techno! album and released sparingly throughout the '90s in close association with producers in Detroit, quickly retorts: "Firstly, that comment comes from a guy who's not even releasing records. When I walk out that door, there are only three guys whose records you are guaranteed to hear within five minutes of standing on a street corner. I'm talking about Juan Atkins, Carl Craig, and Jay Denham." As heartfelt as Young, Shakir speaks proudly of his peers, saying, "They are the people who influence what I do." Delving further into the emotional and cultural components of techno as a Black music, Shakir relays: "Secondly, look at the way rock 'n' roll was based on rhythm 'n' blues. We based techno on the Black experience and that whole sound. It's not based around a bunch of people trying to be big. It's just a question of what can we do with our sounds to make them stand out? To me, it's the British press who are keeping the legacy." Bush presses on, "Is Detroit techno now a formula that anyone can learn, or is it still evolving?" Shakir replies:

> I know I'm still evolving. You've got to remember that all Black music started, not for the mainstream, but for the people making it. It wasn't Black people getting mad at the system. It was like, "Damn, it's Saturday night, I'm trying to get my freak on, fuck it, let's have a good time." And then it's these white people trying to sneak in the club, like, "Can I do that?" Then they head back and do their own thing. It evolves into something else, but it's easier to package and sell. Then it gets blown up to the point where we're saying, "Wait a minute, that's my idea, but it's not me."[257]

Seemingly unable to accept the explanations offered up by his interviewees, Bush pivots to Atkins in hopes of a different answer, one that would keep the British abstract measurement of a hardcore continuum intact: "Juan, you've watched techno develop for longer than anyone. Do you think it's still evolving in the same way that it was 10 years ago?" "I think so, definitely," Atkins replies. "That word 'techno,' is just a name which was put on a movement and anything within that has the capability of being anything it wants to be." Oldham rejoins the conversation, stating: "My expression is through synthesizers, so I'm not going to try to come up with some innovative sound to get off this so-called bandwagon and banish myself. The British press has got too wrapped up in that shit." Returning to his earlier assertion about the technocracy at play in the uptake and remaking of techno as a global industry, Oldham argues: "Almost every single record which comes out gets reviewed and just about the first thing y'all motherfuckers write is, 'Well, it's typical Detroit, it ain't breaking no barriers.' Like, what the fuck do you expect us to do?" Brian Bonds, whose track "Zephyr" with Kenneth "Kech" Harrington on *True People* references Star Trek with a slice of minimal, freewheeling hi-tech soul, interjects to ask: "What is this 'Detroit Sound'? All I ever hear is good music. Period." Oldham picks up on Bonds' question:

257 Ibid.

I think the whole thing with the European press is just a matter of biting that hand that feeds it. And Europe probably resents the fact we won't go away and we still make records. *(general laughing and cheering)*. Because they want to be able to say CJ Bolland started techno, they want to be able to say techno started in Ghent, they want to be able to say Moby started techno. But they can't, just as they can't stop us making music. They want us to, because, the day that we do stop, Luke Slater and all those other cats can have it all to themselves.[258]

Shakir comments, "This whole thing is starting to sound like we're mad at the British press and the Europeans..." To which, Oldham retorts, "Oh, I'm not mad... I love Europeans!" Bush, as moderator, seizes this moment of reprieve from the group's harangue about the habitual cycle of British and European pillaging and appropriation of African-derived innovations and raw material that has played out for the past four hundred and fifty years to ask: "Most of you guys record for European labels. If you had the choice, would you prefer to record for your own record labels and exclusively in Detroit?" With a back catalogue of records released by Berlin's Tresor and the Detroit imprints Serious Grooves and Frictional Recordings, "Kech" Harrington offers: "Having dealt with Detroit and European labels, I figure I could more or less trust someone I know more than someone I'm just faxing to." Shakir builds on this mention of trust and locality: "Let's take this a step further. This is Detroit, the home of Motown, 30 years and still going on. Berry Gordy created something very big, but it only happened once. The same thing with rap. It's Black economic self-sufficiency. You have a group of people who want to employ themselves, so what they've done is create an entity they can employ themselves with."

Bush reroutes Shakir's statement into a question for Larkin and Pullen: "Would you prefer not to have made your albums for R&S?" Larkin responds, "Of course! That's not even a question! Who wouldn't want to be self-sufficient? Nobody is able to push your shit stronger than you can." "Unfortunately, nobody in America wants to give us money for these projects," Atkins says, in light of having signed to the San Francisco label Fantasy with Cybotron over a decade ago. *Deep Space*, Atkins' most recent album at the time of the article, was being distributed by R&S Records as well. "I disagree," says Oldham. "What we're working at now will become the next alternative moment in the United States."[259] With an eye on the rhythm of press media and music consumerism, Oldham points out a subtle trend running through the American recording music industry—which just two years later, at the turn of the twenty-first century, would begin an irrevocable transition away from physical formats like CDs towards digital MP3s[260]:

258 Ibid.

259 Ibid.

260 "In 1998, Seagram Company announced that it was purchasing PolyGram from Philips and merging it with the Universal Music Group. The deal comprised the global pressing and distribution network, including the Kings

Indie rock used to be an alternative movement in the States, but it was the same old guitar shit and it's gone mainstream now. So you had waves of radio stations across America alter their formats just to find that Black music is what their sons and daughters are buying. We are the next alternative. So by React putting out this record, by Tresor and R&S setting up shop here... The six major record companies in the world are not just going to go away. They're going to say, "Oh, you know how to sell this, we'll give you 10 million bucks to sell it for us." It's going to happen and it will happen soon. That shit is a reality.[261]

In the same issue of *Muzik*, Kevin Saunderson talks about Inner City in a cover feature titled "The Good Life?" A decade after he decided to stop DJing house music on the radio to produce his own techno-influenced house tracks, Saunderson was frustrated with the perception of his success and the state of competitive music prosumption. "I'm a producer and a producer doesn't make just one sound," he says, contemplating his varied output under his Reese, Inner City, and E-Dancer monikers. "I stayed away from underground music because I was tired of the 909 and 808, but when I DJ, most of what I play is still in that style."[262] "The fact that I started in New York and then moved to Detroit is why my perception is different," Saunderson explains. "But New York guys are the same, they stick to their sound. Out of most of the people I know, I am the oddball. Just because I do everything." Across three albums, *Paradise* (1989), *Fire* (1990), and *Praise* (1992), the electronic pop ensemble Inner City—with the addition of Saunderson's wife Ann, a house and soul singer—strived to produce uplifting, humanist music for the masses. "I always feel positive. Some people create angry violent music, but no matter what goes on in my life, with my parents or with Ann, we try to keep a positive vibe," he continues. "Good or bad, it's about staying positive, it's about preservation and overcoming." Saunderson also gives credit to the church and to God for his musical abilities: "I don't think God makes me produce a great record, but by being strong and focused, relaxed and controlled, He plays a big part along the way."[263]

Mountain plant. The employees were nervous, but management told them not to worry; the plant wasn't shutting down—it was expanding. The music industry was enjoying a period of unmatched profitability, charging more than fourteen dollars for a CD that cost less than two dollars to manufacture. The executives at Universal thought that this state of affairs was likely to continue. In the prospectus that they filed for the PolyGram acquisition, they did not mention the MP3 among the anticipated threats to the business." Stephen Witt, "The Man Who Broke the Music Business," *New Yorker,* April 20, 2015, https://www.newyorker.com/magazine/2015/04/27/the-man-who-broke-the-music-business.

261 Bush, "Talkin' Techno," 37.

262 Kevin Saunderson, "The Good Life?" *Muzik*, no. 10, March 1996, 80, archived at https://archive.org/details/muzik010_march_1996/page/n79/mode/2up?q=inner+city.

263 "Ann is a very determined and very inspirational girl. I first met her at a studio in England, where I was doing a production for Sam Fox. It was love at first sight. She is a fantastic mother who loves music, athletics and working out. She has a very good nature and she likes to write peaceful songs. How does she deal with my life? Well, she has good and bad points! The most frustrating thing for her is she loves what I do and wants to be where I am. But when you've got kids, you can't always do that. She's hungry to be creative. Even more than me!" Ibid.

Saunderson talks about his move from New York to Detroit in the mid-'80s as offering him a much needed change of pace from the inner-city trouble that he often found himself in: "I believe peer group pressure can win in certain environments. Most of my friends from New York and Detroit have been killed or are in prison." Saunderson himself had spent ten days of a thirty-day sentence in jail in his youth. His decision in the late '90s to move his family to the White Lake Township, twenty miles outside of Detroit city limits, felt natural. "I wanted to take my kids out of these surroundings and bring them up somewhere they won't have to go against their parents," he adds. "I also need to go through a change myself. I wanted to cease my operations in Detroit. As much as I was trying to help people, they just wanted to get money out of me. I was losing my focus." Saunderson is asked if leaving Detroit feels like abandoning the music scene. He responds, "I was always in Detroit, but not in Detroit. It has always been that way. Mike Banks asked me if, by leaving, I felt like I was losing the part of me which put me where I am. But I don't think that's true. Apart from one year in my KMS studio, I have always lived outside of Detroit, so moving here was really getting back to what I'm accustomed to."[264]

In 1998, a cover story in *Muzik*, promising an exclusive in which "the techno playboy tells all," cemented May's reputation as an undesirable voice in the electronic music industry.[265] The article, by Andy Crysell, opens with a question: "With Rhythim Is Rhythim, Derrick May defined the sound of Detroit techno. Yet he hasn't released a record for years and now admits that he's wasting his talent. So should we still love Derrick May?" In the opening paragraphs, Crysell refers to May as "a prick," a "self-regarding bighead," and "techno's leading arse-connected-to-a-sexual-appendage-to-a-wantonly-oversized-ego." In photographs by Vincent McDonald, May is captured shirtless, sensually straddling a "tribal" drum prop. May's behavior, as described by Crysell, certainly isn't endearing—he rates the attractiveness of supermodels and passing women, hurls various insults at British people, and announces that he "can't be bothered with fucking little club girls anymore." After a cab ride to the Arches, a nightclub and live music venue located underneath the Glasgow central station, the article mentions that May is in Europe promoting *Innovator*, "his 'new' album for Transmat/R&S (it's actually a comprehensive collection of his epochal early releases.)" Taking over the decks at the Arches at 2 a.m., May plays a set laced with classic tracks by artists like Lil Louis and second-wave Detroit producers Carl Craig, Moodyman, and Pullen. A young girl stretches over the barrier to show her "appreciation" at the end of the set; May "thanks her warmly then winds up for the 18,462nd (or something) DJ set of his career."[266]

264 Ibid.

265 Andy Crysell, "Derrick May: Nothing to Prove," *Muzik*, no. 37, June 1998, 52–56, archived at https://archive.org/details/muzik037_june_1998/page/n51/mode/2up.

266 Ibid., 54. See also Ellie Flynn, "Multiple Women Report Sexual Assault and Harassment by Derrick May," *DJ Mag*, November 12, 2020, https://djmag.com/longreads/multiple-women-report-sexual-assault-and-harassment-derrick-may.

Crysell maintains this mocking tone, occasionally conceding some admiration of his subject; it is unclear whether the article is a smear piece or an industry inside joke. He offers a condensed retelling of the early days of Detroit techno and of the progressive downfall of the Belleville Three, dwelling on May's lack of productivity without mentioning the many albums released by Atkins and Saunderson throughout the '90s. The three hatched a plan to record together as Intelex, a Kraftwerk-like supergroup that would have signed to ZTT records, until Trevor Horn, the label's founder, decided May was an "erratic crazy man who wouldn't do what he was told." "So techno's chief savant pulled the plug on his productions and, save for the odd remix, hasn't returned to them since," becoming instead "a maximum lucre-earning star on the international DJ circuit." Crysell offers cynical interpretations of May's career:

> You can view it as a sad story—as indeed those in years to come might, when reading about a pioneer who became so disenchanted that he bailed out. Alternatively, you could decree it a major cop-out by someone who's often complained that people don't understand his music; seemingly oblivious to the fact that no one inherently understood Marvin Gaye, Public Enemy or the Beatles; that they made people understand. Or then again, you could choose to sympathise when he says he hasn't felt sufficiently inspired.[267]

He concludes: "What an asshole, eh? What a perplexing, sporadically inspirational, always endearing, ceaselessly fascinating, occasionally frustrating asshole. You've got to admit it, despite everything, he remains a venerable star."[268]

This issue of the magazine contains further examples of the British music establishment's attitude toward techno's American forebears. A shorter news column, titled "American DJs 'A Complete Joke,'" recounts how Dy-Na-Mix, a British DJ agency run by "Evil" Eddie Richards, had just dropped all US DJs from its roster, calling them "a bunch of lazy good-for-nothings."[269] Richards was one of the first DJs in the UK to support and play house music in the mid-1980s; now he wanted to focus on local British talent. A spokesperson for the agency calls the situation with American DJs "tiresome," stating that "the attitudes of the American guys was a complete joke" and that there was "very little consistency in their sets. One night they'd be fantastic then the next you'd be wondering if an imposter had sneaked behind the decks." Saunderson shares his reaction to this news with *Muzik*'s office in response: "I'm really upset about this...Myself, Derrick, and the others had already decided we were leaving Dy-Na-Mix and this is just Eddie trying to put a blemish on our reputations. The truth is we felt bad vibes, like they weren't trustworthy." The column then notes that the current issue's cover star, May, picked up every artist that Dy-Na-Mix had dropped,

267 Ibid.
268 Ibid.
269 "American DJs: A Complete Joke," *Muzik*, no. 37, June 1998, 8.

setting up a UK-based DJ management company/agency called Eman8, and ends with a curt and chiding, "What a palaver, eh?"

As the UK press denigrated US DJs, that same year music journalist Mike Rubin penned a feature on "the racial politics of Detroit techno" in *Spin*, an American magazine covering mostly alternative rock and indie music with the occasional feature on crossover hip hop acts. Detroit in 1998 was the long-suffering site of post-industrial capital, with a majority African American population that still hadn't recovered nearly three decades after the race riots and "white flight," rather than the futuristic city designed for technocrats that Atkins and Davis had imagined it to be in the 1983 song "Techno City."[270] At the time of writing, Atkins' label Metroplex was celebrating the grand opening of its record store. Rubin notes that though the shop had its fill of rare pressings of Model 500 records mounted on the walls, "only the white customers are leafing through the Detroit techno racks"; meanwhile, "the store's few black shoppers are crowded around a display case of rap cassettes." A confluence of both sounds and genres—which by all accounts have shared origins—was played over the speakers of the record store: Detroit bass or ghetto house mixes from DJ Assault, a hip hop musician who spanned into techno and started the record label Electrofunk in 1999 with Mr. De', could frequently be heard. Rubin's article tried to reintroduce techno to the American market: after the Belleville Three returned to America from Europe, they found that their music no longer appealed to the domestic audience.[271] Rubin's article nevertheless reflects a degree of optimism toward all the challenges defining techno's position in the United States and its exploitation and appropriation in Europe. But its proponents seemed less optimistic: "Our audience back home now is primarily white kids," May is quoted saying. "We could go out and promote in the Black community, give out flyers, but they won't come, 'cause they'll say, 'Ah, that music is weird. It ain't what's happening.'"[272] Atkins brought the point home: "In the US, a Black kid can come up with something profound in his basement, and won't get noticed in his own backyard. But kids in the UK can discover it. Because of its racial politics America is falling behind the rest of the world."[273]

270 Rubin, "A Tale of Two Cities."

271 Rubin's article did not only focus on the Belleville Three. It also surveyed various factions of produces, including Carl Craig, Stacey Pullen, and Kenny Larkin, all of whom were associated with Derrick May; the militant collective Underground Resistance; Drexciya, a duo conceptualizing the transatlantic slave trade into a mythscience epic decentralized across many releases; the disco, funk, and smooth jazz-laden Moodymann; and DJ Di'jital, among others. Rubin listed these artists' latest projects, including Atkins' 1997 album as Model 500 titled *Body and Soul*, Kevin Saunderson's solo project as E-Dancer, and Carl Craig's ventures into electronic jazz as Innerzone Orchestra.

272 Derrick May, quoted in Rubin, "A Tale of Two Cities."

273 Juan Atkins, in ibid.

7.
DETROIT-BERLIN AXIS

"It is time that we committed ourselves as a nation—in both the public and private sectors—to assisting democratic development. What I am describing now is a plan and a hope for the long term—the march of freedom and democracy which will leave Marxism-Leninism on the ash heap of history, as it has left other tyrannies which stifle the freedom and muzzle the self-expression of the people."[1]

– Ronald Reagan

"Techno became the soundtrack of reunification-era Berlin for three main reasons: the pure kinetic energy of the new sounds, the magic of the places it was played and the promise of freedom it contained. Suddenly, it seemed, everyone could program his own world: DJ, produce, start magazines, print t-shirts. Techno was a music that called for participation, a sound of flat hierarchies."[2]

– Felix Denk and Sven von Thülen

"We were not Kraftwerk. Kraftwerk had deep pockets."[3]

– Rik Davis

Elected the fortieth President of the United States in 1980, Ronald Reagan began a movement of economic initiatives to develop a national free-market strategy that defined American conservatism and greed for generations to come. Reagan's policy for financial management, or "Reaganomics," prioritized the reduction of government spending and tax on income, while increasing funding to the military and reining in how much the government could regulate individual state governance and budget within the US.[4] In the latter half of the 1970s, the United States was wrought with high unemployment and inflation in consumer goods prices, while also experiencing a rare moment without military conflict. Angling for support from the National Association

1 Ronald Reagan, address to members of the British Parliament, June 8, 1982, in *The Last Best Hope: The Greatest Speeches of Ronald Reagan* (Palm Beach, FL: Humanix Books, 2016), 103.

2 Felix Denk and Sven von Thülen, *Der Klang der Familie: Berlin, Techno, and the Fall of the Wall* [2012], trans. Jenna Krumminga (Norderstedt: Books on Demand, 2014), 6.

3 Richard "Rik" Davis, quoted in Dave Tompkins, "The Things They Buried: On Cybotron's Embattled Techno Sci-Fi Masterpiece, 'Enter,'" *SPIN*, October 30, 2013, https://www.spin.com/2013/10/cybotron-clear-reissue-dave-tompkins-sci-fi-techno/.

4 Grace Dean, "A Huge Study of 50 Years of Tax Cuts for the Wealthy Suggests 'Trickle-Down' Economics Makes Inequality Worse," *Business Insider*, December 16, 2020, https://www.businessinsider.com/tax-cuts-rich-trickle-down-income-inequality-study-2020-12.

of Evangelicals, Reagan promoted the nuclear family structure and reinstated prayer in schools.[5] The "me" decade, as writer Tom Wolfe dubbed the 1970s, coincided with an economic recession in the fallout of the divisive Vietnam War, paradoxically driving a collective shift into nationalist individualism and personal financial growth.[6] At the same time, the country worked through racial conflicts domestically, in the wake of the half compromise of the Civil Rights Act of 1964 and the assassinations of Black liberation and civil rights leaders Martin Luther King, Jr., Malcolm X, and Fred Hampton by the United States government. In 2019, the *Guardian* reported on newly uncovered audio of a jovial 1971 phone call between Ronald Reagan and Richard Nixon; in remarkably disparaging language, they mocked what they saw as the inhumanity of African American and diasporic people: "To watch that thing on television, as I did," Nixon says, "to see those, those monkeys from those African countries—damn them, they're still uncomfortable wearing shoes!"[7]

The Reagan Revolution sought both to assert the US government's dominance over the Republic of China and to demonstrate an outward rejection of the Soviet Union's communist values. A former Hollywood actor and president of the Screen Writers Guild throughout the 1940s and '50s, Reagan had worked to disenfranchise communist efforts and so-called radical politics; identified by the codename "T-10," he also served as an FBI informant, offering up names of communist or sympathizing actors. During the Second World War, Reagan served as part of the US Airforce's First Motion Picture Unit, in which he participated in producing hundreds of flight simulation training films to brief pilots ahead of bombings due to take place in Germany and Japan. Reagan's anti-communist concerns could be traced back to his having stumbled across a reel of film showing Jewish prisoners being freed from the Auschwitz concentration camp while he served in the Airforce: he kept the film as proof of the atrocities of the Holocaust, Nazism, and the communist agenda that he bore witness to.[8] Rejecting political ideology favoring common ownership and wealth amongst a nation of citizens, in the '80s Reagan pushed for supply-side, or trickle-down economics, which sought to reduce the amount of taxes paid by businesses and lessen regulations and restrictions imposed on them by the US government to spur an overall growth in the stock market and pursue increased individual economic freedom.

5 "The birth of the Christian Right is usually traced to a 1979 meeting where televangelist Jerry Falwell was urged to create a "Moral Majority" organization. Falwell founded the Moral Majority along with Paul Weyrich who had also founded the Heritage Foundation in 1973, with funding from brewery magnate Joseph Coors of the Coors beer empire and Richard Scaife, heir of the Carnegie-Mellon fortune." David Livingston, *Black Terror White Soldiers: Islam, Fascism, and the New Age* (n.p.: Sabilillah Publications, 2013), 509.

6 Tom Wolfe, "The 'Me' Decade and the Third Great Awakening," *New York Magazine*, August 23, 1976, 27–48, https://nymag.com/news/features/45938.

7 Lauren Gambino, "Ronald Reagan Called African UN Delegates 'Monkeys', Recordings Reveal," *Guardian*, July 31, 2019, https://www.theguardian.com/us-news/2019/jul/31/ronald-reagan-racist-recordings-nixon.

8 Lou Cannon, *President Reagan: The Role of a Lifetime* (New York: Simon & Schuster, 1991), 486–90.

In 2020, the London School of Economics and King's College London published a study concluding that cutting taxes on the rich increases top income shares, but has little effect on economic performance.[9] The US economy expanded from 1981 to 1988, causing an increase in the number of millionaires, but general wages were not adjusted in this process, creating a much larger wealth gap between the Black and white American populations who were already struggling to peacefully integrate in the previous decades. The economic pressure created by the lack of funding for social programs, in conjunction with the Central Intelligence Agency (CIA)'s involvement with drug trafficking among Black communities,[10] fueled the conditions that ultimately embittered the joyous disco revolution, driving it into the combative, third-wave creations of hip hop and techno as a representative of an outcry or sonic counter strike measure. While Reagan's empirical strategy of open global trade and soaring stocks had the effect of increasing access to electronic music instruments for Black communities, it also suppressed the presence and expression of those same communities in the process. A near cybernetic instrumentalization of the nation's distribution of captured territories and accumulated wealth and resources was a key feature of Reagan's political plan to grab the reins of the United States and leap into the future, in spite of its fraught past.

While on a visit to West Berlin in 1982, Reagan mused: "If I had a chance, I'd like to ask the Soviet leaders one question. Why is that wall there? Why are they so afraid of freedom on this side of the wall?"[11] The Berlin Wall had been constructed in 1961 by the Soviet Union to enforce the "Iron Curtain," a political and ideological boundary meant to push out US, British, and French military presence and protect Berliners from what the government of the German Democratic Republic (GDR) saw as a Western fascist influence, intent on preventing the East's socialist political economy from developing. During an impromptu return to West Berlin as part of a European tour in 1987, Reagan asked writer Peter Robinson to pen a speech to be given at the Brandenburg Gate, addressing the Soviet General Secretary Mikhail Gorbachev. Considering the likelihood of a large crowd gathering around the presidential spectacle, Robinson took the opportunity to weave in notes on Reagan's foreign policy, but

9 David Hope and Julian Limberg, "The Economic Consequences of Major Tax Cuts for the Rich," Working Paper 55, The London School of Economics, December 2020, 4, http://eprints.lse.ac.uk/107919/1/Hope_economic_consequences_of_major_tax_cuts_published.pdf.

10 "I believe that elements working for the CIA were involved in bringing drugs into the country. I know specifically that some of the CIA contract workers, meaning some of the pilots, in fact were bringing drugs into the U.S. and landing some of these drugs in government air bases. And I know so because I was told by some of these pilots that in fact they had done that." Hector Berrellez, "Frontline: Cocaine, Conspiracy Theories & the C.I.A. in Central America." *PBS*, October 19, 2000, https://www.pbs.org/wgbh/pages/frontline/shows/drugs/special/cia.html. See also Central Intelligence Agency, Office of Inspector General, "Report of Investigation: Allegations of Connections Between CIA and the Contras in Cocaine Trafficking to the United States, Volume I: The California Story," January 29, 1998, https://www.hsdl.org/?abstract&did=725779, and "Volume II: The Contra Story," October 8, 1998, https://www.hsdl.org/?abstract&did=725780.

11 Ronald Reagan, speech at Tempelhof Airport, June 11, 1982, quoted in Steven R. Weisman, "Reagan, in Berlin, Bids Soviet Work for a Safe Europe," *New York Times*, June 12, 1982, 1.

was met with resistance from the president's top advisors and West German diplomats alike. In a 2007 article for *Prologue Magazine*, Robinson recalled being told by local diplomats that the President would have to temper the American braggadocio characteristic of his charismatic election campaign: "The President would therefore have to watch himself. No chest-thumping. No Soviet-bashing. And no inflammatory statements about the Berlin Wall."[12] The Wall's presence, Robinson recalled, had already been normalized, and the diplomat saw no need to disrupt its symbolic function. White House Chief of Staff Howard Baker and National Security Advisor Colin Powell found Robinson's draft of the speech—and its inclusion of the now-infamous line "tear down this wall!"—extreme; Reagan, however, found it suitable and necessary for the occasion. He seized the opportunity to speak to both sides of the Wall at once:

> Our gathering today is being broadcast throughout Western Europe and North America. I understand that it is being seen and heard as well in the East. To those listening throughout Eastern Europe, I extend my warmest greetings and the good will of the American people. To those listening in East Berlin, a special word: Although I cannot be with you, I address my remarks to you just as surely as to those standing here before me. For I join you, as I join your fellow countrymen in the West, in this firm, this unalterable belief: *Es gibt nur ein Berlin.* [There is only one Berlin.][13]

President Reagan's speech pulled from the decades-long history of the Cold War that opposed American and Soviet armed forces, comparing how their respective civilizations had developed since the end of the Second World War. Reagan lauded America's technological achievements, making rhetorical fun of a 1956 prediction by Soviet politician Nikita Khrushchev that the communist regime would bury Western industrial colonial capitalism—a pronouncement that many Americans interpreted as a threat of nuclear warfare: "But in the West today, we see a free world that has achieved a level of prosperity and well-being unprecedented in all human history. In the Communist world, we see failure, technological backwardness, declining standards of health, even want of the most basic kind—too little food."[14] At the peak of his speech, Reagan outlined the evidence of America's outward concept that "Freedom is the victor," declaring that "There is one sign the Soviets can make that would be unmistakable, that would advance dramatically the cause of freedom and peace." Reagan proclaimed:

12 Peter Robinson, "'Tear Down This Wall': How Top Advisers Opposed Reagan's Challenge to Gorbachev—But Lost," *Prologue Magazine* 39, no. 2 (Summer 2007), https://www.archives.gov/publications/prologue/2007/summer/berlin.html.

13 Ronald Reagan, address at Brandenburg Gate, West Berlin, June 12, 1987, in *Department of State Bulletin* 87 (Office of Public Communication, Bureau of Public Affairs, 1987), 23.

14 Ibid.

General Secretary Gorbachev, if you seek peace, if you seek prosperity for the Soviet Union and Eastern Europe, if you seek liberalization: Come here to this gate.

Mr. Gorbachev, open this gate.

Mr. Gorbachev, tear down this wall![15]

The demolition of the Berlin Wall began on November 9, 1989, marking the end of the forty-year Cold War and the recession of the Iron Curtain barrier. The Germany of the 1940s was an established country at war; over the next several decades, the country was split between political ideologies and military occupations before being "liberated" into the aggressively expanding free-market economic principles of the Western world. At the center of the reunification of Berlin was a wave of protests sparked by the pent-up energy of East and West Berlin youth, meeting for the first time in the rubble of the wall. When Gorbachev took office as General Secretary of the Communist Party of the Soviet Union in 1985, he wanted to restructure how the government interacted with the civilian population and the economy. Unlike previous Soviet Union leaders, he declined to use military force on the protest movement; instead, a "Temporary Autonomous Zone" (a concept coined by American anarchist writer Peter Lamborn Wilson in 1991[16]), naturally formed amid the delayed political response. Wilson argued that ideological and political spaces outside of the reach of dominant control structures fostered and maintained a freedom of mind, thought, and expression through non-hierarchical relationships, while systematically filtering in supplies and resources for use and survival from the outside. Complementary to Alvin Toffler's conception of the "techno-rebels," the "temporary autonomous zone" between East and West Berlin became a technical glitch in the system of governance.

*

Back in the winter of 1985–86, a Dadaist social experiment called FischBüro (Fish Office)[17] had taken up residency in a building at the edge of the western side of the Berlin Wall in Kreuzberg. FischBüro encouraged performance and free-thinking while providing space and a platform for activities that fostered community building. The basement, a repurposed bomb-shelter accessible only by climbing down a ladder, became known as Ufo, the first tekkno club in Berlin, where local activists Dimitri

15 Ibid.

16 Peter Lamborn Wilson [as Hakim Bey], *T.A.Z.: The Temporary Autonomous Zone, Ontological Anarchy, Poetic Terrorism* (New York: Autonomedia, 1991).

17 "The FischBüro's declared objective was to turn consumers into producers, to encourage people to start something, give a speech, anything." robertdefcon, "'Timothy Leary Loved It': Tresor's Dimitri Hegemann on FischBüro's Dada Experiments," *Electronic Beats*, July 10, 2014, https://www.electronicbeats.net/fischburos-dada-experiments-berlin-experiment-vol-6/.

Hegemann, Achim Kohlenberger, and Carola Stoiber hosted parties soundtracked by acid house and other styles of imported electronic dance music. "There were a lot of suicides in the scene in which I circulated. I was in a serious crisis. We were taking a break from the Atonal festival, and I had no apartment, no nothing," Hegemann says. "One morning, I saw a storefront with fogged-up windows on Wrangelstraße behind which a woman sat at a heating stove repairing shoes. I went in, and we got to talking. At some point, she told me she was leaving. I could have the store—for 200 Deutsche Mark."[18] In the decades following the collective madness of the Third Reich, Hegemann's Berlin seemed without a certain future, caught between the rising capitalism in the West and the final stronghold of communism's presence in the East. Using the time and space afforded to him, Hegemann decided to create something new: "I built a lectern with a friend and opened the Fischbüro [Fish Office]. It was a kind of Dada club. On Saturdays, an eccentric intelligentsia met there to discuss crazy things."[19] Each week, the location of the parties was announced on a dance music show broadcast on the American Forces Network (AFN), a free radio and television service set up by the United States military in Germany in 1945.[20] The state-sponsored radio and television programming provided access to American news, sports, talks shows, movies, music, video games, and specifically "youth culture"; it became hugely influential to the Germans, who were exposed for the first time to exported American music, and in particular to the wealth of Black music that had been bottled up, contained, and distributed by the American music recording industry. Jazz, funk, soul, disco, hip hop, house, techno and pop music, as constructed and standardized by Berry Gordy and Norman Whitfield at Motown Records, poured across the airwaves, introducing German listeners to musicians like Donna Summer, James Brown, Afrika Bambaataa, and countless others. Black music had appeared in Germany almost out of nowhere, in a way that is reminiscent of the counterintelligence initiatives (COINTELPRO) the United States is known to have used in previous scenarios involving military occupation, as well as in its attacks on the Black Civil Rights and separatists movements of the 1960s and '70s.[21] Nevertheless, the music spoke to German citizens, offering a surge of life and a mode of expression both ahead of and during the collapse of the Berlin Wall.[22]

18 Dimitri Hegemann, in Denk and von Thülen, *Der Klang der Familie,* 21.

19 Ibid.

20 "A descendant of the World War II-era Armed Forces Radio, AFRTS's mission is to 'communicate Department of Defense (DoD) information to the internal audience.' AFRTS's Armed Forces Network (AFN), which is run out of the military's Broadcast Center (AFN-BC), part of the Defense Media Center, at March Air Reserve Base near Riverside, California, provides seven separate television 'services.'" Nick Turse, *The Complex: How the Military Invades Our Everyday Lives* (New York: Metropolitan Books, 2008), 202–3.

21 The Black Panther movement itself, as has been shown, was thoroughly infiltrated by the FBI through its notorious COINTELPRO operation. See Livingstone, *Black Terror White Soldiers,* 423, and Jeffrey O. G. Ogbar, "The FBI's War on Civil Rights Leaders," *Daily Beast,* January 16, 2017, https://www.thedailybeast.com/the-fbis-war-on-civil-rights-leaders?ref=scroll.

22 "Around 500 party-goers, among them many Americans, were in the West Berlin nightclub La Belle when a terrorist bomb exploded just after midnight on Saturday, April 5, 1986. Two US servicemen and a Turkish woman

In July 1989, one hundred and fifty people gathered at a birthday party for Matthias Roeingh, or Dr Motte, in Kurfürstendamm, a cobble-stone boulevard lined with luxury commercial retail in West Berlin. Adopting the motto "Friede, Freude, Eierkuchen" (peace, joy, pancakes), the celebration started the first infamous Love Parade festival, which brought together upwards of eighty thousand people to dance to imported electronic dance music in a political act performed in the name of peace and love. "It was initially quite an esoteric event; we wanted the music to last forever, and this, with the power of the ecstasy—I've never felt anything like it before," Dr. Motte told *Mixmag* in 2019. "Ecstasy was the drug of togetherness."[23] He eventually distanced himself from the festival in 2006 due to how "commercialized" he thought the event had become. In its early days, however, Ufo at FischBüro hosted the first afterparty of the Love Parade, creating a regular space for East and West Berliners to meet and empirically experience the soul of techno and acid house in a deracinated zone, removed from the context of the African American community. In *Der Klang Der Familie* (The Sound of the Family), a 2012 oral history of the Berlin underground club scene, Johnnie Stiele, a close friend and affiliate of Ufo, recalled his first encounter with Black electronic rhythm and soul music:

> Dealing with everyday life in East Berlin wasn't particularly difficult, you just had to see that it didn't get boring. Boozing and picking up girls the whole time isn't really enough in the long run. You need something for your head too. That's where music came into play. It had something autistic to it. It was so far away; self-contained scenes. You couldn't develop any cultural connection to it, just experience it. There was no participation there, no intersection with our biographies. It seemed totally different to us—and that was fascinating. I remember when I first heard Marshall Jefferson [as Hercules] on the radio, "7 Ways." It totally blew me away. What is that? Acid house? Wow![24]

Born in 1959, Marshall Jefferson came into contact with dance music through Chicago's Hot Mix 5 radio show in the early 1980s while working late-night shifts at the US Post Office. African Americans had been banned by the US government from working for the postal service from 1802 until President John F. Kennedy signed Executive Order 10988 in 1962, which allowed workers to collectively bargain for their rights from employers while prohibiting the right for a workers strike. This legal

were killed in the blast. Aside from shocking the world and provoking a US attack on Libya 10 days later, the tragedy briefly drew global attention to the existence of the so-called 'Ami-Club' scene associated with American troops stationed in the former West Germany. Since then, little has been heard about this elusive chapter in German-American intercultural relations. In the years following the fall of the Berlin Wall the scene began to fade into obscurity—until now." Von Josie Le Blond, "How US Nightclubs Revolutionized West German Music," *Der Spiegel*, October 14, 2010, https://www.spiegel.de/international/zeitgeist/g-i-disco-revival-how-us-nightclubs-revolutionized-west-german-music-a-722472.html.

23 Dr. Motte, in Will McCartney, "How the Fall of the Berlin Wall Forged an Anarchic Techno Scene," *Mixmag*, November 9, 2019, https://mixmag.net/feature/30-years-since-the-fall-of-the-berlin-wall-anarchic-techno-scene.

24 Johnnie Stiele, quoted in Denk and von Thülen, *Der Klang Der Familie*, 63.

measure created an important avenue for upward class mobility for Black people by the mid-twentieth century.[25] Jefferson was familiar with the struggles for Black workers' rights because of family members affiliated with the militant Black Panther Party for Self-Defense,[26] but his taste in music was diverse and led him to listen to music that was otherwise marketed to primarily white American audiences. "I was listening to a lot of rock music, which was strange for a Black dude," he recounted in 2016. "I started listening to Led Zeppelin, Deep Purple, Black Sabbath, Cream, Yes, David Bowie and Elton John. Those were my main influences, but I also liked Black artists like Isaac Hayes, Jimi Hendrix, Curtis Mayfield and Stanley Clarke."[27] Moving away from the disco influences of the burgeoning Chicago house and DJ scene, Jefferson integrated recorded vocals and expanded house music with more exploratory structures mirroring the virtuosic aspects of progressive rock and soul orchestration.

"7 Ways to Jack" was released by Hercules, Jefferson's project with Michael Smith, through the Chicago label Dance Mania in 1986. A baritone voice sits at the fore of the mix, uttering an instructive narrative over a terse kick drum thump coupled with building exchanges between the hi-hat and toms. Escalated on an unwavering groove, the track wraps the listener's head in a constant pulse, offering seven ways to move the soul and eventually lose control: "Hercules tells you to dance." The song appeared the next year on a split release with fellow Chicago producers Adonis and Larry Heard as Mr. Fingers.[28] Adonis' "No Way Back" also used vocals to communicate a subtle poem evoking a lost future, alongside stiff and delayed claps and a four-on-the-floor groove, whereas Mr. Finger's "Can You Feel It?" presented a warm and full keyboard-laden sound that ushered house music toward a viscerally emotive space at the edges of Detroit techno. House music is fundamentally soul music, comfortably expressed through analog electronic equipment; its particular drive toward the interiority of the present moment stands in opposition to techno's acceleration into the outer reaches of cybernetic possibility by using the best available technology. The production of such house tracks gave Chicago DJ Ron Hardy a unique selection to work from during

25 President Richard Nixon's Executive Order 11491 in 1969 in many ways nullified and overturned Kennedy's directive. Nixon also appointed Ronald B. Lee as the first African American Assistant Postmaster General. "African-American Postal Workers in the 20th Century," United States Postal Service, February 2012, https://about.usps.com/who-we-are/postal-history/african-american-workers-20thc.htm.

26 "In this revolutionary process there has emerged the Black Panther Party, originally a political weapon of self-defense by Black people, but now a growing party with a vision reaching out to the entire world and a practice aiming deep into the communities of Black people. The context of the revolutionary movement within which the Black Panther Party grows is similar to that of other movements, notably the Chinese. As in China during the 1920's and 1930's, there are now the nationalist revolutionaries who want power, identity, and respect for their own race. There are also the 'endorsed spokesmen,' who while often vehement in language believe they can make personal gains by extorting concessions from the national and class oppressors. There are the 'implacables' who desire to break the slave-master's oppressive power by any means necessary." Huey P. Newton, *To Die for the People: The Writings of Huey P. Newton* (New York: Vintage Books, 1972), xviii.

27 Marshall Jefferson, interview by Lauren Martin, "Marshall Jefferson Still Sounds Like the Future," *Red Bull Music Academy Daily,* August 4, 2016, https://daily.redbullmusicacademy.com/2016/08/marshall-jefferson-interview.

28 Adonis, Hercules, Mr. Fingers, *No Way Back / 7 Ways to Jack / Can You Feel It* (London Records, 1987).

his fast and loose residency sets at the Music Box Club, and the name "acid house" and its LSD-related sound emerged through his dancefloor experiments with this new electronic disco music, only to be elevated by Phuture's irregular usage of the TR-303 when creating "Acid Tracks."

As Trax Records and other labels in Chicago began to export techno into the European market, they came to proliferate the German airwaves through the AFT. For many Berliners, neither individuals nor cultural context were attached to the electronic rhythm and soul music they were experiencing, and this anonymity and detached quality became a key feature of how the Berlin underground techno culture peeled apart the layers of this technological Black music and draped over it the diplomatic logos of German intellectualism. In East Berlin, Wolfram Neugebauer organized a regular series of parties called Tekknozid (a combination of the words "techno" and "acid") that disseminated what he deemed to be a new German invention stemming from the African American sound, "tekkno." Despite the general embrace of African American productions, techno's appropriation in this time of liberation and unity in Berlin can be seen as a clear and fraught marker of German nationalism and pride. Yet the widespread absorption and assimilation of East Berlin into the free-market capitalism of the West made the previously annexed zone of the Eastern Bloc quite vulnerable to the entrepreneurial spirit of West Berliners. The affordability and availability of large spaces, along with the existence of a completely untapped demographic, made East Berlin's integration into the West a neocolonial venture, subsequently creating a unique culture that would develop the formerly communist regime into a global tourist attraction.

Berlin *tekkno* is emblematic of a kind of problematic but acceptable sense of freedom that meant a lot of different things to a lot of different people, despite the two German communities uniting. Before reunification, the youth of the GDR would illegally gather in churches that offered their services to promote music as a safe space for nonconformist punks, a culture that East Berliners associated with the failure of capitalism. West Berliners in the 1980s, on the other hand, expressed themselves as urbane artists and creatives who sometimes crossed over into the East. Following reunification, the Tekknozid parties served as a conciliatory platform for alternative expression for the German youth. Wolfram Neugebauer, or Wolle, who organized Tekknozid, formulated the concept of "XDP" (Exstasy Dance Project), envisioning German *tekkno* as distinguishable from its Detroit analog in its embodiment of total ecstasy and the Kantian sublime—a transcendent, out-of-body experience harnessing something subconscious, not unlike early virtual-reality aesthetics, that hadn't yet reached Berlin and its drug-induced psychedelic experiments. Every flyer for the Tekknozid party came with an instructional message, mandated by Wolle:

> Warning: Tekknozid is not a new synonym for disco. The hardest techno beats from house, industrial, hip-hop, electronic body music (EBM), new beat and acid

operate on the subconscious in interaction with psychedelic light installations and effects. The boundaries of time and space disappear in total ecstasy. Visions from the subconscious provide a view into cyberspace, that undefined data space behind monitors, synthesizers and satellite antennas.[29]

This austere vision of German *tekkno* expanded from local congregations of punks into large "raves," featuring light and art installations constructed inside of once abandoned, now leased-out and converted, power plants. Berlin's musical landscape of the 1980s had comprised mostly guitar-based rock and punk, stimulated, from 1982 to 1990, by the yearly Berlin Atonal festival. Founded and organized by Hegemann, the festival booked experimental hardcore and industrial noise acts like Einstürzende Neubauten and Psychic TV.[30] "We wanted to bring together all the protagonists of the independent scene in Berlin, and that was an adventure in itself as an organiser. What appealed to me was the opportunity to present all the projects on one stage. The press at this time called this indefinable and ungroupable noise-sound the 'Berlin disease,'" Hegemann said of the festival.[31] Little did he know, John Peele of BBC Radio had aired many of the festival's performances on his show in the UK. "It was a counterweight to mainstream, programmed music of the German new wave and so on. It developed a new scene, mixing punk, industrial no wave or whatever which coalesced in certain places like Risiko," he remarked. "These people were independent and developed their own style, methods and means of expression. There were like minded people in other cities like Sheffield, New York etc. and they were cross-inspirations. The music was so powerful and the potential so great that it became formative."[32]

<div align="center">*</div>

Five hundred kilometers south of Berlin, in the city of Frankfurt, a culture industry had also been developing around electronic dance music filtering into Germany through the Armed Forces Network. Andreas Tomalla, also known as DJ Talla 2XLC, worked as a sales clerk at City Music record store in Frankfurt throughout the 1980s, where he organized imported electronic music in a section he called "techno," featuring artists like Kraftwerk, New Order, and Depeche Mode. Talla 2XLC recalled the early days of dance music's arrival to Germany:

29 Wolle, quoted in Denk and von Thülen, *Der Klange der Familie*, 68.

30 "Lost in the pre-techno prehistory of the (then West) Berlin industrial and electronic scene, details on the festival's original eight year run from 1982 to 1990 are surprisingly patchy. Founded by the then-newly arrived Dimitri Hegemann, who would later go on to found UFO, Tresor, and a list of other cultural experiments that would eventually change the face of Berlin as we know it, the festival contributed greatly to dragging the bubbling avant garde underground in Berlin above the surface and cementing its connection to the greater world." Albert Freeman, "A Space for Ideas: Berlin Atonal, a History & 2014 Preview," *The Quietus*, August 18, 2014, https://thequietus.com/articles/16036-berlin-atonal-festival-preview-interview.

31 Hegemann, quoted in Denk and von Thülen, *Der Klange der Familie*, 400.

32 Ibid.

The records, however, were cross-sectioned in the dance area and I had to crawl around from A to Z every time to pick out the discs to listen to. That was very annoying. So I thought: now I'll put them all together under one term. Since electronic music and devices were primarily relatively new technology, I thought of the term technology music. But that was too bulky, so I deleted "-logy" and "Music," wrote "Techno" on a divider, and sorted everything that sounded electronic under that.[33]

The collection was significant, as it presented faces to connect with the abstract, instrumental electronic sounds used broadly in rock, pop, and experimental music, while disco, funk, jazz, and hip hop were domestically categorized as "Black music" by German music distributors. This categorical divide provided German and tourist consumers a quick and easy way to source electronically produced music, not necessarily in spite of Black contributions, but because of a preference of taste for the logic of technology over the intuitive groove of soul. Juan Atkins' use of the term *techno* had first surfaced publicly with "Techno City" in 1984, four years after reading Toffler's *The Third Wave*, which inspired him to apply the prefix to his philosophy of music that expresses the possibility of transmitting sonic fictions through electronic equipment as opposed to music that was made with technology. It would be another four years before the sound travelled to European shores with the *Techno!* compilation in 1988. Talla 2XLC explained that he began standardizing the "techno" genre category in 1982 by consolidating Italo disco and European electronic pop music such as Depeche Mode. "I was clearly infected with the 'techno virus' by Kraftwerk, but also by Japanese bands like YMO or Logic System," he remembered. "EBM, the hard sound from Belgium, only came at the end of the 1980s. For me, that was a further development of the softer sounds, which I found very good. Then the house from Chicago and Detroit spilled over seamlessly and it all blended into 'technohouse.'"[34] Comparatively, Atkins recalled in 1994 that he had met Karl Bartos (formerly of Kraftwerk), who admitted to him that "one of his influences was James Brown."[35] He continued:

Today, I think "techno" is a term to describe and introduce all kinds of electronic music. In fact, there were a lot of electronic musicians around when Cybotron started, and I think maybe half of them referred to their music as "techno." However, the public really wasn't ready for it until about '85 or '86. It just so happened that Detroit was there when people really got into it.[36]

33 Talla 2XLC, quoted in sven, "In the Beginning was the Technoclub," *Faze Mag*, October 21, 2019, https://www.fazemag.de/talla-2xlc-am-anfang-war-der-technoclub/.

34 Ibid.

35 Dan Sicko, "The Roots of Techno," *Wired*, July 1, 1994, https://www.wired.com/1994/07/techno/.

36 Ibid.

Talla 2XLC studied industrial business in university and saw the opportunity to capitalize on the concept of instrumental electronic music by opening Technoclub in Frankfurt in 1984. Technoclub hosted the Disco No Name party on Sunday afternoons until the club relocated to a space under Frankfurt's international airport, taking over the Dorian Gray club. The multi-million-Deutsche-Mark nightclub mirrored New York's famous Studio 54 and its luxury leisure capitalist aesthetic of high fashion coupled with low morals; under the direction of Alex Azary, Talla 2XLC, and other organizers, Technoclub at Dorian Gray imbued the glamour of disco into the brutalism of electronic body music.[37] The initiative was historic: in 2010, Talla 2XLC was given a plaque of honor by the Mayor of Frankfurt who felt that he "carried the name of our city all over the world with his innovative music and promoted Frankfurt's international cultural reputation."[38] In 1989, Technoclub launched *Frontpage*, an in-house magazine directed by Jürgen Laarmann, who later moved from Frankfurt to Berlin, where he saw the future of clubbing culture in all its potential.

Seizing the opportunity to scale the *Frontpage* brand on his own when Azary couldn't afford to fund it anymore, Laarmann's incarnation of the magazine instigated a rivalry between Frankfurt and Berlin, and impactfully rewrote Talla 2XLC's definition of techno by calling it "tech house"; what Frankfurt called techno, he argued, was closer to industrial and punk, whereas the Berlin club scene's embrace of Chicago acid house and Detroit techno offered more youthful vitality. In 2018, Laarmann explained: "The impact of the GDR (East German) youth was massive on the movement. It was the sound of revolution… of liberation for them."[39] For Laarmann, and consequently for *Frontpage*, "There was nowhere that German reunification worked better than in the techno scene. On the dancefloor, with smoke, strobes, and a Westbam soundtrack, you couldn't tell who was East or West."[40] In retrospect, the reunification of Berlin was everything the leaders of the German Democratic Republic had feared. Capitalist individualism, along with an industry-driven thirst for drugs and debauchery, had corrupted the "no future generation" and spawned what would become a globally renowned culture of excess. In a scene from *We Call It Techno!*, a 2008 documentary on the rise of German *tekkno*, a roaming "rave-voyeur" camera operator surveys a German club, landing on a pair of skinheads. The cameraman asks the two young

37 "The Dorian Gray was incredible and is hard to describe. It was my second living room for many years. For me, there was and is no comparable club in the world. The fact that the Gray was in the underground of an international airport and had no closing times was also unique. I played there mostly on Fridays at our 'Technoclub' event, but later also often on Sunday mornings. I usually played for two to three hours, and even ten hours on my 20th DJ anniversary." Talla 2XLC, in sven, "In the Beginning Was the Technoclub."

38 "Plaque of honor for DJ Talla 2XLC," *Frankfurter Rundschau*, March 4, 2010.

39 Jürgen Laarman, quoted in Cassidy George, "The '90s Techno Magazine That Shaped German Rave Culture," *Dazed*, April 4, 2018, https://www.dazeddigital.com/music/article/39567/1/the-90s-techno-magazine-that-shaped-german-rave-culture.

40 Ibid.

men: "What is it that inspires you with techno music?" The skinheads reply, "I think techno expresses the emotion of today's times in the best way of all, basically the blankness of society."[41]

Despite the marketed perception of Berlin as a city overflowing with techno music, until the late '80s the city's music scene was dominated by rock, with artists like Van Morrison, Joni Mitchell, Sinéad O'Connor, and Pink Floyd performing in celebration of the fall of the Berlin Wall in 1989. The *tekkno* simmering in the rubble of the collapse of communism would explode more fully in the 1990s, completing a long gestating concept of future music stemming from the German youth. Imagining a better future in spite of material conditions and economic means has been a remarkable staple of German nationalism since the end of the Second World War. The physical reconstruction in the aftermath of the most catastrophic war to have taken place in human history, and the existential rebuilding necessary to redress the collective, national shame at the Nazi party and Hitler's leadership, were much needed; a new German identity was key to moving onward and forward.

One group in particular seemed to embody this ethos. Formed in 1970 in Dusseldorf, the electronic rock band Kraftwerk emerged from the minds and experiments of Ralf Hütter and Florian Schneider, who had collaborated the year before on the project Organisation zur Verwirklichung gemeinsamer Musikkonzepte (Organization for the Realization of Shared Music Concepts) with the newest electronic instruments available at the time, both for commercial and academic use. In a retrospective article on Kraftwerk published in the *New York Times* in 2009, music journalist Mike Rubin notes that the band drew considerable influence from Detroit rock bands like MC5 and the Stooges. During one of their first gigs, at the opening of an art gallery in Düsseldorf, the duo "augmented its usual arsenal of Mr. Schneider's flute and Mr. Hütter's electric organ with a tape recorder and a little drum machine, and they were whipping the crowd into a frenzy with loops of feedback and a flurry of synthetic beats."[42] Video footage of a concert in the small West German town of Soest in November 1970 shows a rock band in a big-budget studio surrounded by electronic equipment, an unwieldy mountable camera, stacks of amp speakers, and an audience of straight-faced, introspective students seated on the floor, politely swaying to the oracular drones of an electronic loop and feedback of German and American cultural expressions.[43] In Rubin's article, Hütter reminisces about that night. At the climax of the performance, he notes: "I pressed some keys down on my keyboard, putting some

41 *We Call It Techno! A Documentary About Germany's Early Techno Scene and Culture*, directed by Maren Sextro and Holger Wick (Germany: Sense Music & Media, 2008).

42 Mike Rubin, "Who Knew That Robots Were Funky," *New York Times*, December 4, 2009, https://www.nytimes.com/2009/12/06/arts/music/06kraftwerk.html.

43 "Kraftwerk – live in Soest (Germany), November 1970," YouTube video, posted March 26, 2014, https://www.youtube.com/watch?v=YF1B4smQL7s.

weight down on the keys, and we left the stage. The audience at the party was so wild, they kept dancing to the machine."[44]

Rather than igniting the flame of an electronic dance movement, the genres of Deutsch-Rock (German rock) and Kosmische Musik (cosmic music) encompassed the technological direction that many German bands like Faust, Ash Ra Tempel, Tangerine Dream, and Neu! were following, seeking to break new ground by using early synthesizers and applying the theoretical practice of *musique concrète*—a kind of electroacoustic music derived from the manipulation of audio artifacts and tape reels.[45] The British music press labeled the German sound "krautrock" (drug rock), a reference to the derogatory term the English used for "performance-enhanced" German soldiers participating in the widespread use of methamphetamine and other pharmaceuticals during the Third Reich.[46] "Tone Float," the twenty-minute titular song of an album by Ralf Hütter and Florian Schneider's previous band, Organisation, laid out a different groundwork for their mechanical art production: they abstracted, extracted, adapted, and applied the Negro organizational rhythmic structure developed by blues musician Bo Diddley as a framework for American rock music in the 1950s into a cerebral and shambolic stereophonic composition, reflecting the free and spiritual jazz exhaled by Sun Ra's Arkestra and John Coltrane's quartet-based improvisational systems. As Kraftwerk, Hütter and Schneider designed a mechanized and postured aesthetic, wearing suits and ties while performing an innovative digital folk music about capitalist industrial objects and the horizon of the German past and present state. Returning the signal to Americans, Kraftwerk's computerized pulse and beat activated a musical Cold War and arms race, as well as a cultural and technological exchange.

44 Ralf Hütter, quoted in Rubin, "Who Knew That Robots Were Funky."

45 "In truth, if there is to be a 'concrete' school, it goes without saying that the word 'concrete' will only do as a temporary banner, or rather a partial label. The 'concrete' aspect of concrete music is clear enough for us to be able to insist on the processes of abstraction that it requires. If, on the contrary, concrete music had only aimed at 'concretizing' music, thereby continuing the historical development where instrument makers and composers, makers of clavichords, viols, ondes, and trautoniums, tried to outdo each other in ingenuity, there would merely have been new instruments, building with greater or lesser success on conventional patterns. German electronic music illustrates this quite well." Pierre Schaeffer, *In Search of a Concrete Music*, trans. Christine North and John Dac (Berkeley: University of California Press, 2012), 115.

46 "Pervitin made it easier for the individual to have access to the great excitement and 'self-treatment' that had supposedly gripped the German people. The powerful stuff became a sort of grocery item, which even its manufacturer didn't want to keep stuck just in the medical section. 'Germany, awake!' the Nazis had ordered. Methamphetamine made sure that the country stayed awake. Spurred on by a disastrous cocktail of propaganda and pharmaceutical substances, people became more and more dependent. The utopian ideal of a socially harmonized, conviction-based society, like the one preached by National Socialism, proved to be a delusion in terms of the competition of real economic interests in a modern high-performance society. Methamphetamine bridged the gaps, and the doping mentality spread into every corner of the Reich. Pervitin allowed the individual to function in the dictatorship. National Socialism in pill form." Norman Ohler, *Blitzed: Drugs in the Third Reich* (Boston: Mariner Books, 2017), 50.

Karl Bartos, who joined Kraftwerk as an electronic percussionist from 1975 to 1991, acknowledged in a 1999 interview that, "We were all fans of American music: soul, the Tamla/Motown thing, and of course, James Brown. We always tried to make an American rhythm feel, with a European approach to harmony and melody."[47] Kodwo Eshun's own reading of James Brown's 1971 live album *Revolution of the Mind* observes the recording as a performance-turned-studio-music that "becomes a replayable machine for generating new mindstates." He adds, "Brownian hifi consciousness abstracts revolution from the decks and applies it to the head," imagining the projection of voice and sensual affect as a prominent feature of "Black Atlantic Futurism" that lulls those within earshot into a sonic fictional cosmology.[48] In a 2014 article, *The Wire*'s publisher, Tony Harrington, observed that "Kraftwerk's genius partly resided in their preternatural ability to instantly detect, absorb and repurpose minute but significant shifts in the fundamental stuff of African-American popular music, which is to say rhythms and technology."[49] The article was a review of a speech delivered at London's Science Museum by David Toop, a professor of audio culture, concerning what Harrington calls "the startling assertion that Kraftwerk were Dusseldorf's answer to The Isley Brothers." Addressing interviews with British DJ and producer Kirk Degiorgio in previous issues of the magazine, Harrington writes that the "source code of 'Autobahn' is routinely located in the music of The Beach Boys. Fine, but then analyse the source of The Beach Boys' sound, which according to Brian Wilson himself, was an attempt to rewire 50s inner city African-American doo-wop and R&B for the car and beach culture of 60s California." He continues:

> During his talk David cued up The Isleys' "Highways of My Life" and Kraftwerk's "Tanzmusik" and played them back simultaneously to make a mischievous-serious point about shared musical roots. In an even more inspired moment, he dropped The Isley's 1969 "Vacuum Cleaner" ("My love is like a vacuum cleaner/ It keeps pulling me in") as an example of the kind of techno-eroticism that had long been a part of the imagery of African-American R&B and would become such a key Kraftwerk trope.[50]

Kraftwerk's 1974 album *Autobahn* opened with a 22-minute, self-titled suite composed with the then-new Minimoog and EMS Synthi AKS analog synthesizers, operating as an ode to the conceptual freedom afforded by the accessible technology of automobiles and their accessory—the highway—just as the German automotive

47 Karl Batos, quoted in Dan Sicko, *Techno Rebels: The Renegades of Electronic Funk* (Detroit: Wayne State University Press, 2010), 10.

48 Kodwo Eshun, *More Brilliant Than the Sun: Adventures in Sonic Fiction* (London: Quartet Books, 1998), 132.

49 Tony Harrington, "Collateral Damage: Tony Harrington on the Soul of Electronic Dance Music," *The Wire* (March 2014), https://www.thewire.co.uk/in-writing/essays/collateral-damage_tony-harrington-on-the-soul-of-electronic-dance-music-29686.

50 Ibid.

industry was beginning to outsell the Motor City of Detroit. Their albums *Radioactivity* and *Trans Euro Express* followed in 1975 and 1977, expanding and upgrading their sound, concept, and equipment considerably after they had opened their own private music recording studio, Kling Klang. The band worked in the studio in shifts of eight to ten hours, considering themselves to be *Musikarbeiter*, or "music workers,"[51] while recording *The Man Machine* in 1978; they characterized their labor-intensive process as a kind of performance of how to create art in the industrial mechanical age. For their eighth album, *Computer World* (1981), Kraftwerk scaled the studio down to a more mobile setup to embark on a world tour, transcending their initial fascination with radio communication outside of the presumably endless European frontier, and verging into the future of live electronic studio performance. "By making transparent certain structures and bringing them to the forefront—that is a technique of provocation," Hütter explained. "First you acknowledge where you stand and what is happening before you can change it. I think we make things transparent, and with this transparency, reactionary structures must fall."[52] Like so many Europeans before them, Kraftwerk began to see the edges and boundaries of the Western continent and developed a taste for worlds beyond their Eurocentric horizon:

> In Germany we have big symphony orchestras, plus all the big opera houses, which we have to pay for with our taxes. It is ridiculous, those people sitting down for bureaucratic music. There is a book from Addonno [sic: Adorno], a German philosopher, called "Music In The Bureaucratic Society." It is all about these visions, music is the expression of a bureaucratic society. It is not the music itself, not Beethoven or Mozart in person, but it is the people who play 100 years later. They are living museums, living marionettes, and it is the Leonard Bernsteins of the world who are holding back creativity.[53]

Computer World, upon release, became a crossover success, reaching number 72 on the Billboard 200 and 32 on Billboard's Top R&B/Hip Hop Albums chart. The lead title, released as a single, was nominated for a Grammy for Best Rock Instrumental Performance in 1982, and later used as the theme for the United Kingdom's project for computer literacy, "The Computer Programme." Kraftwerk's "Numbers" struck a nerve with Black youth, making its way into DJ sets and even featuring on The New Dance Show on Detroit's WGPR TV. In a 2012 personal essay, Juan Atkins recalled how Kraftwerk's German futurism pressurized the electronic rhythm, funk, and soul of Detroit's progressive music scene:

51 "The Musikarbeiter (Ralf and Florian began calling themselves 'music workers' about this time) were industrialising in line with their hi-tech image, so that old-fashioned musical toil was no longer a necessity, freeing themselves to improvise with patterns and structures." Robin Howells, "Musikarbeiter: Live Electronic Performance Examined," *Red Bull Music Academy Daily*, August 2, 2012, https://daily.redbullmusicacademy.com/2012/08/musikarbeiter.

52 Ralf Hütter, quoted in Neil Rowland, "Electronic Zeitgeist," *Melody Maker*, July 4, 1981.

53 Ibid.

Mojo used to play "Trans-Europe Express" and "We Are the Robots" pretty regularly, but the first time I heard "Robots" I just froze. My jaw dropped. It just sounded so new and fresh. I mean, I had already been doing electronic music at the time, but the results weren't so pristine—the sound of computers talking to each other. This sounded like the future, and it was fascinating, because I had just started learning about sequencers and drum programs. In my mind, Kraftwerk were, like, consultants to Roland and Korg and stuff because they had these sounds before any of the machines even appeared on the market.[54]

Acting as a telecommunications ambassador for the inner city, The Electrifying Mojo had a large hand in Kraftwerk's success in the Black community of Detroit. The radio host initially came across Kraftwerk's *Autobahn* in a trash bin left behind by previous studio occupants, admitting to Mike Rubin in 2009 that it "was the most hypnotic, funkiest, electronic fusion energy I'd ever heard,"[55] and playing it regularly on his show, The Midnight Funk Association. Once Atkins heard Kraftwerk, he reconsidered his loose and organic method of playing electronic instruments, adding in more controlled use of sequencers and programming for a "tight robotic feel."[56] Atkins noted the mark that Kraftwerk's computerized pulse music made on his own: "A lot of people think that I was copying Kraftwerk directly, but that's absolutely not the case. For me, they weren't any more of an influence than, say, funk—P-Funk especially."[57] An avid chess player, Atkins sought to shatter the boundaries of Kraftwerk's machine logistics under his Model 500 moniker with a matrix-breaking electronic funk. Harrington's article on the soul of electronic dance music for *The Wire* sheds light on this dynamic: "The origins of techno and electro and all the musics that flow from them lie in the synthesized basslines, applied rhythmic technologies and Afrofuturist concepts developed in the early 1970s—pre-*Autobahn*, pre-*Radio-Activity*—by such African-American visionaries as Herbie Hancock, George Duke, Bernie Worrell and Stevie Wonder, which Juan Atkins et. al. then took to the next level."[58]

Six months after the international release of *Techno! The New Dance Sound of Detroit* in 1988, British fashion magazine *i-D* published "Germany: The Past, Present and Future of Dance Music?," an article by David Swindells, Matthew Collin, and Ralf Niemczyk with photography by Peter Boettcher, for their November issue on "Trash." The article briefly explicates the history of electronic music that had developed in West Germany in the 1960s and '70s with composers like Karlheinz Stockhausen and Klaus Schulze, the psychedelic rock band Can, and "the futuristic computer

54 Juan Atkins, "Juan Atkins on Kraftwerk," *Electronic Beats*, November 10, 2012, https://www.electronicbeats. net/juan-atkins-about-kraftwerk/.

55 The Electrifying Mojo, in Rubin, "Who Knew That Robots Were Funky."

56 Atkins, "Juan Atkins on Kraftwerk."

57 Ibid.

58 Harrington, "Collateral Damage."

geniuses from Kraftwerk."[59] According to these storytellers, German electronic music had predicted the future, condensing the complicated, global narrative of electronic music production into a statement of how it is and can be applied to dance, culture, and community. Notably, the article points out that the first DJ to introduce Chicago house to Germany was Klaus Stockhausen at Front, a renowned basement nightclub in Hamburg with a diverse queer crowd and large share of off-duty American soldiers. "Very early on I was really into Philly and funk and soul. It always had to go from here [motions to heart] to here [motions to groin]. I always hated this sledgehammer method," Stockhausen remarked; he didn't believe in ascribing music to hard and fast categories, and played open-format sets that incorporated Motown, disco, and Chicago house records into his collection of Kraftwerk, Can, Bauhaus, and Patrick Cowley. "My aim was to please the people. I was just into music. I just had fun playing and I was happy and the crowd was going crazy. And when the sweat was dripping from the ceiling, I knew it was okay! I didn't even have a mixer at home, never ever."[60]

Elsewhere, the legitimacy of this globalized form of electronic music made for dancefloors rather than conservatories was being called into question by Karlheinz Stockhausen, one of the so-called great visionaries of twentieth-century music. In a 1995 interview with *The Wire*, the pioneering German electronic composer offered his advice: "I heard the piece [by] Aphex Twin (Richard James) carefully: I think it would be very helpful if he listens to my work 'Song of the Youth,' which is electronic music, and a young boy's voice singing with himself."[61] Stockhausen had intended for his electroacoustic experiments to be an open invitation to German youth to begin making their own individual and unique folk music through infinite variations with electronic instruments. He believed that upon hearing his composition, Aphex Twin would "immediately stop with all these post-African repetitions, . . . look for changing tempi and changing rhythms, and . . . not allow [himself] to repeat any rhythm if it [was] varied to some extent and if it did not have a direction in its sequence of variations."[62] Aphex Twin responded that he actually likes "Song of the Youth," saying, "I thought he should listen to a couple of tracks of mine: 'Didgeridoo,' then he'd stop making abstract, random patterns you can't dance to. Do you reckon he can dance?'"[63]

59 David Swindells, Matthew Collin, and Ralf Niemczyk, "Germany: The Past, Present and Future of Dance Music?," *i-D* 64 (November 1988).

60 Klaus Stockhausen, in Bill Brewster and Frank Broughton, "Klaus Stockhausen on the Front and Germany's Gay Club Scene," originally published on DJhistory.com, 2005, republished in *Red Bull Music Daily*, January 17, 2019, https://daily.redbullmusicacademy.com/2019/01/klaus-stockhausen-interview.

61 Karl Stockhausen, "Stockhausen Meets the Technocrats," *The Wire* 141 (November 1995). See also Christoph Cox and Daniel Warner, eds., *Audio Culture: Readings in Modern Music* (London: Bloomsbury, 2017), 382–83.

62 Ibid.

63 Aphex Twin, in *Audio Culture: Readings in Modern Music*, 383.

Decades prior, Cornelius Cardew, an English potter's son, received a scholarship to attend the Studio for Electronic Music of the West German Radio in Cologne. He then became Stockhausen's assistant, and performed amplified celesta, or bell-piano, in a three-piece chamber music ensemble for the premiere of his composition *Refrain* at Berlin's Haus der Kulturen der Welt in 1959. From this position, Cardew asserts that Stockhausen was a leading figure in the Darmstadt School, which sought "to propagate the music and ideas that the Nazis had banished" in a motion to resurrect and reestablish a mathematical "rule-based" standard of national music.[64] His 1974 book, *Stockhausen Serves Imperialism*, traces "the development of the avant-garde in Germany through the Nazi regime and after the war through the Darmstadt School," addressing the emergence of a military-entertainment complex by way of nationalist cultural manifestations and exchanges such as the US Jazz Ambassadors Program in 1956 and the formation of the Darmstadt International Summer Courses for New Music in Germany during the 1950s and '60s.[65] Rebelliously critiquing Stockhausen's "social function" of presenting "spiritual work to a society that is under so much strain from technical and commercial forces," Cardew declares that "salesmen like Stockhausen would have you believe that slipping off into cosmic consciousness removes you from the reach of the painful contradictions that surround you in the real world."[66] He continues:

> At bottom, the mystical idea is that the world is illusion, just an idea inside our heads. Then are millions of oppressed and exploited people throughout the world just another aspect of that illusion in our minds? No, they aren't. The world is real, and so are the people, and they are struggling towards a momentous revolutionary change. Mysticism says "everything that lives is holy," so don't walk on the grass and above all don't harm a hair on the head of an imperialist. It omits to mention that the cells on our bodies are dying daily, that life cannot flourish without death, that holiness disintegrates and vanishes with no trace when it is profaned, and that imperialism has to die so that the people can live.[67]

Stockhausen's aversion to the "post-African repetitions" being explored by British and European youth could easily be filed away under the century-long tension between the Black expressions of the African American musical continuum and the institutional standards of European art music. In 1936, composer and musicologist Theodor Adorno, one of the foremost members of a society of critical theorists known as the Frankfurt School, which included Ernst Bloch, Walter Benjamin, Max Horkheimer, Erich Fromm, and Herbert Marcuse, published "Über Jazz," a study of African American jazz. Adorno considered jazz a product and prime example of the

64 Cornelius Cardew, *Stockhausen Serves Imperialism* [1974] (New York: Primary Information, 2020), 46–48.

65 Ibid.

66 Ibid., 49.

67 Ibid.

American capitalist culture industry designed by Fordist principles of mass production.[68] Barry Gordy's replication and reengineering of Ford's assembly-line system created the Motown "Hit Factory," forging a multimillion-dollar market of Black popular music amplified by the one-way postwar cultural exchanges of the US Jazz Ambassadors program and the AFN radio and television broadcasts. Adorno's writing on the modernist product of Negro slave culture turned Black expressionist awakening in capitalist America evinces his understanding of jazz as a type of dance music. Yet he could not identify the meaning or benefits of the unstructured, even anarchic nature of Black expression and the multifarious, ancestral referentiality of rhythm and soul. "The extent to which jazz has anything at all to do with genuine Black music is highly questionable," Adorno writes, "the fact that it is frequently performed by Blacks and that the public clamors for 'Black jazz' as a sort of brand-name doesn't say much about it, even if folkloric research should confirm the African origin of many of its practices."[69] Suspending his disbelief of Black secret technology, Adorno held a somewhat reasonable stance against the culture industry—perhaps some psychological trauma resonated in him from years of American militaristic propaganda promulgating itself within the seemingly collective movement to establish an ideal postwar German national identity.

"In 1968, I was one of Herbert Marcuse's graduate students at UC San Diego, and we all benefited both from his deep knowledge of European philosophical traditions and from the fearless way he manifested his solidarity with movements challenging military aggression, academic repression, and pervasive racism," African American political activist, feminist, and philosopher Angela Davis wrote of her teacher Marcuse.[70] She added that Marcuse, a Berlin-born German socio-political philosopher, who from 1943 to 1950 worked for the US government in the Office of Strategic Services (which became the Central Intelligence Agency in 1946) "counseled us always to acknowledge the important differences between the realms of philosophy and political activism, as well as the complex relation between theory and radical social transformation." She remembers, "At the same time, he never failed to remind us that the most meaningful

68 "In producing their critical theory, the Frankfurt School brought together the dialectical versions of history of Hegel and Marx. They were deeply influenced by Hegel's idealism and dialectical interpretation of history, and derived a sense of the power of Spirit (Geist) or of cultural forms in human cultural life. From Marx they derived a sense of the importance of material forces in history and the role of economics in human and social life. They were also heavily influenced by Nietzsche, particularly his critiques of mass culture, society, morality and the state, which in *Thus Spake Zarathustra*, he had denounced the new idol and object of worship. Nietzsche also criticized 'mass man' and conformity, and was one of the first critics of the role of journalism in creating mass opinion. The Frankfurt School agreed with Nietzsche that a lot of the common cultural forms repressed natural instincts, and therefore tried to develop a philosophy that would lead to the supposed emancipation of the human being in society." Livingstone, *Black Terror White Soldiers*, 327.

69 Theodore W. Adorno, "On Jazz" [1936], trans. Jamie Owen Daniel, *Discourse* 12, no. 1 (1989): 45–69.

70 Angela Davis, "Angela Davis on Protest, 1968, and Her Old Teacher, Herbert Marcuse," *Literary Hub*, April 3, 2019, https://lithub.com/angela-davis-on-protest-1968-and-her-old-teacher-herbert-marcuse/.

dimension of philosophy was its utopian element."[71] Davis was born in Birmingham, Alabama, and lived through the Jim Crow era in a neighborhood nicknamed "Dynamite Hill" during an operatic suite of white supremacist attacks waged between 1947 and 1965 by the Ku Klux Klan—fifty planted dynamite explosions ravaged the homes of Reverend Milton Curry Jr, NAACP lawyer Arthur Shores, as well as Monroe and Mary Means Monk, who challenged the city's segregationist real estate zoning laws, before a final bomb at the 16th St. Baptist Church killed four young girls: Addie May Collins, Denise McNair, Carole Robertson, and Cynthia Wesley.[72]

Davis' political consciousness was fostered early in her life when she—decades after Sun Ra, then Herman Blount—attended Carrie A. Tuggle School, a segregated Black elementary school named after its founder, an educator, philanthropist, and social activist who was the daughter of a former Mohawk chief and Negro slave. Sallye Belle Davis, her mother, was a leader of the Southern Negro Youth Congress, and influenced by the Communist Party. During her junior year of high school, Davis was accepted into the religious Quaker Society's American Friends Service Committee program, which relocated Black children in the South to integrated schools in the North. While attending Elisabeth Irwin High School in Greenwich Village, Davis joined the communist youth group, Advance; later, as one of three Black students at Brandeis University in Waltham, Massachusetts, she met Marcuse at a protest against the Cuban Missile Crisis.

Her book *Women, Race, and Class*, published in 1981, is a collection of essays in which Davis applied the Marxist analysis she had learned from the Frankfurt school to the racial-capitalist situation of the Jim Crow South,[73] which influenced eugenist and segregationist practices against Afro-Germans and Jews during the Third Reich.[74]

71 Ibid.

72 "'Terrorism is nothing new to us. . . . It's a new term. We were terrorized back in the 50s and 60s almost every day. It was commonplace,' says Jeff Drew, who still lives in the Dynamite Hill house where he was raised. His parents were close friends of Martin Luther King, and 'Uncle Mike' spent many nights at their house. Despite the violence, the strategic meetings for the Birmingham campaign continued. 'I was with my dad at one time where the Klan called him and said, 'Nigger Drew, we gon' bomb your house tonight.' Dad said, 'What you call me for? Come on, come on. Do it right now. You don't have to call me. Just come on.' Hung the phone up. Dad was courageous as were other people up here." Drew says the families on Dynamite Hill knew they were advancing a righteous cause. "The Civil Rights movement was successful in making Negro-Americans a human being." Jeff Drew, quoted in Debbie Elliott, "Remembering Birmingham's 'Dynamite Hill' Neighborhood," NPR, July 6, 2013, https://www.npr.org/sections/codeswitch/2013/07/06/197342590/remembering-birminghams-dynamite-hill-neighborhood.

73 "The Nazis' familiarity with the Jim Crow segregation laws regarding public transportation is also evident although New York did not have formal laws or social practice against Blacks and Whites sitting together on the subway. In fact, in New York City, despite normal racial tensions, white, Black, Asian, and Hispanic coexistence was the norm, including the shared use of public facilities. What is also insightful here is the recognition of how often the cultural and athletic talents of African Americans are embraced even by those with hardened racist views who would, at the same time, vehemently and physically deny all Blacks political and civil rights." Clarence Lusane, *Hitler's Black Victims: The Historical Experiences of Afro-Germans, European Blacks, Africans, and African Americans in the Nazi Era* (New York: Routlege, 2003), 184.

74 "The relationship between American and German eugenicists was one of mutual admiration. The Nazis not only

238

"Through the convict lease system, Black people were forced to play the same old roles carved out for them by slavery," Davis explained. During the nadir of American race relations at the turn of the twentieth century: "Men and women alike were arrested and imprisoned at the slightest pretext—in order to be leased out by the authorities as convict laborers. Whereas slaveholders had recognized limits to the cruelty with which they exploited their 'valuable' human property, no such cautions were necessary for the postwar planters who rented Black convicts for relatively short terms."[75] She addressed the situation of Black woman under post-slavery Jim Crow judicial and employment system, highlighting the "domestic institution" in which women were assigned to live and work in white households as servants for upwards of forty hours, and "generally allowed an afternoon visit with her own family only once every two weeks." Davis concluded that, alongside the legal alienation from their own labor, family, transportation, property, and voting rights, Black people experienced from approximately 1875 to 1965, "One of the most humiliating aspects of domestic service in the South—another affirmation of its affinity with slavery—the temporary revocation of Jim Crow laws as long as the Black servant was in the presence of a white person."[76] She also wrote of her own feelings of being restricted by Euro-American social standards:

> In Frankfurt, when I was studying with Adorno, he discouraged me from seeking to discover ways of linking my seemingly discrepant interests in philosophy and social activism. After the founding of the Black Panther Party in 1966, I felt very much drawn back to [the United States]. During one of my last meetings with him (students were extremely fortunate if we managed to get one meeting over the course of our studies with a professor like Adorno), he suggested that my desire to work directly in the radical movements of that period was akin to a media studies scholar deciding to become a radio technician.[77]

Despite Adorno's awareness of Davis' lived experience and political heritage as one of her teachers alongside his colleague Marcuse, his evaluation of jazz is laughably calculated and misdirected. He frames the genre's evolution in the twentieth-century as a manufactured orchestration distributed by the American military-entertainment complex, rather than placing it within the lineage of syncopated dance music in the

envied the proposed ideas and programs of their U.S. counterparts but also coveted the policy initiatives that had been implemented. As Tucker notes, 'German scientists saw the United States with its antimiscegenation statutes leading the way.' Unlike the southern United States, with its Jim Crow segregation laws in full force in the first half of the century, Germany at the beginning of the National Socialist era did not have explicit laws that segregated different racial, ethnic, or religious groups. Until Hitler, the practice of racism and anti-Semitism operated mostly de facto rather than de jure. Praise for the eugenics movement in the United States came from many quarters in Germany, but especially from the race scientists." Ibid., 134.

75 Angela Davis, *Women, Race, and Class* [1981] (New York: Vintage Books, 1983), 89.

76 Ibid., 90–91.

77 Angela Davis, "Marcuse's Legacies," in Herbert Marcuse, *The New Left and the 1960s*, ed. Douglas Kellner (London: Routledge, 2005), xi.

Black musical continuum. Adding insult to injury, he misunderstands the encrypted stereophonic transmissions of maps and world systems inherent to Black music, instead describing an uncanny projection of "primitive" and "sado-masochistic" musical forms produced by colonized former slaves, whom he supposes were maladapted to modern society and its props. Put simply, Adorno misconstrued jazz as a concoction comprising elements of minstrel shows in which white Americans wore a "Black face" and performed Black expressions. He writes:

> Even the much-invoked improvisations, the "hot" passages and breaks, are merely ornamental in their significance, and never part of the overall construction or determinant of the form. Not only is their placement, right down to the number of beats, assigned stereotypically; not only is their duration and harmonic structure as a dominant effect completely predetermined; even its melodic form and its potential for simultaneous combinations rely on a minimum of basic forms: they can be traced back to the paraphrasing of the cadence, the harmonically figurative counterpoint. The relationship between jazz and black people is similar to that between salon music and the wandering fiddle players whom it so firmly believes it has transcended—the gypsies. According to Bartok, the gypsies are supplied with this music by the cities; like commodity consumption itself, the manufacture (Herstellung) of jazz is also an urban phenomenon, and the skin of the Black man functions as much as a coloristic effect as does the silver of the saxophone. In no way does a triumphant vitality make its entrance in these bright musical commodities; the European-American entertainment business has subsequently hired the [supposed] triumphant victors to appear as their flunkies and as figures in advertisements, and their triumph is merely a confusing parody of colonial imperialism.[78]

In her book *Jazz as Critique*, London-born and California-based scholar and performing jazz vocalist Fumi Okiji reparatively reappraises Adorno's writings, citing his "mere Eurocentric ignorance" of Black experience. She points out Adorno's own anxious, nihilist incapacity to overcome the apocalyptic conditions of a free modern society of individuals, who are invested in or indebted to postcolonial and postwar ethnostates, their intergenerational and commonwealth-based capitalist systems, and the resulting industrial cultural consumption designed by technical and theoretical experts like himself. "The individual holds a problematic but central position in jazz narratives," Okiji writes. "The term *individual*, which in its most common usage leads us to the image of the defunct bourgeois subject of earlier and less malignant permutations of capitalism, has largely escaped interrogation within jazz studies. Its use has assisted the desire to bring jazz closer to the model provided by Western European concert music and the singularity of the composer and her or his composition."[79]

78 Adorno, "On Jazz," 53.

79 Fumi Okiji, in *Jazz as Critique* (Stanford: Stanford University Press, 2018), 7.

She sees Adorno's tone-deaf critique of jazz as a byproduct of imperial, cultural, and intellectual insensitivity, which could also be the motivating factor behind his self-loathing cynicism towards the lived experience coursing through the invention of jazz and its inherited roots in the work songs and spiritual hymnals of Negro slave culture. "Jazz is pseudo-democratic," Adorno argues, "in the sense that characterizes the consciousness of the epoch: its attitude of immediacy, which can be defined in terms of a rigid system of tricks, is deceptive when it comes down to class differences."[80] Okiji points out Adorno's gloss over the details of the four-hundred-year odyssey undertaken by Africans marooned in capitalist America, quoting his 1953 essay "Perennial Fashion—Jazz." In this text, Adorno projects onto jazz and the Black expression a feeling of nihilism and inadequacy: "I am nothing, I am filth, no matter what they do to me, it serves me right."[81] Reasserting the importance of Black life, Okiji recognizes that Adorno appears to seek what she sees as a false sense of individuality within a collective national interest: "The ideology of individualism, of democratized sovereignty, which allows the system of *universal* domination to continue unabated, is not extended to Black people." She notes further, "Black life can have no stake in the world and so is not party to the modes of deception that accompany the privilege. It is also clear that whatever of their life manages to escape sanctioned and appropriated functions of the mainstream—that is, insofar as they depart from what is presupposed or expected of them—will not show up there."[82]

Okiji finds Adorno's written thought to be trapped in his own misidentification of the human condition under capital and empire as a willing and benefiting participant in it. The original potential of the secular incarnation of the twelve-bar structure of blues, instrumentalized through voice, harmonica, and guitar, is full of "mascon"—a term Okiji lifts from literary critic Stephen Henderson to designate "a massive concentration of Black experiential energy."[83] She explains: "Unsurprisingly, the socioaesthetic significance of the blues is lost once we shoehorn it into the mold of Adorno's method, particularly in light of the compositional focus we find in the verse-refrain analysis."[84] Okiji makes the case for an African American musical continuum hinged on the specificity of Amiri Baraka's concepts of the post-emancipation/pre-commodified expressions of primitive blues and primitive jazz: "To draw out the African American context of the blues, we must look to the profligacy of repetition in the form both within an individual performance and as it manifests itself across numerous interpretations of a piece (both of which suggest something of a temporalized heterophony)." Black music is encrypted and meant for communication specifically between Black people.

80 Adorno, "On Jazz," 50 .

81 Okiji, *Jazz as Critique,* 25. See also Theodore W. Adorno, "Perennial Fashion—Jazz," trans. Samuel and Shierry Weber, *Prisms* (London: Spearman, 1967), 275, 278.

82 Okiji, *Jazz as Critique,* 26.

83 Ibid., 29.

84 Ibid.

Okiji offers this example:

> John Coltrane contended that the collective is often sounded in the "I." In other words, when he plays, listeners should be able to hear the tradition and the wider social context from which the music emerges. When a work of blues is performed, it sets off constellations of communal associations, ranging from other renderings of the same lyrics or melody to a mixed bag of inflection, riff, and theme, to the kinds of associations that revoke Ellison's more esoteric "jagged grain . . . of a brutal experience." The blues musician is compelled to return to these "mascons," but the repetitions are never self-same; driven by a propensity toward deviance, their responses are always reformations, deformations, and interruptions. The gathering of contribution that makes up a standard is a celebration of aberration. Within this understanding the communal quality of the blues is self-regulating: it belongs to no one, and neither will it congeal around common interests.[85]

The "post-African repetitions" and Black expressions criticized by Stockhausen and Adorno would be optimized into the "mascon" of techno—an amateur studio music and independent prosumer economy that was disengaged from the profitability of Black popular culture.[86] "Black people singing slave songs as mass entertainment set new public standards of authenticity for Black cultural expression," suggests Paul Gilroy. "The legitimacy of these new cultural forms was established precisely through their distance from the racial codes of minstrelsy."[87] Gilroy concentrates on the first exportation of the Black sacred tradition of gospel music in 1871, when Fisk University arranged for the Jubilee Singers, an acapella ensemble composed of newly freed slaves, to tour and perform along the path of the Underground Railroad and out into Europe. "It is clear," Gilroy writes, "that for their liberal patrons the music and song of the Fisk Jubilee Singers offered an opportunity to feel closer to God and to redemption while the memory of slavery recovered by their performances entrenched the feelings of moral rectitude that flowed from the commitment to political reform for which the imagery of elevation from slavery was emblematic long after emancipation."[88] One of the songs they sang, "Swing Low, Sweet Chariot," visibly moved Queen Victoria. Adapted by Reverend Alexander Reid, the hymn was originally sung by an enslaved couple that went by the names "Uncle Wallace" and "Aunt Minerva" Willis; they lived

85 Ibid.

86 "[Black] popular culture, commodified and stereotyped as it often is, is not at all, as we sometimes think of it, the arena where we find who we really are, the truth of our experience. It is an arena that is profoundly mythic. It is a theater of popular desires, a theater of popular fantasies. It is where we discover and play with identifications of audiences out there who do not get the message, but to ourselves for the first time." Stuart Hall, "What Is This 'Black' in Black Popular Culture?" in *Black Popular Culture*, ed. Gina Dent (Seattle: Bay Press, 1992), 32.

87 Paul Gilroy, *The Black Atlantic: Modernity and Double Consciousness* (Cambridge, MA: Harvard University Press, 1993), 90.

88 Ibid.

and worked on a plantation owned by a wealthy half-Irish, half-Choctaw farmer, before being forcibly displaced alongside seventy thousand Native Americans of the "Five Civilized Tribes" (Choctaw, Cherokee, Chickasaw, and Seminole Nations) during the Trail of Tears between 1830 and 1850.[89] The antiphonal spiritual was encoded with a message about Harriet Tubman and the Underground Railroad to freedom in Canada, and would feature prominently throughout the Civil Rights Movement of the 1960s, leading the Reich Music Examination Office (*Reichsmusikprüfstelle*) to add it to a list of "undesired and harmful" songs.

*

Over a hundred years after the Jubilee Singers transported African American music to Europe, Atkins' techno sound was consolidated with Detroit progressive music and sold overseas alongside Chicago house on the British and European market, where it ignited the postmodern phenomenon of electronic dance music in the final decade of the millennium.[90] *i-D*'s 1988 overview of dance music in Germany by Swindells, Collin, and Niemczyk, mentioned above, portrayed the thriving electronic music scene as a direct descendant of the radical explorations of technology in music that occupied academics in West Germany throughout the '60s and '70s. Positioning club culture as the latest phase of this evolution, the article offers insight on the differing cultural perspectives of varying cities: Munich was regarded as indifferent to the reunification of Berlin, while Hamburg and Frankfurt were portrayed as having developed a taste for the club culture that was both inhaling and transmogrifying Chicago house and Detroit techno into an identifiably Germanic *tekkno*. Distinguishing between music scenes within Germany, the article compiles a cohesive account that singles out Frankfurt's ambitions for international recognition in the late '80s as home to the second-largest economic stock exchange in Europe, with its own relic of status and success, Alte Oper, an opera house rebuilt in 1981 after being bombed during the Second World War. *i-D*'s three storytellers acknowledge that Frankfurt had no night clubs or bar culture, disclosing one of the ways in which Germans attempted to replicate Midwestern African American electronic dance music:

> The clubs that are there are logically far more important than they would be under other circumstances. Two years ago, the small German record company

89 "Not only the great southern nations were driven into exile, but also nearly all the Native nations east of the Mississippi were forced off their lands and relocated to Indian Territory, seventy thousand people in all. During the Jacksonian period, the United States made eighty-six treaties with twenty-six Indigenous nations between New York and the Mississippi, all of them forcing land sessions, including removals. Some communities fled to Canada and Mexico rather than going to Indian Territory." Roxanne Dunbar-Ortiz, *An Indigenous People's History of the United States* (Boston: Beacon Press, 2014), 111.

90 "[*Postcolonial Melancholia*] considers the plight of beleaguered multiculture and defends it against the accusation of failure. The discourse of human rights is then examined from the vantage point of race politics. Then the argument turns toward the issues of cosmopolitan solidarity and moral agency, which are today condemned by cheap antihumanism and vacuous identity politics alike." Gilroy, *Postcolonial Melancholia*, xiv–xv.

ZYX wanted to benefit from the emerging scene and released a compilation with Frankfurt beats. The title *A New Sound Is Created: The Sound of Frankfurt* is a bold claim, apparently aimed at comparisons with London Records' Chicago House compilation from the same year. On the compilation are the hits "Electrica Salsa" by Off and "Where Are You?" represented by 16 bits that were produced by Frankfurt DJs, but the rest of the compilation consists of sleazy disco tracks that could have been made anywhere between Munich and Milan. In fact, ZYX is a record company that is more interested in marketing than music. "They sell everything that is black and has a hole in the middle," explains a disillusioned Frankfurter. Even if the claim that the city had a certain style was just an invention for the sake of money, the idea of the Frankfurt Beat is finally bearing fruit.[91]

The *i-D* article goes on to name Talla 2XLC as one of the pioneers of the Frankfurt Beat sound through his record company Techno Drome and the Technoclub parties at Dorian Gray. Along with Luca Anzilotti and Michael Münzing, who DJed together as Logic-Master, Talla 2XLC wanted to "turn underground dance into commercial chart hits, similar to Stock, Aitken and Waterman's self-proclaimed 'Hit Factory,' touring smaller clubs in Frankfurt to advertise his music and hold a large influence over the tastes of record buyers." To this end, Talla 2XLC rebranded upbeat disco and house sounds with hard, aggressive beats he called "Aggreppo" (aggressive-positive or aggressive pop music). "In the past, London would have laughed in Frankfurt's face," they concluded, "but for the first time, the UK is taking the Teutonic beat seriously. After 15 years, Germany has finally taken its rightful place in dance music history."[92]

In Berlin, the *tekkno* sound was accelerating. The infamous WMF club opened in 1990 in an abandoned factory, previously occupied by the cookware manufacturer Württembergische Metallwarenfabrik; it had been used for a party just a few weeks prior by Tresor, a new club started by Ufo and Berlin Atonal organizer Dimitri Hegemann.[93] "After Tresor, Planet, WMF, and Walfisch, all opened within a few months. The whole thing grew," said Kati Schwind, who helped organize the Love Parade. "And I could even earn my money off it. That was the fulfillment of my wildest dreams."[94] Black music was a staple of WMF's programming, with hip-hop, reggae, house music, and later, drum & bass being played regularly on the dance floor. Tresor, on the contrary,

91 Swindells, Collin, and Niemczyk, "Germany."

92 Ibid.

93 "In March 1991, Tresor opened up for business. Based in a safe-deposit vault in the basement of the former Wertheim Bank near Leipziger Platz, it became the epitome of techno in Berlin. Tresor was the prototype for Berlin clubs in many ways and it continues to shape the Berlin club scene to this day. Dimitri Hegemann and his Tresor crew applied the principles of interim usage of evicted buildings to East Berlin—often without being totally clear about notions of private property. That's how they ended up with a fixed-term tenancy contract for Tresor as an arts gallery." Jürgen Laarmann, "Tear Down This Wall: Reunification and the Explosion of Techno in Berlin," *Red Bull Music Academy Daily*, September 5, 2018, https://daily.redbullmusicacademy.com/2018/09/techno-and-the-fall-of-the-wall.

94 Kati Schwind, quoted in Denk and von Thülen, *Der Klang Der Familie*, 199.

pursued the Chicago acid house and Detroit techno sound. Opening after the closing of Ufo's East Berlin location due to financial troubles, Tresor was located in the vaults of the Wertheim department store in Mitte, which, like much of East Berlin, had been bombed-out during the war; the store, which opened in 1897, had been "aryanized" by the Nazi Party in the 1930s, who added a tunnel path leading to the Führerbunker air raid shelter where Adolf Hitler spent his last days in 1945. Behind a three-ton steel door, Tresor was to be a space and symbol of freedom, offering new horizons for the German counter culture at the end of the tumultuous twentieth century.

In 1988, Hegemann traveled to America for the first time, to Chicago, to meet music distributors from the independent record label Wax Trax!, which specialized in industrial, punk, and new wave music. During a 2018 lecture and panel discussion, Hegemann recounted his excitement at seeing the city of Chicago, describing how he stumbled upon what would become the second wave of the Detroit techno sound:

> I was there, in this office he had a bucket full of tapes he didn't like. Jim Nash was the owner there, he died recently. He said, "Dimitri, take anything you want. We don't take these." So I grabbed a lottery box, took one thing out and I listened to it and there was this phone number, "313." I called it from Chicago and on the other line was Jeff Mills. I said, "I'm interested. I'm from Germany and I like your music. Are you into it?" And he said, "Yes, do it." And we released it in, I don't know, '88 or '87? And so we were in touch with Detroit, first time. And already in '89 the fall of the wall happened. But I must also say nobody was interested in this music here. We had a hard time to bring records and CDs to record stores, "Can you take some?" And so it was hard; [only the] strong survive.[95]

From 1986 to 1990, a self-taught Jeff Mills DJed on Detroit radio stations WDRQ and WJLB under the moniker The Wizard.[96] At the same time as Atkins was engineering his electronic funk as Model 500, Derrick May was beginning to create his first recordings of hi-tech soul as Rhythm Is Rhythm, and Kevin Saunderson was producing international hits with his group Inner City, Mills was innovating his own style of DJing and remixing his schizoid, industrial culture jams that would permeate the airwaves of the American Midwest. As an heir of sorts to The Electrifying Mojo and

95 Dimitri Hegemann, in conversation with Mike Banks and Carola Stoiber, hosted by Torsten Schmidt, Red Bull Music Academy, Berlin, 2018, https://www.redbullmusicacademy.com/lectures/mad-mike-banks-tresor-berlin-detroit-lecture.

96 "I used to do a radio show in Detroit. And over the years the show got shorter and shorter, because that's just how radio stations are, they make your show shorter because of precious time. But still, there was an abundance of music that had to be played. So I had to figure out a way to be able to play all this music in a very short time very smoothly, so that people would at least hear a little bit of it so that they would go to the shop and actually buy it. We developed a way to be able to play them very, very quickly, or just use the best part of it, and then move on to the next one, best part." Jeff Mills, lecture, hosted by Torsten Schmidt, Red Bull Music Academy, Berlin, 1998, https://www.redbullmusicacademy.com/lectures/jeff-mills-lecture.

an on-air competitor to Duane "In the Mix" Bradley, Mills produced sonic contortions that were less about storytelling, and pursued a kind of fast-paced audio sculpture that hybridized techno, house, hip hop, freestyle and many other urban genres. Unlike the "first wave" of techno producers, The Wizard came from above, bringing techno directly to the home and car stereo systems, often featuring music from Detroit and Chicago. John Collins, a historian of techno and member of Underground Resistance, recalled hiring Mills to spin regularly at Cheeks after seeing him DJ once: "When he auditioned, we were totally blown away by his skills and how fast he was with his hands. . . . No one had ever really done what he was doing. I couldn't believe my eyes and ears."[97] In 1989, Mills began collaborating with another local DJ and musician, Anthony Srock, on a project fusing industrial techno music tropes, as the band Final Cut. That year, after scoring an international club hit with the track "Take Me Away," Final Cut released their album *Deep Into the Cut* on Srock's record label Full Effect. Final Cut performed at the 1990 edition of Hegemann's Berlin Atonal festival, initiating what would become known as the "Berlin-Detroit Axis"—the first formal communication between Detroit techno producers and the German *tekkno* rave scene. Hegemann recalls that "a year later already we stayed in touch and Carola [Stoiber] was always in between, kept the red telephone to Detroit. No iPhone, no internet. Maybe the fax machine, if it worked, so we got new information."[98]

The next year, Hegemann and Carola Stoiber arranged for Mills to fly over again to play at Tresor. Instead of going alone, Mills recruited Robert Hood, a young rapper who had begun experimenting with drum machines like the TR-505, and "Mad" Mike Banks, who had done design and production work for the Final Cut album. Mills had left Final Cut and stayed in contact with Banks, with whom he had worked on a track for the 1988 *Techno!* compilation, with the group Members of House. Learning from the less than satisfactory outcomes of the Belleville Three, Banks and Mills were wary of the exploitative politics of the American music recording industry, which Banks had experienced first-hand as a former studio and touring musician for George Clinton, Parliament, and the United Sound recording studio, where they recorded with professional equipment and mixing boards. They agreed on the basic principle of operating every part of the music production and distribution process themselves, following the example set by Atkins' and May's record labels, Metroplex and Transmat. Combining their skills and the sounds of Members of House and Final Cut, they crafted a tactical guerilla design aesthetic and wrote short manifestos in the place of descriptions, sent to their distributor and press, that communicated a specific, militant ideology necessary to affirm their own agency and autonomy both as artists and as Black men living in the increasingly unequal United States: "Underground Resistance stands for a movement, a revolution . . . it wants change by sonic revolution. It's all underground.

97 John Collins, quoted in Sicko, *Techno Rebels*, 90.

98 Hegemann, in conversation with Banks and Stoiber.

By people listening to that, their minds have been expanded, and things will never be the same again. The music is universal music."[99]

Cultural critic Greg Tate contemplates a problem that would inevitably be inherited a generation later by Mills and Banks in "Preface to a One-Hundred-and-Eighty Volume Patricide Note: Yet Another Few Thousand Words on the Death of Miles Davis and the Problem of the Black Male Genius," writing: "Among Black musics, jazz and hip hop have the effect of making the Black-identified imagination unsatisfied with white supremacist definitions of modernity."[100] As Banks and Mills formed Underground Resistance, they sought to produce music that would be greater than their own visual presence, in an attempt to abstract and reject the image-based consumer model informing the American music recording industry. "Operating out of both Black cultural nationalist and twentieth-century modernist impulses," Tate writes, "Davis embodied the belief that the democratic expansion of Black rights cannot but entail the discomforting inclusion of militant Black cultural differences." Like Miles Davis, Mills and Banks intended to make music that was "Black-derived, not Black-identified." For Tate, ultimately "Miles' legacy challenges other Black cultural nationalists to recognize the affirmation of Black cultural differences as merely a starting point for self-development, not as an endgame to be punted about the end zone of white supremacy."[101] The automotive assembly line companies of Detroit, Motown's studio "hit-music" machine, and Juan Atkins' lean homemade and distributed electronic productions would all be collapsed into the ethos of Underground Resistance—the collective, the record label, and "the final transmission from the forever war,"[102] as it developed the profile of a manufacturer, rapidly and unexpectedly releasing techno as a missile launched directly at the music industry and the fiscally-minded men behind the operation.[103]

In 1991, an early incarnation of Underground Resistance consisting of "Mad" Mike Banks, Jeff Mills, and Robert Hood traveled to New York City in a van with vocalists and musicians from the group Members of the House to attend the New Music Seminar. Promoting their first release "Your Time Is Up," with vocals from Yolanda Reynolds, Underground Resistance garnered much attention for their self-designed

99 Mike Banks, voiceover, in Konrad Becker, "Public Tranceport" event, Vienna, July 11, 1992, https://www.youtube.com/watch?v=Cmcq02ZmXAU.

100 Greg Tate, "Preface to a One-Hundred-and-Eighty Volume Patricide Note: Yet Another Few Thousand Words on the Death of Miles Davis and the Problem of the Black Male Genius," in *Black Popular Culture*, 245.

101 Ibid.

102 Eshun, *More Brilliant Than the Sun*, 116.

103 "As Black musicians, we had to control how our music was being represented and put out, and we had to make sure we were being properly compensated. Black musicians have been exploited so often. We'd learned from that. We said to ourselves that we could do business with record labels from the other side of the world while still retaining our integrity and our character. We were committed to doing it without being taken advantage of or being treated like ignorant Black musicians. That was part of the UR idea as well." Robert Hood, quoted in Denk and von Thülen, *Der Klang der Familie*, 222.

production model, selling the vinyl and t-shirts with their signature logo directly to consumers on the show floor. The seminar's afterparty at the Limelight, a renowned midtown Manhattan club in a deconsecrated Gothic Revival church, featured Mills DJing as Underground Resistance, introducing his sound to a commercial audience. At the end of the night, he was offered a job that would relocate him from Detroit to New York. Underground Resistance returned the next year to perform a brutal, industrial-tinged live set of acid house as a trio: Mills mixed vinyl with a turntable that had been hot-wired and modified to sync with Banks' ensemble of keyboards, synthesizers, and drum machines, while Hood rapped, wearing a gas mask, as the simultaneously motivational and apocalyptic master of ceremonies and "Minister of Information."[104] Tresor's general manager, Carola Stoiber, met Underground Resistance at the seminar, buying a cassette from the group featuring the track "Sonic Destroyer": this led to a transatlantic relationship with a new record store called Hard Wax, started by Mark Ernestus in Kreuzberg, Berlin, which honed in early on the market for house, techno, and Jamaican reggae and dub. Eventually Ernestus and producer Moritz von Oswald introduced Hard Wax's own dub and minimal techno record label, Basic Channel, in 1993. With Hard Wax covering the bookings and Tresor providing a space, the two brands quickly became a two-pronged unit representing the German *tekkno* aesthetic and culture.

Underground Resistance's first project for Tresor was released in 1991 as X-101, leading with the song "Sonic Destroyer." During a 2018 panel discussion with Tresor's Hegemann and Stoiber, Banks explained that "Sonic Destroyer" was a secret weapon meant to "rip off the head of any DJ in front of Jeff [Mills]. 'Cause they would always try to out-spin him, so it was to destroy the DJ." Banks added that the track, like all of Underground Resistance's musical output, was intended to "destroy record companies, corporations, anything we felt was trying to get ahold of us."[105] As The Wizard, Mills felt pressure from radio stations to stop playing tracks from the political hip hop group, Public Enemy, in his sets, to avert possible controversy in disseminating the group's radical Black political messages, especially following their album *Fear of a Black Planet*. Mills and Banks composed "Sonic Destroyer" as a defiant maneuver, using an Oberheim OB-Xa to create what they described as "descending synth voices" and a Yamaha DX100 to digitally produce the bass line that incorporated and built on Hood's solo work as The Vision, which saw him releasing the EPs *The Gyroscopic* (1991) and *Toxin* (1992) on Underground Resistance and Hard Wax.

104 "The enthusiasm we met in Berlin was surreal. But at the same time, it was sort of familiar. We had a common bond, and we knew the bond was there, that we were on the same page. What was surreal was that you came from such different backgrounds. It seemed to me that they wanted to escape their past. And we wanted to escape our past, too, the one so full of racism. Escape and move on. Remember the past, but look for a better world. That, I believe, was the common thread. We were all looking to these futuristic, experimental sounds as an escape vehicle, as a spaceship with which to get away, to transport ourselves into the future where we're all one, where divisions of race and religion and culture are torn down just like the Berlin Wall." Ibid., 223.

105 Banks, in conversation with Hegemann and Stoiber.

The X-101 album developed the anti-establishment rage and collaged sonic weaponry of Public Enemy into a sound that helped Underground Resistance burst onto the German *tekkno* scene as Tresor's first record release.[106] "Sonic Destroyer" was featured as the opening track, followed by songs constructing visions of an accelerative yet degenerating futurism, apt both for post-Wall Berlin and the financial descent of Detroit. The following tracks, "Rave New World," "The Final Hour," and "G-Force," further articulated the necessity of Underground Resistance's harder sound with studio mixing and quality stereo panning, lurching into strong kick drums, synthesizer harmonics, and bass lines that recalled the soul and funk music in which Banks specialized, as well as Mills' penchant for harsh and tectonic industrialist drum programming. "Whatever Happened to Peace" adapted parts of Final Cut's *Temptation* in a proposition that poignantly sampled the voice of a fictional US President, stylized after Ronald Reagan, addressing the aftermath of a nuclear attack from a foreign military enemy in the 1983 film *The Day After*: "During this hour of sorrow I wish to assure you that America has survived this terrible tribulation. There has been no surrender, no retreat."[107] Alexander G. Weheliye, the author of *Phonographies,* a book on twentieth-century Black cultural productions, suggests in a 2015 interview that Underground Resistance was quite alien to Germany upon first contact, despite the country having its own history of racialized white supremacist violence against the African diasporic and immigrant community[108]:

The early-1990s veneration of Underground Resistance—who are, in contrast to earlier Detroit techno producers, explicitly political, putting themselves in a lineage of Black freedom struggles—in Berlin was based on their politicisation of primarily instrumental music, and it also fed into an independent punk-rock ethos that was prevalent in the city at the time. The reception of UR in Berlin also suggested that Blackness and Black music were okay, so long as they didn't involve Black Germans; it took place under the auspices that Blackness was foreign to Germany. Nevertheless, of course UR was hugely important.[109]

Weheliye considers "the narrativization of the reunification and the birth of Berlin Techno and the Berlin republic" to be a part of "a much longer tradition of thinking

106 "For these tracks UR names itself X-101, an unknown audio assault system. X-101 is not an alterego but an altermachine, which connects the X prefix of the fighterplane with the 101 suffix of the synth series." Eshun, *More Brilliant Than the Sun*, 118.

107 X-101, "Whatever Happened to Peace," *Whatever Happened to Peace* (Underground Resistance, 1991), sample taken from *The Day After,* directed by Nicholas Meyer (New York: Kino Lorber Inc., 1983).

108 "In the Nazi era, from 1933 to 1945, African-Germans numbered in their thousands. There was no uniform experience, but over time, they were banned from having relationships with white people, excluded from education and types of employment, and some were sterilised, while others were taken to concentration camps." Damian Zane, "Being Black in Nazi Germany," *BBC News*, May 22, 2019, https://www.bbc.com/news/world-africa-48273570.

109 Alexander G. Weheliye, interview by Annie Goh, "'White Brothers with No Soul': Un Tuning the Historiography of Berlin Techno," *Un Tune—CTM 2015 Festival Magazine*, January 2015, https://www.ctm-festival.de/magazine/white-brothers-with-no-soul.

about Germany and German-ness." Between five and twenty-five thousand Afro-German people were present in Germany during the Nazi regime, some of whom were forcibly subjected to touring in the ethnographic vaudeville exhibition "The German Africa Show" between 1934 to 1940—a spectacle commissioned by Reich Minister of Culture Joseph Goebbels in response to the perceived sonic weaponry of African American jazz music.[110] "Throughout the post-WWII period, Germany had to reconstruct itself in many different ways and imagine itself as untainted by its Nazi past," Weheliye explains. "One way it did that was by performing a kind of multi-cultural openness, however, only as long as that multiculturalism was located outside of Germany."[111] He probes further: "That is one part of the larger discursive structure. The reunification is typically imagined in mainstream histories as a seamless blending together of East and West, which leaves out the virulent racism and violence during this period, especially against non-white bodies. Although called xenophobia rather than racism, it didn't matter whether they were German or not so long as they were not white." Weheliye understands the history of Berlin *tekkno* to be shrouded in a somewhat amnesiac haze of nostalgia, perhaps due to an intense combination of future and culture shock, felt at the end of the perceived German idealist future:

> The other thing for me, at a basic experiential level that really made me take notice, was that these histories are not only recounting the emergence of Berlin techno per se, but are also constructing a very particular story about musical cultures in West Berlin during the 1980s before the advent of techno. What generally gets left out are the not very elaborate but nevertheless very present Black music cultures in GI discos and other clubs that played Black music in West Berlin before the fall of the wall. In these narratives, there is definitely a move to disassociate Berlin techno from Black musical influences. I'm not simply saying "this is the appropriation of Black music" but instead asking "what different histories of Berlin techno and of Germany would we get if we actually opened this up a little bit and looked at other dance music cultures and other forms of clubbing?" For me, it isn't an either-or question, but a matter of highlighting that there existed other forms of clubbing and musical cultures, which are once again being written out of history. This ensures that Berlin techno, Germany and German-ness are continually being imagined as white.[112]

Weheliye stresses the meaning of Underground Resistance's music as being specifically about Black liberation struggles in America, but notes that the feelings and references embedded in the music weren't necessarily understood by the burgeoning German rave culture:

110 Lusane, *Hitler's Black Victims*, 27.

111 Weheliye, interview by Goh.

112 Ibid.

The UR records that were successful in Berlin were not vocal recordings. Their discography, however, is almost evenly split between the tracky, industrial recordings on the one hand, and vocal, often Gospel-inspired house tracks on the other. For UR those things existed side by side and that wasn't a problem, but that wasn't necessarily what the folks in Berlin took their inspiration from. In Berlin, the releases which were popular (the *Riot* EP, *Sonic Destroyer*, *Panic*, and so on) emphasised the former at the expense of the latter, which were perceived as both "Blacker" and more "feminine."[113]

For him, the primary concern of techno was to improve the living and mental conditions of Black people by presenting new possibilities, new outlooks on life, through the expansiveness of unconventionally applied technology. Drawing discrete connections between moments of solidarity between German activist groups and the Black Panther Party in the 1970s, Weheliye specifically points to the paternalistic assumption of Kraftwerk's influence on techno, as an assertion of German identity through aesthetic dominance. Weheliye criticizes Germany's commitment to the political cause "folks of colour not located in Germany," so long as they don't "threaten the idea that German-ness equals whiteness." Undermining the post-colonial multiculturalism projected by Western civilization, Weheliye remarks:

> The historiography of Berlin techno really benefits precisely from the idea of Germany as a newly loosened-up bastion of Teutonic whiteness. I've described this elsewhere as how Germany has had to constantly create a kind of *Unschuld* for itself, an innocence, distancing itself from responsibility for anything that is not related to the Jewish community, which is now conveniently not very present within Germany. And of course the Holocaust did not only affect the Jewish community. These are tendencies which arch through German history and historiography, and which to a degree are due to the fact that large-scale German colonialism "only" lasted from the Berlin Conference to the end of World War I. As a result, colonialism and the longstanding presence of people of colour in Germany can be continually disavowed, because not doing so would mean "un tuning" the white harmonic scaffolding of German collective memory.[114]

Forging a way ahead of the sins of Western civilization's past, Tresor, as an attempted counter-cultural reset and acceleration into a global capitalist community, continued to build a relationship with artists from Detroit, reaching out to other first-wave producers from the scene who had been left behind after the 1988 *Techno!* compilation, such as Blake Baxter, who released his debut album *Dream Sequence* in 1991 on the Tresor label shortly after his *The Prince of Techno* EP came out on Underground Resistance. In 1992, Baxter and Eddie Fowlkes collaborated on *The Project*, a collection of acid

113 Ibid.
114 Ibid.

house and techno songs with additional production and remixing by von Oswald. That same year, Tresor matched the tempo of the Detroit musicians they were distributing and interacting with, releasing *Der Klang Der Familie*, a German *tekkno* and acid house compilation introducing Sven Röhrig as 3 Phase, Dr. Motte, DJ Tanith—a resident at the Ufo club and contributor to the magazine *Frontpage*—as well as Mark Ernestus and von Oswald as Maurizio. Produced by Berliners, *Der Klang Der Familie* and its opening track of the same name by 3 Phase bore a harsher edge, with an even more industrial sound than the Detroit techno the label typically produced, creating a clear distinction between the two sounds. "Drugs Work," by System 01 (Johnny Klimek and Paul Browse), and their 1994 album of the same name, was even more representative of what the German *tekkno* scene associated with the liberatory sounds of electronic dance music, sampling the suggestion, "Maybe you need to do something about your drug and alcohol problem." A corresponding sample retorts, "Somebody comes up to you, and asks you, do you want drugs? What do you tell 'em? Drugs work."[115] This incarnation of Berlin *tekkno* seemed to be removing itself from the geopolitical scale that had originally caused the music genre to appear there in the first place: the new sound of German *tekkno* favored minimalism and a blinding, mechanized precision that simply wasn't coming from the Detroit scene.

Mills—who now lived in Berlin—Banks, and Hood released a second album for Tresor, *Discovers the Rings of Saturn* (1992), under the moniker X-102. The album saw a notable leap in the group's conceptualization of sound: they used the rings of Saturn as an active metaphor for the cybernated futurism of Detroit techno. A short note on the back sleeve reads: "Imagine being in an atmosphere where all your God given senses are ineffective. Where your existence is but a mere fragment in a ring orbiting the planet. You may find yourself caught in the state between the rotation of motion and the rotation of life circulation."[116] In this tale of interplanetary travel, X-102 sought to use the entire listening experience as an opportunity to engulf the listener in a multi-pronged construction of sonic composition and design.[117] Framed by orchestral tones, accelerating and decelerating the introduction and concluding track, "Ground Zero (The Planet)," *Discovers the Rings of Saturn* construes a journey around the celestial body, passing through each of the rings until attaining planetary impact. In conjunction with the music, Mills, Banks, and Hood contacted producer and mastering engineer Ron Murphy of National Sound Corporation (NSC) in Detroit.[118]

115 System 01, sample in "Drugs Work," *The Techno Sound of Berlin* (Tresor, 1992). See also System 01, *Drugs Work* (Tresor, 1994).

116 X-102, back sleeve, *Discover the Rings of Saturn* (Tresor, 1992).

117 "You have to visually describe it on the vinyl—that's what constitutes an X project. The label itself is the actual planet, the grooves are the actual rings, so in a certain way you can give the impression that the grooves are the rings of Saturn." Jeff Mills, quoted in Eshun, *More Brilliant Than the Sun*, 133.

118 "Reverse-engineering the Brownian revolution alters the grooves of the mind, turns hifi consciousness inside out, and confronts you with the Clintonian habitform which is you. Mike Banks explains how the supervisor at the National Sound Cutting pressing plant in Detroit 'showed us a way of changing the direction of the machines just by

Nicknamed "Motown Murphy" for his large collection of Motown records, Murphy had been working with other Detroit techno artists such as Atkins, May, and Mike Huckaby to assist in getting vinyl cut locally and in a timely manner. "In a discreet way, Ron kept the audio quality of the labels—such as Underground Resistance and Axis—at a certain level because he was conscious of where this music was going," Mills recalled.[119] Murphy was a veteran of the old music industry of Detroit, having worked for soul musician Isaac Hayes, on behalf of whom he controlled reverb and echo effects on the track "Walk on By," from the 1971 album *Hot Buttered Soul*. Murphy was a good ally for Underground Resistance and other techno producers: his technical perspective was entrenched in the original Detroit sound and the electronic sounds that succeeded Motown:

> The techno kids here in Detroit had no one to show them how the music industry works. After Motown left the city, there was nothing left. They sat with their cheap equipment in their bedroom studios and just produced. I'd been active in the music industry since the early '60s. I'd done it all, from label to production, and I could give them advice. I well remember, for example, how Mike Banks would come by and we'd discuss what their record deals should look like over lunch. I told him how Motown did it back then. When I was starting with NSC and in the process of slowly building myself a business, I had a lot of time on my hands. I used it to work with the boys on their tracks. Sometimes, we'd sit a whole day in my studio until we had a result we were happy with.[120]

Murphy's experience working with Underground Resistance was seamless: "When Jeff Mills came with *Rings of Saturn*, I offered to just cut a few locked grooves around the track—like the rings of Saturn. . . . I marked the point on the record where I started to cut, then cut exactly one revolution. When I'd finished, I put the loop on first, and it worked perfectly. The very first time. I was totally pumped and just watched as the record kept spinning in a circle playing the same loop."[121] Mills recounts meeting with Murphy about the album and gaining insight into the post-production process: "Actually, X-102 was the first time . . . I learnt how to relate the physical aspects of the vinyl to an actual concept, using the label as the most centerpiece and the hole in the label as the more defendant piece and the grooves leaning into the label and the edge of the record."[122] Re-engineering the physical capabilities of the vinyl playback while projecting the listener into a tangible, yet expansive, world, *Discovers the Rings of Saturn*

changing the belts on the machine's main drive. We use the same machines that they used back in the Motown days, which are ancient compared to the ones today, which you can't tamper with.'" Mike Banks, quoted in ibid., 133.

119 Jeff Mills, in Ashley Zlatopolsky, "Behind the Groove: The Ron Murphy Story," *Red Bull Music Academy Daily*, May 21, 2015, https://daily.redbullmusicacademy.com/2015/05/ron-murphy-feature.

120 Ron Murphy, quoted in Denk and von Thülen, *Der Klange der Familie*, 311.

121 Ibid., 313.

122 Mills, lecture, hosted by Schmidt.

is an astonishing work that elevated what Detroit techno could be and mean outside of the club, pursuing a canonical longevity more in line with omni-dimensional electronic jazz.[123]

In 1993, the *Tresor II (Berlin Detroit - A Techno Alliance)* compilation was released, placing the two scenes side by side for the first time. It featured tracks from Atkins and Fowlkes' respective collaborations with Moritz von Oswald and Thomas Fehlmann as 3MB (standing for three men in Berlin). "Moritz had the 'Ploy' DAT [digital audio tape] with him, the first Maurizio record, the project and eponymous label he'd just started with Mark. We took it to Ron Murphy at his mastering studio, National Sound Corporation. That's where all the Detroiters had their records mastered and cut," Fehlmann recalls.[124] Ernestus adds admiringly, "Ron Murphy was very, very important. He came from a different generation and was a true original." Sure, there were a few cutting studios in Germany. But they were run with a different consciousness than in the States, where there were mastering engineers." He continued: "In Germany back then, people talked more about transfer or rerecording—in other words, transferring the material from one medium to another."[125] Von Oswald and Ernestus anonymously paired up as Quadrant, and released *Infinition*, which was remixed by Carl Craig and distributed by his Planet E label.

Tresor continued to support Detroit techno musicians in getting wider recognition, even as the Berlin rave scene quickly forgot how their national music of unity had made it to the European continent. In 1993, Eddie Fowlkes compiled *The Detroit Techno Soul*, returning to the city's roots but showcasing techno that veered into softer sounds that were closer to house music. The following year, Tresor released Fowlkes' debut album of R&B-infused techno *Black Technosoul*. Mills and Hood, in their own corresponding life journeys, were beginning to see the limits of releasing vinyl in the lean and homegrown manner that Underground Resistance had embraced until then. They considered splitting off to pursue international DJ careers, as the European dance music movement had turned into a multimillion-dollar industry over the past few years. They both contributed to Tresor's Waveform Transmissions series, with releases that marked a transition in their style, from the militant techno that brought them together. In their final collaboration as X-103, the conceptual album *Atlantis*, their sounds merge into an ambient techno that explored the myths and possibilities of that underwater civilization, before splitting again through their later solo outings for Tresor, and eventually their own record labels. Atkins released new music through

123 "*Rings of Saturn* doesn't belong on Earth. With X-102, Trad ambient's weightlessness becomes chamber ◇ crater Techno, frequencies of concussive distortion like basketball played with a wrecking ball on concrete. All the machine rhythms are distorted into unrecognizable metallic stresses, impacts of unknown force, mass and motion. Deep space that sucks your soul dry. Zero gravity that turns into zero-degree trauma." Eshun, *More Brilliant Than the Sun*, 135.

124 Fehlmann, quoted in Denk and von Thülen, *Der Klange der Familie*, 310.

125 Ibid., 310–11.

Tresor in 1998 under the name Infiniti, with the album-length science-fiction venture into melodic dub techno, *Skynet*.

The afterglow of the "German Summer of Love" resonated throughout much of the 1990s, but while the counter culture danced in decadent excess, Berlin annexed itself into a concept—a simulation of freedom at the height of the technological revolution and globalization.[126] "Techno became a universal language with its own values, like tolerance, and denouncing sexism and racism,"[127] Laarmannn reflected on his work documenting Berlin club culture. In 1997, just as the party seemed to be winding down, his magazine *Frontpage* was discontinued due lack of funding. Laarmannn muses, "You know, being there back then, it felt perfect. We really believed we had a bright future of inclusion and freedom ahead of us. We have to ask ourselves what went wrong in between."[128] DJ and music journalist Tobias Rapp reflects on the liminal socio-economic space that club culture has occupied in Berlin. "Seen through slightly rose-tinted spectacles, you could say that Berlin's house and techno scene has retained the positive elements of an independent culture—economic autonomy, artistic integrity, the refusal to compromise—whilst simply leaving the negative features—facile capitalist critique, idealisation of self-exploitation, a lack of professionalism—by the wayside," Rapp writes.[129] "Berlin is a very poor city. People don't have much money here, and there is no financial industry here or manufacturing," he explains. "All the stuff that Germany makes its wealth with is not here. It's in West Germany: we're just the capital. We just have techno and politics. So when investors come to Berlin they're very rarely from Berlin. Most investors who buy apartments are from outside the city, so lots of people who have resentments against tourists think that tourists have created a terrain where investors have sent the rents up. That's utter bullshit."[130]

In the new millennium, the energy of the Love Parade and the social fallout from the political chaos of the 1980s receded with the closure of the Ostgut, a gay techno club which ran from 1998 through 2003. While Osgut was slated to be demolished and replaced by a large arena and corporate retail development, the club's owners Norbert Thormann, a former fashion photographer, and Michael Teufele started a new venture

126 "All of the supposedly 6,000 attendees agreed: They had witnessed the beginning of something huge. The birth of German techno. The event enjoyed international interest. British magazines The Face and i-D, back then the global frontrunners for music and all things trendy, came by, and so did MTV. They reported that there was a new, wild Berlin and waxed poetic about the 'German Summer of Love.' Not only was the parade legendary, the afterparty was, too. The Love Nation party, organized by the Love Parade crew at Halle Weißensee, brought together the crème de la crème of German DJs, all playing for a flat fee of 200 Deutsche Marks. There's never been anything like that ever again. And in retrospect, that weekend marked the starting point of Berlin's nightlife tourism, which is now a whole industry." Laarmann, "Tear Down This Wall."

127 Laarmann, quoted in George, "The '90s Techno Magazine.*"

128 Ibid.

129 Tobias Rapp, *Lost and Sound: Berlin, Techno and the Easyjet Set* (Berlin: Innervisions, 2010), 12.

130 Tobias Rapp, "Berlin in the '90s: An interview with Tobias Rapp," *Resident Advisor*, September 7, 2011, https://ra.co/features/1434.

that would be housed inside of a former power plant leased by Vattenfall,[131] a state-owned Swedish multinational energy company. Thormann and Teufele's new space Berghain," meaning "mountain grove," built on the sexually liberated autonomous zone that Ostgut provided by expanding into multiple rooms—the techno-focused main room, soulful house music in the Panorama Bar house, and the male-only basement sex club, Lab.Oratory—located on the border between East and West Berlin, Kreuzberg and Friedrichshain. "Berghain towers like a techno cathedral on the fringe of the new club mile," Alexis Waltz, a raver and editor-in-chief of the German club culture magazine *Groove Magazine*, noted, describing the club as a kind of gothic postindustrial monument, an institutional autonomous zone: "It stands not only for an uncompromising vision of clubbing, but also for a sound which could only have been created here."[132] Despite once having had a technological function, the power plant that Berghain inhabits now serves as a temple for the Berlin *tekkno* scene of the 2000s, fashioned out of the cultural afterimage of the future and culture shock of reunification at the onset of the Information Age. "Berghain and Panorama Bar have a total of six bars spread over three floors," Waltz remarks, describing the club's mythic interior, which cannot be photographed. "One is the room on the right of Berghain, next to the large dance floor, a space you can imagine as the side aisle of a gothic cathedral. Just as architects of old created a clever interplay of windows and narrow columns to emphasise the direct link with the heavens, here the spotlights are positioned in such a way as to make the ceiling appear even higher than it actually is."[133] Waltz outlines the basic elements of the club and its ritual effect on drug-addled ravers. "The distinction between Berghain and Panorama Bar reflects the dualism of techno and house which structures electronic dance music," Waltz details. "The style of music in the club's predecessor Ostgut, which existed from 1998 to 2003, was no-nonsense techno. Panorama Bar, added later as an extension, was innovative in its musical style. A very particular sound evolved here, ranging between elegant minimal and timeless,

131 "Saddled with a wealth of abandoned space, the energy company Bewag, now Vattenfall, began in the mid-1990s to look for new uses for the thousands of square meters of space available. Since 1998, the company has managed to sell more than 100,000 square meters of space in buildings no longer useful to them. Clients like the German software companies SAP and MetaDesign have moved into old power and transformer stations in the western and eastern parts of the city. The more than 30,000 square meters of space Vattenfall has rented out include nightclubs like Berghain - where true Saturday-night club devotees dance into Sunday afternoon - and the former Vitra Design Museum. 'The scene here thrives on things that aren't finished,' said Hans-Achim Grube, an author of books on industrial re-use and the Vattenfall manager charged with finding new tenants. 'You go inside and you're part of the art project. Nobody wants everything to be finished and polished.' In most cases, Grube says, tenants agree to overtake costs such as heating and ventilation in exchange for a low monthly rent. From 1998 to 2005, the last year statistics were available, Vattenfall earned more than €200 million by renting or selling former plants and power stations." Andreas Tzortzis, "In Berlin, Art Among the Ruins," *New York Times*, May 1, 2007, https://www.nytimes.com/2007/05/01/arts/01iht-berlinart.1.5513672.html.

132 Alexis Waltz, quoted in Rapp, *Lost and Sound*, 128.

133 Ibid., 147–48.

uplifting house."[134] Berghain, and its "ritual of disappearance" in time, would come to symbolize a kind of no-man's-land at the center of the collapse of communism and the overgrowth of capitalism, preserving the hedonistic culture industry of the German *tekkno* movement in Berlin—"the world capital of techno"—even as the city itself grew out of its seemingly anarchic past into a capitalist, conservative, nuclear family-oriented present.[135]

134 Ibid., 130.

135 "Across the globe, people talk of Berghain in reverent tones: the techno Valhalla where Marcel Dettmann and Ben Klock play marathon sets to a crowd of genuine enthusiasts that have made it past the equally legendary bouncer. It is much more than simply a Berlin institution; each week Easyjet and RyanAir flights fill with clubbers wanting to get their fix. And for those poor souls that have yet to make the pilgrimage, Berghain becomes 'Berghain', a kind of magical techno wonderland that you can only dream of. In a recent [Resident Advisor] interview, the Italian techno producer Obtane announced it was his favourite club, despite the fact he's never actually been there. He is hardly alone. In techno circles, Berghain has increasingly taken on an almost mythical status, the place where the music never stops and all your techno dreams come true. And, of course, there are many very good reasons why Berghain is held in such high regard. Nonetheless, I think there is a danger of idealizing Berghain, misunderstanding it, and drawing the wrong lessons from it. When people from outside Berlin talk about how amazing the club is (and it seems like outsiders talk about it much more), they usually do so – either explicitly or implicitly – in reference to their own scene, suggested as inferior and lacking in comparison. In a certain sense, this may be true: it is hard to rival either the talent at Berghain's disposal or the unique constellation of factors that have allowed for its creation and existence . . . Quite simply, the aim should be to build our own Berghain, whatever they may be." chris, "Build Your Own Berghain," *MNML SSGS*, March 27, 2011, http://mnmlssg.blogspot.com/2011/03/build-your-own-berghain.html.

8.
UNDERGROUND RESISTANCE: ELECTRONIC WARFARE FOR THE SONIC REVOLUTIONS

By installing themselves inside the military, UR becomes a WarMachine advancing decades ahead of American music. UR's Sonic Fiction emerges from the Future at its most lethal, imbuing Techno with an enthralling electricity. Yesterday's military fact is tomorrow's science fiction. Reality accelerates past fiction.[1]

– Kodwo Eshun

The idea of "resistance" is very old. A more important question is what are the conditions that cause it? The spirit of resistance survived in us African-Americans throughout the ages and manifested itself into me and Jeff Mills as kids as it did in many of our friends. Our parents were educated and had survived the turbulent 60's and supported the "resistant" Dr. Martin Luther King's Civil Rights Movement and anti-war campaigns. Consequently both Jeff and myself were AWARE.[2]

– "Mad" Mike Banks

In March 1992, the entire country watched footage of the LAPD beating an unarmed Rodney King, cornering him after a car chase. Riots erupted in Los Angeles, leaving 63 people dead, 2,383 injured, and over 12,000 in police custody. The officers were acquitted from charges of assault and excessive force, but the city of Los Angeles would ultimately be held liable for King's injuries and traumatic experience and pay him a symbolic reparative settlement of $3.8 million.[3] Eight months after King's victimization, Larry Nevers and Walter Budzyn, two plain-clothed police officers, approached thirty-five-year-old Malice Green outside of what was locally known to be a crack house in Detroit. The undercover officers reported that Green had refused to drop an object he was holding, prompting one to use his steel flashlight to beat the otherwise unarmed man into submission. As more police arrived to back up the engaged officers, Green lay bloodied on the ground, before eventually being taken into

1 Kodwo Eshun, *More Brilliant Than the Sun* (London: Quartet Books, 1998), 117.

2 Mike Banks, interview by Sven von Thülen, *De:Bug* 109 (October 2007), https://www.discogs.com/group/thread/653528.

3 Richard A. Serrano and Tracy Wilkinson, "From the Archives: All 4 in King beating acquitted," Los Angeles Times, April 30, 1992, https://www.latimes.com/local/california/la-me-all-4-in-king-beating-acquitted-19920430-story.html; Seth Meydans, "Rodney King Is Awarded $3.8 Million," *New York Times*, April 20, 1994, https://www.nytimes.com/1994/04/20/us/rodney-king-is-awarded-3.8-million.html.

medical custody. He died before reaching the hospital.[4] In both cases, King and Green's literal humanity was called into question by state appointed authorities; the prospect of death is deemed rational, if not necessary, by the governing bodies.[5] Detroit's first Black mayor, Coleman A. Young—a former autoworker and Tuskegee Airman—condemned the assault, stating on national television that Green was "literally murdered by police."[6] Young's tenure as mayor from 1974 to 1994—his anti-integrationist perspective, rooted in Black Power in the fallout of the race riots of 1967 and the subsequent white flight—has often been blamed for much of Detroit's decline. Yet he assumed this role after a decade-long economic crisis had swept through the country—a crisis from which Detroit struggled to reemerge to its former prominence. Meanwhile, the United States was still at odds with what kind of nation state it wanted to be, despite every political candidate lurching towards economic nationalism, or "mercantilism," the system in which a government intervenes and regulates the labor of citizens and accumulation of capital as a hallmark of national identity.

In an interview with Michigan State University professors Joe T. Darden and poet Richard W. Thomas, Young spoke about his experience trying to integrate Detroit policing in an effort to correct the conditions that had led to the riots of '67: "When we emerged from what could have been even worse than 1967 without a single person being killed as a result of police action, or actions of citizens against police, that to me is significant. Because it involved people of all races and religions, it told me that Detroit had picked itself up."[7] Young's educational approach to community-building and direct action was credited with shifting the demographic and social empathy of the Detroit police force, subsequently lowering the number of complaints of brutality from 2,323 in 1975 to 825 in 1982. Malice Green's death unsettled confidence in the effectiveness of Young's managerial tactics throughout the 1980s, while he completed his fifth and final term as mayor. In 1993, Young was succeeded by Dennis Archer, a lawyer who served as the first Black president of the American Bar Association. Though crime and unemployment decreased during Archer's mayoral run, race relations in 1993 were not good. Unlike Young, Archer viewed racial separatism in Detroit as an economic disadvantage to both the city and the Black community: he began to reach out to the suburbs in an effort to regain the wealth and trust of the white population, which had upended its investments since the white flight of the 1970s, while trying to make Detroit appear to be multicultural. Archer implemented symbolic

4 Rogers Worthington, "Cops' War on Crack Led to Fatal Beating," *Chicago Tribune*, December 16, 1992, https://www.chicagotribune.com/news/ct-xpm-1992-12-16-9204240551-story.html.

5 "Black male death places Black men and boys within a horizon of finality. They are confined to the present by the denial of futurity." Tommy J. Curry, *The Man-Not: Race, Class, Genre, and the Dilemmas of Black Manhood* (Philadelphia: Temple University Press, 2017), 185.

6 Larry McShane, *Cops Under Fire: The Reign of Terror Against Hero Cops Required to Use Force in the Line of Duty* (Washington, DC: Regnery Publication, 1999), 49.

7 Coleman A. Young, quoted in Joe T. Darden and Richard W. Thomas, *Detroit: Race Riots, Racial Conflicts, and Efforts to Bridge the Racial Divide* (East Lansing, MI: Michigan State University, 2013), 111.

gestures, like erecting a new stadium for the Detroit Tigers, Comerica Park (named after Comerica Bank, which had changed its name from the Detroit Bank and Trust in 1982 to disassociate from the city after its collapse), and allowing the opening of three large casinos within city limits—an economic stimulus maneuver that Young had also favored. In May 1999, a petition for Archer's recall garnered over 120,000 signatures. In the *Detroit Free Press*, Ernest Johnson, a truck driver for the city's water department, explained that "Archer was an elitist who won't listen to the concerns of everyday Black Detroiters. . . . You shouldn't have to have a college degree for the mayor to stop and pay attention to people. A real Black person wouldn't ignore Black people."[8] Archer did not run for reelection in the 2001 mayoral race.

Frustrated with the state of Detroit and the broken promises of a substantive career pursued in the newly erected European dance music industry, "Mad" Mike Banks retreated into the city and began to plan his retaliation. While his label and collective Underground Resistance received support from the Berlin label Tresor through the so-called "Detroit-Berlin Axis," Banks recognized that the US music recording industry was sidelining techno's success in Europe and the UK to get behind the rising popularity of rap music coming from both the East and West coasts. Without a major record deal in the US, Banks had to rethink his approach to releasing music; the structure in place operated on an optimized sure-thing principle and capitalized off of the inflated PR budgets of popular hits.[9] Underground Resistance, which operated as an independent record label and audio production system, positioned itself against the dominant recording industry, both in alignment and in competition with European record labels and distributors, who mainly sold techno and other electronic dance music amongst themselves in a closed oligopolistic circuit and were unable to compete with the production budgets and mass demographic of the US market. Wedged between two closed-circuit trade structures, Banks began to activate the remnants of the Detroit music recording industry, left behind by Motown and Old Hastings Street, into a self-run manufacturing venture that would spread the message of unheard "everyday Black Detroiters," straight from the source.

"I have often been accused of being difficult with European Record Companies as being racist or not liking white people. The truth is I would simply ask for something that would give back to our community from these people. A simple reciprocal deal," Banks reflected, years after techno left Detroit, in a 2007 interview.[10] Banks' words

8 Heath Meriwether, "The Not-Black-Enough Disease Strikes Again," *Detroit Free Press*, May 23, 1999, quoted in Joe T. Darden and Richard W. Thomas, *Detroit: Race Riots, Racial Conflicts, and Efforts to Bridge the Racial Divide* (East Lansing, MI: Michigan State University Press, 2013), 126.

9 "Mid-level artists are, in essence, valuable to labels only in terms of their future potential, or if they garner such great press that they help a particular executive burnish his or her reputation as a sensitive soul. Such repute, alas, is far less valuable in the marketplace than an expertise in marketing megabits or implementing cost-cutting." Danny Goldberg, "The Ballad of the Mid-Level Artist," in *R&B, Rhythm & Business: The Political Economy of Black Music*, ed. Norman Kelley (New York: Akashic Books, 2005), 86.

10 Banks, interview by von Thülen.

carry a sense of sadness and distaste. He asks why European record companies didn't start a charity with their initial releases, or engage in distribution and promotion within the American recording and radio market to help build Detroit and support the originators of techno sounds—though, when considering the relationship between Europeans and Africans across the five hundred years prior to Banks' statement, the request for mutual aid and community engagement now reads as simply too wholesome and humanitarian to have ever been a tangible reality. Banks describes being confronted with stereotypes and false equivalencies by European record labels when trying to divert the promotional planning to urban Black America, where he was living and where the music was being made: "Those people don't listen to techno music they only listen to rap don't they?" He wanted techno to retain its original audience—individuals aging into their adult lives and facing several crises. He wanted economic mobility for this audience, while also diversifying the field and opening it to more global distribution: "It was and is still one of the most difficult aspects of making this music. It's as if we are smart enough to make this music but too fucking dumb to listen to it."[11] By this point, Jeff Mills and Robert Hood had departed from the group to pursue careers overseas, leaving Banks at the helm of Underground Resistance. "Unfortunately what they didn't know was that European Record Companies not only lacked the interest, but they also lacked the muscle and experience to compete in the urban US market." Despite some musicians and DJs gaining success in Europe, a frustrated Banks lamented that "they repackaged the shit and sold hundreds of thousands of records into the UK and Europe only! An easy sell market we had already established! Totally neglecting the States!" He added:

> We need hi-tech dreams and thoughts in the hood even more now than ever because the technology gap is widening! I often wonder if any European artists hear me? Will they be as brave as their forefathers and try to establish their so-called "advanced music" into the hood? How advanced can it be if only one small group of people understand and enjoy it? To truly put your music to the test, see if people in varying environments think it's as good. Like the great Euro electronic bands of the 70's & 80's did! Hopefully some will try or maybe they will all accept the stereotype "Oh they don't listen to techno music"? I'm certainly glad the Detroit pioneers didn't listen to the old bullshit stereotypes twenty years ago "Oh they don't like music with too many beats in it" and "They can't dance anyway" we would have all lost if they did.[12]

Banks then turned to the inherent structural differences between US urban planning and abandonment schemes in contrast to the socialist-leaning capitalism in Europe, which integrated newly built architecture into hundred-year-old communities. He pointed out that "We need our city and manufacturing leaders to travel overseas and

11 Ibid.
12 Ibid.

to realize what Mass Transit means to a city."[13] Imagining that the older continental empire was unaware of the modular, booming and busting financial risk-taking of the American experiment, Banks was keen to point out the nature of the international trade system. With Underground Resistance, he sought to reignite Detroit and techno music, mobilizing them to "drop code and hidden sonic clues in our ongoing electronic warfare with the Programmers who seek to contain our minds." Banks' words, he acknowledged, were coded "for those who know": Underground Resistance couldn't compete with either the American recording or European dance music industries, let alone with a global, capitalist, and colonial technocracy. But he continued on in faith:

> You cannot buy soul, you cannot buy funk, you cannot buy life experiences, you can't pay people to dance when they don't feel it and you cannot copy our uniquely fucked up, warped perspective of this music. . . . In the future even if we are dead and gone. We have been successful as our records will survive us and maybe on some old fucked up 1200 turntable a thousand years from now an unknown young warrior will drop the needle on an old scratched up UR record and the "Moor Horsemen" will ride again.[14]

Throughout the early 1990s, Banks engineered a string of fiery releases through the Underground Resistance production line and the more accessible and collectible label, Happy Records: *Riot*, *Waveform*, and *Punisher* (all released in 1991, the latter produced by Mills) succeeded each other quickly, while *Nation 2 Nation* (also 1991) expanded techno through inflections of jazz and ambient. Both structures fell under the Submerge Records operation, which established itself as a retail shop and museum to the Detroit sound in 1992. With his headquarters in place, Banks launched a global assault through the sub-label World Power Alliance, formed "somewhere in Detroit on May 22nd 1992 at 4:28 pm by various elements of the worlds underground legions."[15] The original trio of Banks, Mills, and Hood assigned themselves roles within their conceptualization of the Rome-Berlin Axis Powers, composed of Germany, Italy, and Japan during their aggressive expansionist war campaign that had as its goal the "advancement of the human race by way of sonic experimentation."[16] The first salvo, "Kamikaze" was released as a one-sided 12-inch vinyl by Banks, poised from the tactical vantage point of Japan, and dedicated to the "unmatched in history, young men sacrifice their lives for something they believe in."[17] Followed by a declaration of war, the vinyl's inscription continues: "With bravery like that one can never be beaten. Somewhere over the skies of the world there flies one more zero, one more Kamikaze, be warned!!" Underground Resistance's embrace of self-sacrifice for a greater cause

13 Ibid.
14 Ibid.
15 Underground Resistance, etchings on the b-side, *Kamikaze* (World Power Alliance, 1992).
16 Ibid.
17 Ibid.

262

co-opted the elemental, mythic force of the Kamikaze, the Japanese special attack unit, and adapted it to the needs and weaponized usages of Black communities living in the fallout of the United States' fascist industrial system. Banks wanted Detroit and the utterance of the name Underground Resistance to become the stuff of legend, of horror even. Ironically, there are in circulation a number of mispressings in which Carl Craig's breakbeat-styled track, "Free Your Mind" replaces Banks' "Kamikaze."

Mills contributed the second sonic missile launch with the single track "The Seawolf," named for the nuclear-powered German U-boat. The liner notes state that, "Somewhere in the depths of our vast seas lurks the seaman's most feared nightmare, Seawolf."[18] Fast-paced TR-909 percussion against accentuated TR-303 acid licks mirror the submerged doppler effects associated with the submariner, while possibly referencing the 1989 Atari 8-bit game *Silent Service*, programmed by strategy video game designer Sid Meier. The game places players at the helm of the US Navy submarine force set in the Pacific Ocean within a simulated Second World War environment.[19] Hood countered with "Belgian Resistance," named after the decentralized armed resistance movement that arose during the German occupation of Belgium from 1940 to 1944. On the A-side of the vinyl, Underground Resistance inscribed a message of meaning and intent: "The underground rebel forces of Belgium fought relentlessly throughout the duration of WWII, only to be overcome by the fierce defense of the axis forces."[20] The active intelligence gathering, media distribution, and militant engagement that had occurred during Belgium's resistance represented the measures that Hood and Underground Resistance deemed necessary for the survival of African Americans in the colonial republic of the United States. Underground Resistance's tactical speculation and choreographed, model-scaled warfare became a weapon for the Black counter-culture of Detroit to strategize and mobilize. Hood's glitchy, rotating percussion and sequencer programming impresses a steady trajectory of shifting groove systems, for "unbeknownst to the inhabitants of the Planet Earth, an underground legion has been breeding and waiting in the dark, battle-scarred caverns waiting for revenge. . . ."[21]

Utilizing the natural resources of sound and frequency, Underground Resistance hacked global music distribution channels and reprogrammed the minds of citizens mentally and emotionally enslaved by industrial capitalism and the rising data-driven Information Age. Underground Resistance declared, much like Ronald Reagan before

18 Underground Resistance, liner notes, *The Seawolf* (World Power Alliance, 1992).

19 "Silent Service employs several graphics screens to relay the information needed to command the sub. The Patrol Navigation Map shows a 150,000 square-mile area of the Pacific Ocean from Midway Island to China (east to west), and Australia to the U.S.S.R. (south to north). This is the strategic map on which you move your sub to find Japanese shipping lanes. Once you've found a convoy, the tactical map kicks in." Neil Randall, "Silent Service," *Compute!* 8, no. 4 (April 1986): 52.

20 Underground Resistance, lyrics, *Belgian Resistance* (World Power Alliance, 1992).

21 Ibid.

them, that "This wall must be destroyed, and it will fall."[22] Mobilizing for electronic war, Underground Resistance wondered, "Isn't it obvious that music and dance are the keys to the universe?" The group's creed acknowledged both modern and ancient technologies, urging "all brothers and sisters of the underground to create and transmit their tones and frequencies no matter how so called primitive their equipment may be. Transmit these tones and wreak havoc on the Programmers!"[23] Their call to arms was inspired by their own lives and growing pains.

In a 2007 interview with the late philosopher and culture critic Mark Fisher for *The Wire* magazine, Banks talks at length about Detroit and how the city's confluence of technology, economics, and music formed the framework for his thinking about sonic revolution: "I learnt from the auto makers. Every year in Detroit they'd have a car show, have cars covered with a veil. They snatched the veil off when they introduced the car, it's pretty much the same how we record."[24] A heavy, deep skepticism lingers throughout much of Banks' perspective as a musician once signed to Motown who had learned from the first generation of Detroit techno and the major music recording industry. He chose to play the music distribution market like a game, but with a poker-faced level of remove and resolve.[25] "I'm not so keen on any and everybody seeing recording techniques because, maybe in Europe it's not a competitive thing, but for the way we were brought up, it certainly was competitive."[26] Referencing the early '80s progressive music scene in Detroit, before the rise of techno, Banks contrives a rational theorization of music as an artform that could be adaptable to a living environment and situation; for Banks, it could be a mechanism for rerouting his competitive spirit outward towards the capitalist system and industrial channels that necessitate competition.

As a project, Underground Resistance organized around the conditions causing a community to take up tactical arms; it was meant to inspire Black and other oppressed people around the world as a tool to change one's destiny through sheer force of will and

22 Ronald Reagan, speech delivered at the Brandenburg Gate, Berlin, June 12, 1987, https://www.americanrhetoric.com/speeches/ronaldreaganbrandenburggate.htm.

23 Underground Resistance, vinyl label, *Kamikaze*.

24 Mike Banks, interview by Mark Fisher, *The Wire* 285 (November 2007), https://www.thewire.co.uk/in-writing/interviews/mike-banks-interview.

25 "The majors will embrace any formula that sells records until it stops working. As a result, the corporate machine cannot deliver an adequate diversity of sounds, only a homogenized, prepackaged product. The indies, on the other hand, are known for their "legitimate" musicians who care about the artistic quality of their product, rather than its "exchange value" or its appeal to a mass audience of mostly teenage consumers. Consequently, the indies are often seen as a collective form of resistance to the corporate regime that dominates the record industry and the entertainment industry as a whole. The indies, so the story goes, represent a collective refusal to 'sell out,' a refusal to allow the marketing wizards of the corporate establishment to reduce their art to mass-produced commodities void of any compelling aesthetic value." Michael Roberts, "Papa's Got a Brand-New Bag: Big Music's Post-Fordist Regime and the Role of Independent Music Labels" in *R&B, Rhythm & Business*, 24.

26 Banks, interview by Fisher.

collective action. With the *Nation 2 Nation* EP and its 1992 follow up, *World 2 World*, Banks began to shift techno out of the cybernetic future and into a transcendental present, updating Derrick May's conception of hi-tech soul into a computer-operated, but manually performed, hi-tech jazz. Quite similar to Amiri Baraka's project for an African Visionary Music, which saw no distinction between John Coltrane's celestial ventures in jazz, the grieving soul of Billie Holiday, and James Brown's defiant funk, hi-tech jazz operates by recapitulating older, traditionally generated iterations of Black music and unity.[27] Banks strove for a transformative edge that partook in a similar methodology as Don Lewis and his Live Electronic Orchestra with the Hammond Concorde and the Ace Tone rhythm box, employing available keyboards with drum machines. With standard compositional models forged underneath the innovative home studio mixing and panning that informed Atkins' electronic funk, Banks restyled techno as a theorization of Black communicative technique, routed through an ensemble of machines that sing alongside the player. The entire stereo field, in this way, becomes a canvas for sound to appear and splash around the listener's mind, achieving healing results. Banks told Fisher that the experience of making and sharing this new music overseas in Europe was gratifying: "I was really blessed to travel late. In fact I travelled to Europe so late that the people from Europe had already come to Detroit way before I got to travel, and I was blessed with people were coming saying, 'I was in drug rehab and a guy in there was playing 'Hi-Tech Jazz' and it really raised my spirits and changed my life.'" Banks' purpose-driven music was a hopeful compliment to the themes of military assault otherwise pervading Underground Resistance's output:

> So, if someone was to say "Hey man, Why did you make Hi-Tech Jazz?" and I described why I did it, because I did have something I was thinking of, if I was to do that I would have fucked up his vision of why he listened to it. So I learned not to describe anything and just leave it like water, clear, with no shape and no form. I think that's what people really enjoy about UR, they get to paint their own picture. We might just make the canvas for them, with the record, and in their mind they paint the picture and that's one of the reasons we sold for so long. We just went faceless, there was no reason for you to know what we look like, you just concentrate more on what the sound was. Unfortunately, people need a face all the time, and for many years I didn't give em any face. But now—internet, cell phone—people take pictures of me, the shit's all over the internet. I figure well, hopefully the people will still have some honour and honour my wish not to be seen in front of my music.[28]

27 Amiri Baraka, *It's Nation Time – African Visionary Music* LP (Black Forum/Motown, 1972).

28 Banks, interview by Fisher.

Banks turned his focus back to the material conditions of Detroit, speaking candidly about taking on the role of mentor to the local youth. As a high-school baseball coach, Banks was able to install himself in the community and reach out to the next generation: "Some of the kids make it, and some of them don't. I lose some of them to the war. Some of my baseball players, they're young, they're full of testosterone, they want to prove themselves, so some of them join the Marine corps."[29] The working-class norm of shuttling the youth of minority and lower-class communities through prison-like educational facilities in an underdeveloped urban landscape was laid bare before Banks, who witnessed an annual rotation of youth transpiring into their adult lives, in which they owed the country their service, whether as participants in the workforce or the US military, or as members of the off-grid, social undercurrent of territorial inner-city violence, drug-addled poverty, and the prison-industrial complex.[30] "One of my favourite players, man, he joined the Marine corps. I was so sad, because I thought he could have made it in baseball. But the recruiters, like in that Michael Moore movie, they're on their ass, they're challenging these boys, almost like challenging their manhood. It's a kid, and of course he's going to step up and defend his manhood, so they end up joining."[31] Watching the American pipeline of school to prison or military up close, Banks lamented that "it's like slavery. You lose two thirds of them on the trip. I'm thinking about not continuing coaching, because you lose so many of them."[32]

At the time of this interview in 2007, the city of Detroit was being led by mayor Kwame Kilpatrick, who had served as a Michigan state representative from 1997 to 2002, and was nicknamed "the Hip Hop mayor" when he was elected in 2002.[33] The youngest mayor of Detroit to date, Kilpatrick headed the city until 2008, when he resigned and was convicted after a six-year investigation into his deviant strategies of intimidating city contractors into laundering $84 million from the Water and Sewage Department through his own shell corporation. Kilpatrick was released in early 2020 after a commutation of his twenty-eight-year prison sentence in the last days of Donald Trump's presidency. Referring to that mayor, Banks told Fisher that he was skeptical of Kilpatrick's ability to turn Detroit into a "world class city." He said, "Sir, I hope you don't take this the wrong way we're never gonna have a world class city

29 Ibid.

30 "What has changed? What went wrong? The bitter irony of integration? The cumulative effects of a genocide conspiracy? The virtual collapse of rising expectations after the optimistic sixties? None of us fully understands why the nihilistic threat is more powerful now than ever before. I believe that the commodification of Black life and the crisis of Black leadership are two basic reasons. The recent shattering of Black civil society—Black families, neighborhoods, schools, churches, mosques—leaves more and more Black people vulnerable to the nihilistic threat. This shattering spawns a deracinated and denuded people with little sense of self and few existential moorings." Cornel West, "Nihilism in Black America," in *Black Popular Culture*, ed. Gina Dent (Seattle: Bay Press, 1992), 41.

31 Banks, interview by Fisher.

32 Ibid.

33 Darden and Thomas, *Detroit*, 127.

until we get mass transit in the city."[34] Detroit's automobile-based futurity was both speculative and limited, compared to European cities in which the infrastructure for driving emerged more or less naturally from existing architecture and citizens' living habits. The future-forward, though shortsighted, thinking that informed the design of Detroit had crashed in the 1970s, as unemployment increased and government spending for the Vietnam War rose. Banks considered the idea that "a car is going to be the dominant mode of transportation" as "so outdated . . . so from the fifties, man, Ozzie and Harriet and Leave it to Beaver shit." In his conversation with Fisher, Banks continued:

> We're so behind, because the former administrations were governed by the auto companies, and in the auto company mind, Detroit was going to be the model city for people to own cars with, and it is: our freeway system is so extensive, you can get from the suburbs fifty miles out, it take you twenty minutes to get downtown, but it take my mother, who lives in the city, an hour and a half on the bus to get downtown. I can see that we're way behind world class cities, and I had to tell the mayor that. I understood it, I travelled more than he did. Of course he couldn't do anything about it, but hopefully one of these administrations will get in there and make an effort to make transportation affordable for poor people in the city, because right now, if you don't own a car and have insurance, or you can't afford the gas, then you can't move. So we got a landlocked city man, and it's deteriorating.[35]

The postindustrial city of Detroit had been built with automotive mobility and financial circulation as primary goals, but throughout the 1990s, economic decay pushed the city to a point of crisis. From the epicenter of the decline of the American empire, Underground Resistance established itself as a touring audio assault unit, helmed by 'Mad' Mike Banks with Jeff Mills, Lawrence Derwin Hall (D-Ha), and Robert Hood as Robnoise, or The Vision. UR began an aggressive expansion of sonic weaponry, first deploying Mad Mike's solo release *Death Star* EP, which broadcasted his target: Star Wars villain Darth Vader and the Sith Empire's home base, a metaphorical stand-in for the American Empire and its military industrial complex. *Message to the Majors*—dedicated to Malice Green—followed in 1992, with two versions of a breakbeat-based techno track laced with undulating acidic sequence, titled "Fuck the Majors." On the inner label of the vinyl was an artwork depicting a pair of looming eyes peering through the opening of a balaclava, next to another figure donning an "LA" cap and gas mask, resembling Banks and Hood's apparel during live performances. The edge of the label read, "Message to all of the murderers on the Detroit Police Force - We'll see you in hell!"[36]

34 Banks, interview by Fisher.

35 Ibid.

36 Underground Resistance, vinyl label, *Message to the Majors* (Underground Resistance, 1992).

Underground Resistance continued to turn its attention to local, current events that year. In August 1992, in the small city of Howell, sixty miles west of Detroit (population: around 9,000 people), "Christian pastor" and former Grand Dragon of the Michigan United Klans of America, Robert E. Miles died.[37] In 1970, Miles had founded the Mountain Church of Jesus Christ the Savior at his home farm in a rural Livingston County—"klan country"—where he taught white supremacist ideologies promoting the importance of a pure, white, Aryan race and nation. A hundred years prior, in 1836, the township of Howell had been the first to establish a post office in the New World. Housed inside of a bar, it was a central component of the colonial settlement that had previously been named Livingston Center—alongside an early twentieth-century library built with money donated by the industrial philanthropist Andrew Carnegie. Howell was a gathering spot for the Ku Klux Klan throughout the twentieth century; the Klan regularly burnt crosses as a symbol of racial terror aimed at Black families living in the outer regions of the Detroit metropolitan area. Miles envisioned the Earth as a secular realm designed for battle between God and a false God, which could be interpreted as a pataphor[38] for the industrial, planned environments built by white men in the place of lush, naturally rooted and occurring native populations, plants, and animals.[39] He was arrested in 1971 for conspiring to bomb a school—a move to forcibly oppose a policy that would enforce race-integrated busing and school districts—even as "white flight" from the city of Detroit continued in full swing after the racialized violence of 1967.

Revolution for a Change, a full-length album from Underground Resistance compiling EPs and singles from the years prior, was released on August 24, 1992, a week after Miles' death. The cover art, composed of two militant, masculine figures depicted in the grain of early consumer video technology, presented the album title in bold red type at the bottom of the sleeve. The back cover split into three vertical panels displaying the album's track list of purpose-filled one liners such as "Riot," "Punisher," "Predator," and "Sonic Destroyer" next to an image of Detroit engulfed in flames, with a text reading "Hard Music from a Hard City" above more degraded video images of UR performing live. Next to these images, a manifesto urged consumers to join the revolution and take up arms in the Black resistance as a collective people's movement,

37 "Former KKK leader Robert Miles Dead at 67," *United Press International*, August 18, 1992, https://www.upi.com/Archives/1992/08/18/Former-KKK-leader-Robert-Miles-dead-at-67/7854714110400/.

38 A dense, loosely defined parody of philosophy and science invented by French writer Alfred Jarry in 1893, which allows a writer's metaphor to be extended into literal reality.

39 "Though the wealth generated by plunder and pillage continues to advantage North American republicans, the racism that served to produce the accumulation of this filthy lucre disadvantages the leaders in Washington, D.C., when it comes to confronting the climate emergency we all must now confront. Nevertheless, if humanity is—somehow—to escape from this diabolical environmental scenario that devilishly awaits, difficult questions must be posed and answered about the maldistribution of resources, which, even without climate collapse, continues to consign millions to an uncertain fate, while generating untoward policies that place the planet in peril." Gerald Horne, *The Dawning of the Apocalypse: The Roots of Slavery, White Supremacy, Settler Colonialism, and Capitalism in the Long Sixteenth Century* (New York: Monthly Review, 2020), 214.

as part of Underground Resistance's concept of the World Power Alliance—a project for collectivizing and designing shared worlds and strategies against racial injustice, industrial capital exploitation, and the preservation of the Earth's delicate ecosystem. The manifesto in full reads:

> Underground Resistance is a label for a movement. A movement that wants change by sonic revolution. We urge you to join the resistance and help us combat the mediocre audio and visual programming that is being fed to the inhabitants of Earth, this programming is stagnating the minds of the people; building a wall between races and preventing world peace. It is this wall we are going to smash. By using the untapped energy potential of sound we are going to destroy this wall much the same as certain frequencies shatter glass. Techno is a music based in experimentation; it is music for the future of the human race. Without this music there will be no peace, no love, no vision. By simply communicating through sound, techno has brought people of all different nationalities together under one roof to enjoy themselves. Isn't it obvious that music and dance are the keys to the universe? So called primitive animals and tribal humans have known this for thousands of years! We urge all brothers and sisters of the underground to create and transmit their tones and frequencies no matter how so called primitive their equipment may be. Transmit these tones and wreak havoc on the programmers!

> Long live the underground...[40]

In his journalistic book of engineered concepts around techno and Black music, *More Brilliant Than the Sun*, Kodwo Eshun notes that the design of UR's *Revolution for Change* resembled and aligned with the political, New York hip hop group Public Enemy, whose run of albums, from *It Takes a Nation of Millions to Hold Us Back* (1988), to *Fear of a Black Planet* (1990), to *Apocalypse 91... The Enemy Strikes Black* (1991), denounced the established white supremacist ideology of the United States as a separate, but united faction, through their Black, nationalistic, full-frontal sonic and media assaults.[41] As Eshun saw it, "UR's *World Power Alliance* expands on Public Enemy's *Fear of a Black Planet*, replacing planetary nationalism with a sonic globalism."[42] Similarly to Public Enemy and The Bomb Squad's studio music production—in which samples of avant-garde music, video and audio, and pro-grammed drum-machine patterns combine into an audio weapon—Underground Resistance launched rapid-fire auditory projectiles, with tracks like "Quadrasonic"

40 Underground Resistance, liner notes, *Revolution for a Change* (Network Records, 1992).

41 "Public Enemy draw fire with the visible target of their logo. The Bomb Squad are acousmatic, heard and unseen, adopting tactics of stealth adapted by Underground Resistance. With the sleeve art for '89's *Welcome to the Terrordome*, engineering becomes imagineering. The 12 is fictionalized as a sonic device, a bomb, 'launched, fuelled, planted and detonated by The Bomb Squad.' In their dub mixes, The Bomb Squad invent a sampladelic electronics at the heart of HipHop that turns up the volume of the world." Eshun, *More Brilliant Than the Sun*, 111–12.

42 Ibid., 122.

and "The Theory" on *Revolution for Change*. Encoding advanced speculative fiction and epigenetic trauma, these tracks deeply embed into the sense-altering quality and framework of Atkins' initial blueprint for techno music. *The Final Frontier*, "launched from Detroit" in 1992, initiated a successive counter-strike of sonic fiction that imagined an expansive battlefield with stealth fighter jets in high-altitude combat. One of its tracks, "Entering Quadrant 5" thrusts the listener into a reprogramming module of appreciated synthesizers and a pulse system contrived of tightly wound kick and hi-hats, before fading into a return flight and debrief at "Base Camp Alpha 808."

*

In Detroit, Banks prepared his arsenal, as the environmental impact of a hundred years of fracking and industrial development began to register materially on the city.[43] In the aftermath of Detroit's chthonic rise and ruin, the city of the future had begun to corrode, along with the environment from which it extracted its resources. Acid rain began to pollute the water supply and take on chemical qualities, prompting a 1999 report by the US Environmental Protection Agency (EPA) that declared that the rain and snow in the American Midwest contained mercury levels forty-two times higher than what they considered safe; their ingestion could cause deadly damage to the human nervous system, brain, lungs, and kidneys.[44] With *Acid Rain*, released in 1992, Banks introduced imagistic titles like "The Storm," "The Fog," and "The Light," gesturing toward the acidic emissions of sulphur dioxide and nitrogen oxide resulting from the overproduction of automobiles and factories, and their interaction with the existing water cycle of Detroit's ecosystem. Banks organized a defensive strategy with Ghetto Tech, a local duo composed of Greg Johnson and Derek Adams. "Piranha" (1992), their single together under the Underground Resistance moniker, featured mutants "Spawned in Detroit" (the title of its B-side) from the environmental effects of America's decaying infrastructure[45]—etchings on the vinyl read: "Swimmers Beware" and "Come to Detroit - And Get Your Ass Bit." In 1993, Underground Resistance returned fire with *The Return of Acid Rain*, subtitled *The Storm Continues*. On the vinyl label, liner notes inform that "Every day tons of sulpher [*sic*] and other pollutants are

43 "The publication in 1987 of Toxic Waste and Race in the United States, a report by the Commission for Racial Justice of the United Church of Christ, was a turning point. It showed that race was the single most important factor in determining where toxic waste facilities were sited in the United States and that the siting of these facilities in communities of color was the intentional result of local, state, and federal land-use policies. In the 1980s, the Reagan administration's practice of cutting the budgets of federal environmental agencies had aggravated racist decisions. The report demonstrated that 'three out of every five Black and Hispanic Americans lived in communities with uncontrolled toxic waste sites.' Twenty years later, the United Church of Christ published another report confirming that 'people of color make up the majority of those living in host neighborhoods within 3 km of the nation's hazardous waste facilities. Racial and ethnic disparities are prevalent throughout the country.'" Françoise Vergès, "Racial Capitalocene," in *Futures of Black Radicalism*, ed. Gaye Theresa Johnson and Alex Lubin (New York: Verso, 2017), 187-88.

44 1999 National Air Quality and Emissions Trends Report, US Environmental Protection Agency, Office of Air Quality Planning and Standard Research (Triangle Park, NC, March 2001).

45 Underground Resistance, vinyl label (side B), *Piranha* (Underground Resistance, 1993).

dumped into the air from Detroit industrial stacks. This pollution spreads throughout the clouds and is returned to earth in the form of acid rain. Death from above..." The text bemoaned the absurd reality of post-industrial corrosion, musing that, "Rain should give life not take it away. Peace."[46] "When Will We Stop?," they asked.

In his book *Techno Rebels,* journalist Dan Sicko argues that Banks' drive and desire for revolution was inherited from his father and a mentor, T.G. Williams, both veterans of the Vietnam War.[47] Their trauma and experiential wisdom was an inspiration for UR's military theme and apparel. For Hood, Underground Resistance represented the progressive politics needed to overturn the last laws and social perceptions of Jim Crow and Antebellum-era America, but he also described UR as "a throwback to the progressive roots of Detroit techno, the underground parties that the world doesn't necessarily know about from back in the days with DJs like Ken Collier, Al Ester, and Dwayne 'In-the-Mix' Bradley; lesser known DJs to the world."[48] Hood grew up with his grandparents after a near-death experience, due to a hemorrhaging blood clot, at the age of one; he often says that techno and Underground Resistance saved his life after a bout of depression nearly ended it, having never fully recovered from the trauma of the murder of his father, a jazz musician, when he was six years old. His grandmother, whom Hood has described as clairvoyant and an oracle, acted as a guiding force, teaching him humility and patience as he grew up in a world that he felt didn't love him. He told *DJ Mag* in 2019 that joining Underground Resistance was "invaluable," recalling "watching the speed and the accuracy of how [Banks and Mills] worked, and how many hours they put into their studio time."[49] Even back then, as he drew influence from the Black Power movement in the '60s, Hood knew "They were making history, and that was my example. I wanted to be like that." He was faced with trauma yet again after he was shot in the face during an altercation with a former employee at a record store he had been working at in Detroit. He remembered the man drawing and firing a gun during their fight, "I caught some shrapnel in my head. I remember wondering if I was going to make it—I thought I was going to bleed out."[50]

As The Vision (a persona named after the organically manufactured android from Marvel Comics), Hood began to produce his own iteration of techno with gear he bought second-hand from a local pawn shop. His sound became a space to store and

46 Underground Resistance, liner notes, *The Return of Acid Rain - The Storm Continues* (Underground Resistance, 1993).

47 Dan Sicko, *Techno Rebels: The Renegades of Electronic Funk* [1999] (Detroit: Wayne State University Press, 2010), 100.

48 Robert Hood, quoted in Ethan Holben, "The Making of *Minimal Nation*: Robert Hood's Techno Masterpiece," *Red Bull Music Academy Daily*, May 23, 2019, https://daily.redbullmusicacademy.com/2019/05/robert-hood-minimal-nation-track-by-track.

49 Robert Hood, quoted in Rob McCallum, "Robert Hood's Sanctuary in Techno," *DJ Mag*, January 14, 2019, https://djmag.com/longreads/robert-hoods-sanctuary-techno.

50 Ibid.

transmute his experiences into a musical form that was decidedly darker and more mechanical than Banks' hi-tech soul and Mills' romantic, industrial techno compositions. "They were concerned about me as brothers," Hood said to *DJ Mag*. "So, I said, 'I'm going to do this. What else have I got?' I'd been shot in the head. I'd been in a mental hospital. I didn't have anything else. So, it had to work."[51] His first release, *Gyroscopic*, came out in 1991 through Underground Resistance's distribution channels, with four sonic expressions, including "Crush, Kill, Destroy" and "Liberation Radio," which spoke to surviving the urban human condition. In a 2014 conversation with Todd L. Burns, Hood tearfully describes his time with UR in his early twenties, referring to it as "a movement," "a revolution," and "a culture."[52] He talks about meeting Mills for the first time, after hearing him conjure Black magic over the radio as The Wizard: "Watching Jeff edit tape is art. It's like a performance. He does it so fast and so precisely. He's like a surgeon. He's so manic in the way he does things. It's just... right now, flip the tape over, cut it, splice it, tape it, and it's cut precisely. It's just amazing." After weaving through topics like Hood's use of the Roland TR-505 to recreate the feeling of live jazz drummers and the progressive attitudes and politics of Chuck D and Q-Tip, the moderator, Todd L. Burns, played footage of Underground Resistance performing live in 1992: a twenty-something Hood appears as Rob Noise, donning a gas mask and rapping in front of the group. "Maybe not the Underground Resistance part, but do those words still resonate for you?" Burns asks Hood after the clip concludes. Moved by the footage, Hood responds that he had never seen himself perform before. Fighting back tears, he says: "This vehicle, this format of music that we've been blessed to be able to express ourselves through and create beautiful music and to beautify this world is just a blessing. It's a privilege." Admitting that he was unprepared to discuss that part of his story, having moved past it to become a remarkable force in the electronic dance music industry, Hood explains:

> This music to me represents the struggle of Black artists from Detroit who came from nothing. I came from Seven Mile living on the west side of Detroit and having nothing. Again, to be blessed, to be able to share this music with the world and to create and be everything that God has intended me to be creatively is humbling. I see this young 22, 23-year-old kid who's trying to find his way and trying to say something that means something to the world.[53]

Catching on to the opening of Hood's last sentence, Burns asks Hood if he felt Underground Resistance was responsible for his exposure to an international audience, showing a photo of Hood at the New Music Seminar in New York in 1992, with Banks, Mike "Agent X" Clark (who had introduced Hood to UR), and the Baltimore

51 Ibid.

52 Robert Hood, hosted by Todd L. Burns, Red Bull Music Academy, Tokyo, December 4, 2014, https://www.redbullmusicacademy.com/lectures/robert-hood.

53 Ibid.

house music production team The Basement Boys (Jay Steinhour, Teddy Douglas, and Thommy Davis). During that trip—his first time outside of Detroit—Hood met hip hop celebrities like Queen Latifah, LL Cool J, Ice-T, and Easy E. He detailed the ten-hour drive to Detroit as a moment of bonding and education: "We were driving into Detroit and coming off the freeway listening to 'The Whistle Song' by Frankie Knuckles on WJZZ. . . When I heard that, coming into Detroit is like a new day, a new sun is rising. I felt a fresh new energy, like I was born again." At the time, while working with Mills on a collaborative project called H&M, Hood found his musical voice with a track called "Sleepchamber," released on the album *Tranquilizer* (1992). He knew that the sound he was creating to pass off to Mills "had a voice and a sound that was completely all me. It had nothing to do with Underground Resistance. It had maybe some elements of Detroit's essence in there, but this was my voice." He recalled creating "Sleepchamber" while illustrator AbuQadim Haqq was in the studio: "I remember hitting a certain chord from the Juno 2 and saying, 'Hey, this is it. This is so Detroit but I have never heard anything like it, but it's all mine and it's something new, it's something fresh and original.'"[54]

Through the winter of 1993, Hood worked with a modest ensemble of equipment, continuing to hone his new sound. He was living on Detroit's West Side, and had fallen on hard times. Hood borrowed a keyboard and sampler from Blake Baxter, accidentally erasing the bassline from his song "When We Used to Play" in the process. "I didn't have any money," Hood recalled. "The equipment I had was pawn shop equipment that I got for like $100, $125 dollars. I found a blue [Roland] SH-101, a [Roland] Juno 2, and I bought a [Roland TR-909] from one of the guys from Drexciya [Gerald Donald]."[55] Placing this gear alongside a borrowed Yamaha DX100, a miniature Yamaha QY sequencer, and a four-channel mixer, Hood attempted to make the best tracks he could with what he had. "A lot of people may not know this, but Ron had the foresight to add a little reverb here and there where it needed it," Hood recalls of working with mastering engineer Ron Murphy. "That was the genius of Ron Murphy, to suggest he heard something that it needed. I'm forever grateful to Ron Murphy. I have a tear in my eye right now as I think about his wisdom and his insight, and his direction, and the talks that we had. He was a big part of that record."[56] Murphy's studio engineering jettisoned Hood's sparse techno into a dynamic and spatial listening experience. The resulting work was *Internal Empire*, first released on Hood's label M-Plant then re-released on Tresor, both in 1994. Next, Hood started working on music for Mills' label Axis, where he strived to improve on the studio techniques he'd learned from Murphy. Hood wanted to make a complete work of, as he considered calling it, "Axis Authorized Repetition"—a kind of techno that would stretch the possibilities of the vinyl format with few parts rotating in endless, mesmerizing grooves.

54 Ibid.

55 Hood, quoted in Holben, "The Making of *Minimal Nation*."

56 Ibid.

Constructing a sound that has the "jacking drums" of Chicago house while centering Detroit's family tree of progressive dance music styles, Hood wanted to reimagine the man-machine dynamic that dominated the global conception of techno, to put "the humanistic dimension back in techno music."[57] While workshopping the tracks, Hood envisioned buildings, highways—Detroit's infrastructure—as a museum containing nearly two centuries of lives, stories, economic developments, technological innovations, and culture, all frozen in time as the world sped ahead into a prefigured future. "I want this to read like a story, like chapters of a book, and so this chapter, this chapter here," Hood says, "I don't know if it necessarily fits. Let me just sit it on the shelf for a later time."[58] The album was released under the title *Minimal Nation*, as a limited test-pressing of one hundred copies. Hood took a dozen copies to Record Time, a landmark music store where Claude Young, Anthony 'Shake' Shakir and Mike Huckaby worked, to start generating a buzz. "They were like, 'Yeah, let me have that,'" Hood recalled. Inscribed on the vinyl's runout groove are the words, "music for the progressive": *Minimal Nation* "minimized" techno's necessary element while also nudging the genre forward and reintroducing Atkins' original methodology of live recording hi-tech funk and soul using the best available technologies.[59] "People were excited about this record. Immediately I knew there was something special about this record, that it was different," Hood recalls of his breakthrough moment. "My idea behind it was to do something that was a departure from what I was hearing in festivals, as well as clubs and at these rave parties."[60]

When Mills and Hood formulated minimal techno, they were considering methods for making Detroit techno that could translate to other countries and contexts. "It really did turn out to be a very universal type of language, because we could take these same tracks, and play in one city, and take them over to the next, and we would get the same response. It wasn't like that before," Mills and Hood remarked. They tried to make their music simpler, easier to DJ and dance to, while retaining techno's form, meaning, and energy. Mills explains: "if the listener becomes conditioned to expect the same thing over and over again, the listener would tend to feel more confident, and in a certain way take their attention away from what they're listening to and begin to feel the track, and begin to modify themselves to what they're listening to because they know the music is not going to change." He continues: "I used to use the psychological idea

57 Ibid.

58 Ibid.

59 "*Minimal Nation* deserves its status as one of the subgenre's key founding documents. With a title that seemed more like a call to arms than a simple description, the album rendered the familiar thump and squelch of Detroit techno even stranger, subtracting all remaining traces of disco and R&B and imagining rhythm as a kind of chattering conversation between sentient machines. Traces of jazz remain, but only as a kind of false memory, with the clash of fixed-interval chords undercutting conventional key signatures." Philip Sherburne, "Robert Hood, *Minimal Nation*," *Wondering Sound*, July 8, 2009, archived at https://web.archive.org/web/20170510123147/http://www.wonderingsound.com/review/robert-hood-minimal-nation/.

60 Hood, lecture, hosted by Burns.

of Pavlov's dog, which is a form of conditioning, where you give the dog something to eat at a certain time every day, and then take it away, and the response is the same."[61]

In the mid-1990s, Mills moved to Berlin to pursue a career in the quickly emerging European dance music industry, and Hood also stepped down from Underground Resistance, feeling a habitual pull to isolate and return to the existential crises of his past, but also explore the possibility of using techno music and the burgeoning electronic music economy to change his own destiny. Leaving Banks at the head of UR, Hood married Eunice Thompson-Hood in 1996, and turned to the protestant Christianity of the Black Belt region as a sanctuary for his soul and as a moral compass amid the hedonism of European rave culture.[62] Banks set out to reorganize and establish firmer roots in Detroit to make it a home base, opening Submerge, a "walk-in" record shop and label house that would encompass Submerge Recordings, Kevin Saunderson's KMS, Fragile Records, Underground Resistance, and Electrofunk Records. Lawrence Derwin Hall, who performed with Underground Resistance, began to work with Banks through the sub-label Happy Records as a new roster formed around UR and Submerge. "I'm just happy that I've been blessed not to DJ," Banks admitted in conversation with Fisher. This gave him the impetus to stay home, where Hood and Mills saw an opportunity to escape the perils of Detroit: "The thing with UR is by me not DJing, I'm home all the time, so whereas maybe the other guys are always on the road out DJing, I'm there. I hear all of the new crazy freaky stuff."[63]

Cornelius Harris later joined in Mills and Hood's place as a manager, foregoing making art of his own to act as a guidepost for other Detroit musicians already engaged in honing their skills. "I had known Mike Banks earlier, when I was doing music actually. That's how I met him, because I was doing music," Harris explains. "But nothing happened with that and when I was writing, Mike had asked about doing press releases and bios for artists at Submerge. And I eventually said 'yes'. So I was approached—but I was already in it, you know?"[64] Harris grew up around music, with a mother who played at home on her baby grand piano and a father who played the flute recreationally; Harris himself played the trombone and bassoon in high school. As a teen, Harris got the opportunity to take over a record store, becoming a music buyer before eventually dipping into music journalism. He met Banks through music. "When I was at Submerge, I learned a lot about the history of the music that I didn't know as somebody working at a record shop. Because when a lot of the stuff started happening in Europe, people would sign these contracts where the European label

61 Jeff Mills, interview by Derek Walmsley, *The Wire* 300, February 2009.

62 McCallum, "Robert Hood's Sanctuary in Techno."

63 Banks, interview by Fisher.

64 Cornelius Harris, quoted in Thomas Venker, "Cornelius Harris 'I decided that I was gonna not be an artist and instead I was going to try to help push other artists,'" *Kaput Magazin Für Insolvenz & Pop*, October 19, 2020, https://kaput-mag.com/stories_en/talking-to-americans_thomas-venker_jonathan-forsythe_cornelius-harris-i-decided-that-i-was-gonna-not-be-an-artist-and-instead-i-was-going-to-try-to-help-push-other-artists_/.

was in control of what happened with the music," Harris recounts, taking note of the pull of perceived legitimacy that Europe held over DJs—an influence exerted by the emergent clubbing market that had formed out of the "Second Summer of Love," when the United Kingdom and continental Europe exploded to the sounds of imported Chicago house and early Detroit techno in 1986. Harris recounts:

> And I remember, all the DJs were coming to the shop to get these records. And I remember a record came out—I can't remember who's record it was, but it was an important one and of course they were much more expensive, and so, I said: well, give it some time, it will be released domestically. But that never happened. And a lot of DJs got very upset about that: because it was like, well man, we built these guys up, we supported these guys music—and now that they're in Europe, they think they're better than us? They think they don't have to let us have the music and only Europeans can have the music? And so there were a lot of DJs who really had a bad reaction to that. It wasn't until again years later when I was at Submerge, that Mike Banks had explained to me about the fact that these guys were in contracts and they couldn't release their stuff domestically. That the labels were responsible for that. But again, at my level, we didn't know that. And the DJs that I worked with didn't know that. And so, all we knew that was we couldn't get this music that was being made by people who are from here. And we thought this is really wrong, this is really obnoxious. And there was a bit of a backlash here. And again, as I got older and I learned more. I'm like okay, it's not the fault of these producers, these are just bad deals. But we didn't know that. And so it was very educational for me, coming into this and learning about some of the things that we couldn't see.[65]

In 1992, as the European dance music import circuit began to gain traction, *Deep Sea Dweller,* an anonymous 12-inch of refracted and stereophonic drum machine and synth exercises, was released through the Shockwave sub-label that had pressed Underground Resistance's *Acid Rain* and *The Return of Acid Rain* earlier that year. Drexciya's debut release offered a startling evolution of the techno sound into more abstract sonologies evoking a scant view into a mythical world of "Sea Quakes" and depressurized rhythm analytical science.[66] "I heard Drexciya, and I thought it was some of the weirdest space shit I ever heard," Banks told Fisher. "I was proud to be able to introduce the world to Drexciya." The next year, *Drexciya 2 - Bubble Metropolis* dove

65 Ibid.

66 "Each Drexciya EP—from '92's *Deep Sea Dweller*, through *Bubble Metropolis, Molecular Enhancement, Aquatic Invasion, The Unknown Aquazone, The Journey Home* and *Return of Drexciya* to '97's *Uncharted*—militarizes Parliament's 70s and Hendrix's 60s Atlantean aquatopias. Their underwater paradise is hydroterritorialized into a geopolitical subcontinent mapped through cartographic track titles: *Positron Island, Danger Bay, The Red Hills of Lardossa, The Basalt Zone 4.977Z, The Invisible City, Dead's Reef, Vampire Island, Neon Falls, Bubble Metropolis*. The Bermuda Triangle becomes a basstation from which wavejumper commandos and the 'dreaded Drexciya stingray and barracuda battalions' launch their Aquatic Invasion against the AudioVisual Programmers." Eshun, *More Brilliant Than the Sun*, 83.

even deeper into a world crossing over into the surface world timeline, taking listeners through a "Fresh Water" induction, an "Aqua Worm Hole" signaling and manifesting realities, and then "Beyond the Abyss," before flipping the vinyl on its "Salt Water" B-side to transmit cerebral depictions of a submerged civilization that stretches across the depths of the Black Atlantic. Arriving at the "Bubble Metropolis," the voice of X205, the director of Drexciya's aquabahn transport system, greets the listener: "This is Drexciyan Cruiser Control, Bubble One, to Lardossen Cruiser 8-203X, please decrease your speed to 1.788.4 kilobahn, thank you." She instructs: "Lardossen Cruiser 8-203X, please use extra caution as you pass the aqua construction site on the side of the aquabahn. I repeat, proceed with caution."[67] In a 2018 conversation with Tresor's Dimitri Hegemann and Carola Stoiber, Banks told the story of how he came to engage with the aquatic mysteries of the Drexciyans:

> Derrick May called me and said "Hey man, go get your thing man, some guys in my house they crazy as hell." And one of them was saluting every time the record would come on and the other one was playing with Derrick's knives or something crazy. Derrick was real worried about them. It's like, all the guys said, "Oh, you need to be on UR, let me call Mike." 'Cause people come up and audition music and Derrick and Kevin and Juan be like, "Hey man, you need to go over there with Mike." 'Cause I like weird music and stuff. Not that they don't, but if it's especially strange. And I feel like they are a part of urban reality 'cause they had a hell of a fantasy there, 'cause I don't think none of them seen the ocean ever. So I said, "OK, well fellas, let's hear the tracks." And when they played them, everything was on 4-track, and everything was like two minutes or barely over a minute and 30 seconds long sometimes and they needed edits. They didn't really need mixing. They just needed edits so a DJ could use it sometimes, 'cause they weren't aware of fading in on the record or any of that kinda stuff, they just did 'em.[68]

James Stinson, who is credited for having discovered and communicated with the Drexciyans as far back as 1989, became fast friends with Banks, along with his collaborators Gerald Donald, Dennis Richardson—who also produced under the name Ultradyne—and James' younger brother, Tyree Stinson. "I thought the music needed to be out, that's how I felt." Banks stated. "I didn't know what would happen with it. We pressed them up, we sent them out to the distributors and all that, and nobody wanted it. Nobody wanted Drexciya. Nobody."[69] Banks had a plan and decided to stock the record at Submerge. He labeled the Drexciyan strain of techno "electro" "'Cause

67 Drexciya, lyrics, "Bubble Metropolis," *Drexciya 2 - Bubble Metropolis* (Underground Resistance, 1993). See also AbuQadim Haqq, *The Book of Drexciya*, vol. 1 (Berlin: Tresor, 2020).

68 Mike Banks, in conversation with Dimitri Hegemann and Carola Stoiber, hosted by Torsten Schmidt, Red Bull Music Academy, Berlin, November 27, 2018, https://www.redbullmusicacademy.com/lectures/mad-mike-banks-tresor-berlin-detroit-lecture.

69 Ibid.

Detroit love electro." Banks remembers a call he received from Richard D. James of Aphex Twin, who expressed interest in releasing a record from Drexciya through his label Rephlex. James told *Resident Advisor* in 2019 that he "didn't immediately like Drexciya coz I was passionate about Kraftwerk and mistakenly wrote it off as a rip off but didn't take long to work out they were just as passionate about it as me and it was fucking excellent and I was wrong. They were just showing their passion directly but bringing a lot more to the table. I mean it's pretty impossible not to be influenced by Kraftwerk, just so profoundly good, I think all their classics just sound better and better… so intense in a completely different way, utter unique genius."[70] Through Banks, Drexciya licensed new factions of alpha and beta particle accelerated sonic experiments to Rephlex, which were published as *Drexciya 3 - Molecular Enhancement.*[71] "I thought OK man, you want to license it or do something. And James had a lot of kids, he's got a lot of kids. I can't walk in his shoes; he needed some cheese and the Rephlex people was very, very nice and I know they cared about it, the music. So I kinda gave the go ahead, do your thing, and he released the album with Rephlex," Banks recalled. "And all of a sudden, all them records I had just started selling. Gimme 2,000, gimme 3,000, I couldn't figure out what was going on. And I guess it was the fact that it was on Rephlex."[72] Banks intuited that Stinson had the potential to be an international artist, that "he would be a good representative of Black folks."[73] He also licensed tracks from Stinson and Gerald Donald to Hardwax, which surfaced in the album *Balance of Terror*, by L. A. M., or Life After Mutation—a collection of psychoacoustic techno purging the "Radius of Infliction" of consumer technology, the "Toxic TV" of the late '80s and early '90s, and the "Nuclear Facelift" that the Western world endured following the Second World War.

In a collective full-frontal assault, Banks, Mills, Hood, Claude Young, and L. A. M. assembled two compilations in 1992, *Global Techno Power* and *Global Techno Power 02:2000AD*. Continuing the themes and tactical measures of the World Power Alliance, *Global Techno Power*, along with an accompanying zine put together by Hood, targeted what geopolitical consultant and former Secretary of State Henry Kissinger outlined as "the roots of international harmony and global disorder" in his 2014 book *World Order.*[74] Having served as the National Security Advisor under the Nixon and Ford administrations, Kissinger analyzed the twentieth-century formations

70 Richard D. James, interview by Oli Warwick, "Aphex Twins on the Rephlex Years," *Resident Advisor*, August 20, 2019, https://ra.co/features/3509.

71 "With the *Molecular Enhancement* EP, the ocean floor becomes the 5th front in The Forever War. Drexciyan technology solidifies the ocean into hydrocubes. These blocs of solid water are part of the electrofictional arsenal of Antivapor Waves, Aquatic Bata Particles and Intensified Magnetrons. The magnetron is the heart of the radiowave transmitter, used to power airborne microwave radar sets during WW2." Eshun, *More Brilliant Than the Sun*, 84–85.

72 Banks, in conversation with Hegemann and Stoiber.

73 Ibid.

74 Henry Kissinger, *World Order: Reflections on the Character of Nations and the Course of History* (London: Penguin, 2004).

of postwar, technologically advanced civilizations, interlocked in military conflict and financial exchange. He determined that there was a larger question of legitimacy and power to address within the "pluralistic international order" and "balance of power" of Europe, the presumed disorder and decline of the Middle East, and the unknowable "multiplicity of Asia." The United States, he opined, could militarily and economically perform on the global stage as the world's conscience on behalf of all mankind, despite its egregious foundational crimes against humanity and nature that gurgled the United States into existence out of the preceding lush melodious landscape and native population that lived in and loved the American continent. In a section of the book titled "World Order in Our Time?" Kissinger argues that:

> The multigenerational enterprise of the world ordering has in many ways come to fruition. Its success finds expression in the plethora of independent sovereign states governing most of the world's territory. The spread of democracy and participatory governance has become a shared aspiration, if not a universal reality; global communications and financial networks operate in real time, making possible a scale of human interactions beyond the imagination of previous generations; common efforts on environmental problems, or at least an impetus to undertake them, exists; and an international scientific, medical and philanthropic community focuses its attention on diseases and health scourges once assumed to be the intractable ravage of fate.[75]

Surveying various US military-backed ethno-nation states across the modern gameboard of global power, and chronicling how these world powers maintained balance amid shifting definitions of order and power, Kissinger—a 1973 Nobel Peace Prize winner and recipient of numerous other "freedom" and "peace" awards on behalf of all mankind—asks the reader whether it is possible to translate differing cultures into a common, neutral system such as "democracy" and "freedom" without broaching the larger question of the Western world's addiction to economic accumulation and catastrophically scaled warfare. He questions "the meaning of history," but determines that history will judge humanity based on how it meets the aforementioned challenges of wrestling nature into submission for human use and peace of mind. Kissinger's notion of world order put forward a model of violence, cruelty, and sedition that UR— as representatives of and militants for the former Black citizens of America, and in stereomodernist solidarity with the African Diaspora and other oppressed peoples of the slowly, though persistently forming, New World Order—took it upon themselves to expose and destroy.

Expanding on his concept of sonic fiction as a "subjectivity engine," Eshun suggests that Underground Resistance's songs and albums are not simply music in the generic, commercial sense, but an overlapping expression of concepts fed as aural sensation.

75 Ibid., 362.

He writes: "The front sleeve, the back sleeve, the gatefold, the inside of the gatefold, the record sleeve itself, the label, the cd cover, Sleevenotes, the cd itself; all these are surfaces for concepts, texture-platforms for PhonoFictions."[76] The military campaign being waged by Underground Resistance takes place in an alternate dimension, just beyond the material world contrived by enlightenment principles of "pure reason."[77] Within the dimension of this writing, quotations will be used to articulate and accentuate the literal actions implied by the titles, liner notes, track titles, and lyrics, as well as text inscribed on the vinyl itself. Banks saw an opportunity to open up the man-machine narrative and function of techno and position it against the manifold geopolitical targets and orders, returning to his concept of hi-tech jazz.[78] In a linear, though ever-expanding arsenal that Banks had forged in 1991 and '92 with the *Nation 2 Nation* and *World 2 World* releases, he formed the live electronic jazz band, Galaxy 2 Galaxy. This band can be seen as a revision of the Kraftwerkian understanding of cybernetic ensembles into structures that were already innovated in Detroit in the pre-techno music scenes of Black Bottom and Paradise Valley: it upturned Joe Von Battle's blues with a mechanized approach to the jazz and bebop configurations cultivated at The Blue Bird music venue by musicians like Miles Davis, John and Alice Coltrane, Horace Silver, Charlie Parker, and Elvin Jones. Conceived and produced by Banks, Galaxy 2 Galaxy's eponymous release broadens his scope of techno and hi-tech jazz into a self-contained world; it is broken into four distinct parts across two vinyls, each side labelled according to the mood and sonic fiction Banks was hoping to project. "I found it, there is existence other than us, I have transformed," Banks inscribed onto the vinyl. "The tones are the keys to it all! I'll be back."[79] Within each phase, a movement of sounds and concepts interact like self-contained, engineered micro-worlds: Side A was "The Dream," side B "The Journey," side C "The Search," and side D was "The Last Transmission." Banks' hi-tech jazz is presented across two

76 Eshun, *More Brilliant Than the Sun*, 121.

77 "What I call applied logic (contrary to common usage according to which it contains certain exercises on the rules of pure logic) is a representation of the understanding and of the rules according to which it is necessarily applied in concreto, i.e. under the accidental conditions of the subject, which may hinder or help its application, and are all given empirically only. It treats of attention, its impediments and their consequences, the sources of error, the states of doubt, hesitation, and conviction, etc., and general and pure logic stands to it in the same relation as pure ethics, which treat only of the necessary moral laws of a free will, to applied ethics, which consider these laws as under the influence of sentiments, inclinations, and passions to which all human beings are more or less subject. This can never constitute a true and demonstrated science, because, like applied logic, it depends on empirical and psychological principles." Immanuel Kant, *Critique of Pure Reason, Second Part* [1781], trans. F. Max Müller (London: Macmillan and Co., 1881), 48.

78 "Hi-Tech Jazz from '93's *Galaxy 2 Galaxy* EP is fusion made synthetic. The 2 parts—the first subtitled *The Science*, the second *The Elements*—suggest that the music is the product of an elementary science. Tapping into atomic processes imbues jazz with a colossal energy. Synthesized bass and kicks charge at you with an inexorable horsepower, the oncoming impact of Galactus crossing constellations. Vaulting astral keyboards wrap you in the arms of Andromeda, sponging you in sussuration, cradling you in a squeezebox seesaw which lulls and pushes into a buoyant fearlessness. With stars for handholds, you climb the skies in a 9 min 35 sec war with yourself. 'Techno to me is the one music that is truly a global music. It might not only be a global music. I think it's a galactic music.'" Eshun, *More Brilliant Than the Sun*, 127.

79 Galaxy 2 Galaxy, label text, *Galaxy 2 Galaxy* (Underground Resistance, 1993).

mixes, one exploring "the elements" and the other "the science," using the distributive format of dance music releases in which singles have multiple mixes vamping on a single jazz standard to more effectively offer a clear example of what hi-tech jazz is and how it could possibly be made. In 1992, *Meet the Red Planet* surfaced on an Underground Resistance sub-label, itself called Red Planet,[80] alongside Banks' Galaxy 2 Galaxy releases; it was credited to "A Martian from Detroit." The album's "Lost Transmission from Earth" track crossed frequencies with Banks' own technological soul experiments, evoking words from the Black Panther Party leader and political activist Eldridge Cleaver: "The spirit of the people is greater than man's technology."[81] On the vinyl's label, a text reads: "The Red Planet will appear only when your mind is open."[82]

Galaxy 2 Galaxy set Banks off on an interstellar adventure chronicling a "Journey of the Dragons" in a track dedicated to "the memory of Chris Hani, Bruce Lee, Brandon Lee & Yoshihiro Hattori" with "additional programming from Juan Atkins," while "Star Sailing" pieced together a Mars-dwelling "Astral Apache" in the likeness of the Native American spiritual leader Geronimo—a prisoner of the Apache-United States wars who offered "Star Stories" as an aid to guide Underground Resistance. "Deep Space 9 (A Brother Runs This Ship)" subtly tells the story of Banks's encounter and collaboration with The Martian while docked at the Deep Space 9, a space station in the *Star Trek: Deep Space Nine* television series, helmed by Commanding Officer Benjamin Sisko—the first Black person to be a lead character in Star Trek. Sisko appears as a democratic mediator between the Bajor race and the imperialistic Cardassians, against whom the Bajor are leading a liberatory guerrilla war. With "The Last Transmission," Banks learns of the "Rhythms of Infinity," beginning with a "Metamorphosis" and "The Creation of I.S.F. Unit ZC-121861"—which marks the date of the beginning of the American Civil War (April 12, 1861 at the Battle of Fort Sumter, recorded on the star date of May 30, 1993). Back on earth, James Pennington, a producer from the first wave of Detroit techno, flanked the Underground Resistance with a three-track EP of brutal biometric grooves under his Suburban Knight moniker.

80 "The Red Planet series assembles a Martian mythology of Astral ⟨⟩ Indian tech-magicians: *Renegades on the Red Planet, Astral Apache, Stardancer, Ghostdancer, Starchild, Windwalker, Skypainter, Firekeeper*. On *Stardancer* from *Red Planet 2*, guitar and synths are processed into an unplaceable iridescence. Synthetic bass drops like a concrete basketball, dragging your feet like traction. Attack velocities fire like catherine wheels in a duet with hihat clap. Chiming trails slowly circle, liquefied comets which stream through you until you're bursting with ascension. Synths surge in marine bass and simultaneously shoot stars across the sky, erupting in exultation. The Martian synthesizes a cosmic disco that colonizes Mars in advance of the landing, 'so that if we come into contact with intelligent lifeforms from another planet we can talk on the same level.' Across each 12, Native Martian shamans escape Earth ⟨⟩ American genocide, dragging you with them as they species-jump to Mars." Eshun, *More Brilliant Than the Sun*, 128.

81 Credited to Eldridge Cleaver by The Martian in "Lost Transmission from Earth," *Meet the Red Planet* (Red Planet, 1992). See also Huey P. Newton, quoted in "Committee Exhibit No. 4: Quotations by the Black Panther Party," in *Hearings Before the Committee on Internal Security House of Representatives: Ninety-First Congress, Second Session*, Part 2 (Washington, DC: U.S. Government Printing Office, 1970), 4394.

82 Galaxy 2 Galaxy, label text, *Galaxy 2 Galaxy*.

Playing on the low-resonance fears of suburban white middle-class families that had fled Detroit a decade prior, the Suburban Knight interpolated the pulp aesthetic of Batman and Detective Comics to wage psychological and diagnostic terror through his release, *Nocturbulous Behavior* (1993).

*

"After relentless sonic assaults launched on the Programmers by UR ranging from the aquatic raids of Drexciya to the international land-based strikes by UR itself and the daring nocturnal stealth attacks of the infamous Suburban Knight,"[83] Underground Resistance presented new inductees, Scan 7, a collective of masked electronic musicians led by Lou Robinson as Trackmasta Lou, with production assistance from Anthony Horton and Marc King under the name The Elohim—the Biblical Hebrew term for god or deities. "Scan 7" derives from the act of verifying authenticity using the number seven—which is both the sum of the letters in the word Detroit and the city's area code, 313. Operating as a tactical coalition, Scan 7 specialized in audio viruses and information overload in a coordinated mission to "decimate Corporate Music Systems through virus warfare, putting UR in control of 'the Programmers' system."[84] The *Black Moon Rising* EP was the group's first psychoacoustic transmission of manufactured funk and gospel-infused earworms, which came with a warning etched by Banks on the vinyl runout groove: "Warning to All Major Record Companies. Your Systems Are Infected. Infection Date 12.1.93.," reads Side A. "We Are in Your System." "You have been warned. Kirk Out. – Mad Mike."[85]

More transmissions from The Martian flickered into Detroit throughout 1993, beginning with the 12-inch vinyl *Cosmic Movement / Star Dancer*, which bears the message: "The red planet will appear only when your mind is open."[86] Eddie Fowlkes communicated with The Martian on his EP *Sex in Zero Gravity* (as Your Favorite Martian), which included "Ultraviolet Images" of the planet and its surface temperature of "808°." On *Journey to the Martian Polar Cap* (1993), Atkins as Model 500 received instructions to "Search Your Feelings" and "Visual Contact" with Mars' "Red Atmospheres." In an allegorical text titled "Particle Shower," part of AbuQadim Haqq's *Technanomicron*—his art book detailing the expanded universe surrounding Atkins' machine mythology, Metroplex, and the Black Atlantic mythscience of Drexciya—The Martian is portrayed as a spiritual essence of the planet.[87] The text tells the story of a Native American meteorologist who encounters The Martian while on a colonial expedition on the red planet with an international team of scientists and

83 Scan 7, additional press notes, *Black Moon Rising* (Underground Resistance, 1993).

84 Ibid., liner notes.

85 Ibid., matrix/runout sides A and B.

86 The Martian, matrix/runout side A, *Cosmic Movement / Star Dancer* (Red Planet, 1993).

87 AbuQadim Haqq, "Particle Shower," in *The Technanomicron* (n.p.: Third Earth, 2008), 24–25.

engineers, sometime in the not-so-distant future. "Once outside of the Biodome, the Colonist felt a presence among the receding swirls of red dust," Haqq writes. The Colonist began to feel like he was being watched as he carried out his study of the surface atmosphere and weather patterns that aroused subconscious memories of his youth on the reservation:

He became obsessed with the particle showers. He thought of the presence he felt when he was beyond the Biodome studying the weather. He thought of what the Native Elders tried to convey to him when he left for the Academy. And then during his sleep cycle a moment of clarity came to him. An epiphany enlightened him to what the Elders were trying to tell him all those years ago. He left his bunk and donned his pressure suit. He knew what he had to do now.

The Colonist opened the airlock to the Biodome. A dust storm was just dissipating. Once outside he walked in the direction of the receding dust storm. Calmly he began to remove his pressure suit, he would not need it where he was going. There in the distance, in the center of the storm stood a tall thin figure. It beckoned him to join him...[88]

Recorded on November 1, 1994, at Black Planet Studios in Detroit, Underground Resistance's *Dark Energy* was the first operation "in a series of sonic strikes engineered by UR to be carried out during the winter equinox of star year 1994–1995, against Programmer strongholds." A briefing from The Unknown Writer (Cornelius Harris) explains the mission as "a primary strike that will consist of a series of 6 dark energy waves."[89] James Pennington (Suburban Knight) contributed three tracks. In his *Technanomicron*, Haqq claims that Pennington's "Dark Vision" of vibrational energy . . . empowered and inspired him. He created armor from dark matter and powered it with his newly discovered energy source and thus became the first knight of Techno."[90] Consumed by this *Dark Energy*, Suburban Knight conjured dark vibrational frequencies that engineer an ultraviolet "Midnite Sunshine," allowing the Underground Resistance to "pinpoint Programmer positions for the now mobile UR divisions moving out of Detroit for the upcoming assault worldwide."[91]

With *Dark Energy*'s vibrational sensory manipulation module in place, a cloaked resistance movement could continue to mobilize through immersive electronic warfare. The album's blood-red inner vinyl label displays an image of the African continent by visualist Franke C. Fultz and Haqq's illustration of a warrior exclaiming "Escape the chains on your music!" Pennington was summoning "Mau Mau (The Spirit)," a

88 Ibid., 25.
89 Underground Resistance, liner notes, *Dark Energy* (Underground Resistance, 1994).
90 Haqq, *The Technanomicron*, 10–11.
91 Underground Resistance, liner notes, *Dark Energy*.

reference to the ruthless 1952 Kenyan rebel guerrilla movement against British colonizers.[92] The militant Mau Mau were a group of Kamba and Maasai peoples, known for their use of extreme brutality while overthrowing their colonial overlords. The sonic fiction in *Dark Energy* reflected the Mau Mau's rejection of both colonial and tribal moral structures, and their complete abandonment of spiritual or secular hope for any past, present, or future; they shuttled towards a full-frontal ballistic assault. Suburban Knight's "Mind of a Panther" maintains dark vibrational technology, while Banks prepares for his leap into the cosmos through a "Stargate" transporter (a reference to the military science-fiction film and media franchise of that name). Tonal communication with The Martian occurs in UR's "Acid Africa (Roots Electric Mix)," with undulating, flanged 808 kick and hi-hat patterns nestled under lean acid licks, dispatched as an interstellar morse code. Finally, a ritual of multi-dimensional spiritual healing is facilitated by the "Atomic Witchdokta," which Eshun has described as "Islamatomic"—meaning that it takes in traditions and metaphysics from the Detroit-founded Nation of Islam and the teachings of Elijah Mohammad through a combinatory "pyramid with an atomic power symbol at its glowing apex and an Islamic crescent to its left."[93] The *Dark Energy* transmission concludes accordingly: "To our brothers and sisters of the Underground - stay low, stay strong, stay Underground. -Out- The Unknown Writer."

Also in 1994, Banks departed in his starship "Cyberwolf," chronicling his next mission in the Underground Resistance album *Acid Rain III - Meteor Shower*. Questions at the center of the album include: "can 303's heal? Do light and soundwaves have emotions? Is there life on Jupiter? What made the Universe?"[94] Instructed to "Shadow the Probe" over the Martian arctic into a "Particle Shower," Banks leaves the planet's orbit, entering its asteroid belt and confronting enemy airspace. A "Code Red" is triggered while en route to asteroid 909, before total "Communications Silence" sets in. Banks is cautious as he cruises into "The Mighty Asteroids of Jupiter" through "Meteor Showers," detecting that the "weather condition in the void is -200c°" with "Meteor showers expected."[95] With shields raised and rear sensors switched on, the hunt continues, as Banks lands on asteroid 909 and begins to analyze the planetoid's "liquid nitrogen based ecosystem, which have for eons been a stronghold for the

92 "The uprising is now regarded in Kenya as one of the most significant steps towards a Kenya free from British rule. The Mau Mau fighters were mainly drawn from Kenya's major ethnic grouping, the Kikuyu. More than a million strong, by the start of the 1950s the Kikuyu had been increasingly economically marginalised as years of white settler expansion ate away at their land holdings. Since 1945, nationalists like Jomo Kenyatta of the Kenya African Union (KAU) had been pressing the British government in vain for political rights and land reforms, with valuable holdings in the cooler Highlands to be redistributed to African owners. But radical activists within the KAU set up a splinter group and organised a more militant kind of nationalism." "Mau Mau uprising: Bloody History of Kenya Conflict," *BBC*, April 7, 2011, https://www.bbc.com/news/uk-12997138.

93 Eshun, *More Brilliant than the Sun*, 121.

94 UR, etchings on vinyl runout, sides A–D, *Acid Rain III - Meteor Shower* (Underground Resistance, 1994).

95 Ibid.

Drexciyan forces, due to their being the only lifeforms capable of withstanding 909's violent, harsh weather conditions." In his captain's log record written across the vinyl, Bank continues:

> The resistance teams, with their old allies Drexciya to join forces and launch "the Cyberwolf" against the Programmers. This hunter, killer designed by "Generator" has had great success for the UR forces in their raids against the Programmers in the void. Cyberwolf will aid UR's crossing of the asteroid belt by seeking out and destroying enemy probes launched from Jupiter. Launched 03.22.94[96]

Through *The Long Winters of Mars* (1994), The Martian, Astral Apache, and Drexciyan warriors—renegades on the Red Planet—forged a novel aquatic assault program that began with a "Wardance," ahead of Banks' arrival to "Base Station 303," bringing the "Season of Solar Wind" with him. At "Base Station 303," Astral Apache, Banks, and the Drexciyan warriors strategize from The Martian's account of the "Skypainter" and mythscience manifold phenomena of a "Spontaneous Lifeform." Dated 2030GR, The Martian's ledger reads:

> sound is life
> not all intelligence
> can be touched…[97]

En route to the Andromeda Galaxy in search of new life, as recorded in *Acid Rain III – Meteor Shower*, the "Cyberwolf," Banks' spaceship, encounters the "Off-Axis Gravitational Fields," maneuvering and initiating warp speed. Banks' captain's log in that album concludes with notes on his second tour into "The Final Frontier":

> In search of infinity as the resistance's ship passes Jupiter and heads towards deep space. Thoughts of their age old battles with the Programmers, kindles new plans of attack. New recruits from lands far away, with similar ideologies to rid all lifeforms of the programmer's grip on our most sacred form of communication, music. Because without the tones we are nothing and will never unite to beat the Programmers, who still have chains on people who think they are free. We will be back—the fight continues![98]

<center>*</center>

96 Ibid., liner notes.
97 The Martian, liner notes, *The Long Winters of Mars* (Red Planet, 1994).
98 UR, vinyl label, side D, *Acid Rain III - Meteor Shower*.

Banks appeared on the cover of the July 1994 edition of the British fanzine, *Jockey Slut*, photographed by Peter Walsh "trainspotting,"[99] in a motocross helmet with a Los Angeles Dodgers baseball cap, as the "leader of Detroit's techno terrorists Underground Resistance."[100] The exclusive interview was conducted with the magazine's co-founder, Paul Benney, who wrote that Banks "rarely does interviews and 'isn't keen' on having his photo taken to say the least. However, seeing as the *Slut* is based in Manchester (which is 'fucked up like Detroit'), and hasn't yet sold its soul to The Man (i.e. IPC), Mike agreed to talk to us." Benney starts the interview by asking about the inspiration behind Banks' music, to which he responds: "I'd have to say my mother." He talks about her playing guitar in college, describing her as a free spirit who participated in the freedom marches led in Detroit by Martin Luther King, Jr. "She really liked that Joan Baez peace, love and harmony music," he says. "I would always hear her play guitar, I can't say I was interested in it. She liked music from India like Ravi Shankar and she also liked a lot of soul and gospel music. Her tastes were pretty varied so we heard a lot of different stuff around the house." He also points to The Electrifying Mojo's pre-techno sonic fictions as an inspiration. "He plays anything he feels like playing and the whole city is always with him man, he's a cat. Mojo would play anything from James Brown and Jimi Hendrix to Alexander Robotnik and Tangerine Dream. We heard Kraftwerk. We heard YMO and all this right in the middle of the inner city, he's been doing it for years." Banks adds, "They kick him off the radio every couple of years, but he's a true rebel, he's like a leader to me." During the 1990s, radio became a popular format for music consumption, with airspace becoming increasingly crowded and competitive. Banks reminisces about Mill's radio show at WDET, where he'd play alternative and independent music, blending industrial with New York hip hop, Chicago house, and Detroit techno. "So at the same time we had Mojo and Jeff Mills on the radio and some heavyweight music getting played," he remembers. "The state of affairs now is we got a little radio show that we're trying to sponsor to educate the kids, but it's gonna' cost a lot of money so we'll have to wait and see."[101]

Banks paints a scene of Detroit as a resilient blue-collar community that produces many athletes and musicians: "I think that's why a lot of our techno musicians and DJs, mix engineers and the guys who master the records—they can do that and that's all they do. There ain't nothing else. No vacations, holidays, or shit like that, that shit don't happen. Only holiday I ever went on is when we had a gig or when I went to jail." Briefly shedding light on his experiences in urban gang culture, Banks explains that he was framed for a shooting. "Did you do it?" Benney probes. "Nahhh. They just picked me at random. Y' know, you get in trouble a lot, but it's fortunate for me that I'm (goes

99 Trainspotting is a hobby in which enthusiasts "spot" and analyze stock and exchange distributed by and across the railway system.

100 Mike Banks, interview by Paul Benney, "Mad Mike / Underground Resistance," *Jockey Slut* (July 1994): 38.

101 Ibid.

into Yogi Bear style voice) smarter than the average bear." Benney moves on, "Do you think the LA riots changed anything?" Banks is skeptical: "I just think the government is just going to think of more pacifiers to give poor people to pacify them. More welfare programs—it'll be a temporary fix. In order for somebody to be rich somebody's gotta be poor." Concerned about the collapse of infrastructure in the Black community in the thirty years following the Civil Rights Movement, Banks admits to having "a dismal outlook on the way our country is run. I'd say eighty percent of the bums here are Vietnam veterans. You need to ask them what they think about America. I wish it could get better, but I'll believe it when I see it."[102] Benney pivots the conversation towards the increasing influence of hip hop[103] on Black popular culture,[104] referencing Ice T as the "most dangerous and subversive Black American." Banks replies, "I'm very glad that Ice T is socially aware with his actions and words now. A lot of people give a lot of the rap artists a lot of credit for being independent, but we've been doing that shit for years. We do our work quietly and efficiently and I'm glad Ice T is socially responsible, because his early records—I didn't particularly care for them."[105] Banks considers his work with Underground Resistance to be a form of counter protest, "I can't speak for anybody else's, but [my techno] is designed to be subversive and mind awakening. There are definite messages there through tonal communication and you can't assess it—that's why techno is deadlier than rap." He explains:

With rap you have to vocally communicate your point, but with techno you don't. I'm a big fan of Public Enemy—to me "Prophets of Rage" and "Bum Hollywood Bum" wore all warning signs of what was going to happen. And the *Riot* EP was too. *Riot* is a warning sign of what can happen when people try to dominate other people. The more you oppress someone the harder you make them—it's just like making a diamond. When they put the shit on the Vietnamese and they tried to force them into cheap labour and all that shit they became so hard that they couldn't beat'em. They couldn't beat the motherfuckers 'cause they're so hard. They go to any lengths to win. That's what the governments are going to create

102 Ibid.

103 "In the area of rap music media, which supports the efforts of radio and the record companies, *Source Magazine*, headed by David Mays, with 449,000 subscribers per month, easily outpaces its main competitor, *XXL* magazine, which is published by Harris Publications, like *Stress* or *Murder Dog*, are no match for these corporate-backed publications. MTV and Black Entertainment Television (B.E.T.), national cable television stations, remain the chief broadcast outlets for rap videos." Yvonne Bynoe, "Money, Power, and Respect: A Critique of the Business of Rap Music," in *R&B, Rhythm & Business*, 202–3.

104 "However deformed, incorporated, and inauthentic are the forms in which Black people and Black communities and traditions appear and are represented in popular culture, we continue to see, in the figures and the repertoires on which popular culture draws, the experiences that stand behind them. In its expressivity, its musicality, its orality, in its rich, deep, and varied attention to speech, in its inflections toward the vernacular and the local, in its rich production of counternarratives, and above all, in its metaphorical use of the musical vocabulary, Black popular culture has enabled the surfacing, inside the mixed and contradictory modes even of some mainstream popular culture, of elements of a discourse that is different—other forms of life, other traditions of representation." Stuart Hall, "What Is This 'Black' in Black Popular Culture?" in *Black Popular Culture*, 26–27.

105 Banks, interview by Benney, 39.

out of the poor, the mismanaged and all that other part of society that they don't like to deal with—they'll create hardcore killers. I see it every day in the street 'cos people out here don't give a fuck about nothing. You can't control them.[106]

Banks shares with Benney his observations of the superstructural-level control systems that had emerged in the United States since the dawn of the Information Age that had initially fascinated a young Atkins. "The message I'm trying to give people around the world is very simple," he offers, "the way the programmers control the masses through audio and visual imagery. They play to you the kind of music that they want to hear, they show to you films that they want you to see and you act accordingly." Harkening back to Alvin Toffler's prediction of an economy formed out of "a warehouse of images," captured, controlled, and distributed by mass media and culture industries, Banks suggests that the Programmers, referenced in many of the Underground Resistance releases, create the possibility of a private world of individuals living inside their own minds, led by the technical experts that orchestrate and optimize society and every-day life.[107] Benney asks if Banks voted in the presidential election in 1993. "Yeah I voted for Minister Farrakhan[108]—he wasn't on the ballot though," Banks reveals.[109] He doesn't believe that a young centrist-minded, fiscally-interested Democrat such as Bill Clinton can control the country, "I think the military controls everything." Benney digs deeper, "Is America a democratic country?" Banks replies, "No. Like I said I think the military runs everything. Military objectives rule the world. There is no such thing as democracy." Banks explains his fascination with outer space in his release as stemming from "wanting to escape from here." Benney makes a joke about the Clinton administration's budget cuts at the National Aeronautics and Space Administration (NASA) in 1995[110]; though the next year, President Clinton broadcast

106 Ibid.

107 "An information bomb is exploding in our midst, showering us with a shrapnel of images and drastically changing the way each of us perceives and acts upon our private world. In shifting from a Second Wave to a Third Wave info-sphere, we are transforming our own psyches. Each of us creates in his skull a mind-model of reality—a warehouse of images. Some of these are visual, others auditory, even tactile. . . . It is difficult to make sense of this swirling phantasmagoria, to understand exactly how the image-manufacturing process is changing. For the Third Wave does more than simply accelerate our information flows; it transforms the deep structure of information on which our daily actions depend." Alvin Toffler, *The Third Wave* (New York: Bantam Books, 1980), 172–74.

108 Louis Farrakhan is the National Representative of the Nation of Islam, appointed by the religious group's founder and former leader, Elijah Muhammad.

109 Banks, interview by Benney, 39.

110 "Today, NASA, along with the Interior Department, the Federal Emergency Management Agency and the Small Business Administration, will take their turn as reinvention exhibits for President Clinton and Vice President Gore. The administration's phase two reinvention effort, which is aimed at keeping the president a step ahead of budget-cutting Republicans, urges federal agencies to look for ways to eliminate and consolidate programs, shift them to the states or private sector and cut back on personnel. Last December, five other agencies promised to reduce spending and create savings of about $20 billion. Space agency officials are scrambling to find jobs to eliminate and more efficient ways of operating as they try to achieve $5 billion in cuts called for in Clinton's five-year budget plan. If reductions that began in 1991 are counted and expected inflation is factored in, NASA's budget will be about 37 percent lower by the end of the century." Kathy Sawyer and Stephen Barr, "NASA Cuts Would Cost

288

this brief televised statement on the subject of the discovery of a meteorite from Mars:

> This is the product of years of exploration and months of intensive study by some of the world's most distinguished scientists. Like all discoveries, this one will and should continue to be reviewed, examined and scrutinized. It must be confirmed by other scientists. But clearly, the fact that something of this magnitude is being explored is another vindication of America's space program and our continuing support for it, even in these tough financial times. I am determined that the American space program will put its full intellectual power and technological prowess behind the search for further evidence of life on Mars.[111]

Banks believes that humans are still too primitive to communicate with alien life forms. "Before that can happen we would have to reach a point of evolution where materialistic things like gold don't mean anything. Right now we're not at that point. We can't imagine it. Until we reach a point where our respect for our fellow man outweighs the dollar we're fucked."[112] He discusses the ethos of Underground Resistance as a way to deprogram an accelerative consumerist society. "It's important for me for Underground Resistance to stay underground because I think it provides inspiration for others around the world to start organisations and not be controlled by the programmers," he says. "I can hear in the music over the last three years that our music is influencing people all over the world . . . For Underground Resistance to go commercial would be like me disrespecting all the people that have supported us over the years."[113]

Banks is optimistic about the development of music from what he's heard throughout his tours and casual listening, but warns that musicians should be mindful of the business aspect of the industry. "For me, I do street business—if you come up here and try and take my record company and control my shit you ain't gonna do it," Banks asserts. "It ain't gonna happen, you gonna get the fuck outta my place or you get hurt. That's what happens." Benney asks Banks if he could ever be bought out. "It's impossible man—I'm an American Indian. I'm an American Indian and Black and I've got warriors from both sides and nobody buys me. Nobody buys me—people would be disrespecting my forefathers if they bought me." Surprised, Benney asks, "You're part American Indian then?" "A lot of Black people are here—it's something that's not talked about a lot," replies Banks, referencing the rebellious Seminole

55,000 Jobs," *Washington Post*, March 27, 1995, https://www.washingtonpost.com/archive/politics/1995/03/27/nasa-cuts-would-cost-55000-jobs/b7c7518e-92ee-41cf-8cd2-648429c4daa7/.

111 Bill Clinton, "President Clinton Statement Regarding Mars Meteorite Discovery," nasa.gov, 1996, https://www2.jpl.nasa.gov/snc/clinton.html. See also Neel V. Patel, "Remember When Bill Clinton Legitimized the Search for Life in Space?" *Inverse*, August 11, 2016, https://www.inverse.com/article/19572-bill-clinton-alien-mars-meteor-extraterrestrial-life.

112 Banks, interview by Benney, 39.

113 Ibid., 41.

Nation that once harbored escaped slaves in a community that stretched across what is now Alabama, Georgia, South Carolina, and Florida, as a resistance movement against European colonizers.[114] "A lot of Black Americans from the south are interbred with American Indians. It's just not being discovered but it's heavy in my family." Elsewhere in the interview, Banks declares:

> I'm a Black American and I'm trying to make these techno records and uphold Detroit's reputation and there's a lot of pressure. I try my best and sometimes I don't always make the best record I wanna make but it's very difficult competing with people much better armed than me, with bigger promotion teams. Bigger computers, and all that. But the Vietnamese were outnumbered and outgunned and they won. And that Geronimo. He was outmanned and outgunned and they never kicked his arse. Those are like my spiritual leaders. I respect Geronimo and I like Bruce Lee—them motherfuckers that were underdogs. That's why I'm in the underground man. I know that I'll never be famous, and on the cover of Billboard. You know what I'm saying, I'm not gonna win no Grammy. I know that this will never happen for me and I've accepted it. To me it's just as much of an honour to be underground as to be a successful commercial artist. I don't want people to think that I'm against all commercial music—I think there are some very gifted commercial artists. It's just the garbage that record companies will feed people to satisfy their monetary situation. Just being a commercial artist doesn't mean you're a sell out it's just when you allow the company to use you to do something that you normally wouldn't do and they make you into something you're not.[115]

Techno, for Banks, is a global if not galactic music, citing his hi-tech jazz progression from "World to World, Galaxy to Galaxy, Universe to Universe." He feels that music is his purpose for living, and shares his intentions to use the vibrational and sonic fictional technology "to prepare my brothers and sisters so that if we come into contact with intelligent lifeforms from another planet we can talk on the same level."[116] He concludes, "What you and me are doing is a mission. You are trying to inform the readers and I'm trying to inform the listeners and that's what brought you and me here on the phone. We don't think of art as that, but I might not ever speak to you again and we did a mission together and it was planned long ago. That's what's

114 "The Seminole Nation was born of resistance and included the vestiges of dozens of Indigenous communities as well as escaped Africans, as the Seminole towns served as refuge. In the Caribbean and Brazil, people in such escapee communities were called Maroons, but in the United States the liberated Africans were absorbed into Seminole Nation culture. Then, as now, Seminoles spoke the Muskogee language, and much later (in 1957) the US government designated them an "Indian Tribe." The Seminoles were one of the "Five Civilized Tribes" ordered from their national homelands in the 1830s to Indian Territory (later made part of the state of Oklahoma)." Roxanne Dunbar-Ortiz, *An Indigenous People's History of the United States* (Boston: Beacon Press, 2014), 101.

115 Banks, interview by Benney, 41.

116 Ibid., 43.

deep—everything in our life is planned. And now you and me have talked on the phone our mission is complete."[117]

On February 1, 1995, the Drexciyan Tactical Seaforces received a briefing that The Unknown Writer claimed was the final mission from the subaquatic warrior race. It contained orders from Underground Resistance's Strikeforce Command to begin an *Aquatic Invasion*, launching a three-movement assault: "Wavejumper," "The Countdown Has Begun," and "Sighting in the Abyss." Alongside illustrations by Frankie C. Fultz, of Drexciyan Wavejumper commandos dispatched "somewhere in the Atlantic," a brief from The Unknown Writer relays intelligence from the battlefield back to UR HQ in Detroit:

> The dreaded Drexciya stingray and barracuda battalions were dispatched from the Bermuda Triangle. Their search and destroy mission to be carried out during the Winter Equinox of 1995 against the programmer strongholds. During their return journey home to the invisible city one final mighty blow will be dealt to the Programmers. Aquatic knowledge for those who know.[118]

At the same time, Drexciya issued a public statement accompanying the release of their next album, *The Journey Home* (1995), through a licensing agreement between Underground Resistance and Warp Records, amid a peak in the global spread of electronic dance music and rave culture, stating that "it's time to return to our original roots."[119] Techno struggled to surface in the inflated CD-focused American music industry, while also being largely left out of the closed-circuit collective psychosis of the UK and European electronic dance music industry. At the same time, the US industrial complex was tipping over into what Alvin Toffler described as a "corporate identity crisis": mass-market demographics that defined the industrial era of civilization were beginning to shrink and split into the "ever-multiplying, ever-changing sets of mini-markets that demand a continually expanding range of options, models, types, sizes, colors, and customizations" associated with the shortsighted, tragically myopic and data-obsessed information era.[120] Toffler explained that the acceleration of transactions amongst subdividing consumer demographics, which ought to be thought of as individual human beings, would dramatically peak before reaching a "general crisis of industrial civilizations as a whole. . . . [U]nlike any other crisis in history" this economic crisis would "bring inflation and unemployment simultaneously, not sequentially."[121] As the celebratory, free-love-inspired and drug-fueled delirium of the UK and continental European rave phenomena of the early 1990s waned into a

117 Ibid.
118 The Unknown Writer, liner notes, Drexciya, *Aquatic Invasion* (Underground Resistance, 1995).
119 Drexciya, statement, *The Journey Home* (Warp, 1995).
120 Toffler, *The Third Wave*, 248.
121 Ibid.

post-rave comedown, Warp Records' *Artificial Intelligence* compilation and series of albums (1992–94) provided the soundtrack to the end of the "Second Summer of Love," and the emergence of a stock market bubble in the tech sector in response to the wide adoption of computers and the internet. A "trans-global language" and atmosphere was born, rendered as ambient, psychedelic, and easy-to-listen-to sound; it leaned into the progressive Black counter-cultural music that had become techno, house, and hip hop between 1973 and 1985, before being imported into the UK between the years of 1983 and 1989.

Drexciya's fifth release through Warp progressed into a built world and mythscience. It unfolded for listeners across various fragments of messages and clues displayed in liner notes and object-oriented track titles, foreshadowing the contours of an underwater civilization designed by a sub-aquatic African warrior race that had been thrown overboard ships during the transatlantic slave trade in the 1500s. *The Journey Home*, unlike previous Drexciya releases, broke the fourth wall, addressing the listener directly:

> People have forgotten about the original form of techno. People like Kraftwerk didn't realize what an impact they would have. DJs used to work their duff off. They would (and a few still do) mix up on four decks, scratching and flipping all sorts of good music. Then it never had a name - now its broken up into rap - techno - hip hop. Too many DJs are just fader flippers. Anyone can be a fader flipper with a 4/4 rhythm - making it all sound like one long record.[122]

Drexciya's track listing and sequence guide the listener into the "Black Sea," where they can encounter "Darthouven Fish Men" and discover Drexciya's "Hydro Theory" on their "Journey Home." Around the same time as the album's release, an interview with *Melody Maker* uncovered James Stinson as one half of Drexciya, during which the writer "Dave Mothersole [was] granted a rare ear-bashing from the Detroit team."[123] Stinson advanced into a battle with the cultural division of the Programmers, asserting that there was a "Caucasian persuasion" over the history and industry of techno: "Ever since the blues and early jazz, Black music has been stolen and exploited." Stinson's frustrations with where techno was going were quite clear in this conversation, in which he asks bluntly: "Why do Richie Hawtin and his Plus 8 family come down here and throw parties in downtown Detroit?" pointing out the influx of white suburban youth gentrifying the music scene, even as they affirmed that techno was an original genre developed by the Black community of Detroit as an expression of joyful resilience in the midst of urban decay and postcolonial melancholy:

122 Drexciya, statement, *The Journey Home*.

123 James Stinson, interview by Dave Mothersole, "The Unknown Aquazone," *Melody Maker*, January 1995, archived at http://drexciyaresearchlab.blogspot.com/2016/10/drexciya-interview-melody-maker-january.html.

As far as I'm concerned, there isn't anybody out there making original Detroit techno—apart from us, and that's not being arrogant. It's a plain and simple fact. A lot of people making so-called techno don't understand where it came from and what it's all about. I know this stuff; I've been doing it for a long time. I've been with the real deal, in the trenches, since this shit was born out of the womb. But so many people have come in and stepped over the name of original techno and toned it down. And that's why we're here: it's time to turn up the heat.[124]

Trackmaster Lou and the Scan 7 ninja squad initiated their own mission, illustrated by Frankie C. Fultz, with their second EP for Underground Resistance, *Undetectible* (1995).[125] Flanking Drexciya's water-based attack, "A basstation is established by wavejumper commando's somewhere under the coast. Allowing UR to continue the fierce 95 winter equinox assault on the programmers," The Unknown Writer details the operation in *Undetectible*'s liner notes:

Scan 7 specialist engineers now skillfully deploy the cloaking devices which will allow Trackmaster Lou and the Scan 7 ninja squad complete invisibility to programmer thermal sensitive radar. Trackmaster Lou's mission is to infiltrate the central broadcast facility and knockout the mind control beam which telecast's the Programmers agenda's daily to millions of uninformed humans worldwide. Once the beam is knocked out Trackmaster Lou will then install into the Programmer's mainframe the new CPU platform chip developed in Detroit by Metroplex engineer's named "Electro - 3132030UR033." This chip will immediately induce viruses and bass frequencies designed to destroy Programmer chips in broadcast facilities worldwide. This will provide humanity an opportunity to clear their minds and prepare for the upcoming electric storms of the spring-summer equinox. With the help of key hackers worldwide Trackmaster Lou and the Scan 7 ninja's will be digitized and returned back to Detroit via the internet sometime in early April undetected. You have been warned.[126]

*

Back in Detroit, Andre Holland broadcast sonic documentation of on-the-ground activity in *City of Fear* (1995). Reconstructing electro TR-808 drum programming within the audio environment of mid-'90s Detroit's urban reality, Holland maintained the home base with a stance that recalls Huey P. Newton's 1967 address "Fear and Doubt" on the emotional ontology of the lower socioeconomic class of the Black

124 Ibid.

125 "The label fiction of Scan 7's *Undetectible* EP therefore extends strategies of stealth into covert ops, digital terrorism. The Programmers use a Central Broadcast Facility to telecast their 'mind control beam' across the world. The Central Broadcast Facility uses computer mainframe and powerful chips." Eshun, *More Brilliant than the Sun*, 122.

126 Scan 7, liner notes, *Undetectible* (Underground Resistance, 1995).

male.[127] Newton addressed the trouble of being born Black in America as a situation of institutional disadvantage, finding only conflicting messages of hope and doom in the modern society and planned environments of the United States' colonial genocidal project. The prescribed perspective of the Black man within the multi-level race and gender hierarchy of investors and workers in America, as Newton remarks, "is a two-headed monster that haunts this man. First, his attitude is that he lacks the innate ability to cope with the socio-economic problems confronting him, and second, he tells himself that he has the ability but he simply has not felt strongly enough to try to acquire the skills needed to manipulate his environment." Newtown continues, "In a desperate effort to assume self-respect, he rationalizes that he is lethargic; in this way, he denies a possible lack of innate ability."[128] In 1995, Princeton University political science professor John Dilulio confirmed the scale of these obstacles when he coined the term "super-predators," a year after President Clinton signed the Violent Crime Control and Law Enforcement Act introduced by then-senator Joe Biden.[129] In "The Coming of the Super-Predators," published in the Weekly Standard, Dilulio resolved that Black inner-city neighborhoods such as Detroit's posed the greatest danger to white American safety, as violent crime perpetrated by African American youth would inevitably spill over into the "upscale central-city districts, inner-ring suburbs, and even the rural heartland" of white America.[130] Diluilo forecast that there would be approximately 270,000 violent youth in the United States by 2010 due to growing "moral poverty" within minority youth—namely, the lower class socioeconomic Black male Newton described in "Fear and Doubt."[131]

Referring back to his Indigenous roots, Banks sought inspiration from the resistance struggles in America, beginning with the three Seminoles Wars that took place between 1817 and 1858. Over a century after the massacre at Wounded Knee Creek in 1890, in which three hundred unarmed Lakota Sioux were slaughtered by gunfire in one of the last battles between the Indigenous population and the European colonizers that would become Americans, Underground Resistance's *Soundpictures*

127 Huey P. Newton, "Fear and Doubt" [May 15, 1967], in *Essays from the Minister of Defense* (n.p.: Minister of Culture, Black Panther Party, 1967), 15.

128 Ibid.

129 "Every time Richard Nixon, when he was running in 1972, would say, 'Law and order,' the Democratic match or response was, 'Law and order with justice'—whatever that meant. And I would say, 'Lock the S.O.B.s up.'" Joe Biden, quoted by Sheryl Gay Stolberg and Astead W. Herndon in "'Lock the S.O.B.s Up': Joe Biden and the Era of Mass Incarceration," *New York Times*, June 25, 2019.

130 John Dilulio, "The Coming of the Super Predators," *Weekly Standard*, November 27, 1995.

131 "It is because the Black male is an affront to virtue and self-improvement that life is divorced from him. Black men and boys are theorized only as the antecedents to their own deaths. Their violence ignites the violence against them. As such, they are always imagined with a certain wrongness as Black males—an original sin of sorts—that explains through a subtle circularity the reason for their failures. The Black male has been formulated by disciplines through anecdotal examples that not only represent him at his worst but also deliberately erase him from history such that his efforts and vulnerabilities remain unknown. Unlike his white male counterpart, he is judged purely by the standard of the politics in our present moment." Tommy J. Curry, *The Man-Not*, 224.

EP in 1995 visualized "Lunar Rhythms" that moved Banks and the Underground Resistance team as they listened to the "Spirits Speak" of ways to harness the atomic vibrational energy cultivated by the Astral Apache and Drexciya during their last mission. "Indigenous peoples offer possibilities for life after empire, possibilities that neither erase the crimes of colonialism nor require the disappearance of the original peoples colonized under the guise of including them as individuals," writes historian Roxanne Dunbar-Ortiz in *An Indigenous People's History of the United States.* "That process rightfully starts by honoring the treaties the United States made with Indigenous nations, by restoring all sacred sites, starting with the Black Hills and including most federally held parks and land and all stolen sacred items and body parts, and by payment of sufficient reparations for the reconstruction and expansion of Native nations."[132] Operation *Dark Energy* was intended to dismantle the social, mental, and economic architecture of Western civilization, disrupting the web of conditions and relations that connect the mind, body, and soul to what Toffler calls the "telecommunity," or the cult of organized life inside of planned environments.[133] The stereo, perception-altering waves of *Soundpictures* (1995) activated The Martian's spontaneous lifeform production module from Base Station 303, evoking the spiritual movement "Ghostdancer" threaded from Banks' ancestral lineage, and possibly in connection with the Indigenous Blackfoot Confederacy, which had led a resistance movement against European colonizers as they attempted to establish domination in the Great Plains (current-day Montana and the Alberta territory of Canada).[134] In the 1890s, the Ghost Dance was an innovation of the Northern Paiute tribe of Nevada that spread across the pre-colonial North American continent[135]; it experienced a second wave when Wovoka, a spiritual leader and "Medicine Man," fell into a coma during the solar eclipse of January 1, 1889, and had a prophetic dream that foretold that the Paiute dead would be raised alongside the removal of white colonizers and their monstrous military industrial complex. The Ghost Dance War was both a prophecy, a curse, and eventually a rapturous panacea as Native Americans danced, reaching for

132 Roxanne Dunbar-Ortiz, *An Indigenous People' History of the United States*, 235–36.

133 Toffler, *The Third Wave*, 388–89.

134 "The Blackfoot Confederacy, sometimes referred to as the Blackfoot Nation or Siksikaitsitapi, is comprised of three Indigenous nations, the Kainai, Piikani and Siksika. People of the Blackfoot Nation refer to themselves as Niitsitapi, meaning 'the real people,' a generic term for all Indigenous people, or Siksikaitsitapi, meaning 'Blackfoot-speaking real people.' The Confederacy's traditional territory spans parts of southern Alberta and Saskatchewan, as well as northern Montana. In the 2016 census, 22,490 people identified as having Blackfoot ancestry." Hugh A. Dempsey, "Blackfoot Confederacy," *Canadian Encyclopedia*, 2010, https://www.thecanadianencyclopedia.ca/en/article/blackfoot-nation.

135 "In Nevada, a thousand Shoshones danced all night, and as the eastern sky turned pale shouts rang out that the spirits of deceased loved ones were appearing among the faithful. A thousand voices shouted in unison, "Christ has come!," and they fell to the ground, or perhaps to their knees, weeping and singing and utterly exhausted. Although many had dismissed the springtime talk of a messiah somewhere in the mountains of western Montana, the rumor seemed only to grow over time. From the Southwest to the Wind River Mountains of Wyoming and on into the plains of South Dakota, Indians spoke of a redeemer to the north." Louis S. Warren, "The Lakota Ghost Dance and the Massacre at Wounded Knee," PBS, April 16, 2021, https://www.pbs.org/wgbh/americanexperience/features/american-oz-lakota-ghost-dance-massacre-wounded-knee/.

a second coming and resisting assimilation into the white American industrializing culture forging ahead into the twentieth century. Audio visions of a "Martian Probes Over Montana," the arrival of a "Starchild," "The Vanishing Race," "The Talking Rocks of Mars," as well as instructions to move, live, and fight like a "Windwalker" filled Banks, leading him on a spiritual journey to discover a mothership due to land in the next millennium.[136]

*

When Atkins first read Toffler's *The Third Wave*, he wondered about the possibilities of a fourth wave to follow the collisions of change that had accompanied the white project of "progress"—the transition out of nomadic existence and the development of agricultural, industrial, and information-based civilizations within the last 1,000 years of European history and 500 years of American genocidal colonialism. The figure of The Martian, as a manifestation of the Ghost Dance religion, presented Underground Resistance with the prospect of societal decline within the United States' economic and technological republic, as a sign of the "second coming" prophesied by the nineteenth-century dances and shouts at the onset of the new Industrial Age. In *Powershift*, the 1990 follow-up to *The Third Wave*, Toffler outlined a "Yearnings for a New Dark Age" amongst a long list of symptoms of "future shock" that reverberate across every level of society. Programmers, he argued, had orchestrated a total information war against civilian users inhabiting and investing in the global telecommunity where one experiences "extra-intelligence" as an "autonomous employee" within "the power-mosaic" of a new system for wealth creation and extraction. With modern civilization burrowing deeper into the simulated environments constructed by colonial futurists and businessmen, humanity within the American experiment began to reach "the decisive decades" as society thrust into the fast-approaching horizon of the twenty-first century.[137] Entrenched in the technocratic world system foreseen by Atkins from Toffler's study, Underground Resistance drafted its "cyber strategy" in preparation for total, all-out *Electronic Warfare (Designs for Sonic Revolutions)* (1995) against the Programmers. "Do not allow yourself to be programmed. For once in your life take control!"[138] UR implored. First launching a "Logic Bomb," UR engaged in scaled combat by deploying the spontaneous lifeform technology "Fiber Optic Commando" and activating "Biosensors in Tunnel Complex Africa," before positioning to "Install 'Ho Chi Minh' Chip"[139] into the Programmers' central main-

136 Also foreseen by Sun Ra, George Clinton, Juan Atkins, and others including Barney and Betty Hill, who were the first to ever report being abducted by aliens on September 19 and 20, 1961.

137 Alvin Toffler, *Powershift: Knowledge, Wealth and Violence at the Edge of the 21st Century* (New York: Bantam, 1990).

138 Underground Resistance, lyrics, "Electronic Warfare," *Electronic Warfare (Designs For Revolutions)* (Underground Resistance, 1995).

139 Pointedly named after the revolutionary prime minister who led the Vietnamese People's Army and the

frame. Finally, "The Illuminator" deprogramming sequence was activated by Banks, completing the multi-dimensional assault and awareness campaign.

In 1995, Rolando Ray Rocha, known as The Aztec Mystic, completed his training after joining Underground Resistance the previous year: he had heard Jeff Mills DJ in the late '80s, and brought to his own productions the cultural influence of Latin rhythms and percussion, inspired by his father and upbringing in the Hispanic district of South West Detroit. DJ Rolando's three-track transmission, *The Aztec Mystic* (1996), revealed further instructions to "follow the shining path!"[140] Meanwhile, James Pennington, the Suburban Knight, broadcast and patrolled *By Night* (1996), in a solo mission utilizing a stealth jet enabled with "Echo Location" and "Nightvision." These sent warnings of the next battle against the Programmers back to the Underground Resistance headquarters. A new transmission from Banks arrived, responding to the Suburban Knight's findings, in the form of the 1996 album *The Return of Drexciya*. It is marked by a fractured and maniacal update on the seaward battlefront in "Smokey's Illegitimate Crime Report," which details a scene involving a few dozen men guarding their next target. In Banks' own report briefing in the album's liner notes, he acknowledged that the Drexciyan forces had endured "heavy casualties" during their last mission due to their more visible, but ultimately more effective, attack strategy. The UR Strikeforce Command lost communications with the Stingray and Barracuda Battalions, though Banks himself managed to infiltrate and hack the Programmer Emission Station servers, gaining access to their global weapons system by installing the "Ho Chi Minh" chip.

Banks' report on the Drexciyan forces alluded to "fog shrouded tones" that can only be deciphered by "those who know." The encrypted missions and messages broadcast by Underground Resistance coincided with President Clinton's endorsement of the Telecommunications Act of 1996, an amendment of the 1934 Communications Act that allowed for both individuals and companies to own multiple media outlets, such as radio, news and entertainment press, publishing, music and film production, video games, and search engines and internet services, in a bid to increase profit and consolidate assets, alongside the stretched-to-the-limit growth of the dot-com stock bubble.[141] Commencing a *Codebreaker* (1997) sequence the following year, Underground Resistance left a message for the Programmers, asking "Can you crack the code?"[142] *The Infiltrator* was released by Andre Holland, reporting to the UR Strikeforce Command "I'm In" and "They Will Never Know"; he performs "The Extraction" and

Việt Minh independence movement, before establishing the communist-ruled Democratic Republic of Vietnam, reunifying with the Republic of South Vietnam in 1976.

140 DJ Rolando, etching on runout groove, *The Aztec Mystic* (Underground Resistance, 1996).

141 "The implications for the legal community are an endless mire of property, privacy, and information issues, usually boiling down to one of the key conflicts between pre- and postcyberian mentality: Can data be owned, or is it free for all? Our ability to process data develops faster than our ability to define its fair use." Douglas Rushkoff, *Cyberia: Life in the Trenches of Hyperspace* (New York: HarperCollins Publishers, 1994), 35.

142 Underground Resistance, etching on runout groove, *Codebreaker* (Underground Resistance, 1997).

leaves with parting words for the Programmers: "Your deadliest enemy is the one closest to you."[143] Meanwhile, another transmission from Drexciya was released in *Uncharted* on Underground Resistance's sub-label Somewhere in Detroit, with Dennis Richardson of Ultradyne, deploying sonic visages of "Hi-Tide" as well as a documentation of "Dr. Blowfin's Experiment." Banks then mobilized and broadcast a three-track EP, *Ambush* (1997), as The Hostile, in which he addressed the Programmers as well as the hippie leisure class of the European electronic dance music and luxury travel industry:

> You've been waiting for your adventure vacation all year and now you're finally here headed up river and you're gonna have fun regardless of the poverty, corruption, political unrest, fragile ECO systems and reports of rebel forces in the area. After all it's your God given right to have fun all over the world wherever you please right? Suddenly your friendly native guides become uneasy. Their acutely tuned jungle senses tell them something is very wrong. All life seems to stop in its tracks, the silence is deafening, your heartbeat sounds in your ears, the boat is close to the bank. The beads and trinkets the travel agency told you to give the natives for safe passage won't work this time. You smile and try to take pictures of these ghosts in the forest to ease the tension but they remain in the underground silently reluctant of your 15 minute fame and pacifying technology. Finally they appear their war painted faces staring. Didn't the missionaries teach them this is wrong? You feel their power of their god thru their eyes, it's the jungle itself. One of the hostiles wears an old shirt, that reads ‹UR unexploitable'. Your immanent destiny calls and as with all pollutants UR consumed by nature as she punishes her children who cannot dance to her drums.[144]

With the Programmers distracted by the speculative inflation of the stock market and the tech and media sectors scrambling toward the digital gold rush, Underground Resistance celebrated their ancestral roots, on the cusp of the new millennium, in *The Turning Point* (1997).[145] *The Turning Point*, which features artwork from Haqq, visualized the transcendental reengineering that Banks implemented within Underground Resistance, activating all "Soul Circuits," generating a "Spirit Caller" from deep within himself and churning it into "Hi Tech Funk," as well as establishing the "First Galactic Baptist Church," with vocals by the First Diva of Outerspace, Paula McPheirson. On the album's label, The Unknown Writer muses:

143 The Infiltrator, etching on side A of runout groove, *The Infiltrator* (Underground Resistance, 1997).

144 The Hostile, liner notes, *Ambush* (Underground Resistance, 1997).

145 "Turning point is a statement—you need to complete the cycle. You need energy from people who listen to the music. We felt the original people who really embraced the music had just been washed away and when we would go to parties and events the energy wasn't there—the audience was boring. The original audience could feel the music, they didn't care who the DJ was. That's world-wide. We felt that the audience had become very closed minded. We saw DJs who couldn't come out of 4/4 'cause the audience didn't understand anything else." Mike Banks, in Tsutomu Noda, "Underground Resistance - Designs for Sonic Revolution," *ele-king* (n.d.), reprinted in *Straight No Chaser* 2, no. 5 (Summer 1999): 29.

Roots: without them you would be like a tree in a strong wind, easily blown over. Link to what we are and the only voice of our ancestors, and soul is the continuation of their experiences. Without roots, music and soul we would be lost, blind, futureless and unable to overcome what we face daily.[146]

DJ Rolando Rocha, as The Aztec Mystic, and Banks went on to merge their soul-generated vibrational technology to conjure a vision of "Aztlan," the mythical home-land of the Aztecs, in a split release with Octave One that envisioned a "DayStar Rising" akin to Peter 1:19-21 in the Biblical scripture: "We have also a more sure word of prophecy; where unto you do well that you take heed, as to a light that shines in a dark place."[147] In July 1998, *Crime Report*, penned by the Galactic Bureau of Investigation (G.B.I.), a space-based branch of the Programmers that could be likened to the F.B.I. or C.I.A., alleged that "There have been reports of a UR special opera-tions sonic insertion team code named I.S.F. (Interstellar Fugitives) in your zone. An imminent 'LP' attack is expected any moment. Beware you have been warned!!"[148] That August, Underground Resistance launched a coordinated attack with *Interstellar Fugitives*, a 15-track sonic blitz and escape plan, after being declared under arrest by the G.B.I. following their hacking of the Programmer mainframe and interplanetary collaboration with the Drexciyans and The Martian. Mike Banks, James Pennington as the Suburban Knight, The Aztec Mystic, Andre Holland as The Chameleon, Marc Floyd as Chaos, Chuck Gibson as Perception, and Gerald Mitchell as The Deacon assembled as a shadow force with assistance from Drexciya: fugitives on the run, they mounted a resistance to a technocratic society. As a collective, Interstellar Fugitives shifted away from Underground Resistance's previously employed tactical maneuvers for upgraded warfare by redeploying the Programmers' technology of psychic control, the "R1"—a "meme"[149] gene that maintains the root of an individual's agency. The lin-er notes for *Interstellar Fugitives* written by the G.B.I. and titled "Unspoken Reality," analyzed and approved for genetic factual content by Dr. Joyce Harper,[150] a professor of human genetics and embryology at the University College London, reveals that,

146 UR, liner notes, *The Turning Point* (Underground Resistance, 1997).

147 2 Peter 1:19-21.

148 Galactic Bureau of Investigation, liner notes, *Crime Report* (Underground Resistance, 1998).

149 "Imagine a world full of hosts for memes (e.g. brains) and far more memes than can possibly find homes. Now ask which memes are more likely to find a safe home and get passed on again? This is a reasonable way to characterise the real world we live in. Each of us creates or comes cross countless memes every day. Most of our thoughts are potentially memes but if they do not get spoken they die out straight away. We produce memes every time we speak, but most of these are quickly snuffed out in their travels. Other memes are carried on radio and television, in written words, in other people's actions, or the products of technology, films and pictures." Susan Blackmore, *The Meme Machine* (Oxford, UK: Oxford University Press, 1999), 37.

150 "Dr. Harper was the consultant on the Interstellar Fugitives project for Underground Resistance back in the 90s. Then she hosted a few of us when UR toured the project in the late 90s. She has always been so kind and generous to me every time I've been to London. She has 3 boys now and what a handful they are! Finally a match for her boundless energy!" AbuQadim Haqq, *Third Earth Visual Arts (1989–2014): 25 Years of Techno Art* (n.p.: Third Earth, 2014), n.p.

"Over the ages, there have been outbreaks of resistance to what the human spirit knows is evil, but is forced to accept as normal." The "R1" gene, they note, is a mutant gene found inside every one out of a thousand humans: "'R1' is older than humanity itself and was sequenced into human genetics by probabilities unknown."[151] The mutant, "resistance-generating" gene is said to communicate and transfer between bodies through rhythm programming and dance, binding the spiritual and physical components of humans into a single supernatural force.

The G.B.I. explains how the "R1" gene developed in its early stages and influenced the Interstellar Fugitives through an accompanying map of revolutionaries across time. "The 'R1' biological instructions found within people who resists hegemonic control are capable of converting the most humble human into a Digital Ebola Guerrilla Operative (D.E.G.O.) with reinforced rhythm awareness capabilities,"[152] suggesting that once the "R1" gene is triggered, due to many years of crimes against humanity in the name of power, it will take control over its host. "Lingering faith in humankind," the Bureau argues, could lead to the host being targeted for destruction by the Programmers. A newly spawned mutant cousin gene of the "R1," labeled the "Z" model (for zero), was created from "the 1400s to the late 1800s in colonized areas throughout the world and especially in the New World of the Americas" as a result of "illicit genetic breeding experiments performed on enslaved human stock."[153] The text unambiguously charges the United States Republic for its crimes against humanity in the form of a near genocide of the Native American and African American populations, and claims that the Programmers—psychotic white colonizers from Europe—attempted to breed a perfectly docile, worker race of human beings without any moral regard. The Galactic Bureau suggests that the "Z" model gene stock was unpredictable, offering "desirable soldier-like features," while also leading to numerous rebellions. The "Z" model traces the trajectory of Native and African American epigenetic trauma and lived experience, ultimately providing an extensive map of a history of people who have been "systematically targeted for destruction (usually by inaccurate lynchings)" committed in the former-Confederate South after the Civil War and into the early-to-mid-twentieth century. The text continues to probe into the microbiotic tensions between Black people and white American colonial oppressors, stating that:

> It is conceivable that large numbers of "R1" and "Z" genes made it North and elsewhere hiding the huge gene pools of workers who would leave the south during the early 1990s. The Northern industrial city of Detroit was well-suited

151 G.B.I., liner notes, "Unspoken Reality," *Interstellar Fugitives* (Underground Resistance, 1998).

152 Ibid.

153 Ibid.

for "R1." This mechanically pulsed city provided "R1" with a perfect rhythm foundation to transmit its subversive instruction sequences to those who know in the city's population.[154]

The Galactic Bureau remarks that a particularly disturbing result of "R1" is a "virus-like consciousness"[155] called Underground Resistance, which, since 1988, "has been responsible for infecting huge parts of the world with R1's teachings via a black vinyl data disk army sonically spawned somewhere in Detroit."[156] Using the Programmers' own digital communications systems, the Interstellar Fugitives launched an all-encompassing attack, as Banks entered into a late-stage development of the "Z" gene called "Negative Evolution," in which human capacities and consciousness begin to fade. The G.B.I.'s report found that the "R1" gene could be traced across nations, and that Underground Resistance intended to spread the gene across the world and even further, across the galaxy, concluding that in order for a smooth continuation of colonization, "the UR tone generators and their operators must be silenced now before even more of their infectious sound waves escape the Earth's atmosphere." Underground Resistance, as the Interstellar Fugitives, left behind a simple and decisive statement for the Galactic Bureau of Investigations: "Righteousness can be perceived as resistance when what one resists is evil."[157]

<p style="text-align:center">*</p>

In 1999, two years after the Interstellar Fugitives evaded arrest by the Galactic Bureau, *Straight No Chaser*, a British music magazine covering Black and electronic music since 1988, republished a feature on Underground Resistance written by Tsutomu Noda. It opened with an assertion by cultural critic Mark Dery, taken from his introduction to the concept of Afrofuturism in a series of interviews with Samuel R. Delany, Greg Tate, and Tricia Rose: "African Americans, in a very real sense, are the descendants of alien abductees; they inhabit a sci-fi nightmare in which unseen but no less impassable force fields of intolerance frustrate their movements; official histories undo what has been done and technology is too often brought to bear on Black bodies."[158] Noting that Underground Resistance was founded two years after the release of Public

154 Ibid.

155 "The gene as a creative mind made intelligible what was most disquieting about living things while apparently absolving us of the charge of vitalism. As human intention explains orderly, sequential, goal-directed action, action that can be flexibly altered according to circumstances and opportunity, as choices made with foresight and purpose explain constancy, change, and variation in human conduct and creation, so does the gene explain constancy and flexibility in biological form and process." Susan Oyama, *The Ontogeny of Information* (Durham, NC: Duke University Press, 2000), 90.

156 G.B.I., "Unspoken Reality," *Interstellar Fugitives*.

157 Ibid., back cover.

158 Mark Dery, ed., "Black to the Future: Interviews with Samuel R. Delany, Greg Tate, and Tricia Rose," in *Flame Wars: The Discourse of Cyberculture* (Durham, NC: Duke University Press, 1994), 180. Quoted by Noda in "Underground Resistance - Designs for Sonic Revolution," 22.

Enemy's *It Takes a Nation of Millions to Hold Us Back* (1988), Noda weighs their respective methods of sonic combat and decodes UR's electronic music as an extension of the struggle for Black civil rights through a cross-examination of the history of African Americans. "Traveling along an elaborate trans-state escape route known as the Underground Railroad," he writes, "19th Century fugitive slaves fled the south in search of the freedom of Canada almost exclusively at night. Guided by the northern star or the Ohio river and helped by 'stationmasters' and 'conductors,' such as ex-slave Harriet Tubman, fugitives escaped to liberty using disguises and codes. Last stop the 2nd Baptist church, last stop Detroit . . . code-name Midnight."[159]

In conversation with Mike Banks and other contributors to *Interstellar Fugitives*, the article presents Underground Resistance as a "counter-narrative" to the existing history of electronic dance music that emerged with the globalization and financialization of Detroit techno and Chicago house music in the late 1980s. Banks succinctly tells Noda that "UR is nothing new, it's an extension of an ongoing struggle..." explaining that the availability of electronic instruments had been something of an anomaly for Detroit musicians, who only gained access to them through the rise and fall of Motown Records: when it closed, Motown left behind gear that could be bought at pawnshops and repurposed by everyday people at an affordable price. Banks also spoke in regional, geographic terms to establish a map of the cultural roots that define and differentiate many of the musicians credited with the invention of techno as a global, technological commodity:

> Chuck Berry, Little Richard, Miles Davis and George Clinton expressed themselves with the instrument they had available in that time frame. If you look at some of the most successful electronic bands—Kraftwerk use classical music which was a root of European music and the world embraced it. Yellow Magic Orchestra took traditional Japanese melodies and rhythms and placed it over electronic music and again the world embraced it. Chicago house music took soul from the South. Anytime you share your roots people usually feel it. This music is an extension of all that soul.[160]

Noda's reading of Underground Resistance and *Interstellar Fugitives* positioned the sonic assault unit and The Unknown Writer's account as urban legends—witnesses to and militant combatants against "systematic social-engineering in which the placatory devices of churches, liquor stores and drugs appear at regularly spaced intervals throughout the inner-city."[161] He quotes Banks on the nature of "God and the spirit world" and the sinful, colonial act of traveling to and stealing another's home in cold blood, prompting Noda to turn to the lyrics of the Suburban Knight's track "Maroon":

159 Noda, "Underground Resistance," 22.

160 Ibid., 23.

161 Ibid.

302

"I am a voice from the past / Standing in the future / to forever haunt you / You should never have done this to us / Because now we can never rest / We are / Black electric / Strong electric."[162] Noda delineates the underlying narrative strategy of *Interstellar Fugitives*: "The slave trade, by way of its oppression, the involuntary displacement of people and breeding programs, engineered a highly-effective deletion of identity and roots in the minds of its victims. Added to this was the conscious erasure of its existence by those who perpetrated it. This weighs heavily in the mind of UR."[163]

Interstellar Fugitives' opening track, Chameleon's "Zero Is My Country," mobilizes The Unknown Writer's extended metaphor of the "Z" model gene as a root from which Blackness and rebellion originate. The following tracks—"Maroon" by the Suburban Knight, "Nannytown" by Underground Resistance, and "Mi Raza" by DJ Rolando—model the concept of an Afro Utopian Black and Indigenous nationalist state in the image of the matriarchal slave rebellion and the resettling of Maroon communities in Accompong Town, Moore Town, Charles Town, and Scott's Hall in Jamaica in 1740. "Both The Suburban Knight's 'Maroon' and UR's 'Nannytown' use ISF [Interstellar Fugitives] as a context in which to articulate the experiences of the Maroons," Noda writes. "Escaped African slaves during the time of the Caribbean slave trade, the Maroons escaped into the wilderness, creating their own settlements such as Nannytown in Jamaica, fiercely challenging colonial powers and creating a new identity out of their mixed African, Native American, and European experience."[164] The unconventional and asymmetric guerrilla tactics employed by Maroon communities, as well as the infamous uprising led by the enslaved preacher Nat Turner, inspired Underground Resistance's own coordinated and spiritual sonic message-bearing attacks.

"If you really read 'Interstellar' it's a warning to everybody," Banks says to Noda, explaining that there is a gene called 'Fragile X' linked to the level of aggression found in some animals, relating this to the capitalist colonial American situation of many different types of humans inhabiting a single place in a fight for survival. "I can't go to Africa and say I'm African or to the Indians and say I'm Indian or to white people and say I'm white, so I have to exist without really knowing my family history," Banks says. "I'm doomed to know very little about where any of us come from." He continues: "It's an empty feeling sometimes. That's what the first track on 'Interstellar' represents ('Zero Is My Country')."[165] Roots and intergenerational knowledge are important to Banks, who discusses what he describes as "a history of indiscriminate violence" that can be traced to his African and Native American family

162 Suburban Knight, "Maroon," *Interstellar Fugitives*.

163 Noda, "Underground Resistance," 24.

164 Ibid.

165 Ibid.

303

in the Deep South. "People that experience this struggle know something else," Banks says, relating that the cultural emptiness and desire to build something from nothing is innate in him, and that the horror of the past is very much a part of who we are and who we will become in the future. "Zero is a part of the struggle to understand nothing. You have a piece of this and a piece of that and you're trying to put it together, but you're so frustrated because you can't do it. You end up with zero... but maybe zero is something."[166]

Holland further explores this feeling of alienation stemming from living and working in an accelerating, technological, colonial society in his track on the compilation, "Unabomber"—a reference to Theodore Kaczynski, an American math professor-turned-domestic terrorist, who built and mailed nearly two dozen primitive homemade bombs to researched targets, including corporate executives, scientists, and university professors, from 1978 to 1995. His manifesto, "Industrial Society and Its Future," published in the *Washington Post* in 1995, argued that scientists perform experiments to exert power and manipulate conditional subjects as material towards their own personal end goal. "When a new item of technology is introduced as an option that an individual can accept or not as he chooses, it does not necessarily REMAIN optional," Kacynzski writes. "In many cases the new technology changes society in such a way that people eventually find themselves FORCED to use it."[167] He denounces the technological civilization brought about by the profit-driven hyperproduction of the Industrial Age, stating that the altered behaviors and social patterns of humans invested in information technologies and industrial capitalism are irreversible, incurable. "The only way out is to dispense with the industrial technological system altogether," he urges. "This implies revolution, not necessarily an armed uprising, but certainly a radical and fundamental change in the nature of society."[168]

The warfare waged in the sonic fiction unfolding throughout *Interstellar Fugitives* serves as a weapon to deracinate both the world order and the collective understanding of modern civilization and democracy. "UR chooses to remain fully independent, generating additional power and resources through its solidarity," Noda writes. Through a reconsideration of explored interpersonal history, Underground Resistance's music is oriented toward the production of a new collective stereomodernist culture: "*ISF* isn't simply an album by Andre Holland, James Pennington or Mad Mike. Individual ethnic identities, personal perceptions and the expression of these experiences, consolidate the message."[169] The track "Something Happened on Dollis Hill" by The Infiltrator references London's Estate, where the code-breaking computer "Colossus" was

166 Ibid.

167 Theodore Kaczynski, "Industrial Society and Its Future," *Washington Post*, September 19, 1995, https://www.washingtonpost.com/wp-srv/national/longterm/unabomber/manifesto.text.htm.

168 Ibid., 18

169 Noda, "Underground Resistance," 27.

weaponized during the Second World War and where Winston Churchill established an ancillary Cabinet War Room bunker code-named "Paddock."[170] Next, the Drexciya aquatic assault unit transmitted an "Interstellar Crime Report" as James Stinson talks to Noda, clarifying his previous interviews and press written alongside *The Journey Home* EP. He reveals that the pressure of media visibility got to them: "I was very dissatisfied with how the techno scene was. I thought okay I call it quits, I'm tired— then I got thinking there's too much work I didn't do, too many final frontiers, too many unlimited possibilities."[171] Corresponding with Drexciya's proverb of a coming "Aquatacizem," Gerald Mitchell, or The Deacon, offers "Soulsaver" as a rejuvenating force and spiritual healing sound, the vibrational practice of being through which one is reciprocally intertwined with objects and events in one's reality, much like the experience of wading in water. To Noda, The Deacon imparts: "I try to keep the soul in my music. You can hear the survival and the struggle from the tears and the pressure. I try to keep the soul in the music and what I feel comes from this body, from inside of me—I would like everyone to experience the same feeling."[172] A terminal transmission from The Infiltrator entitled "UR on Mir" sets up a post-credits scene, in which the Interstellar Fugitives signal into the void from a newly inhabited Soviet space station, situated within Earth's exosphere, that grants them a special vantage point on activities at the planet's surface as well as low-energy access to telecommunications systems, as the space station floats hidden amongst man-made debris caught in orbit. Noda's concluding thoughts on *Interstellar Fugitives* connect the gestalt of the soul of Detroit with the electronic cries of Underground Resistance's sonic messages:

Through such texts and identities, UR is a committed frequency guerrilla never to be underestimated, its sights aimed at oppression, misunderstanding and ignorance. From the opening track "Zero Is My Country"; to the final tracks "Negative Evolution" and "UR on Mir," *Interstellar Fugitives* goes back to the future to transmit a warning, an alert to the potential repetitions of catastrophes which may ultimately jeopardize our whole future co-existence and survival. It demands questions of itself and asks the listener to do likewise.[173]

On the heels of *Interstellar Fugitives,* DJ Rolando returned as The Aztec Mystic with the *Knights of the Jaguar* EP. Haqq's illustration of a warrior from the ancient Aztec civilization, adorned in the hide of a slain jaguar, reinterprets the regional Northern Mexican rhythms of Norteño music by way of hi-tech jazz and soul. Haqq later documented DJ Rolando's embodiment of The Aztec Mystic in his 2008 book, *The Technamonicron*, through the tale of the "Revenge of the Jaguar Knights" recounted in

170 Keith Dovkants, "Dollis Hill's Secret Wartime 'Citadel,'" *Evening Standard*, April 15, 2002, https://www.standard.co.uk/hp/front/dollis-hill-s-secret-wartime-citadel-6318921.html.

171 Ibid.

172 Ibid.

173 Ibid.

one of the book's chapters: "Centuries ago, before the coming of the conquerors, the Aztec Mystics ruled an empire larger than what is now known as Mexico. The symbol of their power was the Jaguar, the powerful creature that stalked the jungles just outside of their monumental cities."[174] Alongside DJ Rolando, Haqq revisited the period in which Spanish colonizers stumbled upon Mesoamerica and the Nahuatl-speaking people in 1519.[175] Under the rule of Moctezuma Xocoyotzin (signifying "He frowns like a lord, the youngest child"), the son of the war leader Axayacatl, the Spaniards led by Hernán Cortés were permitted to stay within the capital city of Tenochtitlan as guests until the social dynamic turned hostile, after Aztec warriors preemptively, and perhaps knowingly, destroyed a Spanish ship, resulting in the Massacre in the Great Temple on May 22, 1520. An Aztec account of the destruction of Tenochtitlan states plainly that the Spaniards murdered the Mexica people while they celebrated the Fiesta of Huitzilopochtli in The Patio of the Gods:

At this time, when everyone was enjoying the celebration, when everyone was already dancing, when everyone was already singing, when song was linked to song and the songs roared like waves, in that precise moment the Spaniards determined to kill people. They came into the patio, armed for battle.

They came to close the exits, the steps, the entrances [to the patio]: The Gate of the Eagle in the smallest palace, The Gate of the Canestalk and the Gate of the Snake of Mirrors. And when they had closed them, no one could get out anywhere.

Once they had done this, they entered the Sacred Patio to kill people. They came on foot, carrying swords and wooden and metal shields. Immediately, they surrounded those who danced, then rushed to the place where the drums were played. They attacked the man who was drumming and cut off both his arms. Then they cut off his head [with such a force] that it flew off, falling far away.[176]

The gruesome account details the Spaniards savagely stabbing, slashing, and smashing the heads of the Aztec people mid-dance, in the midst of spiritual transcendence. The

174 Haqq, "Revenge of the Jaguar Knights," in *The Technanomicron*, 22–23.

175 "What were his immediate motives? Cortés had migrated to the colony of Hispaniola in 1504, dreaming of glory and adventure, but for the first decade and a half, his adventures had largely consisted of seducing other people's wives. In 1518, however, he managed to finagle his way into being named commander of an expedition to establish a Spanish presence on the mainland...In other words, he'd been living beyond his means, got himself in trouble, and decided, like a reckless gambler, to double down and go for broke. Unsurprising, then, that when the governor at the last minute decided to cancel the expedition, Cortés ignored him and sailed for the mainland with six hundred men, offering each an equal share in the expedition's profits. On landing he burned his boats, effectively staking everything on victory." David Graeber, *Debt: The First 5,000 Years* (Brooklyn: Melville House, 2011), 316–18.

176 Fray Bernardino de Sahagún, *Florentine Codex*, book 12, chapter 20, reprinted in Miguel León-Portilla, ed., *The Broken Spears: The Aztec Account of the Conquest of Mexico* (Boston: Beacon Press, 1992), xxvi.

account describes the Spaniards laughing as they murdered people trying to escape by climbing the walls: "The blood of the warriors ran like water as they ran, forming pools, which widened, as the smell of blood and entrails fouled the air. And the Spaniards walked everywhere, searching the communal houses to kill those who were hiding. They ran everywhere, they searched every place."[177] Centuries later, DJ Rolando and Haqq revived this history in the "Revenge of the Jaguar Knights," declaring that the desecration of the city and its spirit would come to haunt the modern world that had emerged in the wake of this massacre and amidst the ruins of Tenochtitlan. When DJ Rolando summoned the Aztec Mystics with the songs "Jaguar" and "Ascension" on the *Knights of the Jaguar* EP, he was enacting the foretold vengeance "on anyone who violated [the Aztecs'] temples and totems," using his ancestral memory and connection to deploy the jaguars as spiritual forces that could "travel through the realms of Death itself" and "stalk their prey through time and exact their ultimate vengeance."[178] The song "Jaguar" became the most commercially successful release from Underground Resistance, spreading quickly through frequent use by both Detroit DJs who played abroad and European colonizers appropriating Black secret technology for their own luxury travel and drug-fueled clubbing industry.

In 1999 Dance Division, a subsidiary of Sony Music based in Berlin, attempted to license The Aztec Mystic's "Jaguar" for release on their label.[179] Underground Resistance refused label manager Dirk Dreyer's deal, citing their anti-corporate music industry ethos. In retaliation, Dreyer commissioned and produced a tone-by-tone remake of "Jaguar" without permission or copyright approval. Dance Division's vinyl of the remade song was stocked in European record stores in early December of that year, resulting in a massive backlash from Underground Resistance fans and music retailers familiar with the collective and their ideology. On December 14, 1999, Cornelius Harris, Underground Resistance's label manager, fired off an email titled "UR Vs SONY" stating:

> Recently, UR (Underground Resistance) has enjoyed the success of the track, "Knights of the Jaguar" by DJ Rolando. Recognizing that UR (Mad Mike, in particular) would be unwilling to license the track, Sony bypassed even making a request and has decided to release a "cover" version titled "Jaguar." Unconfirmed reports even indicate that promotional information on the records imply that it is a UR release. Cover versions traditionally have been done by fans of the original track as an homage to the original. In this case, it is being done as a method of undercutting the sales of the original. While this is an unethical and unprincipled act in and of itself, it is also a very dangerous act. In doing this, a major label,

177 Ibid, 76.

178 Haqq, "Revenge of the Jaguar Knights," 23.

179 Tamara Palmer, "From the Crates: The Aztec Mystic 'Knights of the Jaguar,'" *Insomniac*, December 22, 2016, https://www.insomniac.com/music/from-the-crate-the-aztec-mystic-knights-of-the-jaguar/.

Sony, has determined that it has the right to stomp all over an independent label in its pursuit of profits. With this as a precedent, the question that should concern any and everybody in the music community is who will be next? It is imperative that Sony be held accountable for its actions. We are currently looking into whatever legal options we have as well as any other means to put an end to this. We urge all concerned individuals to flood Sony's offices worldwide with calls, emails, and faxes expressing those concerns. This kind of crap has to stop and it has to stop now.

Anyone with any ideas, comments, addresses, or suggestions, please let me know. Some basic info follows. Any media folks, contact me privately. If anything could get Mad Mike out in the open, well... contact me.[180]

In an open statement addressed to DJ Rolando and "Mad" Mike Banks, Dreyer attempted justification:

I bought the 12" six months ago and enjoyed hearing the Jaguar whole summer. The feedback to the track is amazing, I have never seen people - no matter if house, techno and even trance fans - enjoying one tune like this one. It seems to be the first genre-crossover track for years since the split of 'techno house' from the early 90's to different styles and fanbases. In my way of 'industry thinking' it is a track worth to be available for a lot of people, much more than just people going to vinyl shops.

The philosophy of Underground Resistance not to cooperate with the industry is well known. Your title names like "message to the majors" and the liner notes on your records are not misunderstandable. I understand that you don't want to have any relationship with companies like Sony. Nevertheless we have tried to license the track for a compilation via our vinyl partner Discomania but we did not get a response.

As we don't want to be seen as guys who rip off or bootleg a well known track, we have chosen the way of rerecording the track tone by tone. Indeed the new version has lost some of the typical Detroit flavour, what makes me still prefer the original. On the CD will be the original writer and publishing credits that you get the publishing money that you deserve.[181]

By the time Dance Division pulled their fraudulent 12-inch records from retailers, in mid-December, two thousand copies had already been sold, none of which credited

180 Cornelius Harris, email correspondence with Patrick Haf, December 14, 1999, archived at http://www.detritus. net/contact/rumori/200001/0024.html.

181 Dirk Dreyer, open statement, n.d., archived at http://www.detritus.net/contact/rumori/200001/0024.html.

DJ Rolando or Underground Resistance—instead using an image of an ecstasy pill with the emblem of a jaguar as the cover.[182] The unnamed producers who had illegally recreated the track signed a deal with BMG/Arista Records, and a statement by Dreyer issued to the Dublin-based music and culture magazine *Hotpress* claimed that "Both parties are aware of the protests, they don't care. Sony has no control about further actions and we don't get an override."[183] Dreyer would eventually apologize in a later statement, noting that "We are sorry that we have hurt your feelings. Finally, at least the UR record will benefit from the story. We wish you good luck and a lot of sales for this classic piece of music."[184] In 2004 DJ Rolando left Underground Resistance and moved to Edinburgh, Scotland, with his wife, integrating into the European dance music industry. Reflecting in 2011, he told American dance music culture and technology magazine *XLR8R* that there was "an outpouring of support from people who were ready to give the middle finger to the man," but also that "the first couple years after the release of 'Jaguar,' it was always daunting."[185] With a sigh, DJ Rolando remarked: "People think that you need to do another 'Jaguar,' you need to do just as well or better or the same thing, but I didn't and don't want a bunch of my records sounding the same. 'Jaguar' was just a point in time… and it was quite magical, however corny that might sound." In the end Rolando Rocha felt he needed to pursue a music career his own way. "We did our thing together," he said of his output with Underground Resistance. "They're still doing what they're doing and I'm doing what I'm doing. But to me, that's mostly history, man."[186]

At the edge of the twentieth century, despite the valiant efforts of the interstellar fugitive Underground Resistance, the United States experienced the great awakening into technocratic society with the emergence of 24-hour television programming and the availability of the internet. As the year 2000 approached, the Programmers began to notice a glitch in their systems—a remnant resulting from Scan 7's hacking of the online Bulletin Board System during their *Black Moon Rising* mission, allowing them to plot a coordinated cyberstrike with the installation of the "Ho Chi Minh" chip by Mike Banks during Underground Resistance's *Electronic Warfare* campaign in 1995. Under the name Chaos, Mark Floyd initiated *Condition Red* (2000) from the Mir space station with a transmission from The Unknown Writer: "one small worm can harm a huge tree, by working its way throughout the roots and into the trees manufacturing and distribution systems, the tree's ability to stand strong decreases. the

182 Eamon Sweeney, "Resistance Isn't Futile," *Hotpress*, March 12, 2001, https://www.hotpress.com/music/resistance-isnt-futile-391978.

183 Ibid.

184 Ibid.

185 Rolando Rocha, interview by Thomas Rees, "DJ Rolando on Leaving Underground Resistance and Life After Detroit," *XLR8R*, May 13, 2011, https://xlr8r.com/features/dj-rolando-on-leaving-underground-resistance-and-life-after-detroit/.

186 Ibid.

more worms the more of a chance the tree will fold. you know which trees are rooted in truth and which ones are rooted in lies. what has no foundation will fall... the time is coming..!"[187] On the vinyl runout groove, the words "ELECTRONIC EXTORTION OR DIGITAL RIGHTEOUSNESS" are inscribed, alerting Programmers that "The Safety Is Off" before suffering damage from Chaos' viral attack at point blank range. Underground Resistance's assault on the transnational commerce networked by the Programmers, "the dispersed 'oppressor,'"[188] took place as the online service provider America Online (AOL) bought Time Warner's 182-billion-dollar stock and debt. The merger was the largest financial deal in history and marked the beginning of an inflation hysteria in the United States, as the colonial industrial Programmers cemented the internet as the most valuable currency of the world economy and ushered in the global consciousness of the new millennium. "Together, they represent an unprecedented powerhouse," media analyst Scott Ehrens told CNN Money. "If their mantra is content, this alliance is unbeatable. Now they have this great platform they can cross-fertilize with content and redistribute."[189]

In February 2000, Alan Greenspan, as Chair of the United States Federal Reserve, motioned to raise short-term interest rates as a maneuver to gain control over the increasing imbalance between supply and demand resulting from the rapid acceleration of online systems and their attendant data-based economy.[190] On March 13, Japan, the world's second-largest economy at the time, fell into a recession, spurring a global sell-off of stocks in the tech business sector. The next day, *Forbes* published an article speculating on a potential "mega-merger" between Yahoo! and eBay, stating that, "Both Yahoo! and AOL have shown no hesitancy to splurge billions of dollars to grow through acquisition. And even if they couldn't lure eBay into a merger, they might strike a deal to feature the world's largest online auctioneer on their sites."[191] The article inferred that "Yahoo and AOL are in a neck-and-neck race to establish the largest audience on the Web." On March 15, Yahoo! and eBay ended merger talks, spurring yet another sell-off from investors and a shift in the financial viability of high-performing yet inflated technology stocks, as well as more traditional industrial stocks of the previous millennium. In response, the Federal Reserve raised interest rates again. On April 3, 2001, Judge Thomas Penfield Jackson ruled in the legal case "United

187 Chaos, liner notes, *Condition Red* (Underground Resistance, 2000).

188 "The liberalization of finance has encouraged the growth of some six hundred mega-firms, which used to be called 'multinationals' and which now account for about one fifth of value added in agriculture and industrial production in the world. The term multinational, however, is obsolete. Mega-firms are essentially non-national." Toffler, *Powershift*, 460.

189 Scott Ehrens, "That's AOL Folks," *CNN Money*, January 10, 2000, https://money.cnn.com/2000/01/10/deals/aol_warner/.

190 Frederic S. Mishkin, "The Fed After Greenspan" (presidential address, Eastern Economic Association Meetings, New York, March 5, 2004), https://www0.gsb.columbia.edu/mygsb/faculty/research/pubfiles/1592/05eea.pdf.

191 "Yahoo!, EBay Discuss Business Partnership, Merger," *Forbes*, March 14, 2000, https://www.forbes.com/2000/03/14/mu8.html?sh=5b9019ec705c.

States v. Microsoft Corp." that Microsoft was an illegal monopoly in direct violation of the Sherman Antitrust Act, which led to another decline in technology stocks. On September 11, 2001, *CNN Money* chronicled yet another blow in the article "World Markets Shatter," reporting on the deadliest terrorist attack in American history: "The destruction of New York's World Trade Center near Wall Street sent a shock through overseas financial markets Tuesday as stocks fell, oil prices surged, the dollar tumbled and money flooded into Treasury bonds."[192]

Against this backdrop of expanding, abstracting, and monopolizing global economy, Underground Resistance continued to recruit "hungry sonic assassins and audiovirus creators"[193] such as the Drexciyan unit Aquanauts,[194] led by Tyree Stinson with Lamont Norwood as DJ Di'jital and Milton Baldwin as DJ Skurge; Dutch techno producer Orlando "Fix" Voorn; M.I.A., the Mississippi mutant; Dan Caballero as Dex Nomadico; Santiago Salazar; John Williams as Billeebob; Mark Taylor as Vintage Future; Cornelius Harris as The Unknown Writer/Atlantis; Haqq as The Illustrator, who maintained the collective mythscience of techno; and Timeline, a live "hi-tech jazz" band assembled by Mike Banks and comprised of Gerald Mitchell on keyboards, Raphael Merriweathers, Jr., on drums and percussion, Darren McKinney on saxophone, and Dex Nomadico for mixing and editing. Regrouped and gathering force, Underground Resistance released a new single by Gerald Mitchell entitled *Hardlife* (2001),[195] featuring vocals from his son Ron Mitchell and a remix by the young producer Aaron Carl, which conveyed the message: "In the shadow of perceived success there exist the hardlife."[196] This was followed by a stealth attack with the *Analog Assassin* (2002), which Haqq described in *The Technanomicron* as a stealth suit created from discarded technology with the ability to emit vibrational frequencies from integrated analog gear such as "the Prophet 5, OB-8, Jupiter-8, 909, 808 and the ARP-Omni."[197] Shortly after, Underground Resistance released the single *Inspiration / Transition* (2002), with images of Rosa Parks' protest against segregated seating in Jim Crow-era Montgomery, Alabama, designed by Chuck Gibson. Mixed by Mr. De'

192 "World Shatters Market," *CNN Money*, September 11, 2001, http://edition.cnn.com/2001/BUSINESS/09/11/markets.europe/.

193 Mike Banks, interview by Sven von Thülen.

194 "I was instructed by Mike Banks to take the concept to the next evolutionary level if you will. Since James Stinson's brother was in the Aquanauts, we wanted to keep the same vibe as with Drexciya but change it up slightly." AbuQadim Haqq, "A Qadim Haqq interview," Drexciya Research Lab, August 26, 2008, https://drexciyaresearchlab.blogspot.com/search?q=neptunes+lair.

195 "This statement might seem cliché, but in the case of Gerald Mitchell, it's reality. As a young adult coming up in Detroit during the '80s, there were many hazardous paths one could take. Music has historically provided an alternative avenue for citizens of the Motor City to navigate away from the dangers of street life. Although there were some bumps along the road, Mitchell has earned his place in the electronic musical canon. . . . One of the crown jewels in UR's legendary discography is *Hardlife*, released in the summer of 2001." Tajh Morris, "Rewind: Underground Resistance - Hardlife," *Resident Advisor*, August 22, 2021, https://ra.co/reviews/34216.

196 Underground Resistance, liner notes, *Hardlife* (Underground Resistance, 2001).

197 Haqq, *The Technanomicron*, 21.

(Ade' Mango Henderson Mainor), the song "Transition" centers the voice of Cornelius Harris as The Mercenary, offering words of empowerment:

> There will come a time in your life when you will ask yourself a series of questions:
> Am I happy with who I am?
> Am I happy with the people around me?
> Am I happy with what I'm doing?
> Am I happy with the way my life is going?
> Do I have a life or am I just living?
> Do not let these questions strain or trouble you just point yourself in the direction of your dreams, find your strength in the sound and make your transition.[198]

On September 3, 2002 the fugitives experienced their own casualty with the death of James Stinson. Tyree Stinson, James' brother at the helm of the Aquanauts, released the *Spawn* EP the next year, broadcasting the tributary message: "U R GONE BUT NOT FORGOTTEN - THE X-PERIMENTS WILL CONTINUE AT ALL COSTS EVEN DEATH. YOUR WORLD WILL LIVE ON THRU US." Raphael Merriweathers, Jr., as The Unknown Soldier, transmitted a processional taps in the style of Drexciya, laying James Stinson to rest with the EP *Gone But Not Forgotten*, followed by The Aztec Mystic's *Aguila*—an eagle adorns the cover, flying into the sunset overlaid by words from The Unknown Writer, reading: "Never let any person, substance or thing bring you down! Use this music to fix your wings and fly away. Written in pain."[199] In the aftermath of a national and personal crisis, The Unknown Writer narrates the possibilities for life after death of the Unknown Soldier:

> Inner City Detroit, birthplace of Detroit techno, a completely mutant hybrid form of music spawned by circumstances completely unique to Detroit. Some of these circumstances are beautiful, full of life and soul; others, perceptual nightmares that become the norm. Is Underground Resistance a musical voice of these circumstances?
>
> The homeless people that you see grubbing for food or seeking shelter are a major source of inspiration for The Unknown Soldier. Many of these people are indeed addicted to many of the all too available drugs, alcohol and vices that are present in inner city life. On the other hand, many of these people are Vietnam and Korean war veterans who were sent by America to defend democracy. Men and women who left Detroit unknowing of the horrors they were about to witness. Some of these horrors so intense they cannot be spoken about, so they remain in silence, controlled and contained by King Heroin, crack cocaine, and 5 o'clock.

198 Underground Resistance, lyrics, "Transition," *Inspiration / Transition* (Underground Resistance, 2002).

199 The Aztec Mystic, liner notes, *Aguila* (Underground Resistance, 2003).

The Unknown Soldier, the son of a Korean war veteran heard many sounds of horror before his father's transition. He smelled the stench of decay many years after the battles were fought. He has indirectly witnessed war's lunacy and paranoia decades after the events that caused them took place. He looks out his window only to see a ragged house full of vets with their fatigues on bravely struggling to survive. Trained to be self-sufficient and too proud to ask anyone for help with a ghost that never goes away.

The sounds of admiration, respect and bravery can be heard in The Unknown Soldier as well as the sound of chaos, frustration and violence that was and still is necessary for those without a voice to survive in hoods where the general population is too busy struggling for themselves to possibly give a fuck about what these people and what they went through represent.

The Unknown Soldier is an electronic transfer for those who cannot be heard.[200]

The following year, Underground Resistance and Scan 7's Leslie Jerome Robinson as The Shadow released the split EP *The Theory / Free As You Wanna Be*, offering a message of hope and ethical responsibility, as the fugitives staged their next tactical maneuver: "THE NEEDS OF THE MANY - OUTWEIGH THE NEEDS OF A FEW." That Halloween, the Aquanauts released *The Titanic* EP, warning: "BEWARE: IT WILL NEVER BE SAFE TO GO INTO THE WATER AGAIN!" At that time, an international licensing deal with Underground Gallery, a record label and online music retailer in Kobe, Japan, established new distribution possibilities for Underground Resistance in the market flow that resonated throughout the new millennium. "Determined to keep the ancient arts alive," an underground cell in Japan called the Pagan Design Force contacted Underground Resistance shortly after the market crash of 2001, which appeared to perpetuate the economic stagnation that defined Japan's "Lost Decade" of the 1990s.[201] Despite the loss of value in the tech industry after the dot-com bubble burst in 2001, the Programmers continued their campaign into the Programmed Cultural Initiative (P.C.I.). In collaboration with the Interstellar Fugitives, the Pagan Design Force resurrected the World Power Alliance of the early 1990s and assisted in a mission towards a complete *Destruction of Order*. Compiled into a two-disc CD, *Interstellar Fugitives 2 - Destruction of Order* employed a "mind bomb," just as social media networking services launched global, virtual communities

200 The Unknown Soldier, artist profile on Discogs, https://www.discogs.com/artist/176676-The-Unknown-Soldier.

201 "The 'lost decade.' That's how the Japanese describe their country in the 1990s—the boom years here in the United States. Japan's real estate and stock bubbles had burst. Consumers stopped spending, growth slowed, and the Japanese seemed to be losing clout on the world stage. For conservative American commentators, the Japanese government's response shows the folly of fiscal stimulus spending. Charles Krauthammer, among others, has said 'the Japanese tried huge infrastructure spending in the '90s and got nowhere.'" Richard Koo, "Putting Japan's 'Lost Decade' in Perspective," NPR, Morning Edition, February 24, 2009, https://www.npr.org/templates/story/story. php?storyId=101066132.

in the metaverse. Facebook, Flickr, and Bebo were introduced in 2004 as foundational cultural centers building on the groundwork of MySpace, which was acquired by News Corporation for 580 million dollars in 2005,[202] just as Reddit and Chinese social network Renren went online.[203] In 2006, the P.C.I. expanded further, with the open source journalism of microblogging site Twitter, and even reached the birthplace of techno and Underground Resistance with DetroitCity, an early streaming service and free analytics platform for artists and venues embedded within the local population. As the technocratic free-market economic strategies and manufactured media distribution of the P.C.I. began to attune society to online globalization, the *Destruction of Order* mission set into motion. Cornelius Harris briefs the team in the album's opening track, "Words from Atlantis," which evokes the myth of Drexciya in the absence of James Stinson, urging truth to power in a theoretical reengineering of the Western enlightenment concepts of order and chaos:

Order and chaos. Two primal opposites from the beginning of time. Chaos has led to the destruction of some of the greatest civilizations the Earth has ever known. In the form of drugs, disease and war, we are very familiar with how chaos has asserted itself as the destroyer of the best humanity has to offer. Bringing order to chaos has been a primary concern of people of the world over. But order is not exempt from this destructive dynamic as well. Order is the force behind almost every dictatorship known in human history. American slavery is one of the most orderly systems devised, as well as one of the most brutal. Slaves were carefully accounted for and classified as Negro, mulatto, quadroon, octroon, and so on and each had a relatively specific social and economic function. Germany's Nazi regime asserted order in that country and beyond, at the cost of millions of lives. The chaos of 9/11 has led to an order that asserts itself as a straight jacket on the civil liberties of men, women and children around the world.

But chaos has come to the rescue numerous times throughout history. The chaos of the Civil War opened the door to the end of slavery in the United States (the last country in the Americas to do so). World War II saw the end of the Nazi Regime, war being the definition of chaos. Even Ghandi's nonviolent liberation movement can be seen as creating chaos within the Empire's structure, leading to its eventual downfall. It is impossible to conceive of a revolution that was not born in chaos or cause chaos in the dismantling of the oppressive order. Indeed,

202 Richard Siklos, "News Corp. to Acquire Owner of Myspace.com," *New York Times*, July 18, 2005, https://www.nytimes.com/2005/07/18/business/news-corp-to-acquire-owner-of-myspacecom.html.

203 Christine Lagorio-Chafkin, "How Alexis Ohanian Built a Front Page of the Internet," *Inc.*, May 30, 2012, https://www.inc.com/magazine/201206/christine-lagorio/alexis-ohanian-reddit-how-i-did-it.html; Rita Liao, "The Forgotten 'Facebook of China' Is Sold for $20M," *TechCrunch*, November 14, 2018, https://techcrunch.com/2018/11/13/renren-sold-for-20m/.

it is ironic, or, perhaps destined, that the counter to chaos would be order, and the counter to oppressive order would be chaos.[204]

His voice intoned:

Order and chaos. Two universal opposites from before the beginning of time. While most of us are familiar with the concept of positive order and negative chaos. There is also a such thing as negative order and positive chaos. We are living in a world filled with chaos and order, much of it negative on both accounts. The widespread chaos of drugs, disease and war have taken their toll on the planet while political and corporate order threatens the freedom of not only the human body, but the mind as well. When the mind becomes enslaved to an order that will destroy its freedom and chaos within the soul it becomes necessary to disrupt that order to destroy its power. There is a new chaos coming. One that has been growing over the past century threatening to destroy all that the old order has built. Threatening to create a new order that will have no respect for past, present or future. A past that denies the pain of a people—destroyed. A present that has no understanding of history and its role in the present—it will be destroyed. A future that does not include 4/5ths of the world's population—must be destroyed. Welcome to the Destruction of Order![205]

Stationed alone on Base 3000 in the Andromeda Galaxy, Mike Banks broadcasted a sonic fiction of "Hi-Tech Dreams" and "Lo-Tech Reality," beyond the collapsing, oppressive order and the impending chaos of the global corporate wealth and intangible data-based assets of a fourth wave of change that business consultants Herman Bryant Maynard and Susan E. Mehrtens drafted from Toffler's theories in *The Third Wave* and *Powershift*.[206] In 2006, *Clash* magazine published an article composed of letters written by members of Underground Resistance from varying locations across the Asia Pacific. "We have always embraced incoming technology," Mike Banks wrote from his assignment somewhere in Micronesia. "The whole way Detroit Techno evolved was due to new technology. As the newer hardware came in older hardware was discarded, sold and pawned. This made the shit available to mugs like me!"[207] From somewhere in Malaysia, Gerald Mitchell wrote about the influence of Zydeco—a

204 Atlantis, lyrics, "Words from Atlantis," UR, *Interstellar Fugitives 2 - Destruction of Order* (Underground Resistance, 2005).

205 Ibid.

206 "The Fourth Wave corporation will recognize its role as one of stewardship for the whole in addition to providing goods and services to a particular customer base. It will have shifted its self-image from that of a primarily manufacturing to a primarily serving organization (Harman 1982) and will act as a leader in addressing global issues, focusing on what is best for all. The model of servant leadership originated by Robert K. Greenleaf (see, for example, Kiechel 1992) will become the corporate ethos of the Fourth Wave." Herman Bryant Maynard and Susan E. Mehrtens, *The Fourth Wave: Business in the 21st Century* (Oakland: Berrett-Koehler Publishers, Inc., 1996), 68–69.

207 Mike Banks, quoted in "Underground Resistance: The Singular Most Inspirational Force in Techno," *Clash*, February 5, 2006, https://www.clashmusic.com/features/underground-resistance.

Southern African American style of guitar and accordion-based dance music—on his work as The Deacon: "Many times we randomly reach into our roots as a foundation to go forward. It becomes very difficult when your long-term history is erased so you end up imagining and gluing stuff from your immediate past, future and present, warping things. Or using supersticed coded genetic rhythms embedded in your soul that just come out when you tune in and call for them. There's no real plan to retro-fit any of our music."[208] In a follow-up sent from somewhere in Micronesia, Banks explained the elements that are key to creating music as "soul machines" that bring their own life experiences and imagination to the gear: "I play instruments and by playing them I can still see the lag between the human brain's spontaneity and a computer's attempt at being there. It's a long way off, man... I trust and have faith that others with soul can hear the difference."[209] Stationed in Hong Kong, James Pennington—The Suburban Knight—shared that "Mike communicates with Jeff regularly via two-way devices. He still functions as the lead re-con man in our system. He essentially is the eyes and ears of UR. He has never abandoned his post. Never."[210] From Mongolia, Banks responds to a question about the Detroit techno scene, citing a 1993 interview in which he had explained that he started the Submerge distribution umbrella company, in part, to help establish a dance music economy in Detroit after being left behind by Europe:

> I would want to say it's changed and Submerge helped. But that wouldn't be true. The ironic truth is that history has repeated itself. Just as jazz musicians abandoned Harlem for the greener pastures of Europe and Japan, so have a lot of our guys left Detroit! It is easier to DJ and earn $4,000 to $6,000 dollars a weekend in Europe playing for people that adore you, know every record you play and actually give a fuck of what your perception of life is and have a wine and cheese dinner before every set than it is to produce a record and earn $1,000 every three months in a hot funky basement with an old dogshit aroma as a backdrop... our blossoming scene had the life sucked right out of it! Mugs ran up outta here and Chicago when the world discovered this shit! We lost some of our best producers as they have been on a paper chase for the last fifteen years and are living off old-ass hits! The irony is: can you blame them? Many tried to help their boys and surrounding communities, but the truth is their boys wasn't helping them or weren't capable to help in an increasingly global game. So for many there was no choice. Either leave or be pulled under by the leeches![211]

Contemplating the years between techno's globalization in 1988 and the sonic warfare waged by Underground Resistance in 2006, Banks believed that "the good part about it was their efforts made the Detroit style techno party a global thing. They made the

208 Ibid.
209 Ibid.
210 Ibid.
211 Ibid.

jet-set DJ culture what it is today!" Despite Detroit not reaping much of the financial benefit of one of its greatest exports, techno was able to realize its revolutionary potential in a foreign, colonial market. "They were like bees spreading techno all over the world! They saved the vinyl industry and revived the dying analogue synthesizer industry also! I even think they inspired the development of the internet and various music-related software, man! So maybe Detroit suffered so the world could grow?"[212] From the depths of the deteriorating and diluting futurity of the twenty-first century, Underground Resistance recorded *Electronic Warfare 2.0 - The Other Side of Bling* between Black Planet Studios and somewhere deep in the Paris underground in 2008. Banks and Mr. De', an originator of the hip-hop influenced counterinsurgent spawn of Detroit techno, ghettotech, transmitted calls of resistance as the United States turned the millennial corner toward its rendezvous with destiny and its descent from order into chaos—the logical conclusion to the Programmer's techno-utopian vision of the future implausibly built on colonialism, occupation, exploitation, and greed.

212 Ibid.

9.
THE DREXCIYAN EMPIRE

"The push into the depths of the sea provides us with a mirror image of the drive into outer space, and lays the basis for the third cluster of industries likely to form a major part of the new techno-sphere. The first historic wave of social change on Earth came when our ancestors ceased to rely on foraging and hunting, and began instead to domesticate animals and cultivate the soil. We are now at precisely this stage in our relationship to the seas."[1]

– Alvin Toffler

"(The inspiration for the underwater world) came from deep inside my mind. God gave me this vision and I'm building on it bringing it to life for the whole world to see.... Water is life. Life started on this planet and other planets due to water. It is the cutting edge of creativity and innovation. You have billions of different species in the seas, oceans, lakes, ponds and streams across the world. Millions of species still have not been discovered by man so is that the cutting edge of creativity or what? We approach our music the same way."[2]

– James Stinson

In the summer of 1997, amid a historic outbreak of deadly tornadoes in the city of Detroit and Wayne County, a double CD of licensed and unreleased tracks by Drexciya (James Stinson and Gerald Donald), titled *The Quest,* surfaced on Submerge. It contained a map detailing a holistic vision of the four-hundred-year-long epic of African American subjugation, insurrection, and exodus. Paralleling Juan Atkins' adoption of the three waves of societal and environmental change across the stratum of human history diagnosed by futurist Alvin Toffler, Drexciya's projected timeline, drawn by Frankie C. Fultz, charts a Black exodus from the Maafa (Swahili for "the Great Disaster" of the African-Black Holocaust) and Euro-American modernity, beginning in 1655 with the first large-scale importation of slaves from Jamaica into Manhattan, New York, amid the Dutch-Anglo Wars and the initial rebellions of the Maroon Wars.[3] The map continues to cover the migration of formerly enslaved Black people in the 1930s and '40s, as they relocated from the rural plantocracy of the Deep South

1 Alvin Toffler, *The Third Wave* (New York: Bantam Books, 1980), 159.

2 James Stinson, quoted in John Osselaer, "Drexciya: Twenty Thousand Leagues Under the Sea," *Techno Tourist,* February 2002, archived at https://web.archive.org/web/20020510020232/http://technotourist.org/modules.php?op=modload&name=Sections&file=index&req=viewarticle&artid=15.

3 Gerald Horne, *The Apocalypse of Settler Colonialism: The Roots of Slavery, White Supremacy, and Capitalism in Seventeenth-Century North America and the Caribbean* (New York: Monthly Review, 2018), 97–99.

Confederacy to the industrialized free-market states of the Northern Union. A third panel depicts the folktale of the prodigious young hero Atkins and the philosophically minded veteran, Rik Davis, as they conceptualize techno, which spreads worldwide with the release of *Techno! The New Dance Sound of Detroit* in 1988. The fourth panel portrays a future scenario labeled "The Journey Home," in reference to the 1995 EP of the same name. Techno reaches an oblique climax, portrayed by a prophetic image of lines retracing and connecting the American, African, and Europe continents into a new Black Atlantic geopolitical cartography of the Drexciyan Empire. From this strategic position, a gurgled vocal transmission at the beginning of *The Quest* vengefully proclaims: "The people of Earth listen closely. We are attempting to avoid the Aquatacizem."[4]

In the aftermath of the events recounted in Drexciya's album *Aquatic Invasion* and Scan 7's *Undetectible*, both released by Underground Resistance in winter 1995, the Drexciyan Wavejumper Commandos—despite suffering the loss of the Stingray and Barracuda Battalions—successfully overtake a central Programmer Emission Station, whose surviving fleet of Drexciyan Tactical Seaforces set off with intelligence from the surface world on a *Journey Home* into the eye of a storm forming between Florida, Puerto Rico, and the islands of Bermuda. *The Return of Drexciya* was released a year later, with a written report from Mike Banks describing a sighting in the abyss: "Drexciya was officially listed as M.I.A.—until last week when a strange signal named 'Smokey's Report' was picked up by UR Communications. It was recorded as were three other transmissions. These fog shrouded tones will be available soon 'to those who know' for you to decipher...."[5] In *The Quest*'s liner notes, written by Underground Resistance's label manager Cornelius Harris (The Unknown Writer), theorizations around the urban reality and epigenetic maturation echoing throughout Detroit techno constitute a combination of Black vernacular technological creativity[6] and an intuitive reasoning through white evangelical techgnosis[7] in search of the Drexciyan Black Atlantic:

4 Drexciya, lyrics, "Intro," *The Quest* (Submerge, 1997).

5 Mad Mike, liner notes, Drexciya, *The Return of Drexciya* (Underground Resistance, 1996).

6 According to Rayvon Fouché, Black vernacular creative technology is made up of three components— re-deployment, re-conception, and re-creation—that allow African Americans to process and reimagine the uses of symbols and technologies in the Euro-American New World. See Rayvon Fouché, "Say It Loud, I'm Black and I'm Proud: African Americans, American Artifactual Culture, and Black Vernacular Technological Creativity," *American Quarterly* 58, no. 3 (September 2006): 639–61.

7 "As we'll see, Gnostic myth anticipates the more extreme dreams of today's mechanistic mutants and cyberspace cowboys, especially their libertarian drive toward freedom and self-divinization, and their dualistic rejection of matter for the incorporeal possibilities of mind. Gnostic lore also provides a mythic key for the kind of infomania and conspiratorial thinking that comes to haunt the postwar world, with it terror of nefarious cabals, narcotic technologies, and invisible messengers of deception." Erik Davis, *TechGnosis: Myth, Magic, and Mysticism in the Age of Information* (New York: Three Rivers Press, 1998), 80.

Could it be possible for humans to breath underwater? A foetus in its mothers [sic] womb is certainly alive in an aquatic environment.

During the greatest holocaust the world has ever known, pregnant America-bound African slaves were thrown overboard by the thousands during labour for being sick and disruptive cargo. Is it possible that they could have given birth at sea to babies that never needed air?

Recent experiments have shown mice able to breathe liquid oxygen. Even more shocking and conclusive was a recent instance of a premature infant saved from certain death by breathing liquid oxygen through its undeveloped lungs. These facts combined with reported sightings of Gillmen and swamp monsters in the coastal swamps of the South-Eastern United States make the slave trade theory startlingly feasible.

Are Drexciyans water breathing, aquatically mutated descendants of those unfortunate victims of human greed? have they been spared by God to teach us or terrorise us? Did they migrate from the Gulf of Mexico to the Mississippi river basin and on to the great lakes of Michigan?

Do they walk among us? Are they more advanced than us and why do they make their strange music?

What is their Quest?

These are many of the questions that you don't know and never will.

The end of one thing... and the beginning of another.[8]

Integral to the system of the transatlantic slave trade, which spanned from 1514 to 1866, is a ledger of assets, liabilities, and transactions that form a decentralized account of nearly twelve million Africans subsumed by the tragic mass experiment conducted by Portuguese, British, Spanish, French, Dutch, and Danish investment groups, testing the durability of the mind, body, and will of uprooted and alienated humans.[9] By exploiting the law and debt-based system of indentured servitude that existed in parts of

8 The Unknown Writer, liner notes, Drexciya, *The Quest*.

9 "According to the database project Slavevoyages.com, almost 11 million Africans were enslaved during the trans-Atlantic slave trade between 1514 and 1866. While only 300,000 arrived in the U.S. directly, more came to the present-day U.S. via the intra-American slave trade. It is estimated that 4.5 million enslaved Africans arrived in the Caribbean while another 3.2 million disembarked in present-day Brazil. In total, 20 million Africans were forced to leave their continent during the times of the trans-Atlantic slave trade, the trans-Saharan, the red sea and the Indian slave trade." Katharina Buchholz, "The Countries Most Active in the Trans-Atlantic Slave Trade," *Statista*, June 19, 2020, https://www.statista.com/chart/22057/countries-most-active-trans-atlantic-slave-trade/.

Africa amid intercontinental warfare,[10] financially motivated Europeans were able to construct a commercial industry that instrumentalized human bodies as saleable stock intended to exploit the African and American continents into abstract value and excess goods, such as coffee, sugar, and cotton, to be gambled and traded on the global free market. The triangular trade route directly funded the economic and infrastructural development of European countries as a unified and "enlightened" conglomerate after centuries of feudal warfare between kingdoms abandoned in the fall of the Roman Empire. The maritime expansion of European monarchical and aristocratic rule incorporated persuasive psychological warfare, in which diluted interpretations of the Bible and Aristotle's needless discourse on the nature of slavery were used to justify the enslavement of Africans as a means to an end that could manifest the world into a state of modernity. At the center of the Gregorian millennial timeline[11] introduced by Pope Gregory XIII in 1582,[12] chattel slavery fit within the schema of international, stratified enterprise: it optimized many aspects of labor and wealth cultivation, from so-called Antiquity to the construction of the New World of the Americas and the scientific and industrial revolutions that demolished existing non-European indigenous civilizations. The nautical, cross-continental flow of living and manufactured commodities continued to be used in the following centuries as an ever-present demonic stain on the moral character of the "globalized" Western world. In transport along the Middle Passage, each slave received a maximum of four feet of space; they were packed into ships like cargo, with approximately 15 percent, or two million ill or dying Africans being thrown overboard.[13] As the Biblical book of Matthew asks: "What good will it be for someone to gain the whole world, yet forfeit their soul?"[14]

In his book *The Black Atlantic*, Paul Gilroy surveys the double consciousness of Africans throughout the diaspora, as they experience the transference of "social death"

10 "The serf of the Middle Ages was as totally in thrall as the African slave. . . . So, this institution was characteristic of all mankind, regardless of color. It is erroneous to believe that European slavery, especially in modern times, was but an exceptional and fragmentary social phenomenon. After its contact with Africa, sixteenth-century Europe progressively lost the custom of internal slavery and, taking advantage of its superiority in arms, substituted Black slavery. After the contact with Europe, the lot of Africa's slaves suddenly got worse, since it then became possible for them to be sold to persons who would export them, with the whole chain of well-known evils entailed in these forced crossings." Cheikh Anta Diop, *Precolonial Black Africa: A Comparative Study of the Political and Social Systems of Europe and Black Africa, From Antiquity to the Formation of Modern States*, trans. Harold Salemson (Chicago: Lawrence Hill Books, 1987), 152–53.

11 "Running counter to such enthusiasm is the fact that as an instrument of propaganda the Gregorian calendar is intrinsically flawed. Apocalyptic hopes for AD 2000 systematically confuse millenarian expectations for Christ's thousand year reign (RevXX) with millennialist investment of neat calendric intervals. The midnight of December 31st 1999 does not coincide with achristian festival (christmas), has no historically defensible commemorative relevance, and does not (as Gregorian year MM) even mark the beginning of a new millennium." Cybernetic Culture Research Unit, "Y 2 paniK," in *Digital Hyperstition* (Falmouth, UK: Urbanomic, 1999), 9–10.

12 Britain and the British Empire (including the eastern part of what is now the United States) adopted the Gregorian calendar in 1752. Sweden followed in 1753.

13 Patrick Manning, "The Slave Trade: The Formal Demographics of a Global System," *Social Science History* 14, no. 2. (Summer 1990): 258–60.

14 Matthew, 16:26 (New International Version).

from the damned European kingdoms into enslaved Black bodies.[15] Gilroy proposes that the site and "historical juncture" of the transatlantic slave trade created the necessity for a kind of adaptation in the manner of thinking and being African in modern civilizations—a relationship and pattern erupting from "the stereophonic, bilingual, or bifocal cultural forms originated by, but no longer the exclusive property of, blacks dispersed within the structures of feeling, producing, communicating, and remembering what I have heuristically called the Black Atlantic world."[16] Gilroy's delineative frameworks for re-suturing the disparate hybrid cultures and consciousnesses of Africans spread across Western civilizations is reflected in the epigenetic theories undergirding the liner notes of Underground Resistance's *Interstellar Fugitives* (1997), and later expanded into the thought constructions of "order" and "chaos" explored in their album, *Destruction of Order* (2005). In a 2017 retrospective on Drexciya, writer and musician Greg Tate posited that Drexciya could have its origins in stories of the Igbo, "the Africans least preferred for the slave trade because they were known to jump off ships and drown themselves. There's even myths about them not drowning but walking or flying back to Africa."[17] Those left behind in the Atlantic Ocean could plausibly lay claim to their own mythology—just as Europeans had created the myths of "Antiquity" and "modernity"—thus yielding an alternative possibility of life and growth for the alienated surface dwellers in the underwater civilization of Drexciya.[18]

The Quest's narrative of the myth of Drexciya as one rooted in the Black Atlantic world system adapts historical material into a malleable narrative that inherently runs counter to the history, intentions, and goals of the modern world, founded on the manifestly evil desire for excess and domination. At the same time, the myth of Drexciya reengineers the story of Atlantis, an island sunken in the middle of the Atlantic Ocean as punishment by the gods, relayed in 360 BC by Greek philosopher Plato, shoring it up as an example of how an overly imperial civilization could fail.[19] Plato's

15 Paul Gilroy, *The Black Atlantic: Modernity and Double Consciousness* (Cambridge, MA: Harvard University Press, 1993), 63.

16 Gilroy, *The Black Atlantic*, 3.

17 Greg Tate, quoted in Mike Rubin, "Infinite Journey to Inner Space: The Legacy of Drexciya," *Red Bull Music Academy Daily*, June 29, 2017, https://daily.redbullmusicacademy.com/2017/06/drexciya-infinite-journey-to-inner-space.

18 "Drexciya gives us a different entry into theorizing and sharing Black liberations by pushing us to think differently about how (and why) we gather knowledge: the band, their narratives, their anonymity and unintelligibility, and their lyricless improvised synthesized texts storm and explode identity-personality-embodiment, the moment we honor the creative labor that lies within and across these intertwining narratives." Katherine McKittrick, *Dear Science and Other Stories* (Durham, NC: Duke University Press, 2020), 57.

19 "For Atlantis was a vast island in the ocean, over against the pillars of Herakles, and her people were mighty men of valour and had brought much of Europe and Africa under their sway. And once the kings of Atlantis resolved at one blow to enslave all the countries that were not yet subject to them, and led forth a great host to subdue them. Then Athens put herself at the head of the nations that were fighting for freedom, and after passing through many a deadly peril, she smote the invaders and drove them back to their own country. Soon after there came dreadful earthquakes and floods; and the earth opened and swallowed up all the warriors of Athens; and Atlantis too sank beneath the sea and was never more seen." Plato, *The Timaeus of Plato*, ed. R. D. Archer-Hind (London: Macmillan & Co., 1888), 67. See also Plato's *Critias*.

condemnation of Atlantis, in comparison to his idealization of Athens, laid the philosophical groundwork for his understanding of physical and spiritual worlds bound by the souls and experiences of humans in an eternal, reciprocal dialogue throughout time. During the twelfth century BC, Sea People invaded much of the Middle East, igniting a war with Egypt on the shores of the Nile River; alongside significant developments in climate change, this conflict ushered in the collapse of ancient civilizations from 1200 to 900 BC.[20] Leaping 3,000 years into the nearing collapse of modern civilization at the edge of the twenty-first century, the myth of Drexciya functions as a haunting reminder of the cyclicality of time, human greed, and arrogance, while also offering the Black Atlantic world a message of hope and spiritual transcendence. The historical mythology and coded world-building methods used by Drexciya fascinated British-Ghanian theorist Kodwo Eshun, who studied *The Quest* as an Afro-modernist odyssey whose fragmented message traversed time and space, meeting him on the opposite end of the Black Atlantic:

> In an American context, questions of futurity are absolutely critical: for African-Americans, Latino-Americans, Asian-Americans and all diasporic subjectivities, science fiction is by no means escapism. It's the reverse: science fiction is a kind of theory of escapology which enables you to diagnose the traps that society, especially a society based around police power, based around white supremacy and based around a kind of aesthetic hierarchy which continually refuses to accept African-American aesthetic projects, refuses to give them their due. Under these conditions, science fiction takes on a critical and political role.[21]

In his 1998 article "Drexciya: Fear of a Wet Planet," Eshun considers *The Quest* as a collection of artifacts from the Drexciyan world, postulating that, "Rather than projecting imaginary soundtracks onto the mind's screen, Drexciyan techno puts a distance between you and it. To listen is to be shut out of their inhuman world. You want into that world but all your senses tell you that you won't survive it."[22] Drawing comparisons to Jimi Hendrix's "1983… (A Merman I Should Turn to Be)" (1968), Parliament's "(You're a Fish and I'm a) Water Sign" (1978), and L.T.J. Bukem's "Atlantis (I Need You)" (1993), among other subaquatic premonitions in Black music, Eshun sketches a brief lineage of aquatic-minded music that uses modern studio equipment to conjure fluid stereophonic, forward-thinking audio documents of coded emotional expressions. Eshun makes reference to X-103's 1993 album, *Atlantis*, to locate Drexciya's *Quest* within the extended Afrofuturist crusade broadcasted from Detroit through the vibrational technology of techno:

20 See the temple of Medinet Habu at Thebes, inscription made in Rameses III's eighth year (ca. 1188 BC), "The War Against the Peoples of the Sea," trans. John A. Wilson, in *The Ancient Near East: An Anthology of Texts and Pictures*, ed. James B. Pritchard (Princeton, NJ: Princeton University Press, 2011), 237–38.

21 Kodwo Eshun, quoted in Rubin, "Infinite Journey to Inner Space."

22 Kodwo Eshun, "Drexciya: Fear of a Wet Planet," *The Wire* 167 (January 1998).

By inventing another outcome for the Middle Passage, this sonic fiction opens a bifurcation in time which alters the present by feeding back through its audience—you, the landlocked mutant descendent of the Slave Trade. The sustained cruelty of Drexciya's project is not so much justified as it is distributed and intensified. If the dominant strain in Afrodiasporic pop culture stresses the human, the soul, then the postsoul, posthuman tendency Drexciya belong to rejects the human species by identifying with the alien. From Sun Ra's instruction to the peoples of Earth to Parliament's greetings to the citizens of the universe, from The Martian's astro disco Red Planet series to Dr Octagon's address to Earth people, becoming alien allows an extraterrestrial perspective. The ET discontinuum generates a new emotional spectrum towards the human: attraction, indifference, hostility, medical curiosity.[23]

Beginning in the late 1500s, early Drexciyans organized calculated raids on thousands of ships transporting African captives. On either side of the Atlantic, the Western world erupted into the American Revolution (1765–83) and the French Revolution (1789–99). Thrusting these revolutions forward were the Scientific Revolution initiated by Isaac Newton's destabilization of the natural world order with the invention of mathematical systems that measure and predict acceleration and velocity at planetary scale, and the discovery of optics and theories of light and color in the midst of the widespread bubonic plague of 1666.[24] Over the next four hundred years, the Drexciyans built a "Bubble Metropolis" that would parallel the exponential growth of modern civilization from the bottom of the Atlantic Ocean, mounting an empire beneath the circuit of the Middle Passage.[25] While the transport of African slaves was banned with the passing of the Act Prohibiting Importation of Slaves of 1807 in the US, and the Slavery Abolition Act of 1833 in England,[26] the enterprise of the transatlantic slave trade continued in illegal underground markets until 1860 when the Clotilda, one of the last slave ships to travel the Middle Passage, landed in the port of Mobile at the southern tip of Alabama. The one hundred and sixty African captives from Yoruba, Ewe, and Fon ethnic groups were sold into nearby counties, and

23 Ibid.

24 Mirielle Lopez-Guzman, "Newton's 'Year of Wonders' During the Great Plague," *New York Society Library*, May 12, 2020, https://www.nysoclib.org/blog/newton%E2%80%99s-%E2%80%9Cyear-wonders%E2%80%9D-during-great-plague.

25 "Drexciya are often tagged as Afrofuturists. The aquatopia that spatializes many of their albums promises a science fiction future that is shaped by and has learned from the violence of the Middle Passage. The cosmogony offered by Drexciya is seductive: it not only reminds us of funk and Sun Ra and Octavia Butler but also–perhaps more importantly–takes into account, and gives a regenerative future to, the violences that occurred on the Middle Passage. The killing of enslaved Africans on the Middle Passage was commonplace; the deliberate murdering aboard the slave ship Zong stands out as one of the more studied massacres. According to Drexciya, the hundreds of enslaved people thrown overboard did not die; the enslaved, thrown overboard, gave and gives us life." McKittrick, *Dear Science and Other Stories,* 55.

26 Reuters Staff, "CHRONOLOGY—Who Banned Slavery When?" *Reuters*, March 22, 2007, https://www.reuters.com/article/uk-slavery/chronology-who-banned-slavery-when-idUSL1561464920070322.

a small remaining population of survivors, including historian and storyteller Cudjoe Kazoola Lewis (born Oluale Kossola), eventually established their own freestanding community called Africatown after failed attempts to raise money to return home to West Africa.

W. E. B. Du Bois' 1935 *Black Reconstruction in America* compiled data and general analyses of such attempts by African American communities to build their own culture, metropolitan infrastructures, and sense of modernism and democracy in the years following the Civil War and Emancipation, from 1860 to 1880. In the book's closing chapter, "The Propaganda of History," Du Bois writes that, "No one reading the history of the United States during 1850-1860 can have the slightest doubt left in his mind that Negro slavery was the cause of the Civil War," and concludes: "The panic of 1873 brought sudden disillusion in business enterprise, economic organization, religious belief and political standards. A flood of appeal from the white South reinforced this reaction—appeal with no longer the arrogant bluster of slave oligarchy, but the simple moving annals of the plight of a conquered people."[27]

Neal Shirley and Saralee Stafford's 2015 book, *Dixie Be Damned*, collects a forgotten history of Black insurrection against white capitalist supremacy in the American Deep South that extends Du Bois' articulation of Black Reconstruction during the national crisis of the Civil War.[28] The modern construction of "whiteness" in the United States, they argue, was critical in instituting control and ownership of land and labor, while "Blackness" was fashioned as an opposition to socio-economic constructions of race and class within a new wage system brought to the rural South by the industrialized North. In essence, the "social death" of the Negro slave set into motion the formation of a unified American colonial national identity.[29] "[T]he war's end," they explain, "created power vacuums across the South, where for a period state control was minimal, economic norms were in flux, and populations of laborers were relatively free to

27 W. E. B. Du Bois, *Black Reconstruction in America: An Essay Toward a History of the Part Which Black Folk Played in the Attempt to Reconstruct Democracy in America, 1860-1880* [1935] (New York: Oxford University Press, 2014), xxx.

28 Neal Shirley and Saralee Stafford, *Dixie Be Damned: 300 Years of Insurrection in the American South* (Edinburgh, UK: AK Press, 2015).

29 "The United States is a nation founded on both an ideal and a lie. Our Declaration of Independence, approved on July 4, 1776, proclaims that 'all men are created equal' and 'endowed by their Creator with certain unalienable rights.' But the white men who drafted those words did not believe them to be true for the hundreds of thousands of Black people in their midst. 'Life, Liberty and the pursuit of Happiness' did not apply to fully one-fifth of the country. Yet despite being violently denied the freedom and justice promised to all, Black Americans believed fervently in the American creed. Through centuries of Black resistance and protest, we have helped the country live up to its founding ideals. And not only for ourselves—Black rights struggles paved the way for every other rights struggle, including women's and gay rights, immigrant and disability rights." Nikole Hannah-Jones, "Our Democracy's Founding Ideals Were False When They Were Written. Black Americans Have Fought to Make Them True," *New York Times Magazine*, August 18, 2019, 16.

experiment with new forms of resistance or shore up community infrastructure built underground during slavery."[30]

At the 1900 Paris Exposition, Du Bois exhibited a collection of data visualizations that laid out the story of Black American modernization, followed shortly thereafter by the publication of *The Souls of Black Folk* in 1903, a comprehensive account of the cultural and spiritual progress of African Americans in the Black Belt.[31] Amiri Baraka's writings in his books *Blues People* (1963) and *Black Music* (1967) further processed the "non-American" Black culture systems—such as blues, jazz, and soul—that arose and remained steadfast in the hearts and minds of Africans living and navigating Western colonization and its quickly emerging white techno-utopian ambition to harness "the future" and "global consciousness."[32] In *Blues People*, Baraka asserted that the "secretness and separation of Negroes in America" had a direct effect on the way in which Black people would open themselves to communicating with white America: "By the forties the most contemporary expression of Afro-American musical tradition was an urban one, arrived at in the context of Negro life in the large industrial cities of America."[33] The map that accompanies Drexciya's *The Quest* demonstrates that the Great Migration of Black people from the South to the North in the early twentieth century would begin the process of opening up and optimizing the contained knowledge and codes of African American slaves into a stereo modern Black techno-consciousness.

*

James "Marcel" Stinson began his correspondence with the Drexciyan Empire in 1989, at twenty years old. A decade later, he told music journalist Andrew Duke that he began to make music in the late 1970s as Detroit transitioned from the post-Motown disco era into the turntablist progressive music that congealed into Atkins and Davis' cybernetic blueprint for Detroit techno: "There was the whole musical revolution in the 80s, you know, it goes across the whole entire board—from rock to punk to new wave to R&B to funk to techno to hip hop, so the whole music really

30 Shirley and Stafford, *Dixie Be Damned,* 87.

31 See Whitney Battle-Baptiste and Britt Rusert, eds., *W. E. B. Du Bois's Data Portraits: Visualizing Black America* (New York: Princeton Architectural Press, 2018).

32 "What seems to me most important about these mass migrations was the fact that they must have represented a still further change within the Negro as far as his relationship with America was concerned. It can be called a psychological realignment, an attempt to reassess the worth of the Black man within the society as a whole, an attempt to make the American dream work, if it were going to." Amiri Baraka [as LeRoi Jones], *Blues People: Negro Music in White America* [1963] (New York: Harper Collins Perennial, 2002), 95–96. See also Amiri Baraka, *Black Music* [1967] (Brooklyn: Akashic Books, 2010).

33 Baraka, *Blues People,* 177.

molded us."[34] Stinson expressed an overwhelming urge to contribute his own sound to the collective surge of creative energy flowing across urban Black America, at a time of sharp economic decline and flailing social services. In the mid 1980s, only five years after protesting and ultimately suppressing Don Lewis' unique proto-MIDI innovations in musical engineering, the American Federation of Musicians (AFM) sought to decentralize electronic music through a tax incentive encouraging the whole-sale distribution of outmoded technological equipment, such as drum machines and synthesizers; this, in turn, spurred the progressive, pre-techno music that filled in the culture industry gap left by Motown's closure and departure in 1972.[35] "At that point [when we started recording] it was like we had no choice but to do this because we were busting at the seams,"[36] Stinson noted—the technology was available and there was a vacuum to fill. His releases of hip hop-leaning progressive music as Clarence G with Hyperspace Lab, and his electro collaboration with Gerald Donald as L. A. M. (Life After Mutation) with *Balance of Terror*—so named after a Star Trek episode in which the Enterprise investigates an unseen threat in "the Neutral Zone"[37]—attest to a moment of personal realization as well as the beginning of his conception of the underwater world of Drexciya. "Detroit is very important to our music. It's full of the emotions which come out of this city," he acknowledged in 1997. "The people have this thing about making something out of nothing, especially when times are hard, and they know how to have fun. Right now, there's nowhere else in the world we can experience what we experience here."[38] The arrival of *The Quest* in 1997 stood as the culmination of six years of narrative abstractions broadcast from somewhere in the Atlantic, fleshed out by Stinson, who aspired to create multi-dimensional techno music that could communicate with Drexciya:

> People try to put our music into categories, but it's always different. Every track is way off into its own place. We go over hundreds and hundreds of different angles to put together one piece. That's what the world needs. You've got to work very, very hard, you throw a whole lot of ideas together and throw a whole lot away. You don't settle for less. You have to open up the floodgates of the imagination. A lot of electronic music is straightforward, it doesn't take you on

34 James Stinson, interview by Andrew Duke, "Drexciya," *Cognition Audioworks*, December 13, 1999, http://cognitionaudioworks.com/drexciya.html.

35 "When you ask members of UR how the sound came to be, they'll most likely start by telling you the story of how a slew of sequencers, samplers, and other electronic audio gear became affordable by way of the American Federation of Musicians (AFM)'s tax against electronic music in the mid-'80s. Musicians who could afford this equipment at original cost, and who were finding it difficult to get gigs, would sell their gear at discounted rates or pledge them to pawn shops. This opened the door for a younger, more Black audience to scoop up these toys and start playing." Salome Asega, "Manual Not Included," *Cultured*, July 23, 2019, https://www.culturedmag.com/manual-not-included/.

36 Stinson, interview by Duke.

37 "Balance of Terror," *Star Trek: The Next Generation*, Season 1, Episode 26, aired on May 16, 1988.

38 James Stinson, interview by Tim Barr, "Wave Goodbye," *Muzik*, no. 28 (September 1997), archived at http://drexciyaresearchlab.blogspot.com/2007/12/1997-drexciya-muzik-interview.html.

an adventure. Too many records just go from point A to point A. Our material zig-zags. We want to take you from point A to infinity. The music is there to implant in your imagination and let your psyche take over and run wild.[39]

The relationship between Drexciya and Stinson naturally assumes the "double consciousness" experience Du Bois investigated in 1897 and Gilroy optimized in his own writing in 1993. The considerate yet complicated royal "we" that emerges in conversations with Stinson contains multitudes: from his spiritual strivings for the higher power of God, from whom he claimed to receive his musical ability; to Drexciya, the Black Atlantic empire engaged in vibrational war and intercession alongside Underground Resistance; to the musical production units within Drexciya that would function variously as special operative cells, developing contrasting, multi-angled new strains of Detroit techno.

After the *Aquatic Invasion* of 1995, the extended Drexciyan assault unit, composed of Gerald Donald and Dennis Richardson, formed Ultradyne, releasing *E Coli* (1995) on Warp and *Cities in Ruin & Beings Laid to Waste* (1997) on Sabotage before appearing alongside Drexciya on the *Uncharted* EP (1997). This last album recorded the corrosion of economy, industry, and humanity in the surface world, anticipating the full-length album *Antartica* (1999), which explored the uninhabitable frozen continent, and the EP *Futurist* (2000). Meanwhile, Donald—as Dopplereffekt and Japanese Telecom—investigated the nature of the *Fascist State* (1995) of the current nationalist world order[40]; released *Infophysix* (1996) and *Sterilization [Racial Hygiene and Selective Breeding]* (1997) under the name Dopplereffekt; and compiled his singles released throughout the '90s in the German Romantic compilation, *Gesamtkunstwerk* (1999)—a reference to Richard Wagner's theoretical writings on the "total work of art" in "The Artwork of the Future and Opera and Drama" (1849).[41] Dopplereffket's 1994 essay "Fascist State 4018" pushed this analysis of totality further into the biopolitical sphere, theorizing the intricacies of a "pornocracy," or "a system of government controlled and administered by perverts who use the scientific method to propagate universal societal control through sex."[42] In 1995 Drexciya, Dopplereffekt, and

39 Ibid.

40 "Socialism is an ideal political concept in theory. However, in practice, no one followed Marx's or Engel's instructions and visions to the letter. Therefore it became corrupted. We've seen the collapse of the Soviet Bloc, which had lasted nearly a century. This political theory was designed to place all men in an egalitarian position, and hence create a utopia for the working classes. The purpose of the connection on the album cover was to pay homage to the ideal of this political idea. Music is a communicative medium to represent concepts of any kind, political or otherwise." Gerald Donald, "Master Organism: A.J. Samuels interviews Gerald Donald," *Electronic Beats*, May 29, 2013, https://www.electronicbeats.net/gerald-donald-interview/.

41 Richard Wagner, "The Artwork of the Future" [1849], in *The Art-Work of the Future, and Other Works*, trans. William Ashton Ellis (Lincoln: University of Nebraska Press, 1993).

42 The essay was published as an advertisement in the third and final issue of the Texas-based electronic music fanzine *Hard Sync*, alongside a review of the project's first single "Superior Race/Cellular Phone." Dopplereffekt,

Ultradyne joined forces as Elektroids, releasing the album *Elektroworld*, which put forward a reconsideration of Kraftwerk's German futurist *Computer World* (1981) in the context of American free-market political economics. A promotional sheet accompanying the album vaguely alludes to a sonic fiction about the four young sons of an electrician living in Flint, Michigan, a city 60 miles outside of Detroit. Founded by General Motors in 1908, Flint, much like Detroit, experienced drastic deindustrialization at the end of the twentieth century, leading to a string of financial crises that continued into a water crisis from 2014 to 2019, during which Michigan Governor Rick Snyder allowed for the city's water source to be changed from the Detroit Water and Sewerage Department, which treats and cleans water of dangerous chemicals, to the polluted Flint River. More than 100,000 Flint residents were exposed to, and upwards of 12,000 children contaminated with, lead poisoning from drinking water.[43]

"Drexciya is a very pure world, no drugs, no alcohol, no casualties or easy money. It's about making life a whole lot more enjoyable and making some kind of sense of it all," Stinson explained. "We're trying to get some soul back in the music."[44] *The Quest* would serve as a final transmission from the Drexciyan Empire: "We couldn't find a better way to give Drexciya's last statement. This album gives the best description possible of what it was all about."[45] As a stereophonic scale model of the Drexciyan Empire, *The Quest* (1997) compiles five years of sent and received intelligence and concepts "You Don't Know," through psychosomatic feelings of "Dehydration" and "Depressurization" that propel listeners into a cerebral journey "Beyond the Abyss," in a fatal encounter with "The Mutant Gillmen (An Experiment Gone Wrong)" from the *Bubble Metropolis* (1993). With the new millennium just over the horizon, *The Quest* marked a step forward: "It's time to prepare for the year 2000," announced Stinson. "It's time to move up to the next level." Ultimately, *The Quest* was a final transmission from the Drexciyan Empire. Drexciya and Stinson's techgnostic dialogue and sonic warfare chronicle an experiment in Black Atlantic consciousness merging the statistical reality of the construction of African American modernism and the alternative speculative possibility of a relation to the ancient Sea people at the dawn of the Black Atlantic World. "The thing about mythology is, it does take on a life of its own," explained Harris (The Unknown Writer), Underground Resistance's label manager, who penned the liner notes on *The Quest*. He and Banks interpreted their tonal communications with the Drexciyan Empire as collaborative world-building:

"Fascist State 2018," *Hard Sync* 1, no. 3 (1994), https://1.bp.blogspot.com/-7yZHs9IaRdA/Xpq7X1YyUGI/AAAAAAAACWY/WQVhvhvdgScGD5Ot0yTvm57_5knbFVZfwCLcBGAsYHQ/s1600/84398867_304652194540 0251_1748731230607638528_o.jpg.

43 Merrit Kennedy, "Lead-Laced Water in Flint: A Step-By-Step Look at the Makings of a Crisis," NPR, April 20, 2016, https://www.npr.org/sections/thetwo-way/2016/04/20/465545378/lead-laced-water-in-flint-a-step-by-step-look-at-the-makings-of-a-crisis.

44 Stinson, interview by Barr.

45 Ibid.

It's easy to say that James was the point person for the mythology, but the thing is Mike [Banks] contributed a lot. There are other folks who contributed towards the mythology, and so it becomes difficult to talk about because there was a lot of back and forth. There were times that I'd say something to James and he'd just go on this 20 minute speech about Drexciya, but then there would be other times when it would sort of go in the other direction and he would almost want to distance himself from it, and then other folks would kind of get back to the raw side of it. I think why the mythology is so dense is that even though a lot of it came from that person, it wasn't all from that person. And I think that's kind of how you build a world: you've got a lot of people in that world, a lot of people contributing to that world.[46]

Having been a part of the X-101 and X-102 projects that laid the groundwork for a certain faction of the second wave of Detroit techno and its Berlin counterpart, Banks sculpted *The Quest* as a last communication with the Black Atlantic World of Drexciya before Stinson's death:

I mean actually large parts of *The Quest*, me and James, I wrote most of it based off of the movie *The Abyss*. But James and them already had a concept of the Drexciyans and the warriors and stuff, so we just built on his concept. I would never say I came up with the concept for them, but I liked that they had an imagination, and that's what hit, resonated with me the most. I was always taught that a person with no dreams is a dangerous person. With no hope, with no dreams, certainly they don't carry much of a future with them. Unfortunately in Detroit you can get real, we called it "grayed out." You get grayed out, you done seen so much that... It's like the same as a soldier, when they in the war. You just expect to die at any time 'cause you living like that. So, guys like that, obviously, I ain't got no time for them 'cause my man in a casket anyway. But this guy right here got a dream, even though it's kinda freaky and I'm trying to understand it. I thought the dream had a sound to it, they had characters to it. It was very intriguing to me that guys from neighborhoods like what they come from, which was tight, it was a tight neighborhood, they were from the East side, that they could imagine like this, and I thought they were very unique and their ideology was very unique and I think I guessed right. I think I guessed right and I'm glad I bet on James Stinson.[47]

A year after *The Quest*, Drexciya resurfaced in the comic book-style Underground Resistance crossover event, *Interstellar Fugitives* (1998). The album combined Atkins'

46 Cornelius Harris, in Rubin, "Infinite Journey to Inner Space: The Legacy of Drexciya."

47 Mike Banks, in conversation with Dimitri Hegemann and Carola Stoiber, hosted by Torsten Schmidt, Red Bull Music Academy, Berlin, 2018, https://www.redbullmusicacademy.com/lectures/mad-mike-banks-tresor-berlin-detroit-lecture.

conception of techno metroplexes built within the mind with Banks' militant hi-tech sonic weaponry and Stinson's Black Atlantic mythscience, narrated by the Unknown Writer. In an interview with Tsutomu Noda, Stinson reveals that the loss of the Stingray and Barracuda Battalion while collaborating with Underground Resistance weighed heavily on the Drexciyan aquatic assault unit. "I stay to myself away from the other guys. I don't listen to the radio. I keep myself in a pure environment. I wanna give you a piece of the Drexciyan world," Stinson said.[48] He divulges that the disbanding of the Drexciyan Wavejumper forces after *Aquatic Invasion* was due to how dissatisfied he was with how colonized techno had become in the dance music industry. "I thought okay I call it quits, I'm tired—then I got thinking there's too much work I didn't do, too many final frontiers, too many unlimited possibilities," he explains. "I just want to continue taking people on adventures, take them away from the stench, the cesspool of this world... continue with the experiments. We will take whoever, the world, to another criteria."[49] Stinson felt rejuvenated after taking some time away from music, though his continued exploration of the principles of water brought the looming prospect of climate crisis and change closer into view. He explained to Noda that *Aquatic Invasion* and *Journey Home* were warnings that the melting of polar ice caps as a byproduct of global warming would ultimately shift the balance of the current world order in favor of the Drexciyan Empire; *The Quest*, then, was not the end of the story but was rather a transitional calm before the coming storm.[50]

*

In the last days of the twentieth century, Drexciya's *Neptune's Lair* (1999) emerged along the Detroit-Berlin Transatlantic Axis through an intercontinental licensing and distribution deal with Tresor. Designed to convey the contours of an underwater scientific research development lab, *Neptune's Lair* located itself in the lost city of *Atlantis*, which had been stereographed by Jeff Mills and Robert Hood as X-103 in their 1993 album of that name. "Researchers have proof that something was there, in that area, and there are connections to other civilisations that were connected to Atlantis,"[51] Mills commented in a 2016 interview. Stinson's exploration of Atlantis, he explained, was in direct correspondence with the interstellar mappings developed in *Discovers the Rings of Saturn* (1992), produced as X-102 with Hood and Banks:

> What intrigued me most was how the city was structured; it was a circular city with a temple in the middle, a temple of Poseidon I think, or Europa, I can't

48 James Stinson, interview by Tsutomu Noda, "Underground Resistance - Designs for Sonic Revolution," originally published in *ele-king* (n.d.), 1999, reprinted in *Straight No Chaser* 2, no. 5 (Summer 1999): 27.

49 Ibid.

50 Ibid.

51 Jeff Mills, interview by Ian McQuaid, "The Music of the Spheres: Jeff Mills Talks," *Ransom Note*, n.d., https://www.theransomnote.com/music/interviews/to-infinity-and-beyond-jeff-mills-talks/.

remember. But it was a circular city, and everything focused around this one point. I think the myth goes that Europa, the princess, she had an affair with the Golden Bull in the centre of the city, and that's when God decided to curse Atlantis and sink it into the sea.[52]

Leaving behind sketches of Black Atlantic sonic possibilities, Mills later remarked that "what I was doing with X-103 was kind of expanding the project, so it wasn't just looking at space science, but the mythical side of things as well."[53] Describing an ultimately unreleased X-103 project, he noted that "the fourth one that was supposed to come out, but never did because I left Underground Resistance, was about black holes. All of these things have been of interest to me for a very long time."[54] The stereomodernist mythscience developed when Stinson shared his vision of Drexciya with UR in a coordinated sonic assault on the colonizing Programmers, which accompanied the spread of techno across the Detroit-Berlin Axis. Audio experiments in the expansion and enhancement of Detroit techno through Tresor continued over the course of the '90s, with Mills and Hood's DJ-friendly beat sculptures in the *Waveform Transmissions* series, alongside other releases through the label such as Hood's *Internal Empire* (1994), Atkins' Information Age speculations in *Skynet* (1998) under the name Infiniti, Scan 7's viral rhythmic signals in *Dark Territory* (1996) and *Resurfaced* (1999), Blake Baxter's soulful *Dream Sequence* (1991) and *Disko Tech* EP (1998), as well as Eddie Fowlkes' enhanced perception in *Black Technosoul* (1996). This international axis was vital to the initiative. In a panel discussion with Tresor's Dimitri Hegemann and Carola Stoiber on the formation of the Detroit-Berlin Axis, Banks remarked that he "thought James [Stinson] had the potential to be an international artist 'cause he had a decent temperament." He added that Stinson "was all off into mutated, *Creature from the Black Lagoon* stuff," describing the biological mutations that James imagined had occurred in the process of Africans adapting to the ocean to become Drexciyan. "It used to disturb me sometimes, some of the s--- they be thinking about, I just listen to them and be like, 'Yeah, yeah, let me hear that track.' [laughter]...I put their sound out 'cause I think the world need to know how twisted up you can get. You can get twisted up just staying in the hood the whole time, and everybody ain't got their hat on crooked and selling dope and going to prison. They different guys."[55]

Plunging into the depths of the Black Atlantic, *Neptune's Lair* situates listeners in the "Temple of Dos De Agua"—Spanish for "two of water"—staging a psychoacoustic adventure deep in the Black Atlantic, beyond the borders of the Drexciyan Empire. Credited with thanks to God "who is my strength and my shield" as well as "Andrea

52 Ibid.
53 Ibid.
54 Ibid.
55 Hegemann, in conversation with Banks and Stoiber.

and Kayanna Clementson [his wife and daughter at the time], for rescuing Drexciya from the cesspool of nothingness,"[56] *Neptune's Lair* widened the scope of Stinson's vision, offering the most detailed glimpses of the subaquatic warriors yet. "James Stinson had very specific ideas about *Neptune's Lair*. He had their whole underwater world and civilization thought out in his head," AbuQadim Haqq, the surface world scribe for the Empire, told the archival blog Drexciya Research Lab in 2008.[57] In 1999, around the album's release, Haqq met Stinson in his basement studio to discuss and develop concepts and artwork that would be fleshed out decades later in his graphic novelization, *The Book of Drexciya*: "He gave me very detailed descriptions and then we worked together on the Drexciyan Warrior and Cruiser."[58] According to Haqq, a scientist named Dr. Blowfin, one of the founders of the Drexciyan Empire, discovered *Neptune's Lair* in 1566, and the concept album chronicles the early Drexciyans' expedition to find what Blowfin regarded as "a foundation for the future, a foundation that has been in the making since ancient times," and "a foundation that will build a new nation."[59] In the interview, Haqq reflected on the creative discussions he had with Stinson: "He was brilliant when it came to science fiction and that's always been my favourite subject matter. When we thought out the concepts of the album together it was very natural for me. I think we worked well together."[60]

Over a decade later, in 2020, Haqq spoke with music journalist Marcus Barnes for the British magazine *Mixmag*: "I have been able to visualise pretty much the whole story of Drexciya. It's a story that should be told."[61] His *Book of Drexciya*, published in 2019, grew from the musical world system developed and recorded in *Neptune's Lair* by Stinson. The cover photo depicts Drexciyans in the background of a murky cavernous laboratory, containing thousands of years of old research documents, ancient specimens, and lost technologies. A broader journey emerges that uses Stinson's track titles and conversational musings as a guide to craft an illustrative portal into the album's sonic fictional moment in time. "The warriors are returning home to the Bubble Metropolis after battling," Haqq explains. "I wanted to display the strength and honor they had, so I came up with a trident to show the leaders (the ones with capes and golden helmets). The guys behind them have regular blue helmets."[62]

56 Drexciya, back sleeve, *Neptune's Lair* (Tresor, 1999).

57 AbuQadim Haqq, interview by Stephen Rennicks, Drexciya Research Lab, August 26, 2008, http://drexciyaresearchlab.blogspot.com/2008/08/qadim-haqq-interview.html.

58 Ibid.

59 AbuQadim Haqq, *The Book of Drexciya*, vol. 1 (Berlin: Tresor, 2020).

60 Haqq, interview by Rennicks, Drexciya Research Lab.

61 AbuQadim Haqq, interview by Marcus Barnes, "Mysteries of the Deep: How Drexciya Reimagined Slavery to Create an Afrofuturist Utopia," *Mixmag*, October 19, 2020, https://mixmag.net/feature/drexciya-history-interview-feature.

62 AbuQadim Haqq, in Ashley Zlatopolsky, "The Art of Drexciya," *Red Bull Music Academy Daily*, October 1, 2016, https://daily.redbullmusicacademy.com/2016/10/art-of-drexciya.

He proudly shares that for the Drexciyans, "It's a victorious return because they rarely lose, I'll tell you that much. In the background, you can see the Red Hills of Lardossa, which goes along with the Drexciyan discography and matches their songs." "James [Stinson] talked about the Bubble Metropolis that the Drexciyans lived in and did all of their scientific experiments and research in," Haqq recounts. "They had tendrils going into the aquatic floor to get nutrients and different supplies; that was my vision of the Bubble Metropolis as James told it to me when we were doing the concepts for the album art. You'll also see a Drexciyan warrior, which was my prototype of the common foot soldier of the Drexciyans, with the common armor. The orange and yellow is the ocean floor."[63]

In *The Book of Drexciya*, Dr. Blowfin refers to the wormhole at the center of *Neptune's Lair* as "the progenitor's lab," which can generate tears in the fabric of reality allowing for interdimensional travel: "Above it is the aqua wormhole, where you see the Drexciyan Cruisers emerging from," Haqq explains. "This is all part of the Drexciyan storyline, part of their song discography. I think the music reflects the kind of feeling they wanted to bring about with their different ideas about this warrior race."[64] On the subject of Stinson's understanding of the kinds of re-engineered prehistoric technology that the Drexciyans worked with, Haqq says, "James [Stinson] and I talked about the vehicles the warriors would ride around in. I was watching the Discovery Channel one night when I was thinking of ideas [for the project] and they showed these squids. I said, 'You know, that'll be perfect for the vehicles!' So I converted the squids into the Drexciyan Cruiser, and that's what the Drexciyan Warriors rode around in: modified squids, basically. Hybridized squids."[65] Haqq weaves the mythic underwater civilization of the Black Atlantic into the timeline of the surface world, with the aim of achieving a unified, healing, Black exodus. "I'm trying to make this into an actual character to continue ongoing stories," he says of *The Book of Drexciya*. "There's already a mythos behind Drexciya, about how when the slaves were taken across the Atlantic, the women threw their babies overboard and somehow they survived to become the Drexciyans. What I've done is developed that story into more details and added a few more storylines. I guess it would be considered afrofuturism because the roots are in Africa."[66] Exploring the mysteries that lie deep below the ocean, Haqq constructs a passageway that is critical to the future of the Black Atlantic world. "I hope it will help Black people to relate to these songs and these stories in some way," Haqq remarks. "There are many messages, but one of the main messages is, 'coming from the humblest of beginnings, where you're almost wiped out, then overcoming that and improving yourself, making yourself into the greatest person you

63 Ibid.
64 Ibid.
65 Ibid.
66 Ibid.

can be. Facing all of life's challenges and being the best human being to yourself and your community.' It's about people coming together and unifying."[67]

Neptune's Lair transmits a dense narrative directly into the listener's mind across twenty-one tracks—nested and overlapping sonic fictions materialize cerebral and aural impressions of people, places, things, and events within the Drexciyan Empire. The journey begins in the "Temple of Dos De Agua," voiced by a tenor chorus and an obfuscated orator, telling of a "Species of the Pod" that inhabit undersea territory just beyond the "Andreaen Sand Dunes." In *The Book of Drexciya*, Dr. Blowfin, in the late 1500s, leads an expedition team made up of two adolescent, first-generation Drexciyans named Drexaha, the first Drexciyan, and Anhuru, in search of the mythical, centuries-old lair of Neptune—who the scientist refers to as "The Progenitor," an ancient, other-worldly philosopher-king. Dwelling several thousand feet below the surface of the ocean, Dr. Blowfin sought out artifacts of Neptune's research on genetic intelligence and DNA sequencing, which he intended to apply to his designs of the civic and telecommunication infrastructure of the Bubble Metropolis, sustainably powered by the natural resources of algae, seaweed and "Polymono Plexusgel." Once in place, the Drexciyan Empire would be set to begin a militant campaign towards "Surface Terrestrial Colonization." At the bottom of the ocean, the Drexciyans discover a preserved monument bearing the equation "C to the Power of X + C to the Power of X = MM = Unknown,"[68] engraved into the cavernous walls of The Progenitor's laboratory. Dr. Blowfin is joyous, declaring: "This is a key to unlock many wonders! It is a foundation for the future. A foundation that has been in the making since ancient times! A foundation that will build a new nation."[69]

In the last year of the millennial timeline, *Neptune's Lair* marked a turning point for the Drexciyan Empire, in preparation for *The Journey Home*. "In the past we let up some and gave others the opportunity to help, but never again," Stinson said, outlining what he envisioned for the future of Drexciya in a conversation with John Osselaer in early 2002. The music industry of the internet age allowed for much more flexibility in Stinson's approach: "Now we have Dimensional Waves as our production company. We will be giving 97% complete projects to whoever we wavejump to in the future."[70] In the time between the completion of the aural architecture of *The Quest* and the holosonic exploration of *Neptune's Lair*, the landscape and marketability of electronic music had undergone a drastic shift. "The time gaps between releases are time to experiment and perfect our sound," Stinson continued. "We try not to pile onto whatever is the hot sound at a given time, I really do not like that. We have to cut a new path. If we are going to be leaders on the cutting edge we can not follow someone else's

67 Ibid.

68 Drexciya, "C to the Power of X + C to the Power of X = MM = Unknown," *Neptune's Lair*.

69 Dr. Blowfin, *The Book of Drexciya*.

70 Stinson, in Osselaer, "Drexciya."

current work. That would make us followers and not leaders."[71] His concept of "wave jumping" between record labels and routing through the global music distribution system coincided with the dot-com bubble burst in 2001, which sent ripples through the global market, causing a general downturn in revenue in the music industry and a climate of economic transition. Released in January 2002 through Tresor, *Harnessed the Storm* was described by Stinson as "an ongoing process that consists of seven storms (albums) released around the world." He specified that "so far three of the seven storms have hit earth (Drexciya, Transllusion, The Other People's Place). The next four storms are in a holding pattern."[72]

Unfurling within earshot, *Harnessed the Storm* set into motion a notice of "Under Sea Disturbances" and a coming "Digital Tsunami" of rolling 808 beat patterns, nestled underneath cascading hand-played keys that lull the listener into a sonic voyage fleshed out over eight tracks. In 2005, the Drexciya Research Lab pointed to the ancient astronautical writings of John Philip Cohane as an indication of where Stinson intended to transport the listener, comparing the third song on the album, "Song of the Sea," to a line from Cohane's 1969 book, *The Key*: "Saiwala is the oldest recorded form of the word soul. The word saiwala, or soul, is closely related to the word sea."[73] Weighing the reciprocity between the Platonic concept of the soul and the natural phenomenon of the sea, Stephen Rennicks of the Drexciya Research Lab took note of an acceleration in the pacing of the album with the fourth movement, "Song of the Green Whale." After the opening section of environmental audioscapes, the album tilts the listener into narrative exposition with a glimpse of the Drexciyan Empire at the center of the squall. "Dr Blowfins' Black Storm Stabilizing Spheres" offers a view into the future with percolating binaural sounds, hinged on the pumping piston-like textures of Stinson's drum programming. The final sequence of the album prepares listeners for a "Mission to Ociya Syndor and Back" with an ultimate goal of the "Birth of New Life."

Under the name Transllusion, Stinson embarked on the second phase of the seven storms of dimensional wave transmissions he had promised, with *The Opening of the Cerebral Gate* (2001), released through Tresor's short-lived experimental sub-label Supremat. With a "special thanks to God, for allowing us to be able to transmit sound waves into your cranium receptor units," the album's opening track, "Transmission of Life," floods the ears with sense-altering frequencies and dial tones contorted into percussion, picking up from *Harnessed the Storm*'s "Birth of New Life." Stinson's self-imposed isolation took him away from the world of Drexciya and turned his focus inward, toward an exploration of mental states of heightened perception.

71 Ibid.

72 Ibid.

73 John Philip Cohane, *The Key* (New York: Crown Publishers, 1969), 237, quoted in Stephen Rennicks, "Harnessed the Storm," Drexciya Research Lab, August 1, 2005, http://drexciyaresearchlab.blogspot.com/2005/08/harnessed-storm.html.

Extended communication with Drexciya opened Stinson's mind to new possibilities and the "Unordinary Realities" of the twenty-first century. "Crossing into the Mental Astralplane," Stinson shielded himself from the advancing Programmer technologies of the world wide web[74] through self-isolation, elevating the base form of the techno and electro he grew up with in the 1980s into a fully operable sense-making technology. Also in 2001, Stinson furthered such inquiry in his release *The Lifestyles of the Laptop Cafe* (on UK record label Warp, under the name The Other People Place), in which he reflected on the nature of non-digital human connections, trimming the luminescent demonstrations of *The Opening of the Cerebral Gate* down to a deep house-angled techno analysis.

"We are now in the year 2000," Gerald Donald exclaimed in spring 2002 as Arpanet,[75] intercepting Stinson's signals with the album *Wireless Internet*, in which he presciently questioned the rapid expansion of Programmer wireless digital technology and asked: "Will the personal computer and laptop computer become obsolete technology?"[76] Arpanet, Donald's moniker for this album and the 2005 *Quantum Transposition*, references the acronym for the "Advanced Research Projects Agency Network," which Russian American investigative journalist Yasha Levine has argued in his book, *Surveillance Valley,* helped establish the next frontier of information technologies mobilized toward surveillance and the expansion of military intelligence:

> In the 1960's, the U.S. was in the middle of the Vietnam War. Traditional physical weaponry warfare was proving to be unsuccessful with the challenges faced through drastic cultural differences between the Vietnamese and the U.S. So the U.S. embarked on a counter insurgency and domestic research project, known as ARPA, deeply investing in the behavioral and social sciences—creating a more efficient warfare. "The idea was to understand the enemy, to know their hopes, their fears, their dreams, their social networks and their relationships to power."[77]

Arguing that the commercial internet served as a centralized behavioral intelligence technology designed for the United States military, and drawing connections between Euro-American colonizers, who weaponized tactical intelligence against Native Americans, and intelligence agencies employed abroad and domestically by the US

74 The Pew Research Center's Internet & American Life Project started in May 2000 as a demographic research initiative tracking the internet as it became an essential part of everyday American life, concurrent with the beginning of an economic decline in the wake of the dot-come bubble burst in 2002.

75 Arpanet, lyrics, "The Analyst," *Wireless Internet* (Record Makers, 2002).

76 Ibid.

77 Yasha Levine, *Surveillance Valley: The Secret Military History of the Internet* (New York: PublicAffairs, 2018), 30. Quoted in Ari Melenciano, "Radical Technoculture for Racial Equity," written for the conference "Black Portraiture[s] V: Memory and the Archive. Past. Present. Future.," New York University, New York, October 17–19, 2019, self-published on *Medium*, January 26, 2020, https://ariciano.medium.com/radical-technoculture-for-racial-equity-4831ba268bf2.

military, creative technologist and researcher Ari Melenciano frames the internet in such a way as to give credence to Underground Resistance's concept of the enemy Programmers who intend to saturate and standardize culture into sellable media.[78] The psychological warfare of world-building and information exchange that formed the basis of the Western world and its obsession with the rational progress of humanity can be seen as culminating in an ownable distribution of geolocatable information through individual wireless mobile telephones. *Wireless Internet* was a specific turning point in Donald's work, inaugurating his move toward addressing the particulars of the large-scale reality of settler colonialism, its inherent fascist and eugenic nature, and its progression toward techno-utopianism. Using Vocaloid, a digitally produced singing voice synthesizer software, the track "The Analyst" introduces the album as an audio documentary with an extended soliloquy, an onboarding exercise that asks the listener essential questions about the pervasive implementation of the global internet and data as a burgeoning form of currency:

> In today's fast paced society, people want unlimited flexibility and mobility. This is now mandatory for virtually every aspect of human progress. Almost everyone possesses a cellular telephone and the subscription number is expanding exponentially. One day we will all be wireless and this is a fact. One day we will be able to do almost everything by remote control with a multiple array of digital handheld devices. What will the implications be for humanity? Who will benefit and who will suffer? These are the important questions that we as a society must seriously ask ourselves. We are all atomic and subatomic particles and we are all wireless.[79]

Around the release of *Wireless Internet* in 2002, Donald spoke about its prediction that the human body would quickly become a wireless medium in the Programmers' global consciousness era. As he saw it, "In this world either you move forward or you perish. American auto giants had more human concerns than practical ones. Automation is precise and does not require medical benefits or paid vacations. Sometimes you have to make harsh choices and ultimate sacrifices to sustain life. These are the laws of nature and natural selection."[80] On the subject of cultural exchange through global electronic networks, Osselear asks Donald about his fascination with "Japanese technology and European sophistication," suggesting that the development and export of musical instruments such as the Roland TR-808 and MIDI technology—despite Don Lewis' intellectual and engineering contributions to both—had a direct influence on Detroit techno. "Actually our culture was diluted with inferior ideas for nearly a millennium and we are still not bacteria free, so over time we patchworked many influences in

78 Melenciano, ibid.

79 Arpanet, lyrics, "The Analyst," *Wireless Internet* (Record Makers, 2002).

80 Gerald Donald, in John Osselear, "Arpanet Interview," *TechnoTourist*, April 2002, archived at http://drexciyaresearchlab.blogspot.com/2005/12/arpanet-interview.html.

connection with our already existent high racial spirits to create something uniquely our own, this is our new identity at present," Donald detailed. He maintained that the Programmers were constructing a large surveillance architecture in the backend of the free and open internet, referring to a section of the world's unborn population as "the GPS-generation" that will be " tracked anywhere on the planet by our big brothers via satellite."[81]

By the year 2000, new consumer technologies like Nokia cellular phones, Apple iBooks, and second-generation iPods began to fill households, as the analog technologies that inspired Atkins in the 1980s were progressively converting and optimizing lived experience into a novel, digital Information Age. On June 9, 2002 Stinson spoke with Derek Beere about his shift in focus from the underwater civilization of Drexciya to the anteriority of the mind and body in an emerging, digitally mediated world. "We're going all over the place, we're hitting everything," Stinson said of Drexciya: it was a "360 degree angle" experience.[82] "There's a lot of different angles to this. We want you to feel each and every one of these angles," he explained; all of the storm albums were connected and intended to flow into the next through his production company, Dimensional Ways. When asked about the "faceless" aspect of each of his projects, Stinson replied:

> We try and make it a little more interesting so if it's going to be around a long time and if you come back twenty-years down the line and play it for somebody else, you can tell a story behind the music. It has a reason to exist, a purpose. It lives, it breathes, you can smell it, and you can taste it. It's not like fast-food, this is a home cooked meal, a full-course. This is very, very important to us.[83]

Beere submits that the electronic music industry over the past decade overused the term "techno," extending it beyond the scope of where it had begun in Detroit. How, he asks, would Stinson define it, even as he had artistically and spiritually broken free from the city and sound himself. "Back in the day there were maybe two or three different styles, that doesn't exist anymore. Now it's just a generic name and generic title. Everybody has to just go under the title 'techno' and 'electronic music'. It really has no definition to me any more, and that's the reason why we do what we do and just make music. It's sad to say, but that's just the reality of it." The interview eventually turns away from the competitive aspects of the electronic music industry to focus on the myth of Drexciya. Asked whether the people and locations cited throughout its output could be found in the present day, Stinson flatly denies the general premise of the question:

81 Ibid.

82 James Stinson, interview by Derek Beere, "Drexciya," *Future BPM*, June 9, 2002, archived at http://web.archive.org/web/20020609044525/http://www.futurebpm.com/drexciya.htm.

83 Ibid.

Nope. Sorry. This point is going to have to be rearranged. In other words, what I'm trying to say, is there's going to have to be a great flood again and destroy everything and restart. Somebody has to hit the restart button because, right now, I don't think so. Somebody's opened up Pandora's Box and all hell is breaking loose. That's why I'm pushing the gas and I'm putting out more stuff. The kind of images with Drexciya and stuff, I'm taking people away from here. I feel like Noah's Ark, I'm loading up the Drexciyan-Ark and taking your mind on a trip away from here for a little while.[84]

Stinson, who had only traveled as far as one hundred and fifty miles outside of Detroit through his job as a truck driver, did not intend to perform Drexciya live. "No, I haven't left here yet. I haven't left the country yet. I have too much work to do here," Stinson said, considering the possibility of presenting Drexciya to a live audience, before conceding, "It's not there yet." "One of the main things that makes me tick," he added, "is how I feel, I go on vibes. I listen to that inner voice that tells me what to do and I do it. One of the things that my inner voice told me a long time ago was to stay home." Discussing his isolation in greater detail, Stinson voiced that he would never pursue a world tour, preferring to "wave jump" between record labels while the Drexciyan Empire studied the behaviors of surface dwellers, before initiating their surface terrestrial colonization campaign at full scale. "We'll pop up somewhere, unannounced, you will never see it coming and then we're gone," James warned. "It'll be like 20 minutes before a show. Drexciya live, in Japan somewhere, down in a sea-port or submarine park downtown… that's how it would be."[85]

In his 2002 interview with Osselaer, Stinson shared vague details of his eventual move to Newman, Georgia, in the Deep South, a city forty miles outside of the Atlanta metropolitan area where Du Bois had lived intermittently between 1897 and 1910, and 1934 and '44. "If I want Drexciya and all that I do, then I must stay away. That way when I relocate to Atlanta (TT: Atlantis? ;-) this summer you will not hear a change."[86] Founded in 1830, Atlanta was named by John Edgar Thomson, a chief engineer of the Georgia Railroad and Banking Company, who led the construction of the historically long Atlanta-to-Augusta railroad line.[87] The transportation axis was established as a central throughway for national distribution between the Western and Atlantic regions of the American continent, only months after the forcible removal of the Creek Indigenous people who had inhabited the land for more than eleven thousand years.[88]

84 Ibid.

85 Ibid.

86 Stinson, in Osselaer, "Drexciya."

87 James A. Ward, "J. Edgar Thomson and Thomas A. Scott: A Symbiotic Partnership," *Pennsylvania Magazine of History and Biography* 100, no. 1 (January 1976): 37–65.

88 "In a very real sense, the familiar Creek and Cherokee tribes of the late 18th and early 19th century were not

Atlanta was almost entirely engulfed in flames during the Civil War. General William T. Sherman's "March to the Sea" employed a "scorched Earth" military policy that ordered the Northern Union army to destroy any and all forms of financial and industrial infrastructure and property throughout Georgia as a means of strategically dismantling the Southern Confederate Army.[89] "Some historians have claimed that the British abolition of the slave trade was a turning point in modernity, marked by the development of a new kind of moral consciousness when people began considering the suffering of others thousands of miles away," law professor Mehrsa Baradaran writes of the economics of freeing African American slaves. "But perhaps all that changed was a growing need to scrub the blood of enslaved workers off American dollars, British pounds and French francs, a need that Western financial markets fast found a way to satisfy through the global trade in bank bonds."[90]

The Atlanta compromise speech given in 1895 by educator Booker T. Washington at the Cotton States and International Exposition in Atlanta acted as an unwritten social contract between Black and white Southerners. The compromise wagered that newly freed African Americans would be able to receive funding for vocational, industrial, and university education if they agreed to remain segregated without the right to vote in local or national elections. Washington's address began by leveraging the value of the freed Negro as a central compenent of America's agricultural, mechanical, and commercial future: "One-third of the population of the South is of the Negro race. No enterprise seeking the material, civil, or moral welfare of this section can

unchanged relics of the prehistoric past, but instead reflected a new type of Southeastern Indian society forged out of the dynamic and turbulent centuries of the European colonial era. Although most of the individuals, families, and even towns which made up these new societies descended directly from those of the late prehistoric period, many of them had been forced together (geographically and/or politically) from widely separated regions and cultures, often living in regions once occupied by other peoples. The end result (certainly in the case of the Creeks) was a multi-ethnic aggregate made up of the splintered fragments of many ruined prehistoric societies. Even though this means that the names Creek and Cherokee have very little to do with most of the Georgia's prehistoric past, and that these two tribes bore only a partial resemblance to the chiefdoms of that earlier era, this nonetheless does not detract from their status as important components in the history of Southeastern Indians. Indeed, the formation and survival of the Creek and Cherokee societies, even to the present day, serves as a tribute to the persistence and adaptability of the original inhabitants of this continent. The very fact that these and other groups did survive under conditions of extreme necessity makes them one of the few success stories of the dynamic and often tragic era when the Old World met the New." John E. Worth, "Before Creek and Cherokee: The Colonial Transformation of Prehistoric Georgia," *Fernbank Quarterly* 18, no. 3 (Summer 1993), https://web.viu.ca/davies/H320/Worth.BeforeCreek.Cherokee.htm.

89 "Remembered more pithily as 'War is hell,' the phrase distilled a sentiment that Sherman had voiced on many occasions, including once before the mayor and town council of Atlanta after he had brought that key Confederate city to its knees. The fact that this grand master of scorched-earth devastation abhorred war was, in his mind, neither an irony nor a contradiction. Sherman simply saw his approach to war as the best way of limiting its lethal potential. Others, and not only partisans of the Confederacy, see it differently. To them, Sherman's devastating march through the South opened the way to the kind of warfare that culminated in World War II. Called total war, it goes beyond combat between opposing military forces to include attacks, both deliberate and indiscriminate, upon civilians and non-military targets. But was Sherman truly responsible for the strategic rationale that we now associate with the bombings of London, Dresden, and even Hiroshima? It is a question that historians continue to debate." Jay Tolson, "General Sherman's Destructive Path Blazed a New Strategy," *U.S. News*, June 24, 2007, https://www.usnews.com/news/articles/2007/06/24/general-shermans-destructive-path-blazed-a-new-strategy.

90 Mehrsa Baradaran, "Cotton and the Global Market," *New York Times Magazine*, August 18, 2019, 38.

disregard this element of our population and reach the highest success."[91] The political and educational revolution that took place in the Black city of Atlanta during the Reconstruction era at the end of the nineteenth century was met with an aggressive expansion of segregation and a massacre in the twentieth century.[92] The following years would unravel into a nationwide nadir of American race relations, prompting a nearly four-decade-long civil rights struggle to renegotiate the legal terms of Black citizenship and the potential benefits of integrating into a white capitalist colonial society.[93] In the 1950s and '60s, the deepening of resentment between white former slave owners and Black free communities mounted into a Civil Rights Movement led by Martin Luther King, Jr., against Southern power structures hobbled into place by the rebounding and militaristically violent white aristocracy of the Antebellum era.

"For centuries the Negro has been caught in the tentacles of white power," King wrote of the meaning of Black Power. "Many Negroes have given up faith in the white majority because 'white power' with total control has left them empty-handed. So in reality the call for Black Power is a reaction to the failure of white power."[94] King was concerned about the health of the souls of Black people following the passing of the Civil Rights Act of 1964, integrating the Black community into a settler society with many secrets buried beneath the militarized, capitalist republic of the United States.[95] In his interview with Osselaer in 2002, Stinson was asked whether Drexciya was related to the myth of the Knights of the Jaguar as a means of resisting Euro-American colonizers. Osselaer pondered further still about whether something could be learned from the mythical civilizations representing radical alternatives to the colonized world he presently occupied. "Some of the things of slavery will tell more when the time comes. Stay tuned!" Stinson replies, "I can only tell you a little bit now. After the storm is over I will tell the story. What I can tell you is that in Africa we have a dimensional jump hole. Tell you more later."[96]

91 Booker T. Washington, *Up From Slavery* [1901] (New York: Signet Classics, 2000), 152.

92 Kathy Lohr, "Century-Old Race Riot Still Resonates in Atlanta," NPR, September 22, 2006, https://www.npr.org/templates/story/story.php?storyId=6106285.

93 "A legal status of freedom without actual civil rights would mean almost nothing. The answer of the South to a proposal of civil rights was the Black Codes, which established a new status of slavery with a modified slave.... The Freedman's Bureau and the Civil Rights Bill represented an attempt at Federal intervention to enforce freedom by Federal Law. The South bitterly opposed these attempts on the part of the national government and declared with Johnson that such attempts were unconstitutional." Du Bois, *Black Reconstruction in America*, 329–30.

94 Martin Luther King, Jr., *Where Do We Go From Here: Chaos or Community?* (Boston: Beacon Press, 2010), 33.

95 "The American frontier is one of the great mythic mindscapes of the modern world. An El Dorado of literally golden opportunity, the Western territories were also a landscape of the solitary soul, virtual spaces where the American self could remake and rediscover its longed-for origins. The frontier was a liminal zone beyond the mundane boundaries of civil society, with its archons of politicians, lawyers, and established religious institutions." Davis, *TechGnosis*, 106.

96 Stinson, in Osselaer, "Drexciya."

*

Submerging into future shock, Stinson, in a reversal of the course of the Great Migration of the 1940s, made the exodus from Detroit—a once industrious Black community in a state of rebuilding after decades of neglect and decay—to Atlanta, a city in the Black Belt region undergoing an influx of wealth and demographic shift as a growing center for Fortune 500 companies such as Coca-Cola, Home Depot, and AT&T. "[This] part of the country possessing this thick, dark, and naturally rich soil was," as Booker T. Washington noted, "the part of the South where the slaves were most profitable, and consequently they were taken there in the largest numbers." In his instructive biography, *Up from Slavery*, Washington defined the Black Belt as the origin of Black America: "The term seems to be used wholly in a political sense. That is, to designate counties where the Black people outnumber the white."[97] Over three miles long, the Black Belt's unusually calcium-rich soil was an integral component of the agricultural and industrial flourishing of the American colonization project, which simultaneously used the transatlantic Middle Passage to construct Western modernity. *Cretaceous Deposits of the Eastern Gulf Region*, a 1914 survey of the Black Belt by American geographer Lloyd William Stephenson, showed that the region's fertility was a byproduct of weather limestone remaining from the ancient extension of the Atlantic Ocean that once submerged the South-Eastern Gulf of America.[98] In 2020, Latif Nasser, a co-host of the journalism podcast and sound design platform Radiolab, posted a thread on Twitter explaining the connection between the death of plankton in the Cretaceous era of the American continent and the outcome of the 2020 presidential election, in which Black voters in historically suppressed regions of the South were able to cast ballots in record numbers, pulling Democratic nominee Joe Biden over the edge and ousting the impeached sitting President, Donald Trump.[99] It's likely that by 2002, Stinson was knowledgeable about the geophysical cycles awaiting the surface dwellers of the American Deep South, which he and Banks had conceived in the map that accompanied the 1997 album *The Quest*, imagining "The Journey Home" as a central axis of the North American shoreline, rooted within a Black community three-hundred-years in the making.

On October 21, 2002, Stinson, as Transllusion, returned with a message to the world in the album *L.I.F.E.* (on Aphex Twin's Rephlex label), subtitled "Don't Be Afraid

97 Washington, *Up from Slavery*, 75.

98 Lloyd William Stephenson, *Cretaceous Deposits of the Eastern Gulf Region and Species of Exogyra from the Eastern Gulf Region and the Carolinas* (Washington, DC: Government Printing Office, 1914).

99 Latif Nasser, Twitter, November 2, 2020, in James Crugnale, "This Twitter Thread Reveals the Prehistoric Origins of the Southern Blue Swoosh on the Electoral Map," November 5, 2020, https://digg.com/2020/southern-blue-swoosh-electoral-map-cretaceous-period. See also Bertis D. English, *Civil Wars, Civil Beings, and Civil Rights in Alabama's Black Belt* (Tuscaloosa: University of Alabama Press, 2020); and "Alabama Voters Projected to Eclipse Election Day Turnout Records," *WSDA 12 News*, last updated October 27, 2020, https://www.wsfa.com/2020/10/27/alabama-voters-projected-eclipse-election-day-turnout-records/.

of Evolution": "Life Is Fast Ending - So Live!" The album introduces Stinson's new home in the Black Belt with "Dirty South Strut," a nod to the regional genres of hip hop and electronic music that would branch off from the house and techno of the Midwestern American states and take shape in a Southern network of cities comprised of Atlanta, New Orleans, Houston, Memphis, and Miami. Bounce, trap, chopped and screwed, crunk, and Miami bass converged in Stinson's humid ode to the Deep South, spilling over into the unsettled melodies and 808 contortions of "Memories of Me." A month earlier, Stinson spoke with Tim Pratt of *Detroit Free Press* to discuss the process and workflow behind the ensuing Drexciyan storms. The first three albums *Harnessed the Storm*, *The Opening of the Cerebral Gate*, and *The Lifestyles of the Laptop Cafe* were created in a single year with the intention of capturing a progression of moods and expressions across time and the places where the albums were published, he explained. "We're really pushing the gas pedal now. I'm working at my own pace now. In the past, I would intentionally slow down to see what other people were going to do, but I'm tired of playing games. Now, I'm happy. This is my pace. Get on the gas, get off the gas and end up in a traffic jam."[100] Discussing his own emotional state and his correspondence with the Drexciyan Empire, Stinson divulged: "Sometimes I have to slow down and think because I'm thinking of multiple things all at the same time—it's a domino effect. There has to be a purpose and a reason to exist, it has to be a complete thought." He added:

> Drexciyans like to keep the focus on concept—not us. The calling hasn't come yet, but it's coming soon. I'm starting to get that feeling. When I first started getting into music, it took three years before I felt comfortable to release something. I strive for perfection so much, it doesn't leave here unless it's right. So much work goes into this and I don't believe in failure.

> Really, we operate on a need-to-know basis and we really had nothing to say. Yes, people want to know what's going on. Everyone needs a little information. The problem comes when you give unnecessary information. For many, every release they have, there's this mass interview burst that's unnecessary. They talk about their record and talk about success, and it doesn't make sense. We have no room for that. We say let the concepts and music do the talking for you. After this, there's nothing else to say. We're going back to work. People have misunderstood our secrecy because it's on a need-to-know basis.[101]

Stinson told the *Detroit Free Press*: "If I wouldn't have told you I've been living and moving to Atlanta, nobody would have known, so it doesn't matter. Detroit is a good place. I love it, I was born and raised here."[102] Less a mystery and more of a means of

100 James Stinson, interview by Tim Pratt, "Q&A with James Stinson," *Detroit Free Press,* September 13, 2002.

101 Ibid.

102 Ibid.

documentation, Stinson's style of electronic music conceptualizes the act of creating and listening as a cybernetic operating system capable of infinite invention. "I was born and raised in Detroit, but I'm moving to Atlanta for health reasons," Stinson assured; despite his relocation for the first time from Detroit, he maintained that the new environment wouldn't change the way he approached sound. The pointillist, mutant productions on *L.I.F.E.* embody Stinson's own "Rolling With the Punches of L.I.F.E.," a process that concludes with the album's final track, "I'm Going Home," a fractured, multi-tonal transmission that punctuates the personal pressures and bouts of illness that would lead him to leave Detroit. "Until me and my partner went to high school, the most we knew about this music was from Afrika Bambaataa back in the day," Stinson said of his first encounter with Detroit techno in the '80s. "But what really sparked my interest was what Juan (Atkins) was doing with Cybotron. I was a little kid when 'Alleys in your Mind' was on the radio, but I was just blown away. The years progressed on and the Electrifying Mojo was playing all these groups I liked and I realized it was my destiny—I had to do it."[103] Stinson reflected on his method of producing electronic music in a way that poet and critic Amiri Baraka described as "the Black rhythm energy blues feeling": a "sensibility" that transmits pure expressions of joy, pain and the gradient of emotional sentiments in between.[104] "We don't make songs based on a concept," Stinson said. "We make the songs first and deal with the concept around the songs. The whole thing with the aquatic world was created due to how creative and innovative water is. It's very creative—there's a lot you can do with it. A lot of things that come through water, all these different molecules. That's the way I see the music we do—it's so endless, constantly using different water."[105]

Stinson surmised that "there are little messages that may come back five years later" in his musical world. "I've had things going on from our very first record. There are so many things you have to go back to, to understand the whole story. I'm even thinking of doing a dictionary, a Drexciyan dictionary."[106] Such a project could have been a central reference in reconstructing the Black Atlantic myth and a way to equalize Stinson's day-to-day work in product packing and distribution. When asked if he had regrets at the end of the interview, he simply replied: "The only regret I have is not working harder at the beginning. Instead of pulling the trigger, I hesitated and I wasted a lot of time. I'm not going to dwell on that, though, because I can't change it. I'll get it balanced out somewhere."[107] *Hypothetical Situations* (2003), another storm released by Stinson, this time as Abstract Thought, popped up on the Spanish record label Kombination Research, presenting six simulated sonic environments each representing particular states of being. The album combines and abstracts the concepts

103 Ibid.

104 Baraka, *Black Music*, 175

105 Stinson, interview by Pratt.

106 Ibid.

107 Ibid.

of *The Lifestyles of the Laptop Cafe* (as The Other People Place) and *The Opening of the Cerebral Gate* (as TransIllusion) into a compact and symmetrical examination of mind-body relations when experiencing exterior stimuli, ranging from the "Bermuda Triangle" cloaking the Drexciyan Empire, to the "Synchronized Dimensions" unfolding across his decade-long discography, to the feeling of sexual temptation with low frequency thoughts like "Me Want Woman's Punani." The fifth storm, Lab Rat XL's six-track album *Mice or Cyborg* (2003)[108] was published by the Dutch record label Clone with an untitled tracklist,[109] and a note stating: "This album is the 7th and last storm from Drexciya. R.I.P. James Stinson."[110]

In May 2002, Liz Warner, a DJ and radio host on the Detroit Public Radio station WDET-FM, received a call from Stinson asking if she would like to interview Drexciya.[111] Over a decade later, she joked that she had "wondered if it was a prank call," remarking, "That doesn't happen, right? Drexciya just doesn't pick up the phone to offer a radio interview."[112] Stinson and Warner conversed for half an hour on-air. He described Drexciya as "an infinite journey to inner space." She asked him about his "wave jumping," considering his releasing model as an intriguing distribution strategy for an underground artist, and then inquired about if and when he planned on stopping. Stinson replied, "No, not till I die. That's been a motto, 'Experiments must continue even till death.' Well even if I die next week or whatever there'll still be a lot of music left. I have a nice stockpile left."[113] On October 1, 2002, Tresor released *The Cosmic Memoirs of the Late Great Rupert J. Rosinthrope* by Shifted Phases, "in memory of James Marcel Stinson who died in September 2002."[114] A website titled "Ride Dimensional Waves," "fueled by High Power Groups"[115] and presumably

108 "This Storm will always be the most mysterious due to the untitled tracks and what might have beens but it's also sort of nice that there are still some things which we can never get to the bottom of." Ibid.

109 "Stinson spoke of recording the entire series in one year. Presuming that the recordings were more or less completed by the time the first Storm was released in 2001 or as late as when he began doing the first interviews where he spoke of them being finished, we can guess that 2000 give or take 6 months was the critical time period of their creation. Knowing this, perhaps the general millennium fever of the time was the catalyst to their decision to not waste anymore time and to go all out with this burst of creativity or his health concerns. With this time-frame in mind it's strange to consider that by the time the first Storms were being released into the world a very real storm was about to hit with the attacks of September 11th and their bloody and continuing aftermath. Stinson himself would be dead just days shy of the first anniversary of 9/11 and as we know would not even get to see his Storm series completed." Stephen, "Lab Rat," Drexciya Research Lab, August 27, 2005, http://drexciyaresearchlab.blogspot.com/2005/08/lab-rat-xl.html.

110 Lab Rat XL, back sleeve, *Mice or Cyborg* (Clone, 2003).

111 James Stinson, interview by Liz Warner, WDET-FM, May 2002, https://www.mixcloud.com/backintosh/drexciya-interview-with-liz-copeland-music-overnight-wdet-1019-fm-detroit-052002/.

112 Warner, quoted in Rubin, "Infinite Journey to Inner Space."

113 Stinson, interview by Warner.

114 Shifted Phases, liner notes, *The Cosmic Memoirs of the Late Great Rupert J. Rosinthrope* (Tresor, 2002).

115 Ride Dimension Waves, defunct website, archived at https://web.archive.org/web/20030409042303/http://www.geocities.com/ridedimensionalwaves/1.html.

built by Stinson, listed his various projects and pseudonyms: Drexciya, Transllusion, The Other People Place, Shifted Phases, Abstract Thought, Lab Rat XL, Electroids, and Digital Aphrodisiac. The website, last updated in July 2002, acts as an archive of Stinson's work and a view into his production strategy for a twenty-first-century music industry transitioning into digital marketing, content, and distribution.[116]

Riding the dimensional waves of the seven storms, Stinson embarked on an interstellar journey into the furthest reaches of his mind with *Grava 4* (2002), a sonic fiction that transports listeners to the Drexciyan home universe. A constellation chart and star registry packaged with the album revealed the coordinates of planet Drexciya; a short text informs that an "Earth scientist discovered the home planet of Drexciya on 2-14-2002."[117] Stinson traveled through "Cascading Celestial Giants" using the "Powers of the Deep" to fuel his "Drexcyen Star Chamber." Navigating the "Gravity Waves" by applying the "Drexcyen R.E.S.T. Principle (Research. Experimentation. Science. Technology)" derived from Dr. Blowfin's research on the "Hightech Nomads"[118] of the ancient world, Stinson encountered a solar system composed of the planets Drexciya, Ociya Syndor, Bowslac, and Ceeroze.[119] "700 Million Light Years from Earth," Stinson is instructed to "use the star chart to fix a celestial navigation point, from there you should be able to plot your path back to Earth using rudimentary astronomical guideposts," and "within moments Dr. Blowfin was given the orders to initiate the seven dimensional cloaking-spheres to hide the other three planets from Earth's view."[120]

116 Ibid.

117 Drexciya, back cover, *Grava 4* (Clone, 2002).

118 "In Africa, thousands of years ago, high-tech nomads began to emerge from a dimensional jump-hole. They were coming from Ociya Syndor, 700 million light years from Earth. To those that know, they have left their mark all over the world, but especially in Africa where their traces can be found in the famous Dogon tribe. One day their story will be rediscovered, for they carved forever in stone their journeys path in the Drexcyen Star Chamber. Its location is a subterranean city, deep on the ocean floor. This is where the Africans were brought to when they were thrown off the slave ships. They were rescued and helped to adapt by their ancient cosmic brothers and sisters. Here they became deep sea dwellers in the bubble metropolis and in time went through the hydro doorways and became star travellers themselves.One day, when the need of Earth will be at its greatest, the powers of the deep will be made known to the surface world. For the Drexciyans are never idle, their principle has always been, Research, Experimentation, Science and Technology, from Neptune's time to today." Steve Rennicks, "Grava 4," Drexciya Research Lab, September 29, 2005, http://drexciyaresearchlab.blogspot.com/2005/09/grava-4.html.

119 See star chart in Drexciya, booklet, *Grava 4.*

120 Drexciya, back cover, ibid.

10.
THE COLLAPSE OF MODERN CULTURE

"At the Century's End, the Futurhythmachine has 2 opposing tendencies, 2 synthetic drives: the Soulful and the Postsoul. But then all music is made of both tendencies running simultaneously at all levels, so you can't merely *oppose* a humanist R&B with a posthuman Techno."[1]

– Kodwo Eshun

"The notion of growth is crucial in the conceptual framework of economic technology. If social production does not comply with the economic expectations of growth, economists decree that society is sick. Trembling, they name the disease: recession. This diagnosis has nothing to do with the needs of the population because it does not refer to the use value of things and semiotic goods, but to abstract capitalist accumulation— accumulation of exchange value."[2]

– Franco "Bifo" Berardi

"Now you have the technology to allow you to emulate any sound that anyone ever created. I watch whole labels pop up that live off the whole Chicago house sound. I lived through the '88 shit, no, you're not doing that shit, you know why? Because you're not dealing with the conditions and the reasons and the intentions why they made that music. You weren't dealing with the idea that it's a cultural movement; not just music. You weren't dealing with the idea that there weren't any white people listening to this; it was Black music."[3]

– Theo Parrish

In the early months of 1992, General Motors, headquartered in Detroit, shut twenty-one of its 125 manufacturing factories across the United States, cutting over seventy thousand jobs in the process.[4] Later that year, on October 19, 1992, the third and final televised debate of the US presidential election cycle was held at Michigan State University in East Lansing, opposing then-president George H. W. Bush to

1 Kodwo Eshun, *More Brilliant Than The Sun: Adventures in Sonic Fiction* (London: Quartet Books, 1998), -006.

2 Franco "Bifo" Berardi, "The Future After the End of the Economy," *e-flux journal* 30, December 2011, https://www.e-flux.com/journal/30/68135/the-future-after-the-end-of-the-economy/.

3 Theo Parrish, interview by Alex Nagshineh, *Bonafide*, November 16, 2014, http://www.bonafidemag.com/theo-parrish-interview/.

4 Doron P. Levin, "General Motors to Cut 70,000 Jobs; 21 Plants to Shut," *New York Times*, December 19, 1991, A1.

Democratic candidate Bill Clinton and businessman Ross Perot.[5] The presidential candidates presented their stances on the need for government reforms in the face of a national savings and loans crisis to over sixty-six million viewers. Results of the CNN/USA Today opinion poll issued after the debate favored the independent candidate Ross Perot, an industrialist Texas billionaire, as the winner.[6] Clinton, who was elected as forty-second president, had led off the debate with an opening soliloquy identifying middle-class Americans "as the only group of Americans who've been taxed more in the 1980s and during the last 12 years, even though their incomes have gone down,"[7] alluding to the fact that the wealthiest Americans have been taxed much less under the economic policies put into place in the 1980s by Ronald Reagan, and upheld by his successor, President Bush. Clinton called for a shift away from trickle-down economics and toward direct investment in American infrastructure. A month prior to the debate, the Associated Press reported that Clinton had won the endorsement of many Silicon Valley executives, including from Apple and Hewlett Packard, which set the tone for the Democratic inclination towards a technocapitalist[8] neoliberal order.[9] That same year, the librarian and early internet user Jean Armour Polly coined the phrase "surfing the internet"; ecologist Thomas S. Ray created Tierra, the first computer-simulated organism; and Neil Papworth, a software architect, sent the first ever text message.[10] During that final debate, Clinton foresaw that American "middle-class people will have their fair share of changing to do, and many challenges to face, including the challenge of becoming constantly re-educated."

Bush responded by criticizing Clinton's statement as an assertion of "trickle-down government," preferring to slow government spending and loosen financial regulations on growing businesses: "he says invest government, grow government," Bush parroted, but "Government doesn't create jobs. If they do, they're make-work jobs. It's the private sector that creates jobs. And yes, we've got too many taxes on the

5 George Bush, Bill Clinton, and Ross Perot, "Third 1992 Presidential Debate," East Lansing, Michigan, PBS NewsHour, October 19, 1992, https://www.youtube.com/watch?v=cm-UAfEdWg4.

6 CNN/Time AllPolitics summary of the 1992 Presidential Debates, https://cnn.com/ALLPOLITICS/1996/debates/history/1992/index.shtml.

7 Clinton, "Third 1992 Presidential Debate."

8 "The erosion of public democracy is largely due to the deeply asymmetrical relations of power between governance and the new corporatism. This situation is partly a result of the scale and scope of techno-capitalist corporatism, which are global and mobile, unlike that of public democracy, which are national or local (and therefore confined to a specific territory). Through this asymmetry, the new corporatism can transcend limitations imposed by the boundaries of the national and the local. Accountability can thus be evaded through mobility and through strategies that pit governance structures in different areas against one another by engaging them in competition for investment." Luis Suarez-Villa, *Technocapitalism: A Critical Perspective on Technological Innovation and Corporatism* (Philadelphia: Temple University Press, 2009), 154.

9 "Clinton Endorsed by Silicon Valley Executives," *Associated Press*, September 15, 1992, https://apnews.com/article/3b93c2b683fa146e943321248faa7710.

10 See Piero Scaruffi, "A Timeline of Silicon Valley," *Scaruffi.com*, https://www.scaruffi.com/svhistory/silicon.html; and Tracy McVeigh, "Text Messaging Turns 20," *Guardian*, December 1, 2012, https://www.theguardian.com/technology/2012/dec/01/text-messaging-20-years.

American people and we're spending too much." Jim Lehrer, the debate's moderator, opened the floor to Perot, who promptly suggested that both of his opponents were mistaken in their approach to fixing America's financial deficit: "The basic problem with it," he argued, is that "it doesn't balance the budget." Perot referred to a "financial bleeding" in the US' economic framework. To him, "there's only one way out of this, and that is to stop the deterioration of our job base, to have a growing, expanding job base, to give us the tax base—see, balancing the budget is not nearly as difficult as paying off the $4 trillion debt and leaving our children the American dream intact." His reply was pointed: "We have spent their money," he claimed, "We've got to pay it back." Following the debate, Perot's strongest voting base was young men aged 18 to 34, along with blue-collar workers in the Detroit suburbs who had been Reagan supporters the decade prior.[11] Perot appealed strongly to that constituency throughout his campaign that year, deploying a series of televised media reports on the economic reality of the United States for viewers around the country. Drawing from his background in the US Navy in the 1950s, his career as a salesman at IBM, and his enterprising initiative as an owner of the company Electronic Data Systems, Perot broadcast his analysis of the US economy at a speculative town hall meeting, in which he showed charts displaying a projected increase of 25% in federal spending between 1950 and 2020, even as the current US government, he contended, struggled to adequately deal with the country's decaying infrastructure and an economic recession characterized by drastic decreases in payroll employment, consumer spending, and industrial production.[12]

Democratic nominee Bill Clinton ultimately won the election due to a spike in voter registrations from young eighteen- to twenty-four-year-old first-time voters, spurred in part by the Music Television channel (MTV)'s partnership with the Rock the Vote campaign. MTV was founded in 1990 by Virgin Records America co-chairman Jeff Ayeroff—the same year as Rock the Vote, and only two years after Virgin's UK sub-label 10 Records released *Techno!* The 1992 surge in young voters, however, was unevenly distributed. A 2020 frontpage story in the Houston, Michigan, newspaper *The Daily Mining Gazette*, published as part of a series of articles examining racial disparities within the state, reported that, "In 1992, hip-hop culture was sweeping through America's metro locations and listened to by many African American youths. What Black youths were not getting was proper education about voting."[13] For thirty years, Rock the Vote's mission has been to adapt to "the changing landscapes of media, technology and culture to breakthrough and empower each new generation,"

11 R. W. Apple Jr., "The 1992 Campaign: Political Pulse - Michigan; Michigan Figures to Be, As Usual, Unpredictable," *New York Times*, October 28, 1992, A18.

12 "Ross Perot 1992, Solutions: Balancing the Budget & Reforming Government," infomercial, YouTube video, 28:32, https://www.youtube.com/watch?v=mPIVI0CbCmg.

13 Chris Jaehing, "African American Michigan: Rock the Vote, Suppressing Black Votes," *Daily Mining Gazette*, August 6, 2020, https://www.mininggazette.com/news/2020/08/african-american-michigan-rock-the-vote-suppressing-black-votes/.

by helping young people "navigate obstacles designed to keep them from making their voices heard."[14] The article cites research from the University of Michigan Law School Scholarship Repository on judicial findings of targeted discrimination against Black communities since the 1965 Voting Rights Act. In 1987, under the Reagan administration, the Federal Communications Commission had repealed its fairness doctrine, which ensured that news segments and public discourse broadcast over the radio would include opposing and contrasting viewpoints.[15]

On March 23, 1987, the Economic Development Department of the National Association for the Advancement of Colored People (NAACP) published a report gathering statistical information on allegations of discrimination within the American recording music industry.[16] According to its findings, the Recording Industry Association of America at that time had accumulated a profit of $4.4 billion, with Black artists bringing in nearly thirty percent of that wealth, despite only eleven percent of the industry's consumer demographic being African American. The report further revealed that, "the records of most Black artists are not promoted to white radio stations but are confined to Black-oriented stations, where smaller audiences result in smaller sales. Of the more than nine thousand radio stations in the country, fewer than four hundred target their programming to Black listeners so that the market for Black artists is limited to less than thirty million people in a country of over 230 million."[17] In the report's conclusion, the NAACP's task force determined that:

> The industry is dominated by a handful of giant record companies who employ only a small number of Blacks in creative and managerial positions and limit the power and authority of those they do employ. The companies do not have affirmative-action plans to increase their number of minority employees, nor do they make any effort to use minority entrepreneurs for the many products and services they require. The principal benefits that do accrue to Blacks accrue to performing artists. But even these artists, unless they have reached the status of "crossover," are handled differently than white artists, with smaller financial and other resources being devoted to the advancement of their careers. Many whites profit from the talent of Black recording artists, but very few Blacks are afforded this opportunity.[18]

14 Ibid.

15 Robert D. Hershey Jr., "F.C.C Votes Down Fairness Doctrine in a 4-0 Decision," *New York Times*, August 5, 1987, A1.

16 The Economic Development Department of the NAACP, "The Discordant Sound of Music: A Report on the Record Industry," published March 23, 1987, reprinted in *R&B, Rhythm and Business: The Political Economy of Black Music*, ed. Norman Kelly (New York: Akashic, 2002), 44–58.

17 Ibid., 46.

18 Ibid., 55–56.

In spite of the NAACP's recommendation that the American recording music industry establish a Commission for Equality in the Record Industry, airtime on the radio grew increasingly competitive and skewed towards the majority white consumer demographic. During the mid-'90s, The Electrifying Mojo, grappling with shifting interests, began to experiment with his format in an effort to maintain the mythological relationship he had built with his audience for over a decade. He broadcast his show remotely as he drove through Detroit, interviewing people he encountered in the city against a soundtrack created by his production assistant, Wendell Burke, who controlled the musical backdrop from the WMXD studio. He would also read passages from his 1995 book, *The Mental Machine: A 21st Century Book of Narratives, Poems, and Prose*, which Detroit-based journalist Ashley Zlatopolsky described as "a deep dive into political and societal issues affecting both Black culture and the world, with poems about teen shootings, prostitution, single mothers, the AIDS epidemic, and drugs—a continuation of messages often heard throughout his shows. He precedes each poem with statistics and a cry for change."[19] Eventually, the *Midnight Funk Association* came to an end in 1998. Having shared airspace with The Electrifying Mojo in the late 1980s, Jeff Mills departed from Detroit to Europe, leaving another cultural vacuum behind him. "I had a lot of competition at that time, so you had to really be prepared," he remembered:

> It was another station, and theirs was the Electrifying Mojo. That was my direct competition, we were on at the same time, I was hired to basically battle this guy, and I grew up listening to him. The whole city would tune in to him to listen. I was young, and it was my job to dethrone this guy, so I needed any and everything I could use to do it. It got to the point where I needed to have music which Mojo did not have, or I needed to have versions that were not available. So I began to bring instruments into the radio station. And I was making drum patterns on a drum machine and mixing them into the music. To give the impression that those were records, because no-one would do that at the time. I would have rappers to come in, to rap over those tracks, to give the impression that these were records.[20]

Mills's thirty-minute radio shows on WDRQ and WJLB inspired a wave of DJs, with his aggressive style of playing mere-seconds of techno, house, funk, and hip hop tracks, blending them into a muscular, industrious beat music that planted the seed for the innovation of ghetto tech. "Ghetto Tech was an acceleration of the already highly computerized sound, yet what made it distinct from techno were the colloquial

19 The Electrifying Mojo, *The Mental Machine: A 21st Century Book of Narratives, Poems, and Prose* (Detroit: J-Stone Audio Books, 1995). See Ashley Zlatopolsky, "Theater of the Mind: The Legacy of the Electrifying Mojo," *Red Bull Music Academy Daily*, May 12, 2015, https://daily.redbullmusicacademy.com/2015/05/electrifying-mojo-feature.

20 Jeff Mills, interview by Derek Walmsley, *The Wire* 300, February 2009, https://www.thewire.co.uk/in-writing/interviews/jeff-mills-interview-by-derek-walmsley.

prompts added in tandem with the sound, which became chants on the dance floor," states Taylor Renee Alridge, a native Detroit writer and arts administrator who has written about the rise of progressive music from the 1970s on as indicative of a cultural incline concurrent with the city's industrial decline.[21] "If techno was the musical equivalent of product rolling off the assembly line," she writes, "Ghetto Tech was the progeny of the assembly line: auto workers trying to keep up with an inevitable automation and the growing disposability of the proletariat." She reminisces about hearing ghetto tech from the backseat of her mom's Chrysler van—a vehicle that shuttled her family through the city, built by a company that employed her father, a foreman at the Sterling Heights Assembly Plant:

> Ghetto Tech was the first genre of music that made me curious about where certain sounds were gestated, and the experiences that inspired them, because the authors of these songs were obscure and difficult to identify. They had been chopped, accelerated, and sampled over and over from their origins. I was intrigued by this illegibility. For instance, it wasn't until I reached adulthood and moved away from the city that I found out one of my favorite samples included in a ghetto tech WAXTAX-N DRE mix was from the 1998 *Art of Vengeance* EP, by Iranian techno DJ Aril Brikha—originally at 33 beats per minute. By the time it got to me in Detroit in the same year through R&B and hip-hop radio, the BPM was sped up by double, maybe triple, and sandwiched between mantras about weave, gel, and local dance that weren't at all akin to Iranian techno.[22]

Aldridge describes ghetto tech as embodying the darker, more extractive aspects of industrial capitalism, "under the allure of desires for wealth and prosperity, [leading] into an inevitable ruin. Black Detroit is the Zion of the Matrix, that existed underneath the threat of growing surveillance and deindustrialization in the built environment." Throughout the 1980s, Mills' tenure as The Wizard gifted Detroit with a raw and real alternative to The Electrifying Mojo's shamanic mysticism. Both radio personas ended their shows before Aldridge came of age, in a version of Detroit that was even more vulnerable than their own. "After the turn of the millennium, there were multiple economic disasters happening around the world, but Detroit experienced the brunt of that disaster the hardest. The end of the world happened in Detroit first," she writes. "The paradox is that life became reified through magnanimous loss—through an ecosystem that thrived underneath, one made legible only to those deserving." Aldridge concludes that "Ghetto Tech is that underground that continues to allure, beyond the residue of acceleration and ruin."[23]

21 Taylor Aldridge, "Ghetto Tech: The Soundtrack to Black Ruin," *Three Fold* (Fall 2021), https://threefoldpress. org/ghettotech.

22 Ibid.

23 Ibid

Mills' take on techno's inherent cultural morse code influenced his Detroit disciples. DJ WAXTAX-N DRE marvelled at Mills' unplaceable technique ("it sounds like he has eight turntables or something!'"[24]). Karl Gibson, or DJ Fingers, a member of the early UK hip hop group Sindecut, recalled asking Mills how he managed to get songs to reach the high tempos heard in his mixes: "Every time we got a record from [local store] Buy-Rite, we'd take it home and it wasn't the same tempo as Jeff was doing. I said, 'Jeff, what's going on?' He said, 'Man, open up the Technics turntable. There's a blue button in there that says 'pitch,' there's a plus and a minus—go all the way to the plus.'"[25] Brendan Gillen, one half of the electro duo Ectomorph (with Gerald Donald), remembers Mills' DJ residency at a space in Ann Arbor, a half-hour outside of Detroit: "Nobody had ever witnessed that kind of energy. The way he was cutting up the records was like the atom being split or something. It caused problems all over."[26] Gillen explained that Mills began to attract negative attention from the locals: "They had this racist law—because of how his nights had gone—that I called 'The Wizard Law,' where if there was X amount of Black people together after 1 AM, they were going to be there and break it up."[27]

The term "ghetto tech" was coined by music journalist Hobey Echli in the *Detroit Metro Times* at the end of the decade, in a 1999 review of *Comin' From Tha D*, an album compiled by Jon Layne and edited by Carl Craig with the Buy-Rite record buyer, Sherad Ingram. Titled "Not Just Booty Anymore," Echlin's article caught on to the compilation's sharpened use of electro and bass-heavy dance music emerging in Detroit in the shadow of The Electrifying Mojo and from the shards left behind by The Wizard. These were compressed into a collection of tracks by DJ Recloose, DJ Godfather, Anthony "Shake" Shakir, DJ Assault, Ectomorph, and Keith Tucker, among others that notably made use of techno's fast beats with rap's call-and-response.[28]

In 2017, a group of the key figures in ghetto tech reunited for a conversation about the genre. According to Ade' Mango Henderson Mainor, or Mr. De', president of record label Submerge, "the basis of the sound is the ghetto side of techno—records that could be played in the inner city."[29] Ade' Mainor was keen to make a distinction between styles of techno, based on the ways Detroit's inner-city community responded

24 "Ghettotech: An Oral History" (WAXTAX-N DRE, DJ Assault, DJ Godfather, DJ Fingers, DJ Dick, Mr. De', Brendan Gillen, Anthony Shakir, Tommy Hamilton, Rick Wade, Gary Chandler, Keith Tucker, K-Hand in conversation), *Red Bull Music Academy Daily*, May 24, 2017, https://daily.redbullmusicacademy.com/2017/05/ghettotech-oral-history.

25 Ibid.

26 Ibid.

27 Ibid.

28 Hobey Echli, "Not Just Booty Anymore," *Detroit Metro Times*, November 10, 1999, https://www.metrotimes.com/city-slang/archives/1999/11/10/not-just-booty-anymore.

29 Mr. De', "Ghettotech: An Oral History."

to it, listing "Shake's records, some of Mayday, some Carl Craig, some Mike Banks. Anything that didn't sound too harsh, too European. It could be played in the hood. Then I think the layer on top of that would be Miami bass. Then hard, hard house records. Then the gel putting it together would be hip-hop." Before the term "ghetto tech" was defined, the music was colloquially called booty music. "If you're going to play ghetto tech music," WAXTAX-N DRE advised, "you pretty much got to play either 'Ass N Titties' or 'Gel N Weave.'" Craig De Sean Adams, or DJ Assault, released "Ass N Titties" in 1997 as a single on his own label, Assault Rifle Records, and issued it again in 2000 on a two-disc album called *Belle Isle Tech*, with the British trip hop label Mo Wax. Adams was initially part of a rap duo called Assault N Battery with Cliff Thomas, the owner of Buy-Rite, where he worked: "I shopped [at Buy-Rite] since I was nine or ten. I knew Cliff Thomas from shopping there so much," Adams remembered. "He helped me a lot with playing notes, chords, for the most part, to some degree. He helped a lot with that. He redid all of my rap records. The ideas we had for Assault N Battery, he made the ideas better because he was like a real musician." Adams then transitioned into high-tempo bass music, which he honed in college in Atlanta, just as Miami bass was colliding with Chicago house and Detroit techno. "Why do people like it? I don't know. I guess it's the lyrics," Adams mused of the classic track. "I changed them for the second time, the remix, to make them a bit crazier. That's the one my people know and remember, with all the 'gel and weave' and 'soap and water' and 'ass and titties,' it's kind of like multiple hooks. Because the parts are so ignorant, people remember them, because it's so crazy." Keith Tucker added that the song was popular because women liked it and could dance to the track in clubs. Kelli Hand, who DJed as K-HAND starting in the early '90s, recalled that, "When I was playing the [Club Zippers] residency every week, it was majority women in the club, dancing. Women really enjoyed that [raunchy] style of music a lot. This was '92, '93." To DJ Godfather:

> People just looked at [ghetto tech] as a certain thing, just a bunch of dirty records with swearing in it, when it's not about that. It never was. There are a lot of records that talk about that, but then there's a lot of records that talk about footworking and jitting and dancing. Doing different dance styles. And a lot of the records don't even have words in it.[30]

DJ Assault agreed: "If it's offensive, you take life too serious." Ghetto tech, Gillen proposed, is "absolutely, positively designed to be offensive, and I think it's designed to be listened to while you're inebriated. What cuts through to your brain when you're inebriated and you're out in a social setting?" While in high school in the early 1980s, Tucker started out playing fast-paced electro sets with his breakdancer friend, Tom Hamilton, in a group called the Devo Dancers. In the mid-'80s, they joined up with Anthony Horton and Marcus Greerplay to form the group RX7, which later added the

30 Ibid.

vocalist Andrea Gilmore and changed its name to Sight Beyond Sight, referencing the 1980s American and Japanese cartoon ThunderCats. "Basically I had to learn how to play [Model 500 and Cybotron] songs, basslines, and I played them live while we did the show. That's how I had to learn," Hamilton reminisced about his transition from dancing to occupying a musical role as the collaboration with Tucker developed. "We were just so intrigued by the sounds and the basslines. I think what really I gravitated towards more was the bass sounds and the way the bass was being played, the funk behind it."[31]

Sometime in 1990, Anthony Shakir played Juan Atkins tracks from a one-off project that Tucker had been working on with Jesse Anderson, resulting in the three-track single *Television / Frequency Express* coming out on Metroplex. A few years later, in 1993, Hamilton and Tucker formed the electro group Aux 88 with Anthony Horton and William Smith, releasing *Bass Magnetic* through the label 430 West, started by Lawrence Burden, Lenny Burden, and Lynell Burden of Octave One shortly after that group released a split single with Carl Craig on Transmat. 430 West is a home-grown outlet, featuring music by Eddie Fowlkes, Terrence Parker, and the younger Burden brothers, Lenny and Lawrence, as Random Noise Generation. 430 West's sub-label, Direct Beat, was distributed through Submerge and pressed various projects by Tucker, Anthony Horton, and Hamilton, as well as Lamont Norwood as DJ Dijital, Mike Banks under his Electric Soul moniker, and X-Ile, a minimal electro duo comprised of LaToya Vaughn and Marnita Harris (Aux 88's managers). In 1995, under the name Aux 88 Meets Alien FM, Tucker and Hamilton released *88 FM* with a brief message from the future:

> We interrupt your existence on this planet to bring you vision from a far off galaxy from a world once feared by all. We bring to you our culture, our sight, our touch, scent and feel. Most of all we come to bring you pleasures, commonly and often craved by mortal man. Fear us not, for we come in peace and as an offering of peace we bring to you visions from the future. We bring to you our most prized possession, our music through a sound. Our offering. Now that you know, your world can never be the same. Welcome to the future, the visionary.[32]

Reflecting on the development of Aux 88 and the music projects caught in its orbit in a 2020 interview, Tucker spoke of his first impressions of electronic music at a time when it was still colloquially referred to as "progressive": "While I was in high school Cybotron showed me what Funkadelic and Kraftwerk could be. No doubt Juan Atkins and Rik Davis' strings were like Bernie Worrell (Funkadelic) but the drums were more new wave," he recalled. "It was so satisfying, when it was played on the radio and everywhere in the streets and cars. We were living in an era where every week artists

31 Ibid.
32 Aux 88 Meets Alien FM, liner notes, *88 FM* (430 West, 1995).

were pushing the boundaries for something different that made you dance."[33] When asked if Atkins' solo output as Model 500 was an example of techno and Cybotron an example of electro, Tucker replied that techno and electro "are one and the same," making it clear that "Juan coined the name 'Techno.'" He explained: "In Detroit that is what [electronic music] was—TECHNO, nothing else, whether the beats were 4/4 or alternative." The term, he continued, "came from New York with those electro compilations!" Though he started as a DJ, Tucker wanted to integrate electronic instruments into an ensemble, and hoped that Aux 88 could replicate Cybotron's three-piece band structure. He recalled meeting James Stinson at Submerge, and sheepishly asking him to autograph some of his records: "I would say in the few meetings we only talked about music and he acknowledged that Aux 88 and Drexciya were the only groups doing it correctly and we were the only groups making that music after the 80s style electro craze."[34]

In the early 1980s, Anthony Horton, for his part, was in an R&B band and working for a production company called Diamond Entertainment, but he had set his sights elsewhere: "I wanted to go to the military and get away from Detroit, and from all the drugs and crime of the 80s," he confided in a 2021 interview.[35] Just as he was leaving for the recruiters' office to enlist, Horton received a call from Tucker: "I go over, and Keith comes home from working for GM. At that time, GM had the go-to jobs in Detroit. He comes in and tells me, 'I just quit my job. I want to do music.' I was sitting there like flabbergasted, like, 'Are you fucking kidding me?' He didn't say anything, and I was like 'Okay.' So that cut my military idea right on out (laughing). I've always admired that. We both would've become very different people had I went away or he stayed at his nice job. I think of that often."[36]

While Hamilton continued to work under the Aux 88 moniker, releasing *Is It Man or Machine* in 1996, and William Smith recorded his own music on Direct Drive under the name Posatronix, Tucker diverted into a solo career under the name Optic Nerve. In this outfit, he explored concepts around "space exploration" and "alien worlds," following in the tradition of Underground Resistance's Red Planet Series, Galaxy 2 Galaxy, and Model 500. Dedicated to Gerald Sims, *Children of the Universe*, Tucker's lithe and minimal 1997 debut album as Optic Nerve articulated a reconstitution of Detroit techno as an emotional exercise in painting meaning through stereo, as suggested by its opening song "The Hommage (Detroit Spiritual Mix)." *Children of the Universe*'s insert offers "first and foremost, praise and eternal gratitude to the

33 Keith Tucker, interview by Ralph Lawson, *2020 Recordings*, September 9, 2020 https://www.2020recordings.com/news-1/2020/9/9/keith-tucker-aka-dj-k-1.

34 Ibid.

35 Anthony Horton, interview by Acid_303 (aka Saboteur), "Focus On: Blak Tony (Alien FM, AUX88, Scan 7)," *Electronic Tesseract,* January 14, 2021, https://electronictesseract.com/2021/01/14/focus-on-blak-tony-alien-fm-aux88-scan-7/.

36 Ibid.

Almighty God for helping me grow and work through the good as well as the bad times." Tucker issued special thanks to:

My parents for their understanding and willingness to help me.
The Burden Brothers for taking a chance on me and promoting my career.
Juan Atkins for giving me the chance to work and perform with my mentor.
Mike Banks for being real and showing what hard work can do.
Anthony "Shake" Shakir for your advice and True Friendship.
Claude Young for bringing back the true beauty of strings.
Eddie Fowlkes for showing me how to have confidence in my music.
Elyes Record for guidance and all the right advice.
Aux 88 for showing me a different definition of loyalty.[37]

Horton continued collaborating with Tucker while also joining the stealth assault unit Scan 7 in the 1990s: "My first overseas tour was with them. Did a couple of records. I did the vocal for and wrote 'You Have the Right,' one of our bigger tunes. Big song. Yeah, I'm bragging. That's a big brag (laughing). I learned so much."[38] Taking on the name Blak Tony while performing as an MC for Scan 7, Horton asserted a connection to his roots: "I grew up in an Afrocentric/Black Pride household. If I was going to do this, I wanted to portray a positive Black man in the future. I want to represent that and make my ancestors proud." When working with Tucker, Horton developed a story around the music: "Keith and I used to be insomniacs—we didn't get much sleep, and when we did, it wasn't the best sleep. We would have nightmares or whatever." With the song "Nightmare" they set out to record that feeling:

I went up to the microphone, not knowing what I was going to say, and just said the first thing that came to mind that worked with the tone of my voice, and we mixed it with the sci-fi theme. "I'm drifting in and out of space" but going through a mental thing at the same time from lack of sleep. Keith was like, "That's odd." I said, "Let's do a tune on it and it will work, because it's truth."[39]

Horton recalled a vocoder that Tucker used for the Alien FM project, which appended a slight echo effect onto his voice: "Every time I went to the mic, I would do different things. Keith would ask about them, but I wouldn't know how I did them—it was just something that came out when I projected my voice a certain way. It works." He explained that, "Most people in Detroit have a southern drawl. Keith and I have a southern drawl and southern roots, but his voice is a little higher than mine in the

37 Keith Tucker, insert, Optic Nerve, *Children of the Universe* (Omnisonus, 1997).
38 Horton, "Focus On."
39 Ibid.

register. Keith has asthma also. He didn't want to do vocals because of that. I told him, that's going to be your character, nobody will ever be able to copy that voice."[40]

Growing up hearing Motown and classical music, which his mother, a poet, played in their home, Horton held an early fascination with music and science fiction. He attended the same high school as James Stinson and Gerald Donald: "Both electro groups came from the same side of town. I don't know what it is about the east side of Detroit that just gravitates to electro. We just like that funk and that groove," while "more of the house sound and four-four stuff," he clarified, "was coming from the west side of Detroit." He met the Drexciya members at Submerge during a meeting with Underground Resistance ahead of the 1995 release of *Origins of a Sound*, organized by Lenny Burden and Mike Banks, which compiled tracks from Atkins' collaboration with the L'uomo club DJ Reckless Ron Cook as Audiotech, Drexciya, Aux 88, "Mad" Mike Banks, and Andre Holland. Designed by Sean Deason, the album's cover bears the image of a digitally rendered globe composed of 808s and 303s, overlaid by an abstracted map of the Detroit highway routes; the title appears below, with a bold subtitle scrawled across the top that reads: "The City That Forced the World Into the Future." Inside the album's four-page insert, special thanks are given to Charles Hicks and the Soul Night Crew Outcast Club, The Electrifying Mojo, and "everybody on 7-Mile and the east side for kickin' the BASS for so many years."[41] *Soul from the City*, an album compiled by Mike Banks with Lenny and Lawrence Burden and artwork by Frankie Fultz, was released through Submerge that same year, pulling together tracks from Sight Beyond Sight, Members of the House, Random Noise Generation, and others under the subtitle: "The Definitive Detroit House Collection."

The reignited energy of techno's second wave spurred Jay Denham, a DJ and producer, to design his own sonic fiction through his record label Black Nation, started in 1992. Based in his hometown of Kalamazoo, Michigan, a city nearly equidistant to Chicago and Detroit and built on Hopewell tradition Native American territory, Denham absorbed influences from the two surrounding cities and his experience working for Transmat. He began to collaborate with his cousin Donnell Knox, who had been working with rappers in the area in the late '80s and '90s. Distributed through Submerge, Black Nation was conceived as an outpost for the electronic warfare being waged by Underground Resistance, and as a meeting point for the disparate visions of Black counter culture present in Chicago and Detroit. The label's first release was the compilation *Birth of a Nation,* a reference to D. W. Griffith's 1915 epic film, which adapted Thomas Dixon Jr.'s 1905 book *The Clansman: A Historical Romance of the Ku Klux Klan* into a cinematic retelling of the Reconstruction era during the nadir

40 Ibid.
41 Ibid.

of American race relations.[42] Denham's Black Nation label and solo releases were heavily influenced by the Black Power Movement, and, through a series of pointedly titled releases—*White Flight* (1995), *Race Riot* (1995), *A Day of Atonement* (1996), *People's Revolution* (1997), *Escape to the Black Planet* (1998), *Synthesized Society* (1999)—reframed techno and house as a post-Civil Rights Black expression within the Fordist industrial economic regime that had built the city of Detroit.

Meanwhile, Soul City, Banks' Detroit house label, launched with the compilation, *Luv + Affection* by The Brothers Burden, presenting Detroit singer, songwriter, and bassist Paul V. Randolph performing as L'Homme Van Renn. *Soul Sounds*, the label's second release, came from Kenny Dixon, Jr., who had debuted as Moodymann two years prior. Moodymann's *The Day We Lost the Soul* (1994) and *Inspirations from a Small Black Church on the Eastside of Detroit* (1995) introduced a culturally grounded vision of Detroit in the midst of the sonic warfare being waged by Underground Resistance and Drexciya at the end of the '90s. "I Like It," Moodymann's debut single through his own KDJ records, mixed with his childhood friend, Sherard Ingram, provided "Emotional Content"—a dimension that wasn't otherwise surfacing in Detroit techno. His 1996 single "I Can't Kick This Feeling When It Hits" featured vocals, bleeding over a suspended chord and pads, that intoned: "I'm tired of motherfuckers coming up and telling me that 80% of material from Detroit ain't good material. You see, what you don't understand is that 80% of that shit ain't from Detroit. So don't be misled."[43] Moodymann introduced a warmer, jazz, soul, and roller disco quality to techno, with diegetic sampling and voiceovers that played out Blaxploitation film scenarios and recounted the curbside knowledge imparted by the neighborhood elder and mystic. Unlike his contemporaries, Moodymann was not interested in technological futures; his style of production preferred to place the listener firmly within a seductive reality. In 2010 he recounted how he used to make music with borrowed equipment: "I went in Guitar Center, quietly testing out something, so they thought. I had my cassette and I was in there making a track."[44] Spending an hour in the music equipment store, Moodymann "put that motherfucker out about six months later. That's true. Anywhere I could get acknowledgement from. I mean, I put two tape decks together and made it." He says the music turned out to be "wack" and "nothing to talk about," only pressing twenty copies. "But I'm going to tell you something," Moodymann

42 "Originally distributed as The Clansman, *The Birth of a Nation*, under the patronage of Woodrow Wilson, became the first movie to be shown at the White House. (While in office, the Virginia-born Democratic president resegregated the federal workforce.) It also helped inspire the Ku Klux Klan's revival at Stone Mountain, Ga., and was used as a recruiting tool by the 20th century version of the Klan. (The historian John Hope Franklin observed that, had it not been for The Birth of a Nation, the Klan might not have been reborn.)" Andrew Glass, "*The Birth of a Nation* Premieres in L.A., Feb. 8, 1915," *Politico*, February 8, 2019, https://www.politico.com/story/2019/02/08/the-birth-of-a-nation-premieres-in-la-feb-8-1915-1148027.

43 Moodymann, lyrics, *I Can't Kick This Feeling When It Hits* (KDJ, 1996).

44 Moodymann, lecture, hosted by Benji B, Red Bull Music Academy, London, 2010, https://www.redbullmusicacademy.com/lectures/moodymann-henny-and-kenny.

imparts: "It ain't what you got. It's what you do with what you have. It ain't what you do, it's how you do it."[45]

Moodymann's *Silentintroduction* (1997) album featured a gatefold sleeve which reinforced this message, with photographs of family and community members, and the message: "I want to say 'what's happenin' to all the niggaz that live and die in detroit everyday," and "to all you white suburban kids, sampling Black music all the time, try some rock'n'roll for a change, you're making Black music sound silly, weak, and tired."[46] Detroit-by-way-of-Chicago producer and DJ Theo Parrish, who emerged in 1996 with his *Baby Steps* EP, echoed this sentiment in a 2014 interview. The "obsession with Detroit has been going on for a long time," he said, reflecting on his experience in Detroit:

> Henry Ford (founder of Ford Motors) was one of the most racist motherfuckers on the planet yet he employed more Black people than just about any other major corporation. There are all these dichotomies and ironies in the American story when you talk about Detroit. There was this huge amount of activity and it was reduced deliberately. This was not an accident. When I graduated from high school, my parents moved to Detroit and I would visit. It was like I'd stepped off onto the moon, I didn't know what this place was, it was crazy. Getting in fights, getting in all types of crazy shit. But what was killer was there was this dope record store called Buy-Rite. Over the course of my years at school I would go back, grab records.[47]

Buy-Rite was a central retailer for the Detroit techno and electro sound. Its managers, Mr. De', DJ Assault, and Sherard Ingram, ushered in ghetto tech when the global electronic dance music industry was beginning to feel a lull. While Underground Resistance, Drexciya, and Moodymann launched their attacks on the appropriation of techno across the deindustrializing world, Mike Huckaby—a manager at a music store called Record Time—began to record his first releases, *Deep Transportations* (1995) and *The Jazz Republic* (1997). "I would say that working in a record store definitely did have its advantages, and even working at Buy-Rite Music had its advantages," Huckaby explained in 2015. "A lot of people don't realize, but Buy-Rite Music was the founding record store in Detroit, through the beginning of Detroit electronic music and then much before that Everyone owes a lot to Buy-Rite Music because that's just where it started, and that's where you came up as a DJ."[48]

45 Ibid.

46 Moodymann, sleeve, *Silentintroduction* (Planet E, 1997).

47 Theo Parrish, interview by Alex Nagshineh, *Bonafide*, November 16, 2014, http://www.bonafidemag.com/theo-parrish-interview/.

48 Mike Huckaby, "Mike Huckaby on the Berlin-Detroit Connection, Ron Murphy and More," *Red Bull Music Academy Daily*, September 28, 2015, https://daily.redbullmusicacademy.com/2015/09/mike-huckaby-feature.

In 1987, while working at Buy-Rite, Ingram appeared in a project called NASA with Scan 7's Lou Robinson. Recorded data obtained at Detroit's Techno Sound Lab and documented in liner notes formed the basis of NASA's sole single, "Time to Party," released on vinyl with remixes by Atkins and Rick Wilhite. Ingram started making tracks of his own, telling Derek Walmsley in *The Wire* in 2010 that "the first single I released under Urban Tribe was 'Covert Action', in 1990 on a compilation put out by Carl Craig."[49] Ingram described his interest in "Afrocentric studies," remarking that "I guess 'tribe' and then me being in the city, I put the two together. Still being a member of a tribe, but in an urban setting." The concept of Urban Tribe evolved over time into a full-length album, entitled *The Collapse of Modern Culture*, released in 1998 on Mo Wax through a deal set up by Carl Craig and James Lavelle during a business trip in the UK. "Shake had helped me out quite a bit, Carl with his studio and his guidance, I had Rick Willhai do a mix, I had Ken [Dixon, Jr.]. And so I was just like, hey, you know what, these guys, far as I'm concerned, they're part of Urban Tribe because they give valuable . . . invaluable . . . assistance, because this was my first time ever trying to do a full length LP." Ingram admitted that he was "awestruck" at how large the project had become, "and those guys helped not only in encouragement and technical advice, but actual hands-on assistance . . . You know all of them played their little part. But chiefly I would say it's a concept, initially it was a concept invented into my own mind but it evolved into a collective."[50] The album's title, *The Collapse of Modern Culture*, held special significance for him and Detroit more generally:

> When I was saying *The Collapse of Modern Culture*, I didn't mean you were go-ing to have buildings going down, bridges on fire, starvation in the streets. I was thinking more how computers and technology were kind of changing the whole way people tend to do things. The more personable face to face transactions, or where you would talk with a human being over the phone, that kind of thing. And how technology changed, even down to the roles men and women play, where gender roles were being skewed, where you had kids with disposable income at early ages. And then some of it was apocalyptic too. It did seem things were on the brink of chaos at the time, with the Gulf War, with the second war coming around... well that didn't go until 2000 but we were still in a kind of Big Brother-ish era. I was under the influence of reading a lot of things about the impending New World Order. So that's what kind of led me to go with *The Collapse of Modern Culture*, the New World Order, changing gender roles, the changing of cultural construct within America.[51]

49 DJ Stingray, interview by Derek Walmsley, "DJ Stingray Unedited," *The Wire*, April 10, 1998, https://www.thewire.co.uk/in-writing/interviews/dj-stingray-unedited.

50 Ibid.

51 Ibid.

Detroit and the fast-paced changes it was experiencing were a major inspiration for Ingram while he was making the album. Citing the twenty-year tenure of mayor Coleman Young, who represented Black Power during a time of white flight and economic decline, Ingram pointed to the perceived boundaries between the city and the suburbs as a racial line that would, over time, restructure Detroit. He drew hope from the regional cooperation taking place around the revitalization of the downtown area, noting in 2010 that "there are some neighbourhoods that are neglected, no question about it, but I think on the whole, there's a genuine heartfelt effort to revitalise not only the city and the region."[52] Over the course of an hour, *The Collapse of Modern Culture* depicts sonic images of a mundane dystopia that is only perceptible deep within the subconscious. "Decades of Silicon" sets the album into motion with blownout bass blockading underneath suspended chords, resolving into a brighter, though considerably clouded-sounding "Nebula." The album confers the image of years of mass-consumer usage of man-made materials, as well as the collection of "space junk" deposited by humans into the Earth's exosphere. Slowly, as the album unfolds, Urban Tribe builds the case for *The Collapse of Modern Culture* with song constructions that reinstate the percussive samples of downtempo trip hop in the context of hi-tech soul, blending then-modern post-rave electronic music with the age-old expression of blues, soul, and jazz. At stake was nothing less than the African American double-consciousness experience, solemnly becoming "At Peace With the Concrete" of urban living. Occupying the role of the "Social Theorist," Ingram employed the Urban Tribe moniker as a critique of industrialism's acceleration during the Information Age, documenting the beginning of the end of the American settler-colonial empire.

Contributing additional keyboard parts to *The Collapse of Modern Culture*'s ending track "Peacemakers," Carl Craig—like Ingram—had begun to explore a techno and jazz iteration of hi-tech soul that edged the commercial music industry and its potential into the coming twenty-first century. Craig revived his Innerzone Orchestra in 1999 with the album *Programmed*, expanding into a full ensemble with Francisco Mora Catlett, keyboardist Craig Taborn, Blakula, Tassili Bond, theremin by Frank Rotundo, Greg Tyler, Paul Randolph, violin by Michael Smith, additional programming by Richie Hawtin, and vocal contributions by Steve Rachmad—one of the first DJs to mix and record Detroit techno in the Netherlands as a teen in the mid-'80s.[53] Two years later, in 2001, Craig contributed to Herbie Hancock's forty-fourth album, *Future 2 Future*, alongside A Guy Named Gerald, saxophonist Wayne Shorter, bassist Bill Laswell, jazz drummers Tony Williams and Jack DeJohnette with Chaka Khan and Imani Uzuri providing vocals, building on the live electronic music experiments

52 Ibid.

53 "I wanted to enhance the sound itself and take it up to 21st century standards. I also realized after so much happened in electronic music, the basis of Detroit techno was still in full effect. So these re-interpretations could be interesting as some sort of marker of how basic Detroit techno can sound in these 'modern' times." Steve Rachmad, "Steve Rachmad Interview: Detroit will always be taken to new grounds," *Skiddle*, last updated January 29, 2016, https://www.skiddle.com/news/all/Steve-Rachmad-Interview-Detroit-will-always-be-taken-to-new-grounds/27666/.

of previous albums such as *Sextant* (1973) and *Future Shock* (1983). "I would say that this record uses the heart of a jazz influence but in a non traditional way," Hancock noted, "it's a very spontaneous record, there's hardly any pre-conceptions of melody or harmonies which is why it sounds a little quirky."[54] *Future 2 Future* was an experiment in genre forms as well as "genre-time," or the expression of shared modes of composition that articulate the climate of a group or community.[55] "Most of what was done on this record was done reactively," Hancock recalled. American hip hop producer Robert Aguilar (Rob Swift) features on the track "This is Rob Swift," contributing turntablist scratching techniques with breakbeats slowed to match the pace of a human drummer. Introduced by an instructional voiceover that explains the basics of programming percussion, the track demonstrates the form and function of electronic music as a tool for connecting people through "stimulating staccato rhythms." By the early 2000s, digital audio workstations were readily accessible to the average consumer, which pushed professional musicians like Hancock into a new space of sonic exploration that superseded the sounds of the twenty-first century by drawing from twentieth-century jazz techniques.

The years leading up to the new millennium would bring even more waves of change. Alvin Toffler's book *Powershift* (1990) concluded his trilogy of texts that included *Future Shock* and its sequel *The Third Wave,* with a stark study of the elements of an emergent American technocratic capitalism that was soon to become a global reality. Toffler considered that "even these upheavals in the distribution of world money-power reveal less than the whole story. They will be dwarfed in history by a revolution in the nature of wealth itself. For something odd, almost eerie, is happening to money itself—and all the power that flows from it."[56] The next year, Toffler and his wife Heidi penned an article expanding on his earlier writing by explaining the way in which information shared through telecommunities operates much like a war machine, disseminating an abstract economy of user data and their exchange of wealth and knowledge:

> In today's economy, mass production itself is increasingly outmoded. Customized production, based on the economies of intelligent technology, is superseding it in many fields. This demassification of output is matched by the breakup of mass markets into "niches." In turn, advertising, which once depended on the mass

54 Herbie Hancock, interview by Neon Suntan, "Herbie Hancock – Reinventing the Wall of Sound," *WithGuitars*, August 2011, https://www.withguitars.com/herbie-hancock-reinventing-wall-sound/.

55 "Simply put, knowledge corresponds to the past. It is technology. Wisdom is the future, it is philosophy. It is people's hearts that move the age. While knowledge may provide a useful point of reference, it cannot become a force to guide the future. By contrast, wisdom captivates people's hearts, and has the power to open a new age. Wisdom is the key to understanding the age, creating the time." Elenni Davis-Knight, lyrics, "Wisdom," *Future 2 Future* (Transparent, 2001).

56 Alvin Toffler, *Powershift: Knowledge, Wealth and Violence at the Edge of the 21st Century* (New York: Bantam Books, 1990), 59.

media, is shifting to demassified media like direct mail, multiple cable channels, direct broadcast satellite and even more specialized media, in order to reach carefully pinpointed micro markets. All of these steps break up the old homogeneity of the mass industrial society, and are themselves mirrored by changes in family structure, which is becoming polymorphic, and in culture, which is growing more and more heterogeneous.[57]

The Tofflers' joint writing once again stood as anticipatory of the shifting perception of how war-derived consumer technologies would influence society and culture. They concluded their introduction into the "thinking systems" of technocratic capitalism stemming from the colonial republic of the United States by stating:

> While our book systematically foreshadowed the demassification of economic production and society, [Maj. Gen. Don Morelli of the U.S. Army Training and Doctrine Command][58] noted, we had made no mention of what he called "the most important change in warfare since Vietnam—the development of precision-targeted weapons." In effect, what we were already beginning to see, Morelli said a decade ago, was the "de-massification of de-struction in parallel with the de-massification of pro-duction."[59]

To this end, at the turn of the century, media companies began a slow transition from print to screen; Detroit techno, in the following years, would be rebranded as "retro techno," while magazines such as the UK's *Mixmag*, Germany's *Frontpage*, and Japan's *ele-king* went on to document techno and its abstraction on a global scale. European rave culture—from the summer of 1986 until the global pandemic of 2020—narrated techno through the haze of three decades of drug addiction. Article headlines like "Why Does Speed Kill More People Than Ecstasy?" and "Are Drugs Driving You Mad?" (*Mixmag*, August 1996 and February 1997, respectively), are just two in a string of such reporting. Meanwhile, the Information Age that had inspired Rik Davis and Juan Atkins led the global economy into an inflated bubble that burst in 1995. As the internet crept into the centerfold of daily consumer habits, print magazines like *Muzik*, *Frontpage*, and *Jockey Slut* fell out of circulation and late '90s

57 Alvin Toffler and Heidi Toffler, "A New Theory of Warfare: The 'Third Wave' Arrives: We Make War the Way We Make Wealth—With Information: War Is Won Today by Information, Not Industrial Power or Strength of Troops. First of Two Parts," *Los Angeles Times*, March 5, 1991, https://www.latimes.com/archives/la-xpm-1991-03-05-me-22-story.html.

58 Maj. Gen. Donald R. Morelli is a premiere military strategist of the United States Army, and the architect of a combat style favoring agility, mobility, and counterstrike tactics based on the art of deception from behind enemy lines. His strategic doctrine, AirLand Battle, is "the most fundamental change in strategy since the Civil War," according to his obituary in the *New York Times*, and "departs from the traditional emphasis on a war of attrition with massed firepower on a well-defined front." James Brooke, "Maj. Gen Donald Morelli, 51; Helped Design Strategic Plan," *New York Times*, July 4, 1984, D15.

59 Alvin and Heidi Toffler, "A New Theory of Warfare."

clubbers aged out of the prime consumer demographic.[60] Other publications such as *Mixmag* veered away from American and British pop culture coverage, and towards the travel industry, targeting a luxury leisure lifestyle demographic made up almost entirely of white, European, male consumers.

*

In 1997, MTV set out to introduce viewers in the United States to electronic dance music with the weekly late-night program *Amp*, created by Todd Mueller and Burle Avant, which employed a "video mix" format inspired by DJ sets, and spawned two compilation albums before leaving the air in 2001, having amassed a small but dedicated audience. On the other side of the Atlantic in 1997, *Party Zone*, MTV's European dance music television show hosted by Simone Angel, produced a feature on the Detroit techno scene, which, Angel proclaimed, "has made a form of music that has changed the whole music scene forever."[61] Angel lists the variety of ways in which techno, as a sound and ideology, influenced counter cultures around the world engaged with the oncoming future of the new millennium. In the episode, Atkins responds to a question about techno's political agenda: "I was making music long before I realized how political the music business was, and when I ran into that, I didn't really understand it at first. I had to learn how to deal with it." He briefly discusses his new album *Mind and Body* under his Model 500 moniker for R&S, which he says features more emphasis on vocals before saying that he's always wanted to program a radio station more established than the pirate broadcasting that he had done in the early '90s with May and Saunderson on Deep Space. "I think America needs it big time," Angels says. "We got some pretty good ones in Europe…"

Over a montage of videos of Detroit juxtaposed with footage of Terrence Parker DJing in an underground space, holding a telephone to his ear rather than wearing headphones, Angel asks Parker if he ever feels left out because his music isn't what the world perceives as Detroit techno. Reminiscent of classic disco edits, Parker's sound skews more towards the dancefloor than Atkins', but his physical presence in Detroit and proximity to techno's creator calls into question how related techno and the city's pre-techno progressive music actually are. "It was very, very difficult when I was starting out," Parker says. "At the time when I was trying to develop my style,

60 "Commentators declared the end of the ecstasy generation and spoke poetically of a 'comedown'. We'd all partied far longer than the ten years any respectable musical movement is permitted, and now it was time to stay in, eat bananas and turn the phone off. The love-drug that had helped house sweep the world had become a juvenile indulgence; it was commonplace and uncool. The fact that pills cost as little as £2 in some parts of the country only confirmed this. In its place as the club high of choice had come cocaine. Cheaper and more easily available than ever, coke fed the controlled champagne opulence of the UK garage scene and the ruffneck rocks-and-reefer leanings of drum and bass and UK hip hop." Bill Brewster and Frank Broughton, *Last Night a DJ Saved My Life: The History of the Disc Jockey* (New York: Grove Press, 2006), 548.

61 *MTV Party Zone: Detroit Special*, recorded November 29–30, 1997, https://www.youtube.com/watch?v=2ND9hPzjHBw.

366

you know, had I been in Chicago or maybe New York, easily people would say this cat makes house music, we can identify him as that—it's very simple." But, he explains, "Because I was here in Detroit, I noticed, especially some various European magazines when they would review my records they would say well this is techno soul… and you know I was like 'techno soul?' What is that? It got to a point where I had to call people and say 'do not call my music techno soul,' it's house music." He talks about how local record companies wouldn't sign him because his music wasn't specifically techno, but mentions he did find an outlet through Mike Banks' labels and The Burrell Brothers in New York.[62] In another scene, Kenny Larkin calls Detroit home, and says that he'd rather become a big artist in the city that raised him than compete in places like New York with a large machinic media presence. "Every time somebody puts out a really big project from Detroit, everybody else in the world who's doing this dance music—and these journalists—they expect people from Detroit to reinvent the wheel, and if they don't reinvent the wheel… It's a lot of pressure. Who wouldn't like to be an innovator like that and take the music to the next level?" He continues: "You don't necessarily have to break boundaries to make a good track."

As the episode moves along through the players of the Detroit techno scene, more figures express their exhaustion. When asked where he sees himself in ten years, Alan Oldham suggests that he won't be DJing anymore, and hopes to be successful enough to not have to travel and play music; whereas Stacey Pullen philosophizes about the nature of electronic music as it relates to the economic conditions of Detroit. "Music is a universal language, so we want to express the fact that, you know, we're here in Detroit," he says to Angel. "It's kinda sad, but at the same time it gives us balance because, you know, when we travel overseas most of the time there's a balance because we don't have to be around a lot of spotlight or magazines and always doing interviews, which is good. But when we come back here, it gives us a sense of balance and focus." Later, we encounter Kelli Hand, who engineers sample-based techno underscored by impassioned drum programming as K-Hand. Having already released the *Global Warning* EP (1994) on Warp Records and four albums—*On a Journey* (1995), *Soul* (1997), *Ready for the Darkness* (1997), and *The Art of Music* (1997)—as well as starting her own label Acadia, Hand talks about her own unique perspective on techno and the dance music industry. Angel remarks that K-Hand has been the only visible woman producer in the Detroit scene. "For one, I love competition," K-Hand

62 "Twin brothers Ronald (Rhano) and Rheji Burrell first fell in love with music when they were children. 'When I was in 10th grade, a guy just came up to me and said, 'I heard you playing keyboards. Want to be in a band?' Ronald recalls. 'I went to the audition, and my brother came with me. The guy who invited me to the rehearsal asked my brother, 'Well, what do you do?' and my brother said 'Everything that he does!' The duo soon began working on their own demos in their mother's basement. With the Roland Doctor Rhythm drum machine providing the pulse, the brothers crafted a series of recordings that showcased their unique take on soulful dance music. Eventually, the duo signed a deal with Virgin Records, releasing the album *Burrell* in 1988. Though the Burrell brothers saw some success with Virgin, their style of soulful uptempo dance music didn't exactly find a home on commercial R&B and hip-hop radio." John Morrison, "Lifetime Achievement: The Burrell Brothers," *Bandcamp Daily*, September 11, 2019, https://daily.bandcamp.com/lifetime-achievement/lifetime-achievement-burrell-brothers.

says, "I really don't like to address the issue of being the only woman because I think the music is more important, more so than being the only one, but I am one of the very few." She talks about the appeal of being competitive and assertive. "I don't know what every other woman is doing, but most of them are maybe out partying, or behind the desk [working 9-to-5 jobs]." K-Hand talks about the closeness she feels to the city she grew up and spent her whole life in, despite the perceived urban decay: "Detroit is a place where you can live and actually go somewhere else, because the economy here is very low." Seemingly distracted by the urban environment, Angel shouts that a car is coming down the road at high speed, which prompts K-Hand to joke, "It might be a drug drop."

In the next scene, a house overtaken by kaleidoscopic art and oblong sculptures of many colors is identified as the Heidelberg Project, a public art project that spanned three blocks of Detroit's East Side and was initiated by artist, former autoworker, firefighter, and military veteran, Tyree Guyton.[63] "In 1986 before I started this project, it was a problem, but my job was to come up with a solution, and here's the solution," he says to Angel. He jokes that he'd love to take the project to the White House, to transmit his creative commentary on the state of economic decline in Detroit to the leader of the so-called free world. Mirroring this sentiment, Angel meets Carl Craig at the Detroit Riverfront, where she says that she feels there's something special about the city that she can't quite put her finger on. Craig retorts: "Where else can you buy a building with four levels that costs $70,000?" Staring out across the river to Windsor, Canada, Craig shows Angel America's reflection, a parallel universe consisting of a more humane, post-colonial, governmental policy, with a remarkable possibility for societal well-being. Eddie Fowkles tells Angel: "You got a lot of people selling their souls to get somewhere. You got a lot of people who think because they DJ for three years that they're a DJ . . . oh fuck no, you got a lot of records to come back and present." He adds: "And let's see a DJ work a Black crowd, and then when you come to do parties in Europe, you got a crowd there . . . you ain't gotta work it, so anybody can be a DJ, come to my neighborhood, and have people paying $5-7, they'll be ready to beat you up because you ain't making me dance."[64]

At the end of the episode, Angel gathers the second-wave groups, Octave One, Aux 88, and X-lle. Lawrence Burden of Octave One asserts that newer labels will begin to shut down as the dance music industry transitions into its second decade, pointing out that many label owners will realize that they should have been producing their own

63 "Even though Guyton's work has been lauded by critics throughout the world and has appeared in magazines like *People, Art News,* and *Newsweek,* much of the Heidelberg Project has now been destroyed. He even made an appearance on 'The Oprah Winfrey Show' to discuss opposition to his work. Although currently discouraged by the city's brutal response, Guyton has, as always, remained dedicated to continuing his work in the face of those determined to dictate the terms of art. Despite these and other negative turns of events, the struggle for a truly radical and transformative culture continues in the beleaguered city of Detroit." Kofi Natambu, "Nostalgia for the Present: Cultural Resistance in Detroit 1977–1987," in *Black Popular Culture,* ed. Gina Dent (Seattle: Bay Press, 1992), 186.

64 *MTV Party Zone: Detroit Special.*

music rather than running a distribution network for profit, leaving more established labels to take the majority of the market. "The newer labels are going to start falling off realizing that they are producers, and hey I really just want to make music," Burden says. His speculation resonated at the same frequency as the impending downturn of the peaking arc of the financialization of dance music, queued to the height of the dot-com economic boom. Burden admits, "I don't want to pay taxes, or worry about this artist over here, I just want to make music and have my music placed on a label that understands what they're trying to do."[65]

As the twentieth century drew to a close, Burden's prediction of where the dance music industry was headed came to pass. The economic highs of the dot-com bubble receded into a decline, setting the stage for what could be considered a transitional moment of dance music, as its prime demographic grew into adulthood. In 1998, rock music journalist Simon Reynolds published a somewhat complete history of the British and European history of rave culture in his book *Generation Ecstasy: Into the World of Techno and Rave Culture*.[66] Alongside his series of articles published in the 1990s in *The Wire* that defined the British "hardcore continuum," Reynolds' writing helped to structure a hazy series of events spurred by the importation of African American counter-cultural electronic music and the drug ectasy—forever altering a generation of European youth more or less destined for a life of postindustrial economic conservatism. A year later, *Mixmag*'s US editors, Bill Brewster and Frank Broughton, published *Last Night a DJ Saved My Life*, a definitive history of DJing and dance music, retold in the afterglow of Europe's decade-long hedonistic spiral into a boom and bust cycle. That same year, Wayne State University in Detroit published *Techno Rebels: The Renegades of Electronic Funk* by Detroit-based music journalist Dan Sicko, marketed as the definitive book documenting the "collective dreaming" that originated progressive music, techno, and electro. Sicko's transcription of Detroit techno's oral history infers:

> To watch techno progress, one needs to keep an eye on the smallest of details rather than the big picture. No one could have predicted the eruption of drum & bass out of clever sequencing and sampling, nor did synth manufacturer Roland ever dream of the sounds techno would summon from the machines it created to emulate real drums and bass guitars. And Detroit's role as a cultural mecca caught everybody by surprise—even most of its producers. One needs to follow the optimists: artists, DJs, producers and promoters who transcend the politics and stifling framework of the record business, and who are still seeking new ways to connect to other human beings.[67]

65 Ibid.

66 Published in the UK as *Energy Flash: A Journey Through Rave Music and Dance Culture* (London: Picador, 1998).

67 Dan Sicko, *Techno Rebels: The Renegades of Electronic Funk* [1999] (Detroit: Wayne State University Press, 2010), 145.

As the new millennium began, the burst bubble of the inflated early internet economy left a frontier-like ambient commons that structured a new free and open marketplace—a particularly useful means for reinvesting in the unregulated clubbing industry and its adjacent currencies of illegal drugs, alcohol, travel, and music equipment. In 2000, Telekom Electronic Beats, a European music marketing initiative, was founded by Deutsche Telekom AG, one of three businesses—alongside Deutsche Post (DHL) and Deutsche Postbank—to develop out of the formerly state-owned, privatized German telecommunications company Deutsche Bundespost in 1995.[68] Shifting focus from its original function as a monopolized internet and postal service provider, Deutsche Telekom intended Electronic Beats to be a cultural platform that would reframe the aging rave culture industry into a lifestyle circulating between arts, fashion, and emerging technologies. In the following years, the advertisement brand would, in some ways, lead the deadstock market of dance music into its online future by establishing a web publication and television show, alongside programming a series of offline concerts and club nights at Cologne's Palladium, featuring electronic musicians from around Europe.[69]

In 2001, Discogs, a music database, and *Resident Advisor*, an online music magazine and commercial community platform, were founded, establishing a standard across dance music that catered to the refinancing of the industry with a somewhat elitist and technical mindset. If the 1990s were a time for Europeans to discover and experiment with techno as the basis of contemporary electronic music, then the 2000s marked techno's full transformation into a hobbyist industry, with the idea that if you have the gear, the software, or even listen to music you should be making money off of it. To this end, Discogs operates as a kind of stock market, setting the global value of various physical music releases based on how readily available they are for purchase; likewise *Resident Advisor* sought to connect regional European clubs and scenes on a single platform, and overtime created a ticketing service and job board that together assert a kind of monopoly on the process (other club ticket providers include Ticketmaster and Skiddle). In 2002, the audio engineering website Gearslutz emerged as a community

68 "Deutsche Telekom was in part unable and in part unwilling to follow an innovative strategy pursuing the young internet access market in Germany in the years from 1996 to 1998. A closer look was therefore necessary. The material permitted three explanations why DTAG was unable to pursue a future-oriented course. Firstly, the management of Deutsche Telekom may simply have underestimated the 'disruptive technology' of the internet. Secondly, Deutsche Telekom was under steep cost pressure in the whole period under examination. It also had to reduce its large debt. Thirdly, its network infrastructure was unprepared to meet steep demand for internet access and the company lacked know-how in the internet field. Most traditional telecommunications firms were facing similar problems in that period. The two latter problems were strongly aggravated by DTAG's history as a monopoly carrier before privatization in 1994. The management of Deutsche Telekom emphasized this correctly. Yet, an argument could also be made that DTAG could in some cases have acted less defensively in the years 1996, 1997, 1998 and beyond, especially given the capital market's exuberant enthusiasm for a bold, network economy strategy in this period." Niko Marcel Waesche, *Internet Entrepreneurship in Europe: Venture Failure and the Timing of Telecommunications Reform* (Cheltenham, UK: Edward Elgar Publishing, 2003), 162.

69 Electronic Beats, "20 Years of Electronic Beats: A Walk Through Our Biggest Moments," n.d., https://www.electronicbeats.net/20years/#.

board for professionals and amateurs wanting to focus primarily on the technical expertise aspect of electronic music. In 2003, online electronic music store Beatport was started in Denver, Colorado, by Jonas Tempel, Bradley Roulier, and Regas Christou, the owner of several nightclubs including The Church and Vinyl, as a platform that would work with record labels and some independent proprietors to catalogue and standardize dance music by genre and salability—with notable early investments and support from Richie Hawtin and John Acquaviva.

By the mid 2000s, Beatport had accumulated over a million purchases, and began a partnership with German music equipment and software manufacturer Native Instruments, in a move to capture, monopolize, and integrate the usage of downloadable music with their own hardware products and gain a majority share of the brand platform. Beatport soon claimed to be "the most relevant online source of electronic music in the world," built from the low-stakes content and trade of electronic dance music in the United States, rivaling Apple's iTunes by offering high-quality digital music as a convenient utility for working DJs and producers. A 2012 lawsuit from Roulier accusing Christou of stealing Beatport's concept outlined that "Beatport's dominance in the Electronic Dance Music community meant that Beatport became financially important for DJs."[70] The court filing also alleged that "favorable promotion, or the lack thereof, on Beatport can 'make or break album sales'" for creatives in an industry already fraught with stolen intellectual properties, bad record distribution deals, illegal drug trades, and an unstable and unaccountable circuit of investors and conglomerates.[71]

*

Over a decade after techno left Detroit and spread throughout the world, rumors of a music festival in Detroit began to surface; there was hope of bringing the techno sound back to its home city. The Detroit Electronic Music Festival was a concept that Kevin Saunderson, Derrick May, and Carl Craig had been planning since 1996. While they brainstormed, May contacted Carol Marvin, an event planner from the production company Pop Culture Media, which had previously organized two jazz

70 "Defendant Bradley Roulier is a co-founder and member of Beatport, LLC ('Beatport') and founder and member of BMJ & J, L.L.C. d/b/a Beta Nightclub ('Beta'). Starting in 1998, Mr. Roulier was employed by Mr. Christou as a talent buyer and assisted in booking top DJs to perform at SOCO venues. While he was still employed by Mr. Christou, Mr. Roulier, along with several partners, conceived of the idea that would become Beatport. In 2003, Beatport was founded as an online marketplace for downloading music that catered to consumers and producers of Electronic Dance Music. Mr. Christou cosigned a $50,000 loan to start Beatport in exchange for Mr. Roulier's promise that Mr. Christou would later be given partial ownership of the company. Mr. Christou also initially assisted in Beatport's promotion by advertising Beatport in SOCO's print and online advertisements, distributing promotional flyers, and financing a promotional video. Mr. Roulier never transferred any ownership interest to Mr. Christou." Christou v. Beatport, LLC, Class Action No. 10-cv-02912-RBJ-KMT, United District Court, Colorado, March 14, 2012, https://www.leagle.com/decision/infdco20120315912.

71 Ibid.

festivals in Detroit and a party for the World Cup in 1994. Eventually May dropped out of producing the event, and Carl Craig took his place as a co-organizer.[72] Marvin was confident that she could create a festival that would be representative of Detroit's culture. Reaching out to Phil Talbert, the Special Activities Coordinator of the Detroit Recreation Department, in 1999, Marvin showed city officials videos of dance music festivals in Europe and pitched May's idea: Detroit could host the festival in the scenic downtown waterfront space at Philip A. Hart Plaza, which could fit up to 40,000 people. The main goal was to show mayor Dennis Archer what electronic music was, and how techno was born and raised in the city of his jurisdiction, while reintroducing the genre to a younger audience. Ahead of the event, which took place on Memorial Day weekend 2000, Craig compiled a promotional CD titled *Launching the First Annual Detroit Electronic Music Festival* with Pop Culture Media, pulling together tracks from Saunderson as E-Dancer, Kenny Larkin, May as Rhythim Is Rhythim, and others. The back sleeve of the album announced:

All proceeds from the Detroit Electronic Music Festival benefit the Detroit Recreational Department BE A PARTNER children's program,

ELECTRONIC DANCE MUSIC is the most popular music in the world.

A festival of this magnitude in the city of its origin - FREE-OF-CHARGE - will make history.

To get in the DEMF groove, please enjoy our exclusive compilation CD of Detroit electronic artists.[73]

In a 2010 retrospective of the festival on *Resident Advisor*, Todd L. Burns gathered interviews from over fifty artists, organizers, journalists, city officials, and more to form a comprehensive oral history of the first ten iterations of the festival. Journalist Josh Glazer of the *Real Detroit Weekly* remembered receiving an urgent call from the newspaper's publisher, instructing him to go to Craig's house for an announcement: "I got to Carl's place and it was him and Carol Marvin. We sat down and they kind of told me the whole plan. They had literally just signed the contracts with the city in the past 24 or 48 hours."[74] *Real Detroit* became the festival's media partner, and as Glazer recalled, "while I was kind of reporting on the festival and doing that whole end of it, I was also stamping and sending flyers all over the Detroit area, and all over the country with our mailing list." Saunderson and Hawtin expressed disbelief that the festival

72 Todd L. Burns, "Put Your Hands Up: An Oral History of Detroit's Electronic Music Festival," *Resident Advisor*, May 18, 2010, https://ra.co/features/1186#2000.

73 Various, back cover, *Launching the First Annual Detroit Electronic Music Festival* (Pop Culture Media, 2000).

74 Josh Glazer, quoted in Burns, "Put Your Hands Up."

would happen; indeed, Craig remarked that "the city didn't sign the contract until the day before the festival." He explained:

> We didn't officially have the $300,000 that we were promised or even the permission to use Hart Plaza. Everyone did their part to make it happen. My brother-in-law used to work in the Mayor's office, and he went to his boss who has known my family for a long time. I came up to meet her on Wednesday, and brought various types of music to show her what it was all about because I don't think anyone in the Mayor's office really knew what was going on. After the meeting, I was told that his boss went to the Deputy Mayor and told him that it had to happen, and after that it was locked in.[75]

Over the course of three days, the Detroit Electronic Music Festival maintained a consistent attendance of over one million people, gaining notice from city officials and Kwame M. Kilpatrick, the "hip-hop mayor," who took office the next year, in 2002. The festival itself was an iconic display of Detroit's near-century-long history of musical innovation, with curation that centralized much of the disparate global electronic music that had emerged over the last decade.[76] Fowlkes performed with a percussionist and Members of the House; Berlin's Basic Channel played an improvised live set with groove boxes; a member of the Lost Poets joined Moodymann on stage as an impromptu MC; Stacey Pullen played a song that sampled a speech given by Martin Luther King, Jr.; Mills joined Hawtin on stage during his DJ set. The ghetto tech scene and its unique style of fast-paced mixing and dance culture stood out as an integral experience of the festival, displaying a purely on-the-ground side of Detroit techno and progressive music that veers closer to hip hop and lives in the "now" rather than appealing to farflung futures. "The best thing was that it was a free festival," Craig enthused. "It brought in a lot of people who didn't know what electronic music was, let alone techno. Or didn't care. People would just come to see Mos Def play." Ectomorph's Brendan Gillen asked "the big question" of the Detroit community following the festival: "What is going to happen to the next generation? Will there be one? Is it going to be Dutch guys just imitating parts of what we do? Are we now the

75 Ibid.

76 "When the sun set on the first Saturday, enthusiasts, suburban visitors, city residents, and random passersby flocked to the free festival, converging on Stacey Pullen's DJ set on the main stage. Hart Plaza was at or near capacity. The weather was perfect. Downtown Detroit came alive with strange, yet familiar sounds. What everyone slowly realized was that they were witnessing and participating in the reunion of the city with its long-lost, homegrown Wunderkind. Detroit finally 'got' techno—it was emotional, magical, and as hyperbolic as you might imagine. The reported numbers by city officials and the police department for that first weekend were a bit off the charts (as high as 1.5 million!), but it would take several years to come down from the high of such a successful launch to scrutinize attendance. It certainly felt like a million people had decided to soak up the music on the waterfront all at the same time. Emotion got the better of mathematics and logistics—quite the poetic techno ending to an improbable story." Sicko, *Techno Rebels*, 187.

blues?" Gamall Awad, of the boutique PR company Backspin Promotions, observed: "In some ways it did feel at the time that we were witnessing history."[77]

The second annual DEMF, in 2001, was free and open to the public, thanks to $435,000 in support from the Ford Motor Company; it was renamed the Focus Detroit Electronic Music Festival and advertised on television with Atkins' "No UFOs" as its soundtrack. Three weeks before the launch, Craig was fired by Marvin, creating a wave of controversy. In an interview with Lisa Collins of the *Metro Times*, Marvin says the Detroit Electronic Music Festival came to her, and her alone, as divine inspiration, which she described as God bringing heaven down to Earth through her leadership. "I decided to do it based on prayer," she said. "I'm a Christian, and I live my faith on a daily basis in all I do."[78] Her response to Collins' probing into Craig's firing remained elusive. Regardless of how the conflict manifested, the Ford Motor Company did not renew its sponsorship contract, and the festival was eventually faced with four lawsuits over non-payments—one of which was filed by Craig. "I don't think a lot of people dug for what actually happened," Sicko opined. "I think once it got out that they fired one of Detroit's more beloved and long standing entities in the scene, people reacted to that more than anything else. I don't think they cared about the story behind it."[79]

In its third year, the festival continued its transformations, with May at its helm and support from mayor Kwame Kilpatrick. Scheduled on Memorial Day weekend 2002, it changed its name to Movement. In 2005, Kevin Saunderson took over the festival before passing it on to the event production company Paxahau the next year. Though Movement continues to work as a yearly socio-economic stimulus for Detroit, techno was increasingly sidelined as a feature of the city and its culture, instead establishing a low-risk, repeatable business model of popular music acts for the common public. "Detroit needs more things that can be celebrated without any drama," Sicko says. "This thing had its own drama, but a lot of that has fallen away now. Yes, it is a paid thing now, but it's something Detroit can count on celebrating, I think that's probably the single best thing about it. Now it's a known quantity. People aren't wondering if it's going to happen from year to year." Despite the shift in format and focus, Saunderson is proud of the festival and the work that has been put into it. "Everybody had an impact and played a role to help it get to where it's at today," Saunderson voices. "We had to go through growing pains to be where we are today with the festival, but that's OK."[80]

77 Gamall Awad, quoted in Burns, "Put Your Hands Up."

78 Lisa M. Collins, "God's Event," *Detroit Metro Times*, May 22, 2002, https://www.metrotimes.com/detroit/gods-event/Content?oid=2173796.

79 Dan Sicko, quoted in Burns, "Put Your Hands Up."

80 Ibid.

The festival was recognized for its historic significance by British writer and critic Geoff Dyer, who reported on its first edition for the *Guardian*: "Not only did techno originate in Detroit, it's also been the city's most important musical export since Motown."[81] Following the trail of photographer Camilo José Vergara's documentation of Detroit in 1995, Dyer pieces together an image of the city that retains its original architectural and idealist beauty, even in a state of ruin. Dyer admitted that a three-day free music event "was quite a gamble":

> For a start, dance music has become indelibly associated with drugs and Detroit is a city that has suffered from drugs every bit as much as London has benefited from them. And the venue for this festival was not some abandoned industrial wasteland but the riverside Hart Plaza, overlooked by plush expense-account hotels and spanking new corporate developments, such as the Renaissance Center (headquarters of General Motors, 74 storeys high, topped off with a revolving restaurant).[82]

Dyer's long-form prosaic assessment of Detroit's historical arc excavates techno as a "local brand of post-industrial folk music"; he argues that "the DEMF cannot bring about economic resurrection, but it heralds a possible future of regeneration and liberation." Dyer reasons that the festival itself wasn't political, but its existence, much like the UK's Second Summer of Love and Berlin's Love Parade, displayed a sense and possibility of modernity:

> This was made explicit on Saturday night when Stacey Pullen sampled Martin Luther King's "I have a dream" speech, culminating with the famous declaration "Free at last! Free at last! Thank God almighty we are free at last." We associate this address—which has since been rapaciously sampled by DJs—with the march on Washington in 1963, but King actually delivered a version of the speech in Detroit two months earlier. With this historic resonance in mind, it would be difficult to exaggerate its relevance to—or the rapture with which it was received in—Detroit this time around.[83]

In the closing chapter of his 1967 book, *Where Do We Go from Here: Chaos or Community?* Reverend Martin Luther King, Jr., explored the concept of the "World House"—anticipating the Information Age and the call for human rights and economic justice within a globalizing technological world hinging on European colonial values and perspectives. Written in isolation a year before his assassination and during a summer of race riots that overtook Detroit and other cities around the United States,

81 Geoff Dyer, "Detroit: Where the Wheels Came Off…," *Guardian*, July 8, 2000, https://www.theguardian.com/theobserver/2000/jul/09/life1.lifemagazine5.

82 Ibid.

83 Ibid.

King's "World House" condemns global poverty and military intervention, while presenting the possibility of instrumentalizing the "world-wide freedom revolution" spurred by the violent colonial spread of the scientific and technological advancements towards a universal and common good for all people. To King, the Black civil rights struggle served as a direct example of the response to the uneven and oppressive distribution of technological futures:

> The present upsurge of the Negro people of the United States grows out of a deep and passionate determination to make freedom and equality a reality "here" and "now." In one sense the civil rights movement in the United States is a special American phenomenon which must be understood in the light of American history and dealt with in terms of the American situation. But on another and more important level, what is happening in the United States today is a significant part of a world development.[84]

King suggested that "Every society has its protectors of the status quo and its fraternities of the indifferent who are notorious for sleeping through revolutions. But today our very survival depends on our ability to stay awake, to adjust to new ideas, to remain vigilant and to face the challenge of change." His anticipatory take on technological and social change in "World House" relates, in many ways, to Marshall McLuhan's concept of the "global village," amplifying it with nuanced concerns over the embeddedness of African American citizenship within the financial and technological sovereignty of the United States on the grand chessboard of the Western world order. King wrote:

> The large house in which we live demands that we transform this world-wide neighborhood into a world-wide brotherhood. Together we must learn to live as brothers or together we will be forced to perish as fools. We must work passionately and indefatigably to bridge the gulf between our scientific progress and our moral progress. One of the great problems of mankind is that we suffer from a poverty of the spirit which stands in glaring contrast to our scientific and technological abundance. The richer we have become materially, the poorer we have become morally and spiritually.[85]

On Thursday, April 4, 1968, Martin Luther King, Jr., was assassinated in Memphis, Tennessee, while working with a sanitation workers' strike initiative and writing his sermon for that Sunday, titled "Why America May Go to Hell"[86]:

84 Martin Luther King, Jr., *Where Do We Go From Here: Chaos or Community?* (New York: Harper & Row, 1967), 181.

85 Ibid.

86 Vern E. Smith and John Meacham with Veronica Chambers, "The War Over King's Legacy," *Newsweek*, April 6, 1998.

And I come by here to say that America, too, is going to hell if she doesn't use her wealth. If America does not use her vast resources of wealth to end poverty and make it possible for all of God's children to have the basic necessities of life, she, too, will go to hell. And I will hear America through her historians, years and generations to come, saying, "We built gigantic buildings to kiss the skies. We built gargantuan bridges to span the seas. Through our spaceships we were able to carve highways through the stratosphere. Through our airplanes we are able to dwarf distance and place time in chains. Through our submarines we were able to penetrate oceanic depths." It seems that I can hear the God of the universe saying, "Even though you have done all of that, I was hungry and you fed me not, I was naked and you clothed me not. The children of my sons and daughters were in need of economic security and you didn't provide it for them. And so you cannot enter the kingdom of greatness." This may well be the indictment of America.[87]

Two years before his murder in 1965, Malcolm X gave a speech entitled "God's Judgement of White America (The Chickens Come Home to Roost)" in response to a question concerning the recently assassinated President John F. Kennedy and his failures to protect the Black community from state-sanctioned racialized white supremacist violence in Black communities. Malcolm X stated:

The hour of judgement and doom is upon white America for the evil seeds of slavery and hypocrisy she has sown . . . America is the last stronghold of white supremacy. The Black revolution, which is international in nature and scope, is sweeping down upon America like a raging forest fire. It is only a matter of time before America herself will be engulfed by the Black flames, these Black firebrands.[88]

Malcolm X claimed that if Black people "are a part of America, then part of what she is worth belongs to us. We will take our share and depart," and "[i]f the government of white America truly repents of its sins against our people, and atones by giving us our true share, only then can America save herself!"[89] He ended his speech with a declaration: "White America, wake up and take heed, before it is too late!"[90]

In 1991, a decade after Alvin Toffler's *The Third Wave*, author and playwright William Strauss penned *Generations*, a lexical "history of America's future" spanning the years 1584 to 2069, with writer Neil Howe. Looking at the five-hundred-year colonization effort of the Americas, Strauss and Howe propose a generational theory

87 Martin Luther King, Jr., *The Radical King* (Boston: Beacon Press, 2016), 248.

88 Malcolm X, "God's Judgement of White America (The Chickens Come Home to Roost)," in *The End of White World Supremacy: Four Speeches by Malcolm X*, ed. Benjamin Karim (New York: Arcade Publishing, 1989), 184.

89 Ibid., 218.

90 Ibid., 219.

based on historical cycles of people moving through time towards a holistic American national legacy. *Generations* grappled with the very definition of white America by examining the process by which British and European settlers evolved into American citizens, mapping this progression to the scale of a human life and to the aggregate, reproductive structure of the American family. As Strauss and Howe note in their preface, *Generations* "presents the 'history of the future' by narrating a recurring dynamic of generational behavior that seems to determine how and when we participate as individuals in social change—or social upheaval." They postulated that "if the future replays the past, so too must the past anticipate the future."[91] They explore what they call the concept and completion of a thousand-year cycle in human history; "as America moves into the ensuing Crisis era," they write, "long-deferred secular problems can be expected to reemerge with fearsome immediacy."[92] From the vantage point of 1991—the same year the *Retro Techno / Detroit Definitive* compilation reset the origins of techno at the beginning of its commercialization—*Generations* speculated about the collapse of the American experiment in socializing greedy colonizers, working-class immigrants, and marooned slaves into an economic, pseudo-democratic republic:

> The climatic event may not arrive exactly in the year 2020, but it won't arrive much sooner or later. A cycle is the length of four generations, or roughly 88th years. If we plot a half cycle ahead from the Boom Awakening (and find the 44th anniversaries of Woodstock and the Reagan Revolution), we project a crisis lasting from 2013 to 2024. If we plot a full cycle ahead from the last secular crisis (and find the 88th anniversaries of the FDR landslide and Pearl Harbor Day), we project a crisis lasting from 2020 to 2029. By either measure, the early 2020s appear fateful.[93]

Five years later, and coinciding with the release of *The Return of Drexciya* (1996), Strauss and Howe published *The Fourth Turning*, which predicted an "American prophecy" and "rendezvous with destiny."[94] "In the Fourth Turning," they write, "as every generation reenacts the legends and the myths of its ancestors, we can together establish new legends and myths—ones that can shape, and teach, posterity."[95] Strauss and Howe interpret the rhythm and growth of American society much like stocks and bonds, hypothesizing that "History is seasonal, and winter is coming."[96] Relative to

91 William Strauss and Neil Howe, *Generations: The History of America's Future, 1584 to 2069* (New York: William Morrow and Company, 1991), 16–17.

92 Ibid., 381.

93 Ibid.

94 William Strauss and Neil Howe, *The Fourth Turning: An American Prophecy* (New York: Broadway Books, 1997), 7.

95 Ibid., 328.

96 Ibid., 6.

Toffler's *Third Wave,* Strauss and Howe's *Fourth Turning* calibrates the thousand-year transition from antiquity to modernity as a functional chronology of recognizable patterns in Anglo-American society across the unraveling events, behaviors, and innovations of human history, picking up where *The Third Wave*'s sequel, *Powershift,* left off: it anticipates a revolution in the scientific, technological, economic, and cultural foundations of everyday life. "For three hundred years Western science pictured the world as a giant clock or machine, in which knowable causes produced predictable effects," Toffler writes in *Powershift*'s coda à propos of freedom, order, and chance.[97] This temporal progression towards a presupposed "freedom" manifests across many generations of white settlers throughout the colonization of the American continent, and correlates with Strauss and Howe's outlining of the "four turnings": "an American High" (1946–64), a "Consciousness Revolution" (1964–84), an era of "Culture Wars" (1984–2005), and a historical return in the early years of the 2000s—the "years of the reality check, of worries about a looming national payback as Americans of all ages begin focusing on how poorly they and their government have prepared for the future."[98] Strauss and Howe believe these cycles of peaking and cascading historical rhythms were brought over to the North American continent by Anglo-Saxon settlers, still entangled in the English language, British politics, and European economics. "Though not directly linked to the origin of the cycle, the stories of African Americans and non-Anglo immigrants are closely linked to the cycle's rhythm," they juxtaposed. "From the Stono Uprising of 1739 to Nat Turner's Rebellion of 1831, from W.E.B. Du Bois's turn-of-the-century Black consciousness movement to the long, hot summers of the 1960s, America's loudest challenges against racism have coincided with the coming of age of the Prophet archetype."[99]

*

In 1999, Drexciya unveiled the equation at the core of a speculative Black Atlantic world with *Neptune's Lair* before initiating a seven-album cycle forging a conceptual "journey home." When superimposed onto Toffler's three waves of technological change and spooled into Strauss and Howe's seasonal turnings of the American genealogical legacy, Drexciya's migration map in *The Quest* (1997) plots a multi-century Black alternative reality that exists in a singular imagined "world game,"[100] including

97 Toffler, *Powershift,* 467.

98 Strauss and Howe, *The Fourth Turning,* 251.

99 Ibid., 94–95.

100 The fictional worlds and product design strategies employed in Detroit techno mirrors American architect and systems theorist Buckminster Fuller's work at Southern Illinois University in 1961 on an educational computer simulation game called "How to Make the World Work," which seeks to solve the dilemmas of overpopulation and world peace: "In playing 'the game' the computer will remember all the plays made by previous players and will be able to remind each successive player of the ill fate of any poor move he might contemplate making. But the ever-changing inventory might make possible today that which would not work yesterday. Therefore the successful stratagems of the live game will vary from day to day. The game will not become stereotyped. If a player resorts to political means for the realization of his strategy, he may be forced ultimately to use the war-waging equipment

Atkins' simulation of a utopic creative class technocracy, Metroplex, and the Afro-Indigenous sonic warfare deployed by Underground Resistance. In *The Quest*'s liner notes, Cornelius Harris, the Unknown Writer, forecasted "the end of one thing... and the beginning of another."[101] Haqq's cover art for *Neptune's Lair* offers the first glimpse of the Drexciyan Empire, and the aqua wormhole of the Bermuda Triangle that transports them to the surface world. That same year, The Ancient (Haqq) captured scenes of Martians living harmoniously for the Red Planet compilation *LBH - 6251876* (1999), for which he also wrote liner notes that describe the catastrophes Native Americans foresaw during the spiritual Ghost Dance War of 1890, before phasing into outer space and building civilizations on the surface of Mars. According to Haqq, the planet is abundant with plants, animals, and microbial beings brought over from Earth, endowed as it is with hidden oceans and aquatic life. "However, a human can only witness it for a short period of time because of the toll it takes on human physiology."[102] The Martians respected the Red Planet, Haqq explained in his writing:

> These brief flashes of life from Mars provide certain glimpses of the beauty of the Martian way of life. Having no material technology, the technology on Mars is based on thought and spirit. Certain humans who are blessed with this gift can attune themselves to the vibrational wavelength of Martian reality. Their language and ways of communication are quite musical and melodic. Their social ties are based on close knit families, clans and tribes and is very simplistic. Despite the simplicity of the Martian culture and way of life. Martian civilization is thousands of years more advanced than humanity's.[103]

From the 21st (1999), Jeff Mills' debut album, arrived months before *Neptune's Lair* and the Red Planet compilation. "Around 2000, people were very fearful, there was Y2K, the world's about to come to an end, and this whole kind of what-if kind of scenario, so I made an album based on that," recalled Mills.[104] Having DJed across Europe throughout the '90s, Mills had become frustrated with rave culture's stasis: it had commodified dance music only to watch the industry's economic value decline a few years later. He felt creatively restricted by the format of the club, and its insistence on positioning the DJ as a ready-made, traveling shaman who crafts a sonic backdrop for grey zone nightlife experiences. "In Futurism, they embraced risk, used it as some kind of symbol against the status quo," Mills says. "In the mid-90s I understood it

with which all national political systems maintain their sovereign power. If a player fires a gun-that is, if he resorts to warfare, large or small—he loses and must fall out of the game." Buckminister Fuller, "How to Make the World Work," in *Utopia or Oblivion: The Prospects for Humanity* (Zurich: Lars Müeller Publishers), 205.

101 The Unknown Writer, liner notes, Drexciya, *The Quest* (Submerge, 1997).

102 The Ancient, liner notes, The Martian, *LBH - 6251876 - A Red Planet Compilation* (Red Planet, 1999).

103 Ibid.

104 Mills, interview by Walmsley.

wouldn't be easy to materialise some of these ideas slightly beyond the dance floor in electronic music." He continued: "Actually there's quite a lot of resistance against changing or using music in other things. People thought I was wasting my time—why would I?"[105] Starting a sub-label called Tomorrow, Mills released *Preview* (1999), an anticipatory glimpse at the new millennium with four tracks of ambient audioscapses that lead into a final, ten-minute candid conversation between a woman named Andrea Covington and a man named Glen about life on Earth in the distant future: "In 500 years we human beings we'll almost come around God, we are going to come so intelligent, we could be able to directly link each individual human mind into one super computer, it's like the ultimate neuro-network,[106] forget the internet, that's just plug-in your computer in, it's like you can plug your own brain into the internet..."[107]

Mills continued to work as the year lapsed into the new millennium, releasing an imagined score he composed for Fritz Lang's 1927 science fiction film *Metropolis* on Tresor. Considering the film's relevance to Germany's economic devaluation during the Weimar period, Mills used *Metropolis'* theme of industrialists and businessmen stepping in to bring a dying civilization into the future as an inspiration for the situation of Detroit and the eventual downfall of the global economy. "Our parents put us in the same situation... " he muses, "and as we get older, you want to kind of go back, and drag these things into your profession and your life..."[108] Mills continued to work his way through the media of his past and his intentions for the future: "Movies like Metropolis and Blade Runner, these kind of 'what-if' theories, because there was a 'what-if' comic book on Marvel, just... Looking at space travel the same way, and reducing it down to normal travel . . . just the same way that we would read the comic book."[109] In 2001, his albums *At First Sight* and *Time Machine* interposed his ideas with the varying epochs of human history, traveling between the built worlds of his mind and the epigenetic chronology leading up to his twenty-first-century reality:

> Let's say, when I was young, Martin Luther King was assassinated, and watching how my parents react to that would probably prepare me—and I hope it never happens—for if Obama is assassinated, and I react to this and my daughter sees me, how I react to it. And that passes down a certain type of mentality of how to deal with the issues, and that I think is the influential thing that creates these

105 Ibid.

106 "When computers first arrived in corporate offices about three decades ago, the press was filled with speculation about the coming of the 'giant brain.' This electronic mega-brain would contain all the information needed to manage a firm. . . . Such megalomaniac fantasies vastly underestimated the increased diversity and complexity in a super-symbolic economy. They arrogantly underrated the role of change, intuition, and creativity in business. Most important, they also assumed that the people on top of a business knew enough to specify what information was, or was not, needed by the people working below them in the hierarchy." Toffler, *Powershift*, 147.

107 Jeff Mills, lyrics, "Glen21," *Preview* (Tomorrow, 1999).

108 Mills, interview by Walmsley.

109 Ibid.

cycles I think. . . . Being American, we're all pushed and raised in the same way, perhaps the generation of my parents and their neighbours and their children was probably a very much similar situation. They didn't go onto the streets and start shooting white people, they were very sad of course, but kept control. So I think that's the most impactful thing. It's how you react to certain things, because we're always going to have crises in different situations, and things we did not expect. But how you react to them determines how you move on.[110]

In 1980, at the beginning of the Information Age, the Detroit youth counter culture that re-engineered outmoded audio equipment to create a world-building and liberation technology all fit within an age bracket that Strauss and Howe call "13ers," or the thirteenth generation of Americans born between 1961 and 1981 (colloquially known as "Gen Xers"). "Broken into shards," they write, "13ers will privately find ways of making small things work in disordered environments."[111] Strauss and Howe penned a more in-depth exploration of the 13ers in a 1993 book of the same name, outlining the ways in which elder American generations looked down on their ability to situate and integrate into modern society, much like in previous eras of American history: "When 13er babies first appeared in a nation bursting all over with worldly marvels, from 8-track stereos to Apollo moon launches, adults figured these kids would be nothing if not affluent."[112] Later, Strauss and Howe explain that the 13ers bore the burden of the Reagan-era failure of so-called "trickle down economics," which had inflated the US' overall wealth without distributing it evenly between races and generations. In turn, Reaganomics destabilized the traditional understandings of class structures by replacing the ability to accumulate capital through labor and ownership with speculative free-market investments in stock futures. "During the Bush years, most of today's 40 million 13ers living on their own hit their first recession," Strauss and Howe pointed out. "And behold: This was the only cyclical downturn ever recorded in which all the net job loss landed on the under 30 age bracket."[113]

*

Gerald Donald, a child of the technological innovations and financial speculations of the 1980s, set out on his own following the death of James Stinson, in pursuit of a transgressive art form and method for independent musicians to conceptualize and distribute their recorded material in a post-Fordist culture industry. In 2003, Donald, as Dopplereffekt, released the full-length album *Linear Accelerator* through the German label International Deejay Gigolo, inspired by experiments in particle physics performed by the Deutsches Elektronen-Synchrotron national research

110 Ibid.
111 Strauss and Howe, *The Fourth Turning*, 252–53.
112 Neil Howe and William Strauss, *13th Gen: Abort, Retry, Ignore, Fail?* (New York: Vintage Books, 1993), 93.
113 Ibid., 98.

center in Germany. The next year, under the name Arpanet, Donald released *Quantum Transposition* through Rephlex, examining the theoretical principles charted by physicists Werner Heisenberg, Max Planck, and Anton Zeilinger as they sought to understand the dematerialization and rematerialization capacities of the transporter technology introduced in the television series *Star Trek*. With a cover photo credited to the Institute of Experimental Physics at the University of Vienna, Dopplereffekt was positioned as an obscure Oz-like figure, toiling away in a secret laboratory, probing the meaning and matter of universal structures through vibrational experimentation.

"For untold years, music has been a battleground for these forces of chaos and order," Harris, using another moniker (Atlantis), opined in the liner notes for Underground Resistance's second Interstellar Fugitives album, *Destruction of Order* (2005). Recording technology, he argued, reigned in the freedom with which Black music could be performed. "Jazz musicians and others fought to prevent this, while pop stars willingly gave in and became programmed artists, producing music from order rather than chaos, a theoretical impossibility."[114] Considering the development of electronically produced music and the oppressive standardization of the Euro-American colonial order throughout the twentieth century, the Unknown Writer of Atlantis proposed that The Wizard and The Electrifying Mojo's radio broadcasts spawned a new form of "chaotic musical expression" that directly inspired the rebellious techno music emerging out of Detroit's Black counter culture. "Chaos would not remain beyond the new technology, the accessibility of recorded music allowing for marginalized artists to gain fans from places they'd never been, and providing a forum for R1 and Z-gene figures to communicate with others."[115] In 2006, John "Bileebob" Williams, an affiliate of Underground Resistance and member of the Drexciyan Aquanauts, produced a self-released album with Scott McEntyre of Black Echo Zone, titled *Biological Machines*, that adapted the possibilities of studio dubbing and equalization to the Detroit techno style. Similarly, Dennis Richardson's work as Ultradyne developed out of his collaboration with Drexciya on the 1997 EP *Uncharted*, building off of Drexciya's *The Quest* to hone the singular perspective of a mundane dystopia sleepwalking into a crisis, with releases such as *Age of Discontent* (2003), *The Privilege of Sacrifice* (2004), and *Wrath of the Almighty* (2007). Elsewhere, Ade' Mango Henderson Mainor, or Mr. De', Mike Banks, Orlando Voorn, Raphael Merriweathers, Jr., and a number of others formed a full-scale hi-tech funk band called Blak Presidents, releasing *Fight the Future* in 2007—one year before Barack Obama was elected America's first Black president.[116]

114 Atlantis, liner notes, UR, *Interstellar Fugitives 2 - Destruction of Order* (Underground Resistance, 2005).

115 Ibid.

116 "Barack Obama's victories in 2008 and 2012 were dismissed by some of his critics as merely symbolic for African Americans. But there is nothing 'mere' about symbols. The power embedded in the word nigger is also symbolic. Burning crosses do not literally raise the Black poverty rate, and the Confederate flag does not directly expand the wealth gap. Much as the unbroken ranks of 43 white male presidents communicated that the highest office of government in the country—indeed, the most powerful political offices in the world—was off-limits to

The first decade of the new millennium only seemed to confirm the onset of this dystopia in Detroit. On September 15, 2008, a bubble in the United States housing market burst in response to the sudden bankruptcy of the global financial services firm Lehman Brothers, creating a severe financial crisis; the Programmers' technocratic society and world order slid back into a global recession. On Devil's Night, Michigan's colloquial name for the eve of Halloween, CBS News reported concern over the potential of increased arson and destruction throughout the city of Detroit—an unfortunate tradition since the 1967 race riots. Despite a decline in acts of arson in the years leading up to 2008, "This year, officials worry that the national foreclosure crisis, and a spate of vacant homes left in its wake, could be tempting targets for arsonists. Detroit ranked as the 14th hardest-hit metropolitan area in the third quarter of this year by foreclosure listing service RealtyTrac Inc."[117] The state of Michigan was hit harder than most of the US, losing more than eight hundred thousand jobs between 2000 and 2009, while the housing bubble burst, foreclosing hundreds of thousands of homes as two of the Big Three automotive manufactures in Detroit—General Motors and Chrysler—filed for bankruptcy. The following Halloween, the *Guardian* published an article by Paul Harris that described how Detroit had become a "ghost town": "Officially, America is on the up. The economy grew by 3.5% in the past quarter," but, "for tens of millions of Americans such things seem irrelevant." For the residents of Detroit, "the recession is far from over." Harris concludes:

> There is little doubt that Detroit is ground zero for the parts of America that are still suffering. The city that was once one of the wealthiest in America is a decrepit, often surreal landscape of urban decline. It was once one of the greatest cities in the world. The birthplace of the American car industry, it boasted factories that at one time produced cars shipped over the globe. Its downtown was studded with architectural gems, and by the 1950s it boasted the highest median income and highest rate of home ownership of any major American city. Culturally it gave birth to Motown Records, named in homage to Detroit's status as "Motor City."

> Decades of white flight, coupled with the collapse of its manufacturing base, especially in its world-famous auto industry, have brought the city to its knees. Half a century ago it was still dubbed the "arsenal of democracy" and boasted almost two million citizens, making it the fourth-largest in America. Now that number has shrunk to 900,000.[118]

Black individuals, the election of Barack Obama communicated that the prohibition had been lifted. It communicated much more." Ta-Nehisi Coates, "My President Was Black," *The Atlantic*, January/February 2017, https://www.theatlantic.com/magazine/archive/2017/01/my-president-was-black/508793/.

117 Associated Press, "'Devil's Night' Fires Doused in Detroit," *CBS News*, October 30, 2008, https://www.cbsnews.com/news/devils-night-fires-doused-in-detroit/.

118 Paul Harris, "How Detroit, the Motor City, Turned Into a Ghost Town," *Guardian*, October 31, 2009, https://www.theguardian.com/world/2009/nov/01/detroit-michigan-economy-recession-unemployment.

The effects of Detroit and its industries sinking further into crisis were felt across the Western world. The aftershocks of the 2008 financial crisis became a point of fascination for The Otolith Group (Kodwo Eshun and Anjalika Sagar),[119] who in 2010 premiered their film *Hydra Decapita*, which revisits the mythscience of Drexciya in the context of the accumulation of American intergenerational and European common wealth within a presently failing system of global capitalism. Much like the works of Drexciya, the film abstractly references varying imagined worlds as they intersect with crucial moments in history. Eshun, who led the research and development for the film, reflected on the impact of his discovery of Drexciya's series of EPs on Underground Resistance's Shockwave Records and Aphex Twin's Rephlex in the 1990s. "There was this strange kind of void around their work," he noted. "So that was the first attempt to analyze the kind of mytho-poetic impetus that they were unfolding."[120] Just as Eshun felt he was able to grasp the coded messages embedded in Drexciya's music and liner notes, *The Quest* and its attendant map were released, further deepening the mystery. "The text they published alongside it gave a kind of cognitive map to read those EPs," he explained. "And then, once James Stinson of Drexciya died in 2002, that brought this kind of intense interest in reconstructing the biographical elements of Drexciya." In his book *More Brilliant Than the Sun* (1998), Eshun returned to Drexciya, examining it within the context of a larger sonic fiction he derived from the many Black Atlantic strains of electronic music that had emerged throughout the '90s. *The Quest*'s map itself displays the rise and fall of globalization through the corporatization of the transatlantic slave trade, beginning in 1655 when the first investment of around five hundred African slaves were imported to the Dutch-American colony of New Amsterdam, and ending with the descendents of those same Africans receiving a return on that initial investment, in a speculative future in which they journey home. Eshun considers this from the vantage point of the United Kingdom, peering into the distributive labor and economic system of the United States:

> By the time of 2010, the question for us is abstraction. Drexciya started to be-come something like an allegory for how to analyze the financial crisis of '08. It became a question of how we could analyze this confrontation with a new vocabulary of financial crisis. 2008 confronted us all with the arcane language of "credit derivatives," "credit default swaps"; and we felt something that we

119 "Formed in 2002, the London-based Otolith Group (which comprises Kodwo Eshun and Anjalika Sagar) doggedly investigates these temporal slips and Utopian dreams of 'the temporality of past potential futurity', as they put it. Their use of documentary footage, of archives both familiar and alien, provides a melancholy window onto worlds not created and paths not followed. . . . An otolith is the part of the inner ear that senses tilt. *Otolith I* (2003), the group's first film (which includes camera work by Richard Couzins), imagines a world in which sustained periods of microgravity on space stations have led to a permanent impairment in the human ability to cope with terrestrial gravity. Humanity has been literally dispossessed of its own worldliness; everything is unbalanced, weightless." Nina Power, "Waiting for the Future," *Frieze*, March 1, 2010, https://www.frieze.com/article/waiting-future.

120 Kodwo Eshun, interview by Christoph Cox, "Afrofuturism, Afro-Pessimism and the Politics of Abstraction: A Conversation with Kodwo Eshun," August 2014, posted on Cox's faculty website, http://faculty.hampshire.edu/ccox/Cox.Interview%20with%20Kodwo%20Eshun.pdf, 1.

felt again the next year in Fukushima. When you have these infrastructural crises, a huge amount of discursive abduction takes place in which you can feel citizens exposed to a kind of arcane expertise. So everybody's forced to embark on a kind of accelerated process of trying to educate themselves in economics. Everybody's trying to come up with a language. We started to think we needed a visual language which was as abstract as that of the real abstraction of living through a crisis.[121]

Eshun understands the Drexciyan mythology to be indicative of the African American necessity to resist against, and escape from, a financial empire built on their bodies. "The key book for us was Ian Baucom's *Specters of the Atlantic*, which argues that the slave trade was the beginning of a kind of world market, which can be seen in the kinds of naval insurance, the kinds of credit that the slave trade involved, the way in which slaves were effectively credit-bearing bodies," Eshun explains. The Africans being shuttled from their home continent across the Atlantic Ocean "weren't any old commodities. They were special commodities, credit-bearing commodities traded on the basis of promises to buy and sell. So it was as if you could begin to see the beginnings of the market."[122] Eshun considers the legal case of a massacre aboard the slave ship Zong in 1781, during which 132 of 442 Africans were thrown overboard by the crew to lighten the load, as a potential site for exploration into the Drexciyan mythology. "When the captain of the Zong gets back to land, the case is not the question of murder but the question of insurance," he says. "It's basically an argument between the Liverpool shareholders who invested in the Zong and who were claiming insurance and the marine insurance company which refused to pay. And so this seemed to offer a nexus between death, financialization, abstraction, and exchange." He continues: "It all seemed to converge on the Zong. And so the Drexciya mythos which had begun in '97 as a question of mutation and posthumanity started to take on these questions of abstraction, finance, and death. And that made it current for us."[123]

As a cinematic expansion of Drexciya's sonic fiction, *Hydra Decapita* repositions the narratives and concepts explored in *The Last Angel of History* a decade prior, placing the viewer in the perspective of the Data Thief who navigates fragments of externalized time-collapsed events and forges a path toward a holististic truth about the internal nature of the Black Atlantic. Beyond this narrative, the liberal financial growth and expansion over the ten years leading into the crisis of 2008 becomes central to Eshun's reexamination of the myth of Drexciya. Gerald Donald, as the sole surviving member of Drexciya, is present in the film as a disembodied, submerged voice, known simply as "the Author," who prefaces the film with the ominous message: "There is no more

121 Ibid., 2–3.
122 Ibid., 3.
123 Ibid.

Drexciyan dimension; that dimension is closed, like a wormhole, like a stargate."[124] Eshun says that he refused to be credited as a member of Drexciya, prefering to be characterized as a remnant of a hydrogen particle—not unlike Haqq's illustration of Drexciya as a single cell-organism in the artwork for *Interstellar Fugitives*. "I spent four days with [Donald]; and he said the most fascinating things. He said that he and James Stinson used to imagine themselves in a submersible descending to the bottom of the ocean, the absolute depths of the Mariana Trenches—absolute silence, blackness, crushing pressure, the creaking of metal," Eshun recalls. "He said that they would think themselves into this space and then they would start making music from this perspective of insulation and isolation. We'd talk for hours, but I'd only record an hour a day. And I suddenly thought, 'o.k., I'm going to go through the names of every Drexciya composition and I just want you to free associate a response.'"[125] Donald wouldn't explain to Eshun what any of the track titles meant or what his quotes throughout the film addressed, but together they built a science fiction, using his voice as the source material. "He'd given us all these constraints. We couldn't film him, couldn't film his house. We couldn't use any Drexciya music. In the end, he was like 'you can't even use my voice.'" Eshun pleaded with Donald, "I was like, "please! Gerald, we have to use your voice.' It's a really good voice. So this was the only thing he let us use. But that was enough."[126]

Hydra Decapita does not show or reference Drexciya directly, instead favoring a kind of "reduction and subtraction" of their presence that allowed for Haqq's illustrations of Drexciya "as wave jumpers with fins and aqua-lungs" to remain the sole visual example of what Black Atlantic people could look like. In imagining the mythic world of Drexciya, the film refers back to Eshun's statements in *The Last Angel of History*: that there was something alien about the African American experience, the abduction and the probing, mutating, and reengineering of the mind and body to attune to the New World and its speculative democracy, economy, and society. Eshun was aware that "the sub-aquatic depths are less explored than the surface of the moon or even the surface of Mars, that it's more difficult to land a submersible in the Mariana Trenches than it is to land the Sojourner on the surface of Mars"[127]—a parallel relationship that manifests in "Wardance," a collaborative track by Drexciya and the Astral Apache (Mike Banks) on the album *The Long Winter of Mars* in 1994. "That was there since '97; but by 2010, that notion of hidden depths had to be evoked with the surface," Eshun asserts. "We spent a lot of time discussing how to film water and settled for this notion of filming the surface. It was quite influenced by Roni Horn's book *Another*

124 Gerald Donald, *Hydra Decapita*, directed by The Otolith Group (London: Lux, 2010). See also Mike Rubin, "Infinite Journey to Inner Space: The Legacy of Drexciya," *Red Bull Music Academy Daily*, June 29, 2017, https://daily.redbullmusicacademy.com/2017/06/drexciya-infinite-journey-to-inner-space.

125 Eshun, interview by Cox, 4.

126 Ibid., 4–5.

127 Ibid., 5.

Water, in which she photographed the Thames, focusing on the Thames as a grave-yard, a liquid graveyard, where there have been a number of suicides. And from her, we got the idea of blocking out the sky. If you block out the sky and the beach, you take away two reference points that allow a kind of metaphorical escape route. If you took those out, the metaphor changes and it becomes more carceral."[128]

Luminous celestial bodies, distant stars, and solar systems line the sky backdrop of one of Haqq's earliest techno-inspired paintings, *313 Detroit* (1992),[129] which de-picts a dystopian vision of an eroded urban city of the future. Foregrounded above a still-operable monorail system, Haqq envisioned a building that once housed the General Motors headquarters emerging out of urban wreckage. Behind many of the individual sonic fictions emanating from Detroit techno, Haqq has used his cover designs as a method of installing fragments of mythological infrastructure that ac-cumulate into an established world-system. Beyond this, Haqq's illustrations are about the merging of humans with machines and the vibrational technology that has been cybernetically hot-wired out of electronic equipment by Atkins, Underground Resistance, and Drexciya, as well as many other Detroit musicians who have sculpted alternative future outcomes for a society accelerating through one fiscal and environ-mental crisis after another. "I had an idea for Model 500 being a robot series and it would go off to war on different planets," he remembered. Actuator, another character central to the 2003 eponymous album, Haqq explains, "could tap into networks and different computer systems and retrieve information."[130] His work culminates in a mythscience that augments the historical timeline of his reality into the single universe of *The Technanomicron* (2008)—"one final testament dedicated to the beauty and glory of their world."[131]

Two years later, Haqq collaborated with Japanese anime director Shinichiro Watanabe on *Requiem for a Machine Soul* (2010), a twenty-page graphic novel released as a part of a joint exhibition at Gallery IKOI in the Netherlands, curated by Misuzu Watanabe. Rick Wade, a longtime friend of Haqq's who began DJing in the mid-1980s alongside Mills at the Nectarine Ballroom while attending the University of Michigan, created a mini-album version of the book, lifting off from a decade of ghetto tech releases, a ra-dio show on WCBN named *Journey to the Land of House*, and his deep house albums *Dark Ascension* (2004) released on his own label, Harmonie Park, and *Darkskills (A Soldier's Story)* (2005). "Whenever I create a track it's with the purpose of either creating an emotion (happiness, nostalgia, etc.) or transference of an emotional state

128 Ibid., 5.

129 "It came to us from another planet. A satellite city, eight wonders from America's seventh city. At long last, 313 has arrived, a flash of light for these dark times, music that is out there in a world of its own." Chris Abbot and Kris Needs, liner notes, *313 Detroit* (Infonet, 1992).

130 AbuQadim Haqq, in conversation with Voltnoi & Quetempo, "Enter Afrofuturism," Onassis Foundation, November 2017, https://www.youtube.com/watch?v=wgwzEf4D_6k.

131 AbuQadim Haqq, *The Technanomicron* (n.p.: Third Earth, 2008), 1.

(usually frustration, sadness, or anger)," explains Wade.[132] As an Instructional Systems Designer, Wade approached music-making intuitively, without a keen knowledge of music theory, instead relying on nonverbal feedback between his own ear and other producers in the scene, like Mick Huckaby and Theo Parrish. "I simply try to become 'one' (sounds cheesy, I know) with the music, getting lost in the melody and letting it guide my thought/creative process. That's why a lot of my productions are more like grooves as opposed to full on 'tracks' because for me, the most important part of a track is the groove or melody."[133] Haqq and Wade worked together on *Never Ending Reflections* in 2011, expanding on the story developed in *Requiem for a Machine Soul* of an android named Gina, disassembled after she displayed an emotion, love. Next, Haqq painted a meditating figure enmeshing with a room-scale computer mainframe as the cover illustration for *Surkit Chamber - The Melding* (2011), a debut album by Reel By Real (Martin Bonds), a first-generation techno producer who collaborated with Atkins, Shakir, and members of Aux 88 throughout the '80s and '90s while working at Saunderson's KMS studios as a sound engineer in training. Bonds' smoothly executed electronic funk retools the now-classic formulas of analog techno and electro with layers of vocals and effects processed with modern digital audio equipment. On "Freedom from Want," Bonds samples Franklin D. Roosevelt's address to the US Congress on January 6, 1941, in which he promised that American citizens—and people "everywhere in the world"—may one day in the future, look forward to a world of freedom, progress, and security.[134]

*

During the final months of 2010, Italian philosopher Franco "Bifo" Berardi wrote an essay titled "The Future After the End of the Economy," in which he described the concept of "the future" as "the cultural collapse of the most important mythology of capitalist modernity."[135] Berardi's survey establishes that "economics is not a science," and defines the intellectual discipline as "a form of knowledge free of dogma," which he felt could "extrapolate general laws from the observation of empirical phenomena,"

132 "Fifteen Questions Interview with Rick Wade," 2020, https://15questions.net/interview/fifteen questions-interview-rick-wade/page-1/.

133 Ibid.

134 "In the future days, which we seek to make secure, we look forward to a world founded upon four essential human freedoms. The first is freedom of speech and expression—everywhere in the world. The second is freedom of every person to worship God in his own way—everywhere in the world. The third is freedom from want—which, translated into world terms, means economic understandings which will secure to every nation a healthy peacetime life for its inhabitants—everywhere in the world. The fourth is freedom from fear—which, translated into world terms, means a world-wide reduction of armaments to such a point and in such a thorough fashion that no nation will be in a position to commit an act of physical aggression against any neighbor—anywhere in the world. That is no vision of a distant millennium. It is a definite basis for a kind of world attainable in our own time and generation. That kind of world is the very antithesis of the so-called new order of tyranny which the dictators seek to create with the crash of a bomb." Franklin D. Roosevelt, "Annual Message to Congress, January 6, 1941," *Speeches in World History,* ed. Suzanne McEntire (New York: Facts on File Inc., 2010), 355.

135 Berardi, "The Future After the End of the Economy."

and could "therefore predict something about what will happen next" through a process of speculation and data analytics. Economists, however, he argues, are dogmatic in their understanding and pursuit of "growth, competition and gross national product," more or less diluting and skewing reality in favor of positive affirmation: "Economists cannot recognize changes in the social paradigm, and they refuse to adjust their conceptual framework accordingly. They insist instead that reality must be changed to correspond to their outdated criteria." Professing the notion of an overall end of economic growth and of the accumulation of wealth through labor extraction in the face of an unemployment crisis, Berardi traces the origins of the concept of infinite growth and expansion of ownership back to the origins of modern society, in the Roman Empire. During the euphoric rise of stock indexes of the dot-com bubble years, he suggests, the current technocracy found itself intellectually incapable of grappling with the problems and constrictions of reality, while also extracting and exhausting "psychic energy," such as attention to its unnatural limits:

> After the illusions of the new economy—spread by the wired neoliberal ideologists—and the deception of the dot-com crash, the beginning of the new century announced the coming collapse of the financial economy. Since September 2008 we know that, notwithstanding the financial virtualization of expansion, the end of capitalist growth is in sight. This will be a curse if social welfare is indeed dependent on the expansion of profits and if we are unable to redefine social needs and expectations. But it will be a blessing if we can distribute and share existing resources in an egalitarian way, and if we can shift our cultural expectations in a frugal direction, replacing the idea that pleasure depends on ever-growing consumption.[136]

In November 1976, over two decades before the emergence of the internet, former auto worker and activist James Boggs spoke to a graduate class in architecture at the University of Michigan, offering an analysis of the future and the possibility of the American population settling for a continuation of the present, with all of its faults and effects on the global economic market. He asked: "Are we ready to settle for a society in which each of us acquires more material things each year but is only a consumer and a contributor to the Gross National Product?"[137] The speech was later edited and published by Alternatives, a Detroit-based organization, under the title "Towards a New Concept of Citizenship." Boggs passionately outlined the incessant nature of the American cycles of presidential elections within a two-party system and the bureaucracy that distances American citizens from their government-operated military industrial complex and welfare state. Within a technocratic system, Boggs questioned

136 Ibid.

137 James Lee Boggs, "Towards a New Concept of Citizenship" (speech, School of Architecture, University of Michigan, Ann Arbor, MI, November 9, 1976), published as *Towards a New Concept of Home* (Detroit: National Organization for an American Revolution, 1979).

390

the nature of a society that actively designs environments and scenarios that enforce isolation and competition against its neighbors: "In order to be human, we need to feel that we belong to a community where people of different ages and interests have grown to depend upon one another because over the years our personal lives and the life of the community have become interdependent." He reminded the students that the "technological explosion" that created the modern societies of the twentieth and twenty-first centuries was only possible after the Second World War:

> Today, as a result of our modern technology, we are an expiring mobile society of consumers, buying the products as fast as they can be produced and made known to us by advertising. Instead of being people, we have become masses—individuals who believe that consumption and possession are what life is all about and therefore believe in ways that can easily be predicted by market researchers. The technology that we continue to develop is intervening with Nature itself with the result that we live in constant danger of the whole planet being destroyed. The atmosphere and vegetation, which we depend upon for our sustenance, is being fundamentally altered and even the chemistry of our bodies is being changed by such technological creations as the "pill."[138]

Monitoring the changes occurring in the first years of the twentieth century, Sherad Ingram, as Urban Tribe, took inspiration from the shifting geopolitical order, consumer culture, and economic climate. In 2010 Ingram reflected on the thirteen years that had elapsed since he first released *The Collapse of Modern Culture*: "Truthfully I think that the world is shrinking. I feel like there is less and less room for the individual, it seems like everything is being just standardised as the world shrinks, with communication and commerce."[139] A passive interest in microbiology and genetics informed Ingram's productions in the albums *Authorized Clinical Trials* and *Acceptable Side Effects*, released through Rephlex in 2006 and 2007, respectively. "When I talk about 'Authorized Clinical Trials,' that's really kind of a title that has to do with how drug companies these days rush things out. As soon as a drug comes out, no more than two years later you're getting all these recalls," Ingram explains. The song "Biohazard" articulates the qualities of molecular revolution through a brief fictional story, describing scientists in pursuit of a "microbiological hazard," which begins and ends with the declaration: "African contained." Alongside his concerns about a fully automated technocracy taking shape at the beginning of the Fourth Turning, Ingram spoke about infusing elements of new jack swing—a commercial relative of techno produced and engineered on a Roland TR-808 by Teddy Riley—into his music as an experiment in sampling and rhythmic pattern referencing. Applying the business principles of calculated risk, the Urban Tribe moniker served as

138 Ibid.

139 DJ Stingray, interview by Derek Walmsley, "DJ Stingray Unedited," *The Wire*, April 2010, https://www.thewire.co.uk/in,-writing/interviews/dj-stingray-unedited.

a platform for Ingram to reverse engineer the rising daily intrusions of telemarketing and media prosumption. Towards the end of the first decade of the 2000s, Ingram adopted the alias DJ Stingray, a name given to him by the late Stinson in 2003, ahead of a Drexciyan tour.

Even before meeting Stinson and Donald, Ingram often played their tracks at Outcast in the '90s, a hardcore club in Detroit that opened in 1969 for a one-percenter demographic of men who rode Harley-Davidson motorcycles, with the motto: "We Ride for Piece." He met Donald at Buy-Rite, where he worked, and where Stinson and Donald sold some of their earliest recordings. Ingram's experience at Buy-Rite, where he observed buying habits, led him to believe that electronic musicians wouldn't be able to "break that stranglehold that R&B, rock and pop music has" on the American market. "It's just too big of a machine, and they just have too much money, and they have too many people that support it," he observed. "They've got video, and all kinds of things that support those genres. So breaking that grip is, unless we employ those tools, I don't think we have much of a hope of penetrating those scenes here in Detroit." He continued to explain the dilemma of an American music consumer culture transitioning into the digital ecosystem of streaming services and music magazines-turned-online media platforms:

> We need radio stations, we need to do videos, we need to write songs, we need billboard advertisers. We need to do everything these big guys are doing without compromising our sound and our aesthetic. And I think a lot of people feel like, as soon as you start putting things on billboards and you start going for the radio, you have to change your sound, no. You just have to be brave, you have to be strong, and we need people who can invest and pool their money, who are willing to invest if we can't do it ourselves. We have to be willing to invest ourselves. And so those are the tools that I'm referring to, the internet, we need to use everything that these big machines use. And stop treating ourselves as the step-children of the music industries. And let's get out there and push our efforts, our sounds, our concepts out there. Why can't we capture the 18-34 market, why not?[140]

Shortly after the first Detroit Electronic Music Festival in May 2000, Stinson contacted Ingram, asking him to join Drexciya's debut live tour as Drexciyan Stingray, a name that Ingram stopped using after Stinson's death.[141] "I still had DJ commitments that we had already signed to, so I continued for a while more, and then later on I dropped the Drexciyan, just started DJ Stingray," Ingram reflected. "Partly as a homage to him, and then partly as it gave me a new identity and a new avenue for expression. Because

140 Ibid.

141 "Did I feel like a stingray? Never. But I wasn't going to argue with James Stinson. I felt it and I understood what he wanted, because I understood the Drexciya legacy. I was Stingray from that day on." DJ Stingray, interview by Dave Jenkins, "DJ Stingray Is the Future-Focused Selector at the Helm of the Electro Renaissance," *DJ Mag*, October 30, 2018, https://djmag.com/longreads/dj-stingray-future-focused-selector-helm-electro-renaissance.

I love the uptempo style, so-called electro style." He explains, "To me it's techno. And it gave me an outlet for expression. And so I stuck with it and that's why I started producing under that name seemingly so late."[142] In 2007, DJ Stingray introduced himself to the public with the EP *Aqua Team*, following with the extended album *Aqua Team 2* the following year, both released on the Belgian label WéMè Records. Tracks on the album like "NWO" (New World Order) and "Counter Surveillance" draw attention to advancements in the Programmer's initiative to transform the United States into a full-scale information-based civilization that utilizes surveillance capitalism[143] to harvest and instrumentalize its population in service of the growth of the national economy. Retracing Stinson's "Star Chart" from *Grava 4*, Ingram came to understand that "It's All Connected," as suggested by the title of the album's closing song. In 2009, DJ Stingray and Donald—under the code name Heinrich Mueller—released the *Drexciyan Connection* EP, using a redrawn Black Atlantic map of the "journey home" as cover art, with three tracks exploring drone factories and the manufacturing of automated warfare.

That same year, in the American political commentary magazine *The New Republic*, an article by Katherine Tiedemann and Peter Bergen outlined the basis of what they called the "Drone War": The technique of using unmanned aerial vehicles to surveil and strike targets in Pakistan, Afghanistan, and Yemen in search of Al Qaeda and Taliban leaders, they argued, was a newly emergent phenomenon of modern industrial automation and warfare, which "has been waged with little public discussion or congressional investigation of its legality or efficacy, even though the offensive is essentially a program of assassination that kills not only militant leaders, but also civilians in a country that is, at least nominally, a close ally of the United States."[144] Over the next few years, Ingram, as Stingray313, shifted his "Sphere of Influence" and adjusted his "Sentiment" towards a consideration of the media and the government amid the rise and spread of a global decentralized *Misinformation Campaign*, the focus of a 2011 EP. In March of that year, it was revealed that the US military had been developing software for a spy operation designed to secretly manipulate social media sites by using fake online personas to influence internet conversations and spread pro-American propaganda.[145]

142 DJ Stingray, interview by Walmsley.

143 Social psychologist and philosopher Shoshana Zuboff defines surveillance capitalism as "a new economic order that claims human experience as free raw material for hidden commercial practices of extraction, prediction, and sales." She understands this new digital framework and model of labor extraction to be "a parasitic economic logic in which the production of goods and services is subordinated to a new global architecture of behavioral modification." This specific kind of evolution after the Industrial and Information Ages, she writes, constitutes "a mutation of capitalism marked by concentrations of wealth, knowledge, and power unprecedented in human history." Shoshana Zuboff, *The Age of Surveillance Capitalism: The Fight for a Human Future at the New Frontier of Power* (New York: Public Affairs, 2019), front matter.

144 Peter Bergen and Katherine Tiedemann, "The Drone War," *New Republic*, June 3, 2009, https://newrepublic.com/article/61767/the-drone-war.

145 Ian Cobain and Nick Fielding, "Revealed: US Spy Operation That Manipulates Social Media," *Guardian*, March 17, 2011, https://www.theguardian.com/technology/2011/mar/17/us-spy-operation-social-networks.

In 2012, DJ Stingray released *Psyops for Dummies* through Presto?!, followed by the full-length album *F.T.N.W.O.*—Fuck the New World Order—featuring a cover photo that showed Ingram fighting with a masked intruder. The opening track, "Evil Agenda," transmits the ambience of American prime-time crime television; it is punctured by pitched voices stating, "The system thinks you're stupid, it thinks you're morons. Blood sacrifices, demonic sequences, are you following me? All of you that buy into the evil, all of you that buy into the corruption, thinking it's cool to screw somebody else, are gonna be screwed by somebody bigger and badder and more evil above you!" *F.T.N.W.O.* sprawls out of Ingram's previous experiments pumping the techno format full of the overstimulated aggression of right-wing conservative talk radio and the killer instinct of accelerated modern warfare tactics. The track "Denial of Service" broadcasts a mesmerizing sequence illustrating the act and mindset of a consumer shopping online, contrasted with the insistent refrain that the internet "opened doors to heaven or hell," before informing the listeners of "online black outs." The following track, "Interest Rates," asserts that debt is "one of the most ingenious scams of social manipulation ever created," noting that, "at its core, it is an invisible war against the population," and declaring that "debt is the weapon used to conquer and enslave society." Ingram suggests that debt and doubt have wormed their way into the center of modern civilization, unraveling into a self-made crisis. In "Lead from the Shadows," he asks, "If more of our so-called leaders would walk the same streets as the people who voted them in, live in the same buildings, eat the same food instead of hiding behind glass and steel and bodyguards, maybe we'd get better leadership and a little more concern for the future?"[146]

In September 2013, Donald, again as Dopplereffekt, resurfaced with *Tetrahymena*, an EP released on the German label Leisure System, in which he experimented with sonic scenarios, replicating "Gene Silencing," or the regulated and suppressed expression of certain genes in a cell. "There has to be a conceptual one-to-one correspondence between the visual and sonic," he explained of this process. "The graphical component has to manifest the concept musically and thematically. This is very critical in conveying a concept comprehensively." He continued:

> Technical devices allow the rank and file to express their ideas and to move forward in the socio-economic continuum more effectively. There are many demonstrations of this, including mobile communication, social media sites, the Internet in general and especially the production and publication of one's own musical data. These advances have allowed many common men to be free of brokers and corporate monopolies on certain industrial processes and services.[147]

146 DJ Stingray, lyrics, various tracks, *F.T.N.W.O.* (WéMè Records, 2012).

147 Gerald Donald, interview by A.J. Samuels, "Master Organism: A.J. Samuels interviews Gerald Donald," *Electronic Beats*, May 29, 2013, https://www.electronicbeats.net/gerald-donald-interview/.

Branching off from his sonic experiments in genetic modification, Donald and DJ Stingray, under the moniker NRSB-11, released the album *Commodified* (2013), a cumulative study of the unraveling of the global economic market. Donald outlines the cyclical technocratic world system that was beginning to connect and reshape the twenty-first-century unskilled global citizen. Dissecting the value of the prosumer, Donald suggests that "Such individuals must first pass through initial steps and gain the required proficiency prior to pronouncement."[148] In an introductory track, the stereo field is flushed with a sea of voices simulating the emergent schizo-culture of the second decade of the twenty-first century; one phrase penetrates the shroud of black noise, softly warning: "they give you a pill to erase your memory." The next track, "Consumer Programming," engineers piston-like electronic pulses and luminous pads to shape an image of mass marketing and consumption in the flat space of online retail. Taken as a whole, *Commodified* forms the culmination of decades of research and development for both Donald and Ingram, articulating across twelve tracks the concepts and structures underpinning the latest stage of the settler colonial project, specifically the notion and action of "Globalization" under the United States-led Western world order. In these tracks, they consider the mass exploitation of "Living Wage" entangled in "Market Forces," "Offshore Banking," and visions of a "Dead Civilization" transmitted by their uncovering of a worldwide "Industrial Espionage" and the revelation of "Economic Collapse" at the end of a ponzi/pyramid scheme. Donald, while observing a major tipping point in the stability of the global economy, explains the rationale behind his approach:

One has to be careful when bifurcating fact from fiction because the fiction is a projection of what may one day become fact. The only reason it is fiction is because certain technologies have not come to pass and matured. That is, critical understandings of nature remain open. Keep in mind that many technologies and discoveries that were once in the realm of fantasy, such as lasers, nuclear fusion and nanotechnology, are now commonplace in our society.[149]

In 2016, Donald, as Dopplereffekt, along with DJ Stingray, reconvened at Olympic Park's pool in Montreal, Quebec, built for the 1976 Summer Olympics. Titled *Poseidon's Kingdom*, the single-day event commissioned by Red Bull Music Academy transformed the pool, at the center of a more than three-thousand seat stadium, into an aquatic "multilayered listening environment" with an underwater sound system custom-built by Wet Sounds. Joel Cahen, the sound and visual designer behind the sound system, explained that "[Sound underwater] doesn't really travel through your eardrums. It automatically vibrates the skull, and from that, your ears."[150] The next

148 Ibid.
149 Ibid.
150 Joel Cahen, quoted in Paula Mejia, "Listening to Music Underwater," *Red Bull Music Academy Daily*, October 19, 2016, https://daily.redbullmusicacademy.com/2016/10/listening-to-music-underwater.

year, Dopplereffekt unveiled their experiments in *Cellular Automata*, a model of logical computation invented by John von Neumann in order to solve the problem of eventual decay and entropy in self-replicating systems. Amidst the American crisis at the end of the global economy, Dopplereffekt sought to discover and establish the key to a "Gestalt Intelligence," while Ingram relocated to Berlin to pursue a DJ career, continuing the Drexciyan legacy. "The plan was just to be near where the love was," says Ingram, who considered the move to be a gamble. "I started analysing the types of clubs and crowds that I play for, for want of a better word my 'market', and they're small to medium clubs that don't have too much of a budget. They can't fly me transatlantic, but it's easier to fly me from Berlin than it is Detroit."[151] Though an alternative, corporate version of electronic dance music (shortened to the marketable term "EDM"[152]) had risen in the United States, Ingram was intent on circulating the more established European clubs as a relic of techno's origins. "Black people don't listen to techno. America doesn't listen to techno," he proclaims. "The strength of Detroit lies in its artistic community. We have so many artists concentrated in the urban centre of the city. You've got hip-hop, gospel, RnB, jazz, pop music, rock 'n' roll… These are monolithic structures that have pervaded American culture, they've been our soundtrack. But this also means there is no way techno could become a culture like it is in Berlin and Amsterdam."[153] Ingram's experience working in a record store gave him a view of dance music's distribution channels, which he planned to navigate as an independent prosumer rather than a middleman vendor.

The introduction of Platform Capitalism—a digital infrastructure that enables individuals to interact within the roles of a user or producer to build and exchange their own products in a "lean production model" that sells online content "wholesale"—to the music industry through companies such as Spotify, Apple Music, and Tidal in the 2010s changed the way in which music had been previously valued and exchanged. Ingram, as a music seller, recognized this shift in the "music factory" that Toffler described in *The Third Wave*. "The power of digital is undeniable," Ingram acknowledged in 2017.[154] His own albums, *F.T.N.W.O.* and *Commodified*, were both kept

151 DJ Stingray, interview by Angus Thomas Paterson, "The Unrelenting Energy of DJ Stingray," *Crack Magazine*, July 14, 2017, https://crackmagazine.net/article/long-reads/the-unrelenting-energy-of-dj-stingray/.

152 "As EDM began to spread across America, the time-honored tradition of adults sneering at young people's music resurfaced like clockwork. Dance-music purists mostly held their noses while older generations raised on guitar music wrote it off as wub-wub nonsense for ecstasy-addled kids. But for an entire generation of young millennials, EDM was the first music that felt like it belonged solely to them—to us. Fueled by subbass (and, yeah, sometimes substances), it was a pure break from the harsh realities of life. The rock bands handed down to me by my older cousins suddenly felt like relics from a bygone era, even if they held parallels in their dynamic principles. Where Nirvana nicked the quiet-loud-quiet dynamic of the Pixies, the late Avicii took after progressive house forerunners like Eric Prydz, perfecting the build-up and drop. Tastes change, but teenage rage is forever." Noah Yoo, "Dance Dance Revolution: How EDM Conquered America in the 2010s," *Pitchfork*, November 7, 2019, https://pitchfork.com/features/article/2010s-reverberations-of-edm-skrillex-zedd/.

153 DJ Stingray, interview by Paterson.

154 Ibid.

scarce during the rise of streaming, with only 250 vinyls made of each. The future of music seemed to be less about where audio could go, and more about how the concept of music itself could be redefined as an artform in order to maintain its aesthetic and economic value when divorced from a physical format:

> We're in the 21st century, why would I want my music to sound like I made it 30 years ago, what sense does that make? I like using effects. Say I've got 32 inputs in my digital workstation, if I have enough RAM then I can put up to eight effects on every single channel. Each of these effects I can automate, I can manipulate their parameters down to micro units. It's only limited by your imagination, the power there is phenomenal. Don't recreate Kraftwerk. That's what the future sounded like 30 years ago. You wanna recreate that energy, recreate that same awe and fascination as when they first heard that music. You should be pushing for new sounds with each and every release. Let's push it to the limit.[155]

Ingram's vision of music in the 2010s comes with a backend knowledge of its formatting and industrialization. "I might still have a dystopian view of the world, but I realise it is a vision that has been shared by others for centuries," he reflected. Techno was always prepared for the implementation of a format like music streaming, which in some ways frees how music can be expressed and released—but this online marketization also works against music's potential by literally commodifying it into digits, an abstract data indicator or a channeled resource, sold like water, or electricity. As a DJ, Ingram perhaps imagines that he can still be a middleman proprietor, a prosumer that buys music and distributes it through professional selection in front of a live audience—the way Ken Collier, Frankie Knuckles, and Larry Levan used to do with promotional records from the major music industry brokers. The socialization of music through DJing operates as a human alternative to the automation of streamed playlists, which fundamentally changes the way that music was intended to be packaged and distributed; if the album format changes, everything about the music culture industry changes. "There's always somebody proclaiming the sky is falling," Ingram acknowledges. "I've realised it's not our instinct to destroy ourselves. I'm hoping our instinct to survive overrules our instinct to fight each other."[156]

In the background for most of the development and exportation of techno, the lone Detroit DJ and producer Terrence Dixon met Mike Banks in the mid-1990s, and learned how to craft electronic music at the Submerge studios. "I was originally going to be a part of Interstellar Fugitives. But when it came to creating music, they didn't agree with my take on things,"[157] he recalled in 2017. For the next few decades, he

155 Ibid.

156 Ibid.

157 Terrence Dixon, interview by Aaron Coultate, "Detroit Minimalism," *Resident Advisor*, August 16, 2017, https://ra.co/features/3061.

tended to his children and made music for himself on a Juno-106 and an SH-101 interlocked with a couple of TR-303s in a single-bedroom apartment, as a way to generate secondary income. Releasing his first album, *Unknown Black Shapes* (1994), as Population One, Dixon charted a new terrain of minimal techno parallel to Robert Hood's albums *Internal Empire* (1994) and *Minimal Nation* (1994), trimming down the scope and density of techno's rhythmic and harmonic pressure into mesmerizing, miniscule sequences of frequency modulation that carried with them brief messages, qualities, or sound pictures, as in "Free Falling Forever," "Flower Children," and "B.P.M." Dixon understood techno to be a product of "forward-thinking ghetto electronics," choosing to operate as a rogue agent who corresponds with the collective consciousness of the Detroit techno movement from a distance. In 2000, Dixon unveiled his vision *From the Far Future* on Tresor, which also released Mills' score for Fritz Lang's *Metropolis* the same year. An intentional deconstruction of the auditory relationship that the technological innovation of cinema has with Eurocentric classical music as its standard, Mills' work, like Dixon's, reimagines the future through the depth and flexibility of the muted perspective.

Communicating across vast reaches of time, Dixon's second album, *From the Far Future* (2012), released twelve years after his first, depicted a post-industrial Detroit, the largest city in the United States, as a "Dark City of Hope" in an era of American crises. The city's population had been in freefall: "Since 2000, Detroit's population has declined 26 percent. There are now just 706,000 people in the city, way down from 1.85 million during its industrial heyday in 1950," reported *The Washington Post* in 2013. "Meanwhile, Detroit owes around $18.5 billion to its creditors . . . Given its ever-worsening economic slide, Detroit was in no position to pay off all its obligations."[158] The same year, journalist Brad Plumer also reported on the fact that, while the automobile industry had received assistance amidst the financial crisis, the city as a whole had not. News headlines, he pointed out, often refer to the Big Three automakers as "Detroit," drawing attention to the untethered financial relationship between the Motor City and the corporations that built it, rather than the city itself. "That helps explain why Ford, Chrysler, and GM have all been thriving since the auto bailout in 2009 while the city of Detroit continued to deteriorate and has now just declared bankruptcy."[159] With the help of Michigan's legislature, Detroit was ultimately able to avoid bankruptcy. Theo Parrish, a house producer from Chicago living in Detroit, called into question *American Intelligence* with his 2014 album, after evoking an exit from the current state of affairs into *Parallel Dimensions* (2000), over a decade prior. Parrish spent the 2000s arranging, mixing, and recording improvised and occasionally

158 Brad Plumer, "Detroit Just Filed for Bankruptcy. Here's How It Got There," *Washington Post*, July 18, 2013, https://www.washingtonpost.com/news/wonk/wp/2013/07/18/detroit-just-filed-for-bankruptcy-heres-how-it-got-there/.

159 Brad Plummer, "We Saved the Automakers. How Come That Didn't Save Detroit?" *Washington Post*, July 19, 2013, https://www.washingtonpost.com/news/wonk/wp/2013/07/19/we-saved-the-automakers-how-come-that-didnt-save-detroit/.

ensemble-based hi-tech jazz and soul on his own record label, Sound Signature. *Parallel Dimensions* consolidated the separate industrial lives of Chicago house and Detroit techno into a distilled optimization of the potential of the late-twentieth century Black youth counter culture's progressive music output. Parrish's songs of encouragement came with a message of intent on the back of the album, describing the need to communicate inspirational "action in movement, action in emotion, action in mental stimulation." He notes: "The difference between imitation and emulation is specific experience. No one else has walked your path, lived your vision."[160]

*

By the mid 2010s, it seemed the dance music industry had moved on from techno to a fully automated technocapitalist investment in the dual frontiers of the redeveloping European clubbing industry and the emerging American "EDM" financial boom. The crisis left many in the music industry even more skeptical, as business closures and mergers in the dance music industry inevitably began to occur. In 2013, Robert F. X. Sillerman founded a second iteration of the Los Angeles-based event promotion company SFX Entertainment (he had started the first in 1996, and sold it to radio broadcasting firm Clear Channel [later iHeartMedia] for $4.4 billion in 2000).[161] The new SFX Entertainment absorbed Beatport to assume control over the digital music download economy, while also consolidating live music promoters in the United States—rivaling the dance music industry that was under mass reconstruction in Europe. In a 2015 interview with the *Independent*, *Mixmag*'s global editorial director Nick DeCosemo seemed to announce a new phase of techno for his British company, which had been covering the rave revolution since its beginnings in the 1980s: he spoke about an "explosion of dance music" in the United States. "Now a lot of the kids here are getting bored of that everything-turned-up-to-11, full-on stadium EDM sound, and they're looking for cooler, deeper DJs like Jamie Jones, Richie Hawtin or Loco Dice, who play cool house music or more underground techno. They have a new respect for, and knowledge of, the culture." DeCosemo commented on the protective stance toward what the British considered to be "true" house music, particularly as *Mixmag* was beginning to grow its presence in the US market: "LA without a doubt is having a moment; friends of mine say it feels like London in 1990, 1991…Every week, another tranche of European DJs arrives in LA."[162]

With no specific or obvious connection to the electronic dance music culture industry in Europe, large-scale music festivals like The Coachella Valley Music and Arts

160 Theo Parrish, liner notes, *Parallel Dimensions* (Sound Signature, 2000).

161 "Clear Channel Buys SFX," *CNN Money*, February 29, 2000, https://money.cnn.com/2000/02/29/bizbuzz/sfx/.

162 Tim Walker, "Mixmag Is Still in the House: Former Electronic Dance Music Bible Has Reinvented Itself in LA," *Independent*, June 11, 2015, https://www.independent.co.uk/arts-entertainment/music/features/mixmag-still-house-former-electronic-dance-music-bible-has-reinvented-itself-la-10314476.html.

Festival, Electric Daisy Carnival, Nocturnal Wonderland, Winter Music Conference, and productions from SFX Entertainment were amassing millions of dollars in revenue and thousands of millennial-aged clubbers in attendance. From there, EDM emerged as a new sound and industry, spreading out of the underground rave scenes in the American Midwest throughout the 1990s, which were largely influenced by Richie Hawtin's Plus 8 parties in Detroit.[163] "EDM's precipitous initial storm had many factors driving it," writes music journalist Michaelangelo Matos. "A big one was sheer pop synergy—beginning in the late 2000s, a number of Billboard chart-toppers were beginning to hire hardcore dance producers to make hits with."[164] After a decade of investments and networking, dance music was becoming a growing business in America with a steady incremental increase of consumer interest, until the term EDM began to break through to the mainstream in 2008.

Media attention continued to flock toward the music industry's staples, expanding into uncharted territory in the US market. On July 12, 2015, the *New York Times* interviewed *Resident Advisor*'s founders Nick Sabine and Paul Clement on the occasion of their expansion into the United States by way of Brooklyn and Los Angeles office spaces. The article, titled "Influential Site Inhabits Fringe of an Electronic Dance Music Culture," compared *Resident Advisor* to its American competitors *Dancing Astronaut*, *YourEDM*, and *Thump*—the latter of which was a short-lived dance music vertical of the Canadian-American magazine *Vice*—implying that *Resident Advisor*'s long-form editorial was of a higher level of sophistication than that of American EDM media brands. Sabine commented: "I see EDM—the big festivals, that side of things—and the stuff we cover as two different worlds." He continues: "Those two worlds intersect, but I still see them as separate."[165] That same year, the online independent music website *Pitchfork*—which had just been acquired by Condé Nast after nearly two decades of independence—published a comprehensive "Timeline of How EDM's Bubble Burst," written by editor Philip Sherburne: "The only thing the media loves more than a success story is a spectacular fall, and thus the death knell for

163 "'Part of the explosion of the whole electronic music scene has been totally tied to the Internet, and the way we can communicate over vast distances,' says Richie Hawtin, who as Plastikman was an early rave icon. 'The Midwest—and maybe national—scene wouldn't have become so interconnected without the rise of the Web circa 1994-95,' agrees Matt Massive (born Matt Bonde, though we'll identify him here by his pen name), the publisher of *Massive*.... Many times, ravers had good reason for such secrecy. 'I worked so much overtime trying to talk about how the rave scene wasn't all about drugs,' says Ariel Meadow Stallings, who published and edited the rave zine Lotus in Seattle during the late '90s. 'It was very noble of me, and I still do believe it wasn't all about drugs. But it is a drug culture. Even if you're not on drugs, the culture of the party is determined by the fact that there are people there who are.'" Michaelangelo Matos, "How the Internet Transformed the American Rave Scene," NPR, "The Record," July 11, 2011, https://www.npr.org/sections/therecord/2011/07/17/137680680/how-the-internet-transformed-the-american-rave-scene.

164 Michaelangelo Matos, "The Mainstreaming of EDM and the Precipitous Drop that Followed," NPR, November 13, 2019, https://www.npr.org/2019/11/13/778532395/the-mainstreaming-of-edm-and-the-precipitous-drop-that-followed.

165 Ben Sisario, "Influential Site Inhabits Fringe of an Electronic Dance Music Culture," *New York Times*, July 12, 2015, https://www.nytimes.com/2015/07/13/business/media/influential-site-inhabits-fringe-of-an-electronic-dance-music-culture.html.

EDM has been ringing louder and louder in recent months."[166]

In February 2016, SFX Entertainment filed for bankruptcy after its stocks devalued by over 95%. "Despite SFX's problems, the dance-music world has largely remained strong," noted an article in the *New York Times* on the company's solvency. "Festivals like Coachella, which involve many dance acts as headliners, are still popular, and by one estimate the global market for dance music, including recordings, live performances, endorsements and other deals, is worth $6.9 billion a year."[167] That March, SFX auctioned off Beatport, after a loss of $5.5 million in 2015,[168] though the company eventually suspended the sale. An article in *Billboard* retraced the rise and fall of the inflated currency of dance music in the United States:

> After five years of explosive growth and climbing DJ fees, there's a growing industry debate over whether the EDM bubble has burst. At least seven festivals—including two produced by SFX—have been canceled for 2016, and though Ben Turner, a founder of the 8-year-old International Music Summit EDM conference, contends the industry is evolving, not collapsing, he predicts "a big implosion" of mid-tier DJ fees in Las Vegas. It's hard to say whether this contraction played a role in SFX's nosedive, but it's clear Sillerman helped inflate the EDM economy by growing too fast and paying too much for the companies he acquired and the DJs he employed.[169]

In the end, Sillerman was able to double down, and gamble his losses into a new company called LiveStyle, based in Los Angeles. Three months later, *Thump* ran an article by Alexander Iadarola with the headline "The Global Electronic Music Industry Is Now Worth $7.1 Billion."[170] Sillerman's heist had inflated the dance music's value by 60% more than it had been three years prior, according to a business report written by British strategy specialist Kevin Watson for the International Music Summit, a three-day annual conference held in Ibiza (founded by the British DJ and radio presenter,

166 Philip Sherburne, "Popping the Drop: A Timeline of How EDM's Bubble Burst," *Pitchfork*, April 5, 2016, https://pitchfork.com/thepitch/1086-popping-the-drop-a-timeline-of-how-edms-bubble-burst/.

167 Ben Sisario,"SFX Entertainment Declares Bankruptcy," *New York Times*, February 2, 2016, https://www.nytimes.com/2016/02/02/business/media/sfx-entertainment-declares-bankruptcy.html?_r=0.

168 Glenn Peoples, "SFX to Auction Off Beatport in May, Looks to Sell Fame House," *Billboard*, March 1, 2016, https://www.billboard.com/articles/business/6897144/sfx-selling-beatport.

169 Robert Sillerman, interview by Robert Levine, "Former SFX CEO Robert Sillerman Speaks Out for the First Time About His Company's Implosion: 'I Don't Begrudge the Employees' Anger,'" *Billboard*, June 9, 2016, https://www.billboard.com/articles/business/7400341/edm-sickest-robert-sillerman-sfx-fiasco-feature.

170 Alexander Iadarola, "The Global Electronic Music Industry Is Now Worth $7.1 Billion," *Vice*, May 2016, https://www.vice.com/en/article/wnyz8x/ims-business-report-2016-edm-bubble-burst.

Pete Tong, in 2007[171]). Iadarola probed the language of the report in his article, which "found that EDM was expanding into promising new markets in South America and China, that streaming was the fastest growing format globally, and that, in the USA, recent rapid growth looks like it will translate into 'sustainable wide-scale appeal.'" The dance music industry, despite the closure and consolidation of many of its infrastructural companies, the expansion of its youth demographic continued. Watson clarified, "The EDM bubble isn't so much bursting, as it is bopping along the surface of the water."[172]

Meanwhile in Detroit, a bailout of General Motors and Chrysler, through President Obama's Task Force on the Auto Industry, temporarily saved over a million of jobs throughout the United States. Drafting plans for the city's recovery, Idea City—a conference and week-long studio laboratory initiated by the New Museum in New York in 2011—took place in Detroit, prompting a recapitulatory article titled "Trying to Plan a Future Detroit Without Leaving the Past Behind," by Taylor Aldridge, in the online arts magazine *Hyperallergic*.[173] As a Detroit native, Aldridge observed presentations with city representatives and cultural producers like Maurice Cox, Detroit's urban planner; she attended panels on food justice services and visited sites like the defunct public hospital and Herman Keifer complex in an effort to address the city's infrastructural needs. "Outsiders often look upon Detroiters as refugees or survivors who have withstood the bankruptcy, corruption, and crime," Aldridge remarked. "These are stigmatized narratives, often lacking in full context, that make me cringe. Thus I work to provide a counter narrative, one that doesn't stereotype the city but rather humanizes it; one that amplifies its beauty, not its blight." Aldridge's assessment of the conference offered a new way of thinking and feeling about a city with a history as long, turbulent, and soulful as Detroit:

> Over the course of the week, in order to provide ideas for the city's reconstruction, I had to focus on Detroit's many issues all at once. I had to acknowledge the fact that I romanticize too much of the past. Many of us are holding on to the old Detroit in a way that may erase us from the new one. If we, Black Detroiters, do not carve out a future for ourselves in this rapidly changing metropolis, we will

171 "I am a partner in a very exciting new venture to bring back a focus to the electronic music industry in probably the most obvious and ideal location in the world. Ibiza is really where the music industry looks for influence due to the length of the season, the incredible talent that passes through from the genre, and the hundreds of thousands of partygoers who come for dance music. We feel the industry has changed, is changing by the day, and we want to bring back a focus and a back to business ethos to what we do. The electronic industry is very unique, it's very global, and it needs to install a new vision and ethos going forward to strengthen the genre and its image." Peter Tong, interview at the International Music Summit, Ibiza, *Internet DJ*, n.d., https://www.internetdj.com/news/interview-with-pete-tong-international-music-summit-ibiza.

172 Iadarola, "The Global Electronic Music Industry Is Now Worth $7.1 Billion."

173 Taylor Renee Aldridge, "Trying to Plan a Future Detroit Without Leaving the Past Behind," *Hyperallergic*, May 9, 2016, https://hyperallergic.com/297275/trying-to-plan-a-future-detroit-without-leaving-the-past-behind/.

be carved out of the city itself, or co-opted into the imaginations and machinations of its developers.[174]

Weeks later, the city's mayor Mike Duggan announced that the Detroit City Council would establish a "Detroit Techno Week" during the month of May, honoring Juan Atkins, Kevin Saunderson, Derrick May, Carl Craig, Jeff Mills, Eddie Fowlkes, Kelli Hand, and Underground Resistance for their "outstanding achievement or service to the citizens of Detroit."[175] That July, Theo Parrish issued a solemn and stern rebuke of the dance music industry's silence on the subject of the police killings of two Black men—Alton Sterling and Philando Castile—only a year after the killing of Sandra Bland while in police custody, and three years after the acquittal of George Zimmerman in the trial over his targeted murder of seventeen-year-old Trayvon Martin:

> Overwhelmed. I wish I was shocked. Embarrassed at the lack of overt commentary from this art form. An art form rooted in reaction to racism, birthed in struggle, how do you dance to this? Somehow you better. Somehow you better realize when the music you're dancing to comes from people that have been exploited, the best tribute you can have is setting yourself loose in unity with the exploited. How do you do that when on the same weekend you're playing, in the same city, a man just like you has quietly, arbitrarily, been silenced by one paid to protect him and the public?
>
> How do you dance when we still swing from trees, when we still are murdered in front of our loved ones, murdered while subdued and harmless? How do you dance when our very image as a people is used to manipulate sympathy for a system of belief that wants you and your children to be dead or in jail? You better. You better learn to listen with your body, you better play from your heart. It was a preference before, now it's essential. Escapism has always been an adjective used to describe the dance. That's an outsider's view. Solidarity is what it really offers...[176]

At the tail-end of the US EDM boom and bust, *Mixmag* lost millions during its transition into a global media platform, alongside the failings of SFX. In 2017, Mixmag Media Network changed its name to Wasted Talent Ltd., positioning themselves as *Mixmag*'s parent company, although the staff and leadership remained relatively the same. This rebrand came after a revenue loss of £883,284 (~$1,155,000) in

174 Ibid.

175 Claire Lobenfeld, "Carl Craig, Jeff Mills and Belleville Three Honored with Spirit of Detroit Award," *Fact Magazine*, May 26, 2016, https://www.factmag.com/2016/05/26/spirit-of-detroit-award-winners-2016/.

176 Theo Parrish, Facebook post, July 2015, quoted in "Theo Parrish 'Embarrassed' at Dance Artists' Failure to Support Black Lives Matter," *Guardian,* July 13, 2016, https://www.theguardian.com/music/2016/jul/13/theo-parrish-embarrassed-dance-artists-black-lives-matter.

2016 followed by another loss of £1,072,236 (~$1,400,000) in 2017.[177] In December 2018, Wasted Talent Ltd. was required to file a Solvency Statement, explaining that the company would be able to repay its debts over the next twelve months. Wasted Talent Ltd. announced that it would be purchasing rock magazine *Kerrang!* and style magazine *The Face*—both historically iconic British brands, forming a trifecta brand identity with taste and influence across mainstream rock and pop music, nightlife and clubbing culture, and fashion and streetwear.[178] That same month, Cameroonian philosopher and political theorist Achille Mbembe published *Critique of Black Reason*, a reevaluation of the history of Black people's role in racial capitalism. The overall failure of a UK company's attempt to colonize a gold rush on the American continent, nearly three hundred years after the Revolutionary War for independence from British taxation, implies a cyclical moment in history and economic growth. Mbembe frames "neoliberalism" as a moment in human history in which the corporations and technologies that emerged from and optimized the functions of the transatlantic slave trade came to dominate society and its consumption. Consolidating many ideas expressed in Juan Atkins' reading of *The Third Wave* and Drexciya's map of Black presence within the global, capitalist world from 1655 to the unforeseeable future, Mbembe traces the accumulation of extractive economies and the central role that Africans have played in the five-hundred-year process of colonization and global world building. Mbembe writes of a corporatized logic morphing the reality of nature and humanity into a matrix of rational categories that ought to perform according to the script of systematic socio-economic growth. Fictitious financial capitalism for Mbembe buffers reality into sellable goods and usable data indicators that create what he sees as "an infinite series of structurally insolvent debts," according to his translator Laurent Dubois.[179] He recognizes this fiction of economic extraction and growth to be so potent for Euro-American society: people are not just workers, but nomadic laborers, waiting to be bludgeoned for capital and consumption. "If yesterday's drama of the subject was exploitation by capital, the tragedy of the multitude today is that they are unable to be exploited at all. They are abandoned subjects, relegated to the role of a 'superfluous humanity.'"[180]

177 Wasted Talent Ltd., filing history, Gov.uk, https://find-and-update.company-information.service.gov.uk/company/04333049/filing-history?page=1.

178 "When I think of the media brands that defined music and culture in the UK and globally over the last few decades, few were more relevant than this collection of titles. Over the past two years, we've established Mixmag as a truly innovative, fully integrated media platform in the US, and are working with some of the world's leading consumer brands and partners. We look forward to doing the same with *Kerrang!* and *The Face*." Rebecca Jolly, quoted in Kat Bein, "Mixmag Parent Company Acquires *Kerrang!* & *The Face* Magazines," *Billboard*, May 9, 2017, https://www.billboard.com/articles/news/dance/7791982/mixmag-kerrang-the-face-wasted-talent.

179 Laurent Dubois, introduction to Achille Mbembe, *Critique of Black Reason*, trans. Laurent Dubois (Durham, NC: Duke University Press), 3.

180 Ibid.

Mbembe's functional understanding of the political economic designation of "Black" refers to a intensive loss of life, in service to the industrial society for which the slave trade had originally been created. He surmises that neither Europe nor the United States knows where to place the Black population in its most technologically optimized form. "Capital hardly needs them anymore to function," Dubois writes. "A new form of psychic life is emerging, one based on artificial and digital memory and on cognitive models drawn from the neurosciences and neuroeconomics. With little distinction remaining between psychic reflexes and technological reflexes, the human subject becomes fictionalized as 'an entrepreneur of the self.'"[181] Within this, Mbembe sees the labor of African slaves who survived the transatlantic slave trade, the plantation, and the systemic oppression of the multi-pronged industrial complexes throughout the building of the New World as "an essential mechanism in a process of accumulation that spanned the globe."[182] Moreover, he writes, the descendents of those slaves are witnesses of the elimination of the indigenous population and the natural ecosystem of the American continent, and serves "as the very kolossos of the world, the double of the world, its cold shadow."[183] This kolossos of the old world becoming "new" is a symptom of the European concept of a "World-outside"—a border and enclosure around those who are deemed "civilized," a "free space of unrestricted conflict, open to free competition and free exploitation, where men were free to confront one another as savage beasts."[184] Mbembe observes that this is only one world in which we live, writing that "The birth of the racial subject—and therefore of Blackness—is linked to the history of capitalism"[185]—a power structure that seeks to enclose and subdivide both the world and its inhabitants into valuable resources that can be stimulated and extracted for a small, hierarchical conglomerate of investors. He argues that instead, "Sharing the world with other beings was the ultimate debt. And it was, above all, the key to the survival of both humans and nonhumans." Mbembe concludes: "In this system of exchange, reciprocity, and mutuality, humans and non-humans were silt for one another."[186]

In 2018, Matthew Angelo Harrison, a Detroit artist working with machines and industrial design techniques, began creating two series of sculptures titled "Dark Silhouettes" and "Dark Povera." Replicating many of the modeling processes he had learned while working at the Ford Motor Company, Harrison used a computer-controlled cutting machine to make prototype models of imagined African artifacts. The connection between Ford, the largest employer of Black people in Detroit, and the four-hundred-year history of African labor in industrialized systems was of interest to

181 Ibid.
182 Mbembe, *Critique of Black Reason*, 47.
183 Ibid., 53.
184 Ibid., 59–60.
185 Ibid., 179.
186 Ibid., 181.

him as he began crafting his first art objects. "All of my training is informal," he says. "It's very important how you arrive at discovering something. The journey is what shapes the aesthetic. Sometimes it's better to be less efficient. The time you spend is going to give you a more interesting result."[187] While working at Ford, Harrison lived at home with his mother, using his salary to buy aluminum motors, stepper motors, and sensors as his first steps towards this project. His practice is in the interest of "prototypical possibilities," taking the sonic fictional elements of techno and applying them to abstract art-making with consumer products manufactured for a global culture industry. "Being African American and being freed up from the specifics of place, I don't have direct lineage or a pedigree that extends to Africa. That's totally severe," he explains. "There are some elements that come through music or dance, but it's not really clear; it's murky."[188] His appropriation of semi-automated industrial labor opened up new possibilities for his craft in ways that were not immediately available to Juan Atkins when he first set out to create the sound of music and technology having a conversation with one another. Harrison's aim is to design an "abstract ancestry" by reverse engineering his acquired skillset. "I can construct my own idea of what a homeland is," he says. "I can make that and see how that affects the world. It's modular, too. I can change pieces of it."[189]

Taking inspiration from the mythscience of Drexciya written in the liner notes of *The Quest*, Harrison combines precolonial African artifacts with European art design as a means of referencing the aesthetic, cultural estrangement of the global art market, which the dance music industry mirrors through the trade and consumption of techno, disembodied from its creators and community. Specifically, his sculptures inspire a kind of material world building from inside of the industrial empire, referencing the mask and sculpture making in the religious traditions of the Dogon tribe, a group of approximately 800,000 in the present day Niger and Congo region of Africa.[190] Harrison's assembly-line speculative modeling of Dogon, Makonde, and Mozambique artifacts evokes a larger pseudo-scientific reading of pan-African cosmology, in which ancient Africans were able to communicate with aliens on other planets within the Sirius star system,[191] which can be seen in broad daylight under specific conditions

187 Kim Bell, "Matthew Angelo Harrison: Future Perfect," *Sculpture Magazine*, May 17, 2019, https://sculpturemagazine.art/matthew-angelo-harrison-future-perfect/.

188 Ibid.

189 Ibid.

190 "Among the ancient Dogon people, the unending labor of reparation had a name: the dialectic of meat and seed. The work of social institutions was to fight the death of the human, to ward off corruption, that process of decay and rot. The mask was the ultimate symbol of the determination of the living to defend themselves against death. A simulacrum of a corpse and substitute for the perishable body, its function was not only to commemorate the dead but also to bear witness to the transfiguration of the body (the perishable envelope) and to the apotheosis of a rot-proof world. It was therefore a way of returning to the idea that, as long as the work of reparation continued, life was an imperishable form, one that could not decay." Mbembe, *Critique of Black Reason*, 181.

191 "The information which the Dogon possesses is really more than five thousand years old and was possessed by the ancient Egyptians in the predynastic times before 3200 B.C., from which people I show that the Dogon are

that could align in the year 2023.[192] Two decades before this unique vantage point will be afforded to citizens of a dying Earth, James Stinson foretold that he would produce music that would transport listeners through "a dimensional jump hole" in Africa.[193] The Drexciyan-by-way-of-Dogon mythology of an Afrofuturist "journey home" that Harrison manufactures in many ways corresponds with Mbembe's writing in the *Critique of Black Reason*, and his practical theoretical solutions for Black survival at the end of economy of "the New World." He suggests that, "To build a world that we share, we must restore the humanity stolen from those who have historically been subjected to processes of abstraction and objectification. . . . From this perspective, the concept of reparation is not only an economic project but also a process of reassembling amputated parts, repairing broken links, relaunching the forms of reciprocity without which there can be no progress for humanity."[194] Mbembe explores the necessity of societal ethics of restitution and reparation as a means of reimagining the world beyond commodifiable values, allowing each living thing to be a conscious agent worthy of care. "This share of the other cannot be monopolized without consequences with regard to how we think about ourselves, justice, law, or humanity itself," Mbembe proposes, "the project of the universal, if that is in fact the final destination."[195]

*

In 2019, Jeff Mills was beginning to experiment with ways to connect artists and creators in Detroit, reaching out to Eddie Fowlkes and poet Jessica Care Moore, whose first album *Black Tea: The Legend of Jessi James* (2014) was produced with Jon Dixon of Underground Resistance. Pulling from their experience in Detroit's Black communities and working together under the name The Beneficiaries, the trio experimented with combinations of spoken word, techno, and free improvisation. "Music,

partially descended culturally, and probably physically as well. . . . The Dogon preserve a tradition of what seems to have been an extra-terrestrial contact. It is more satisfactory not to have to presume the preposterous notion that intelligent beings from outer space landed in Africa, imparted specific information to a West African tribe, then returned to space and left the rest of the world alone. Such a theory never really struck me as possible. But in the beginning it did have to serve as a working hypothesis. After all, I had no idea that the Dogon could have preserved ancient Egyptian religious mysteries in their culture. I also had no idea that the ancient Egyptians knew anything about Sirius. I was in that state of ignorance so common among people who know nothing more about ancient Egypt than that the Egyptians built pyramids, left mummies, had a Pharaoh named Tutankhamen, and wrote in hieroglyphs. My own academic background concerned oriental studies, but I never touched on Egypt except regarding the Islamic period after A.D. 600. I knew almost nothing whatsoever about ancient Egypt. If I had, perhaps I might have saved myself a lot of time." Robert K.G. Temple, *The Sirius Mystery: New Scientific Evidence of Alien Contact 5,000 Years Ago* (New York: St. Martin's Press, 1976), 1.

192 Gianluca Sordiglioni, "06451-1643 AGC 1AB (Sirio)," Double Star Database, 2016, https://www.stelledoppie.it/index2.php?iddoppia=27936.

193 James Stinson, quoted in John Osselaer, "Drexciya: Twenty Thousand Leagues Under the Sea," *Techno Tourist*, February 2002, archived at https://web.archive.org/web/20020510020232/http://technotourist.org/modules.php?op=modload&name=Sections&file=index&req=viewarticle&artid=15.

194 Mbembe, *Critique of Black Reason,* 182.

195 Ibid., 183.

especially dance music, used to be more political," Mills says. "The make up of the people back in the 1970s and early 1980s was very mixed between gay and straight, people from everywhere, it was a melting pot," which, "made it easier to speak about certains ideas like violence, brutality and racism."[196] In his time as a professional DJ and creative, Mills was able to explore more abstract and intellectual concepts that had been on his mind while the economy of the dance music industry boomed and busted twice in nearly thirty years. "Now electronic music is primarily made by a certain type of people, typically middle class[197] that probably have a pretty comfortable lifestyle," he says, disturbed by the way in which the music from his home of Detroit had been appropriated for industrial capitalist means. "People come to those parties because they want to shut themselves off for those few hours in the middle of the night and they don't want to think about the American president—they don't want to think about people dying at the border with Mexico, they don't want to think about terrorism or the situation in Sudan."[198] Though he has become one of the most notable figures in the dance music industry, Mills reminds his audience of why he and other Black people from Detroit imagined these new worlds: "Based on the American government, when I was a young kid, their plans for me would be either be in jail or dead—so for young Black kids in America, there was no help."[199]

During a moment of societal collapse in 2020,[200] The Beneficiaries released *The*

196 Agence France Presse, "Techno Pioneer Mills Says Electro Music Now 'Too Middle Class,'" *France 24*, July 11, 2019, https://www.france24.com/en/20190711-techno-pioneer-mills-says-electro-music-now-middle-class.

197 "The context of my quote 'dance music has become too middle class,' was about how relaxed electronic music has become. So much to the point that such subjects like innovation, creativity, and new thinking are often overlooked in favor of things that are easy, convenient, and predictable. Middle class means an understanding that things have been prepared especially for you and when you want them. So when there were times where music lovers should have spoken up and out about what's happening to music—like when Apple sold music for $.99 to sell computers, many stayed silent. When Napster opened up the category of free music by sharing, which practically paralyzed independent music and artists, people stayed silent. I can go on and on, but my point was that if it is true that we love music as much as we say we do, then why, at times when music needed to be protected the most, did we not answer that call? Maybe it was because too many people believed or still believe that music will always be here and available. But, there is no reliable way of knowing how many people have been affected by those two incidents, but I sense many. For younger artists, my message is simple: sometimes in order to be able to live within something and flourish, you have to maintain and take care of it. Even if it doesn't directly benefit you. Spend more time thinking about it rather than yourself." Jeff Mills, "Rhythm Runs Deep," *Kaleidoscope* (Fall/Winter 2021–22), n.p.

198 Ibid.

199 Ibid.

200 "At some point in the next few months, the crisis will be declared over, and we will be able to return to our 'nonessential' jobs. For many, this will be like waking from a dream. The media and political classes will definitely encourage us to think of it this way. This is what happened after the 2008 financial crash. There was a brief moment of questioning. (What is 'finance,' anyway? Isn't it just other people's debts? What is money? Is it just debt, too? What's debt? Isn't it just a promise? If money and debt are just a collection of promises we make to each other, then couldn't we just as easily make different ones?) The window was almost instantly shut by those insisting we shut up, stop thinking, and get back to work, or at least start looking for it. Last time, most of us fell for it. This time, it is critical that we do not. Because, in reality, the crisis we just experienced was waking from a dream, a confrontation with the actual reality of human life, which is that we are a collection of fragile beings taking care of one another, and that those who do the lion's share of this care work that keeps us alive are overtaxed, underpaid, and daily humiliated, and that a very large proportion of the population don't do anything at all but spin fantasies, extract rents, and generally get in the way

Crystal City Is Alive, conveying a sonic fictional Detroit conjured by a collection of African ancestral spiritual energy, emphasized through cover art painted by Sabrina Nelson. In the liner notes, Greg Tate asks: "Who are The Beneficiaries?" The open-ended and suggestive syllogism leads him to reflect on the failures of the American Dream. "In retrospect, perhaps the problem . . . several generations got sold, was there was too much materialism and not enough dream." Questioning the concept of dreaming without a firm handle on reality, Tate writes that "19th century Detroit set a high bar internationally for forward-thinking in industry and architectural design—a futurist bent that had produced a skyline full of miracles by mid-century, many of the most magnificent of which are still standing."[201] Revisiting more than a century of African American migratory history from the terrorism of the South to the futurism of the North, Tate asserts that despite being economically left behind, Black music "would become the most globally impactful, influential and inspirational musical culture the world had seen since the Baroque and post-Baroque eras." Its lineage and legacy culminates into what he calls "musical thought-leaders," including pre-techno Afrofuturists such as Sun Ra, George Clinton's Parliament-Funkadelic, The Art Ensemble of Chicago, Prince, and the Clark Sisters. The Beneficiaries, he posits, mark an advancement of the Black radical tradition; Jeff Mills, Eddie Fowlkes, and Jessica Care Moore stand as the "beneficiaries of Black Detroit's multi-dimensional legacies of self-sufficiency and sonic futurism" at the end of modernity.

"There's a special way of communicating that comes from our ancestry," Mills explained in 2020. "There are certain [identifiable] traits you find in culture where you don't need to be told it's a Black American doing it, you just know it instinctively."[202] The trio conceptualized the project across many conversations that reflected on the futurity of a "Black space" like Detroit. "When we see things happening, Breonna Taylor, George Floyd, these horrible acts inform us as artists from this space," Moore proclaimed. "We have to be resistance artists, techno is resistance music and it's Black music that doesn't get called Black music enough."[203] Fowlkes brought in Detroit-based percussionists Sundiata O.M. and Efe Bes to record with the electronic instruments in Joseph Anthony "Amp" Fiddler's studio. "Sometimes oppression makes you create good music," Fowlkes added, "because you're so unhappy it's got to come out some way. Other times you get in touch with your spirituality, or your ancestors, whoever they might be."[204] Sharing this sentiment of bringing the sacred tradition of

of those who are making, fixing, moving, and transporting things, or tending to the needs of other living beings. It is imperative that we not slip back into a reality where all this makes some sort of inexplicable sense, the way senseless things so often do in dreams." David Graeber, "After the Pandemic, We Can't Go Back to Sleep," *Jacobin*, March 4, 2021, https://www.jacobinmag.com/2021/03/david-graeber-posthumous-essay-pandemic.

201 Greg Tate, liner notes, The Beneficiaries, *The Crystal City Is Alive* (Axis Records, 2020).

202 JMarcus Barnes, "The Beneficiaries: 'We Are Resistance Artists, Techno Is Resistance Music,'" *MixMag*, October 20, 2020, https://mixmag.net/feature/the-beneficiaries-jeff-mills-eddie-fowlkes-jessica-care-moore.

203 Ibid.

204 Ibid.

African American music into the secular practices of jazz, Mills hoped that "this is not the last project coming from Detroit featuring artists from electronic music and other artforms. Hopefully this puts some pressure on people to do things."[205] His desire to create even more technological accelerations and iterations of Black music informs a text accompanying his 2021 album *The Clairvoyant*, which suggests using techno as a time machine to jettison into the future. "There are many ways to imagine the future," he wrote in the liner notes. "One might be to look back in the past to see what has similarities to what we are seeing today."[206] Mills decided to open up his record label Axis to other artists after the release of *The Clairvoyant,* inviting Detroit producers Terrence Dixon and Keith Tucker as Optic Nerve, among others, to participate in the building of a collective interstellar sonic fiction, titled *The Escape Velocity.* The series of digital music projects is bound to a publication "born out of a precautionary reaction from the abrupt slow down we experience due to the World Pandemic in early 2020."[207]

Artwork by Haqq, the scribe of the surface world, illustrates the cover of the online magazine, depicting a space shuttle breaking free from the Earth's gravitational pull at 25,000 miles per hour and hurtling towards the tenth planet, far beyond in the Drexciyan home universe of Grava 4, located in the Sirius Star system. Haqq's myth of the *Technanomicron* envisions the vinyl as the prototypical modeling of a cosmic disc containing the spiritual energy that makes up Black secret technology. That disc, which contains all of the data and information that had been researched by many unknown ancient civilizations, was shattered into a thousand pieces. In the documentary *Universal Techno* (1996), Haqq theorizes that the asteroid fields between Mars and Jupiter were once a planet that was destroyed billions of years ago. He imagines that the Drexciyan myth, in alignment with the Dogon tribe's cosmology, could potentially reassemble this planet at the end of a toxic planetary cycle on Earth. "There are supposedly nine planets in the solar system," he explains. "Each planet is a musical note, and there's ten notes in a scale, and the tenth planet will complete the scale!"[208]

Corresponding with Mills and Haqq's Escape Velocity concept, Terrence Dixon's vision *From the Far Future* (2020) transmitted a "Lost Communication Procedure"—a holosonic mosaic of blurred scenarios devised by a "Remarkable Wanderer." It was followed in 2021 by his album *Reporting from Detroit*. Dixon, in conversation with Mills in *The Escape Velocity*, discusses his album *Galactic Halo* (2020), which maps his premonition of the far future, in the year 2976, when a new planet, similar in size and composition to Saturn, would reveal itself: "the Halo ring is a sign of infinity that I

205 Ibid.

206 Jeff Mills, liner notes, *The Clairvoyant* (Axis, 2021).

207 Jeff Mills, "Editor's Letter," *Escape Velocity Magazine*, no. 1 (February 2021): 4.

208 AbuQadim Haqq, *Universal Techno*, directed by Dominique Deluze (Paris: Les Fil à Lou and La Sept ARTE, 1996).

receive if I complete one mission around."[209] According to the liner notes of his album *Uncharted* (2021), Keith Tucker, as Optic Nerve, responds to a distress signal, and pilots the "Black Futura" ship into a quadrant of outer space known as the Far Gone. "Androgynous Beings," an ancient alien race, intercept his travels, offering him the gift of song to "enhance the mind beings across the universe and beyond."[210] Hurling through a dimensional portal, Optic Nerve and the Androgynous Beings visit one of three "Ocean Worlds" within the *Grava 4* universe, before setting a course towards an uncharted quadrant inhabited by the "Tribes of Rigel 4"—a community enthralled in ritual, liberatory song and dance embodying a global consciousness interwoven in planetary unity.

*

In the year 2020, the post-industrial global consciousness era that Alvin Toffler had studied in *The Third Wave* began to overshoot itself and collapse. A millennial crisis occurring at the end of the future was beginning to sour society into an inert state of pro-sumerism, latched on to a world system of infinite wealth accumulation and extraction. Two decades after the initial wave of the British and European rave revolution, a new American corporatized iteration of dance music bubbled up in the United States and experienced passing popularity amongst the millennial generation entering adulthood at a time of great devaluation. "Millennials needed a genre to call their own—rock and hip-hop have run their course," Joshua Erenstein, a co-founder of Your Link to Electronic Dance Music (LEDM Group) told *Forbes* in 2014.[211] "Electronic dance music provides a new sound, a fresh energy, and a clean space that needed the attention of the youth generation in order to bring it to prominence." He speculated that millennials growing up in "the emerging age of social media" live completely online, where a computerized type of music such as EDM could thrive as viral content—separate from both its origins in Detroit and the historical canon of the British hardcore continuum and European rave culture. For Erenstein, "EDM and Millennials go hand in hand." He explained further that, according to his abstract data analytics and gambler's instinct, "Millennials crave life experiences on a global scale, and EDM culture nurtures that desire with its worldwide fan base, magical and spectacular festival moments, and the constant flow of content."[212] Music journalist Alexander Iadarola diagnoses the rise of EDM as a universal "disavowal of reality," stemming from the soaring financial growth in speculative digital economies and the euphoric escapism of the new online content industrialization of electronic dance music:

209 Jeff Mills, "A Conversation with Terrence Dixon," *Escape Velocity Magazine,* no. 1 (Axis Records, February 2021), 31.

210 Optic Nerve, liner notes, *Uncharted* (Axis, 2021).

211 Joshua Erenstein, interview by Will Burns, "Is Electronic Dance Music the Ticket to Reach Millennials?" *Forbes*, May 26, 2014, https://www.forbes.com/sites/willburns/2014/05/26/is-electronic-dance-music-the-ticket-to-reach-millennials/?sh=648bd67665da.

212 Ibid.

411

It is no accident that EDM rose to popularity immediately following the financial crisis of 2008. The culture surrounding the genre offered a highly effective set of conditions and practices for millions of people seeking to recuperate affective and libidinal deficits incurred by the extractive logics of the ongoing financial crisis. Ultimately, EDM also replicates the financial political economy that structured its very existence as well as its effects on subjects.[213]

The spread of techno worldwide, he surmised, ignited an imagined shared utopia, one that was traded colloquially and made generic, only to be sublimated into the global music factory and economy: "EDM utilizes a host of tools foundational to the contemporary military industrial complex, borrowing techniques from both sonic warfare and more abstract forms of cognitive-physiological territorialization. . . . Certain styles of music reward contemplation because they suggest rich new worlds of sonic possibility—the sounds actively seek to adjust the shape of things to come—and, by contrast, EDM is frighteningly interesting for how at home it is in the ouroboros of financial logic."[214]

In March 2020, Carl Craig was commissioned to produce a sound installation for the lower level of the contemporary art museum Dia: Beacon in New York, redesigning the space into a large-scale sound sculpture titled *Party/After Party*. Craig envisioned a monument honoring the postindustrial Black expression of techno as an electronic studio music and sonic fiction at the end of the future—an artifact of dance music's excess and financialization three decades after *Techno! The New Dance Sound of Detroit* transmitted a snapshot of Detroit electronic music. At the time of the exhibition, the global dance music industry had been valued at 7.4 billion dollars.[215] A few months later, the onset of the coronavirus pandemic would signal an industry wide decline to 3.4 billion by July of 2020.[216] In this context, Craig's transformation of the literal underground space of Dia—a former Nabisco packaging factory—reconstructed the transcendental arch of nightlife culture and the economic bubble that accelerated clubbers through a durational peak and comedown phase that could also be traced through his own life journey as a touring DJ. In an online statement issued ahead of the exhibition, Craig shared that "The work itself is a reflection of my reality—the visual, sonic, and emotional connections or disconnections that I have experienced over the past thirty years as a DJ on the road."[217] His spatialized compositions merge his own memory visions of the Music Institute,

213 Alexander Iadarola, "Paradise: On EDM, Speculation, and Finance," *Rhizome*, January 16, 2020, https://rhizome.org/editorial/2020/jan/16/paradise-on-edm-speculation-and-finance/.

214 Ibid.

215 International Music Summit Report, 2019, https://www.internationalmusicsummit.com/wp-content/uploads/2019/05/IMS-Business-Report-2019-vFinal.pdf.

216 International Music Summit Report, 2020, https://www.internationalmusicsummit.com/the-ims-business-report-2020/.

217 Carl Craig, artist's statement in press release, "New Immersive Sound Installation by Carl Craig Opening at Dia:Beacon on March 6, 2020," https://www.diaart.org/about/press/new-immersive-sound-installation-by-carl-craig-opening-at-diabeacon-on-march-6-2020/type/text.

Detroit's "prototype techno club," and Berghain, Berlin's "church of *tekkno*," as a reflection of "the isolation of the many hours spent alone in hotel rooms and the tinnitus that I, and many other artists, have to contend with as a result of our work." He continues, "I make music to satisfy my soul, and when I perform, I invite others into my world."[218]

Party/After Party, as a large-scale artifact of dance music's excesses, is configured across a multichannel fugal structure that can be implicitly experienced in two parts, an intelligible cycle of booms and busts. Opening within days of the first confirmed coronavirus case in the United States, the exhibition dealt with the long-term effects of working, creating, and traveling in an international nightlife economy on the cusp of indefinite collapse. "I'd drink Patron straight from the bottle and then share the bottle with fans. That ritual is now over," Craig jokes. "Shit is going to happen the way shit is going to happen. This is, in my mind, like when 9/11 happened. Everything screeches to a halt."[219] Though the premiere took place in 2020, Craig had been visiting and developing the project with curator Kelly Kivland for five years. He was attracted to the institutional rigor of archiving and canonization in the art world. "When Detroit was going bankrupt, [the creditors] went straight to the Detroit Institute of Art and said, 'Okay, you've got hundreds of millions of dollars right here in artwork. Let's sell 'em!'" Craig chides. "When people don't have respect for art, when they don't have the love or passion for it, the first thing they think of doing is selling the property and selling the artwork."[220] Techno is an artform to Craig, and carries meaning beyond the European club spaces that appropriated it as a purely dance music. "In the early days of techno, Juan Atkins talked about how computerization and robotics and auto plants had a big influence on his sound. Ford, General Motors, Chrysler all still have a very strong presence here, even though we don't see the factories; they are all automated," Craig explains, remarking that Atkins predicted the normalization of computer technology, however inevitable it may seem from a twenty-first-century perspective. "There are places that we'll never experience in our lifetime or our children's or our grandchildren's lifetime. But there's the possibility to use that imagination for the development of the art of making techno music."[221]

Party/After staged the dimming afterglow of techno's ignition of the global touring industry that had mounted itself on Detroit's innovation. "Detroit techno is always going to be tethered to Kev[in Saunderson] and Juan [Atkins], and that's really important," Craig says. "It's important that those are the guys everybody knows, but it's also important that the new kids coming around can keep their legacy alive." Drawing

218 Ibid.
219 Carl Craig, interview by Hannah Ongley, "'Techno Has Always Been About Imagination'—Carl Craig Still Forges Sounds from a Future World," *Document Journal*, April 2, 2020, https://www.documentjournal.com/2020/04/detroit-techno-producer-carl-craig-party-afterparty-interview/.
220 Ibid.
221 Ibid.

together the many people and sounds that have sprawled out of Atkins' modest exper-
imentations, Craig articulates that "Detroit techno has morphed into house and other
aspects of electronic music, but it's still, in my opinion, Detroit techno."[222] For him,
"Moodymann, Theo Parrish, Kyle Hall, and Delano Smith, Jay Daniel—guys like that
are all Detroit techno to me. It doesn't matter whether they make slowed down beats
or uptempo beats—it's all Detroit techno." During the collective moment of pause
that had befallen the dance music industry and the technocapitalist industrial society,
erected out of five hundred years of Euro-American colonialism, Craig observes:

> Techno is always about the imagination that you put into it. Derrick May and I,
> when we would create music at his loft, we had all the synthesizers and sequenc-
> ers and stuff on the floor surrounding us. We would sit there with our legs crossed
> and play keyboards and drum machines with one of us handing off on another
> instrument. Our inspiration was *Blade Runner*, our inspiration was movies that
> were about the future and about the possibilities of what the future would bring
> to us in our lifetime on Planet Earth. So we're talking 30 years later that we still
> have to use our imagination but our imagination can go a lot further.[223]

In the midst of a crisis, *Party/After Party* registers as an elliptical sonic fictional Black
secret technology that serves a similar function as the Greek obelisks that take their
inspiration from the tekhenu sculptures of Ancient Egypt, as an artifact of the post-
industrialization of techno.[224] Writing on Craig and the exhibition, Gamall Awad, one
of the only music PR consultants of color, placed the installation within the context
of African American musical history, commenting on "[t]he desire . . . for techno to
be fully accepted, first and foremost, as a vital African-American–created artform"
but ultimately estimating that that "techno has never been fully appreciated as such in
the United States of America. Now it's time to recognize that techno is as American
as jazz."[225] Awad continues, "direct arrival in a major American museum via the work
of Craig, one of its most creative artists, can only be seen as a new level of acknowl-
edgment of the form." To Awad, Craig's exhibition embodied what techno feels like:
a spatialized, durational experience. *Party/After* reflected Craig's inner thoughts and
visions of the globalized industrial future's past.

222 Ibid.

223 Ibid.

224 "The Black Man serves as the kolossos of our world to the extent that our world can be understood as a giant
tomb or cave. In this immense and empty tomb, to say 'Black' is to evoke the absent corpses for which the name is
a substitute. Each time we invoke the word 'Black,' we bring out into the light of day all the waste of the world, the
excess whose ab- sence within the tomb is as strange as it is terrifying. As the kolossos of the world, the Black Man
is the fire that illuminates the things of the cave—the things of the empty tomb that is our world—as they really are."
Mbembe, *Critique of Black Reason*, 53.

225 Gamall Awad, "Gamall Awad on Carl Craig," *Dia Blog*, May 23, 2020, https://www.diaart.blog/home/
on-carl-craig.

"African-American expression is neither an affirmation of personal autonomy nor a reluctance to relinquish a faded and now-defunct social category of a bygone era," writes Fumi Okiji in her 2018 book *Jazz as Critique*—an examination of the lineage of Black music. Considering its inherent refusal of Western culture and order, Okiji suggests that Black music is "a facet of a life that cannot help but be a critical reflection on the integrity of the world."[226] Okiji regards jazz as an early iteration of the kind of Black expressionist engagement with and commentary on the newly erected monoliths of Eurocentric mythology; she discusses the genre in the context of Black oral tradition, transmitted from teacher to student and mastered across one's entire lived experience. "Jazz records are undeniably indispensable, but as a document of the creative process of jazz, they are also inadequate," Okiji observed. Practically and experientially, records present limitations and constraints within the recording process. The "studio performance," then, took on a central role in the development of Detroit techno—a Black innovation of home studio performance music. Even prior to adolescent Atkins's pre-MIDI experiments with discontinued drum machines and pawnshop synthesizers, Detroit techno took root as a technological optimization of the centuries-old sacred and secular African American musical traditions. Amiri Baraka has suggested that jazz was "the exact replication of The Black Man In The West," as well as the primal "expression of the culture at its most un-self- (therefore showing the larger consciousness of a *one self*, immune to bullshit) conscious."[227]

Techno, thereafter, was the technical process of conducting and composing rhythm and soul music with hot-wired, unquantized electronic instruments. Not specifically or necessarily limited to the production and financialization of arranged frequencies and beats, techno was intended to contain the sound of machines being possessed with the concentrated expressions of soul, blues, jazz, and funk. Though many communal and commercial genres and styles of music would emerge after the turbulent 1970s, the creative, technological practice of hacking, circuit-bending, and wave jumping outdated drum machines and rhythm synthesizers collapses the distinctions between the primitive and modern music created and cultivated by African descendents of slaves in the New World. The live, impromptu home studio aspect of Atkins' work with Davis, as well as the philosophical implications of the language, objects, places, and worlds they created as Cybotron, launched a specific process of elevating and liberating Black consciousness into a stereophonic intelligence capable of coding and broadcasting emotions and affects, stimulating the senses toward a shared experience of multi-dimensional world systems and Black exodus strategy.

226 Fumi Okiji, *Jazz as Critique: Adorno and Black Expression Revisited* (Stanford, CA: Stanford University Press, 2018), 13.

227 Amiri Baraka, "The Changing Same (R&B and New Black Music)," in *Black Music* (Brooklyn: Akashic Books, 2010), 173.

Discography

3 Phase featuring Dr. Motte, *Der Klang Der Familie* (Tresor, 1992)
4 Hero, *The Head Hunter* (Reinforced Records, 1991)
4 Hero, "Mr. Kirk's Nightmare," on *In Rough Territory* (Reinforced Records, 1991)
4 Hero, *Golden Age* (Reinforced Records, 1993)
4 Hero, *Journey from the Light* (Reinforced Records, 1993)
4 Hero, "Universal Love," on *Parallel Universe* (Selector, 1994)
69, *4 Jazz Funk Classics* (Planet E, 1991)
69, *The Sound of Music* (R&S Records,1995)
808 State, *Newbuild* (Creed Records, 1988)
808 State, "Pacific State," on *Quadrastate* (Creed Records, 1989)
808 State, *90* (ZZT, 1989)
A Guy Called Gerald, *Hot Lemonade* (Rham!, 1988)
A Guy Called Gerald, *Voodoo Ray* (Rham!, 1988)
A Guy Called Gerald, *Trip City* (Avernus, 1989)
A Guy Called Gerald, *Automanikk* (CBS/Subscape, 1990)
A Guy Called Gerald, *28 Gun Bad Boy* (Juice Box, 1993)
A Guy Called Gerald, *Black Secret Technology* (Juice Box, 1995)
A Number of Names, *Sharevari* (Capriccio Records, 1981)
Abstract Thought, "Bermuda Triangle," Synchronized Dimensions," "Me Want
 Woman's Punani," and "Consequences of Cloning," on *Hypothetical Situations*
 (Kombination Research, 2003)
Adonis, *No Way Back* (Trax Records, 1986)
Adonis / Hercules / Mr. Fingers, *No Way Back / 7 Ways to Jack / Can You Feel It*
 (London Records, 1987)
Afrika Bambaataa & The Jazzy 5, *Jazzy Sensation* (Tommy Boy Records, 1982)
Afrika Bambaataa & Soulsonic Force, "Planet Rock" and "Looking for the Perfect
 Beat," on *Planet Rock - The Album* (Tommy Boy, 1986)
AlanD.Oldham, *Enginefloatreactor* (Generator Records, 1997)
Alien FM, "Nightmare," on *Alien FM* (430 West, 1995)
Andre Holland, *City of Fear* (Underground Resistance, 1995)
Aquanauts, *Spawn* (Underground Resistance, 2003)
Aquanauts, *The Titanic* (Underground Resistance, 2005)
Arpanet, "The Analyst," on *Wireless Internet* (Record Makers, 2002)
Arpanet, *Quantum Transposition* (Rephlex, 2005)
Autechre, *Anti* (Warp Records, 1994)
Aux 88, *Bass Magnetic* (430 West, 1993)
Aux 88, *Is it Man or Machine* (Direct Beat, 1996)
Aux 88 Meets Alien FM, *88 FM* (430 West, 1995)

The Aztec Mystic a.k.a. DJ Rolando, *Knights of the Jaguar* (Underground Resistance, 1999)

The Aztec Mystic, *Aguila* (Underground Resistance, 2003)

Barrett Strong, "Money (That's What I Want)," on *Money* (Tamla, 1959)

The Beneficiaries, *The Crystal City Is Alive* (Axis Records, 2020)

Bileebob & Black Echo Zone, *Departing the Future* (Equal Recordings, 2019)

Black Box, *Dreamland* (Groove Groove Melody, 1990)

Black Echo Zone, *Biological Machines* (n.p., 2006)

Blackman, *A Day of Atonement* (Black Nation Records, 1996)

Blak Presidents, *Fight the Future* (Submerge Recordings, 2007)

Blake Baxter, *Dream Sequence* (Tresor, 1991)

Blake Baxter, *The Prince of Techno* (Underground Resistance, 1991)

Blake Baxter, *Disko Tech* (Tresor, 1998)

Blake Baxter and Eddie Fowlkes, *The Project (*Tresor, 1992)

The Brothers Burden, *Luv + Affection* (Soul City, 1996)

Carl Cox, *F.A.C.T.* (React, 1995)

Carl Craig, "Mind of a Machine" and "Science Fiction," on *Landcruising* (Blanco Y Negro, 1995)

Carl Craig, *More Songs About Food and Revolutionary Art* (Planet E, 1997)

Cenac, Lady E, and MC Harmony, *Freak City Rapping* (unreleased, 1980)

Cerrone, *Love in C Minor* (Cotillion, 1976)

Channel One, *Technicolor* (Metroplex, 1986)

Chaos, *Condition Red* (Underground Resistance, 2000)

Charles Mingus, "Oh Lord Don't Let Them Drop That Atomic Bomb on Me," on *Oh Yeah* (Atlantic, 1961)

Chill Rob G, *The Power / Let the Words Flow* (Somersault, 1990)

The Clash, *The Clash* (CBS, 1977)

Cybersonik, *Thrash* (Plus 8 Records, 1991)

Cybotron, "Cosmic Raindance," on *Alleys of Your Mind* (Deep Space, 1981)

Cybotron, "Cosmic Cars" and "The Line," on *Cosmic Cars* (Deep Space, 1982)

Cybotron, "Clear," on *Enter* (Fantasy Records, 1983)

Cybotron, *Industrial Lies* (Fantasy, 1983)

Cybotron, *Empathy* (Fantasy, 1993)

Cybotron, *Interface: The Roots of Techno* (Southbound, 1994)

Cybotron, *Cyber Ghetto* (Fantasy, 1995)

Detroit Count, *Hastings St. Opera* (J-V-B, 1948)

The Detroit Escalator Co., *Soundtrack [313]* (Ferox Records, 1996)

The Detroit Escalator Co., *(Excerpts)* (Peacefrog Records, 2000)

The Detroit Escalator Co., *Black Buildings* (Peacefrog Records, 2000)

DJ Assault, *Ass-N-Titties* (Assault Rifle Records, 1997)

DJ Assault, *Bell Isle Tech* (Mo Wax, 2000)

DJ Stingray, "Counter Surveillance," on *Aqua Team* (WéMè Records, 2007)

DJ Stingray, "NWO," "Star Chart," and "It's All Connected," on *Aqua Team 2* (WéMè Records, 2008)
DJ Stingray, "Evil Agenda," "Denial of Service," "Interest Rates," and "Lead from the Shadows," on *F.T.N.W.O.* (WéMè Records, 2012)
DJ Stingray, *Psyops for Dummies* (Presto!?, 2012)
DJ Stingray / Henrich Mueller, *Drexciyan Connection* (WéMè Records, 2009)
Doctor's Cat, *Feel the Drive* (Durium, 1983)
Dopplereffekt, *Fascist State* (Dataphysix Engineering, 1995)
Dopplereffekt, *Superior Race/Cellular Phone* (Dataphysix Engineering, 1995)
Dopplereffekt, *Infophysix* (Dataphysix Engineering, 1996)
Dopplereffekt, *Sterilization [Racial Hygiene and Selective Breeding]* (Dataphysix Engineering, 1997)
Dopplereffekt, *Gesamtkunstwerk* (International Deejay Gigolo Records, 1999)
Dopplereffekt, *Linear Accelerator* (International Deejay Gigolo Records, 2003)
Dopplereffekt, *Tetrahymena* (Leisure System, 2013)
Dopplereffekt, "Gestalt Intelligence," on *Cellular Automata* (Leisure System, 2017)
Drexciya, *Deep Sea Dweller* (Shockwave Records, 1992)
Drexciya, *Drexciya 2 - Bubble Metropolis* (Underground Resistance, 1993)
Drexciya, *Drexciya 3 - Molecular Enhancement* (Rephlex, 1993)
Drexciya, *Aquatic Invasion* (Underground Resistance, 1995)
Drexciya, *The Journey Home* (Warp Records, 1995)
Drexciya, "Smokey's Illegitimate Crime Report," on *The Return of Drexciya* (Underground Resistance, 1996)
Drexciya, "The Mutant Gillmen (An Experiment Gone Wrong)," "You Don't Know," "Dehydration," "Depressurization," and "Beyond the Abyss," on *The Quest* (Submerge Recordings, 1997)
Drexciya, "Temple of Dos De Agua," "Species of the Pod," and "Surface Terrestrial Colonization," on *Neptune's Lair* (Tresor, 1999)
Drexciya, *Grava 4* (Clone, 2002)
Drexciya, *Harnessed the Storm* (Tresor, 2002)
Drexciya / Ultradyne, *Uncharted* (Somewhere in Detroit, 1997)
Eddie "Flashin" Fowlkes, *Goodbye Kiss* (Metroplex, 1986)
Eddie "Flashin" Fowlkes, *Get it Live / In the Mix* (Metroplex, 1987)
Eddie Flashin' Fowlkes, *Black Technosoul* (Tresor, 1996)
Egyptian Lover, *On the Nile* (Egyptian Empire Records, 1984)
Egyptian Lover, *One Track Mind* (Egyptian Empire Records, 1986)
Elecktroids, *Elektroworld* (Warp Records, 1995)
F.U.S.E., *Approach & Identity* (Plus 8 Records, 1990)
Farley "Jackmaster" Funk & Jessie Saunders, *Love Can't Turn Around* (House Records, 1986)
Final Cut, "Temptation," on *Deep Into the Cut* (Full Effect Records, 1989)
Final Cut w/ True Faith, *Take Me Away* (Move the Crowd Records, 1989)
Fingers Inc., *Another Side* (Jack Trax, 1988)

Forgemasters, *Track With No Name* (Warp Records/Outer Rhythm, 1989)
Forgemasters, *The Black Steel* (Network Records, 1991)
Frankie Knuckles, *The Whistle Song* (Virgin, 1991)
Frankie Knuckles and Bryan Walton, "Bad Boy," on *Frankie Knuckles Presents -
 Music Selected and Edited by Ron Hardy* (Trax Records, 1989)
Frankie Knuckles and Bryan Walton, *Baby Wants to Ride / Your Love* (Trax
 Records, 1987)
Frankie Smith, *Double Dutch Bus* (WMOT Records, 1980)
Frequency, *Television / Frequency Express* (Metroplex, 1990)
Galaxy 2 Galaxy, *Galaxy 2 Galaxy* (Underground Resistance, 1993)
The Gap Band, "You Dropped a Bomb on Me," on *The Gap Band IV* (Total
 Experience Records, 1982)
George Clinton, "Loopzilla" and "Atomic Dog," on *Computer Games* (Capitol
 Records, 1982)
Gerald Mitchell, *Hardlife* (Underground Resistance, 2001)
Ghetto Tech, *The Might / Ghetto Virus* (Ghetto Tech, 1992)
Glass Domain, *Glass Domain* (Pornophonic Sound Disc, 1991)
Goldie Presents Metalheads, *Inner City Life* (FFRR, 1994)
Goldie, *Timeless* (FFRR, 1995)
Grandmaster Flash & The Furious Five, *The Message* (Sugar Hill Records, 1982)
H&M, "Sleepchamber," on *Tranquilizer* (Axis, 1992)
Hallucinator, *Landlocked* (Chain Reaction, 1999)
Hallucinator, *Frontier* (Chain Reaction, 2000)
Hallucinator, *Morpheus* (Chain Reaction, 2003)
Herbie Hancock, *Future 2 Future* (Columbia, 2001)
Herbie Hancock, *Sextant* (Columbia, 1973)
Herbie Hancock, *Future Shock* (Columbia, 1983)
Hercules, *7 Ways* (Dance Mania, 1986)
Hit Squad MCR, "Line of Madness," on *Wax on the Melt* (Eastern Bloc Records, 1988)
The Hostile, *Ambush* (Underground Resistance, 1997)
Imamu Amiri Baraka, *It's Nation Time – African Visionary Music* (Black Forum/
 Motown, 1972)
The Infiltrator, *The Infiltrator* (Underground Resistance, 1997)
Infiniti, *Skynet* (Tresor, 1998)
Inner City, "Ain't Nobody Better" and "Do You Love What You Feel?," on *Paradise*
 (10 Records, 1989)
Inner City, *Big Fun* (Virgin, 1989)
Innerzone Orchestra, *Bug in the Bass Bin* (Planet E/Mo Wax, 1992)
Innerzone Orchestra, *Programmed* (Planet E, 1999)
Intercity, *Groovin' Without Doubt* (KMS, 1987)
Isaac Hayes, "Walk on By," on *Hot Buttered Soul* (Enterprise, 1969)
Isley Brothers, "Get Into Something," on *Get Into Something* (T-Neck, 1969)
The Isley Brothers, "Vacuum Cleaner," on *The Brothers: Isley* (T-Neck, 1969)

The Isley Brothers, *Highways of My Life* (Epic, 1973)
J.M. Silk, *Music Is the Key* (D.J. International Records, 1985)
J.M. Silk, *I Can't Turn Around* (RCA, 1986)
Jacob's Optical Stairway, *Jacob's Optical Stairway* (R&S Records, 1995)
Jay Denham, *Synthesized Society* (Disko B, 1999)
Jay Denham, *People's Revolution* (Black Nation Records, 1997)
Jay Denham, *Escape to the Black Planet* (Black Nation Records, 1998)
The Jazz Defektors, *The Jazz Defektors* (Factory, 1988)
Jeff Mills, *From the 21st* (SMEJ Associated Records, 1999)
Jeff Mills, *Preview* (Tomorrow, 1999)
Jeff Mills, *Metropolis* (Tresor, 2000)
Jeff Mills, *At First Sight* (React, 2002)
Jeff Mills, *Time Machine* (Tomorrow, 2001)
Jeff Mills, *The Clairvoyant* (Axis, 2021)
Jessica Care Moore, *Black Tea: The Legend of Jessi James* (Javotti Media, 2015)
Jesse Saunders, *On and On* (Jes Say Records, 1984)
Jimi Hendrix, "1983… (A Merman I Should Turn to Be)," on *Electric Ladyland*
 (Reprise Records, 1968)
Jocelyn Brown, "Love's Gonna Get You," on *One From the Heart* (Warner Bro.
 Records, 1987)
Juan Atkins, *The Future Sound* (Underground Level Recordings, 1993)
K Hand, *Global Warning* (Warp Records, 1994)
K. Hand, *On a Journey* (!K7 Records, 1995)
K. Hand, *The Art of Music* (!K7 Records, 1997)
K-Hand, *Ready for the Darkness* (Distance, 1997)
K-Hand, *Soul* (Ausfahrt, 1997)
Karlheinz Stockhausen, *Kontakte; Refrain* (Candide, 1968)
Ken Collier, *82-83-84* (n.p., n.d.)
Kenny Dixon Jr. / Moodymann, "Emotional Content," on *I Like It* (KDJ, 1994)
Kenny Dixon Jr., *Soul Sounds* (Soul City, 1996)
Kenny Larkin, *We Shall Overcome* (Plus 8 Records, 1990)
Kenny Larkin, *Integration* (Plus 8 Records, 1991)
Kenny Larkin, *Azimuth* (R&S Records, 1994)
Kenny Larkin, *Metaphor* (R&S Records/Warp Records, 1995)
Kraftwerk, "Tanzmusik," on *Ralf & Florian* (Philips, 1973)
Kraftwerk, *Autobahn* (Philips, 1974)
Kraftwerk, *Radio-Activity* (Capitol Records, 1975)
Kraftwerk, "Trans Europa Express," on *Trans Europa Express* (Kling Klang, 1977)
Kraftwerk, "The Robots," on *The Man-Machine* (Capitol Records, 1978)
Kraftwerk, *The Computer World* (Kling Klang/EMI Electrola, 1981)
Kreem, *Triangle of Love* (Metroplex, 1986)
L. A. M., *Balance of Terror* (Hardwax, 1992)
L.T.J. Bukem, *Demon's Theme / A Couple of Beats* (Good Looking Records, 1992)

L.T.J. Bukem, *Music (Happy Raw) / Enchanted* (Good Looking Records, 1993)
L.T.J. Bukem, *Atlantis* (Good Looking Records, 1993)
L.T.J. Bukem, *Horizons* (Looking Good Records, 1995)
L.T.J. Bukem, *Logical Progression* (Good Looking Records/FFRR, 1996)
LTJ Bukem, *Atlantis (I Need You)* (Good Looking Records, 2000)
Lab Rat XL, *Mice or Cyborg* (Clone, 2003)
Larry Heard, *Sceneries Not Songs, Volume One* (Black Market International, 1994)
Larry Heard, *Sceneries Not Songs, Volume Tu* (MIA, 1995)
Larry Heard, *Alien* (Black Market International, 1996)
Larry Heard, *Genesis* (Mecca Recordings, 1999)
Larry Heard, *Love's Arrival* (Alleviated Records, 2001)
Lee "King" Perry, The Sensations with Lynn Taitt & His Band, *Run for Cover*
 (Doctor Bird, 1967)
Lee (King) Perry / Burt Walters, *People Funny Boy / Blowing in the Wind*
 (Upset, 1968)
Lee Perry, *Africa's Blood* (Trojan Records, 1971)
Lee Scratch Perry, "Dub Revolution (Part 1)," on *Arkology* (Island Jamaica, 1999)
Lee Perry and The Upsetters, "Dub Revolution Part 1"
Lightnin' Rod, *Hustlers Convention* (United Artists Records, 1973)
Lil' Louis & The World, *From the Mind of Lil Louis* (Epic, 1989)
Loose Ends, *Zagora* (MCA Records, 1986)
Mad Mike, *Death Star* (Underground Resistance, 1992)
Mad Mike, *Hi-Tech Dreams / Lo-Tech Reality* (Underground Resistance, 2007)
Mad Mike and DJ Rolando Rocha (The Aztec Mystic) / Octave One, *Aztlan /*
 DayStar Rising (Underground Resistance, 1998)
Mandré, *Mandré* (Motown, 1977)
Mandré, *Mandré Two* (Motown, 1978)
Mandré, *M3000* (Motown, 1979)
Mantronix, "King of the Beats Lesson #1," on *Join Me Please... (Home Boys - Make*
 Some Noise) (Capitol Records, 1988)
Manu Dibango, *Abele Dance* (Celluloid, 1984)
The Martian, "Lost Transmission from Earth," on *Meet the Red Planet* (Red Planet,
 1992)
The Martian, *Cosmic Movement / Star Dancer* (Red Planet, 1993)
The Martian, *Journey to the Martian Polar Cap* (Red Planet, 1993)
The Martian, "Wardance," on *The Long Winter of Mars* (Red Planet, 1994)
The Martian, *Ghostdancer* (Red Planet, 1995)
The Martian, *LBH - 6251876* (Red Planet, 1999)
Marvin Gaye, "Sexual Healing," on *Midnight Love* (Columbia, 1982)
Maxayn, *Bail Out for Fun!* (Capricorn Records, 1974)
Mayday, *Nude Photo '88* (Transmat 1986)
Mike Huckaby, *Deep Transportations* (Harmonie Park, 1995)
Mike Huckaby, *The Jazz Republic* (Cross Section Records, 1997)

Mirage Featuring Chip E., "It's House," "Time to Jack," and "House Energy," on *Jack Trax* (House Records, 1985)

Model 500, "No UFO's" and "Future," on *No UFO's* (Metroplex, 1985)

Model 500, *Testing 1-2 / Bang the Beat* (Metroplex, 1986)

Model 500, "Sound of Stereo," on *Classics* (R&S Records, 1987)

Model 500, "Interference Mix 1" and "Interference Mix 2," on *Interference / Electronic* (Metroplex, 1988)

Model 500, *True Techno* (Network Records, 1992)

Model 500, *Deep Space* (R&S Records, 1995)

Model 500, *Mind and Body* (R&S Records, 1999)

Moodymann, *The Day We Lost the Soul* (KDJ, 1994)

Moodymann, *Inspirations from a Small Black Church on the Eastside of Detroit* (KDJ, 1995)

Moodymann, *I Can't Kick this Feelin When It Hits / Music People* (KDJ, 1996)

Moodymann, *Silentintroduction* (Planet E, 1997)

Moodymann, *Mahogany Brown* (Peacefrog Records, 1998)

Moodymann, *Forevernevermore* (Peacefrog Records, 2000)

Mr. Fingers, *Mystery of Love* (Alleviated Records, 1985)

Mr. Fingers, "Can You Feel It?," on *Washing Machine / Can You Feel It* (Trax Records, 1986)

Mr. Fingers, *Amnesia* (Jack Trax, 1989)

Mr. Fingers, "What About This Love?" on *Introduction* (MCA Records, 1992)

Mr. Fingers, *Outer Acid* (Alleviated Records, 2016)

Mr. Fingers, *Cerebral Hemispheres* (Alleviated Records, 2018)

NASA, *Time to Party* (Express Records, 1987)

Newcleus, *Jam On Revenge* (Sunnyview, 1984)

Newcleus, *Computer Age (Push the Button)* (Sunnyview, 1984)

Newcleus, *Space Is the Place* (Sunnyview, 1985)

Nightmares On Wax, *Dextrous* (Warp Records/Outer Rhythm, 1989)

Nightmares On Wax, *A Word of Science: The 1st and Final Chapter* (Warp Records, 1991)

NRSB-11, *Commodified* (WéMè Records, 2013)

Optic Nerve, "The Hommage (Detroit Spiritual Mix)," "Optaphonik," "Vortex," and "Dimensia," on *Children of the Universe* (Omnisonus, 1997)

Optic Nerve, *Uncharted* (Axis, 2021)

Organisation, *Tone Float* (RCA Victor, 1970)

The Other People Place, *Lifestyles of the Laptop Café* (Warp Records 2001)

Paperclip People, *Throw / Remake (Basic Reshape)* (Planet E, 1994)

Paperclip People, *The Secret Tapes of Dr. Eich* (Planet E, 1996)

Paris Grey, *Don't Make Me Jack (Tonite I Wanna House You)* (Housetime Records, 1987)

Parliament, *The Mothership Connection* (Casablanca, 1975)

Parliament, "(You're a Fish and I'm a) Water Sign," on *Motor Booty Affair* (Casablanca, 1978)
Phuture, *Your Only Friend* (Trax Records, 1987)
Phuture, "Temple of Dos De Agua," "Species of the Pod," and "Surface Terrestrial Colonization," on *Acid Tracks* (Trax Records, 1987)
Planet Patrol, *Play at Your Own Risk* (Tommy Boy, 1982)
Plastikman, "Spastik," on *Spastik* (NovaMute, 1993)
Population One, "Free Falling Forever," "Flower Children," and "B.P.M." on *Unknown Black Shapes* (Utensil Records, 1994)
Power Jam featuring Chill Rob G, *The Power* (Wild Pitch Records, 1990)
Prince, *Dirty Mind* (Warner Bros., 1980)
Prince, *Controversy* (Warner Bros., 1981)
Prince, *1999* (Warner Bros., 1982)
Psyche \ BFC, *Elements 1989–1990* (Planet E, 1996)
Psychic Warfare, *Race Riot* (Black Nation Records, 1995)
Public Enemy, "Prophets of Rage," on *Don't Believe the Hype* (Def Jam Recordings, 1988)
Public Enemy, *It Takes a Nation of Millions to Hold Us Back* (Def Jam Recordings/Columbia, 1988)
Public Enemy, "Burn Hollywood Burn," on *Fear of a Black Planet* (Def Jam Recordings, 1990)
Public Enemy, *Apocalypse 91... The Enemy Strikes Black* (Def Jam Recordings/ Columbia, 1991)
Quadrant, *Infinition* (Planet E, 1993)
The Ragga Twins, *Reggae Owes Me Money* (Shut Up and Dance Records, 1991)
Rebel MC, *Rebel Music* (Desire Records, 1990)
Rebel MC, *Black Meaning Good* (Desire Records, 1991)
Rebel MC, Word, *Sound and Power* (Big Life/Tribal Bass Records, 1992)
Reel by Real, *Surkit Chamber - The Melding* (a.r.t.less, 2011)
Reese & Santonio, *The Sound* (KMS, 1987)
Reese & Santonio, *The Sound / How to Play Our Music / Groovin Without a Doubt* (Kool Kat, 1988)
Reese, *Just Want Another Chance* (Incognito Records, 1988)
Reese, *Rock to the Beat* (KMS, 1989)
The Renegade Featuring Ray Keith, "Terrorist," on *Terrorist / Something I Feel* (Moving Shadow, 1994)
Rhythim Is Rhythim, "Nude Photo," on *Nude Photo* (Transmat, 1987)
Rhythim Is Rhythim, *Strings of Life* (Transmat, 1987)
Rhythim Is Rhythim, Derrick May, Mayday, *Innovator - Soundtrack for the Tenth Planet* (Network Records, 1991)
Rhythm Controll, *My House* (Catch a Beat Records, 1987)
Rhythmatic, *Beyond the Bleep* (Network Records, 1991)
Rhythmatic, *Energy on Vinyl* (Network Records, 1992)

Rick Wade, *Dark Ascension* (Music Is…, 2004)
Rick Wade, *Darkskills* (Harmonie Park, 2005)
Rick Wade, *Requiem for a Machine Soul* (Ikoi Gallery, 2009)
Rick Wade, *Requiem for a Machine Soul* (Harmonie Park, 2010)
Rick Wade, *Never Ending Reflections* (Harmonie Park, 2011)
Rik Davis, *Methane Sea* (Deep Sea, 1978)
Robert Hood, *Internal Empire* (M-Plant, 1994)
Robert Hood, *Minimal Nation* (Axis, 1994)
Robert Owens, *Rhythms in Me* (4th & Broadway, 1990)
Ron Hardy, *Sensation* (Trax Records, 1985)
Roy Shirley with Lynn Taitt & His Band, *Hold Them / Be Good* (Amalgamated
 Records/Doctor Bird, 1967)
Scan 7, *Black Moon Rising* (Underground Resistance, 1993)
Scan 7, *Undetectible* (Underground Resistance, 1995)
Scan 7, *Dark Territory* (Tresor, 1996)
Scan 7, *Resurfaced* (Tresor, 1999)
Shifted Phases, *The Cosmic Memoirs of the Late Great Rupert J. Rosinthrope*
 (Tresor, 2002)
Shut Up and Dance, *Dance Before the Police Come!* (Shut Up and Dance
 Records, 1990)
Shut Up and Dance, *Death Is Not the End* (Shut Up and Dance Records, 1992)
Shut Up and Dance featuring Peter Bouncer, *Raving I'm Raving* (Shut Up and
 Dance Records, 1992)
Silent Phase, *(The Theory of)* (R&S Records/Transmat, 1995)
Sleezy D., *I've Lost Control* (Trax Records, 1986)
Snap!, *World Power* (Logic Records, 1990)
Snap!, *Rhythm Is a Dancer* (Arista, 1992)
Soul Connection, *Rough & Ready* (Intrigue Records, 1988)
Stacey Pullen, "Ritual Beating System," on *Bango* (Fragile, 1992)
Steve "Silk" Hurley, *Jack Your Body* (Underground, 1986)
Steve "Silk" Hurley featuring M. Doc, *Work It Out* (Atlantic, 1989)
Steve Poindexter, "Work That Mutha Fucker" and "Computer Madness," on
 Work That Mutha Fucker (Muzique Records, 1989)
Steve Pointdexter, *Chaotic Nation* (Chicago Underground, 1991)
Steve Pointdexter, *Man at Work* (ACV, 1996)
Stingray313, *Sphere of Influence / Sentiment* ([NakedLunch], 2010)
Stingray313, *Misinformation Campaign* (TRUST, 2011)
Suburban Knight, *By Night* (Underground Resistance, 1996)
The Suburban Knight, *Nocturbulous Behavior* (Underground Resistance, 1993)
Sun Ra, *Nuclear War* (Y Records, 1982)
Sun Ra, "Sun Ra Accepts the Key to the City of Detroit," on *Sun Ra and The
 Omniverse Jet Set Arkestra - The Complete Detroit Jazz Center Residency*
 (Transparency, 2008)

System 01, *Drugs Work* (Tresor/BMG/Logic Records, 1994)
T-Coy, *Cariño* (Deconstruction, 1987)
Technotronic, *Pump up the Jam* (ARS Productions, 1989)
Terrence Dixon, *From the Far Future* (Tresor, 2000)
Terrence Dixon, "Dark City of Hope (Main Mix)," on *From the Far Future Pt. 2* (Tresor, 2012)
Terrence Dixon, *Galactic Halo* (Axis, 2020)
Terrence Dixion, *Reporting from Detroit* (Rush Hour, 2021)
Theo Parrish, *Baby Steps* (Elevate (7), 1996)
Theo Parrish, *Parallel Dimensions* (Sound Signature, 2000)
Theo Parrish, *American Intelligence* (Sound Signature, 2014)
Think, *Once You Understand* (Laurie Records, 1971)
TransIlusion, "Dirty South Strut" and "Memories of Me," on *L.I.F.E.* (Rephlex, 2002)
TransIlusion, "Transmission of Life" and "Unordinary Realities," on *The Opening of the Cerebral Gate* (Supremat, 2001)
Tuff Little Unit, *Inspiration* (Warp Records, 1991)
Tuff Little Unit, *Join the Future* (Warp Records, 1991)
Ultradyne, *E Coli* (Warp Records, 1995)
Ultradyne, *Cities in Ruin & Beings Laid to Waste* (Sabotage Recordings, 1997)
Ultradyne, *Antartica* (Pi Gao Movement, 1999)
Ultradyne, *Futurist* (Pi Gao Movement, 2000)
Ultradyne, *Age of Discontent* (Pi Gao Movement, 2003)
Ultradyne, *The Privilege of Sacrifice* (Pi Gao Movement, 2004)
Ultradyne, *Wrath of the Almighty* (Pi Gao Movement, 2007)
Underground Resistance w/ Yolanda, *Your Time Is Up* (Underground Resistance, 1990)
Underground Resistance, *Nation 2 Nation* (Underground Resistance, 1991)
Underground Resistance, *Punisher* (Underground Resistance, 1991)
Underground Resistance, *Riot* (Underground Resistance, 1991)
Underground Resistance, *Waveform* (Underground Resistance, 1991)
Underground Resistance, *Acid Rain* (Shockwave Records, 1992)
Underground Resistance, *Belgian Resistance* (World Power Alliance, 1992)
Underground Resistance, *Kamikaze* (World Power Alliance, 1992)
Underground Resistance, *Message to the Majors* (Underground Resistance, 1992)
Underground Resistance, *Revolution for Change* (Network Records, 1992)
Underground Resistance, *The Seawolf* (World Power Alliance, 1992)
Underground Resistance, *World 2 World* (Underground Resistance, 1992)
Underground Resistance, *Soundpictures* (Somewhere in Detroit, 1995)
Underground Resistance, *Interstellar Fugitives* (Underground Resistance, 1998), especially Chameleon, Chameleon, "Zero Is My Country"; The Suburban Knight aka James Pennington, "Maroon"; UR, "Nannytown"; The Aztec Mystic aka DJ Rolando, "Mi Raza"; The Infiltrator aka Andre Holland, "Something Happened on Dollis Hill" and "UR on Mir"; Drexciya, "Interstellar Crime Report" and "Aquaticizem"; The Deacon aka Gerald Mitchell, "Soulsaver"; Andre Holland, "Unabomber"

Underground Resistance, *Inspiration / Transition* (Underground Resistance, 2002)
Unique 3, *The Theme* (10 Records, 1989)
The Unknown Soldier, *Gone But Not Forgotten* (Underground Resistance, 2003)
Upsetter, *Cloak and Dagger* (Upsetter, 1972)
Upsetter, *Black Board Jungle* (Upsetter, 1973)
Upsetters, *Eastwood Rides Again* (Trojan Records, 1970)
Upsetters, *Return of Django* (Upsetter, 1968)
The Upsetters, *Clint Eastwood* (Pama Records, 1970)
UR, *The Final Frontier* (The Final Frontier, 1992)
UR, *Piranha* (Underground Resistance, 1992)
UR, *The Return of Acid Rain - The Storm Continues* (Underground Resistance, 1993)
UR, *Acid Rain III - Meteor Shower* (Underground Resistance, 1994)
UR, *Dark Energy* (Underground Resistance, 1994)
UR, *Electronic Warfare (Designs for Sonic Revolutions)* (Underground Resistance, 1995)
UR, *Codebreaker* (Underground Resistance, 1997)
UR, *The Turning Point* (Underground Resistance, 1997)
UR, *Analog Assassin* (Underground Resistance, 2002)
UR, *Actuator* (Underground Resistance, 2003)
UR, *Interstellar Fugitives 2 - Destruction of Order* (Underground Resistance, 2005),
 especially Atlantis (13), "Words from Atlantis"
UR, *Electronic Warfare 2.0 - The Other Side of Bling* (Underground Resistance, 2007)
UR / The Shadow, *The Theory / Free As You Wanna Be* (Underground Resistance, 2004)
Urban Tribe, "Decades of Silicon," "Nebula," "At Peace With Concrete,"
 "Social Theorist," and "Peacemakers," on *The Collapse of Modern Culture*
 (Mo Wax, 1998)
Urban Tribe, "Biohazard 17284," on *Authorized Clinical Trials* (Rephlex, 2006)
Urban Tribe, *Acceptable Side Effects* (Rephlex, 2007)
Various, *313 Detroit* (Infonet, 1992)
Various, *Artificial Intelligence* [Series] (Warp Records, 1992–1994)
Various, *Bio Rhythm - "Dance Music With Bleeps"* (Network Records, 1990)
Various, *Bio Rhythm 2 - "808 909 1991"* (Network Records, 1990)
Various, *Birth of a Nation Vol. 1* (Black Nation Records, n.d.)
Various, *Comin' From Tha D* (Intuit-Solar, 1999)
Various, *Crime Report* (Underground Resistance, 1998)
Various, *Detroit Techno Soul* (Tresor, 1993)
Various, *From Our Minds to Yours, Vol. 1* (Plus 8 Records, 1991), especially Chrome
 (7), "My Reflection"; Xenon, "Xenophobia"; and Prophet 5, "Invasion of the
 Techno Snatchers"
Various, *Global Techno Power* (Alfa International, 1992)
Various, *Global Techno Power 02:2000AD* (Alfa International, 1992)
Various, *Global Underground* [Series] (Global Underground Ltd., 1996–2001)
Various, *The House Sound of Chicago* (DJ International, 1986)
Various, *Intergalactic Beats* (Planet E, 1992), especially Florence, "A Touch of Heaven"

Various, *Launching the First Annual Detroit Electronic Music Festival* (Pop Culture Media, 2000)
Various, *Low Berth Equinox / The Beginning / Nite & Da - A Retroactive Compilation* (Buzz, 1991), especially Urban Tribe, "Covert Action"
Various, *The New Sound of Frankfurt* (ZYX Records, 1987), especially Off, "Electric Salsa" and 16 Bit, "Where Are You?"
Various, *Origins of a Sound* (Submerge, 1995)
Various, *Relics - A Transmat Compilation* (Transmat, 1992), especially Derrick May & Carl Craig, "Interval" (I-VIII); Model 500, "Info World"; Suburban Knight, "The Art of Stalking"
Various, *Retro Techno / Detroit Definitive - Emotions Electric* (Network Records, 1991)
Various, *Soul from the City* (Submerge, 1995)
Various, *Techno 2: The Next Generation* (10 Records, 1990), especially Psyche, "Elements"
Various, *Techno! The New Dance Sound of Detroit* (10 Records, 1988), especially Juan, "Techno Music"
Various, *Tresor II* (Berlin Detroit - A Techno Alliance) (NovaMute, 1993)
Various, *True People: The Detroit Techno Album* (React, 1996)
Various, *Ultimate Breaks & Beats* [Series] (Beat Street Records, 1986–91)
Various, *White Flight* (Black Nation Records, 1995)
Virgo, *Go Wild Rythm Trax* (Other Side Records, 1985)
The Vision, *Gyroscopic* (Underground Resistance, 1991)
The Vision, *Toxin 12* (Hardwax, 1992)
X-101, *Whatever Happen to Peace* (Underground Resistance, 1991)
X-101, *X-101* (Tresor, 1991)
X-102, *Discovers the Rings of Saturn* (Tresor, 1992)
X-103, *Atlantis* (Tresor, 1993)
X-Ray, *Let's Go* (Transmat, 1986)
Yazoo, *Situation* (Sire, 1982)
Yellow Magic Orchestra, "Firecracker," on *Yellow Magic Orchestra* (Alfa, 1978)
Yellow Magic Orchestra, *Solid State Survivor* (Alfa, 1979)
Yellow Magic Orchestra, *Tighten Up* (Alfa, 1980)
Your Favorite Martian, *Sex in Zero Gravity* (Red Planet, 1993)
Zapp & Roger, "Doo Wa Ditty (Blow That Thing)," "A Touch of Jazz (Playin' Kinda Ruff Part II)," and "Dance Floor," on *Zapp II* (Warner Bros. Records, 1982)

Individual chapters in the book are titled after and alongside the following references:

White Silence: Introductory Notes on How the West Was Won
Psyche \ BFC, "How the West Was Won," on *Elements 1989–1990* (Planet E, 1996)

Techno City, the Final Frontier
Cybotron, "Techno City," on *Techno City* (Fantasy, 1984)

Drifting Into a Time of No Future
Drexciya, "Drifting Into a Time of No Future," on *Hydro Doorways* (Tresor, 2000)

The Spirit of the People Is Greater Than Man's Technology
Elektroids, "Japanese Elecktronics," on *Elektroworld* (Warp Records, 1995)
The Martian, *Meet the Red Planet* (Red Planet, 1992)
Tsutomu Noda, *Black Machine Music & Galactic Soul: Disco, House, to Detroit Techno* (Tokyo: Kawade Shobō Shinsha, 2001)
Various, *Global Techno Power 01* (Alfa International, 1992)
Various, *Global Techno Power 02:2000AD* (Alfa International, 1992)

Hi-Tech Dreams, Lo-Tech Reality
Mad Mike, *Hi-Tech Dreams / Lo-Tech Reality* (Underground Resistance, 2007)

Wake Up America, You're Dead!
Steve Sutherland, "New York Story: Wake Up America, You're Dead!," *Melody Maker,* August 4, 1990

Underground Resistance: Electronic Warfare for Sonic Revolutions
UR, *Electronic Warfare (Designs for Sonic Revolutions)* (Underground Resistance, 1995)

The Collapse of Modern Culture
Urban Tribe, *The Collapse of Modern Culture* (Mo Wax, 1998)

Thanks to AbuQadim Haqq for contributing to the visual identity of this book and guiding my research into the narratives and artifacts that define Detroit techno. Thanks to my parents, DeForrest and Cassandra Brown, as well as my extended family, whose lives and legacies I hope to pay homage to and continue through this assembled Black cultural history. And thanks to my loving partner, Ting Ding 丁汀, whose patience and support was especially meaningful during the emotional process of writing this book.

Assembling a Black Counter Culture
© 2022 DeForrest Brown, Jr.

ISBN: 978-1-7344897-3-6

Second Printing

Cover image by AbuQadim Haqq, *Workers of the Future Operating the Machinery of a New Reality*, 2019, digital painting. Courtesy of the artist.

Image on p. 4 by Oliver W. Markley, *Two idealized alternative future outcomes to the threat of overshooting the carrying capacity of "Spaceship Earth,"* in "Global Consciousness: An Alternative Future of Choice," Futures 28, no. 6/7 (August-September 1996): 623. © 1995 O.W. Markley, Partnership Associates, Inc., and UHCL Institute for Futures Research.

Image on p. 4 by Drexciya, *The Quest* (Submerge, 1997). CD inside tray art. Concept: M. Banks; Art: J. Trammell. © Underground Resistance.

Editor: Rachel Valinsky
Editorial Consultants: Ting Ding 丁汀
and Camille Crain Drummond
Copy Editor: Madeleine Compagnon
Designer: Scott Ponik

Primary Information
232 3rd St, #A113
The Old American Can Factory
Brooklyn, NY 11215
www.primaryinformation.org

Printed by Versa Press

Earlier versions of the essays in this book previously appeared as: "The Timeline of Black Exodus Technology," in *TECHNO WORLDS*, ed. Mathilde Weh, with Justin Hoffmann and Creamcake (Berlin: Hatje Cantz, 2022); "Interview with Jeff Mills," *Kaleidoscope* 39 (Fall/Winter 2021–2022); "*THING*, the Revolutionary Magazine That Chronicled the Birth of Chicago's Queer, Black Club Culture," *Document Journal* 18 (November 2021); "Black Sonic Warfare in the Global Village," *Kaleidoscope* 38 (Spring/Summer 2021); "Social Music," *CTM Festival*, April 2021; "Techno Is Black, Tekkno Is German," *Dweller Forever*, January 26, 2021; "Stereomodernism: Black Techno Consciousness," as Speaker Music, in the booklet accompanying the album *Black Nationalist Sonic Weaponry* (Planet Mu, June 2020), also included in the exhibition/publication *You got to get in to get out: El continuo sonoro que nunca se acaba* at La Casa Encendida, Anamas Projects, April 2021; "How the Dance Music Industry Failed Black Artists," *Mixmag*, October 21, 2020; "Stereomodernism," *Triple Canopy*, July 23, 2020; and "How Platform Capitalism Devalued the Music Industry," *Medium*, February 4, 2020.

Primary Information is a 501(c)(3) non-profit organization that receives generous support through grants from the Michael Asher Foundation, Empty Gallery, the Graham Foundation for Advanced Studies in the Fine Arts, the Greenwich Collection Ltd, the John W. and Clara C. Higgins Foundation, the Willem de Kooning Foundation, the Henry Luce Foundation, Metabolic Studio, the National Endowment for the Arts, the New York City Department of Cultural Affairs in partnership with the City Council, the New York State Council on the Arts with the support of Governor Andrew Cuomo and the New York State Legislature, the Orbit Fund, the Stichting Egress Foundation, Teiger Foundation, The VIA Art Fund, The Jacques Louis Vidal Charitable Fund, The Andy Warhol Foundation for the Visual Arts, the Wilhelm Family Foundation, and individuals worldwide.